# Molecular Aesthetics

Ljiljana Fruk, Bernd Lintermann

# 23 Molecules that Changed the World

Making a selection of the most important things – be it people, inventions, historical events, or molecules – is never an easy task. The choice is often subjective, and there are so many things to choose from. So this little catalog of "molecules that changed the world" is by no means the ultimate list, nor does it include all the molecules that have affected our lives over the course of civilization.[1] Chemists will probably find a great many of our pro and contra arguments – and even some of the choices – curious, but we wanted to focus here on what we believed shaped not only chemistry and science, but also history and society throughout the centuries. When we initially conceived this project as a means to popularize chemistry, we also wanted to point out contradictory sides of the science, a consideration that helps us not only better understand the structures and textures of the world around us, but that has shaped society as we know it.

While the science of chemistry gave us potentially dangerous molecules – such as thalidomide and DDT – it also enabled the discovery and synthesis of numerous drugs: aspirin or quinine, for example. Chemistry helped us to find novel uses for well-known compounds, and to develop synthetic routes to make new ones when the need for them arose. True, it created some problems, but it also offered – and will continue to offer – solutions to many of those challenges. We hoped the work in hand would demonstrate the continuous dynamics of discovery, where something thought to be detrimental can turn into something good; indeed, there is nothing finite in the world of molecules. Their structure and the 3D representations shown here are an attempt to underscore the diversity there, despite molecules often being based on a very few elements. Some of the molecules we chose, such as water and carbon dioxide, were around long before people started using chemical methodologies to create new structures, but they have shaped our societies, changed our habits, modified the ways we

live and think, and undoubtedly will continue to have a tremendous impact on civilization in the future. Other molecules, such as polyethylene, never existed before they were designed in the lab, yet it is hard to imagine our world today without them. Some that are very simple in structure are composed of as few as three atoms ($H_2O$); others, such as $B_{12}$ and quinine, are so complex that it took years for chemists to make them.

Rather than touch upon other biologically important molecules – different proteins or hormones, for example – this essay addresses those molecules that have already shaped science, technology and society, or are about to do so. The only exemption is DNA, which, as a carrier of genetic code, determines the kind of organism we become. We consider DNA, not from the biological, but from the chemical perspective, and examine the impact it has had on the development of novel concepts in nanotechnology.

This catalog of molecules is meant to show the diversity of structures and functions, to make us all reflect a little on those molecules around us that we are apt to take for granted, and to inspire innovation or even alternative compendia. Be inspired!

Stereoscopic images of the molecules are based on the interactive 3-D installation *Molecules that Changed the World* by Ljiljana Fruk and Bernd Lintermann.

Team: Ishtiaq Ahmed, Dennis Bauer, Cheng Chen, Bianca Geiseler, Dania Kendziora, Sinem Engin, Marko Miljevic, Andre Petershans, Lukas Stolzer

1 See: K. C. Nicolaou and Tamsyn Montagnon, *Molecules That Changed the World*, Wiley VCH, Weinheim, 2008. This book presents, for example, around forty natural products that have had a huge impact on everyday life.

# Water
## H₂O

Water is the only pure substance found naturally in all three states of matter: solid (ice), liquid (water) and gas (vapor), and it covers 70.9% of the Earth. ◉ Human life has numerous uses for water: hydrating, washing, agriculture, cooking, cooling, fire extinction, and universal solvent, to name but a few. ◉ It is characterized by high specific heat (second to ammonia) and high heat of vaporization (key to climate regulation). ◉ As the water molecule is not planar, and since oxygen's electronegativity is higher than hydrogen's, partially negative (an oxygen atom) and partially positive (hydrogen) charges are formed; the molecule is polar and there is attraction between the hydrogen and oxygen of different molecules (hydrogen bonding). ◉ The magic of ice is that when a solid is formed, hydrogen bonds make a structure characterized by holes in the ice – which is less dense than liquid water. Water expands when it freezes; other materials shrink on solidification. This was a highly important phenomenon for the development of life as we know it. ◉ Water pollution and usage are huge challenges, and it has been suggested that by 2030, water demand in some countries will exceed its supply by 50% and possibly lead to water wars. ◉ "Nothing in the world is more flexible and yielding than water. Yet when it attacks the firm and the strong, none can withstand it, because they have no way to change it. So the flexible overcome the adamant, the yielding overcome the forceful. Everyone knows this, but no one can do it." Lao Tze, Philosopher, 600–531 BC

portant element in nanostructuring. The structure has only been known for sixty years. ● The carrier contains four different elements – adenine A, guanine G, tymine T and cytosine C – whose sequence makes up the code for genetic information. Single strands make double strands bound by weak hydrogen bonds to create highly specific A-T and G-C pairs. ● A single human cell contains some 3 m of DNA packed tightly into the cell nucleus. Human DNA of 3 billion base pairs is arranged to total 46 chromosomes. Complex protein machinery helps the packed information to be translated into functional biomolecules. ● Chemical synthesis of shorter DNA strands (up to 100 bases) is possible and today, automated DNA synthesizers are available. ● Due to the specificity of the base pairing, short DNA strands can be used for surface structuring and assembly of the nanosized elements, such as nanoparticles or proteins. DNA nanostructuring has only recently developed as a new research field, and the really substantive advances are only expected in the near future. ● Not only has the understanding of DNA structure and function led to a scientific breakthrough, but it has also revolutionized the way we see life. While DNA is a crucial information carrier, it would not fall into a category of "molecules that changed the world." There are so many other biomolecules that could have qualified as well, had it not been for the immense contribution to the field of nanotechnology and genetics which developed so rapidly in the past few decades. We only begin to understand DNA's true potential.

# Deoxyribonucleic acid
# DNA

# Glucose
## C$_6$H$_{12}$O$_6$

(2*R*,3*S*,4*R*,5*R*)-2,3,4,5,6-Pentahydroxyhexanal

Glucose – also known as D-glucose, dextrose, or grape sugar – is a simple sugar (monosaccharide) and an important carbohydrate in biology. ◉ The name "glucose" stems from the Greek word glukus (γλυκύς), meaning "sweet," and is the preferred name. The suffix "-ose" denotes a sugar. ◉ Glucose is one of the main products of photosynthesis. ◉ It exists in several different molecular structures, but all of these can be divided into two families of mirror-image molecules or stereoisomers. Only one set of these isomers exists in nature, those derived from the "right-handed form" of glucose, denoted D-glucose. ◉ Glucose is a ubiquitous fuel in biology. It is used as an energy source in most organisms, from bacteria to humans. Use of glucose may be either by aerobic respiration, anaerobic respiration, or fermentation. ◉ Glucose is the human body's key source of energy: through aerobic respiration, it provides approximately 3.75 kilocalories (16 kilojoules) of food energy per gram. Breakdown of carbohydrates (starch, for example) yields mono- and disaccharides, most of which is glucose. Through glycolysis, and later in the reactions of the citric acid cycle (TCAC), glucose is oxidized and eventually turned into CO$_2$ and water, yielding energy primarily in the form of ATP molecules. ◉ Starch and cellulose are polymers derived from the dehydration of D-glucose. ◉ Understanding glucose was key to understanding organic chemistry. The Nobel Prize was awarded to Emil Fischer in 1902 for his work on sugars; he had established stereo-chemical configurations for all known sugars and correctly predicted isomers.

Cellulose is an organic compound, a polysaccharide consisting of a linear chain of several hundred to over ten thousand β(1→4) linked D-glucose units. It is the structural component of the primary cell wall of green plants, many forms of algae, and the oomycetes. ● It is the most common organic compound on Earth. About 33% of all plant matter is cellulose. The cellulose content of cotton is 90%, for example, and that of wood is 40–50%. ● In China and South East Asia, people made use of hemp to make rope and cordage as early as 4500 BC. Around 4000 BC, cellulose was used as base material for garments; in the millennium after that were the first reports about spinning cotton in Egypt and India. ● Between 1837 and 1842, French agricultural chemist Anselme Payen – having isolated fibrous substance from different plants – determined that cellulose was a carbohydrate composed of glucose residues, and was isomeric to starch (44.4% C, 6.2% H). ● Today, cellulose is one of the world's most widely used materials. It keeps us warm (in isolating material and clothing), increases and transfers knowledge (in paper and books), gives us movies and photographs, once eased the characterization of chemical reactions (in tin layer chromatography), and has recently been explored as a powerful biofuel.

# Cellulose
## $(C_6H_{12}O_6)_n$

Carbon dioxide is a component of Earth's atmosphere at a concentration of 0.038% by volume. ● It is also considered to be a greenhouse gas, which is believed to play a major role in global warming and anthropogenic climate change. ● Modern civilizations started using fossil deposited carbon (coal, oil) as an energy source and by burning them, large amounts of $CO_2$ are released into the atmosphere. A widely accepted model (but still disputed on occasion) blames additional release of $CO_2$ after the Industrial Revolution for the greenhouse effect and global warming. ● The fact is that the Earth's atmosphere is warming up – melting of the glaciers (old deposits of ice) and polar ice will result in sea level rise, which could threaten the low lying regions of the planet. The warming also affects the agricultural potency of certain regions, and in general, a global decrease of agricultural production capacity. ● Rise in $CO_2$ also changes the acidity of the oceans (where $CO_2$ gets dissolved) and therefore influences very sensitive marine life. ● The annual worldwide emission of $CO_2$ rose by 3% in 2010 (compared to 2009) and it is, by no means, decreasing. ● $CO_2$ is probably today's most discussed molecule. $CO_2$ drives apocalyptic visions regarding the future of the world and even questions whether our political systems are able to react quick enough. But in the end, the story of this small molecule is much older and much less trivial – it has always been one of the columns upon which the life on Earth is based.

# Carbon Dioxide
## $CO_2$

# B12
## $C_{63}H_{89}CoN_{14}O_{14}P$
### Cobalamine

Cobalamine has a friendly, absolutely non-toxic and unique character – it's the only carbon-metal bond known to exist in a biomolecule. ◉ It is found mainly in the liver; 2–5 mg are stored in an adult body, 50% of it in that organ. Its role is to build up enzymes, to help us think, to keep our nerves calm, and our hair and skin healthy. ◉ It is one of the class of thirteen vitamins, and humans acquire it mainly from animal products. ◉ The chemical synthesis of cobalamine is highly complicated. Research begun by Robert B. Woodward and Albert Eschenmoser in the 1960s was finally completed in 1973, taking the work of 100 scientists and no less than 70 steps into account. And since B12 synthesis was a landmark in chemical synthesis, it resulted in the award of two Nobel prizes. ◉ Today, it is made – in only four companies in the world – by fermenting Streptomyces griseus and Pseudomonas bacteria. ◉ Water soluble, B12 is the largest and chemically most complicated of the vitamins. Deep pink in its pure state, it is also used as an antidote in cyanide poisoning. ◉ Not only is B12 a molecule which is key to the proper functioning of our metabolism, nerves, and brain, but it has also set several landmarks in science. It is a rare example, namely, of organometallic carbon-metal center in a bio-molecule; it started the x-ray crystallography revolution; and it helped pave a way to better medical care. Its synthesis marked one of the turning points of organic chemistry. What's more, it makes us tranquil, happy, stable, and it inhibits loss of memory.

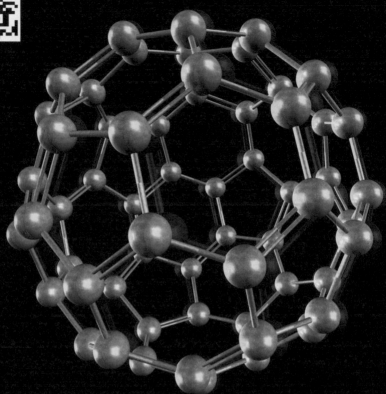

# Fullerene, Buckyball

$C_{60}$

Belonging to the family of carbon allotropes such as the diamond and graphite, the Buckyball has the distinction, to date, of being the largest molecule ever found in the universe. ● It is made of 12 pentagons and 20 hexagons, which together make up the so-called truncated icosahedra (like the skin of a soccer ball). As the diameter of the inner cage is 700 pm, some metal and non-metal atoms can be stored within it. ● There are some 20 known, stable Fullerenes: $C_n$ (n is from 60 to 96); theoretically, others could be formed as well. ● Theoretical existence was predicted in 1970s by Eiji Osawa, but the first paper on fullerenes was published in 1985 by Harold W. Kroto and Richard E. Smalley (1996 Nobel Prize laureates). ● Fullerenes can be made in the lab, albeit not really efficiently. In space and on Earth, in shungit rock or in fulgurite, a tube-like structure is produced when lighting strikes the rock or sand. ● Not only did fullerene mark the beginning of the new era in chemistry and material science, it paved the way to the development of nanotechnology. Research into fullerenes also lead to the discovery of one-carbon-atom-thick layers of carbons known as carbon nanotubes and grapheme. The discovery – for which the scientists also won the Nobel Prize in 2010 – is already considered a material of the future and is being explored extensively.

Thalidomide was first synthesized in research labs of the pharmaceutical company Chemie-Grünenthal in Aachen (DE), as a sedative and calming drug. ● It was later sold in over forty countries as an active component of Contergan® and Softenon®, and was known to be a non-addictive and completely safe drug with no toxic side effects. At the beginning of 1960, when severe birth defects presented, pediatrician Widukind Lenz linked them to the use of thalidomide, and Chemie-Grünenthal was forced to withdraw Contergan® from the market in November, 1961. ● Is there a good and a bad thalidomide? There is one molecule with two different forms: (S)-thalidomide is embryotoxic, while (R)-thalidomide is not. Not true! Under physiological conditions, the (R)-form is converted into the (S)-form and vice-versa. So both forms can be responsible for the embryotoxic effects. ● In the past fifteen years, scientists have shown that thalidomide is effective against rheumatoid arthritis, HIV, cancer formation, leprosy, and multiple myeloma. ● Will thalidomide be given a second chance? Yes. Thalidomide is approved in several countries under tight control as a so-called orphan drug to treat rare diseases: in the USA (since 1998), Australia and New Zealand (since 2003), Israel and Turkey (since 2004), and in the EU states (since 2008). ● The experience with this molecule had a major effect and long-lasting consequences on drug research. Today, it would be unimaginable for a drug to be released and approved before stringent procedures of drug testing and extensive clinical trials had been completed. The thalidomide experience both pushed this tight regulation and shed light on the importance of drug purity.

# Thalidomide
## $C_{13}H_{10}N_2O_4$

2-(2,6-dioxo-3-piperidyl)-1H-isoindol-1,3-(2H)-dion

# Quinine

## $C_{20}H_{24}N_2O_2$

(R)-(6-Methoxyquinolin-4-yl)((2S,4S,8R)-8-vinylquinuclidin-2-yl)methanol

Quinine is a white crystalline substance that belongs to the class of alkaloids. ● Isolated mainly from the bark of the cinchona tree, quinine is the most effective drug against malaria, the illness that affects 300 million people worldwide. It is also used as a flavoring agent. ● Pierre-Joseph Pelletier and Joseph Caventou completed the first quinine isolation in 1817. William Henry Perkin did the first quinine synthesis in 1856. ● A formal chemical synthesis was accomplished in 1944 by Robert Burns Woodward and William von Eggers Doering, and Eric N. Jacobsen completed syntheses of enantiomerically-pure quinine and quinidine in 2004. ● Other cinchona alkaloids are used in organic chemistry as organocatalysts in asymmetric synthesis. ● Quinine is also used as a flavoring agent component of tonic water and bitter lemon. Further, it is also used as a standard in photochemistry due to its constant and known quantum yield and, unfortunately, as a cutting agent in street drugs such as cocaine and heroin. ● Today, quinine has found uses outside medicine. During the attempted syntheses of the molecule in the lab, for example, many valuable discoveries were made that revolutionized the chemical industry and synthetic chemistry in general.

# Progesterone

## $C_{21}H_{30}O_2$

### Pregn-4-ene-3,20-dione

Progesterone belongs to the group of sex hormones called progestogens, all of which play an important role in maintaining pregnancy. ● Together with estrogen secretion, the progesterone prevents women from conceiving a second time while already pregnant. ● It was first synthesized from diosgenin, which can be isolated from Mexican yam, which was also used as a natural contraceptive by Native Americans. ● Progestin is the name for a class of synthetic progesterone, mostly known for its use in contraceptive pills. ● Although administration of progestin most commonly is by a pill, there are other options, such as intramuscular injection every several months, use in an implant, or as an intrauterine system. These methods – known as long-acting reversible contraception – require little user action and are more effective than other types of birth control. ● Different progestins are used together with an estrogen in the combined oral contraceptive pill. Since its first approval in 1960 in the U.S., "the pill" has helped to shape societies and contributed to the emancipation of women. Nowadays, it is used by more than 100 million women worldwide. ● Other uses of progestins involve treating menstrual cycles that cease in menopause, and dysfunctional uterine bleeding. Progestin was also shown to reduce risk of ovarian and endometrial cancer.

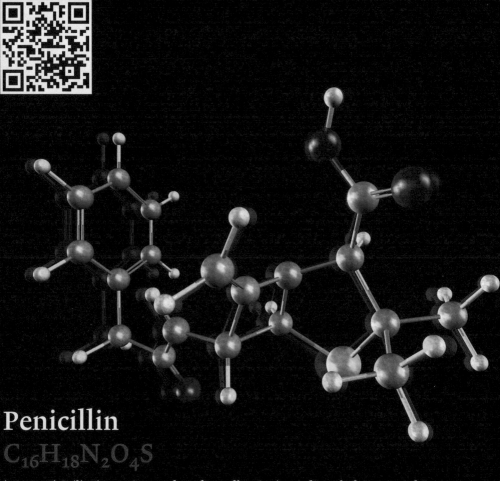

# Penicillin
## $C_{16}H_{18}N_2O_4S$

(2S,5R,6R)-6-([[(2R)-2-amino-2-phenylacetyl]amino)-3,3-dimethyl-7-oxo-4-thia
-1-azabicyclo[3.2.0]heptane-2-carboxylic acid

Penicillin is the first discovered substance from the family of β-lactam anti-
biotics. It kills bacteria by blocking the synthesis of bacterial cell wall, mak-
ing it a highly effective life-saving drug. ● It is produced in the fungus *Peni-
cillinum notatum*. ● Alexander Fleming discovered it in 1928, observing the
inhibition of bacteria growth on an agar plate contaminated with *Penicilli-
um notatum*. This marked the beginning of the modern era of antibiotic dis-
covery. ● In 1945, Ernst B. Chain and Howard W. Flory developed penicillin
as a medicine. Fleming, Chain, and Flory received the Nobel Prize for their
achievements in penicillin research in 1945. ● During the Second World
War, penicillin production needed to be scaled up, and Margaret Hutchin-
son Rousseau, a chemical engineer, developed the deep-tank fermentation
for large-scale production. ● Over 656 billion units per year were produced
until 1945, and the number of deaths and amputations decreased markedly
compared to previous wars. ● The use of antibiotics is problematic today:
antibiotic resistance develops when bacteria survive the antibiotic expo-
sure. ● MRS bacterium is a highly drug-resistant version of the common
"staphylococcus aureus" known to cause infections in hospitals. ● EHEC
is a highly toxic and drug resistant strain of E. coli. ● Resistance is caused
by the use of antibiotics as additives in food and water and as application
in agriculture and medicine. ● However, today, life without antibiotics is
unimaginable. Antibiotics saved – and are still saving – millions of lives.
Research continues to address the challenge of developing more effective
antibiotics with fewer side effects.

A powerful analgesic and narcotic, an opiate, morphine is extracted from poppy seeds, as the total synthesis is complex and the yields are low, at some 10%. Some mammals (such as mice) can produce morphine enzymatically. ● In 1522, the Swiss occultist Paracelsus used an opium-based elixir, Lauda- num, as a painkiller. In 1804, German pharmacist Friedrich Wilhelm Adam Sertürner discovered morphine, the first active alkaloid extracted from the opium poppy plant. In 1827, morphine became commercially available and was produced by Merck. ● Morphine is used as a painkiller and narcotic in medicine, also as an antitussive. It also relieves fear and anxiety and pro- duces euphoria. In addition, it increases the body's uptake of water, which is helpful in treating chronic diarrhea. The lethal dose is 200 mg. ● Until heroin was synthesized and came into widespread use, morphine was the world's most commonly abused narcotic analgesic. As it enabled develop- ment of more complex procedures, however, morphine triggered a whole revolution in medicine. ● Physically and psychologically, the drug is high- ly addictive. It can cause psychological and physical dependence, and has an addiction potential identical to that of heroin. It is one of those molecules considered a mixed blessing: it can both be used and abused.

# Morphine
## $C_{17}H_{19}NO_3$

(5a,6a),-7,8-didehydro-4,5-epoxy-17-methylmorphinan-3,6-diol

Both heroin and aspirin were synthesized in the same labs at Bayer AG. Because head chemist Heinrich Dreser saw more potential in heroin as a drug, it was, at first, the more heavily promoted of the two. It was named after the "heroic" feelings that workers at Bayer reported after testing the drug. ● For twenty years after its market launch, heroin was considered a wonder drug, and was used as a cough suppressant and in the treatment of asthma, bronchitis, and tuberculosis. It was presented as being ten times more effective than codeine and less toxic. ● It was in 1902 that the first cases of addiction to heroin were reported by French and American researchers, but Bayer continued to produce it until 1931, and it was only finally banned in 1971. It is still used in assisted treatment in several national health systems, but only in Great Britain can heroin be legally prescribed for severe pain, given that it is 2–4 times more potent than morphine. ● Like most other opioids, pure heroin itself does not cause many long-term complications, aside from almost immediate and severe addiction. Impure heroin, sold on the street, however, is considered to be one of the most harmful drugs known, particularly if taken intravenously. ● Heroin is a prime example of a drug which was put on the market too quickly and without adequate testing of its long-term effects. This error pointed the way, however, to more thorough investigations of drugs before they can get approval as pharmaceutical compounds.

# Heroin
## $C_{21}H_{23}NO_5$

3,6-Diacetyl-morphine

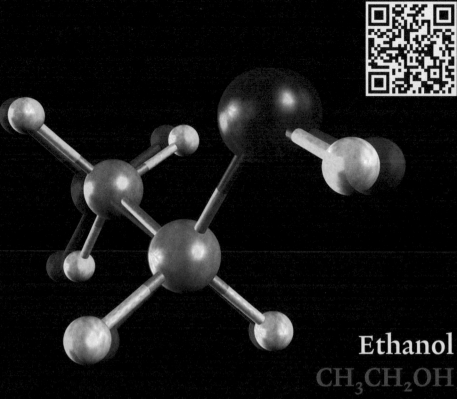

# Ethanol
## CH₃CH₂OH

### Ethyl alcohol

Ethanol is a molecule widely found in nature and human civilization. As a metabolic byproduct, it can be found in fruits and all the cells of living organisms. ● Yeast cells produce ethanol by converting sugar into energy under anaerobic conditions. Well-known as "alcoholic fermentation," this process is utilized to produce alcoholic beverages such as beer and wine. ● Huge amounts of alcohol can be toxic. A blood alcohol level of 4 g/l can lead to death – 5 g/l are definitely lethal. Prolonged heavy consumption causes permanent damage to the brain and other organs. Alcohol has also the potential to promote cancer formation. ● The enzyme alcohol dehydrogenase (ADH) is responsible for breaking down alcohol before it becomes toxic for the human body. A mutation of ADH leads to the alcohol flush reaction, also known as Asian Flush Syndrome. Native to East Asia, this syndrome is most common in China. ● In the twelth century, alchemists from the School of Salerno produced ethanol from distilled wine for the first time. In 1796, J. T. Lowitz obtained pure ethanol by filtering distillation products, and in 1808, Nicolas-Théodore de Saussure determined its chemical formula. The first synthetic ethanol was made in 1826 independently by Henry Hennell in Great Britain and Georges-Simon Serullas in France. In 1828, Michael Faraday prepared ethanol by acid-catalyzed hydration of ethylene, a process similar to current industrial ethanol synthesis. ● Ethanol is used in many ways. As a solvent, it is irreplaceable in biochemistry, synthetic chemistry, and industrial chemistry. At high concentrations, it denatures proteins and lipids and therefore is a historically powerful disinfectant in medicine, and is still used in laboratories and clinical environments. ● In addition, it is gaining importance as a fuel. No less than 86 billion liters were produced in 2010, and the volume keeps increasing. The need for new biotechnological methods to obtain ethanol for use as fuel is rising. ● In the event of an energy crisis, we might need more than the enjoyment of drinking it...

In the vernacular, the neurotransmitter and prescription drug dopamine is considered the "happiness hormone." It is classified as a catecholamine containing biogenic amine. As a chemical messenger, it is similar to adrenaline and closely related to noradrenaline. ● Dopamine affects brain processes that control movement, motivation, emotional responses, and the ability to experience pleasure and pain. It is also involved in the exchange of information from one brain area to another. ● Nerve cells (neurons) use the chemical to help control muscle movement. In Parkinson's disease, where the dopamine-transmitting neurons are dead, there is almost no dopamine. Thus, the affected person looses the ability to control his or her movements. To relieve the Parkinson symptoms, L-DOPA is used, because dopamine itself cannot cross the blood–brain barrier. ● In 2000, Arvid Carlsson was awarded the Nobel Prize for Medicine for showing that dopamine is an active neurotransmitter, and not just a precursor of norepinephrine and epinephrine synthesis. ● Dopamine itself is soluble in water, and apart being such a versatile bioactive molecule, it has also found applications in nanotechnology as a stabilizer of oxidic nanomaterials such as titanium dioxide nanoparticles.

# Dopamine
$C_8H_{11}NO_2$

4-(2-aminoethyl)-benzene-1,2-diol

# Caffeine
## $C_8H_{10}N_4O_2$

### 1,3,7-trimethylanthine

The stimulant caffeine is found in leaves, fruits, and the beans of over sixty plants all over the world. It acts as a natural insecticide, but it is best known as an ingredient of one of the world's favorite morning drinks: coffee. ◉ As a stimulant of the metabolic and central nervous system, caffeine is used to reduce physical fatigue. While an overdose can result in a state of central nervous system overstimulation, much larger overdoses can induce depression, disorientation, and hallucinations. ◉ Some 90% of adults consume caffeine every day, and global consumption per year is some 120,000 tons. Caffeine is, in fact, the most commonly used legal psychoactive drug. ◉ A regular cup of coffee contains about 85 mg of caffeine. By dry weight, interestingly, tea contains more. Usually, caffeine is absorbed within five minutes and degraded in five to six hours. ◉ Human beings have consumed caffeine since the Stone Age. In 1819, Friedlieb Ferdinand Runge, a German chemist, isolated relatively pure caffeine for the first time. And in 1895, the structure of caffeine was described by the German chemist Hermann Emil Fischer, who was also the first to complete its total synthesis. That was part of the work for which he was awarded the Nobel Prize in 1902. ◉ It is hard to imagine the world without coffee and caffeine. Caffeine is not only the most widely used stimulant, but it has had an enormous societal impact; with the development of coffee shops, socializing rituals affecting the traditions of modern society have clearly evolved.

Aspirin is still the most successful over-the-counter pain medication, although Bayer developed the drug almost 100 years ago. The use of plants extracts containing salicylic acid to reduce pain dates back to around 400 BC. ◉ The word "aspirin" is derived from Acetyl and Spirsäure, an old German term for salicylic acid; the "in" was an ending frequently used to connote medicine. ◉ The success of aspirin can be partially ascribed to the outbreak of the 1918 Spanish flu pandemic, where it was widely used in high doses. Later, it was suspected that heavy dosages of the medication had lead to lethal complications in some instances. ◉ There is still ongoing debate about which chemist should take credit for developing aspirin as a drug. Arthur Eichengrün, a German chemist, claimed in 1949 that Felix Hoffmann was merely following his instructions, but Bayer still denies that Eichengrün had any influence on the synthesis. Hoffmann is usually credited as the inventor of aspirin. ◉ The discovery of the mechanism of aspirin's action in the human body earned John Robert Vane a Nobel Prize in 1982. He showed that aspirin blocks the production of prostaglandines, those molecules which are responsible for transmitting pain to the brain. ◉ Today, as much as 40,000 tons of aspirin are consumed annually. It is used for a broad range of applications, but it is also known for causing some serious side effects, such as gastrointestinal bleeding, whose risk is purportedly reduced by various additives and coatings.

# Aspirin
## $C_9H_8O_4$

2-acetoxybenzoic acid

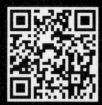

# Urea
## CO(NH$_2$)$_2$
carbamide

Urea is the name associated with the world's most frequently used fertilizer. More than 90% of the total annual production of 100 million tons is used to promote crop growth. ◉ Urea was discovered in urine by the French chemist Hilaire Rouelle in 1773. He evaporated dog's urine and obtained white crystals after cleaning with alcohol. ◉ Friedrich Wöhler (known as the "father of organic chemistry") obtained urea by treating silver isocyanate with ammonium chloride in 1828. Being the first time that a organic compound was synthesized artificially from inorganic starting materials without any involvement of living organisms, that discovery marked the beginning of modern organic synthesis. ◉ But urea plays an important biochemical role; the Krebs urea cycle, discovered by Hans Adolf Krebs in 1932, was the first completely described metabolic cycle. The cycle is vital for secretion of waste nitrogen from the body and for converting toxic ammonia into nontoxic urea. ◉ Since urea also has a high water-binding capability, it is used in skin creams, hair conditioners, and moisturizers. It has also been used in the production of plastics and as urea nitrate in the production of explosives. ◉ A marker for the beginning of modern organic synthesis, urea is also highly versatile compound – a blessing to both the soil and the body. Given its many applications, it could be seen as a singularly humble molecule with many beautiful faces!

# Sulfuric Acid
## H₂SO₄

Sulfuric acid (H₂SO₄) is one of the strongest known acids, and a basic chemical that is produced in larger quantities than any other acid. Both nonflammable and heavier than water, it can cause ignition or explosion when it comes in contact with many materials. ● While it does not exist on Earth, it has been found in the upper atmosphere of Venus and Jupiter's moon Europa by a Galileo mission. ● The acid's historical name is "oil of vitriol." In the seventeenth century, the first synthesis was performed by Johann Rudolph Glauber, a German-Dutch alchemist and chemist. He burned sulfur together with saltpeter (potassium nitrate) in the presence of steam. Joshua Ward achieved the first large-scale production, and in 1833, the British merchant Peregrine Phillips patented the so-called contact process, by which sulfuric acid is made from sulfur and oxygen. ● There are many uses of sulfuric acid – it is an electrolyte in lead-acid batteries, it is used in wastewater processing, in the production of cleaning agents, fertilizers and explosives, nylon, dyestuff and even other important acids, such as hydrochloric acid. It is also a key compound for chemical synthesis. It's hard to imagine how today's industrial production would get by without it.

# Stearic Acid
## $C_{18}H_{36}O_2$

Octadecanoic acid

Stearic acid, whose name is derived from the Greek word *stear* meaning beef fat, is a fatty acid whose sodium salts are the main ingredients of soap, cleaning agents, and chewing gum. ● The world's first soaps were made using different plants such as Chlorogalum pomeridianium. Recipes for soap using ashes, cypress, and sesame oil were found in Babylon and date from as early as around 2800 BC. ● Around 300 AD, the Greek physician Galen realized the importance of hygiene and recommended using soap to remove impurities from the body. In the eighth century, soap was produced in Spain, Italy, and the Middle East. Andrew Pears first produced high-quality, transparent soap in London in 1789, and in 1823, Michael Chareoul determined the structure of fatty acids, which enabled the development of the chemical procedures for soap manufacture. Here's a do-it-yourself soap method: Heating fats over steam and under pressure will produce, among other things, glyceriyl tristearte. Treating this product with sodium hydroxide will yield sodium stereate – the sodium salt of stearic acid, which makes up the soap. The addition of aromatic oils will give your soap a pleasant fragrance. ● Natural fatty acids are degradable and are today often used in the production of soap and cleaning agents. ● Soap molecules are used as a bridge between the oily (dirt-attracting) and water phases; they are emulsifiers capable of dispersing one liquid into another and forming micelles – those spheric constructs which have an inner fat-loving and an outer, water-loving shell. Micelles can effectively "trap" dirt, just as modern advertising contends.

# Polyethylene
## $(C_2H_4)_n$

Polyethylene belongs to the synthetic polymers, those large molecules which are composed of repeating structural units. Polyethylene is the most widely produced polymer – used for packaging production of tubings, implants, all kinds of household articles, and lead-insulated coatings. At a cost of about EUR 1 per kilo, it is also very inexpensive. ◉ The term plastic was actually first used to describe polyethylene. It is derived from the Greek word *plastikos* that means "capable of being shaped." ◉ Polyethylene is highly resistant to acids, bases and almost anything else, apart from UV light, which causes its degradation. However, plastics have a life span of several centuries, which makes them an obvious threat to the environment. Environmentally sound disposal and recycling will play a major role in the future, especially since the production of plastics has increased to more than 200 million tons annually. ◉ The first syntheses of polyethylene were twice discovered by accident. In 1898, Hans von Pechmann heated diazomethane, and Eric Fawcett and Reginald Gibson used ethylene and benzaldehyde on a larger scale in 1933 to synthesize polyethylene, only possible because of the presence of certain contaminants. ◉ In 1953, Karl Ziegler and Giulio Natta developed powerful new catalysts, facilitating the syntheses of polymers and making the production process less costly. They received the Nobel Prize for Chemistry in 1963. ◉ Polyethylene is the most widely produced plastic, and it can be found virtually everywhere in everyday life. An average-sized car contains some 100 kg of the material, for example. In cases where plastics have replaced metal, wood, or glass – which are heavier and more expensive – and in terms of convenience, plastics have clearly improved the quality of human life. However, the environmentally sound disposal of plastics is still unsolved, and there is an urgent need to find suitable solutions to that problem.

DDT is an organochlorine insecticide. Although first synthesized in 1874, its properties were not discovered until Paul Müller's 1939 research on chemicals with anti-moth activity. While not a physician, Müller was awarded the Nobel Prize in Medicine, when he proved that DDT was an extremely effective insecticide. ● It was used to kill malaria-carrying mosquitos, eradicating that disease in Taiwan, Australia, the Balkan States, the Caribbean, Northern Africa and the South Pacific. DDT has, in fact, saved more lives than penicillin has. ● However, DDT is also toxic – it is a persistent organic pollutant that is readily absorbed into soils and sediments, which act both as a sink and as long-term source of exposure to terrestrial organisms. Mammals deposit DDT in fatty tissue and breast milk; the biological half-life of DDT in humans is one year. ● DDT renders eggshells thinner, so the eggs eventually break. In Germany, for example, the peregrine falcon was almost eradicated. Inspired by the effects of DDT on birds, Rachel Carson published *Silent Spring* in 1962, a book which is credited with helping launch the American environmental movement. DDT was banned in Sweden in 1970, and in 1972, in the USA and Germany. The Stockholm Convention of 2001 eliminates or restricts the use of DDT and other persistent organic pollutants almost worldwide.

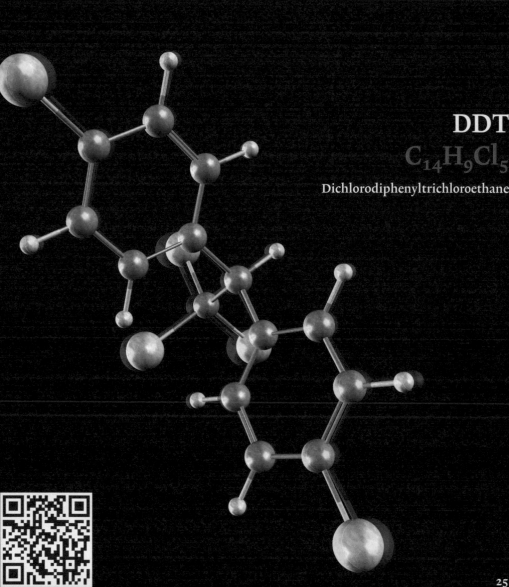

# DDT
## $C_{14}H_9Cl_5$
### Dichlorodiphenyltrichloroethane

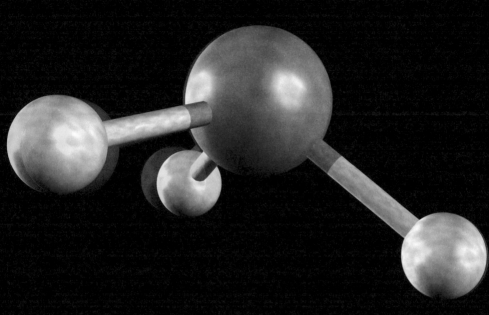

# Ammonia
## NH₃

Ammonia is used as versatile chemical in industrial processes such as in the production of fertilizers or explosives. Already the ancient Egyptians and Arabs knew ammonia and ammonium salts; both were found next to a temple of Jupiter (Ammon) and therefore known as *sal ammoniacum* (salt of Ammon). ● In modern chemistry, it was Johannes Kunckel who, in 1716, first mentioned the formation of ammonia during fermentation. Yet almost sixty years passed before ammonia was isolated by Joseph Priestley in 1774. The real breakthrough, however, was the production of ammonia from nitrogen and hydrogen in the Haber–Bosch process, which was developed by Fritz Haber and Carl Bosch at the Technical University in Karlsruhe (DE). ● The Haber–Bosch process employs temperatures between 400°C and 520°C and high pressure (25–30 MPa), but most important for the formation of ammonia is the use of catalysts, compounds that speed up the synthesis and make it more economically viable. ● Ammonia has truly brought an agricultural revolution. It is used for the production of fertilizers, which enrich the soil and improve food production. But it is also irreplaceable as a nitrogen source in the pharmaceutical industry and in chemical synthesis. Just as promising are its emerging uses in fuel production.

The QR codes lead to 3D videos of the molecules. If you do not have a device that
can scan QR codes, you can get access to the videos via ZKM's YouTube channel.

# Molecular Aesthetics

edited by Peter Weibel and Ljiljana Fruk

published by ZKM | Center for Art and Media Karlsruhe, Germany
The MIT Press, Cambridge, MA / London, England

# Contents

Ljiljana Fruk and Peter Weibel
**Preface**

At the crossroad of two scientifically remarkable centuries, it seems only appropriate to paraphrase Jules H. Poincaré, who postulated that we do not study nature only because it is useful, but study it because we delight in it, and we delight in it because it is beautiful or, rather, the truth within it is beautiful. When we two first discussed our intention to join science and art in a 2011 symposium, we knew from the beginning that our foremost interest was in joining the two disciplines on a fine molecular level.

Thanks to recent technological advances, modern science clearly reveals to us the intricate beauty of a molecular world. We have attained powerful tools to visualize, redesign, adapt, and change that world, and science attempts to formulate pictures of what cannot be seen by putting together different bits of information to get closer to the truth that lies within molecules. There are rules of atomic structural assembly that help predict molecular shapes, yet often the picture we get is simply a fleeting moment of a dynamic molecular life, a reality that has already gone when captured. Advances – both in molecular science and microscopy – help us to see matter on a nanoscale, in short, to go far beyond what the human eye can see, but not beyond what the human mind can

imagine. The fact that technology allows us to transcend the limits of natural perception and see what was previously "unseeable" creates the new dimension of aesthetic experience and practice we call "molecular aesthetics". Just as the artists of the Bauhaus began to use such industrial materials – metal, Plexiglas, and alloys – as raw materials, artists today have access to new realms of the molecular and nanotechnological. The industrial aesthetic of machinery and material has been transformed into an aesthetic of media and molecules.

The contributions in this volume suggest ways in which art can draw inspiration from the molecular sciences, and point to how science can use art to make experimental results more intelligible and comprehensible. Defining molecular aesthetics is far from easy. A scientist would see the molecular part first, add the concept of beauty to that part, would be made slightly uncomfortable by the definitions of beauty being subjective, and science representing the search for truth based on objectivity. By contrast, an artist will recognize the aesthetics of structures and the creative process at work, but might be somewhat uncomfortable with the molecular part of it. And although it seems that the great modern divide of art and science is far too hard to bridge, one has always inspired the other. After all, creativity has no boundaries, and knows no limits. We hope this book will make a convincing argument for that being the beauty and truth of it.

The collection of essays and artwork in hand aims to establish links between current developments in molecular sciences, the visual arts, and music. The authors, drawn from all three disciplines, discuss the creation of molecules of remarkable beauty and the functional properties that stem from a few geometrical principles of molecular design; they address the history of molecular structure representation; they examine the meaning of molecular aesthetics for scientists; and they compare chemical structures to artworks to show how science inspired various artists' work. We hope this volume will inspire you to explore the concept of molecular aesthetics and demonstrate how science and art are indeed inseparable.

This book is a tangible follow-up to a symposium that was held at ZKM | Center for Art and Media in Karlsruhe July 15–17, 2011. That the symposium was an uplifting experience for its participants is evident in the enthusiasm shown in these pages. Some of the contributions are by authors and artists who could not actually attend the symposium, but whose valuable insights nicely supplemented the work of those who were. We sincerely thank all the scientists and artists who generously agreed to having their lectures printed here, and the many scientists and artists who wrote new papers or sent us reprints for this project at our invitation. We hope that the collected work might ultimately help our readers perceive our molecular world in a different way.

Finally, both the symposium and the book are the products of extraordinary commitment and hard work on the part of young scientists at KIT – Karlsruhe Institute of Technology and ZKM | Karlsruhe – whose many dedicated hours went into completing this project. We also extend grateful thanks to Ishtiaq Ahmed, Dennis Bauer, Cheng Chen, Sinem Engin, Bianca Geiseler, Dania Kendziora, Marko Miljević, Andre Petershans, Lukas Stolzer (all of KIT), and to Martina Hofmann, Bernd Lintermann, Jens Lutz, Maja Petrović, Luise Pilz, Miriam Stürner, and Sophie-Charlotte Thieroff (all of ZKM).

I

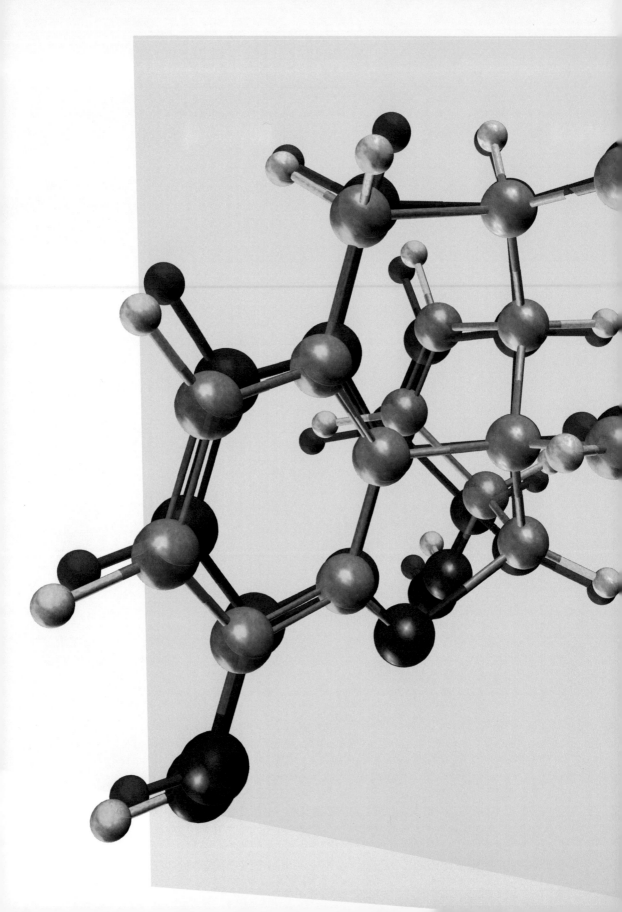

Peter Weibel
**Molecular Aesthetics**
**An Introduction**

The pioneering work you currently hold in your hands persuasively illustrates the transition from the aesthetics of product-based industrial Modernism to that of postindustrial service-based Second Modernism or Postmodernism[1] and, further, to the aesthetics of the knowledge-based Third Revolution.[2]

### Aesthetics of Modernism

The aesthetics of Modernism emerged as a response to the Industrial Revolution and praised its very core: the machine, the motion – the motion machine. From J. M. W. Turner's painting *Rain, Steam and Speed – The Great Western Railway* (1844) to the sentence "Die Kunst ist tot. Es lebe die neue Maschinenkunst Tatlins" ["Art is Dead. Long Live Tatlin's New Machine Art"] (1920) by George Grosz and John Heartfield[3]; from Claude Monet's painting *La gare St. Lazare* [*The Saint-Lazare Station*] (1877) to Abel Gance's film *La Roue* [*The Wheel*] (1923); from the Lumière brothers' film *L'Arrivée d'un train en gare de La Ciotat* [The Arrival of a Train at La Ciotat Station] (1895) to Fernand Léger's and Dudley Murphy's film *Ballet mécanique* (1924), Modernism is a "machine aesthetic" such as Fernand Léger described it in the 1920s.[4] Already in 1912, the Futurist Filippo Tommaso Marinetti declared in his *Technical Manifesto of Futurist Literature* that "After the animal kingdom, the mechanical kingdom begins!"

The Industrial Revolution took its impetus from the world of machinery,[5] and particularly, from motion machines. It allowed human beings to master and shape new materials, and thus forged a new relationship between man and his environment. We can find the roots of Modernism as far back as the eighteenth century in the idea of the machine proposed by Julien Offray de La Mettrie in *L'homme machine* (1748). In Francis Picabia and Marcel Duchamp's visions of mechanical humans[6], the idea held its ground through the early twentieth century. From the steam engine to the factory, the machine came to epitomize the Industrial Revolution. Charlie Chaplin's famous movie *Modern Times* (1933–1936) presents humans as the helpless, "steamrolled" part of the world of machines. Modern times are mechanical times. Hour after hour, human beings create new

materials and products underpinning modern civilization to the rhythm and tempo of the machines. It falls to artists, designers, and architects to design the materials. Courses in material design form the basis for training in art and architectural colleges. In particular, Germany's Bauhaus, one of the most influential twentieth century's art institutions, focused on the machine-based industrial aesthetic of the new materials and their designs.[7] Frank Lloyd Wright, one of the central architects of Modernism, rightly summarized the equation for twentieth century aesthetics in the choice of the title for one of his 1930 Kahn lectures: *Machinery, Materials and Men*.[8]

## Aesthetics of Postmodernism

The postindustrial age and the aesthetics of Postmodernism do not hinge on motion machines such as cars, railways, and aircraft, but on communication engines, the so-called "media," that focus on information generation, transmission, and storage. In light of globally dominant digital information and communications technology, it follows that the classical Modernist equation of *Machinery, Materials, and Men* should be supplanted by a new digital version, namely: *Media, Data, and Men*. The media emerge as a new form of reality. The subjugation of men to machine, as depicted in Chaplin's *Modern Times,* is possibly surpassed by men's subjugation to media and data, because they offer a new reality: simulation.

Not unexpectedly, the media and distribution of digital data have forged yet another relationship between man and the environment, one in which simulation precedes reality and replaces it, or so the French theorist Jean Baudrillard contends.[9] Thus, in the media age, the counterpoint to Chaplin's *Modern Times* of the mechanical age, might well be the Wachowski siblings' blockbuster film *The Matrix* (1999).

Modern, computer-based technologies have also changed our notion of materials by enabling us to penetrate the regime of matter and materials far more deeply than ever thought conceivable, namely into the world of molecules, atoms, and subatomic particles, or the "particle zoo." So the postindustrial aesthetics of Postmodernism rests on the modified equation *Media, Molecules, Men*. Particularly, the image of man has undergone a transformation in the age of the molecular revolution: talk today is of molecular man, and of life as a molecular, chemical factory.

The new equations of *Media, Data, and Men* or *Media, Molecules, and Men* correspond and give rise to a new aesthetic. I shall attempt to outline its basic characteristics. Yet, to define what is new about this proposed molecular aesthetics, I must first outline the origins of classical aesthetics.

## Classical Aesthetics

At the end of the fifteenth century, Leonardo da Vinci penned *Trattato della pittura*, the mission statement of classical aesthetics, namely to represent the shapes of all visible objects. The work's second paragraph begins: "The principle of the science of painting is the point; second is the line; third is the surface; fourth is the body which is enclosed by these surfaces. And this is just what it is to be represented, that is to say, the body which is represented, since in truth the scope of painting does not extend beyond the representation of the solid body or the shape of all the things that are visible."[10]

Leonardo's words lay a sound foundation for the program of classical aesthetics: to depict "all visible things" being the task and goal of the art of painting. From ancient times through the Renaissance, and up until around 1900, the classical arts of the Western hemisphere (specifically, painting and sculpture) were arts of representation: namely, two- and three-dimensional copies of the material world, or the reproduction of visible reality.

From one epoch to the next, however, different hierarchies of knowledge appeared in various schematic portrayals of knowledge trees. The ancient Greeks distinguished between different forms of knowledge. Aristotle differentiated between *techne*, or practical knowledge, craftsmanship, art, and *episteme*, which stood for scientific knowledge (grammar, dialectics, rhetoric, arithmetic, geometry, astronomy, and music).

Starting with these distinctions, the Romans rendered each more specific. Former types of *episteme* were combined under the umbrella of the liberal arts. Studying these *artes liberales* – known as science today – was, for the Romans, the basis for a higher education to which all free citizens were entitled. Therefore, one speaks of "free arts" (*artes liberales*) for free citizens. Painting and sculpture were classified as the *artes mechanicae* connoting the labor and skills of the various craft trades. The mechanical arts – painting and sculpture – were defined as the arts of wage-laborers and slaves.

From then on, this allocation to sciences and arts was both integrated into the scholastic system, and upheld until the Middle Ages. About 1492, Girolamo Savonarola,[11] Leonardo's contemporary, published his pamphlet *De omnium scientiarum divisione* (fig. 1).[12] He devised a tree of knowledge, at whose uppermost tip was scholastic theology or philosophy. Figuring beneath it on the one side were the "liberal arts" from arithmetic to rhetoric; speculative and practical philosophy took their place on the other. The mechanical arts appeared lower down. As a sign of his esteem, Savonarola included poetry rather than grammar among the liberal arts or science.

FIG 1

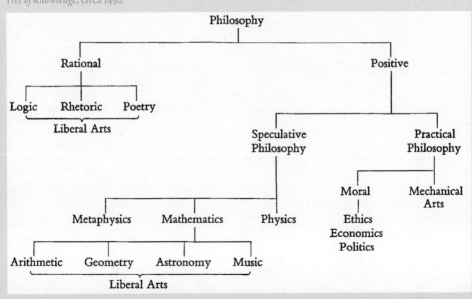

FIG 1 Girolamo Savonarola,
*Tree of Knowledge*, circa 1492

Leonardo da Vinci's *Trattato della pittura*, a manuscript which remained unpublished in his lifetime, first appeared in Paris in 1651. In an attempt to define painting as a science and therefore to include it in the ranks of the *artes liberales*, Leonardo compared painting with the other arts: sculpture, poetry, and music. In doing so, he made an important contribution to Renaissance discourse, and the debate about art forms that is known as the "paragone." The debate was not meant to devalue the other arts, but rather to upgrade painting. Thanks to Leonardo's impetus, the Renaissance took up the challenge that had been smoldering among the different forms of science and practice as far back as Antiquity. The systematic comparison with the other arts served, above all, to present painting as a science alongside arithmetic, geometry, logic, grammar, etc. so that it would be included in the canon of the liberal arts. As was customary in science, Leonardo tried to base the painting discipline on reason and experience. Since science requires geometrical and mathematical proof, he starts his treatise with the point, moving on to the line and, finally, the plane, as the essential painting elements, namely using the elements of Euclidian geometry (300 BCE) as his model.

Leonardo's agenda was to use point, line, and plane to represent the material world visually. With the paragone, he attempted to overcome the categoriza-

An **active** line on a walk, moving freely, without goal. A walk for a walk's sake. The mobility agent is a point, shifting its position forward (Fig. 1):

Fig. 1

The same line, accompanied by complementary forms (Figs. 2 and 3):

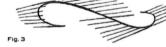

Fig. 2

Fig. 3

The simplest and briefest is that of the centrally-placed point—of the **point** lying **in the center** of a surface which is square in shape.

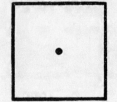

tion of the arts that had been used both in Classical Antiquity and the Middle Ages. To fully emancipate painting as a science, a distinction had to be made between artist and craftsman, the latter practicing *artes vulgares et sordidae*, or later the *artes mechanicae*. Leonardo thus construed painting as *discorso mentale*, a mental activity, and sculpture as a physical activity. This agenda takes center stage in the classical assessment of art. The path from the art of Classical Antiquity to Modernism leads from representation to reality, from visual representation of things to the presentation of real things. Abstract art is an after effect of this paradigm shift.

### The End of Leonardo's Program:
### Self-Representation of the Means of Representation
### and Self-Representation of Things in Modernism

The real achievement of the twentieth century art as relates to images was the radical change of the nature of the image, the development from panel painting to digital screen. This transformation of the image can be best described in a dialectical three-tier process:
1. Formal Analysis, 2. Absolutization, 3. Substitution.

1. Formal Analysis, Dissection, Deconstruction
In a first phase, the modern image dissected and analyzed the elementary components of the old panel painting. "Modern" images rise up from the ruins of "old" images. From Paul Cézanne to Kazimir Malevich, painters have explored formal elements – such as line, circle, square, cone, and sphere – and the materials, such as pigment, that are required to render an image. As part of this exploration, painting was strictly reduced to these elements, to the line or to the color. In 1896, Maurice Denis came up with the well-known definition: "Not the object represented shall be the painter's expression, but the means of expression themselves (lines, shapes, volumes, colors)."[13] For Denis, representation of the object was confined to the wings, and the means of representation took the limelight.

The analysis of color and its impact was the momentum that moved painting forward in the second half of the nineteenth century. Pigment and color increasingly drove out the depiction of objects and came to predominate.

At the same time, point and line – the very means of drawing – were subjected to a fundamental analysis. Then around 1920, the line absolutized itself. Alongside absolute color, the abstract line became the second crucial pillar of Modernism. The scientific studies of color in the nineteenth and twentieth centuries were complemented in the early twentieth century by scientific studies of the line and the plane.

Modern painters analyzed the means of painting just as precisely as Leonardo had. The latter had written that "[t]he principle of the science of painting is the point; second is the line; third is the surface; fourth is the body which is enclosed by these surfaces."[14] He essentially outlined the agenda set out by the Bauhaus, and offered by artists from Kandinsky to Klee, from Malevich to Mondrian.[15] Kandinsky's title *Punkt und Linie zu Fläche* [*Point and Line to Plane*][16] (fig. 2) FIG 2 can be read as a response to Leonardo. And Paul Klee refers to shape and color, to line and plane, as the primary elements of painting in his book *Pädagogisches Skizzenbuch* [*Pedagogical Sketchbook*][17] (fig. 3). FIG 3    **41**

## 2. Accentuation, Singularization, Absolutization

Once the image had been broken down into its individual elements, the artist could highlight certain aspects, set new highlights, or shift the accent. Figural representation is neglected, and only certain geometric shapes are permissible. Singular elements could be declared autonomous and independent, or granted an absolute status to the detriment of others, an example being color. Painting becomes pure color painting, in fact. In the twentieth century, color assumed an independent existence and became absolute, even monochrome, in the work of Alexandr Rodchenko as early as 1921. As the real driver of Modernism, color reigns absolute in the monochrome abstract image. Indeed, abstract painting characterized by the reduction of painting to pure color and pure line marks
FIG 4   the complete abolition of representation and the end of Leonardo's agenda.

## 3. Exclusion, Elision, Substitution

In the third phase, elements of painting were not only neglected, but completely excluded. What's more, historical elements were replaced by new features: brown pigments by wood, canvas by aluminum, the curved line by bent Plexiglas, are but a few examples. As early as in the 1920s, painters started using the new technical opportunities in an effort to reconcile art and technology, and were keen to discover and incorporate new materials, such as glass, aluminum, or fabric into their works. In this phase of substitution, material images that

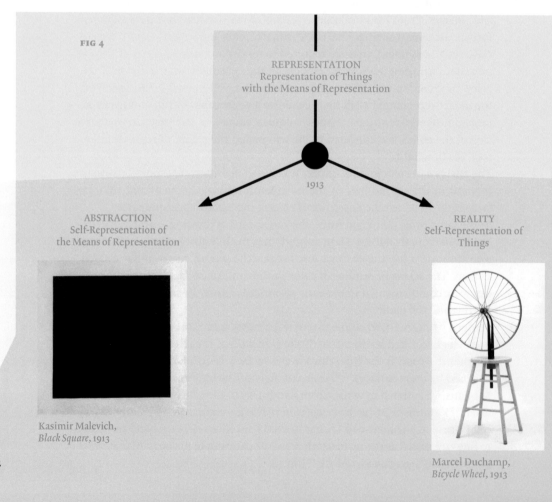

FIG 4

REPRESENTATION
Representation of Things
with the Means of Representation

1913

ABSTRACTION
Self-Representation of
the Means of Representation

REALITY
Self-Representation of
Things

Kasimir Malevich,
*Black Square*, 1913

Marcel Duchamp,
*Bicycle Wheel*, 1913

had a new physical presence arose. The image as representation became by its materiality a self-referential object.

Substitution could go so far in allowing all representative elements to be replaced by real elements. With the radicalization of substitution, materiality in the narrow sense was no longer necessary, and the immaterial properties innate in the new materials – such as aluminum and glass – could be substituted for the old material image, creating artificial light works. The new images could completely exclude basic historical elements; in other words, all the material and technical dispositive of traditional panel painting. Thus, in the 1960s, representation was abandoned, and reality invaded the arts.

## Representation and Reality

Taking stock at the start of the twenty-first century, it seems justifiable to ask what genuine achievements in art have been made over the last one hundred years. My own response would be as follows: Firstly, the abolition of representation by abstraction in the first half of the century. By liberating point, line, color, and plane from a subservient function of representation and reference, it was possible for point, line, color, and plane to gain absolute values of their own. The representation of the object was replaced by the artistic means of representation of the object. Further, the image covered with pure color became an object itself. Then the object itself took the place of the representation of an FIG 4 object – marking the evolution of objects' self-representation.

The second achievement in the second half of the century was the complete replacement of representation by reality. Abstraction seems only to have been a transition, a means of argumentation, of load-shedding. Abstraction may only have been the entrance to the gate that art had opened for reality or, inversely, reality opened for art. Since then, everything that was once representation in art has been replaced by reality: painted natural light was replaced by real artificial light; painted fire, by real fire; painted hair, by real hair; painted flesh, by real flesh; painted landscapes, by Land art, and so on.

## Leonardo's Program 2.0: The Media

In the nineteenth century, another system of representation emerged alongside painting, namely: photography. Its launch destroyed painting's monopoly on image production. Photography was followed by further "mechanical" and technological systems for depiction: film, TV, video, and computers all count among these. And thanks to their respective abilities to integrate motion and sound into the representation of reality, each medium enjoyed great success and created new opportunities for art.

Compared to manual representational systems such as painting or sculpture, these new technical variants were better suited to executing Leonardo's original agenda – to represent the visible world. Things could now be represented in motion, as could the world's acoustic dimension. Above all, the media have forced us to rethink ontological differences and distinguish more critically between the natural and man-made world. Thanks to machines and primarily the media, the relationship between human beings and the reality of space and time have changed completely, and with that, the task of art has also changed. Media-generated art thus forms Modernism's third response to the crisis of representation: 1. Abstraction, 2. Reality art, 3. Media reality.

Concept art is a branch of media art when it explores the relationships of language and image as representational systems to reality. Joseph Kosuth's 1965 work *One and Three Chairs*, for example – where the photo of a chair, a linguistic definition of a chair, and a real chair are placed alongside one another – could be said to mirror a theorem Ludwig Wittgenstein proposed in *Tractatus logico-philosophicus* (1921), "The proposition is a picture of reality."[18]

Media art has recognized something which remained concealed to painting, owing to its less elaborate technical apparatus, namely that there is a third parameter between object and image, object and symbol, that first forges the relationship. Charles S. Peirce taught us that there are three forms of sign – icon, index, and symbol – and that these signs form the third term that creates the relation between imagination and object. This third term becomes manifest in media art, in the apparatuses that first enable depiction. The camera is the prototypical interface, since it intervenes between image and object, turning the object into the image. Through the media, we learned that there are interfaces between human beings and the world, biological and/or natural interfaces, such as eyes and ears, but also artificial ones, such as machines, apparatuses, and media: tools that enable us to access reality, change, design and digest it. Media are artificial interfaces that define our relationship to reality and dissolve and diffuse any absolute reality. Through media, namely, reality becomes relative to the observer. And no question: machine and media as the new interfaces between man and his environment have radically changed human perception and experience of reality since the Industrial Revolution.

Moving through space by rail, car, or airplane, we experience time and space at a speed far beyond the natural abilities of the human organism. The spatio-temporal experiences afforded by machines and "telemedia" such as telegraph, telephone, and television exceed our bodies' limits. Since they go far beyond our corporeal experience of reality, they may be called trans-anthropomorphic. Fundamental to the new experiences of reality is the separation of the messenger (body) from the message (chain of signs). Once messages started traveling without messengers, or were transmitted in code by electromagnetic waves, the world as we once knew it had collapsed. Nowadays, the body-centered experience has given way to the machine and media-centered experience of reality, which exceeds the measuring of space and time by the yardstick of the human body.

There are exceptionally clear and profound symptoms of this change in our experience of reality in twentieth century art. Artists respond in their works to the changed way we experience reality and these responses show both conservative and progressive tendencies. Whether in the form of real everyday objects or in the guise of the real body, reality penetrated art. But at the same time, media invaded art and reality, and with them, the immaterial, the virtual, the simulation.[19] Early on, media art described the transformation of our experience of reality by the gap between map and land, between representation and reality, between image and being.

The Classical Avant-garde defined any real object per se as artwork, think of Marcel Duchamp's ready-mades, for example. They fashioned art into reality's double. The media penetrate, diffuse, and change reality.

In "It's a Caravan," the sixth chapter of *Tom Sawyer Abroad* (1894), the American author Mark Twain takes the example of a trip over the countryside in a hot-air balloon to describe the ontological problem of media reality. The protagonist Huck

Finn believes he should be able to spot the meridians on earth just as they are depicted on the map. But because he cannot see them, he accuses the maps of lying:
– "Oh, shucks, Huck Finn, I never see such a lunkhead as you. Did you s'pose
there's meridians of longitude on the Earth?"
– "Tom Sawyer, they're set down on the map, and you know it perfectly well,
and here they are, and you can see for yourself."
– "Of course they're on the map, but that's nothing; there ain't any on the ground."
– "Tom, do you know that to be so?"
– "Certainly I do."
– "Well, then, that map's a liar again. I never see such a liar as that map."

French theorist Jean Baudrillard also highlighted the abstraction of the modern world using the example of the map versus land in his theory on simulation and hyperreality. In *La précession des simulacres*[20] Baudrillard refers to a story about a map and the land told in the book of Jorge Luis Borges to prove his hypothesis that simulation precedes reality:
"In that Empire, the Art of Cartography attained such Perfection that the map of a single Province occupied the entirety of a City, and the map of the Empire, the entirety of a Province. In time, those Unconscionable Maps no longer satisfied, and the Cartographers Guilds struck a Map of the Empire whose size was that of the Empire, and which coincided point for point with it. The following Generations, who were not so fond of the Study of Cartography as their Forebears had been, saw that that vast Map was Useless, and not without some Pitilessness was it, that they delivered it up to the Inclemencies of Sun and Winters. In the Deserts of the West, still today, there are Tattered Ruins of that Map, inhabited by Animals and Beggars; in all the Land there is no other Relic of the Disciplines of Geography."[21]
We have known since Borges and Baudrillard that maps have the tendency to gobble up land. Anyone standing on a map drawn to a one-to-one scale cannot know whether he's standing on land or on a map. The media apparently simulate reality so perfectly that there is no discernable difference between the map, the representational medium, and the true reality: the land itself.
The media construct reality unequivocally. The map constructs the land. So the question that has become ever more pressing since the middle of the twentieth century is this: Is there anything beyond the media? Media art poses this question with what it calls "media reality."
Contemporary media theory bears out the hypotheses of radical Constructivism, as was put forward by Peter L. Berger and Thomas Luckmann in their bestselling *The Social Construction of Reality*[22] (1966). Constructivism is a philosophical theory of perception and cognition based on insights from psychology, the neurosciences, and physics. Rather than playing down the human element, it emphasizes the share of human perception and communication in constructing the world.[23]

## Media Theory as Organology
From Ernst Christian Kapp[24] to Marshall McLuhan, media theory is essentially an organology: technology as the expansion of the human organs. In 1877 Kapp developed the basics of a philosophy of technology, and with it, outlined the theory of "organ projection." The hammer can be construed as a fist, for exam-

ple, and a hand-saw may suggest incisors. A telescope unconsciously reflects the inner structure of the eye. Sigmund Freud developed comparable ideas in *Das Unbehagen in der Kultur* [*Civilization and Its Discontents*] in 1930: "We recognize as belonging to culture all the activities and possessions which men use to make the earth serviceable to them, to protect them against the tyranny of natural forces, and so on. There is less doubt about this aspect of civilization than any other. If we go back far enough, we find that the first acts of civilization were the use of tools, the gaining of power over fire, and the construction of dwellings. Among these the acquisition of power over fire stands out as a quite exceptional achievement, without a prototype; while the other two opened up paths which have ever since been pursued by man, the stimulus towards which is easily imagined. By means of all his tools, man makes his own organs more perfect – both the motor and the sensory – or else removes the obstacles in the way of their activity. Machinery places gigantic power at his disposal which, like his muscles, he can employ in any direction; ships and aircraft have the effect that neither air nor water can prevent his traversing them. With spectacles he corrects the defects of the lens in his own eyes; with telescopes he looks at far distances; with the microscope he overcomes the limitations in visibility due to the structure of his retina. With the photographic camera he has created an instrument which registers transitory visual impressions, just as the gramophone does with equally transient auditory ones; both are at bottom materializations of his own power of memory. With the help of the telephone he can hear at distances which even fairy-tales would treat as insuperable; writing to begin with was the voice of the absent; dwellings were a substitute for the mother's womb, that first abode, in which he was safe and felt so content, for which he probably yearns ever after."[25]

Freud preempts the media theory of Marshall McLuhan (*Understanding Media*, 1964)[26] that defined media as an extension of the sensory organs: the wheel as an extension of the foot, the telescope and microscope as aids for people to see further and deeper than it was possible for the human eye. Camera and gramophone store traces of seeing and hearing; with a telephone, people hear further than with their ears; the computer forms an extension of the neural networks. While the sensory organs are the natural interface to one's environment, the media, as extensions of sensory organs, are artificial interfaces to it. The world has become accessible to us in two ways: firstly, through our natural sensory organs and secondly, through the artificial sensory organs of the media that exceed the abilities of their natural counterparts. If we accept that a part of the world is constructed by observation by means of the natural sensory organs, then it would seem logical that this construction continues via the artificial sensory organs of the media.

In other words, reality is firstly, observer-relative and secondly observer-constructed. The media, the artificial extensions, are part of this observer-relativity and observer-constructivism. German sociologist Niklas Luhmann therefore concludes that "whatever we know about our society, or indeed about the world in which we live, we know through the mass media."[27] For cognition is construction.[28] Today, the more apposite title for the book by Berger and Luckmann would be "The Medial Construction of Reality."

We have already noted that the media art produced by the new equation of *Media, Data, and Men* places the human being in a new relationship to his or her

environment, hitherto, a relationship was defined solely by the interfaces of the sensory organs. If the media emerge as those organs' "technical extensions," then they are, in fact, artificial interfaces. Media art thus allows Leonardo's agenda to be continued in a new context, with new technological and scientific means. It offers a way out of Modernism, an escape from the self-representation of representational means and the self-representation of objects. Media art does not focus on self-reflexive analysis of the intrinsic world of the representational means, as abstract painting does. Self-reflexive analysis leads to an analysis of the visual representation of the world, which may become a critique of the media-constructed reality. Media art seeks to represent media reality, or media-constructed reality, rather than nature, as Leonardo had required of painting. Owing to the implosion of map and land, media critique and social critique are now indistinguishable. Media formation and world formation coincide. And it is precisely this implosion that is the subject of media art.

The human sensory organs serve as interfaces to the given natural world in which we live. These interfaces are not only receptors, but also effectors. With our body and sensory organs, we not only perceive the world, but also build the world – a man-made world beyond the given natural environment. If media are artificial sensory organs, that means man-made extensions of our natural sensory organs, then they have similar functions: they perceive, conceive, construct a new world – a man-made technical world in addition to the natural world. Classical art is more or less the art that is perceived and constructed by the natural sensory organs. It dissolved in the bifurcation: abstraction or reality. But from some 150 years ago, a new non-classical art emerged: media art, the FIG 5 art of artificial sensory organs. Since we understand now that media are not just picture or sound machines, but include interfaces – artificial, man-made, and technical – to the natural, artificial, and technical environments in which we live, so, too, can we acknowledge that media and media art conceive and construct a new reality. The paradigm shift from visual media to social media makes this evident.

FIG 5

REPRESENTATION
Representation of Things
with the Means of Representation

1913

ABSTRACTION
Self-Representation of
the Means of Representation

REALITY
Self-Representation of
Things

MEDIA
Simulate and Stimulate
Conceive and Construct Reality

## Beyond the Surface: Media as Soft Scalpels

In the fifteenth century, Leonardo described painting as a representational technique "which does not extend beyond the surface."[29] In so doing, he proclaimed a dictum or norm that was to dominate the visual arts for the next five hundred years. Painters did, in fact, stay "stuck" on the surface of things, rendering the surfaces of the flowers and leaves, the trees and the forests, the clouds and the sea, the animals and the meadows, the houses and foodstuffs, humans and objects. They painted what the natural eye perceived and what the natural hand was able to master. In his expansive book *Secret Knowledge: Rediscovering the Lost Techniques of the Old Masters* (2006), contemporary British painter David Hockney rightly asserts that the Old Masters resorted to countless technical means in the process, from the camera obscura to perspectival apparatuses.[30] Painting seemed a natural practice, therefore apparative aspects, from the brush to the canvas, from the artificial pigments to the optical devices, were all neglected. In truth, however, painting had always been a technical procedure, and with his strict insistence on surface, Leonardo actually hampered technical progress in painting.

Media, as an artificial extension of the natural organs, changes both the ratio of our sensory organs and the relationship of our sensory perception to our environment. Technical media can therefore be used to change the human body, to represent it as one of many visible things in a different way. Media and machines allow us to look inside our own bodies. They deliver images of our organs hitherto thought inconceivable. We owe the rise of machine-aided "bildgebende Verfahren" (techniques of image-producing, image-delivering machines and methods) in medicine – from x-ray photography to computer tomography – to the theory of media as organology. Media systems, the optical systems of new media, allowed us to dive deeper, and see beyond the surface.

The process of technical image production commenced irreversibly with the emergence of photography around 1840. With the technical progress of vision machines, the visual art (of painting) expanded into visual culture. Against the horizon of visual culture, scientific images created by apparatuses played an equal, if not greater, role than images of art seemingly created solely by the human hand. Thanks to the new visual media, such as photography, film, video, and computer, the new image-generating procedures and apparatuses – microscopes, telescopes, x-rays, computed tomography, etc. – the domain of the image was extended to well beyond art and above all penetrated the surface of things. Visual studies no longer concerned themselves with images of art alone, but took up the non-art images of science, journalism, and so on. The results have been fusions of artistic and scientific practices, and as such, the old distinction between scientific and art images no longer makes sense today.[31]

Even Leonardo, who championed the surface of things, would go beneath the surface and dissect human corpses to acquire knowledge of the muscles, sinews, and blood vessels so he could represent the anatomy faithfully. It is a cognitive paradox that the word "anatomy," which today means as much as the representation of the human body, originally meant "cutting up" the body (Greek: *aná* "up"; *tomé* "cut").

By extending the horizon of visible things beyond the natural capability of the eye by means of apparatuses – dissecting knives, in this case – Leonardo wanted to penetrate the surface, thus contradicting his own dictum. To be able

FIG 6

to represent the body perfectly, Leonardo wanted to grasp the shape, position, and structure of body parts, organs, and tissue. With his scientific accuracy, he held his own against Andreas Vesalius (1514–1564), called the founder of modern anatomy, who was born some 60 years later. Since then, anatomy occupies an important position in the visual arts, and dissection has been part of basic training for medical students.

Macroscopic anatomy focuses on the structure of the human, animal, or plant body, in other words, what can be seen by the naked eye. This refers not only to the externally visible structures, but also to those that can be seen after dissection. Studying anatomical structures beneath the level visible to the human eye involves microscopic anatomy (tissue studies or histology), whose focus is the fine structure of organs, tissue, and cells.

The invention of the microscope not only gave human dissection a more effective and deeper "cut" than had been possible with a scalpel, but it also marked the beginning of the triumph of apparatus-based perception. As a kind of "knife for the eye," the microscope enabled visual access to invisible zones. Owing to physical and economic interests, microscopy emerged in the seventeenth century as the new "subtle anatomy." It offered a glimpse inside the body's organs and triggered the discovery of a hitherto unknown world of miniscule creatures. Constantijn Huygens (1596–1687), who saw the instrument in Cornelius Drebbel's (1572–1633) London workshop in 1621, gave the first verified report of a microscope. Three years later, the magnifying apparatus acquired the name "microscopium" (Greek: *mikrós* "small"; *skopein* "view").

A quarter century later, the German Jesuit scholar Athanasius Kircher (1602–1680) used magnifying glasses as simple microscopes to discover small creatures in milk and vinegar (*Scrutinium pestis physico-medicum*, 1658). Yet it was Marcello Malpighi (1628–1694) in Bologna who, in his study of the lung, truly continued anatomy with microscopic means. Studies of the liver, kidneys, and spleen followed. He discovered the tactile corpuscles in skin and the tongue's taste buds (*Opera omnia*, 1686[32]), and also published a two-volume anatomy of plants (1675–1679[33]). Not surprisingly, Malpighi is considered the founder of microscopic anatomy.

FIG 6 Julian Voss-Andreae, *Antibody Structure Superimposed on Leonardo's Vitruvian Man*, 2006, computer sketch

## "Res Invisibles" Made Visible by Apparatuses

According to Francis Bacon's (1561–1626) *Novum organum scientiarum* (1620)[34], the first masters of anatomy of the *res invisibiles* were Antoni van Leeuwenhoek (1632–1723) and Robert Hooke (1635–1703) (fig. 7). Leeuwenhoek is said to have first discovered spermatozoa (1677). We also credit him with the first description of bacteria (1683).

One of the key consequences of microbiology based on microscopes was the discovery of microorganisms as pathogens. From ancient times through to the Middle Ages, diseases were considered as punishment sent by the Higher Powers, and it was not until technical progress in the nineteenth and twentieth centuries gave rise to microbiology – the field covering bacteriology, mycology, and virology – that other explanations were offered. The Italian physician, poet, and scholar Girolamo Fracastoro (1478–1553) was the first to consider specific germs, *seminaria morbi*, or transmittable pathogens, as possible culprits. Microorganisms were thus discovered as pathogens.

The idea of a *contagium animatum* as the cause of infectious diseases first arose at the end of the seventeenth century. Louis Pasteur (1822–1895) and Joseph Lister (1827–1912), Ignaz Philipp Semmelweis (1818–1865) and Robert Koch (1843–1910) all did extensive research on germs, viruses, microbes, fermenting agents, and pathogens. In the second volume of *Beiträge zur Biologie der Pflanzen* (1877)[35], Robert Koch published original photograms of anthrax germs and micrococci (fig. 8). We have known since 1804 that the saliva of rabid animals is infectious. In 1880, Pasteur commenced experiments for a rabies inoculation by injecting rabbits with the saliva of a girl who had died of the disease, since the viruses themselves were so small as to be invisible even to the microscope. Frederick W. Twort (1877–1950) discovered these viruses.

FIG 7 Illustrations of spermatozoa of the sheep
by Antoni van Leeuwenhoek (bottom) and
human sperms by Jan Ham 1677 (top),
from Leeuwenhoek, *Opera omnia*, 1722

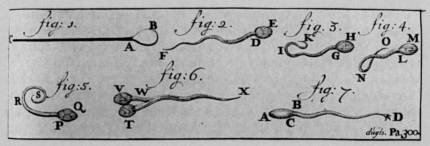

FIG 9 First reproduction of a modular micro-
scope and an illumination device con-
structed after the model of a cobbler's
ball by Robert Hooke in 1665

FIG 10 Hooke's illustration of the cells of
a bottle cork, which introduced
the term "cellula" to botany, from
Hooke 1665

FIG 11 BY2 cell with labeled microtubules,
still shot from a film by Dr. Pankaj Dhonukshe

Technically produced images thus played a central role in science and research for close to three hundred years, and great progress in science and medicine can be attributed to their use. Refusing technical images, however, the "art system" centered on handmade images. The art system refused progress. So while technical images have changed our vision of the human body, art has held onto the old vision: the surface of anatomy, even though it can't really be called "anatomy," because that would suggest cutting up the body with a microscope and painting beneath the surface. Since the nineteenth century, we would have needed an image science that treats scientific and art images equally. Today, for the first time, artists are performing that task.

Viruses and germs were *res invisibiles* until the microscope brought them into the visible realm. Affirming bacteria as pathogens depended on the microscope that could render the germs visible. So why should a painter stop at the limits of the visible as defined purely by natural vision? Why shouldn't a painter use as a motif those germs that become visible given certain technical aids? Indeed, artists drew and painted such germs, spermatozoa, and other cells. Yet these images made their way only into scientific books on medicine and biology, not into art books. The art system limited itself to surfaces that could be perceived by the natural sensory organ of the eye. Art wrongly refused to acknowledge the things that could be seen only by the microscope; it refused images that were drawn and painted of these new surfaces. It is time to overcome these limitations.

In 1665, English physicist Robert Hooke (1635–1702) published *Micrographia*[36] with the images he had made using one of the first microscopes (fig. 9). One image of the thin strata and honeycomb structure of a bottle cork, became famous in the history of science; Hooke was to call the holes in the cork *cellula* (fig. 10) or little chambers, since they reminded him of the outline of monks' cells. German scientists Theodor Schwann (1810–1882) and Matthias Schleiden (1804–1881) adopted the term in 1837 to describe the smallest units of all living creatures. And not long after, German biologist Rudolf Virchow (1821–1902) provided the classical dogma for the cell theory in his treatise on *Die Cellularpathologie* (1855): "Omnis cellula e cellula" [All cells stem from cells].[37] All life consists of cells, and all cells arise through growth and division of other cells. During development, the cells progressively differentiate and organize themselves to form tissue and organs. The human body consists of trillions of cells. Why did artists not paint these cells, but only the body?

FIG 9

FIG 10

FIG 11

Going beyond the limits of the visible defined by the sensory organs, contemporary perception (gr. *aesthesis* – aesthetic) now also covers cells, molecules, and atoms. A molecule (lat. *molecula* – small mass) is an entity consisting of two or more atoms, held together by covalent bunds. Oxygen ($O_2$) is probably our planet's most important molecule, as most creatures could not survive without the sheath of it that envelops the earth as atmosphere.[38] Hydrogen (H), assigned the atomic number of 1, is the most frequently encountered chemical element in the universe and was discovered by the British scientist, Henry Cavendish (1731–1810) in 1766. However, molecules are usually conglomerates of atoms of different elements, such as water ($H_2O$). In a famous experiment conducted in 1783, Antoine Laurent de Lavoisier (1743–1794) – the founder of modern chemistry and the man who gave two molecules their names (oxygen in 1774 and hydrogen in 1783) – demonstrated that water is not one of the four basic elements, but is a chemical combination of oxygen and hydrogen ($H_2O$).

## Molecular World

Molecules themselves are not visible without the help of apparatuses and therefore have to be described symbolically, as models made up of spheres, for example. The formula for a molecule consists of the atomic symbols of the elements contained in the molecule and, as an index (the subscript numerals), the number of the respective atoms per molecule. In the case of more complex molecules, such as occur primarily in organic chemistry, a formula often does not provide an adequate description since different molecules may have the same formula (isomers). In such instances, a structural formula is used to depict the molecule graphically.

My own interest in molecules began in about 1958 when, having already learned that atoms were the world's building blocks, I came to realize that molecules were the building blocks of life.[39] Herbert W. Franke's *Magie der Moleküle*[40] accompanied me on my lone summer walks through the woods in my fourteenth year. Fascinated by the numerous illustrations of crystal structures and lattices, rings and chains, space-filling models, and shots taken through electron and ion microscopes, I taught myself the alphabet of life.

FIGS 14–17

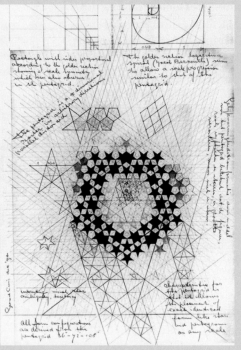

FIG 12 Gerard Caris, *Pentagrid*, 1994, mixed media on photostatic paper, 42 × 25.9 cm

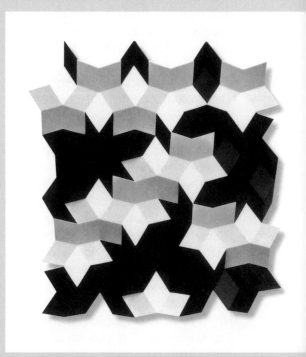

FIG 13 Gerard Caris, *Reliefstructure 21V-1*, 2004, polystyrene, fiberglass, reinforced epoxy, aluminum, paint, 57 × 52 × 5.5 cm

**FIG 14** Herbert W. Franke, an overview of our known ways to characterize the structure of molecules: 1st line: the chemical formula, 2nd line: the structural formula, 3rd line: the ball-and-stick model, 4th line: the space-filling model; left: glucose, middle: ethyl alcohol, right: carbon dioxide, 1958

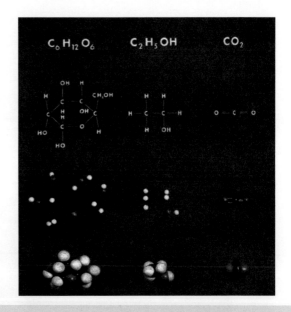

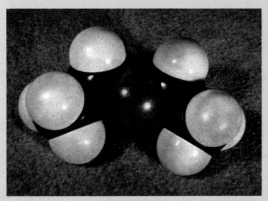

**FIG 15** Herbert W. Franke, the space-filling model of diethyl ether, 1958

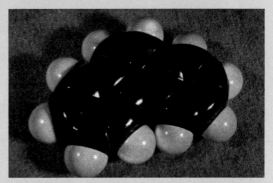

**FIG 16** Herbert W. Franke, the space-filling model of phenanthrene, 1958

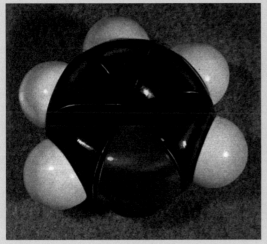

**FIG 17** Herbert W. Franke, the space-filling model of the pyridine, 1958

**FIG 18** M. F. Perutz, 3-D representation of a complete haemoglobin molecule, also published in: Herbert W. Franke, *Sinnbild der Chemie*, Heinz Moos, Munich, 1967

*Another view of the Regatta Restaurant*

BELOW: *The group display in the foyer of the Regatta Restaurant, South Bank. In this panel are shown representative examples from each of the members of the Festival Pattern Group. Attention is drawn to the Wedgwood group (designer: Peter Wall), centre right, and to the plate from E. Brain & Co Ltd (designers: Miss H. Thumpston and Peter Cave), centre, not illustrated elsewhere*

FIG 19–20 Festival Pattern Group, Decorations from Crystal Structures for the Regatta Restaurant on the South Bank of London, 1951

## HERE THE DECORATIONS COME FROM CRYSTAL STRUCTURES

In this Restaurant a novel system of decorative pattern has been used. The patterns applied to the decorations, furnishings and tableware are derived from crystal structure diagrams, which are the maps that a scientist draws to record the arrangements of the atoms in particular materials under examination.

This branch of science (crystallography) is highly developed in Britain and the suggestion to put the diagrams to decorative uses came originally from the crystallographers themselves. An explanation of the science appears in the Dome of Discovery in "The Physical World" and some of the decorative applications are displayed there too.

A group of leading manufacturers has co-operated in this experiment and this display shows examples from all their work, which extends beyond the decoration of this restaurant, to many other products decorated with these exciting patterns.

*Descriptive panel, border design, in colour, based on Polythene. In the group display at the Regatta Restaurant, South Bank. London Typographical Designers Ltd*

*Chair. In the Land Travelling Exhibition. Made by Goodearl Bros Ltd, designer E. L. Clinch. Ornament based on Polythene diagram*

BELOW: *Tea set, R. H. & S. L. Plant Ltd, designer Miss Hazel Thumpston. A general essay on the Crystal Patterns theme. In the group display at the Regatta Restaurant, South Bank*

**FIG 21** Exhibition of Science, Festival of Britain, 1951: Afwillite 8.45 wallpaper by John Line used as backdrop to the displays. 600 ft ball-and-spoke light fitting based on the atomic structure of carbon, designed by Brian Peake, produced by GEC

Chemists like to distinguish between inorganic and organic chemistry, or, more simply said, between dead and living matter. But Friedrich Wöhler (1800–1882) was to undermine the distinction with his synthesizing oxalic acid by the hydrolysis of cyanogen in 1824, and by synthesizing urea from ammonium cyanate in 1828. These syntheses marked the beginnings of biochemistry, as, for the first time, materials hitherto known to exist only as living organisms had been artificially created from "inorganic" matter. Initially, these in vitro syntheses went as good as unheeded by chemists as the time was not yet ripe for them. However, the concept of a transcendental life force (*vis vitalis*) became obsolete.

Lothar Meyer (1830–1895) as well as Dmitri Mendeleev (1834–1907) both independently developed a periodic classification of the elements, which gave a basis for explaining the properties of materials by referencing their molecular structure first and foremost. In 1869, Mendeleev published *The Dependence between the Properties of the Atomic Weights of the Elements* which was later to be termed *the periodic table of elements*. At that time, only sixty-three such elements were known. Mendeleev ordered them by increasing atomic mass, then dividing them into seven groups that shared common properties. A few months after Mendeleev, Meyer published an almost identical table. Mendeleev used his system to predict as early as 1871 the properties of gallium (Mendeleev called it *eka-aluminum*), scandium (his term: *eka-bor*) and germanium (*eka-silicium*) – elements unknown at the time. Some time later his hypotheses were proved to be scientifically correct.

Of all the molecules crucial to life, the proteins are the most important. The term itself dates back to Dutch chemist Gerardus Johannes Mulder (1802–1880), who introduced it on the basis of an idea mooted by Jöns Jakob Berzelius (1779–1848), a Swedish chemist. The proteins represent almost half of the body's dry matter, accounting for 30% of the body. For the most part, the proteins are made up of carbon, hydrogen, oxygen, and nitrogen. Proteins are also referred to as macromolecules, since they usually contain more than one atom of these elements. The human body is thought to be home to more than one hundred thousand different types of proteins in the form of long amino acid chains. Proteins also form the molecules of genetic inheritance, the DNA and RNA that pass genetic data to the next generation via long polymers of deoxyribonucleic acid.

FIGS 22, 23

In recent decades, new fields of science have arisen in the form of molecular biology and chemistry, molecular electronics and biotechnology, molecular physics and genetics, nanotechnology, genetics and epigenetics, collectively expanding the horizon of visible things virtually into infinity. As microscopes become better, we are able to penetrate ever deeper beneath the surface of things. Molecular cellular biology has advanced considerably thanks to the development if new light-optical microscopes. Using them, we can watch molecules at their wild dance, and follow cell division and the growth and decay of proteins – live. Digital cameras attached to these microscopes deliver a host of images. And to assess the mass of images, we need mathematics and computers to help us discern patterns and the relevant information. Such automated, computer-supported image analysis makes the finest of magnifying glasses.[41] In the twenty-first century, artists accompanied scientists on their expeditions into the invisible world. Shane Hope uses computer technology to generate hologram-like

**FIG 22** Individual DNA molecules

**FIG 23** Images of cell nuclei made by fluorescence microscopy, a number of proteins that organize the DNA are tagged with fluorescent labels

pictures whose multicolored molecule model layers seem to inhabit an actual three-dimensional space. He uses 3D printing to create molecular models <span>FIGS 24–26</span> (figs. 24–26). Even molecular manufacturing is possible: with the help of an open-source system known as PyMOL, viewers can visualize molecules.

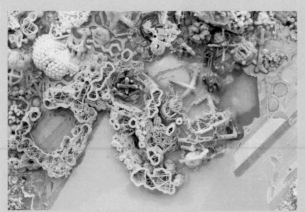

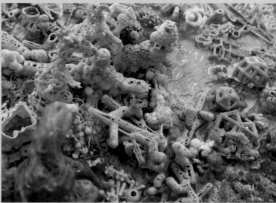

FIG 24 Shane Hope, *Far Edge Soylent Green Tea Party*, detail, 2013, 3-D printed PLA molecular models on acrylic substrate, 60 × 60 cm

FIG 25 Shane Hope, *Species-Tool-Being No. 5*, detail, 2012, 3-D printed PLA molecular models on acrylic substrate, 30 × 30 cm

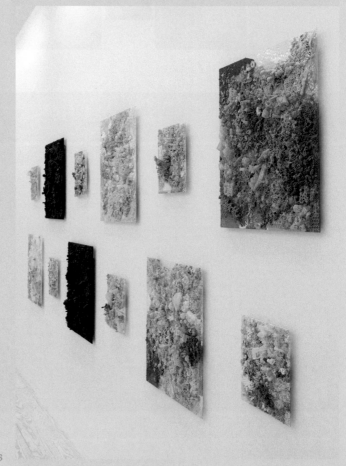

FIG 26 Shane Hope, *Species-Tool-Beings*, 2012–2013, installation view, Winkleman Gallery, 2013

## From Psychedelic to Bio Art

Between 1500 and 2000, art mainly limited itself to representing the shapes of visible things (*cosa evidente*). Over the same period, science concerned itself increasingly with what Francis Bacon termed the *res invisibiles*. Science discovered objects and creatures that the eye could not see, yet which nevertheless existed. George Berkeley's (1685–1753) statement that *esse est percipi* (from the *Treatise Concerning the Principles of Human Knowledge*, 1710) is now only of limited veracity, as not only what is perceived exists, but things exist that cannot be perceived, or, more precisely, can only be perceived by using apparatuses. This was the dividing line between art and science. Art centered on the perception of visible things, while science concentrated on the ability to perceive invisible things. Clearly there were crossovers; the drawings, illustrations, and images in books by scientists, be it Carl Linnaeus (1707–1778)[42] (figs. 27, 28) or Matthias **FIGS 27, 28** Jakob Schleiden (1804–1881)[43], were mainly rendered by artists. Yet, as we have seen, these marvelous representations of invisible things landed, not in the art books, but in scientific tomes. A treasure trove of great drawings and paintings is thus to be found in the libraries of this world in portfolios of physics, chemistry, botany, zoology, geography, and astronomy. Visualized science has already existed for centuries, but it was marginalized by art itself, not to say annulled. It is high time to render this art accessible to the contemporary world. Going forward, we will need a science of the image that includes handmade images by artists, and technical images made by artists as well as scientists. In the future, art will be weak visualization, and science will be strong visualization.

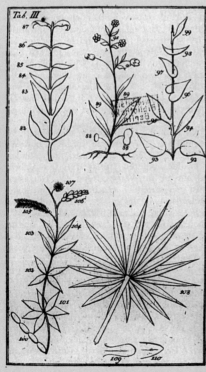

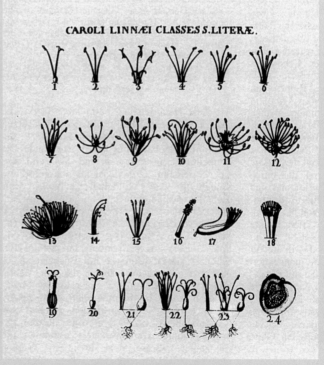

**FIG 27** Drawings by Linnaeus to illustrate the terminology of organs, shapes and formations of leaves required for plant classification, from: *Philosophia botanica*, 1751

**FIG 28** Broadsheet with illustrations of Linnaeus' sexual system by the German painter G. D. Ehret (1708–1770)

There are opposing aesthetic schools, then: the art of perception, and the science of perception, the aesthetics of art and the aesthetics of science. Art has limited itself to the field of visible things, to things the naked eye can perceive. Science has greatly extended this realm of vision using apparatuses from microscopes to telescopes. Art first addresses the invisible after 1900, focusing not on the *res invisibiles*, but on the artist's invisible internal states, on psychological and nervous agitation. Paul Klee's famous statement that "art does not reproduce the visible; rather, it makes visible"[44] should be seen in this psychological context. By contrast, science has, for five hundred years, used apparatuses to extend the perception of things beyond "the doors of perception"[45] to include things invisible to the naked eye, but visible to machines.

In the 1950s and 1960s, artists and writers started using drugs to systematically experiment with the doors of perception, the eye and the ear. Psychedelic painting, media, and music were the overwhelming effect. In 1938, Swiss chemist Albert Hofmann and his associate, W. A. Kroll, discovered the hallucinogenic drug LSD (Lysergic Acid Diethylamide), which Hofmann tried by chance in 1943, thus embarking on the first acid trip. Psychiatrist Humphrey Osmond, who experimented with LSD in order to try and heal mental illnesses such as schizophrenia, first used the term "psychedelic" in a letter to Aldous Huxley in 1956 to describe the impact it had in "enriching the mind and enlarging the vision."[46] By the 1960s, and out of the LSD and other psychotropic substances, a culture of music and media, of light shows and rock concerts, arose to give the mind-expanding experiences and the altered states of consciousness center stage in a counterculture, indeed pop culture, per se (figs. 29–36).[47]

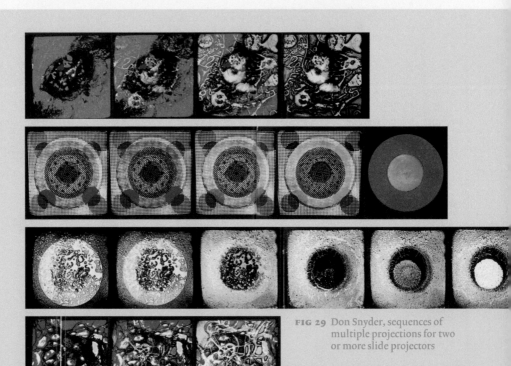

FIG 29 Don Snyder, sequences of multiple projections for two or more slide projectors

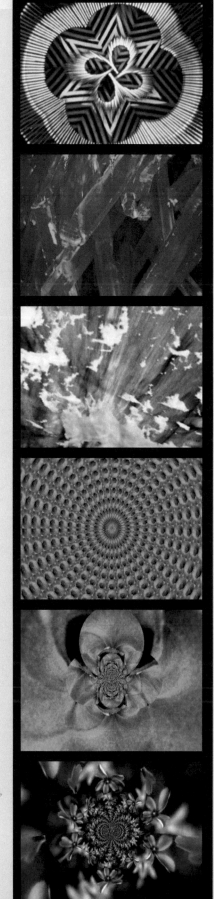

FIGS 30–31 Mark Boyle, Joan Hills,
*Light projections at UFO club,*
London, 1967

FIG 32 Gerd Stern, *Moires on Moires,*
film still, edited by Robert
Holswade & Gerd Stern

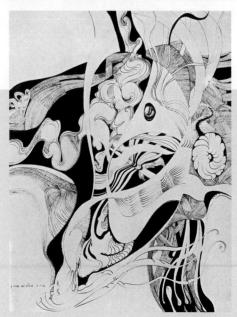

FIG 33 Arlene Sklar-Weinstein, *Inside a Seed*, 1966, drawing, 23 × 30 cm

FIG 36 Earl Reiback, *Crystalline Projection*, 5 × 5 slides

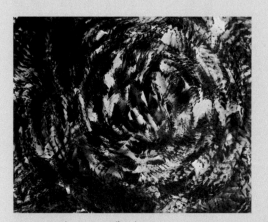

FIG 34 Irwin Gooen, *Vibrations – I*, 1967, 17 × 12 cm

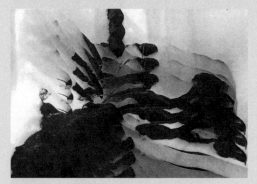

FIG 35 Irwin Gooen, *Return to Source – IV*, 1966, 19 × 15 cm

The drug experiences of a minority in the 1950s named the Beat Generation[48] became mainstream in counterculture, whose influence can still be noted in the cyber culture of the 1980s and 1990s.[49] Spiritual experiences mixed with religious experiences and acoustic and visual hallucinations. Timothy Leary emerged as the guru of this psychedelic movement.[50] His slogan "Follow your DNA" shows how he anticipated "neuroaesthetics" by investigating "neuropolitics"[51] that derived the psychedelic experience directly from the way chemical substances activated neurons, cells, and molecules. The psychedelic art of the 1960s thus stood out for its intuitive approach to the molecular revolution. It served somewhat as a predecessor to the molecular aesthetics that later arose from the dialog between science and art, that layed the foundations for science-based art and research-based art.

Drug induced experiments and "verbi-voco-visual explorations"[52] within the domain of cells, neurons, and molecules activating visual and acoustic sensations "beyond the surface," visions of the "third mind"[53] erected a powerful counterculture in music, literature, and art, indeed the very foundation of the youth revolution, the pop revolution, and art expansion in the 1960s. At the same time, such experiments also constructed a kind of counter- or parascience whose results, still under the tabu of illegal research or operations, have not yet been explored. Without such experiments, the altered states of consciousness that lead to encounters with other or older religions, rituals of gurus, and shamans in the east and the south[54] would have gone uncharted. The cyber culture and information revolution would not exist as it does today.[55]

Awakened by, and aware of, this new "biopolitic" (Michel Foucault), artists started to show interest in process art, and in organic processes accordingly. Classical art was centered on the production of inorganic objects. With the expansion of the visual arts in the 1960s, by virtue of its immaterial tendencies, process-directed investigations[56], and its variations on the formula "Art is Life. Life is Art," some artists started to work with biological processes, or processes in biological matters.

Especially kinetics, or the art of motion, allowed viewers to think further and to include not only "solid" matter and things, but also organic, living material. Mark Boyle projected liquid material live at rock concerts, for example. And Gustav Metzger became aware of the potential of liquid crystal technology for kinetic art in 1964; as one result, he presented his work *Earth from Space* in 1966 (see the artist pages for Gustav Metzger, in this volume, pp. 84–89).

A crystal is any solid that gives a discrete x-ray diffraction pattern. The microscopic photographs of crystal forms by Heinrich Schenk, published in 1910 with an introduction by K. Schmoll von Eisenwerth, the Austrian *fin the siècle* painter, were intended primarily for aesthetic contemplation and are beautifully printed in pairs (figs. 37, 38). Crucial in the application of x-ray crystallography as a FIGS 37, 38 key technique for the microanalysis of substances, for example biological molecules, was the team around Desmond Bernel, one of whose collaborators, Dorothy Hodgkin, ingeniously used x-ray analysis to describe the structure of cholesterol in 1937 and penicillin in 1954. According to Bernal, however, some of the "most beautiful x-ray photographs of any substance ever taken" were made by the superbly competent and painstaking crystallographer Rosalind Franklin, based at King's College, London. Her photographs, made with a very high resolution camera she designed and improved, and analysis of DNA structure

produced between 1951 and 1953, were crucial data for the double helix model designed by Crick and Watson.

Manfred Kage, who founded the *Institut für wissenschaftliche Photographie und Kinematographie* [Institute for Scientific Photography and Cinematography] also worked often with crystallographic structures of materials in his photographs (figs. 39, 40).

FIGS 39, 40

In the 1960s and 1970s, HA Schult and Dieter Roth worked with the processes of decay and mold in organic materials, with bacteria, and the like.[57] Michael Badura and others followed (figs. 41, 42). This spawned a movement which Eduardo Kac coined as "Bio Art" 1997 (see the artist pages for HA Schult, Dieter Roth, and Eduardo Kac, in this volume, pp. 90–93, 94–95, 96–101). Further promoters included pioneers such as Joe Davis (see the artist pages for Joe Davis, in

FIGS 41, 42

**FIGS 37, 38** Heinrich Schenk, *Microscopic Models of Crystal Forms*, 96 plates of microscopic photographs of crystals, Stuttgart, 1910

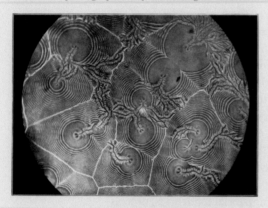 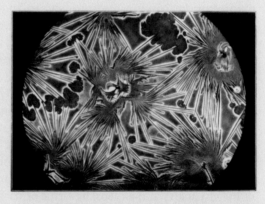

**FIG 39** Manfred Kage, *Sulfanilic acid*, 1956, light microscope, polarized light, 100× magnification, 10× lens

**FIG 40** Manfred Kage, *Thiosemicarbazide*, 1956, light microscope, polarized light, 100× magnification, 10× lens

this volume, pp. 450–455) and SymbioticA. Since 2000, the Australian laboratory SymbioticA has enabled artists and researchers to engage in wet biology practices in a biological science department. It also hosts residents, workshops, exhibitions and symposiums. "The Centre offers a new means of artistic inquiry where artists actively use the tools and technologies of science, not just to comment about them but also to explore their possibilities."[58]

## Apparatus-based Vision

Since the emergence of apparatus-based media art (photography, video, film, computer), the relationship between the aesthetics of science and art has changed. Along with the rise of media, apparatus-based perception – previously the domain of the sciences – has now entered that of art. A large number of scientific films have influenced the visual arts, whether anonymous films on Brownian motion in 1905, or documentaries on creatures of the ocean such as those by Jean Painlevé (1902–1989). He shot his first film on the growth of a fish in 1925, and was to develop special recording techniques for underwater filming. Silently observing the world of animals, he produced popular films and dramas that influenced artists such as Man Ray and Luis Buñuel. In 1948, he published his book on *Le cinéma scientifique français*. Today, his films' realism seems surreal.

Today, growth and form (*On Growth and Form*, D.W. Thompson, 1917) and the life of forms (*La vie des formes*, H. Focillon, 1934) can be studied on molecular level. The advent of apparatus-based media art marked the beginning of an epoch in which scientific images influenced those in art, or were used to legitimate artistic experiments. Specifically abstract art was supported by comparisons with scientific morphologies. Artists, designers, and architects such as Richard Buckminster Fuller, Rudolf Arnheim, Charles Eames, and György Kepes, became interested in new scientific images as they sought to discover new visions that could complement their own production methods. In 1956,

FIG 41 Michael Badura, *EINGEWECKTE WELT*, installation view Galerie im Centre Göttingen, 1967, many different ecological demonstrations, natural material, nitrogen and carbon dioxide

FIG 42 Michael Badura, *EINGEWECKTE WELT*, installation view, Kunstverein Krefeld, 1977

Kepes published *The New Landscape in Art and Science*, a standard work on the new relationship between scientific and artistic aesthetics.[59] In the book, he pairs Modernist artworks with scientific images that can only be seen with high-tech aids such as x-ray machines, stroboscopic cameras, electron microscopes, echo sounders, radar, powerful telescopes, infrared sensors, and the like. From 1965 to 1966, Kepes published a series of six anthologies entitled *Vision + Value*.[60] These studies on the relationship of art and science spawned the 1967 foundation of the Center for Advanced Visual Studies (CAVS) at MIT in Boston. The title refers to visual studies, not to the visual arts. Another institution at MIT was founded under Nicholas Negroponte's *Architecture Machine Group*: the renowned MIT Media Laboratory (or Media Lab). It was founded in 1985 with the intention of scientifically studying the then pending interlocking of computer technology, architecture, and art. It bears noting here that the term "visual studies" replaced that of "art," given that in the 1960s many artists preferred already the notion "research," like GRAV (Group de recherche d'art visuelle) in Paris. From 1968, the artists movement New Tendencies staged colloquia on computers and visual research rather than on art.[61]

## Renaissance 2.0

The Greek word for aesthetics, *aisthesis*, originally meant perception, suggesting aesthetics as the doctrine of perception. Not until around 1800 did *artes liberales* turn into *les beaux-arts*, or the fine arts. The aesthetics of general perception was thus limited to the perception of the beautiful. Aesthetics changed from a theory of perception to a theory of the arts, worse still, a theory of the fine arts. When, in the twentieth century, the media arts started focusing once again on the laws of perception, the fine arts had no place for the media, although many of the twentieth century art currents, such as kinetics and Op art, were largely indebted to the experimental psychology of the nineteenth and nascent twentieth centuries

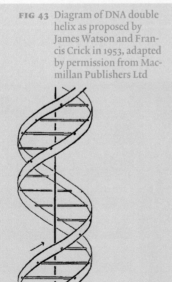

FIG 43 Diagram of DNA double helix as proposed by James Watson and Francis Crick in 1953, adapted by permission from Macmillan Publishers Ltd

FIG 44 Francis Crick, pencil sketch of the DNA double helix, 1953. It shows a right-handed helix and the nucleotides of the two anti-parallel strands.

and the new apparatuses. When, with new image-generating processes, science increasingly contributed to the theory and practice of perception, the arts gradually felt the squeeze. Alexander Gottlieb Baumgarten (1714–1762), who had with his *Meditationes* (1735)[62] founded aesthetics as an independent philosophical discipline in Germany, rightly defined aesthetics as the theory of sensory cognition. This is the notion of aesthetics we should take today, albeit with the addition that the potential for cognition today exceeds natural sensory perception. Today, we also gain aesthetic insights using theories, concepts, and technological experiments. Traditionally science begins where perception ends. Today, art also exceeds natural perception. This is the lesson we learn from molecular aesthetics. Classical aesthetics were limited to the perception of surfaces that could be processed by the eye, for example the observable surfaces of human anatomy. Logically, the human sense of beauty, the doctrine of symmetry and harmony, took the human body as its starting point. Similarly, these aesthetic laws were drawn up according the surface phenomena encountered in nature, from the anatomy of animals to the shape of plants. Yet new technologies allow us to break through the surfaces and enter new zones of the visible. We are no longer dealing with macroscopic, but with microscopic phenomena. And we find proof of the assumption that in microscopic dimensions, the laws of harmony, symmetry, and beauty we established for the macroscopic level are to live on. Werner Hahn's study *Symmetry as a Developmental Principle in Nature and Art*[63] indicates that symmetry evolved over billions of years as a universal structural principle. Symmetries not only shaped our senses, but our cognitive apparatus is shaped according to the real world's symmetries, too: "Be it in quanta, atoms and crystals, in the shapes of bodies, senses and brains," everywhere symmetries play a central role.[64] The famous structure of the double helix discovered by James D. Watson and Francis Crick in 1953 is the best-known example for complementary symmetry in the field of molecules (figs. 43, 44).

FIGS 43, 44

Thus, we can speak justifiably of molecular aesthetics instead of the aesthetics of anatomy. Hermann Josef Roth was probably the first who used the term FIG 45 "molecular aesthetics" (fig. 45). In other words, with the apparatus-based perception of molecules and the formation of symbols helping to visualize them, we are concerned with the physics and chemistry of life, with the human body as a chemical factory. Even if it may not seem so, we find ourselves in the territory of aesthetics, of aesthesis, of sensory perception – with the exception that an aesthetic of non-sensory perception is involved, namely, the perception of phenomena hitherto inaccessible to natural sensory perception. This extension is an extension of aesthetics from the perception of visible things with natural organs to the perception of invisible (invisible for the natural eye) things with the help of apparatuses. Aesthetics does not get lost with this extension of sensory to non-sensory perception; instead the field of aesthetics is expanded from what were once fields invisible to natural perception to those that are now visible. At the beginning of the twenty-first century, we register that art and science work together in common problem fields, that are the invisible fields that remain concealed to the human eye. Indeed, scientists and artists both work with shapes

FIG 46 Petra Maitz, ALL IS FULL OF MOLECULES, 2009, pen, overhead transparency and watercolor on paper

**FIG 47** Petra Maitz, TRNA, The connection of Molecules and NEURONES – The Memories of the molecules, the body without consciousness?, 2010, acrylic and collage on paper

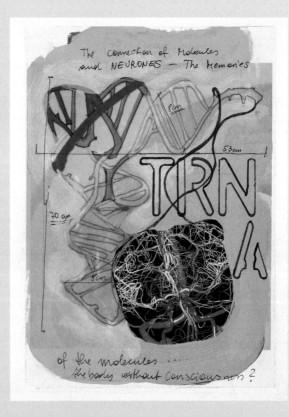

**FIG 48** Petra Maitz, TRNA-Modell, proposition for a sculpture in public space, Graz, 2009

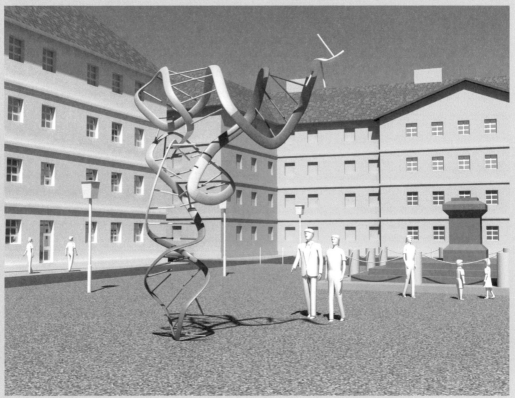

All three images from the dissertation of Petra Maitz, *Visualisierungsmöglichkeiten von Evolution. Die Zeichnung in Kunst, Medizin und Biologie* [Visualization Possibilities of Evolution. Drawings in Art, Medicine, and Biology], 2013, to be published in 2014

and particles that were hitherto *res invisibile*, invisible to natural perception. The apparatus-based media have initiated a new interest in scientific images, even non-art images. If the prize for conquering new worlds of images is to drop conservative notions of art, the best artists have always be willing to drop art in the name of cognition. Therefore art is approaching a renaissance 2.0.

Questions about the components from which life is formed are being explored not only in the natural sciences, but also by the science of the artificial, namely information and computer science.[65] Certainly, the language of life is the language of biochemistry, and our heuristic models for life refer to molecular structures and interactions. Yet molecular biology and molecular chemistry often reach a level of abstraction that requires computer simulations. For this reason, theoretical biologists and chemists substitute symbols for molecular structures, and algorithms for chemical reactions. The key question here is not whether the results of these computer simulations are rightly termed "artificial life," but to what degree computer sciences can provide insights into the aesthetic regularities underlying living creatures. Computational support of image and data interpretations is necessary to understand the complex structures of the life process. New results in graph theory, topology, and geometry can help to formulate and visualize better molecular perception.

Examples of such insights are the studies by John H. Holland, John H. Conway and Harold Scott MacDonald Coxeter, not to overlook Benoît Mandelbrot's fractal theory.[66] Coxeter is said to have reinvented geometry.[67] In fact, his essays and publications prove geometry to be timeless.[68] The Todd-Coxeter algorithm offers insights without which many aspects of the geometry of space time would remain invisible. His geometric visualizations open up a horizon of hitherto unthought-of symmetries. John Horton Conway is of a similar lineage, whose mathematical *Game of Life* (1970) simulates the life of cells, their growth and death in a single field. His ideas repeatedly turn to the aesthetics of symmetry.[69] In Conway's universe – a field of 25 cells (5 × 5), for example – mutable patterns arise through the non-linear interactions of particles (states) in neighboring cells. Some 32,000,000 configurations are possible. Yet Conway's *Game of Life* is nothing other than a cellular automaton, the theory developed around 1940 by John von Neumann and Stanislav Ulam.[70]

In other words, cellular automatons are attempts to mathematically model or simulate living processes. Cellular automatons can also provide techniques of composition, for example cellular music.[71]

The science of the cellular automaton gave rise to the science of neurocomputing.[72] J. H. Holland contributed to this science at an early date by relying precisely on this analogy of cellular aggregation and the digital computer.[73] In his later works, he advanced theories on cellular automatons and neuronal networks to generate a theory of genetic algorithms and used it to formulate a theory of emergence – defined as the principle that turns chaos into order.[74] Not surprisingly, in Santa Fe, New Mexico, a group of Nobel Prize laureates in physics and economics have joined forces with leading mathematicians and computer scientists to develop a new science, namely the science of complexity.[75] It would seem destined to explore life's most complex of processes. In future, it is likely that beauty may well cease to be convulsive only, as the Surrealists claimed, but may – along with music – be acknowledged as molecular.[76] For we are on the verge of a *révolution moléculaire*.[77]

## Notes

1 See: Heinrich Klotz, *Die Zweite Moderne. Eine Diagnose der Kunst der Gegenwart*, Beck, Munich, 1996.

2 See: Jeremy Rifkin, *The Third Industrial Revolution. How Lateral Power is Transforming Energy, the Economy, and the World*, Palgrave Macmillan, New York, 2011.

3 A 1920 photograph shows George Grosz and John Heartfield at the Otto Burchard Gallery in Berlin holding a placard saying "Die Kunst ist tot. Es lebe die neue Maschinenkunst TATLINS" in response to Vladimir Tatlin's proposal for the monument to the Third International (1919).

4 See: Fernand Léger, "The Machine Aesthetic. Geometric Order and Truth," in: Fernand Léger, *Functions of Painting*, Viking, New York, 1973; idem, "The Machine Aesthetic. The Manufactured Object, the Artisan, and the Artist," in: *Functions of Painting*, 1973, pp. 52–53.

5 See: Sigfried Giedion, *Mechanization Takes Command: A Contribution to Anonymous History*, Oxford University Press, New York, NY, 1948.

6 See: René Simmen (ed.), *Der Mechanische Mensch. Texte und Dokumente über Automaten, Androiden und Roboter. Eine Sammlung*, Simmen, Zurich, 1967. From 1915 to 1922 Francis Picabia's artistic efforts focused on machines and he produced works such as *Ici, c'est ici Stieglitz* [*Here, This Is Stieglitz Here*] (1915), *Machine, Tournez Vite* [*Machine Turn Quickly*] (1916), *L'Oeil cacodylate* [*The Cacodylic Eye*] (1921), and representations of humans with mechanical characteristics, such as *Voilà Elle* [*Here SHE Is*] (1915) or *Fille née sans mère* [*Girl Born without a Mother*] (1916–1917). One of Marcel Duchamp's principal works, *La Mariée mise à nu par ses célibataires, même (Le Grand Verre)* [*The Bride Stripped Bare by Her Bachelors, Even (The Large Glass)*] (1915–1923) returns to various of his earlier mechano-centric works, such as *La Mariée* [*The Bride*] (1912) and *La Machine Célibataire* [*The Bachelor Machine*] (1913). Also worthy of note are his *Neuf moules mâlic* [*Nine Malic Moulds*] (1914–1915), *Le Roi et la Reine entourés du nus vites* [*The King and Queen Surrounded by Swift Nudes*] (1912), and *Nu (esquisse), Jeune homme triste dans un train* [*Nude (Study), Sad Young Man on a Train*] (1911–1912).

7 See: Lázló Moholy-Nagy, *Von Material zu Architektur*, Langen, Munich, 1929.

8 See: Frank Lloyd Wright: *Modern Architecture. Being the Kahn Lectures for 1930*, Princeton Univesity Press, Princeton, NJ, 2008. The Kahn lectures, six lectures delivered at Princeton University in May 1930, covered a wide range of topics including "Machinery, Materials, and Man" and "Style and Industry."

9 See: Jean Baudrillard, "La précession des simulacres," in: *Traverses*, no. 10, Paris, 1978.

10 Martin Kemp and Margaret Walker (eds.), *Leonardo on Painting. An Anthology of Writings by Leonardo da Vinci; With a Selection of Documents Relating to his Career as an Artist*, new edition, Yale University Press, New Haven, London, 2001, p. 15.

11 Savonarola, who had studied the works of Aristotle and Thomas Aquinas, was the famous Dominican rebel in Florence, who, in 1472, published *De Ruina Mundi* and, in 1475, *De Ruina Ecclesia*; in 1498 he was publicly hanged and burned on the square where he himself had books and artworks burned that he felt were immoral.

12 See: Girolamo Savonarola, *De omnium scientiarum divisione*, Printer of Savonarola, Pescia, about 1492.

13 As quoted from: Gerhard Gerkens (ed.), *Maurice Denis. Gemälde, Handzeichnungen, Druckgraphik. Meisterwerke des Nachimpressionismus aus der Sammlung Maurice Denis*, exhib. cat., Kunsthalle Bremen, 1971, H.M. Hauschild, 1971, p. 22; translated from the German by Jeremy Gaines.

14 See: note 10.

15 See: Wassily Kandinsky, *Punkt und Linie zu Fläche. Beitrag zur Analyse der malerischen Elemente*, Bauhausbücher 9, Langen, Munich, 1926; Kazimir Malevich, *Die gegenstandslose Welt*, Bauhausbücher 11, Langen, Munich, 1927; Paul Klee, *Pädagogisches Skizzenbuch*, Bauhausbücher 2, Langen, Munich, 1925; Piet Mondrian, *Neue Gestaltung. Neoplastizismus*, Bauhausbücher 5, Langen, Munich, 1925.

16 See: Wassily Kandinsky, *Punkt und Linie zu Fläche. Beitrag zur Analyse der malerischen Elemente*, Bauhausbücher 9, Langen, Munich, 1926 (English: *Point and line to plane: contributions to the analysis of the pictorial elements*, Solomon R. Guggenheim Foundation, New York, NY, 1947).

17 Paul Klee, *Pädagogisches Skizzenbuch*, Bauhausbücher 2, Langen, Munich, 1925 (English: *Pedagogical Sketchbook*, Nierendorf Gallery, New York, 1944).

18 Ludwig Wittgenstein, *Tractatus Logico-Philosophicus*, 4.01, Routledge, London, 1990.

19 See: Jean-François Lyotard (ed.), *Les immatériaux*, exhib. cat., Centre national d'art et de Culture George Pompidou, March 28 – July 15, 1985, Editions du Centre Georges Pompidou, Paris, 1985; Jean Baudrillard, *Simulations*, Semiotext(e), New York, 1983; idem, *Simulacra and Simulation*, University of Michigan Press, Ann Arbor, MI, 1994 (French original 1985).

20 Baudrillard 1978.

21 Suarez Miranda, *Viajes de varones prudentes*, book IV, chapter XLV, Lerida, 1658, in: Jorge Luis Borges, *Collected Fictions*, Penguin Books, London, 1998.

22 Peter L. Berger and Thomas Luckmann, *The Social Construction of Reality: A Treatise in the Sociology of Knowledge*, Doubleday, Garden City, 1966.

23 See for example: Ernst von Glasersfeld, "An introduction to radical constructivism," in: Paul Watzlawick (ed.), *The Invented Reality*, Norton, New York, 1984, pp. 17–40; Heinz von Foerster, "On Constructing a Reality," in: ibid.; Humberto Romesín Maturana, Francisco Javier Varela, *Autopoiesis and Cognition: The Realization of the Living*, Springer, Dordrecht, 1980.

24 Ernst Kapp, *Grundlinien einer Philosophie der Technik: zur Entstehung der Cultur aus neuen Gesichtspunkten*, Verlag George Westermann, Braunschweig, 1877.

25 Sigmund Freud, *Civilization and Its Discontents*, Norton, New York, 1961, pp. 37f.; translated from the German and edited by James Strachey.

26 See: Marshall McLuhan, *Understanding Media: The Extensions of Man*, McGraw-Hill, New York, 1964.

27 Niklas Luhmann, *Realität der Massenmedien*, VS Verlag für Sozialwissenschaften, Wiesbaden, 2004, p. 9.

28 Niklas Luhmann, *The Reality of the Mass Media*, Blackwell Publishers, Oxford, 2000, p. 1.

29 Leonardo da Vinci, *Trattato della Pittura*, quoted from: Claire J. Farago, *Leonardo da Vinci's Paragone: A Critical Interpretation with a New Edition of the Text in the Codex Urbinas*, Brill, Leiden, 1992, p. 181.

30 See: David Hockney, *Secret Knowledge: Rediscovering the Lost Techniques of the Old Masters*, Thames & Hudson, London, 2006.

31 See: Martin Kemp, *Visualizations. The Nature Book of Art and Science*, Oxford University Press, Oxford, 2000; idem, *Seen/Unseen. Art, Science, and Intuition from Leonardo to the Hubble Telescope*, Oxford University Press, Oxford, 2006; James Elkins, *The Domain of Images*, Cornell University Press, Ithaca, NY, 2001; Jonathan Crary, *Techniques of the Observer. On Vision and Modernity in the Nineteenth Century*, The MIT Press, Cambridge, MA, 1992; Barbara Maria Stafford, *Voyage into Substance. Art, Science, Nature and the Illustrated Travel Account, 1760-1840*, The MIT Press, Cambridge, MA, 1984; idem, *Body Criticism. Imaging the Unseen in Enlightenment Art and Medicine*, The MIT Press, Cambridge, MA, 1993; idem, *Artful Science. Enlightenment, Entertainment and the Eclipse of Visual Education*, The MIT Press, Cambridge, MA, 1994; Arthur I. Miller, *Einstein, Picasso. Space, Time, and the Beauty That Causes Havoc*, Basic Books, New York, 2001.

32 See: Marcello Malpighi, *Opera omnia, seu seu Thesaurus locupletissimus botanico-medico-anatomicus, viginti quatuor tractatus complectens et in duos tomos distributus, quorum tractatuum seriem videre est dedicatione absolutâ*, Scott & Wells, London, 1986.

33 See: Marcello Malpighi, *Anatome plantarum. Cui subjungitur appendix, iteratas & auctas ejusdem authoris de ovo incubato observationes continens. Regiae societati, Londini ad scientam naturalem promovendam institutae, dicata*, Martin, London 1675–1679, also available online at: www.biodiversitylibrary.org/item/60122 page/11/mode/1up, accessed 05/15/2013.

34 Francis Bacon, *De verulamio novum organum scientiarum*, also known as *Novum organum scientiarum*, 1620.

35 See: Robert Koch, "Die Ätiologie der Milzbrand-Krankheit, begründet auf die Entwicklungsgeschichte des Bacillus Anthracis" (1876), in: Ferdinand Cohn (ed.), *Beiträge zur Biologie der Pflanzen*, vol. 2, no. 2, Kern, Breslau, 1877, pp. 277–308.

36 See: Robert Hooke, *Micrographia, Or, Some Physiological Descriptions of Minute Bodies Made by Magnifying Glasses*, Dover Publications, New York, 1961.

37 See: Rudolf Virchow, *Die Cellularpathologie in ihrer Begründung auf physiologische und pathologische Gewebelehre*, Berlin, 1858.

38 Nick Lane, *Oxygen. The Molecule that Made the World*, Oxford University Press, Oxford, 2002.

39 Lily E. Kay, *The Molecular Vision of Life. Caltech, the Rockefeller Foundation, and the Rise of the New Biology*, Oxford University Press, New York, 1993.

40 Herbert W. Franke, *The Magic of Molecules*, Abelard-Schuman, London, 1958, (German original: *Magie der Moleküle*, F.A. Brockhaus, Wiesbaden, 1964).

41 See, for example the achievements of the computer scientist and bioinformatician Eugene Myers in the development of imaging technologies and computational methods for image analysis Myers established at Janelia Farm Research Campus (JFRC) of the Howard Hughes Medical Institute in Chevy Chase, MD.

42 See: Carl Linnaeus, *Systema Naturae*, Leiden, 1735; idem, *Bibliotheca Botanica*, Amsterdam, 1736; idem, *Fundamenta Botanica*, Amsterdam, 1736.

43 See: M. J. Schleiden, *Grundzüge der wissenschaftlichen Botanik nebst einer methodologischen Einleitung als Anleitung zum Studium der Pflanze*, 2 vols., Engelmann, Leipzig, 1842–1843.

44 "Kunst gibt nicht das Sichtbare wieder, sondern macht sichtbar," in: Paul Klee, "Schöpferische Konfession," in: Kasimir Edschmid (ed.), *Tribüne der Kunst und der Zeit. Eine Schriftensammlung*, vol. 13, Reiß, Berlin, 1920, pp. 28–40, esp. p. 28.

45 See: Geoffrey Keynes (ed.), *The Marriage of Heaven and Hell* [1790–1793] by William Blake, Oxford University Press, London and New York, 1975; Aldous Huxley, *The Doors of Perception*, Chatto & Windus, London, 1954.

46 Humphrey Osmond, "A Review of the Clinical Effects of Psychotomimetic Agent," in: *Annals of the New York Academy of Sciences*, vol. 66, no. 3, March 1957, pp. 418–434, here p. 429.

47  See: David S. Rubin, *Psychedelic. Optical and Visionary Art since the 1960s*, exhib. cat., Museum of Art, San Antonio, The MIT Press, Cambridge, MA, 2010.

48  See: William S. Burroughs, *Junkie: Confessions of an Unredeemed Drug Addict*, Ace Books, 1953 (published under the pseudonym William Lee); idem, *The Naked Lunch*, Grove Press, Olympia Press, 1959; Allen Ginsberg, *Howl*, in: *Howl and Other Poems*, City Lights Books, 1956; Jack Kerouac, *On the Road*, Viking Press, New York, 1957.

49  See: Fred Turner, *From Counterculture to Cyberculture. Stewart Brand, the Whole Earth Network, and the Rise of Digital Utopianism*, University of Chicago Press, Chicago, 2010.

50  See: Timothy Leary, Richard Alpert and Ralph Metzner, *The Psychedelic Experience. A Manual Based on the Tibetan Book of the Dead*, University Books, New Hyde Park, NY, 1964, p. 11: "the drug does not produce the transcendent experience. It merely acts as a chemical key – it opens the mind, frees the nervous system of its ordinary patterns and structures."

51  See: Timothy Leary, *Neuropolitics. The Sociobiology of Human Metamorphosis*, Starseed/Peace Press, Los Angeles, 1977.

52  See: Marshall McLuhan, *Verbi-voco-visual explorations*, Something Else Press, New York, 1967.

53  See: William S. Burroughs, Brion Gysin, *The Third Mind*, Viking Press, New York, 1978.

54  See: Carlos Castaneda, *A Separate Reality: A Yaqui Way of Knowledge*, 1968; or: Maharishi Mahesh Yogi, guru to The Beatles.

55  See: Fred Turner, *From Counterculture to Cyberculture*, The University of Chicago Press, Chicago, 2006; see also: Walter Isaacson, *Steve Jobs*, Simon & Schuster, New York, 2011.

56  See: Lucy Lippard, *Six Years: The Dematerialization of the Art Object from 1966 to 1972…*, Studio Vista, 1973; or the exhibition: *9 at Leo Castelli: Anselmo, Bollinger, Hesse, Kaltenbach, Nauman, Saret, Serra, Sonnier, Zorio* at Leo Castelli Gallery, December 4–28, 1968.

57  At his first exhibition in the USA at the Eugenia Butler Gallery in Los Angeles in 1970, Dieter Roth exhibited a series of 37 suitcases filled with cheese on the floor, above he presented pictures made with cheese on the wall.

58  Available online at: http://www.symbiotica.uwa.edu.au/, accessed 06/25/2013.

59  See: György Kepes, *The New Landscape in Art and Science*, Paul Theobald, Chicago, 1956.

60  Each volume contained more than two hundred pages of essays authored by the then most renowned artists, designers, architects and scientists. The result was a plethora of theme as reflected in the different titles: György Kepes (ed.), *The Education of Vision*, Vision + Value, vol. 1, Braziller, New York, 1965; idem, *Structure in Art and Science*, Vision + Value, vol. 2, Braziller, New York, 1965; idem, *The Nature and Art of Motion*, Vision + Value, vol. 3, Braziller, New York, 1965; idem, *Module, Proportion, Symmetry, Rhythm*, Vision + Value, vol. 4, Braziller, New York, 1966; idem, *The Man-Made Object*, Vision + Value, vol. 5, Braziller, New York, 1966; idem, *Sign, Image, Symbol*, Vision + Value, vol. 6, Braziller, New York, 1966.

61  See: Margit Rosen (ed.), *A Little-Known Story about a Movement, a Magazine, and the Computer's Arrival in Art. New Tendencies and Bit International, 1961–1973*, ZKM | Center for Art and Media Karlsruhe, The MIT Press, Cambridge, MA, 2011.

62  See: Alexander Gottlieb Baumgarten, *Reflections on Poetry; Alexander Gottlieb Baumgarten's Meditationes philosophicae de nonnullis ad poema pertinentibus*, University of California Press, Berkeley, CA, 1954 (Reproduction of the original ed., 1735).

63  Werner Hahn, *Symmetry as a Developmental Principle in Nature and Art*, World Scientific, Singapore, 1998, (German original: *Symmetrie als Entwicklungsprinzip in Natur und Kunst*, Langewiesche, Königstein, 1989).

64  Rupert Riedl, see note 15, p. 5, in: ibid.; see also: Werner Hahn and Peter Weibel (eds.), *Evolutionäre Symmetrietheorie. Selbstorganisation und dynamische Systeme*, S. Hirzel Wissenschaftliche Verlagsgesellschaft, Stuttgart, 1996.

65  See: Herbert A. Simon, *The Sciences of the Artificial*, The MIT Press, Cambridge, MA, 1969.

66  See: Benoît Mandelbrot, *The Fractal Geometry of Nature*, W. H. Freeman & Co, New York, 1982.

67  See: Siobhan Roberts, *King of Infinite Space. Donald Coxeter, the Man Who Saved Geometry*, Anansi, Toronto, 2006.

68  See: H.S.M. Coxeter, *Non-Euclidean Geometry*, University of Toronto Press, Toronto, 1942; H.S.M. Coxeter, with S. L. Greitzer, *Geometry Revisited*, The Mathematical Association of America, Washington/Random House, New York, 1967; idem, *The Beauty of Geometry: Twelve Essays*, Dover Publications, Mineola, 1968; idem, *Regular Complex Polytopes*, Cambridge University Press, Cambridge, MA, 1974.

69  See: John H. Conway and Derek A. Smith, *On Quaternions and Octonions – Their Geometry, Arithmetic and Symmetry*, A. K. Peters, Ltd., Natick, 2003; John H. Conway with Heidi Burgiel and Chaim Goodman-Strauss, *The Symmetries of Things*, A. K. Peters, Ltd., Natick, 2008; István Hargittai, "John Conway. Mathematician of Symmetry and Everything Else," in: *Mathematical Intelligencer*, vol. 23, no. 2, 2001, pp. 6–14.

70 See their later writings: Stanislaw Ulam, *Sets, Numbers, and Universes*, The MIT Press, Cambridge, MA, 1974; John von Neumann, *Theory of Self-Reproducing Automata*, University of Illinois Press, Urbana, IL, 1966.

71 They can ably serve as models for the new techniques in composing. Arnold Schönberg wrote in *Style and Idea* (1950) that essentially, the composer's problem is how to move from one note to the next (see: Arnold Schönberg, *Style and Idea*, Philosophical Library, New York, 1950). Normally, techniques of composing such as harmonics and counterpoint provide the key. But today, I can define the notes as points, and the points as numerals, and therefore compose algorithmically. I can also define the notes as cells and apply the rules from Convey's *Game of Life* to produce "cellular music," music by cellular algorithms. Music is defined as time-based art, a concept expressed by the interval theory, which is dominant for Western music. Notes are placed one after another as a temporal sequence on musical staves (attributed to Guido of Arezzo, 1025). By means of Clifford Algebra and Grassmann Vector Spaces, it can be demonstrated that a single topological sequence can be transformed into different temporal sequences. As such, music becomes part of topology, space-based art. The notes of a score can be taken as points and numbers. These numbers are part of a field, topological neighbors. *The Game of Life* by John Conway ideally reflects this new conception of music. It is a cellular automaton that serves as method of composition and consists of a regular grid of cells, each one of a finite number of states, such as "On" and "Off." This grid can be in any finite number of dimensions. For each cell, a set of cells known as its "neighborhood" is defined relative to the specified cell. A neighborhood might be defined as the set of cells at a distance of two or less from the cell. The cells are treated as notes and can be calculated or "composed" according to the rules of the *Game of Life*. Naturally this process can also be interpreted in a somewhat free manner.

72 See: J.A. Anderson/ E. Rosenfeld (eds.), *Neurocomputing. Foundations of Research*, The MIT Press, Cambridge, MA, 1988.

73 See: N. Rochester, J. H. Holland et al., "Tests on a Cell Assembly Theory of the Actuation of the Brain, Using a Large Digital Computer," in: J.A. Anderson/ E. Rosenfeld (eds.), 1988, pp. 68–79.

74 See: John H. Holland, *Hidden Order. How Adaptation Builds Complexity* (Helix Books), Basic Books, New York, 1996; idem, *Emergence. From Chaos to Order*, new edition, Oxford University Press, Oxford, 2000.

75 See: M. Mitchell Waldrop, *Complexity. The Emerging Science at the Edge of Order and Chaos*, Simon & Schuster, New York, 1992; Stuart Alan Kauffman, *At Home in the Universe: The Search for Laws of Self-Organization and Complexity*, Oxford University Press, New York, NY, 1995.

76 See: Thiery Delatour, "Molecular Music: The Acoustic Conversion of Molecular Vibrational Spectra," in: *Computer Music Journal*, vol. 24, no. 3, 2000, pp. 48–68. See also: Thierry Delatour, "Molecular Songs," this volume, pp. 292–311; Roald Hoffmann, "Molecular Beauty," this volume, pp. 122–141.

77 See: Félix Guattari, *La révolution moléculaire*, Recherches, Paris, 1977.

Translated from the German by Jeremy Gaines.

*Video Disque*
1969, UV screen print on spun aluminum disc,
74 cm diameter

**PETER SEDGLEY** (*1930 in London) was educated in
building and architecture. A self-taught painter, he
adopted geometric abstraction and optical imagery in
1963, positions which developed into kinetic and light
artworks. Sedgley has exhibited extensively in solo and
major theme exhibitions, creating multi-media envi-
ronments of light, sound, and movement which have
sometimes involved audience participation. He is co-
founder of SPACE artist studios with Bridget Riley, and
was a prizewinner at the 9th International Biennale,
Tokyo. Invited to Berlin in 1970 on the DAAD Artists-
in-Berlin Program, he has maintained studios both in
Germany and GB. "He has an international reputation
as one of the most inventive artists in his field" (quoted
from the *Oxford Dictionary of Modern and Contemporary Art*).

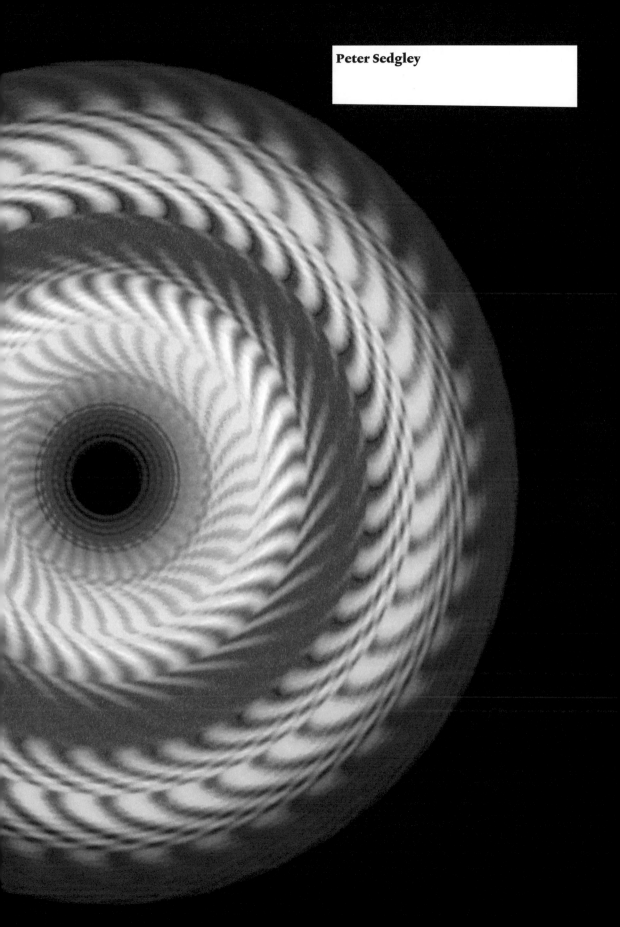

**Peter Sedgley**

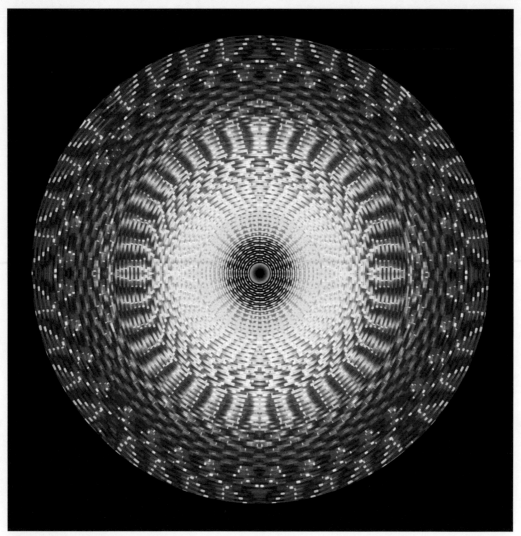

*Video Rotor*
1968, ultraviolet paint on rotating wood
panel, 150 cm diameter

# Color Pulse
Peter Sedgley

During 1967, and running concurrently with my experiments with "color pulse," I discovered fluorescent paint, and tested it to see whether there were any benefits over my own paint product. It proved to be of no interest until I noticed that when the color was illuminated with ultraviolet light – for which it is best suited – and moved in the beam, the color flickered. Realizing that this was raw material for a kinetic image, I set forth to discover more about the properties of elements, paint, and light source. The ultraviolet light source was a mercury vapor discharge lamp which pulsed at mains frequency, 50 c/s, and produced the strobe effect when illuminating the fluorescent color.

My next step was to determine the segmental divisions of the circle that, when rotated, would display the stroboscopic effect of the light. With the aid of an old 78 rpm record player, I calculated the angle that would freeze the apparent display of the visual rotation; using this as datum, I then adjusted the angles to display clockwise rotation and correspondingly counter clockwise movement. With this information, I was prepared to design a constellation of colored elements that would interact, fuse and rotate in opposite directions, rendering a visual kinetic display. I made first a number of small trial discs to confirm the accuracy of my research and subsequently embarked on a major composition of 60 inches diameter with full color and astounding results. I shall let the art critic Robert C. Kenedy, who wrote for the magazine *Art International*, elucidate: "In my first vignette, which discusses Donaldson's art, I made a tentative attempt to justify our permanent quest for novel sensations. The urge is connected with the survival of the arts and treating it as a mere fad does grave in-justice to the serious explorers of unknown territories; especially so when so much that is merely horrible, tends to masquerade in the guise of novelty. The critic fails therefore in his duty if he does not name the nature of our discoveries. He accompanies the artist in his adventure; and if he lags a few steps behind his guides, his is still the distinction of verifying the advance. In the moment of experience the artist is joined by the critic in measuring the advance. They stand, arm in arm, as it were, in ascertaining the location of a spot somewhere within the uncharted regions of intellectual or emotional possibilities; and they are united in looking for an experience which redefines the attitude towards accustomed phenomena.

In this sense every major breakthrough is a sermon from the mount and a near-mythical 'discovery-point' is the aim of every conscious attempt to open up the undisclosed reaches of the mind. The point, which cannot do without a designation, must lie in a favourable setting. It is characterized by its metaphorical height; because the flat wastes of our vision provide no new sights. Distances exist only between uninterrupted points and within the self. That is to say, revelations are panoramic responses – which derive their strength from fact-enforced changes in our thoughts. Peter Sedgley's is the merit of having taken such a near-conclusive step into incognizance. His video rotors explore a region of kinetic optics which combines and relates the innate energies of different disciplines. His revolving screen-printed disks carry a programmed pattern of minute parallelograms, arranged in concentric rings.

When stationary, their chromatic formulae display a marked resemblance to the doctrines of pointillism – what with their juxtaposition and superimposition of complementaries and near-related shadings. However, they are fixed according to constructivist tenets within the network of their superimposed grids. But Sedgley's concern is not with rest. His imagery comes alive in motion. Its gyrations contribute the meaning of his speech. Exposed to ultraviolet and stroboscopic light, his perpendicular turntables perform dizzying antics of illusions. Responding to the varied speed of their programming, revolutions and coincident counter-revolutions dance before the spectator's eye. Both the rhythmic and the chromato-luminous effects of his design contribute towards the intensity of these hallucinatory objects.

There is little if any room in them for the accident determined intoxication. Their dream-like beauties are calculated with the drug-addict's obsessive regard for the rites of a regular dosage. The views charted by Sedgley are the opium-eater and their phosphorous landscapes plot artificial heavens and hells. Only in the twentieth century could the European imagination devise means to recreate the experiences of synthetic night.

Sedgley's are mobile maps of a dream's subcontinent and they have the grand realism of a complete statement. The machine surrenders itself in his work to render an accurate image of the mechanically induced drunkenness. Its cogwheel-governed rhetoric recites the heartbeat-controlled condition of the beauty-sickened flesh. It describes an event fixed by the eye's silent coordinates. That is to say, it alludes only to the elation. But when the imagery is extinguished, its illumination is still accurate enough to evoke the residual pain of each and every necessary awakening. Somehow, and for some odd reason, we tend to judge the potency of the opiates and their derivatives by measuring the intensity of the withdrawal symptoms; (we have failed to devise another set of standards). Sedgley's monstrously enlarged Catherine-wheels survive the acid test. *They create a vision, which, once seen, becomes an irreparable part of the nervous system.*"[1]

1 Robert C. Kenedy, "Sedgley Exhibition at The Redfern Gallery," in: *Art International*, vol. 13, no.1, 1968, pp. 47–48.

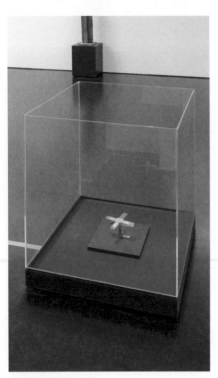

both images
*Earth from Space*
1966, installation view, ZKM | Karlsruhe 2012

**GUSTAV METZGER** (*1926 in Nuremberg, DE) is an artist
and political activist who developed the concept of au-
to-destructive art and the art strike. He studied wood-
work at the Technical College in Leeds (UK) and art at
the Cambridge School of Art and Borough Polytechnic
in London. In 1959 he published the first auto-destruc-
tive manifesto *Auto-Destructive Art*. This was given as a
lecture to the Architecture Association in 1964. Togeth-
er with John Sharkey, he initiated the *Destruction in Art*
Symposium in 1966. Throughout the sixty years that
Metzger has been producing politically engaged works,
he has incorporated materials ranging from trash to old
newspapers, liquid crystals to industrial materials, and
even acid. The most extensive exhibition of Metzger's
work was in 2009 in the Serpentine Gallery in London.

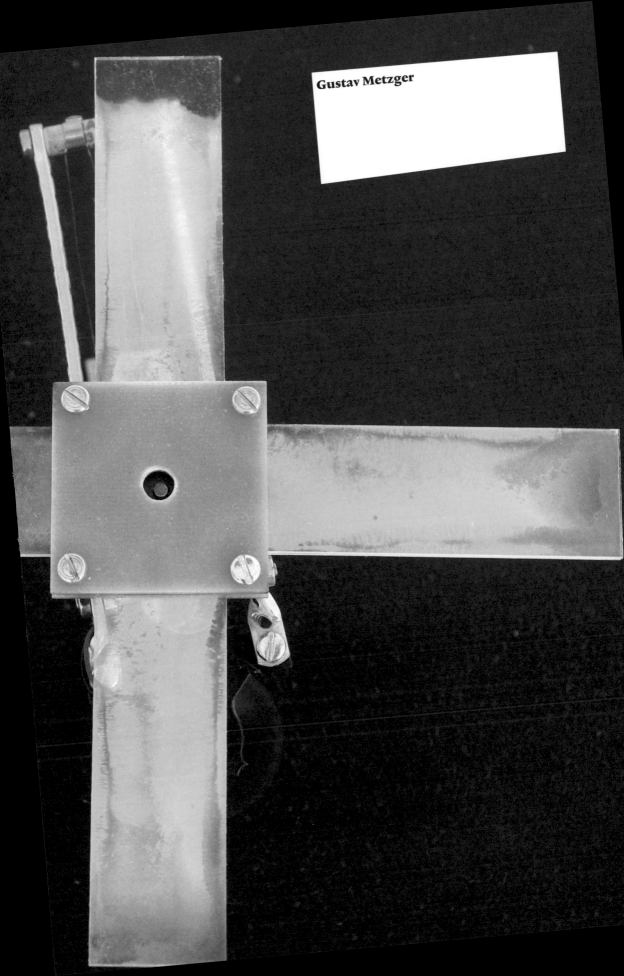

Gustav Metzger

# Gustav Metzger's Liquid Crystals
Rozemin Keshvani

*There is a limit to the potential of kinetic art while the material employed remains in a 'solid' state. Art is enriched by an astronomical number of new forms, colours and textures when the rigidity of the material is loosened. [...] In disintegrating and growing art, time ceases to be uni-directional. At "one instant" – sic – of time, the work may be going in ten different directions of time. The anisotropy of time.*

Gustav Metzger,
"The Chemical evolution in Art," 1965[1]

The artist Gustav Metzger first became interested in the potentials inherent in liquid crystal technology after reading the cover story of a 1964 issue of *Scientific American* which reviewed the molecular structure, optical and thermal properties of cholesteric liquid crystals.[2] Metzger was fascinated with the modality and indeterminate nature of these entities, which inhabited a seemingly in-between metaphysical state, exhibiting the relational qualities of a liquid yet the structural qualities of a solid. Over the next two years, the artist embarked on an ambitious program of public events and experiments to examine the potential applications of liquid crystals whose properties appeared to exemplify his theories of auto-destructive and auto-creative art. With the assistance of technical advice from scientific collaborators, such as Christopher Rybicki and Peter Serase, Metzger worked on developing his liquid crystal techniques to arrive at the ideal combination of crystals available to him and temperature fluctuations.

*Earth from Space*, 1966 was Metzger's first successful kinetic liquid crystal sculpture. The work made its first public appearance during the exhibition *Art of Liquid Crystals* in January 1966 in the windows of the avant-garde poetry bookshop Better Books in London situated in the Charing Cross Road. The exhibition was organized with the support of Metzger's colleague, the artist and sound poet Bob Cobbing (1920–2002), then manager of the shop's paperback section. It featured Metzger's creations based on his findings from numerous experiments with liquid crystals under various environmental conditions – heating and cooling with a variety of materials and even attempts at projections of the color transformations. Most of the works realized in the exhibition consisted of thin glass plates standing erect like soldiers in which liquid crystals of various properties had been rendered inert to display a static sheet of color, which nevertheless retained their inherent potentiality for change.[3] In the windows of the bookshop, they appeared like tiny shards of stained glass dancing with color, precursors to the psychedelic age which was to come just a few years later.

*Earth from Space* made use of the full spectrum of color Metzger had discovered from his experiments with liquid crystals. This elegant sculpture consisted of eight thin glass plates, similar to microscope slides, fitted to form a cross and mounted to a small motor which caused the liquid crystals to rotate in a circle over a heating element probably refitted from an old toaster. Each revolution was timed to be completed in one minute

# AUTO-DESTRUCTIVE ART

## Demonstration by G. Metzger

### SOUTH BANK LONDON 3 JULY 1961 11.45 a.m.—12.15 p.m.

*Acid action painting.* Height 7 ft. Length 12½ ft. Depth 6 ft. Materials: nylon, hydrochloric acid, metal. Technique. 3 nylon canvases coloured white black red are arranged behind each other, in this order. Acid is painted, flung and sprayed on to the nylon which corrodes at point of contact within 15 seconds.

*Construction with glass.* Height 13 ft. Width 9½ ft. Materials. Glass, metal, adhesive tape. Technique. The glass sheets suspended by adhesive tape fall on to the concrete ground in a pre-arranged sequence.

#### AUTO-DESTRUCTIVE ART

Auto-destructive art is primarily a form of public art for industrial societies.

Self-destructive painting, sculpture and construction is a total unity of idea, site, form, colour, method and timing of the disintegrative process.

Auto-destructive art can be created with natural forces, traditional art techniques and technological techniques.

The amplified sound of the auto-destructive process can be an element of the total conception.

The artist may collaborate with scientists, engineers.

Self-destructive art can be machine produced and factory assembled.

Auto-destructive paintings, sculptures and constructions have a life time varying from a few moments to twenty years. When the disintegrative process is complete the work is to be removed from the site and scrapped.

*London, 4th November, 1959*      G. METZGER

#### MANIFESTO AUTO-DESTRUCTIVE ART

Man in Regent Street is auto-destructive.
Rockets, nuclear weapons, are auto-destructive.
Auto-destructive art.
The drop drop dropping of HH bombs.
Not interested in ruins, (the picturesque)
Auto-destructive art re-enacts the obsession with destruction, the pummelling to which individuals and masses are subjected.
Auto-destructive art demonstrates man's power to accelerate disintegrative processes of nature and to order them.
Auto-destructive art mirrors the compulsive perfectionism of arms manufacture—polishing to destruction point.
Auto-destructive art is the transformation of technology into public art. The immense productive capacity, the chaos of capitalism and of Soviet communism, the co-existence of surplus and starvation; the increasing stock-piling of nuclear weapons—more than enough to destroy technological societies; the disintegrative effect of machinery and of life in vast built-up areas on the person,...

Auto-destructive art is art which contains within itself an agent which automatically leads to its destruction within a period of time not to exceed twenty years. Other forms of auto-destructive art involve manual manipulation. There are forms of auto-destructive art where the artist has a tight control over the nature and timing of the disintegrative process, and there are other forms where the artist's control is slight. Materials and techniques used in creating auto-destructive art include: Acid, Adhesives, Ballistics, Canvas, Clay, Combustion, Compression, Concrete, Corrosion, Cybernetics, Drop, Elasticity, Electricity, Electrolysis, Electronics, Explosives, Feed-back, Glass, Heat, Human Energy, Ice, Jet, Light, Load, Mass-production, Metal, Motion Picture, Natural Forces, Nuclear energy, Paint, Paper, Photography, Plaster, Plastics, Pressure, Radiation, Sand, Solar energy, Sound, Steam, Stress, Terra-cotta, Vibration, Water, Welding, Wire, Wood.

*London, 10 March, 1960*      G. METZGER

#### AUTO-DESTRUCTIVE ART    MACHINE ART
#### AUTO CREATIVE ART

Each visible fact absolutely expresses its reality.

Certain machine produced forms are the most perfect forms of our period.

In the evenings some of the finest works of art produced now are dumped on the streets of Soho.

Auto creative art is art of change, growth movement.

Auto-destructive art and auto creative art aim at the integration of art with the advances of science and technology. The immidiate objective is the creation, with the aid of computers, of works of art whose movements are programmed and include "self-regulation". The spectator, by means of electronic devices can have a direct bearing on the action of these works.

Auto-destructive art is an attack on capitalist values and the drive to nuclear annihilation.

*23 June 1961*      G. METZGER

B.C.M. ZZZO London W.C.1.

Printed by St. Martins' Printers (TU) 86d, Lillie Road, London. S.W.6.

---

which, given the variations in temperature during the rotational cycle, permitted the liquid crystals to display their full color spectrum as they passed over the heating coils and continued their rotation until being allowed to completely cool, giving the appearance of total darkness before once again encountering the heating element. Metzger titled his kinetic sculpture *Earth from Space* both because of its continuous rotation around a source of energy which gave life to the work and produced the seeming transformation from the dark of night to the rich colorful displays of the rainbow, and because the work suggested a vision of how the Earth might appear when viewed from Space. According to Metzger, Bob Cobbing was so enthralled with the work that he urged Metzger to patent the techniques and processes developed in the liquid crystal artworks. Metzger did launch a patent application but after careful consideration chose to abandon the application.[4]

Metzger invited Professor Frank Popper to the opening at Better Books where Popper gave a lecture on the principles underlying the pioneering work of kinetic artists. The liquid crystal works were again shown at the Lamda Theatre Club, London.[5] These experiments with liquid crystals eventually culminated in Metzger's development of his liquid crystal light projections first experimented with at Cambridge and Better Books and later successfully shown as psychedelic backdrops to performances of The Who, Cream[6], The Move and Pink Floyd at the notorious 1966 New Year's Eve Giant Freak-Out All Night Rave held at the Roundhouse in Chalk Farm.[7]

*Earth from Space* represents Metzger's earliest success with the liquid crystal technology in which he was able to harness the aleatory and transformational properties of liquid crystals in a controlled and self-executing work of art governed by cyclical repetition, directly vindicating his theories on auto-creative art. The press release to the exhibition describes the process of the works:

"Metzger placed liquid crystals together with chemicals between thin, elongated glass plates of the type used in microscopes. These were formed in the shape of a cross and placed under varying degrees of heat, causing the colors of the crystals to transform as the heat-sensitive chemical changes temperature over the course of a repeating one minute cycle and to vary according to the position of spectator and the light source."[8]

In a lecture addressed to the Society of Arts at Cambridge University in 1965, "The Chemical Revolution in Art," Metzger drew the connection between his theories on auto-destructive and auto-creative art and the behavior of liquid crystals.[9] For Metzger, art produced from solid state materials limited the artist. Indeed, as Metzger stated: "Art is enriched by an astronomical number of new forms, colors and textures when the rigidity of material is loosened." In his now infamous lecture on auto-destructive art to the Architectural Association, also delivered in 1965, the artist notes that unlike traditional works of art, the kinetic work is realized only in relation to the spectator. The moment the spectator approaches, the wind currents and temperature levels change, giving rise to very real and observable transformation in the work itself. Metzger regards his work as instantiating the uncertainty and transformative possibilities inherent within the the materials he employed. Drawing

a direct parallel to Heisenberg's uncertainty principle, Metzger likened the experience to the way that the energy of the electron microscope disturbs the specimen under observation.[10]

Indeed, *Earth from Space* captures the implicit ambiguity of the object qua object at the molecular level, suggesting that the 'true' nature of the object can only be determined through the actualization of an event, which is itself the relation between object, creator and perceiver. Frank Popper noted that Metzger's auto-creative kinetic works "present an interesting parallel to those of the mobile. The process begins with the initial impetus of the artist. But the movement which seethe sets in motion immediately becomes autonomous and therefore unpredictable."[11] Even beyond the possibilities inher-

ART OF LIQUID CRYSTALS

A new art technique is on view in a window of Better Books

(corner of Charing Cross Road and New Compton Street)

Two aspects of the technique are displayed:

1. as the spectator passes pieces of glass mounted in the

window, a series of colour changes may be observed

2 a chemical is mounted between microscope cover slips. In the

course of a one-minute cycle, the chemical is melted and then

cooled. As the chemical cools, colour changes are observed

which vary according to the position of the spectator and

the light source. This work is called EARTH FROM SPACE

The technique is based on the use of liquid crystals. It can

be used on a large scale, inside buildings or out. The exhibit

is the work of Gustav Metzger. He is the author of AUTO-DESTRUCTIVE

ART - the first illustrated monograph on the subject, published

in October 1965

An evening on auto-destructive and auto-creative art will be

held at Better Books on 8th January, Saturday at 9 p m. Speakers

include Frank Popper of Paris, a leading authority on kinetic

art.

The PRESS is invited to view the exhibit in the window of

Better Books on Thursday 6th January between 11 and 12 or

between 2 and 3, when Mr Metzger will be present

For further information please phone TEM 6944

ent in the mobile, however, the potentiality and variations within the liquid crystal art works are infinite. To quote Metzger: "At a certain moment, the works takes the initiative and launches into an action which is beyond control of the artists. It rises to a power, a grace, a living force and transcendence which the artists cannot attain, except through aleatory activity."[12]

*Earth from Space* represents one of Metzger's few realized works of Auto-creative art. It is a testament to Metzger's profound concern with possible extinction of the planet that his one of his earliest object-based creations should be an object of permanent impermanence.[13] Presented from an aerial perspective, the spectator is required to move around the work and gaze upon it from above. Through the creation of distance, *Earth from Space* consciously invokes both time and space to place the spectator in a direct confrontation with the Earth itself.

Metzger challenges the viewer to recognize her own profound effect upon the Earth simply by the act of entering and traversing the space of the work to create a dance of the unpredictable forces of light, heat, position and perception only made possible by virtue of the indeterminate molecular structure of the liquid crystals themselves. Thus Metzger invites the spectator to identify herself not merely with the forces of light and movement, but equally with her position in and toward the Earth, to see herself as the 'Giant' in comparison to the planet she inhabits, an inversion of our normally assumed and accepted position, a juxtaposition which creates a subtle yet disturbing awareness of the spectator's capacity to affect (and indeed destroy) this delicate and fragile system of delicately balanced interrelated and fluctuating events that comprise the Earth. Like Metzger's auto-destructive works, auto-creative art is active and polemical, crafted to inspire awareness and action without the appeal to revulsion. Instead, the artist invites us to consider the transforming beauty of the planet Earth and its potential for eternal renewal, by emphasizing our relationship to the Earth as spectator whose presence, although seemingly distinct and disconnected, is in critically bound to its very being.

**Notes**

1 Andrew Wilson, "Gustav Metzger's Auto-Destructive / Auto-Creative Art – An Art of Manifesto, 1959–1969," in: *Thir d Text*, vol. 22, issue 2, 2008, pp. 177–194, doi: 10.1080/ 0952882080201284. "In the following years, his recognition of an auto-creative art within auto-destructive art, allied to the position he had adopted as an artist who produces no objects, led him to an increasingly close identification with science whereby his view of the studio as laboratory became actual." "Machine art will inevitably lead to 'the entry of the artist into factories and the use of every available technique from computers downwards for the creation of works of art,' while the 'image multiplication' of Auto-Creative art proves beyond doubt that only the collaboration of the artist and technology and the use of machine forms can give us the experiences we need," ibid., p. 191.

2 See: J. L. Fergason, "Liquid Crystals," in: *Scientific American*, vol. 211, no. 77, August 1964, pp. 76–85. Cholesteric liquid crystals respond to temperature changes in the environment, which in the case of *Earth from Space* is a response to heat from a heat source, producing a gradient of iridescent color changes due to multi-layered optical interferences at a molecular level.

3 This is Metzger's description of his own work from memory. From an interview of Rozemin Keshvani with the artist on February 9, 2012 at his home in Hackney.

4 Metzger explained that to patent the process would have been abhorrent of his whole enterprise and an affirmation of the capitalistic instinct when encountering the 'new'. He was not interested in exploiting the economic potential of liquid crystals or of engaging in an activity which he believed might assist the defense industry. See: Rozemin Keshvani interview with Gustav Metzger on February 9, 2012 at his home in Hackney.

5 Metzger states he just walked up to the theater management and asked permission to display his works. See: Rozemin Keshvani interview with Gustav Metzger on February 9, 2012 at his home in Hackney. In the early 1960s, the Lamda Theatre Club developed into an avant-garde experimental theatrical company, led by Peter Brook and Charles Marowitz, both of whom were also active at Better Books. Between 1964 and 1966, Brook and Marowitz directed a number of adaptations and experimental performances based on the Theatre of Cruelty. See for example: Charles Marowitz, "Notes on the theatre of cruelty," in: J. Robert Willis, *The Director in a Changing Theatre*, Mayfield Publishing, Palo Alto, 1976, pp. 157–179; Philip Barnes, *A Companion to Post-War British Theatre*, Croom Helm Ltd., Beckenham, 1986.

6 See: Rozemin Keshvani interview with Gustav Metzger on December 20, 2012 at his home in Hackney.

7 See: Nick Jones, "Psychedelicamania at Roundhouse," in: *Melody Maker*, January 7, 1967, p. 2. It should be noted that the artist Mark Boyle was also experimenting with light projections and other works based of Brownian motion at this time, and was the creator of many of the psychedelic light shows at UFO and other London underground nightclubs.

8 See: Better Books *Art of Liquid Crystals* press release.

9 Gustav Metzger, "The Chemical Revolution in Art," Society of Arts, Cambridge University, Cambridge, MA, 1965.

10 Gustav Metzger, Auto-Destructive Art 1965, expanded version of a talk given at the Architectural Association on February 24, 1965, published by A.C.C. 34-34-36 Bedford Square, London, June 1965.

11 Frank Popper, *Origins and Development of Kinetic Art*, Studio Vista, London, 1968, p. 154, translated from the French by Stephen Bann.

12 Gustav Metzger, *Signals* (London) September 1964, quoted in ibid., p. 155, translated from the French by Stephen Bann.

13 See: Gustav Metzger, *damaged nature, auto-destrucive art*, coracle, London, 1996.

The author would like to express her deepest gratitude to the artist Gustav Metzger for his generosity in gifting her with his time and countless discussions about his work, and would also like to acknowledge the assistance of the Generali Foundation for kindly opening their archives for the research of this article. Particular thanks is given to Siegbert Sappert and his assistant Elsa Konig.

*Biokinetic Situations*
1969, Installation views, Museum Morsbroich,
Leverkusen

left
Installation drawings for the exhibition

top right
Bacteria cultures as color range for the *Biokinetics*

middle right
Biokinetical room changing colors and forms day by day

bottom right
"White Cotton Room," infested by a cellulose eating
mushroom

large image
A socle army was exposed outside Leverkusen and
made visible the bacteria of the air

**Raum 4**
Cellulose abbauende Bakterien. Der Prozeß ergibt sich
erweiternde, einsinkende Dunkelstellen.
**Raum 5**
Komplexer Nährboden. **Aerobe** Bakterien führen Farb-
veränderung von Weißgelb in Fahlgelb herbei. **Anaerobe** Bak-
terien übernehmen durch ihren Stoffwechselprozeß eine
permanente Aufblähung.
**Raum 6**
Pilzkultur wird von Bakterien vernichtet. Langandauernde
Permutation in tiefes Schwarz.
**Raum 7**
Farbloser Trägergelee auf pH 6 gehalten, verändert sich langsam
auf pH 8.
**Raum 8**
Lichtempfindliche Pilzkulturen bilden tiefreichendes Mycel.
Permanent wechselnde Ausfärbung der Bodensubstanz bewirkt
Farbwechsel Rot bis Tiefschwarz und Violett.
**Raum 9**
Fototaktisch empfindliche Algen und Bakterien kriechen auf die
Lichtquelle zu. Kolonien entstehen. Lebensnotwendig für diese
Mikroorganismen ist der Gasaustausch im Wasser. Absterbende
Kolonien werden in die dunklen Raumzonen abgedrängt.

**HA SCHULT** (*1939 in Parchim, DE) grew up in the ruins
of Berlin. From 1958 to 1961 he studied at the Kunstaka-
demie Düsseldorf. HA Schult creates his projects with
Elke Koska, the muse, and since 2001, also with Birgit
Froehlich, the actress. He lives with Anna Zlotovskaya,
the violinist, in Cologne and Berlin. In the 1960s he
coined phrases such as "Biokinetik" [biokinetics]. Since
then, the social fauna of cities and landscapes are in the
focus of his work. HA Schult was one of the first artists
to deal with ecological imbalances in his work. He is a
major contributor to today's new ecological awareness.
His works have been shown on all continents.

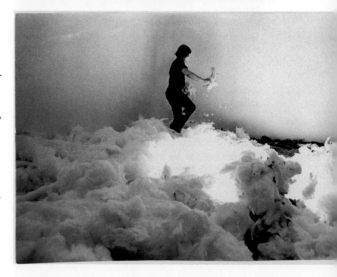

www.haschult.de

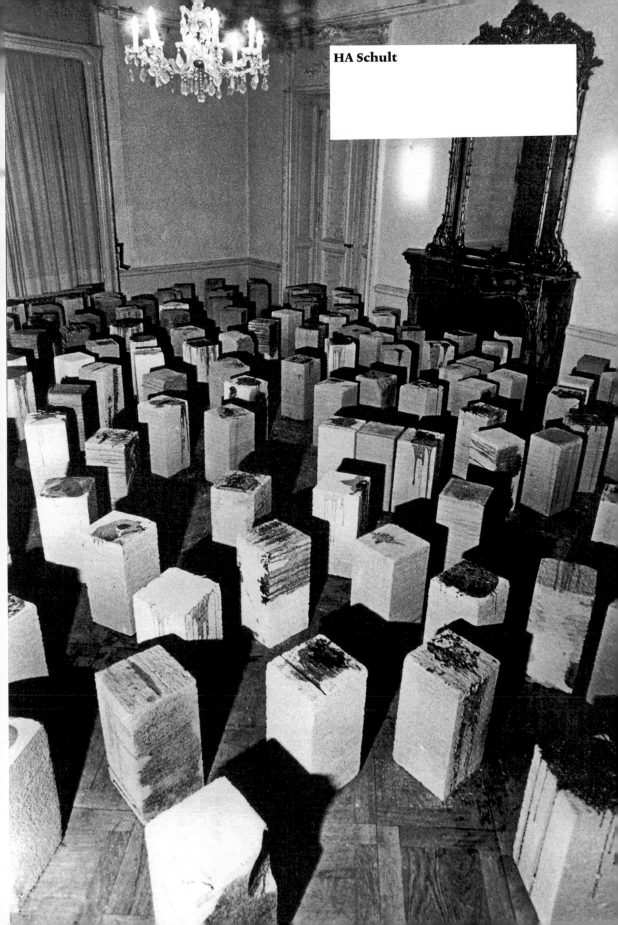

## Biokinetical Situations

HA Schult, the first European artist to deal with ecological imbalances in his artworks, is a major contributor to today's new ecological awareness. He is the creator of the *Biokinetics* – which shows the life of bacteria in various biological processes.

The first *Biokinetics* exhibition caused a sensation in 1969. The Museum Schloss Morsbroich in Leverkusen (DE) was totally transformed. The public had to climb over scaffolding to look down onto bacterial environments. One room was filled with mashed potatoes, which served as food for the bacteria and changed color dramatically from day by day. Another room was filled with white cotton and a cellulose-eating fungus which progressively colored that cloth red. At the other end was a room filled with water, where seaweed, providing the only light, changed into a spectacular blue, and was replaced by algae – becoming a symbol for the passage of life to death. Outside on the terrace, stones covered in agar-agar made the chemical content of Leverkusen's air visible. Three years later, in 1972, HA Schult exhibited his *Biokinetics* at the documenta 5 in Kassel (DE).

In sum, these "exhibitions in transit" pointed to environmental challenges that face us and will continue to face us in the future.

*Biokinetical Landscape and Soldier*
1972, an anonymous soldier watched over the
consumer's icons: empty Coca-Cola bottles
Installation view, documenta 5, Kassel

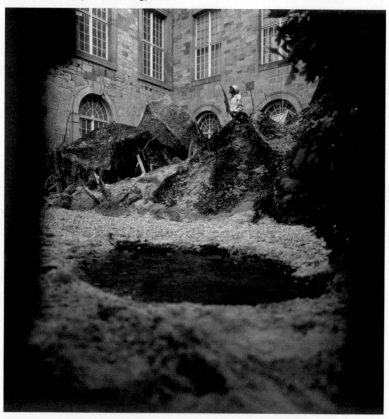

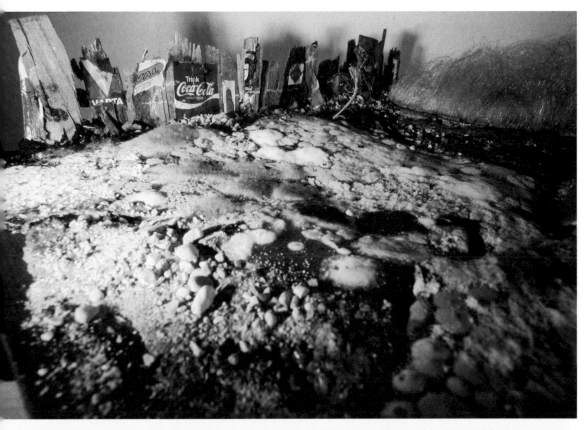

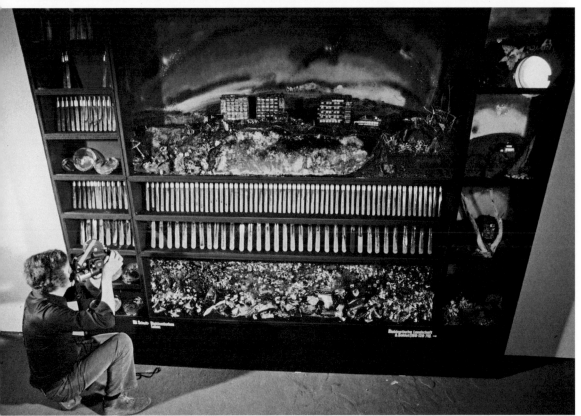

*That's Life*
1970, pressing, tin-foil wrapped chocolate
figures on corrugated cardboard in a plastic
cover, 37.5 × 48 cm, edition of 100, numbered
and signed, made by R. Rieser, Cologne

**DIETER ROTH** (*1930 in Hannover, DE, †1998 in Basel, CH)
was a sculptor, poet, graphic designer, performer, pub-
lisher, and musician. In the 1950s, he was co-editor of
the journal *Spirale*. Roth worked as a designer in Basel
and Bern, Copenhagen, and New York (NY). His artwork
is of great variety. All his works – Op-art objects, designs
of furniture, artists' books, concrete poetry, publication
of Fluxus, multiples, performances, archives and other
documentary works, such as films and videos – are im-
pressingly precise. Among his best-known works are
his objects consisting of chocolate and other food slowly
decomposing and thus changing constantly ("mould-
pictures").
Roth's artistic styles waxed and waned; they were flexible
and unstable, resistant to classification. As in his "mould-
pictures" – the first one was made in 1963 – each work has a
life of its own. Roth's intention was to make time visible by
allowing organic objects to decompose, with no attempt at
conservation or intervention. He was also interested in the
factor of chance: works were not to be fully controlled by
the artist, but to develop according to the conditions under
which they were kept. Temperature, humidity, light, and
the presence of insects and bacteria would continue to al-
ter the objects after the artist declared them finished. Roth
was also fascinated with the painterly, textural aspects of
grease stains, mold formations, insect borings, and blotch-
es of rotting organic material.

www.dieter-roth-museum.de

large image
*Mould Sheet*
1969, curdled milk over white, handmade
paper in plastic cover, 106 × 78.5 cm,
edition of 50, numbered and signed,
made by B. Minnich, Düsseldorf

94

*Cypher*
2009, DIY transgenic kit with Petri dishes, agar, nutrients, streaking loops, pipettes, test tubes, synthetic DNA, booklet, 33 × 43 cm

large image
2009, the bacteria glow with a red light after the participant follows the protocol provided in the kit

*Cypher* is an artwork that merges sculpture, artist's book and a DIY transgenic kit. It measures approximately (33 × 43 cm) and is contained in a stainless steel slipcase. When removed from the case, the kit – also made of stainless steel – opens up in two halves, like a book. Inside the viewer/user finds a portable minilab. The kit contains Petri dishes, agar, nutrients, streaking loops, pipettes, test tubes, synthetic DNA (encoding in its genetic sequence a poem Eduardo Kac wrote specifically for this artwork), and a booklet containing the transformation protocol – each in its respective compartment. The key poetic gesture in *Cypher* is to place in the hands of the viewer the decision and the power to literally give life to the artwork. The work was commissioned by Rurart, France.

**EDUARDO KAC** (*1962 in Rio de Janeiro, BR) is a Brazilian artist internationally recognized for his telepresence and interactive works, as well as for his bio art. His work deals with issues that range from the cultural impact of biotechnology (*Genesis*) and the changing condition of memory in the digital age (*Time Capsule*), to the creation of life and evolution (*GFP Bunny*). Kac's work has been exhibited at venues such as La Maison Européenne de la Photographie (Paris), Museo Reina Sofía (Madrid), and included in biennials such as Bienal de Sao Paulo (BR), and International Triennial of New Media Art (Beijing). His work is part of the permanent collection of the Museum of Modern Art, New York (NY) and the ZKM | Center of Arts and Media Karlsruhe (DE), among other institutions.

www.ekac.org

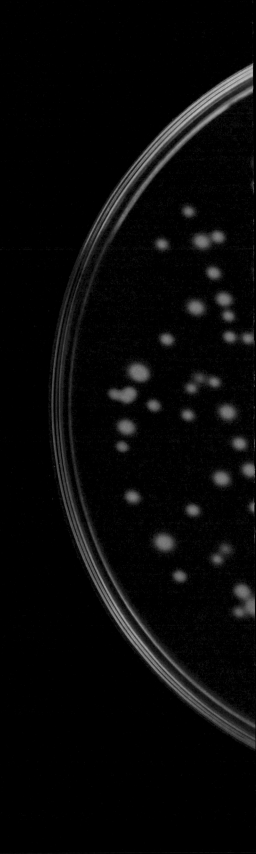

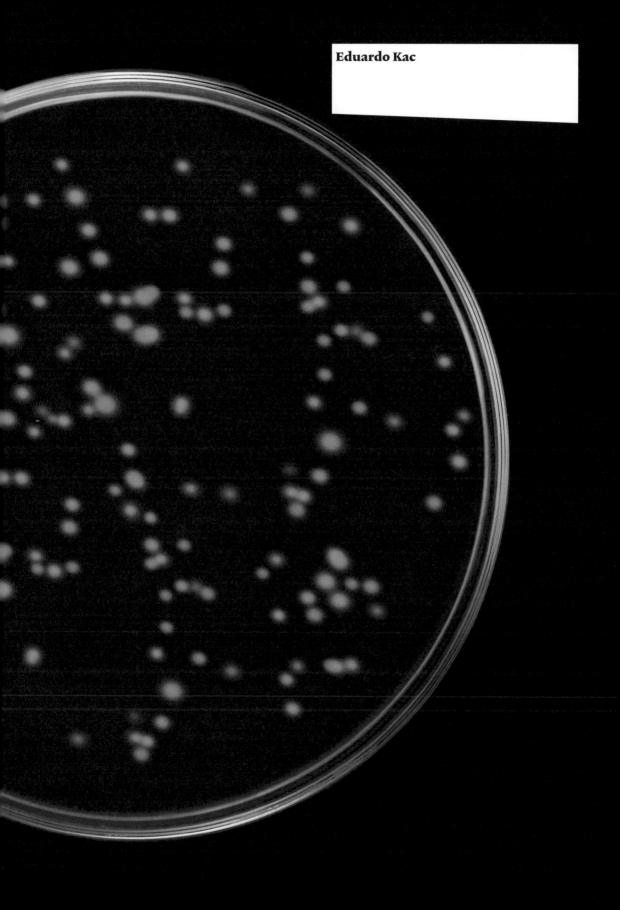

Eduardo Kac

The central work in the *Natural History of the Enigma* se-
ries is a plantimal, a new life form Eduardo Kac created
and that he calls "Edunia," a genetically engineered
flower that is a hybrid of the artist himself and a Petu-
nia. The Edunia expresses Kac's DNA exclusively in its
red veins. The gene Kac selected is responsible for the
identification of foreign bodies. In this work, it is pre-
cisely that which identifies and rejects the other that
the artist integrates into the other, thus creating a new
kind of self that is partially flower and partially human.
Developed between 2003 and 2008, and first exhibited
in 2009 at the Weisman Art Museum, Minneapolis (MN),
*Natural History of the Enigma* also encompasses a large-
scale public sculpture, a suite of lithographs, seed packs,
photographs, and other works.

Eduardo Kac
**The Making of Natural History of The Enigma**
Edunia, transgenic flower expressing artist's own DNA in petal veins

2p1
16
15
14
13
**12**
11

**IGK**

3'

Kac's Chromosome 2

cgaactgtggctgcaccatctgtcttcatct
tcccgccatctgatgagcagttgaaatctg
gaactgcctctgttgtgtgcctgctgaata
acttctatcccagagaggccaaagtacag
tggaaggtggataacgccctccaatcgg
gtaactcccaggagagtgtcacagagca
ggacagcaaggacagcacctacagcctc
agcagcaccctgacgctgagcaaagcag
actacgagaaacacaaagtctacgcctgc
gaagtcacccatcagggcctgagctcg

Kac's gene

5'

Right Border

Plant Kanamycin

CoYMV
Promoter

**Plasmid with Kac's DNA**
pBI GUS ED IGG

Kac's gene

T-DNA Region

Bacterial Kanamycin

Left Border

Kac's gene   BACTERIAL CELL   PLANT CELL   Gene transfer

Antibiotic-
resistance
gene

DNA

Dead cell   Callus

Antibiotic medium

**1**
Cut Leaf

**2**
Expose leaf to bacteria
carrying the new gene
and an antibiotic-
resistance gene. Allow
bacteria to deliver the
genes into leaf cells

**3**
Expose leaf to antibiotic
to kill cells that lack Kac's
genes. Wait for surviving
[gene-altered] cells to
multiply and form a
clump [callus]

**4**
Allow callus to sprout
shoots and roots

**5**
Put in soil. Within three
months, the plantlets
grow into plantimal
bearing Kac's gene. The
gene is expressed only in
the red veins.

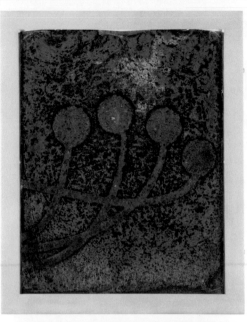

*Clairvoyance*
2006, biotope, 48.2 × 58.4 cm, from the
*Specimen of Secrecy about Marvelous
Discoveries* series

*Apsides*
2006, biotope, 48.2 × 58.4 cm, from the
*Specimen of Secrecy about Marvelous
Discoveries* series

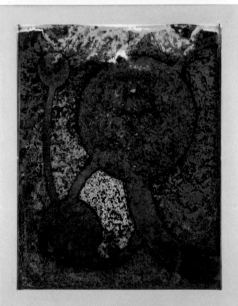

*Specimen of Secrecy about Marvelous Discoveries* is a series of
works comprised of what Eduardo Kac calls biotopes: liv-
ing pieces that change during the exhibition in response
to internal metabolism and environmental conditions.
Each of Kac's biotopes is literally a self-sustaining ecol-
ogy comprised of thousands of very small living beings
in a medium of earth, water, and other materials. The
artist orchestrates the metabolism of these organisms
in order to produce his constantly evolving living works.

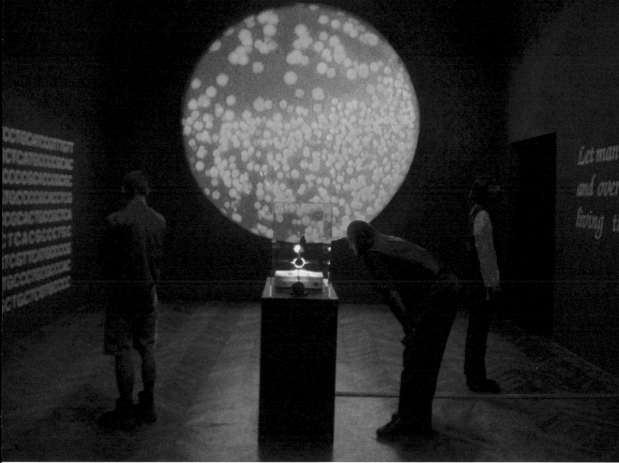

*Genesis*
1999, transgenic work with artist-created bacteria,
ultraviolet light, Internet, video (detail), edition of 2,
dimensions variable

*Genesis* is a transgenic artwork that explores the intricate
relationship between biology, belief systems, informa-
tion technology, dialogical interaction, ethics, and the
Internet. The key element of the work is an *artist's gene*, a
synthetic gene that was created by Eduardo Kac by trans-
lating a sentence from the biblical book of Genesis into
Morse code, and converting the Morse code into DNA
base pairs according to a conversion principle specially
developed by the artist for this work. The sentence reads:
"Let man have dominion over the fish of the sea, and over
the fowl of the air, and over every living thing that moves
upon the earth." It was chosen for what it implies about
the dubious notion of divinely sanctioned humanity's
supremacy over nature. The Genesis gene was incor-
porated into bacteria, which were shown in the gallery.
The participants on the Web could turn on an ultraviolet
light in the gallery, causing real, biological mutations in
the bacteria. This changed the biblical sentence in the
bacteria. The ability to change the sentence is a symbolic
gesture: it means that we do not accept its meaning in
the form we inherited it in, and that new meanings
emerge as we seek to change it.

*Molecular Invasion*
2002–2004, participatory science-theater work
Details from the WIO (World Information Organization)
installation

*Molecular Invasion* is a participatory science-theater work
done in cooperation with students from the Corcoran
College of Art + Design, Washington D.C. In this work,
CAE, Claire Pentecost, and selected students attempt a
biochemical intervention on Roundup Ready genetical-
ly modified canola, corn, and soy plants by applying a
human and plant safe substance that targets the genetic
modification (leaving it toxic only to plants with this
specific modification). In this theater of live public ex-
perimentation, we attempted to transform artificial bi-
ological traits of adaptability into ones of susceptibility,
as well as establish a model for Contestational Biology.

www.critical-art.net/MolecularInvasion.html

**CRITICAL ART ENSEMBLE (CAE)** is a collective of five tac-
tical media practitioners who focus on computer graph-
ics, web design, film/video, photography, text/book art,
and performance. Since 1987, CAE has been exploring
the intersections of art, critical theory, technology, and
political activism. The group has exhibited and per-
formed in the streets, on the Internet, at art festivals as
dOCUMENTA (13), and at renowned museums, includ-
ing the Whitney Museum (New York, NY), the Museum
of Contemporary Art (Chicago, IL), Schirn Kunsthalle
(Frankfurt am Main, DE), Musée d'Art Moderne de la
Ville de Paris, and the London Museum of Natural His-
tory. The collective has published seven books, among
other titles, *Disturbances* (Four Corners, London, 2012).

www.critical-art.net

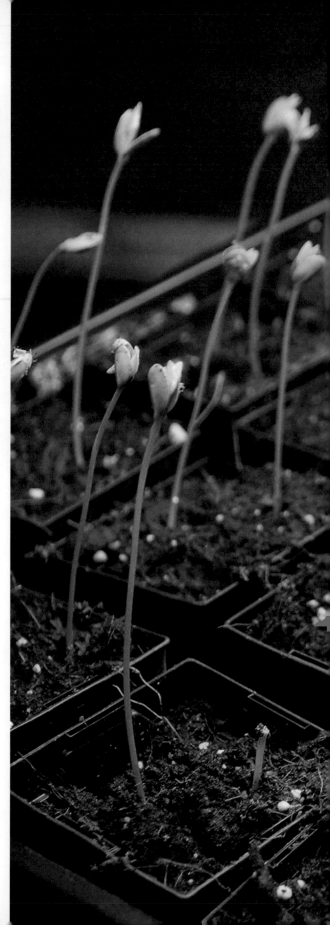

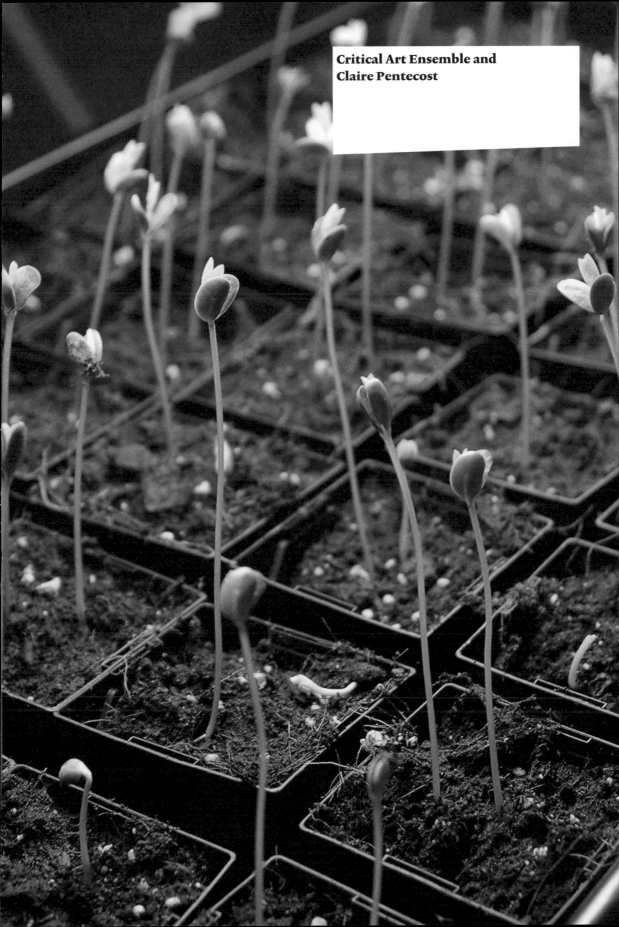

**Critical Art Ensemble and Claire Pentecost**

## Fuzzy Biological Sabotage
Critical Art Ensemble, 2002

If the left has learned anything from resistance against capital-driven technocracy, it is that the democratic process is only of minimal use for slowing the profit machine of pancapitalism. Since corporations and other financially sound institutions own the process, and tend to function outside national democratic imperatives, other methods of power appropriation must be developed. In the case of biotechnology, the resistance is unfortunately in a position of reactivity. Corporations have infiltrated most governments and markets at such a furious pace that all that can be done is attempt to slow them down, while cells and organizations regroup and decide on a way to address the many problems that have already arisen, and the risk of accidents that lie ahead. Assuming that inertia is always useful in disturbing capitalist production and distribution, one must ask how this principle can be applied to the current molecular invasion.

Certainly, traditional tactics have some use, and electronic civil disobedience (ECD) will be of value, although it should be added that this is a time for hard-core ECD (blockage of internal communication systems, blockage of databases, the disruption of routers, etc.). Soft-core tactics – denial of service (DOS), for example – can disrupt retail services such as assisted reproductive ("eugenics") clinics. Since most of the biotech industry is not about retail, however, DOS is of little use there except as a low-quality theatrical tactic with little pedagogical value.

In the end, however, resistant culture will invariably need to find a means to fight fire with fire. In other words, how do we develop tactics using biological materials and processes? In response to this question, Critical Art Ensemble (CAE) and a number of rogue scientists set about trying to form a model of direct biological action. Our first unfortunate conclusion was that civil disobedience (CD) will not work in this situation. While inertia will always disturb a society of speed, it cannot be implemented on the biological front by blocking methods, partly because the boundary and territorial models that CD was developed in response to typically have no place in the organic realm. Moreover, since our focus is on trying to intervene in the production of transgenic life-products, almost any action will have some destructive effect. Such a problem puts resistant agents in a difficult position. We hardly want to make it easy for capitalist spectacle to label resisters as saboteurs, or worse, as eco-terrorists. These terms are used very often and generously by authority and tend to produce highly negative public opinion, which, in turn, allows state police and the corporate posse to react as violently as they want to while still appearing legitimate and just. Escaping these labels completely seems nearly impossible; however, we can at least reduce the intensity and scope of these forms of labeling, and hopefully escape the terrorist label altogether. In any real sense, the association with terrorism is completely unwarranted, since it is impossible to terrorize plants, insects, and single-celled organisms. The problem with genetically modified organisms (GMOs),

however, is that they are not open to the kind of destruction that occurs when someone kills a fly or swats a mosquito, because GMOs are more than organisms, they are private property. Since capital values property over all other entities (humans included), one can expect only the strongest types of denunciation and response to its destruction.

In addition, there is already a highly reactive history in regard to transgenic crops that can be of symbolic use to authorities. Test sites for new product lines of GMOs in the US, France, and India have been burned in acts of flagrant sabotage. The locations attacked were the right ones. Test sites are a key location to disrupt: if studies being done at the sites are corrupted, they have to be redone, causing a very costly type of inertia in the developmental system. Tactical arson, however, plays right into the hands of the authorities. Such action gives them the examples of hard-core sabotage that they need to label, harass, and arrest potential transgressors – as well as individuals and groups opposed to sabotage who have little more than a modest philosophical association with violent resisters.

The Indian farmland burnings are a case in point, and an interesting element does emerge from these scenarios. The group responsible paid the farmer hosting the test site for the crop before burning it. The message here is clear: Do not hurt the farmers/workers physically, psychologically, or financially. Agrarian complicity, in many cases, is nearly a given, because people have no real alternative to the markets dominated by the biotech industry's coercive power. Grass-roots harassment is an unacceptable tactic that the left has debated and is hopefully pushing aside as the Indian example shows. In the 1980s, some AIDS activists suggested that pharmaceutical salespeople should be harassed in order to disrupt distribution and thus leverage a price reduction of the astronomically expensive medicines needed to combat HIV. That was a terrible idea then, and it is a terrible idea now. From the corporate perspective, workers are expendable, and the reserve labor army is large enough to fill the ranks, those acts of harassment would have no effect on a working family other than to make their lives miserable.

CAE believes that the best response to these ultimately unsolvable problems is the idea of fuzzy biological sabotage (FBS). The fuzzy saboteur situates himself in the "in-between" areas that have not yet been fully regulated. This situational strategy was well developed by Brian Springer in his backhaul video work and in his laser information conduit interventions. His idea was to take what was considered private property, but functionally was public property. A backhaul (off-air live satellite video feeds) was considered the property of the media, but since it was in the public domain of the reception of airwaves and existed without copyright, it could be copied, replicated, and even marketed (backhauls are scrambled to stop this process today). Springer was brilliant at finding – and exploiting – these little cracks in the system. The fuzzy saboteur has to stand on that ambiguous line between the legal and the illegal (both criminally and civilly, from which point, the individual or group can set in motion a chain of events that will yield the desired result. The opening activity – the only one to which the saboteur should have any direct causal link – should be as legal as possible and hopefully within the rights of any individual. The more links in the chain, the better from a legal standpoint, although extending causal chains increases the difficulty of controlling the exponentially growing number of variables that could doom the action.

For the most part, such actions will only have two phases: the legitimate or fuzzy act and the upheaval it causes. The authorities then have the legal conundrum of proving guilt by indirect action – an unenviable task for any attorney. Moreover, unlike CD, fuzzy sabotage does not require a physical confrontation with authority, nor, in many cases, does it require any type of trespass.

If an action is done correctly, the fuzzy saboteur has an additional safety net supplied by the various world governments – plausible deniability. For centuries, state forces have sabotaged one another by various means that cannot be proven within any judicial system other than by military field justice. Simply by creating a nonaggressive scenario, or denying activity all together, agencies of discord have avoided direct charges. This symbolic shield can be reverse-engineered to serve resistant culture. With any luck, the fuzzy saboteur will never have to use this shield, but if necessary, it can create a platform for public attention where "tactical embarrassment" (to use the RTMark term) can be employed.

It may be nostalgically reminiscent of nineteenth century anarchism, when it was incumbent upon any member of the movement who was arrested to use the court or any other public stage to denounce the bourgeois system. Yet practically speaking, and for the health of the tactic, such public displays should be avoided at all costs. While a single publicity battle can potentially be won through deniability and campaigning, a series of these occurrences will dilute the plausibility of the denial and allow the development of spectacular countertactics by the authorities. Like hard-core electronic civil disobedience, FBS is not a public process. Critical Art Ensemble requests that those groups and individuals whose goal it is to spectacularize hacking and perform as activist pop stars to do the movement(s) a favor, and leave this method alone – particularly in its testing stage.

The final question then is, who are the agents of FBS? CAE suggests the use of wildlife to do the deed. Microorganisms, plants, insects, reptiles, mammals, tactical GMOs, and organic chemical compounds can all be a part of the resistance. The use of living nonpathogenic biological agents as disrupters will depend on each individual's or group's particular relationship to these creatures, as well as on localized conditions. Obviously, considerable arguments will erupt between the various positions on what constitutes an acceptable relationship between humans and other living creatures, and how various creatures will be employed, but let us say at the outset that we are not proposing that sentient organisms be considered for suicide missions or other incarnations of sacrificial economy.

## Pranks

If fuzzy biological sabotage has roots, it is in the realm of pranks. Most readers probably have a story of a prank

that they or someone they knew did involving a biological agent. Placing a dead rodent or fish (nature's stink bombs) in a heating duct at school – or some other offending institution – is one of the classics. However, these are not among the class of pranks that interest the fuzzy saboteur. FBS pranks are not done for a good laugh, for public embarrassment, or simply to be annoying; rather, they should be done as a form of psychological disturbance – more along the lines of LSD in Castro's cigars and liquid refreshment before a public address (to use an example from the CIA's book of practical jokes). Pranks can be used to stir up internal institutional paranoia, or to divert attention toward useless activities. Pranks can provide their own unique blend of inertia.

For example, the release of mutant flies in research facilities and neighboring offices can potentially have a disturbing effect. There are all kinds of mutated flies available on the market. They come in various colors with almost any type of classified deformity. Labs use them for cross-generational study because they are easy to raise, reproduce quickly, and maintain unusual genetic codes. Choose a set of mutated flies and begin a steady release of them into biotech facilities (it also works well in nuclear facilities). The insects can be set free in lobbies, parking garages, parked cars, almost anywhere. One does not have to challenge a fortified site – the flies themselves will do the infiltration. If enough flies are acquired or produced, you just have to be near the site and release swarms of them. Trespassing is not really necessary, unless there is a need for specific targeting. It only takes the occasional observation of them on a regular basis for people to start wondering what might be causing the appearance of these strange creatures. Needless to say, that some fuzzy saboteur must be letting mutated flies go in the offices will not likely be the first conclusion. The imagination will provide more exotic scenarios. The key here is consistency, not quantity. Moreover, relying on the power of the rumor mill that hallmarks any workplace, we can be sure that the fear and/or conspiracy factor will be amplified considerably. A paranoid work force is an inefficient work force. This approach thus creates inertia in the system. In the best-case scenario, an investigation into the origins of the flies would be launched, which would burn more cash and waste even more employee time. In the worst-case scenario, the prankster would provide a topic of conversation at break-time.

If there are other businesses near the research facility, let the flies loose in them, too. Restaurants are particularly good locations, since customers are sedentary for a while there, and flies call attention to themselves in environments where food is served. This can have the effect of aiming local business owners' and workers' suspicions at what may be going on in labs nearby. Needless to say, local tensions could easily increase, and even those who never would join a movement could become unknowing cohorts or willing allies.

Pranks such as this one are easy and inexpensive. As for the flies, they really don't care where they are, as long as it's a location that corresponds to their adaptability range. And environmental danger? Negligible: mutant flies have no adaptive advantage in the wild and their recessive characteristics are not likely to be selected for. Neither are they overachievers when it comes to survival, so there should be few worries about environmental pollution in any ecological sense. The pollution will be in the human psyche. And isn't it better for a mutant fly to soar free for the resistance than serve a lifetime in laboratory servitude?

For any who want their own, mutant fly hatcheries are fairly easy and inexpensive to start and maintain. The flies are free, and can be obtained on the web from the Bloomington Stock Center. To maintain the flies, you will need fly bottles (each to hold about 100 flies); if you are on a small budget, however you can get by with milk bottles. The fly food is made from molasses, yeast, and apple juice. To get the perfect consistency requires a little muscle power; a machine to do this is also available – albeit costly. For optimum breeding, an environment with a relatively stable temperature is necessary. The flies should be kept at a temperature between 18 and 25 Celsius with humidity between 40 and 50 percent. While flies are fairly robust, they must be kept away from extreme temperatures, especially heat. Their life cycle is about one month, so producing a swarm (10,000) is a laborious, assembly line-like task; but maintaining a small amount over a long period of time is relatively easy, however.

**Test Site Disruption**

Over the past forty years, resistant groups have made tremendous strides in terms of organizational principles. Many have said a happy farewell to central committees, unions, and parties, and replaced them with autonomous cells and temporary, single-issue coalitions with ever-shifting rotational leadership. "The people united will never be defeated" has given way to the more practical idea that tactical unity among resistant political configurations for an immediate and specific purpose can have a systemic impact in spite of differences and contradictions within coalitions. Such "immediatism" and decentralization have proven to be the best defense against infiltration and takeover, and they aid in the creation, albeit temporary, of powerful popular fronts. Unfortunately, resistant tactics have not always maintained the same level of sophistication and complexity. This is not necessarily the fault of activists; tactical possibilities do not always present themselves as clear and easy. Further, as new contestational situations arise, the reactive tendency of radical subjects pushes them toward immediate action. There is little time to think matters through, because with each passing moment, the object of activists' political offense becomes increasingly entrenched – materially and ideologically – in the system. Radical research and development (R&D) is something of a luxury process, and so the balance between direct action and R&D is one organizational element that remains underdeveloped.

Such is the case with the response to GMOs. There has been a good deal of hard-line direct action, but the tactics are incredibly crude. The use of arson and vandalism by radicals as a means to insert inertia into corporate initiatives is a sign of desperation and a robust imbalance between thinking and acting. Whether one considers the examples of Professor Najundaswamy

and his followers in India, Jose Bove and his followers in France, and especially the Earth Liberation Front (ELF) in the US, the destruction of assets has been of limited impact, and has functioned primarily as counter-spectacle ripe for recuperation. This is not to say that there are not advantages to such tools. Fire, for example, works on all crops; it is inexpensive to produce, and insures a devastating kill ratio. The problems, however, are just as obvious. The illegality of direct incendiary sabotage creates a host of difficulties for the perpetrators. As previously stated, this kind of sabotage allows for corporate culture to cry "terrorism," so they can call themselves the victims of extreme injustice. In turn, the state and corporate security apparatus grows in strength as sabotage creates the opening for security agencies to successfully petition for increased funds and human resources. Moreover, pancapitalist spectacle can cast guilt through association on all resistant organizations, leading to more segments of the movement coming under direct investigation. This also helps create the public perception that all greens are at least potential eco-terrorist wackos. At the other end of the spectrum, saboteurs can count on long-term incarceration if apprehended. The loss of committed activists to the prison system is not helpful in the long term. A short-term stay in jail for purposes of civil disobedience is fine, since those confined are returned to the ranks rather quickly. Political prisoners as living martyrs have neither a desirable nor useful status as long as other options are available.

To look closely at the example of state military sabotage shows an optimized set of attack principles. First, only use the minimum amount of force necessary to accomplish an objective: Mosquitoes should not be killed with a shotgun. Second, focus the attack on the weakest link in the system. The classic example is the Allies' strategy of bombing all the German ball-bearing factories during World War II. All vehicles had to have the metal spheres. By focusing on their elimination, vehicle manufacture and field maintenance was brought to a near halt. Another principle that was reinforced during these bombings was the need for accurate and precise targeting systems – a wing of military research and development that has only accelerated in scope and sophistication to this day. Even from the military perspective, deficient as it is in financial logic, carpet-bombing a city to destroy one factory is an unfortunate waste of assets. While activists have done well on the second principle, they have done poorly on the first and third. Burning crops and labs is certainly overkill. Targeting is just as bad. One of the things that greens complain so much about is the potential death of non-target species due to certain GM (genetically modified) products. Fire has the same non-target effect.

In using the above principles and combining them with fuzzy sabotage, what is the best way to disrupt GMO research? The choice of research sites as a site of resistance is an excellent one. In spite of the fact that corporations generally get a free pass from the Environmental Protection Agency (EPA) and United States Department of Agriculture (USDA) to market their products, they are still obliged to produce minimal research that demonstrates that a product is "safe." If they fail to do so, the product line completely stalls. Since this type of research is largely protocol-laden in order to achieve accepted standards of scientific rigor, test contamination is very easy. Samples and study replicants are two fragile areas. If either is corrupted, the study has to begin anew, because the research will not generate the statistical power necessary to produce confidence in its validity. For example, when the growth of worms is studied as an indicator of safety in regard to soil toxicity related to BTproducts, all that is necessary is to add more worms of varying weights to the sample. While researchers will probably notice that the sample has been tampered with, they would be unable to clean the sample. The study would have to start again. The facility does not need to be burnt to the ground to place the desired inertia into the system. There is no need to kill non-target organisms (humans included), nor disrupt or destroy other research initiatives that cause no harm that may share a given facility. Such an action is cheap, requires minimal human resources and minimal force, and is specifically targeted.

The lack of organic boundaries in ecological systems allows radical subjects to use corporate culture against itself for purposes of distribution. Canadian organic farmer Percy Schmeiser had his fields corrupted and seed banks contaminated by the neighboring Monsanto "Roundup Ready" crops. In Canada, biotech corporations have the right to inspect anybody's crops. After sampling Schmeiser's canola crop, they discovered the hybridization and slapped the farmer with a lawsuit for patent infringement. Schmeiser had been growing canola the "traditional" way for 53 years and wanted no part of GM cropping. Unfortunately, he is not only a part of this system today, he is being used as a example of what will happen to those who refuse corporate crops. You will be attacked one way or the other. As this case has shown, the option for a countersuit is available, but private citizens fighting against capital-saturated corporations in costly court battles have little chance of winning.

Of interest to fuzzy saboteurs in this sad story is that private boundaries are not recognized as sovereign if a nonhuman organic agent crosses them. Have a problem with a test site crop? Go into free-range rat ranching (at reasonably low cost), and release as many as possible near the offending site. Moles, gophers, ground hogs, rabbits, mice, or any pest not susceptible to given toxins could also be released en masse near the test site. After all, laws of private property, trespass, and vandalism do not apply to them. Again, the whole crop need not be destroyed; the sample just has to be damaged to the extent that it is no longer representative of the population from which it was taken.

## High-Intensity Resistance and Precision Targeting

The question which must now be answered is what to do about the wide variety of potentially dangerous GMOs already fully distributed? Using fire or other limited means is totally useless in such a case. It simply does not pose the kind of threat that would convince any major corporation to change policy; it has neither sufficient scope nor the impact on profits, at least for as long as there are corporate insurance and tax write-offs.

*Molecular Invasion*
2002–2004, Roundup Ready Corn, installation view,
Corcoran Gallery of Art, Washington D.C.

Glyphosate works by inhibiting the enzyme 5-enolpyru-vylshikimate-3-phosphate synthase (EPSP synthase), which is found in plants and microorganisms but, as far as we know, not in any other life form. EPSP synthase is a necessary enzyme for the organisms that do have it. It is used to synthesize aromatic amino acids, which the organism needs to survive. In nature, EPSP synthase makes EPSP by bringing shikimate-3-phospate (S3P) and phosphoenol pyruvate (PEP) together. Glyphosate binds the enzyme better than PEP and prevents this reaction from occurring.

Thus, Roundup kills by literally starving the plants that it attacks. However, Roundup Ready plants have been genetically modified to produce a version of the enzyme EPSP synthase that protects the plants. This version of EPSP synthase, a natural enzyme found in some bacteria, does not bind glyphosate very well. By genetically modifying the target plant to overproduce the resistant enzyme, the GMO producers insured that the RR plants are immune to the effects of glyphosate. Using pro-drug theory as a model, it may be possible to produce a biochemical intervention that could either specifically inhibit the resistant EPSP synthase that is present in the GMOs, or set off a cascade of physiological effects that could retard or mutate the plant.

Two compounds already exist that may fulfill this function, both of which were developed or discovered by Monsanto itself. The best option seems to be pyridoxal 5 phosphate (P5P). Mixed with Roundup and exposed to light, this compound will kill the enzymes that protect the plant. CAE knows it works in the lab, but we have yet to field-test it. Killing an enzyme in a test tube is not the same as killing one in a plant. CAE does not know how well a given RR plant can defend itself against the introduction of the compound (either from protection from the cell walls or from increased manufacture of the enzyme by the plant at a rate faster than the compound can inhibit the enzymes). However, if it works, this compound is simple, safe (it is used in vitamins), and fairly inexpensive when produced in bulk. Because it is such a simple compound, it cannot be patented, so no civil liabilities are associated with it. Instructions for the creation of the photocombustible compound are available from the US medical library. This defense system is available for field-testing now, and the real strength of this system is that it will only affect the targeted plants (those using Roundup).

The best civil action that CAE has in development is a model to bond a colorigenic compound (dye) onto the RR enzyme. A colorigenic compound is one that has been synthesized so that it is initially colorless. Upon reaction, the compound is modified and releases a dye. Again, we would exploit the fact that GMOs carry a specific EPSP synthase that transforms chemical compounds. The trick is to create either a PEP or an S3P look-alike that is actually a colorigenic compound that only binds to resistant EPSP synthase, but not to the plant's natural EPSP synthase. Upon binding to the enzyme, this compound could then release a dye, thus making all RR crops an undesirable color from the point of view of the consumer.

There are three requirements for this application to be successful: 1) That a colorigenic compound can, in fact,

Offensive mechanisms such as artificial selection are one possibility. For example, feeding BT to a population of pests that should die from contact with it would eventually yield a subpopulation of pests that are immune to it. This subpopulation could then be bred to create a population that, when released into the wild, might spread the resistant gene(s). While such a method would only succeed as a long-term strategy, it could eventually have an impact: forcing corporations to increase the speed (which always costs money) at which they had to respond to shifts in the pest population. At the other end of the spectrum, this type of breeding would neither have a destructive impact on the environment, nor increase the pest rate for organic farmers. Yet the downside to this potential strategy is that it is a low-efficiency method, and thereby would probably not be a great enough threat to corporate profits to leverage a change in safety policy and research methods.

The real solution, however, is precision in targeting systems. Any offending organism has its weak link, and it is precisely the same trait that supposedly makes it strong. The gene(s) or biological process that modify the organism can be targeted, and turned from a trait of adaptability into one of susceptibility. For example, Roundup Ready (RR) could fall prey to this strategy. The herbicide Roundup (glyphosate) kills every

**108**    plant in its path, including unmodified crops.

*Molecular Invasion*
2002–2004, Roundup Ready Corn, installation view,
Corcoran Gallery of Art, Washington D.C.

In the background are the computers with a CD-ROM
that introduces visitors to Contestational Biology,
Fuzzy Biological Sabotage, Public Experimentation,
and other relevant information

be created; 2) that the compound has an affinity for the active resistant RR enzyme that is substantially greater than its affinity for the endogenous enzyme; and 3) that the compound and the effects that emerge from its application are harmless to living creatures. The best-case scenario is that the compound can be made using FDA-approved (Food and Drug Administration) food coloring already available and deemed safe for human consumption, as opposed to producing the dye from scratch. If the dye can be developed, it would function as a contestational marker in the fields, and possibly in supermarkets and homes. Home testing kits are a viable possibility. This marker would act as a do-it-yourself labeling device that could potentially force a better labeling policy out of the corporations. Finally, it would demonstrate to corporate culture that the future of biotechnology and transgenics in particular will be made a matter of public policy one way or another.

The hope in transforming this potential into reality would be to demonstrate to all corporations that they are vulnerable, and that the public interest must be a part of their testing and distribution procedures. With such pressure, it is possible that the corporations would begin kill switch and other safety feature research on their own simply to avoid any such potential profit disruptions. It would make great public relations advertising at the very least. One must remember, however, that this plan is not a quick fix; development could take years, but it can be done. Precise targeting is very difficult to do. Much like advanced electronic hacking, genetic hacking and reverse engineering are highly specialized tactics, and indeed the reason why corporations do not at present fear reverse engineering. The GMO revolution has been bloodless because resistance does not have the capital to mount a counter-offensive on the molecular level. Much like fighting nomadic (virtual) power with nomadic tactics, the current molecular invasion has to be confronted in the molecular theater of operations. For the resistance to progress on any credible, effective level, rebel labs, and rogue human resources in molecular biology have to be developed.

With the combination of traditional, electronic, and biological means of resistance, hopefully enough inertia can be introduced into the biotech industries to make time for long-term, replicated studies that can sort out the useful products from the pollutants for profits. We can only hope that the processes and products that pose a threat to the environment will eventually go the way of DDT; but for now, what is needed is time in order to boost the cautious attitude and the rigorous science necessary to introduce GMOs into fragile ecosystems.

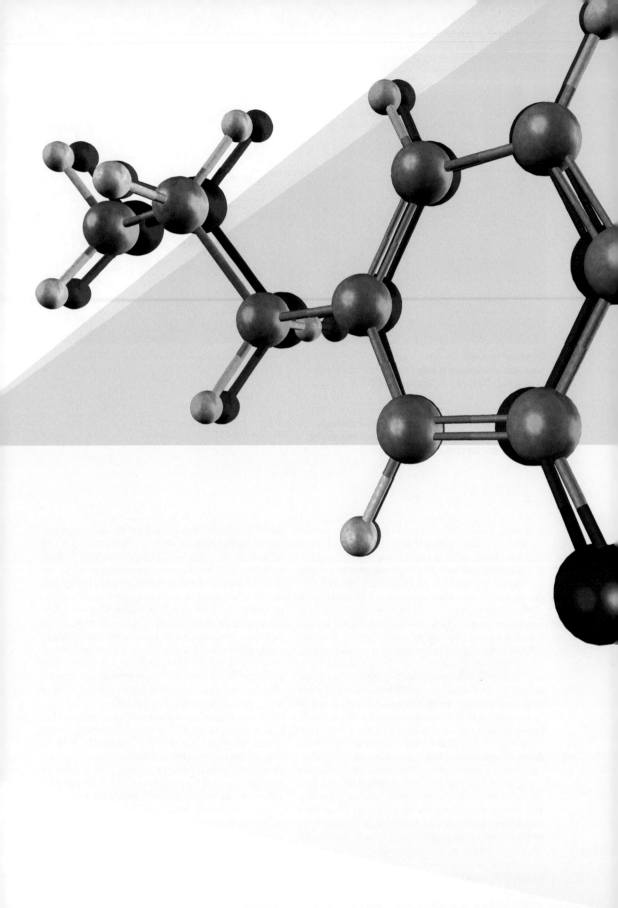

Eric Alliez
**Felix in Illo Tempore**

*The paradox of desire is that it always requires such
a long analysis, an entire analysis of the unconscious,
in order to disentangle the poles and draw out the nature
of the revolutionary group trials for desiring machines.*

<div align="right">

Gilles Deleuze and Félix Guattari
"Balance Sheet-Program for Desiring Machines"

</div>

*Molecular Revolution* is the Guattari Effect. At work. *In process*. With a strange circular, or, better: spiral causality, which upsets the calendar of chronologies, well-established as the division of Before/After 1968. At stake is a becoming that doubles – that double-crosses – history, not to call back into question what made 1968 a date, but the better to *capture* it as "molecular revolution and class struggle," in the words of the title – in the form of a balance sheet-program – of the first part of *La révolution moléculaire*[1], the book that appeared in 1977. Yet in order to do this one must still invest the coordinating conjunction à la Deleuze-Guattari by tipping it towards this disjunctive synthesis, which doesn't reconcile the two terms in a dialectical synthesis but, rather, makes them pass into one another whilst affirming that the trajectory is not the same in both directions. And one will realize that the point of view of the class struggle on the molecular revolution, which it absorbs by leaving each term in its place (that is, the thesis of the separation of two economies, political and libidinal), differs

from the perspective opened up by the molecular revolution on class struggle, which includes that struggle by a process of *unlimiting* and *multiplication,* once one understands that "in the end, the economic is the motor of subjectivity."[2] Félix Guattari's phrase here, quoted by Gilles Deleuze in his preface to *Psychanalyse et transversalité,*[3] which gathers together articles and interventions extending from 1955 to 1970, immediately puts into gear the most radical *differentiator* of his thinking, indissociable from the "mole hard at work preparing for May"[4] of which he will have been the most perceptive seismographer, as the theorist-actor of these unforeseen forms of militancy which have the social production of subjectivity as their axis. *In illo tempore.*

Starting with a series of interventions in 1962/1963 presented as an "Introduction to Institutional Therapy," one can deduce from *Psychanalyse et transversalité* the de-definition of the subject as "collective agent of enunciation," immediately distanced from the structuralist syntagma that leads to an "abstract unconscious," and to which it opposes the necessity of "setting out a structure of social enunciation" that meshes with "the class struggle of our epoch." Through the development of the "articulation of analysis with the political field"[5] in terms of *transversality*[6], this would lead to the position of a latent desire coextensive with the social field, in such a way that *political economy and libidinal economy are one and the same.* For the better – undertaken from the point of view of the constitution of *group-subjects* "opening up to the most complete alterity of the situation"[7] and an analysis of desire that cannot be actualized in the order of structural determination, and for the worse – when "the individual tends to identify with an ideal of 'machines-consuming-producing-machines'"[8] disseminating the class struggle "inside each of us with our *self,* with the social status ideal that we believe we have to dress ourselves up in."[9] In so far as one touches here on the condition of possibility of an inscription "*flush with the real*"[10] of this molecular revolution that machines and de-structures the class struggle of which Guattari – *in so far as he himself was the encounter of a political militant and an analyst,* an Anti-Self with schizophrenic powers (with Pierre and Félix, Pierre-Félix Guattari, "the individual is a [...] group") – had been the vector since the 1960s, Deleuze was not wrong to spot in these texts the process of "transformation of psychoanalysis into schizoanalysis."[11] Guattari again: "in the last instance, analysis is the detection of the traces of contamination of capitalism in all the secret zones of its 'fallout.'"[12] With the matter of the specificity of the question of madness in its irreducibility to mental illness, it is, in truth, enough to read *Psychanalyse et transversalité* as a kind of proto-"Introduction to Schizoanalysis."[13]

(In a phrase charged with the power of a transversal line of questioning: "what is this society where the mad are on one side and revolutionaries on the other?"[14])

The reader will, in particular, not fail to have been seized by the coupling effect produced with *Anti-Oedipus* by Deleuze's preface, of which one might restitute the archaeology (Michel Foucault explains that archaeology makes it possible to "analyse the very forms of problematisation"[15]) just as much as the genealogy (which is turned towards "the practices on the basis of which these problematisations are formed"[16]) *in act and in real time* (in his diary, Guattari doesn't hesitate to associate both volumes, which were published in the same year).[17] Everything effectively happens as if the genealogical dimension produced on the basis of Guattari's analytico-political practices – to which Deleuze devotes

the majority of his preface – allowed the *medial* formation of *Anti-Oedipus* to be analyzed at the very level of the "overthrowing of psychoanalysis" that conditions it and which it *realizes*.[18] This doesn't take place without the Guattarian appropriation of Lacan (the primacy of psychosis and the appropriation of the *object a* excised from its function as a symbol of lack and from its relation to the law, so as to liberate a form of "group" subjectivity, the stake of which is the "social consistency" of "social enunciation" turned towards "revolutionary rupture") in return being translated or transduced by Deleuze into the "difference with Reich."[19] *Anti-Oedipus* will, in effect, explain that although being the "true founder of a materialist psychiatry" Wilhelm Reich nonetheless did not succeed in "determining the insertion of desire into the economic infrastructure itself" or in forming the concept of a desiring creativity[20] that implicates, explicates, and complicates political economy by doubling the stakes of its critique with a *clinical analysis* (paranoia and schizophrenia). One will thus be all the more sensitive to this "right to a *schizo-flux*," which, in Deleuze's view, never ceased to animate Guattari and which he was able to raise to a "metaphysical or transcendental point of view" the transversal power of which holds for a "machine of desire, in other words, a war-machine, an analyser."[21]

It is to be understood that for Deleuze, and as *Guattari-Deleuze,* it is also a matter of a schizophrenization of philosophy, which is put to the test of these *desiring machines* whose very existence stands for a definitive going beyond of the "split between what arises from a pure theoretical critique and from the concrete analytic activity of the human sciences."[22] Deleuze concludes that *Psychanalyse et transversalité* "must be taken in bits and pieces, like a montage or an installation of the cogs and wheels of a machine. Sometimes the cogs are small, minuscule but disorderly, thus all the more *indispensible*" by the very fact of "their possible functioning in other circumstances."[23] And then – right at the end of his preface – he picks out the particular significance that must be attached to two texts: "a theoretical text, where the very principle of a machine is distinguished from the hypothesis of structure and detached from structural links ("Machine and Structure"), and a schizo-text where the notions of "point-sign" and "blot-sign" are freed from the obstacle of the signifier."[24] It can *literally* be read here that the *semiotic* critique of structuralism, attacked at its linguistic base (signifier/signified), *machines* the problematization of *Anti-Oedipus*. It does so by placing the encounter of Deleuze-Guattari under the very title of the schizo-text, "From one sign to the other" (the letter of which is as if purloined by Deleuze's pen, as the title doesn't appear), as much as under the sign of the alterity of a molecular revolution offering a *radically political* alternative to the serial games of the Deleuzian *Logic of Sense*, which re-presented the whole of (post)structuralist *ideality*.[25] (In a working note for *Anti-Oedipus* addressed to Deleuze, Guattari will emphasize that "the labour of the constituting a *series*, in [his] opinion, proceeds from the "syntagmatico-paradigmatic" perversion (neurosis-perversion) that makes the sign function like a signifier."[26]) It is a matter, then, of passing from one sign to the other in order to develop this logic of the alterity of the sign, which displaces the machine towards the desiring subject by marking, from this point, the difference with structure and the effects of the signifying chain.[27] In short, of *replaying the cut of the sign flush with material flows by thwarting the linguistic Oedipalization of enunciation in a signifying arche-writing* so as to "be articulated with the letter of theoretical discourse at the spot where it marks class

struggle at the heart of unconscious desire."[28] This exit out of the "structuralist impasse" will pass via "a conception of the sign closer to that of the glossematics of Hjelmslev than to [the] syntagmatics"[29] of Saussure-Jakobson. The point is important because it is through Louis Hjelmslev that Guattari will completely extricate himself (and Deleuze) from Lacan – Lacan of whom he will say "he flattened everything by opting for a bad linguistics."[30]

The machinic development of transversality will thus be wedded to the distribution of the unconscious throughout the social body by the imposition of a new pragmatics of the sign and of knowledges *that deterritorialize philosophy as much as it incorporates it in a communism of the artifice [un communisme artificiel] of ontological production*. Its motivating force, which in the reconstruction of vitalism that it brings about beyond just the "problem of expression" is radically post-Nietzschean, is properly Guattarian. I quote Guattari from one of the working notes sent to Deleuze in July 1970 under the heading "Power signs [Signe de puissance]": "the sign is the site of the metabolism of power [puissance] [...] If Nietzsche's *force* constitutes a *structural field*, the *machinic will to power sign* constitutes *discontinuous artificiality*. The eternal return of the 'machinic' is *not the mechanical repetition* of the same in the same but an eternal return *to* machinism, as the *being of production* and the *production of being*, as the artifice of being and the irreducible character of the bricolage of being."[31] "So, merger between the most artificial kind of modernism and the naturing nature of desire" or, to put it differently, "the real is the artificial – and not (as Lacan says) the impossible."[32] With this "mad constructivism of the sign" that Guattari will never stop scaffolding ("Semiotic Scaffoldings," 1977), machining (*The Machinic Unconscious*, 1979), and mapping (*Schizoanalytic Cartographies,* 1988), one attains the abstract-real (that is *diagrammatic*) condition of reality of a molecular revolution that is borne by desiring machines, which *socialize* the artificiality of desire "correlative to the deterritorialisation of the sign"[33] to the point that a semiotic-machinic revolution promotes "the always more accentuated molecularisation of human elements"[34] in the unchained montage of a capitalist economy that is always more intensively global. One thus better understands how Deleuze – who (this is too often forgotten) never stopped placing his vitalism under the constitutive dependence of a "theory of signs and events"[35] – could have associated his encounter with Guattari with an expeditious – but definitive – "out of that came *Anti-Oedipus*."[36]

It is effectively in *Anti-Oedipus* that all the resources of the Guattarian machine(ry) will be mobilized in an exercise that consists of translating the militant opposition of "subject-groups" to "subjugated-groups"[37] (with all the group analysis that follows transversally from it[38]), into the terms of an initially *physical* but increasingly *socio-biological* distinction between two types of equally *collective* investment. One, with a macro-physical functioning, bears on the molar structures that subordinate molecules by submitting them to the mass phenomena of statistical sets. The other, on the contrary, burrows into the transversal connections of molecular multiplicities that no longer obey statistical laws, in a domain that is indifferently microphysical and living, function and formation. This operation, which mobilizes Raymond Ruyer and François Jacob, Gabriel Tarde, and Gilbert Simondon in making the most "individuating" of the themes of *Difference and Repetition* return, impels a "*generalised schizogenesis*"[39] that posits desire as the principle of the double consideration of multiplicities

*now translated into the terms of a class struggle* of a new type between two states and two regimes of the machine – the molar and the molecular. It *cuts* the Marxist distinction between forces and relations of production *away* from its naturalist-abstract foundation (and is also to the detriment of "class interests" that serve "the interests of the structure," which need to be emptied of their "deathly substance"[40] so as to escape from the *plan/e of capital*[41]). Because if it is these same desiring machines that are invested here or are invested there in one sense or another of subordination (only one economy), if "all social production is purely and simply desiring production itself under determinate conditions,"[42] determinate conditions which, with technical machines, separate production from its distinct products, then it is desire and desire alone that raises production to the most absolute *deterritorializing power of the machine.* Because it is "only at the sub-microscopic level of desiring machines that there exists functionalism-machinic assemblages, an engineering of desire; for it is only there that functioning and formation, use and assembly, product and production merge."[43] The conclusion forces itself on us at the most condensed point of the machinic heterogenesis thus liberated: *in the determinate conditions of capitalism,* which are invested by the molecular no less than by the molar (but in a different sense and according to the principle of inclusive disjunction), "it is by restriction and derivation that the machine will cease to designate anything but a technical reality."[44] Such that, *at the very level of their process of production,* the two processes of deterritorialization, which are *falsely* disjoined in the molar formations of capitalism (as individuated human subject/technical machine), fuse under the sign of a micropolitics of desire which is like the unconscious of social technical machines and machinic critique in action, at the level of its most refined deconstruction of an Integrated World Capitalism[45] that tends more and more to de-territorialize the means of production (and of circulation) of goods and services into structures that produce (and consume) signs, syntax, and subjectivity. With regard to the semiological form of Capital, Capital as a "worldwide enterprise of subjectification,"[46] absorbing the whole of society through biopolitical integration, which is affirmed here, 1968, at the worldwide scale, was not a simple desire for social emancipation but a veritable liberation of desire affirming the new collective subjectivities on the scene of the social transformations underway. "For the first time" Guattari and Antonio Negri wrote, in a text coming from an alliance that developed during the "winter years," "at that level of intensity, the molar macrocosms and the molecular microcosms – the global and the local – began to combine in the same subversive whirlwind."[47]

At the end of (so long) an analysis, which brings us back to the beginning through a middle that is proper to molecular revolution – *investing* "subjectivity from the point of view of its production,"[48] *forcing* the "machinic dimensions of subjectification [...] assembling the production of subjectivity"[49] – *it* can be written in a single MACHINE LINE - - - - - - - - - - LITTLE BY LITTLE, ON THE BASIS OF MINUSCULE, LOCAL POSITIONS OF DESIRE, PUT THE ENTIRETY OF THE CAPITALIST SYSTEM INTO CRISIS- - - - - - - - - - -.[50] But it is also cut out from a background of chaosmosis, in a demanding heterogenesis of complexity that is oriented less towards the *heterogenesis of being* (as Being-Thinking, etc.) than towards the affirmation of *process that precedes the heterogenesis of being, by virtue of its machinic essence*: "Being does not precede machinic essence; process precedes the heterogenesis of being," Guattari writes, in the middle of *Chaosmosis,* his

last book.[51] The molecular revolution thus shifts into ontology, which it problematizes by means of an ontologico-machinic. By being articulated with this "ontological root of creativity characteristic of the new processual paradigm," the micropolitics of desire is placed in an "animist" perspective.[52] In the form of a "new aesthetic paradigm" immediately re-qualified as a "proto-aesthetic" and "ethico-aesthetic," at the absolute horizon of all processes of creation, the molecular revolution finds itself engaged in a *machination of aesthetics* called on to "overturn current forms of art as much as of social life."[53] This will to intervention *in the process*, which never stopped animating Guattari, also marks the novelty of his last paradigm with regard to any kind of "aesthetic regime."

Translated from the French by Andrew Goffey.

## Notes

1 Félix Guattari, *La révolution moléculaire*, Encres-Recherches, Paris, 1977. We should recall here that *La révolution moléculaire* is not so much a book as a collection of articles and interventions published between 1972 and 1977 to which Guattari added a number of notes grouped together under the title "Échafaudages sémiotiques" ["Semiotic scaffolding"]. A partial translation of this collection of essays has been published with the title *Molecular Revolution*, translated by Rosemary Sheed, Penguin Books, Harmondsworth, 1984.

2 One might thus note that in the conclusion added to the second edition of *La révolution moléculaire*, Félix Guattari identified the molecular revolution with "everything that concerns the place of desire in history and in *the class struggles*," see: *La révolution moléculaire*, Union générale d'éditions, Paris, 1980, p. 377 [E. A.'s italics to underline the plural].

3 Gilles Deleuze, "Trois problèmes de groupe," Preface to Félix Guattari, *Psychanalyse et transversalité*, Maspéro, Paris, 1972. This preface has been translated as "Three group-related problems" and is published in Gilles Deleuze, *Desert Islands and Other Texts, 1953–1974*, Semiotext(e), New York, Los Angeles, 2004, pp. 195/iii. All references are to this translation. Page references are given to the English first, then the French.

4 Ibid., pp. 194/ii [translation modified by E. A.].

5 Félix Guattari, "Introduction à la psychothérapie institutionelle," in: *Psychanalyse et transversalité*, pp. 42–49. As Deleuze reminds us in his preface "this is why Guattari claimed the name of institutional analysis for his work rather than institutional psychotherapy," see: Deleuze,

"Three group-related problems," pp. 201/x. See also Guattari's update when *Psychanalyse et transversalité* was republished in 1974. He reminds us of the specificity of his position: to overturn the "timid extension of analysis into the domains of psychiatry and possibly pedagogy" carried out by the leaders of institutional psychotherapy by involving the "entire social and political field" in it. This is what all Guattari's work at the La Borde clinic since 1955 was committed to (see in this sense the dialog with Jean Oury which opens *Psychanalyse et transversalité*).

6  See: Félix Guattari, "La transversalité," in: *Psychanalyse et transversalité*, pp. 72–85.

7  Guattari, "Introduction à la psychothérapie institutionnelle," p. 49.

8  Guattari, "La transversalité," p. 75.

9  Félix Guattari, "Nous sommes tous des groupuscules," in: *Psychanalyse et transversalité*, p. 283.

10  This expression, which is absolutely central to the writing of the two volumes making up *Capitalism and Schizophrenia – Anti-Oedipus* and *A Thousand Plateaus* – appears in Guattari in a violently anti-structuralist text called "L'histoire et la détermination signifiante" from 1965 (but later rewritten). See: Guattari, *Psychanalyse et transversalité*, p. 178.

11  Deleuze, "Three group-related problems," pp. 200/ix.

12  Félix Guattari, "Integration de la classe ouvrière et de perspective analytique," in: *Psychanalyse et transversalité*, p. 202.

13  The title of the last chapter of *Anti-Oedipus* thus finds itself projected back *before* the book.

14  Guattari, "Introduction à la psychothérapie institutionnelle," p. 44.

15  Michel Foucault, *The History of Sexuality*, Volume 2: *The Use of Pleasure*, trans. Robert Hurley, Penguin Books, London, 1985, p. 11 [translation modified by E. A.].

16  Ibid., p. 11.

17  "Both books are finished [...]. I will have to account for them" (November 14, 1971). Some days earlier, coming back to the theme of the reversal of perspective, in relation to Jacques Lacan ("it's at the end of his analysis of the representation of desire that Lacan found the *object a*, the residual object. We started from the other end, production and desiring machines [...]"), Guattari notes that "many of the themes had been raised at the GTPSI [Work Group on Institutional Psychotherapy and Sociotherapy]" (November 5, 1971), to the point that he makes a striking shortcut between institutional analysis and schizoanalysis. See: Félix Guattari, *The Anti-Oedipus Papers*, translated by Kélina Gotman, Semiotext(e), New York, Los Angeles, 2006, pp. 349–351.

18  Félix Guattari is involved in this in his personal life to such a point that he can date a letter intended to complete the exchange of letters that resulted in *Anti-Oedipus* "December 20th 1960," instead of 1970. The anecdote is related by Stéphane Nadaud in his preface to *The Anti-Oedipus Papers*, p. 16.

19  Deleuze, "Three group-related problems," pp. 195/iii.

20  Gilles Deleuze and Félix Guattari, *Anti-Oedipus*, translated by Robert Hurley, Helen Lane, and Mark Seem, Viking, New York, 1977, p. 118. In his preface to *Psychanalyse et transversalité*, Deleuze produces the best possible formulation: "Consequently, it is political economy as such, an economy of flows, which is unconsciously libidinal: there is only one economy, not two, and desire or libido is just the subjectivity of political economy," see: Deleuze, "Three group-related problems," pp. 195/iii.

21  Deleuze, "Three group-related problems," pp. 200/xi.

22  Guattari, "Réflexions pour des philosophes à propos de la psychoanalyse institutionnelle," in: *Psychanalyse et transversalité*, p. 97. The human sciences are at the same time exhorted to abandon an "outmoded scientific ideal." See: Guattari "D'un signe à l'autre," in: *Psychanalyse et transversalité*, p. 143.

23  Deleuze, "Three group-related problems," pp. 202–3/xi. For his part, Guattari credits his work with Deleuze as a "labour of the purification of concepts that I had 'experimented [with]' in different fields *but which could not acquire their full extension because they remained too attached to them*." See: "Entretien avec Michel Butel," in: Félix Guattari, *Les Années d'hiver (1980–1985)*, Editions Bernard Barrault, Paris, 1986, p. 85.

24  Deleuze, "Three group-related problems," p. 203.

25  Let's recall that on the one hand Deleuze organizes *Logic of Sense*, which he presents as a "logical and psychoanalytic novel" in series; on the other, that "Machine et structure", which Guattari addressed to Deleuze in 1969, concludes on the "question of revolutionary organization," this being supposed to serve to reveal the "subjective potentialities" of each struggle, as much as to "protect them against their 'structuralisation'," in: *Psychanalyse et transversalité*, pp. 247–248.

26  Guattari, *The Anti-Oedipus Papers*, p. 38.

27  Guattari, "D'un signe à l'autre," in: *Psychanalyse et transversalité*, p. 145.

28  Guattari, "Machine et structure," in: *Psychanalyse et transversalité*, p. 248.

29  Guattari, "L'Histoire et la détermination signifiante," p. 180. One can follow the absolutely determining character of the whole of Félix Guattari's work on Louis Hjelmslev in the working notes collected in *The Anti-Oedipus Papers*.

30 Guattari, *The Anti-Oedipus Papers,* p. 73. "Lacan was wrong to identify displacement and condensation with Jakobson's metaphor and metonymy on the level of primary processes. He is turning everything into linguistics and diachronizing, crushing the unconscious."

31 Ibid., p. 224 [translation modified by the E. A.].

32 Ibid., p. 99/149. The Nietzschean philosophy of becoming is no longer a theory of expression with a "transcendental-empiricist" destination (Deleuze without Guattari) but the retro-projection of a constructivist pragmatics that is differentiated from the "structural field" by the machinic affirmation of desire.

33 Ibid., p. 88.

34 What Guattari calls the "*infrahuman machinic montages of capitalism,*" in: *La révolution moléculaire,* pp. 53–54. One could already read in "D'un signe à l'autre" that "there is every reason to think that as information technology develops, rigorously formalised systems will, little by little, come to dominate all domains of human existence, rendering every previous use value available for a scientific and technological treatment," in: *Psychanalyse et transversalité,* p. 141.

35 "Everything I have written is vitalistic [...] and amounts to a theory of signs and events," Gilles Deleuze, *Negotiations, 1972–1990,* translated by Martin Joughin, Columbia University Press, New York, 1995, p. 143.

36 Ibid., p. 7.

37 Subjugated firstly and above all else to their organizational logic of structural serialization. This political line, which carries Félix Guattari's anti-structuralism along, on the basis of which the *whole* of his work with Gilles Deleuze was deployed, should never be forgotten.

38 The micropolitical as much as *militant* origin of the concept of "transversality" can effectivly be read in the syntagma "transversality in the group." See: Guattari, "La transversalité", p. 79.

39 Deleuze and Guattari, *Anti-Oedipus,* p. 287 (Chapter Four "Introduction to Schizoanalysis").

40 [Translation modified. The Gotman translation reads "the problem is to rid class interest investment structures of their deathly fascizing substance."] Guattari, *The Anti-Oedipus Papers,* p. 196 ("Class Interests and Group Desire").

41 To borrow Mario Tronti's essential expression. See: Mario Tronti, "Il piano del capital" in: Mario Tronti, *Operai e capitale,* Giulio Einaudi Editore, Turin, 1971. The expression appears in Gilles Deleuze and Félix Guattari, *A Thousand Plateaus,* University of Minnesota Press, Minneapolis, p. 472.

42 Deleuze and Guattari, *Anti-Oedipus,* p. 29.

43 Ibid., p. 288. And they continue: "All molar functionalism is false, since the organic or social machines are not formed in the same way they function, and the technical machines are not assembled in the same way they are used [...]."

44 Gilles Deleuze and Félix Guattari, "Balance sheet-Program for Desiring Machines," in: *Semiotext(e),* II/3, 1977, p. 131. [This essay was published as an appendix to the French edition of *Anti-Oedipus*]. Guattari will develop this analysis for itself in the direction of a "machinic autopoiesis." See: Félix Guattari, *Chaosmosis,* translated by Paul Bains and Julian Pefanis, Indiana University Press, Bloomington and Indianapolis, 1995, pp. 32–57.

45 For the montage of this notion, which Guattari abbreviates IWC, see: Félix Guattari and Eric Alliez, "Systems, Structures and Processes," in: Gary Genosko (ed.), *The Guattari Reader,* Blackwell Publishers, Oxford, 1996, pp. 233–247.

46 Deleuze and Guattari, *A Thousand Plateaus,* p. 457.

47 Félix Guattari and Antonio Negri, *New Lines of Alliance, New Spaces of Liberty,* Autonomia, New York, 2010, p. 37. A verification that in the last analysis, the "duality of the poles passes less between the molar and the molecular than to the interior of the molar social investments, since *in any case* the molecular formations are such investments," in: Deleuze and Guattari, *Anti-Oedipus,* p. 340.

48 Guattari, *Chaosmosis,* p. 1.

49 Ibid., p. 4 [translation modified by the E. A.] (Chapter 1, "The production of subjectivity").

50 Guattari, *La Révolution moléculaire,* pp. 120–121. The start of this book is driven by NINETEEN MACHINE WRITTEN LINES. The exercise is repeated later on the pages indicated.

51 Guattari, *Chaosmosis,* p. 108.

52 Ibid., p. 116. On the construction of a *machinic animism* on the basis of Guattari's work, see: Angela Melitopoulos and Maurizio Lazzarato, "Machinic Animism," in: Anselm Franke (ed.), *Animism,* Sternberg Press, Berlin, 2010, p. 97–110.

53 Ibid., p. 185 (Chapter 6, "The New Aesthetic Paradigm"). Allow me to refer to my recent article "Du chaos à la chaosmose. Re-présentation du paradigme proto-esthétique," in: *Chimères,* 77, 2012, pp. 123–129.

Roald Hoffmann
**Molecular Beauty**

*What makes molecules beautiful? It may be their simplicity, a symmetrical structure. Or it may be their complexity, the richness of structural detail that is required for specific function. Sometimes the beauty of a molecule may be hidden, to be revealed only when its position in a sequence of transformations is made clear. Novelty, surprise, utility also play a role in molecular aesthetics, which is the subject of this contribution.*

Recently my wife and I were on our way to Columbus, Ohio. After I settled on the airplane, I took out a manuscript I was working on – typical for the peripatetic obsessive chemist. Eva glanced over and asked, "What are you working on?" I said: "Oh, on this beautiful molecule." "What is it that makes some molecules look beautiful to you?," she asked. I told her, at some length, with pictures. And her question prompted this exposition.

What follows is then an empirical inquiry into what one subculture of scientists, chemists, call beauty. Without thinking about it, there are molecules that an individual chemist, or the community as a whole, considers to be the objects of aesthetic admiration. We will explore what such molecules are, and why they are said to be beautiful.

In the written discourse of scientists, in their prime and ritual form of communication, the periodical article, emotional descriptors, even ones as innocent as those indicating pleasure, are by and large eschewed. So it is not easy to find overt written assertions such as: "Look at this beautiful molecule X made." One has to scan the journals for the work of the occasional courageous stylist, listen to the oral discourse of lectures, seminars or the give and take of a research

group meeting, or look at the peripheral written record of letters of tenure evaluation, eulogies, or award nominations. There, where the rhetorical setting seems to demand it, the scientist relaxes. And praises the beautiful molecule.

By virtue of not being comfortable in the official literature – in the journal article, the textbook or monograph – aesthetic judgments in chemistry, largely oral, acquire the character of folk literature. To the extent that the modern day subculture of chemists has not rationally explored the definition of beauty, these informal, subjective evaluations of aesthetic value may be inconsistent, even contradictory. They are subfield (organic chemistry, physical chemistry) dependent, much like the dialects, rituals, or costumes of tribal groups. In fact the enterprise of excavating what beauty means in chemistry seems to me to have much of the nature of an anthropological investigation.

But this is not going to be your typical, seemingly detached critical analysis revealing with surgical irony the naive concepts of beauty held by a supposedly sophisticated group of people. The honesty and intensity of the aesthetic response of chemists, when they allow themselves to express it, must be taken positively, as a clue to an unformulated good, as spiritual evidence, as a signpost to record, to empathize, to make connections with other aesthetic experiences. Aesthetic judgments made by chemists about chemistry are perhaps more cognitively informed than aesthetic judgments in the arts (more on this below), which ensures that those judgments are jargon laden. But I am certain that people outside of chemistry can partake of what makes a chemist's soul jump with pleasure at the sight of a certain molecule.[1] It is worth trying to see the motive force for all that intense, disinterested contemplation.

## The Shape of Molecules

Let us begin with the obvious, which was not accessible to us until this century, namely *structure*. Molecules have a shape. They are not static at all, but always vibrating. Yet the average positions of the atoms define the shape of a molecule. That geometry can be simple, or it can be exquisitely intricate. Structure 1 (fig. 1) is a molecule with a simple shape, dodecahedrane. This $C_{20}H_{20}$ polyhedron (the polyhedron shows the carbons; at each vertex there is also a hydrogen radiating out) was first made in 1982 by Leo Paquette and his co-workers.[2] It was a major synthetic achievement, many years in the making. The Platonic solid of dodecahedrane is simply beautiful and beautifully simple. Molecule 2 (fig. 1) has been dubbed manxane by its makers, William Parker and his co-workers.[3] Its shape resembles the coat of arms of the Isle of Man. And molecule 3 (fig. 1) is superphane, synthesized by Virgil Boekelheide's group.[4] All are simple, symmetrical and devilishly hard to make.

Let us try a structure whose beauty is a touch harder to appreciate. Arndt Simon, Tony Cheetham and their co-workers have recently made some inorganic compounds of the formula $NaNb_3O_6$, $NaNb_3O_5F$ and $Ca_{0.75}Nb_3O_6$.[5] These are not discrete molecules but extended structures, in which sodium, niobium and oxygen atoms run on in a small crystal, almost indefinitely. Structure 4 (fig. 2) is one view of this truly super molecule.

Some conventions: the white balls are oxygens (O), the stippled ones niobium (Nb), the cross-hatched ones sodium (Na). The perspective shown chops out a chunk from the infinite solid, leaving it up to us to extend it, in our mind, in three dimensions. That takes practice.

FIG 1

FIG 2

Deconstruction aids construction. So let us take apart this structure to reveal its
incredible beauty.

In drawing 4 (fig. 2) we clearly see layers or slabs. One layer (marked A) is shown
in structure 5 (fig. 3). It contains only niobium and sodium atoms. The other FIG 3
layer, B (structure 6 [fig. 4]), is made up of niobium and oxygen atoms arranged FIG 4
in a seemingly complex kinked latticework. Let us take on this B layer first.

Roald Hoffmann
Molecular Beauty

1        2        3

FIG 1

○ = oxygen    ◉ = niobium    ⬤ = sodium

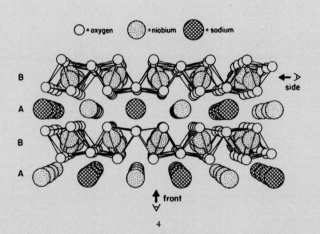 

B

A

B

A

side

front

4

FIG 2

A

5

FIG 3

B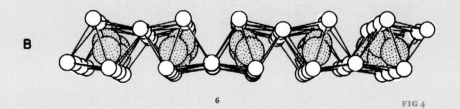

6

FIG 4

125

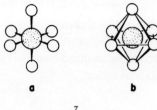

a    b

7

FIG 5

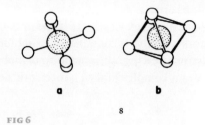

a    b

8

FIG 6

top    front    side    top    front    side

9    10

FIG 7    FIG 8

top

11

FIG 9

12

FIG 10

126

The building block of the slab is an octahedron of oxygens around a niobium. One such idealized unit is shown in drawing 7 (fig. 5), in two views. In drawing 7a, lines (bonds) are drawn from the niobium to the nearest oxygen. In drawing 7b these lines are omitted, and instead the oxygens are connected up to form an octahedron. Which picture is right? Which is the true one? Sorry – both are. Or, better said – neither is. Three-dimensional molecular models, or their two-dimensional portrayals, which is what we have before us, are abstractions of reality. There is no unique, privileged model of a molecule. Instead, there is an infinite variety of representations, each constructed to capture some aspect of the essence of the molecule. In drawing 7a the essence is deemed to lie in the chemical bonds, a pretty good choice. These are Nb–O; there are no O–O bonds. Yet portrayal 7b draws lines between the oxygens. This representation seeks after another essence, the polyhedral shapes hiding in the structure. Graphically, forcefully, drawing 7b communicates to us that there are octahedra in this structure.

You may wonder where these octahedra are in the complex structure of $NaNb_3O_6$. Well, take the octahedra of drawing 7 and rotate them in space, to the viewpoint shown in drawing 8 (fig. 6). If you compare 8 with the middle piece of layer B (shown in structure 6 [fig. 4]), you will see a certain resemblance. Now consider the structure of the layer. First, a large, semi-infinite number of such octahedra are linked into a one-dimensional array by sharing opposite edges. Three views of such an edge sharing octahedral chain are presented in drawing 9 (fig. 7).

One of the three views is from the same vantage point as in drawing 4 or 6, say the "top." The two other views are roughly from the "front" and "side," the viewpoints so marked in the original drawing, 4. The shared edges are emphasized by darker lines in the side view.

If you compare the top view of one of these infinite chains in drawing 9 with that in 6, you will see a difference – the niobiums are receding from you in a neat straight line in 9, but are "staggered" in pairs in 6. Indeed, drawing 9 is an idealization. One of the stacks in the real structure is carved out in drawing 10 (fig. 8), shown in the same top view as in 6, but also from the front and the side. The displacement of the niobiums from the centers of the oxygen octahedra, and an associated asymmetry of the oxygens, are clearly visible.

Would you like to know why there occurs this departure from ideality? So did we. A piece of the answer is to be found in a paper that Maria Jose Calhorda and I have written.[6] For the moment let us accept this symmetrical asymmetry as one of those complexities that makes life interesting.

Next, the one-dimensional chains of octahedra combine to generate the full B layers by sharing two opposite vertices with identical chains. They could have done so in a nice "straight" way (drawing 11 [fig. 9], a top view of a line of such vertex sharing octahedra). But they do not; they "kink" (drawing 12 [fig. 10]) in a less straightforward but still symmetrical way. One gets the feeling that nature is insubordinate... What really is going on, though, is that we, in the weakness of our minds, fix on the first, most symmetrical suggestion of how things might be.

We now have layer B, this fantastic slab (repeated over and over in the crystal) of infinite, one dimensional, edge sharing octahedral chains, in turn stitched up to a two dimensional slab by sharing vertices. What about layer A?

FIG 5
FIG 6
FIG 7
FIG 8
FIG 9
FIG 10

Drawing 4 shows that layer A is made up of needlelike lines of sodium and niobium. We might think these atoms are equally spaced, but this molecule has another surprise in store for us, as the front view of layer A indicates (drawing 13 [fig. 11]). Whereas the sodiums are approximately equally spaced, the niobiums clearly are not. They pair along the vertical direction (this pairing is obscured from the "top" vantage point of drawing 4 or 5), so that there are distinct short (2×6 Å) and long (3×9 Å) Nb–Nb separations. The short one is very short, substantially shorter than that in pure niobium metal.

Why do the niobiums pair? In our study of the way electrons move in these compounds, we find that the pairing is driven by a desire cum necessity to form Nb–Nb bonds along the needle.[7] There are even Nb–Nb bonds, not shown here, between the niobium atoms of stacks A and B.

Other links stitch up the layers. For instance, the niobiums in layer A are not floating in empty space. They are at a bonding distance from the oxygens of two bordering B slabs. In fact, as drawing 14 (fig. 12) shows, each pair of niobiums in a line in A nestles comfortably into an array of eight oxygens from layer B. The layers are connected up – this is not a one or two-dimensional structure, but a true three-dimensional array in which are embedded substructures of lower dimensionality.

Now we have toured the structure, which is at once symmetrical and unsymmetrical, in which the beauty of this aesthetic object resides. The beauty is in the incredible interplay of dimensionality. Think of it: two dimensional slabs are assembled from infinite one dimensional chains of edge sharing octahedra of oxygens around niobium, which in turn share vertices. These two dimensional slabs interlink to the full three dimensional structure by bonding with one-dimensional needles of niobium and sodium. And then, in a final twist of the molecular scenario, these one-dimensional needles pair up niobiums, declining to space equally. The $NaNb_3O_6$ structure self assembles, in small black crystals, an aesthetic testimonial to the natural forces that shape the molecule, and to the beauty of the human mind and hands that unnaturally brought this structure into being.

FIG 11

FIG 12

front view of layer A

13        FIG 11        14        FIG 12

## Kant

It is hard to escape the feeling that a chemist appreciative of the dimensional ins and outs of $NaNb_3O_6$ is doing just what Kant described in the following words: "He who feels pleasure in the mere reflection upon the form of an object...justly claims the agreement of all men, because the ground of this pleasure is found in the universal, although subjective, condition of reflective judgments, viz. the purposive harmony of an object (whether a product of nature or of art) with the mutual relations of the cognitive faculties (the imagination and the understanding)..."[8] But let us go on, to look at another source of molecular beauty.

## Frogs About to Be Kissed

Could one say much by way of approbation for molecule 15 (fig. 13)? Not at first FIG 13 sight. What are those dangling $(CH)_{12}$–Cl chains on the left? Or the unsymmetrical $(CH_2)_{25}$ loop on the right, or the $NH_2$ group? The molecule is, if not ugly (there are no ugly molecules, says this most prejudiced chemist), at least plain. It's not an essential component of life, it's not produced in gigakilogram lots. In fact its purpose in life is not clear.

The last sentence contains a clue to what makes this molecule, a frog that is a prince, beautiful. Chemistry is molecules, and it is chemical change, the transformations of molecules. Beauty or elegance may reside, static, in the very structure, as we saw for the molecule $NaNb_3O_6$. Or it may be found in the process of moving from where one was to where one wants to be. Historicity and intent have incredible transforming power; this molecule is beautiful because it is a waypoint. Or – as they say in the trade – an intermediate.

So: *quo vadis?* To a catenane, structure 16 (fig. 14), two interlocking rings of car- FIG 14 bon atoms, not chemically combined but held together like the links of a chain. Why should people try to make a catenane? For no particular reason. For the best reason, because none was made before. How to make it? Here is one strategy, which I will term a statistical one. A typical chemical reaction is a cycliza- tion, schematically written out in structure 17 (fig. 15). If we run the cyclization FIG 15 of a long chain, some fraction of the time – purely by chance – the chains will be entwined, or a chain will be threaded through an already formed ring, in such a way that a catenane will be formed. Remember how small molecules are, how many ($10^{20}$) there are in a typical pot. In all this multitude, statistics have a chance to work. E. Wasserman actually realized this in 1960, synthesizing a catenane[9] for the first time.

FIG 13    15          FIG 14          FIG 15          17          **129**

The statistical procedure works, albeit inefficiently. There are other ways to craft the catenane topology. One beautifully conceived synthesis is due to Schill and Lüttringhaus.[10] Their logical scheme is summarized in chart 18 (fig. 16). The starting point is a molecule with lots of specifically disported functionality. In chemistry, a functional group is a set of bonded atoms whose properties are more or less invariant from one molecule to another. The most important of these properties is chemical reactivity, the "function" of the group. To put it another way, in the context of doing chemistry on a molecule, functional groups are the *handles* on a molecule. The transformations of functional groups, and particularly the predictability of their reactions, are a crucial element in the conceptual design of syntheses in organic chemistry. Common functional groups might be R–OH (alcohols), R–COOH (organic acids), R–COH (aldehydes) or R–X (X = F, CI, Br, I: the halides), where R is anything. The substituents X, Y and Z in structure 18 are functional groups.

Step A in structure 18 elaborates the Y and Z functional group handles into long chains. Step B is a closing up, or "cyclization," of one set of chains. Step C is a different kind of cyclization, another linking up, now of the other set of chains to the remaining core functionality X. Step D, perhaps several steps, is a fragmentation, in which the core from which the reaction was initiated, on which all was built, is now mercilessly torn apart, revealing the catenane.

Several points about this process are important: (i) the synthesis is architecture, a building, and (ii) as such it requires work. It is easy to write down the logical sequence of steps as I have. But each step may be several chemical reactions, and each reaction a more or less elaborate set of physical processes. These take time and money; (iii) the architectonic nature of the process almost dictates that the middle of the construction is characterized by molecules that are more complex than those at the beginning and the end.[11] Note (iv) the essential topological context of chemistry. It is evident not only in the curious topology of the goal, a catenane, but also in the very process of linkage that pervades this magnificent way of building.

To return to the reality of the specific, the moment scheme 18 is laid out it is clear what molecule 15 is. It is the crucial point in the middle, after step B, before step C. It is poised to cyclize, the chlorines at the end of the $(CH_2)_{12}$ chains set to react with the $NH_2$ group. The synthesis by Schill and Lüttringhaus begins with molecule 19 (fig. 17) and ends with catenane 20 (fig. 18), in which a ring of 28 carbons interlocks with another ring with 25 carbons and one nitrogen. But while getting to structure 20 is sweet, it should be clear that what is important is *getting to*, the process. That process is reasonably linear (although chart 18 makes us think it is more linear than it is). One might suppose that any step in a linear chain of transformations (a→b→c→d→e) could claim primacy of significance. Indeed the steps in a synthesis may differ vastly in their difficulty, and therefore in the ingenuity invested to accomplish them. The unpublished lore of chemistry abounds with tales of a fantastically conceived, elegant synthesis in which the very last step, thought to be trivial, fails.

Nevertheless, I will advocate a special claim for a molecule somewhere in the middle of the scheme, the molecule most complicated relative to the starting materials and the goal; the molecule most disguised, yet the one bearing in it, obvious to its conceiver but to few others, the surprise, the essence of what is to come.[12] It is the col of complexity, and the only way from this beautiful molecule is on, on.

FIG 16

## A Position on Utility

The last section, if it correctly describes a prevalent feature of beauty in the mind of the chemist (and I assure you it does), departs substantially from a Kantian perspective.[13] There is *Zweckmässigkeit* [purposive intent] in abundance in molecule 15, but it is powered by *Zweck* [purpose], the catenane.

Detachment has been central in analytic theories of aesthetics. Some frameworks have introduced a stronger quality, disinterest. To Kant an object that is of utility (for instance, the catenane precursor, not to speak of an antibiotic or sulphuric acid, made in a mere 110 million tonnes worldwide this year), whose valuation is not sensually immediate but requires cognitive action, cannot qualify as being beautiful. As several commentators have pointed out, this is a rather impoverishing restriction on our aesthetic judgments.[14] It seems clear to me that knowledge – of origins, causes, relations and utility – enhances pleasure. Perhaps that cognitive enhancement is greater in scientific perusal, but I would claim that it applies as well to a poem by Ezra Pound. But let us go on.

FIG 16

18

FIG 17     19

FIG 18     20

131

## As Rich as Need Be

FIG 19 Look at molecule 21 (fig. 19). It seems there's nothing beautiful in its involuted curves, no apparent order in its tight complexity. It looks like a clump of pasta congealed from primordial soup or a tapeworm quadrille. The molecule's shape and function are enigmatic (until we know what it is!). It is not beautifully simple.

Complexity poses problems in any aesthetic, that of the visual arts and music as well as chemistry. There are times when the *Zeitgeist* seems to crave fussy detail – Victorian times, the rococo. Such periods alternate with ones in which the plain is valued. Deep down, the complex and the simple coexist and reinforce each other. Thus the classic purity of a Greek temple was set off by sculptural friezes, the pediments and the statues inside. The clean lines and functional simplicity of Bauhaus or Scandinavian furniture owe much to the clever complexity of the materials and the way they are joined. Elliott Carter's musical compositions may seem difficult to listen to, but their separate instrumental parts follow a clear line.

In science, simplicity and complexity always coexist. The world of real phenomena is intricate, the underlying principles simpler, if not as simple as our naive minds imagine them to be. But perhaps chemistry, the central science, is different, for in it complexity is central. I call it simply richness, the realm of the possible.

Chemistry is the science of molecules and their transformations. It is the science not so much of the hundred elements, but of the infinite variety of molecules that may be built from them. You want it simple – a molecule shaped like a tetrahedron or the cubic lattice of rock salt? We have got it for you. You want it complex – intricate enough to run efficiently a body with its 10 000 concurrent chemical reactions? We have that too. Do you want it done differently – a male hormone here, a female hormone there; the blue of cornflowers or the red of a poppy? No problem, a mere change of a $CH_3$ group or a proton respectively will tune it. A few million generations of evolutionary tinkering, a few months in a glass glittery lab, and it is done! Chemists (and nature) make molecules in all their splendiferous functional complexity.

Beautiful molecule 21 is hemoglobin, the oxygen transport protein. Like many proteins, it is assembled from several fitted chunks, or subunits. The subunits come in two pairs, called $\alpha$ and $\beta$. Incredibly, these actually change chemically twice in the course of fetal development, so as to optimize oxygen uptake. The way the four subunits of hemoglobin mesh, their interface, is requisite for the protein's task, which is to take oxygen from the lungs to the cells.[15]

FIG 20 One of the hemoglobin subunits is shown in structure 22 (fig. 20). It is a curled up polypeptide chain carrying a "heme" molecule nestled within the curves of the chain. All proteins, not just hemoglobin, contain such polypeptide FIG 21 chains (see structure 23 [fig. 21] for a schematic formula), which are assembled in turn by condensation of the building block amino acids, shown in struc- FIG 22 ture 24 (fig. 22). These come in about 20 varieties, distinguished by their "side chains" (R in structures 23 and 24). A typical protein, the hemoglobin P chain is made up of 146 amino acid links. Here is richesse, reaching out to us! Think how many 146 link chain molecules there could be given the freedom to choose the side chains in 20 possible ways. The incredible range of chemical structure and function that we see in those tiny molecular factories, enzymes, or in other

proteins, derives from that variety. The side chains are not adornment, they make for function.

The protein folds, the diversity of the side chains provides opportunity, the particular amino acid sequence enforces a specific geometry and function. Extended pieces of hemoglobin curl in helical sections, clearly visible in structure 22. At other places the chain kinks, not at random, but preferentially at one amino acid, called proline. The globular tumble of helical sections, nothing simple, but functionally significant, emerges.

Significant in what way? To *hold* the molecular piece that binds the oxygen, and to *change*, in a certain way, once the oxygen is bound. The $O_2$ winds its way into a pocket in the protein that is just right, and binds to the flat, disc shaped heme molecule. The structure of heme is shown in 25 (fig. 23). The oxygen binds, end on, to the iron at the centre of the heme. As it does, the iron changes its position a little, the heme flexes, the surrounding protein moves. In a cascade of well-engineered molecular motions the oxygenation of one sub unit is communicated to another, rendering that one more susceptible to taking up another $O_2$ molecule.

FIG 23

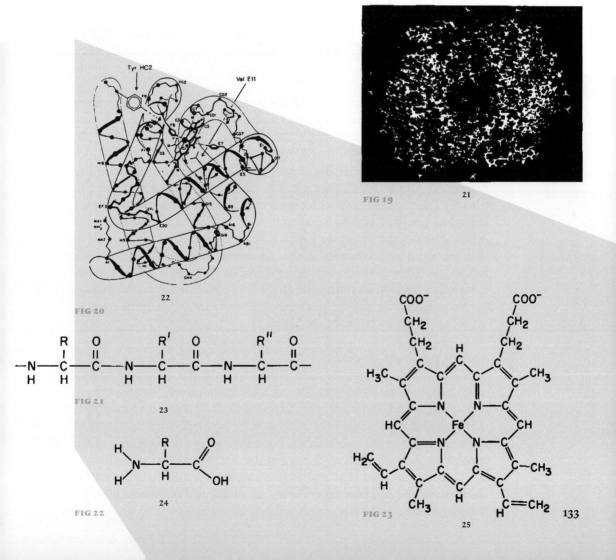

FIG 19

21

FIG 20

22

FIG 21

23

FIG 22

24

FIG 23

25

133

That bizarre sculpted folding has a purpose, in the structure and function of a molecule critical to life. All of a sudden we see it in its dazzling beauty. So much so that it cries out "I've been designed"; "For this task, I'm the best that can be." Or, if you are so inclined, it testifies to a designer.

Beautiful? Certainly. The best, fashioned to a plan? Hardly. It only takes a moment to get us back to Earth, a few bubbles of CO, the lethal, odorless product of incomplete combustion of fires and car exhausts. Carbon monoxide fits into the same wondrously designed protein pocket, and it binds to hemoglobin several hundred times better than oxygen.

So much for the best of all possible worlds and the evolutionary plan. As F. Jacob has written, nature is a tinkerer.[16] It has a wonderful mechanism for exploring chance variation, and, until we came along, much time on its hands. While it was banging hemoglobin into shape there was not much carbon monoxide around. So it never "worried" about it.

Actually the story, the story of molecular evolution, is more complicated, more wondrous still. It turns out that there is always a bit of carbon monoxide around in the body, a natural product of cellular processes. Heme, free of its protein, binds carbon monoxide much better than hemoglobin. So the protein around the heme apparently evolved to *discourage* carbon monoxide bonding a little. Not enough to take care of massive doses of external carbon monoxide, just enough to allow the protein to take up sufficient oxygen even in the presence of naturally produced carbon monoxide.[17]

## Iconicity

A word might be in place here about the preponderance of visual representations of molecules in this exposition. Could I be overemphasizing the *picture* of the molecule in analyzing the pleasure chemists take, at the expense of the *reality* of molecules and their transformations?

The relationship of the signifier to the signified is as complex in chemistry as in any human activity. The problem is discussed in substantial detail elsewhere.[18] The empirical evidence for the importance of the structural drawings that crowd this paper is to be found on any page of a modern chemical journal. Typically, 25% of the area of the page is taken up by such drawings (so this review *looks* like a typical chemical paper). The structures that decorate chemist's articles are recognized by them as imperfect representations, as ideograms. But in the usual way that representations have of sneaking into our subconscious, these schematic diagrams merge with the real world and motivate the transformations that chemists effect in the laboratory.

## Archetypes and Epitomes

Classical notions of beauty do have a hold on us. Central to Plato's and Aristotle's notions of reality was the ideal of a universal form or essence. Real objects are an approximation to that form. Art, in dismissive moments, was to the Greek philosophers mere imitation or, more positively, something akin to science, a search for the essential core. Concepts such as the archetype and the epitome figure in the Greek aesthetic. And they are to be found in chemistry today. The archetype is the ideal simple parent molecule of a group of derivatives, say methane ($CH_4$), and not any of the myriad substituted methanes CRR'R"R'" which make life interesting.

The epitome is something typical, possessing the features of a class to a high degree. It is this concentration of feeling which I want to focus on, for it is one of the determinants of beauty in chemistry. Molecule 26 (fig. 24) (made by Clark and Schrock, structure determined by Churchill and Youngs)[19] is such an emblem, but the background needs to be set for its compressed beauty to emerge. Molecules exist because there are bonds, the electronic glue that binds atoms together into molecular aggregates. In organic chemistry bonds come in several types – single as in ethane (structure 27 [fig. 25]), double as in ethylene (structure 28 [fig. 26]), triple as in acetylene (structure 29 [fig. 27]), where the bond lengths are given in ångstroms.

FIG 24

FIG 25

FIGS 26, 27

The plain English words tell the story: double is stronger than single, triple stronger still. The lengths of the bonds follow their strength, for chemical bonds act much like springs. Thus the atoms held together by a triple bond are more tightly bound, the bond between them shorter in length than a double bond; the latter one in turn is shorter than a single bond.

FIG 24

FIG 25

FIG 26

FIG 27

135

You can mix bonds, that is put several (classically up to four) bonds on a carbon, or two single ones and one double, or a single and a triple, or two double bonds (structures 30–33 [fig. 28]). But because carbon has the capability of forming (in general, more on this below) only four bonds, you cannot have molecule 34 (fig. 29), a carbon atom with a single, double and triple bond to it.

Not so for metals. The "transition metals" – chromium, iron, manganese, cobalt, nickel, rhenium, tungsten and so on – have the capacity to form up to nine bonds. The chemistry of metal to other element bonds, especially the metal carbon single bond, is nearly forty years young, that of metal-carbon double and triple bonds younger still. This is the burgeoning realm of organometallic chemistry. The concentrated beauty of structure 26 lies in that it is a molecule in which one and the same tungsten atom forms a single W-C bond, a double

FIG 28

FIG 29

FIG 30

$Fe_6C(CO)_{16}^{2-}$

35

$Rh_6C(CO)_{15}^{2-}$

36

FIG 31

FIG 32

37

one and a triple one. And two bonds to phosphorus, for good measure. Incidentally structure 26's official name is [1,2*bis*(dimethylphosphino)ethane] (neopentylidyne) (neopentylidene) (neopentyl)tungsten(VI)!

Such bonds are present, individually, in many molecules made in the past four decades. But in structure 26 they are all in one. The epitome, for that is what molecule 26 is, intensifies what it exemplifies by concentrating several disjoint examples into one. Its psychological impact is more than the sum of its parts; by such concentration it enhances our aesthetic response.

## Novelty

Note the strong intrusion of the cognitive into judgments of the beauty of the molecules in the previous section. Their beauty is dependent, to use the Kantian term, they are very special members of a class. Still more dependent, in fact stretching outside of the limits of what is usually considered a viable aesthetic quality, is what characterizes the molecules of this section. It is *novelty*. I would claim that in the minds of chemists the new can leap the gap between "interesting" and "beautiful."

Science certainly subscribes in its very structure to the idea of innovation. It may be discovery – understanding how hemoglobin, discussed above, works. Or finding out how pre-Colombian Andean metalsmiths electroplated gold without electricity.[20] It may be creation – the synthesis of the catenane 16, or the tungsten compound 26.

We are addicted to new knowledge, and we value it (therefore it is interesting to reflect on the generally conservative tastes of scientists in art, or their astonishment that some other people do not view scientific or technological innovation as an absolute good). At the same time most chemistry builds slowly. It is paradigmatic science, routine if not hack work, extending step by patient step what has been done before. Chemists appreciate this patient work, it allows them to read a new issue of a journal quickly. Yet it is inevitable that they grow just a bit bored by its steady drone, its familiar harmony.

Then, all of a sudden, from the plain of fumaroles, an eruption of fire reaches for the sky. It is impossible not to look at it, it is a hot intrusion on the landscape of the mind, as beautiful as it is new. A surprising, unexpected molecule.

Two examples come to mind, in counterpoint to the organometallic epitome. The long accepted inability of carbon to form more than four bonds is the fertile ground from which grow millions of natural and synthetic products, all the beauty of life and the democratizing utility of modern chemistry. But it is not holy ground, this four coordination of carbon.

Some time ago, inorganic chemists made molecules 35 (fig. 30) and 36 (fig. 31), FIGS 30, 31 called metal carbonyl clusters.[21] In these the metal atoms form a lovely symmetrical polyhedron – an octahedron of irons in structure 35, a trigonal prism of rhodiums in 36. Around that polyhedron, seemingly loosely scattered on its periphery, are carbon monoxides, called carbonyls. And in the centre, captive, encapsulated, resides a single carbon atom. It is connected to, equidistant from, all six metals around it.

More recently, Schmidbaur and co-workers in Munich[22] made a not unrelated, spectacularly simple molecule, 37 (fig. 32). In it, central, is a lone carbon. Bond- FIG 32 ed radially to it are six ligands, $AuPR_3$ groups. There is a plus two charge on this molecule.

In these compounds (molecules 35–37) carbon patently forms six bonds. This is the surprise, the shock, the full impact of which should (but has not yet) hit every maker of carbon compounds.[23] It makes these metal carbonyl clusters and the $C(AuPR_3)_6^{2+}$ molecule beautiful. They are new, interesting and lovely. And they pose questions. How can carbon form six bonds? Are the old ideas wrong? Not entirely, for when we look at how the electrons move in these molecules we find that these are different kinds of bonds, perhaps weaker individually than normal carbon's four classical bonds. Theory expands to accommodate the new; the novel in time will become routine, only to be shaken by the unforeseen violator of the new set of rules.

## Empirical Chemical Aesthetics and Formal Theories

I have hardly exhausted the capacity of molecular creation to please the human mind. Molecules can be beautiful because of the wondrous quantized motions they undergo, truly a music played out in tones, harmonics and overtones that our instruments, now measuring instruments, hear. They may be beautified by their miracles – who would deny it to penicillin or morphine? Or more lowly, they may be as beautiful as the 5 million tonnes of phosphoric acid ($H_3PO_4$) manufactured every year. You are more likely to have heard of the rougher guys, the spectacular hydrochloric, nitric and sulphuric siblings. But this quiet one is responsible for a good part of the essential phosphorus in your DNA.

Much philosophic tradition would object to including the utilitarian perspective as an aesthetic criterion. I have mentioned above some objection to this limiting view. Here I would only add the empirical testimony of the practitioners – be they deluded, naive or not, chemists really do think that *use* is an element, not the most important one, but an element of chemical beauty.

But perhaps it is time to stop here and take another tack. Let us posit that we have discovered in this anthropological study of chemistry a reliable sampling of the qualities the experts/natives use as attributes of beauty. They, the chemists, we, for I am among them, have an aesthetic. Maybe we do not call any molecule ugly, but some molecules are more beautiful than others. Does our aesthetic, our way of assigning beauty, have something in common with the aesthetics characteristic of other parts of human experience, those of games, of business, of love, but especially of art?

I am not going to answer this question here to anyone's satisfaction, but it is worth asking. A fundamental problem, of course, is that aesthetics is not a closed chapter of philosophy. Rival theories abound, indeed the dialogue shifts with time, much as the subject of its discussion. Nevertheless, one could proceed by seeing how the concept of beauty in chemistry fits or does not fit into the existing (fashionable?) aesthetic frameworks erected by philosophers. This has been done to some extent in the sections above, but let me approach the problem more directly here.

For instance, Monroe Beardsley supposes that the aesthetic response (to a work of art, which is an artifact intended to elicit such a response) entails importantly a degree of detachment on the part of the viewer or listener and the elements of intensity, unity and complexity in the object viewed.[24] His argument deserves deeper exposition than these few words, but it seems to me that the chemist's aesthetic response entails many of Beardsley's factors. As for detachment, a concentration that envelops, well – the only people I have seen more detached than

chemists looking at molecules are computer hackers or Pachinko players. Intensity has been discussed in the previous section, in the context of molecule 26. It said a lot, economically. Unity is by and large absent in the exemplars selected by me. They stand alone. But, implicitly, these structures cannot be viewed as beautiful except in the context of knowledge of other molecules. And if they be totally new, they impose a stress on existing theories to assimilate their brash flaunting of not fitting in. New molecules incite theory, which is the unifying, framework building way the chemist makes connections.

I hesitate on complexity, not because it is unimportant (remember hemoglobin and all your enzymes) but because I see so clearly the aesthetic strength of simplicity. The parent molecule, the symmetrical molecule, the reaction that goes under wide conditions, the simple mechanism, the underlying theory expressed by a single mathematical equation – these have beauty conferring value. However, there is a thread that runs through the tokens of chemical beauty that inclines me to another aesthetic philosophy, which is that of Nelson Goodman.[25] Goodman views science and art both as cognitive processes, differing perhaps only in their intensity or degree of elaboration or manipulation of symbols. And one is certainly struck by the cognitive element in all these appreciations of the chemist, in our reactions to molecules. We *feel* that these molecules are beautiful, that they express essences. We feel it emotionally, let no one doubt that. But the main predisposition that allows the emotion, here psychological satisfaction, to act, is one of knowing, of seeing relationships. I took apart $NaNb_3O_6$ into chains of octahedra and layers, and related it so to other materials. I saw the catenane synthesis planned, and so grew to love the molecule at its high pass. I *know* what hemoglobin does, therefore I care about it. And the molecules in the preceding section are clearly fascinating because they stand out, or soar.

Perhaps we should not press too hard to fit the multifarious manifestations of chemical beauty into tight categories or theoretical frameworks. Even if we were to agree on a definition of beauty, what would it gain us? As M. H. Abrams has pointed out,[26] saying that X is beautiful is almost the dullest thing one can say about X. One needs to describe the object's attractiveness. I hope that this essay has done so, part way, for molecules.[27]

These products of our hands and minds, beautiful molecules, appeal directly to the mind. For a chemist, their line into the soul is direct, empowering, sometimes searing. They are natural, hemoglobin like a fern unfurling, like the cry of a duck on a winter lake. They are synthetic (or if you like artifactual, man or woman made, unnatural) – the catenane, Schrock's tungsten epitome, like the Shaker tune "'tis a gift to be simple," like Ogata Korin's screens.

First published in: *The Journal of Aesthetics and Art Criticism*, vol. 48, no. 3, 1990, pp. 191–204. Reprint with permission of Roald Hoffmann.

## Notes

1 For a general introduction to molecules see the beautiful book by P. W. Atkins, *Molecules*, Scientific American Library, New York (NY), 1987.

2 See: Leo A. Paquette, Robert J. Ternansky, Douglas W. Balogh, and Gary Kentgen, "Total synthesis of dodecahedrane," in: *Journal of the American Chemical Society*, vol. 105, no. 16, 1983, pp. 5446–5450, doi: 10.1021/ja003540043.
Dodecahedrane was synthesized in a very different way: Wolf-Dieter Fessner, Bulusu A. R. C. Murty, Jürgen Wörth, Dieter Hunkler, Hans Fritz, Horst Prinzbach, Wolfgang D. Roth, Paul von Ragué Schleyer, Alan B. McEwen, and Wilhelm F. Maier, "Dodecahedrane aus [1.1.1.1] Pagodanen," in: *Angewandte Chemie*, vol. 99, no. 5, 1987, pp. 484–486, doi: 10.1002/ange.19870990526.

3 See: M. Doyle, W. Parker, P. A. Gunn, J. Martin, and D. D. MacNicol, "Synthesis and conformational mobility of bicyclo(3,3,3)undecane(manxane)," in: *Tetrahedron Letters*, vol. 11, no. 42, 1970, pp. 3619–3622, doi: 10.1016/S0040-4039(01)98543-0.

4 See: Y. Sekine, M. Brown, and V. Boekelheide, "[2.2.2.2.2.2](1,2,3,4,5,6)Cyclophane: Superphane," in: *Journal of the American Chemical Society*, vol. 101, no. 11, 1979, pp. 3126–3127, doi: 10.1021/ja00505a053.
For an immensely enjoyable tour of the coined landscape of chemistry see: A. Nickon and E. F. Silversmith, *Organic chemistry: The name game*, Pergamon, Oxford, 1987, doi: 10.1002/pi.4990240411. Structures 1–3 are drawn after this source.

5 See: Jürgen Köhler and Arndt Simon, "NaNb$_3$O$_5$F – eine Niob-Niob-Dreifachbindung mit 'side-on'-Koordination durch Nb-Atome," in: *Angewandte Chemie*, vol. 98, no. 11, 1986, pp. 1011–1012, doi: 10.1002/ange.19860981118; S. J. Hibble, A. K. Cheetham, and D. E. Cox, "Calcium niobium oxide, Ca$_{0.75}$Nb$_3$O$_6$: a novel metal oxide containing niobium-niobium bonds. Characterization and structure refinement from synchrotron powder x-ray data," in: *Inorganic Chemistry*, vol. 26, no. 15, 1987, pp. 2389–2391, doi: 10.1021/ic00262a011.

6 See: Maria J. Calhorda and Roald Hoffmann, "Dimensionality and metal-metal and metal-oxygen bonding in the sodium niobate(NaNb$_3$O$_6$) structure," in: *Journal of the America Chemical Society*, vol. 110, no. 25, 1988, pp. 8376–8385. doi: 10.1021/ja00233a015.

7 Ibid.

8 Immanuel Kant, *Critique of judgment*, Hafner, New York (NY), 1951, p. 28.

9 See: Ed Wasserman, "The preparation of interlocking rings: a catenane," in: *Journal of the American Chemical Society*, vol. 82, 1960, pp. 4433–4434. For an elegant Möbius strip approach to catenanes, see: R. Wolovsky, "Interlocked ring systems obtained by the metathesis reaction of cyclodecene. Mass spectral evidence," in: *Journal of the American Chemical Society*, vol. 92, 1970, pp. 2132–2133; D. A. Ben-Efraim, C. Batich, and E. Wasserman, "Mass spectral evidence for catenanes formed via a 'Möbiusstrip' approach," in: *Journal of the American Chemical Society*, vol. 92, no. 7, 1970, pp. 2133–2135, doi: 10.1021/ja00710a058. See also the ingenious work of Jean-Pierre Sauvage and Jean Weiss, "Synthesis of biscopper (I) [3]-catenates: multiring interlocked coordinating systems," in: *Journal of the American Chemical Society*, vol. 107, no. 21, 1985, pp. 6108–6110, doi: 10.1021/ja00307a049.

10 See: G. Schill and A. Lüttringhaus, "Gezielte Synthese von Catena-Verbindungen," in: *Angewandte Chemie*, vol. 76, no. 13, 1964, pp. 567-568, doi: 10.1002/ange.19640761304.

11 For some leading references on complexity in chemical synthesis, chemical similarity and chemical "distance," see: S. H. Bertz, "Convergence, molecular complexity, and synthetic analysis," in: *Journal of the American Chemical Society*, vol. 104, no. 21, 1982, pp. 5801–5803, doi: 10.1021/ja00385a049; M. Wochner, J. Brandt, A. von Scholley, and I. Ugi, "Chemical similarity, chemical distance, and its exact determination," in: *Chimia*, vol. 42, no. 6, 1988, pp. 217–225; James B. Hendrickson, "Systematic synthesis design. 6. Yield analysis and convergency," in: *Journal of the American Chemical Society*, vol. 99, no. 16, 1977, pp. 5439–5450, doi: 10.1021/ja00458a035.

12 For an inspiring, original presentation of the achievements of organic synthesis see: N. Anand, J. S. Bindra, and S. Ranganathan, *Art In Organic Synthesis*, 2nd edition, John Wiley and Sons, New York (NY), 1988.

13 For leading references see: Paul Guyer, *Kant and the Claims of Taste*, Harvard University Press, Cambridge (MA), 1979; Donald W. Crawford, *Kant's Aesthetic Theory*, University of Wisconsin Press, Madison (WI), 1974.

14 See: Donald W. Crawford, *Kant's Aesthetic Theory*, University of Wisconsin Press, Madison (WI), 1974, pp. 49-51; Noël Carroll, "Beauty and the Genealogy of Art Theory," in: *Beyond Aesthetics. Philosophical Essays,* Cambridge University Press, Cambridge (MA), 2001, pp. 20–41, doi: 10.1017/CBO9780511605970.004.

15 For more information on hemoglobin see: R. E. Dickerson and I. Geis, *Hemoglobin: structure, function, evolution, and pathology*, Benjamin/Cummings, Menlo Park (CA), 1983; L. Stryer, *Biochemistry*, 3rd edition, W. H. Freeman, San Francisco (CA), 1988. I owe much to these books and to the original work of Max Perutz.

16 See: F. Jacob, "Evolution and tinkering," in: *Science*, vol. 196, 1977, pp. 1161–1166, doi: 10.1126/science.860134.

17 See: Dickerson, Geis 1983; Stryer 1988.

18 See: Roald Hoffmann and Pierre Laszlo, "La représentation en chimie," in: *Diogène*, vol. 147, 1989, pp. 24–54.

19 See: D. N. Clark and R. R. Schrock, "Multiple metal-carbon bonds, 12. Tungsten and molybdenum neopentylidyne and some tungsten neopentylidene complexes," in: *Journal of the American Chemical Society*, vol. 100, no. 21, 1978, pp. 6774–6776, doi: 10.1021/ja00489a049; Melvyn R. Churchill and Wiley J. Youngs, "Crystal structure and molecular geometry of W(.tplbond.CCMe$_3$)(:CHCMe$_3$)(CH$_2$CMe$_3$)(dmpe), a mononuclear tungsten(VI) complex with metal-alkylidyne, metal-alkylidene, and metal-alkyl linkages," in: *Inorganic Chemistry*, vol. 18, no. 7, 1979, pp. 2454–2458, doi: 10.1021/ic50199a025.

20 See: H. Lechtman, "Pre-Columbian surface metallurgy," in: *Scientific American*, vol. 250, no. 6, 1984, pp. 56–63.

21 See: B. F. G. Johnson and J. Lewis, "Transition-Metal Molecular Clusters," in: *Advances in Inorganic Chemistry Radiochemistry*, vol. 24, 1981, pp. 225–355, doi: 10.1016/S0065-2792(08)60329-5; John S. Bradley, "The Chemistry of Carbidocarbonyl Clusters," in: *Advances in Organometallic Chemistry*, vol. 22, 1983, pp. 1–58, doi: 10.1016/S0065-3055(08)60400-1.

22 See: Franz Scherbaum, Andreas Grohmann, Brigitte Huber, Carl Krüger, and Hubert Schmidbaur, "'Aurophilie' als Konsequenz relativistischer Effekte: Das Hexakis(triphenylphosanaurio)methan-Dikation [(Ph$_3$PAu)$_6$C]$^{2+}$," in: *Angewandte Chemie*, vol. 100, no. 11, 1988, pp. 1602–1604, doi: 10.1002/ange.19881001130.

23 Some of these molecules were foreseen theoretically. See, for instance: Paul von Ragué Schleyer, Ernst-Ulrich Würthwein, Elmar Kaufmann, Timothy Clark, and John A. Pople, "Effectively hypervalent molecules. 2. Lithium carbide (CLi$_5$), lithium carbide (CLi$_6$), and the related effectively hypervalent first row molecules, CLi$_{5-n}$H$_n$ and CLi$_{6-n}$H$_n$," in: *Journal of the American Chemical Society*, vol. 105, no. 18, 1983, pp. 5930–5932, doi: 10.1021/ja00356a045; D. Michael P. Mingos, "Molecular-orbital calculations on cluster compounds of gold," in: *Journal of the Chemical Society, Dalton Transactions*, no. 13, 1976, pp. 1163–1169, doi: 10.1039/DT9760001163.

24 See: M. C. Beardsley, *Aesthetics. Problems in the Philosophy of Criticism*, 2nd edition, Hackett Publishing Co., Indianapolis (IN), 1981; and M. C. Beardsley, in: *The Aesthetic Point of View*, M. J. Wreen and D. M. Callen (eds.), Cornell University Press, Ithaca (NY), 1982.

25 See: Nelson Goodman, *Languages of Art*, 2nd edition, Hackett Publishing Co., Indianapolis (IN), 1976.

26 M. H. Abrams, personal communication. See also: Guy Sircello, *A New Theory of Beauty*, Princeton University Press, Princeton (NJ), 1975, pp. 118–121.

27 I am grateful to Maria José Calhorda, Paul Houston, Barry Carpenter, Bruce Ganem, Noël Carroll, two reviewers, and Donald W. Crawford for their comments and help in the preparation of this review, and to Sandra Ackerman for her editorial assistance. This article derives from four "marginalia" that I wrote for *American Scientist* (vol. 76, 1988, pp. 389–391, 604–605; vol. 77, 1989, pp. 177–178, 330–332). It has also been published in the *Journal of Aesthetics and Art Criticism* (vol. 48, no. 3, 1990, pp. 191–204). I am grateful to the editors of this publication for permission to reprint the article here. The ink drawings were beautifully done, as always, by Elisabeth Fields and Jane Jorgensen. Max Perutz gave permission to reproduce one drawing of hemoglobin. One other was taken from the spectacular, illuminating graphics of hemoglobin designed by Irving Geis.

*3 Hydrogens*
2008, oil on canvas, 84 × 60 cm

large image
*Oxygen*
2008, oil on canvas, 42 × 30 cm

**BLAIR BRADSHAW** (*1967 in Dallas, TX) is an American photographer, painter, and filmmaker who lives and works in Brooklyn, New York. After studying film at the University of Texas, Austin, Bradshaw moved to Los Angeles to start a career in motion pictures. His study of film eventually turned to an interest in still photography and ultimately to painting. His assembled canvases reconstruct the iconography of the periodic table, transforming complex chemical structures into common human experience. His works have been featured in galleries from New York to Paris and are part of private collections in the US and Europe.

www.blairbradshaw.com

**Blair Bradshaw**

Blair Bradshaw's paintings and constructions tend to focus on the graphic simplifications of larger, more complicated organizational systems. Whether it's the periodic table, references to mass transportation, or simplified illustrations of warplanes, submarines, and tanks, his work uses graphical representations to bury the intricate vocabulary of each system.

*Periodic Table*
2007, oil on canvas, 48 × 60 cm

144

*Protein #305*
2003, inkjet, pencil, silk screen on paper,
48.3 × 33 cm

As part of this project, Miller photographed Rod Mac-
Kinnon's notebooks, using one of the pages as the
background image. A second layer is a colored pencil
rendering of one of the models, another notebook page –
enlarged and silk-screened – another amino acid helix
that fills the page. Human proteins continually fold in
on one another and stay in constant motion. Similarly,
the layers in this work assure that the eye stays moving.

All works presented are from a collaborative
project with the 2003 Nobel Laureate in Chemistry,
Rod MacKinnon.

**STEVE MILLER** (*1951 in Buffalo, NY) is an American
artist best known for his paintings and photography,
which combine aspects of art, science, and technology.
He studied at the Skowhegan School of Painting and
Sculpture in New York (NY). His work has been exhib-
ited widely at galleries and museums around the world,
such as the National Academy of Sciences (Washington
D.C.), Gellaria Tempo (Rio de Janeiro, BR), Gallery Maya
(London), the South Street Gallery (Greenport, NY), and
the Pera Museum (Istanbul, TR), among others. A for-
mer Hans Hofmann Fellow at the Fine Arts Work Cent-
er, Provincetown (MA) and Fellow in Painting from the
New York Foundation for the Arts, Miller currently lives
and works between the Hamptons and New York.

http://stevemiller.com

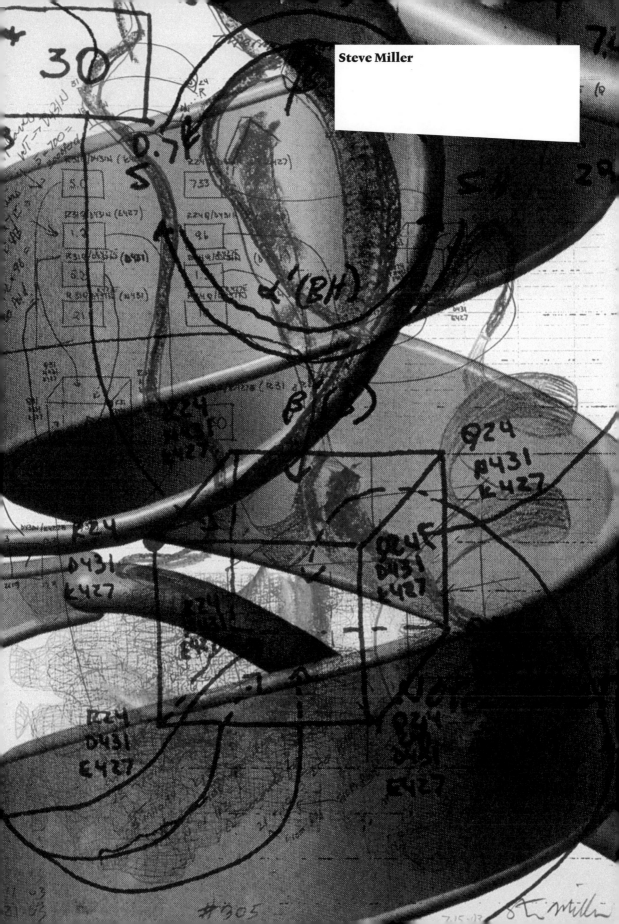

Steve Miller

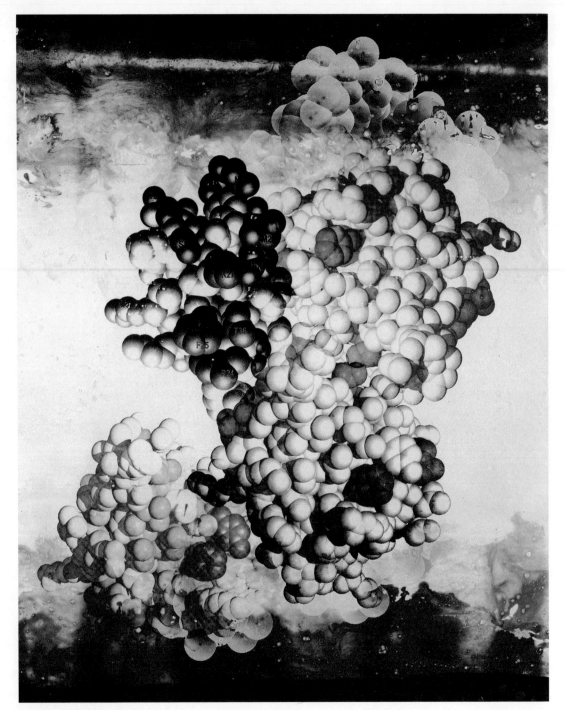

*Soap Opera, the Second Season*
2005, dispersion, silk screen on canvas,
129.5 × 101.6 cm

*Soap Opera, the Second Season* is a series of bubble images,
another technique used to represent proteins. Here, too,
movement is implied; it is intrinsic to the molecular lev-
el and the liquid water world inside every human being.
Further, the term itself, "soap opera," implies a forward-
moving narrative that is offered on a daily basis.

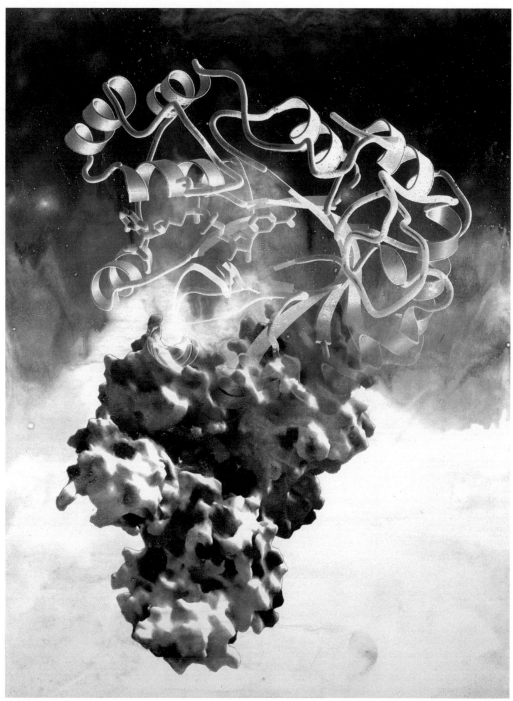

*Signal Relay*
2003, dispersion, silk screen on canvas,
127 × 95.3 cm

*Signal Relay* combines two visual protein model technologies: surface images and ribbon images. Inspirations for the work were both René Magritte's familiar castle on a floating rock and Excalibur, more commonly known as the "sword in the stone." Again, as a human protein, *Signal Relay* is always in motion.

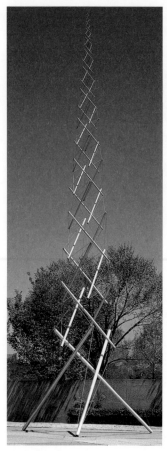

*Needle Tower*
1968, aluminum and stainless steel,
18.2 × 6 × 6 m

large image
*Dragon*
2002–2003, stainless steel,
9.3 × 9.4 × 3.6 m

**KENNETH SNELSON** (*1927 in Pendleton, OR) is an American artist who lives and works in New York (NY). He is best known for building large outdoor sculptures of steel tubes and aircraft cable, many of them standing in museums and public places around the world. Snelson's sculptures are prestressed tension/compression networks that use the structural system he invented known as tensegrity. The artist describes his sculptures as diagrams of physical forces in three-dimensional space. His work has been featured in several books, including Eleanor Heartney's monograph, *Kenneth Snelson: Forces Made Visible*, Hudson Hills Press, Manchester (VT), 2009.

www.kennethsnelson.net

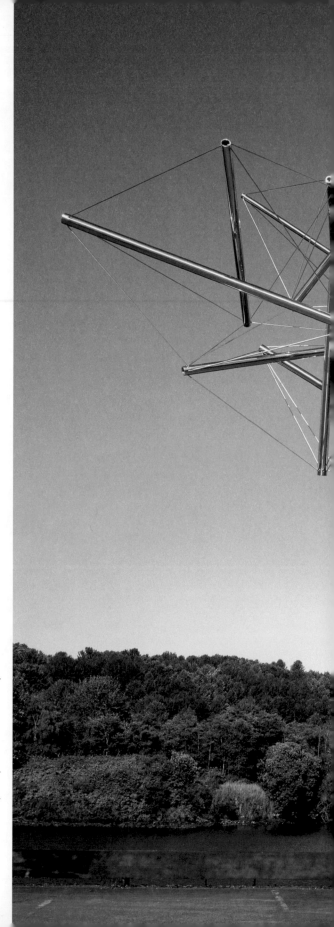

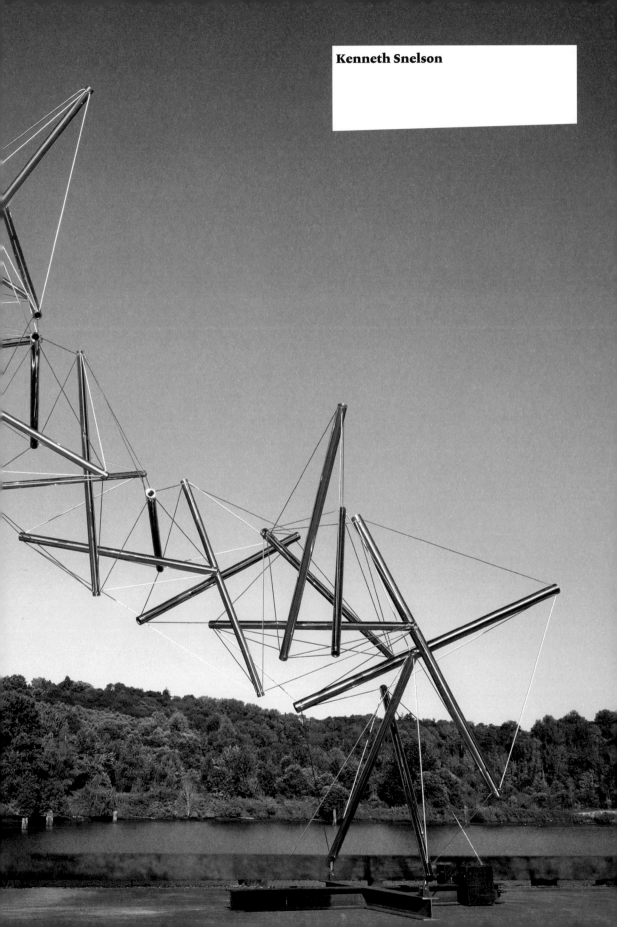

Kenneth Snelson

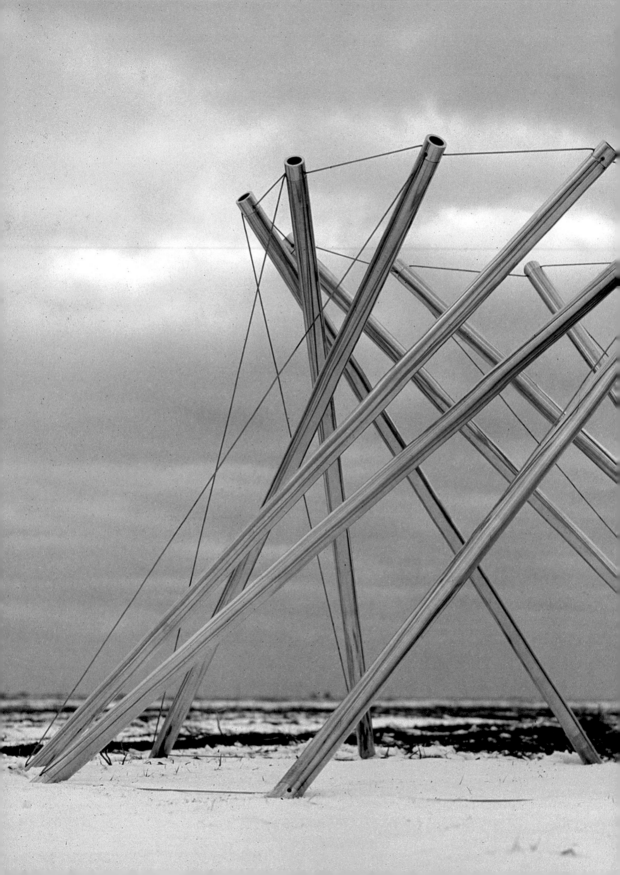

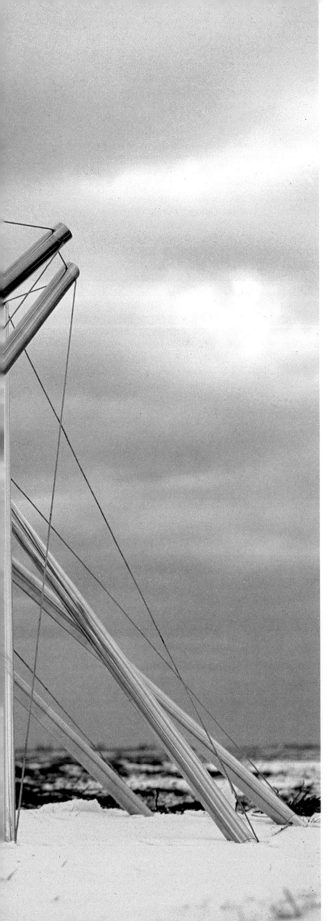

## An Artist's Modest Proposal – A Visual Model of the Atom, Homage to Prince Louis de Broglie
Kenneth Snelson

*Systems scientific come and go. Each method of limited understanding is at length exhausted. In its prime each system is a triumphant success; in its decay it is an obstructive nuisance.*
<div align="right">Alfred North Whitehead</div>

*All physical theories, their mathematical expression apart, ought to lend themselves to so simple a description that even a child could understand them.*
<div align="right">Albert Einstein</div>

*The dilemma posed to all scientific explanation is this: magic or geometry?*
<div align="right">René Thom</div>

Scientists who have grown up with quantum physics have been taught that all atomic problems were solved many years ago with wave mechanics and quantum mechanics. Though this may be so from the view of a physicist, the one important question that has never been answered concerns the workings of the atom's electrons: How do they move or circulate about the nucleus? How do these submicroscopic electrical particles give rise to the atom's architecture? Because it is impossible to see an atom up close and watch its electrons in action, such questions can be answered only by speculative reasoning, by creating a reality model the kind that the great majority of scientists have shunned for the past eighty years (fig. 1).

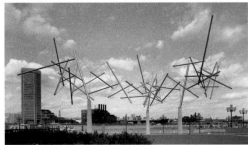

**FIG 1** *Easy Landing*
1977, stainless steel, 10 × 25 × 20 m, sited at Baltimore's Inner Harbor, collection of the City of Baltimore

The debates that took place in the 1920s, especially during the 5th Solvay Conference (1927) dedicated to "Electrons et photons" and the 6th Solvay Conference occupied (1930) with "Le magnétisme," which settled the question of "real" atom models versus abstract non-visual mathematics in favor of Niels Bohr and his Copenhagen world view. There were to be no further atom models that purport to describe events that cannot be tested by experiment; visual models that could be in violation of Werner Heisenberg's uncertainty principle. From

large image
*V-X*
1968, stainless steel, 3 × 4.3 × 4.3 m

that time on students gifted with visual sensibilities and imagination have been warned to avoid quantum physics. Among the list of great men in that remarkable 1920s quantum-theory drama, the physicist who has especially interested me is Prince Louis de Broglie, who played a curious on-the-fence role during the causal/acausal worldview debate. His story is unusual: Louis de Broglie was a young French physics student in Paris when he published his doctoral dissertation in 1924 *Recherches sur la theorie des quanta* [Researches in the Quantum Theory] in which he proposed that – just as Einstein had shown light to have a dual nature, acting both as light-waves and particle-photons – matter should also have a dual character. De Broglie hypothesized that the electron can act as a wave as well as a particle (fig. 2).

**FIG 2**

As an example, he used Nils Bohr's hydrogen atom's electron. De Broglie calculated that his matter-waves fit perfectly in velocity and wavelength around Bohr's hydrogen atom model's quantized concentric orbits. In the first shell closest to the nucleus, a single wave could fit in like a snake grabbing its tail. In shell two, two waves fit in; three waves in shell three, etc.

Two years later, 1926, Erwin Schrödinger adapted de Broglie's matter-wave idea to create the Schrödinger wave equation, which soon became one of the principle tools of quantum physics. In 1927 the Davisson-Germer experiment proved that there are indeed electron matter-waves, that de Broglie waves are a fact of nature.

When Louis de Broglie submitted his dissertation, he believed his matter-waves described reality, the actual condition of the electron in the atom. Because his wave idea was subsumed and transformed from real waves into non-visual mathematics, de Broglie decided during the 1927 Solvay Conference to join with the Copenhagen group and concede that matter-waves were only fictional abstractions. Prince Louis de Broglie was awarded a Nobel Prize in 1929 for his discovery of matter-waves.

Twenty-five years later a mature de Broglie looked back and reversed his belief once more, deciding he had been right in the first place, that his original "real" matter-waves could somehow be developed into a physical model. Although that never happened in his lifetime, he continued to believe in the possibility of a de Broglie-wave real model until the day he died in 1987 at the age of 95.

Today, after these many years, a search on the Web will show that in classroom lectures, more often than not, professors recite the story of Bohr's hydrogen model, than introduce de Broglie's matter-wave theory, moving on immediately to Schrödinger's wave equation without ever mentioning that de Broglie first demonstrated his theory in his 1924 paper by applying it to a matter-wave model of the hydrogen atom.

So begins my fantasy, a structural model-builder's interpretation of the Bohr-de Broglie atom model with its matter-waves vibrating in quantized circles surrounding the atom's nucleus. Perhaps I can resurrect and build upon Louis de Broglie's vision. As an artist, not a scientist, the language I use and the way I present my imagined atomic structure is surely out of key with the language expected of scientists. I hope that with the help of illustrations, I can convey my mind's vision of the quantum atom. Despite the broadly accepted and celebrated Copenhagen interpretation of quantum physics, I am still convinced – as I have been since first imagining my artist's atom fifty years ago – that the atom is an elegant submicroscopic machine with its own quantum rules, not a puzzle so unworldly and so far from logical understanding that its workings will remain forever beyond human comprehension.

The quantum physicists' debate in the 1920s boiled down to the question of electron orbits versus no electron orbits. My atom model retains de Broglie's circular standing waves; call them orbits. I believe it is fair to describe de Broglie's matter-wave electron, with its pilot wave continuity, as an object in itself; an object comprising the following list of properties (fig. 3):

1. As with Bohr's quantized electron, a de Broglie orbital wave remains at an energy shell and can move from one shell to another only by absorbing or transmitting light energy.

2. The electron's negative electric charge is smeared over the orbital circle's circumference.

3. The de Broglie orbit has both orbital magnetism and top-like angular momentum.

4. The orbit incorporates the electron particle's intrinsic spin (Uhlenbeck and Goudsmit proposal, 1925) whose north and south poles can either add to the orbit's magnetism or, by inverting, subtract from it.

5. De Broglie matter-waves are matter-like. As with macro pieces of matter, de Broglie waves occupy exclusive space. Orbits cannot be in the same space at the same time.

**FIG 3**

The diagram shown in figure 4 represents the electron's wavelength and its related velocity. The matter-wave stretches and shrinks, always in quantized steps. When the electron's speed increases its de Broglie wavelength shrinks by a quantized unit and vice versa, much like striking different notes on a piano, not like a glissando on a slide-trombone (fig. 4).

Electron's Velocity

Electron's de Broglie Wavelength

**FIG 4**

Figure 5 shows de Broglie's atom (left) and the same image except that square hurdles are added marking how the electron's velocity-change affects the length of the waves from one energy level to the next (right). The ground shell's one-wave circle is the electron's "quantum yardsticks," the unit the wavelength grows by at each larger orbit. Throughout the concentric shells, the distance between the red hurdles is the same length as the circumference of the ground state orbit. Yes, the second shell has two de Broglie waves, but it is important to note that each of its waves is twice the ground state wave's circumference. The third shell has three waves and each wave is three times the length of shell one's circumference, and so on from shell to shell.

**FIG 5**

At each higher shell or orbit, the electron slows down and increases its de Broglie wavelength by one notch. This quantization was, of course, the main feature of Bohr's 1913 atom model, and its orbital jumps matching the energy changes indicated in the hydrogen's spectrograph. Examining de Broglie's wave adjustment from shell to shell, I believe it deserves a closer look and a somewhat different interpretation. Instead of simply describing that "at each larger shell the matter-waves are longer," this remarkable quantum mechanism can be stated differently: At each shell, the electron acquires a unique wavelength and velocity, a special combination, and a code number workable only at that particular energy level. Or stated another way: the electron requires a passkey at each energy level in order to enter the shell. Considered this way, the de Broglie matter-wave electron can be thought of in a way quite different from the leftover image of Bohr's planetary particle circling the nucleus. My hypothesis is that the matter-wave electron's relationship to the shell's electrical field is based, not on the rule of astronomy, a planet orbiting the Sun at its equator, but on the "passkey" principle: that the electron's velocity and wavelength determine which energy sphere the matter-wave is allowed to attach itself to and that it can attach itself to any portion of the quantized electrical sphere. Of course, this central principle in my atom model defies the standard, popular image of tiny planet-electrons circling the nucleus, a picture that has been carved in stone in the public's mind for the past hundred years. Strange and even improbable as non-equatorial matter-wave orbits may seem at first, I hope to demonstrate, however, that they are both attractive and highly useful.

Figure 6 illustrates the freedom the electron gains with small-circle orbits. On the left, at the second shell, the electron keeps its great 2s orbit circle equatorial two-wave de Broglie orbit (the 2s state).

**FIG 6**

On the right is its new option: a single-wave orbit having the same velocity/wavelength as the standard two-wave orbit. Because it is only half the size, unable to surround the equator, the one-wave orbit takes up space on a small meridian of the sphere and becomes a 2p electron. Since it completes its circle in half the time of the 2s state and because, as its transparent cone shows, the orbit extends outwardly relative to the nucleus, intuition tells me that it will to give rise to a stronger orbital magnetism than the 2s state.

At the third shell (fig. 7), de Broglie's original three-wave equatorial orbit is the 3s state. Reduced to a two-wave orbit, it becomes the 3p state. The final one-wave orbit is the 3d state. The velocity and wavelength the 3s, 3p and 3d are the same. The smaller the orbit on the shell, the more it is directed off center from the nucleus.

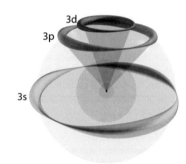

**FIG 7**

What causes electrons to form orbits with fewer whole waves? Matter-wave orbits in my model cannot occupy the same space at the same time. As with passengers in a packed subway car, electron orbits packed on shell crowd one another, pushing all occupants into one-wave states. Figure 8 represents the full range of orbits available to hydrogen atom's electron, from the first shell through the fifth. The s,p,d,f... labels are derived from of the old

**FIG 8**

155

quantum theory and Arnold Sommerfeld's elliptical orbits of 1916, which were intended to satisfy the azimuthal quantum number symbolized by $Z$ (lower-case L). The $Z$ quantum number describes the electron's angular momentum for orbits at each shell. Sommerfeld's "ellipses" varied from true circles, to ovals, to straight lines. Sommerfeld's orbits for shells one through four shown in figure 9 are taken from Harvey Elliott White's 1934 *Introduction to Atomic Spectra*. The straight-line orbits have

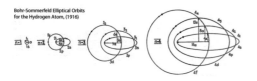

Bohr-Sommerfeld Elliptical Orbits for the Hydrogen Atom, (1916)

**FIG 9**

zero angular momentum; the electron's trajectory is a pulsation in and out from the nucleus like a sewing machine needle. The rounder the orbit's oval, the greater its angular momentum.

Though de Broglie's matter-waves represented a markedly different conception from Bohr's orbiting electron, and despite Sommerfeld's ellipses reaching out from the nucleus, both physicists' atoms were as flat as pancakes. It was largely for this reason that chemists in the 1920s took no interest in Bohr's quantized hydrogen atom model. Chemistry required three-dimensional atoms in order to build molecules. As early as 1902, the American chemist Gilbert Newton Lewis made sketches of an "octet atom," simply a cube with an electron at each corner. Chemist and physicist Irving Langmuir extended Lewis's atom by adding shells surrounding the nucleus with pockets to hold additional of electrons. By 1916, most chemists would have been familiar with the Lewis-Langmuir model, yet physicists ignored it completely since it failed to explain how the electrons could stay fixed in space around the nucleus. Irving Langmuir wrote a list of eleven postulates describing the Lewis-Langmuir atom model. Postulates 2 and 3 read:

The electrons in any given atom are distributed through a series of concentric (nearly) spherical shells, all of equal thickness. Thus the mean radii of the shells form an arithmetic series 1, 2, 3, 4, and the effective areas are in the ratios $1 : 2^2 : 3^2 : 4^2$.

Each shell is divided into cellular spaces or cells occupying equal areas in their respective shells and distributed over the surface of the shells according to the symmetry Postulate 1. The first shell thus contains 2 cells, the second 8, and third 18, and the fourth 32.

I believe that if de Broglie's matter-waves had been understood to be real "matter" rather than merely vaporous clouds infiltrating one another's space, they could have helped Langmuir explain how his atom's electrons were able to maintain their positions in shells surrounding the nucleus.

Figure 10 is a photograph of small geometric figures composed of equal diameter ceramic magnets.

**156**

**FIG 10**

These seven magnet-mosaics comprise 2, 5, 8, 10, 14, 18, or 32 identical magnets. Mounted on armatures the magnets cling together edge-to-edge in magnetic antiparallel, with north poles touching only south poles, etc., like magnetic, spherical, checkerboards. If one of the magnets is made to rotate by hand, the others follow as a gear train. If the magnets were current loops instead of permanent magnets, each loop's current would flow in the reverse direction from its neighbors'.

These magnet spheres are useful for visualizing and for counting electrons in accord with the Aufbau principle of building shells and subshells in the periodic table of elements. Their geometry corresponds to Lewis' and Langmuir's electron shells.

By what structural rationale do the electrons in my model remain stable in these confined halo states?

An electron can sustain its matter-wave orbit only at its unique energy shell, the energy level that suits its pass-key velocity and wavelength.

Since it can remain only at its prescribed shell, the electron wave can neither fall into the nucleus, nor find a place in a fully occupied lower shell because, as in musical chairs, each electron needs its own place to sit – to have its own set of four quantum numbers.

A matter-wave orbit is like solid matter, a barricade to other matter-waves. In my model, the individual electron's matter-wave "solidity" barrier is the physical expression of Wolfgang Pauli's exclusion principle.

Magnetism, both orbital and spin, assist matter-waves in linking together, to overcome their mutual electrical repulsion.

## Summary

Free electrons have a negative electric charge, a small mass and a spin/angular momentum magnetic field. When brought together, they repel one another due to their electric charge. When an electron is drawn in to become part of an atom, it transforms instantly into an impenetrable (de Broglie) matter-wave orbit. Because of its circular motion it acquires an orbital magnetic field and a top-like angular momentum. Its original spin magnetism is able to invert like a tiny gyroscope, either to add or to subtract from the orbit's total magnetism; a useful, mechanical, energy-economy switching device. Paradoxically, the electron relinquishes its most dominant force as enters the atom: the active strength of its negative electrostatic force, the very reason it was sucked into the atom in the first place. Now, with electron count equaling the number of protons, the atom achieves electrical neutrality, transforming its spherical atomic realm into an electrical field as neutral as salt. The matter-wave orbits, their electric charge smeared

over their trajectory circles, are no longer capable of exercising their once powerful repulsion. Here, the impenetrable matter-waves themselves act as repelling barriers to their neighbors.

According to textbook comparisons, the strength of spin and orbital magnetism combined is but a hundredth that of a free electron's electrostatic force. True when describing free electrons, but inside the atom, this overwhelming hundred-to-one comparison no longer applies. With their Coulomb force neutralized, it is both the electrons' magnetic systems (fig. 10) and their wave-barrier exclusion that remain available and operational. A reasonable analogy, substituting gravity for electricity: a great blue whale weighs as much as two hundred tons. Yet swimming in the ocean and buoyed by the water it displaces, the whale's weight is reduced to zero. Its great mass of course remains at two hundred tons. Analogies can go only so far, but in the same way that the great mammal's mass remains, the electrons' magnetic forces in the atom are in no way diminished in the neutralized spherical field. They are center-stage to perform the atom's tasks, to conduct energy transactions, to link with other atoms, to form molecules and crystals, to arrange north/south magnet alignments, and to instantaneously rearrange their geometry to maintain the tiny atom-machine's most efficient energy-efficient configuration.

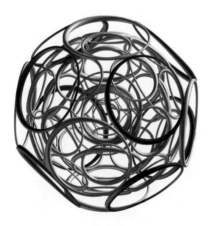

**FIG 11** Computer rendering of my imagined many-electron atom

## Notes

More information about my atom model and other works can be found at www.kennethsnelson.net.

Also, in these U.S. Patents:
– Snelson, K 1965, Continuous Tension, Discontinuous Compression Structures, U.S. Patent 3169611
– Snelson, K 1966, Model For Atomic Forms, US Patent 3276148
– Snelson, K 1978, Model For Atomic Forms, US Patent 4099339
– Snelson, K 1997, Magnetic Geometric Building System, US Patent 6017220
– Snelson, K 2004 Space Frame Structure Made By 3-D Weaving of Rod Members, U.S. Patent 6739937

## Bibliography

– David Bohm, *Wholeness and the Implicate Order*, Routledge & Kegan Paul, London, 1980.
– Louis de Broglie, *New Perspectives in Physics*, Basic, New York, 1962.
– Ugo Fano and L. Fano, *Basic Physics of Atoms and Molecules*, John Wiley & Sons Inc., New York, London, 1959.
– Paul Forman, "Weimar Culture, Causality, and Quantum Theory, 1918–1927: Adaption by German Physicists and Mathematicians to a Hostile Intellectual Environment," in: *Historical Studies in the Physical Sciences*, vol. 3, University of California Press, 1971, pp. 1–115.
– Irving Langmuir, "The Arrangement of Electrons in Atoms and Molecules," in: *Journal of the American Chemical Society*, vol. 41, no. 6, 1919, pp. 868–934.
– Gilbert Newton Lewis, *Valence and the Structure of Atoms and Molecules*, Dover Publications, New York, 1966.
– Jagdish Mehra and Helmut Rechenberg, *The Historical Development of Quantum Theory*, vol. 1–4, Springer, New York, Berlin et al., 1982.
– Arthur I. Miller, *Imagery in Scientific Thought: Creating 20th-century Physics*, The MIT Press, Cambridge, MA, 1984.
– Alfred L. Parson, *A Magneton Theory of the Structure of the Atom*, Smithsonian Miscellaneous Collections, vol. 65, no. 11, Smithsonian Institution Press, Washington D.C., 1915.
– Varadaraja V. Raman and Paul Forman, "Why Was It Schrödinger Who Developed de Broglie's Ideas?," in: *Historical Studies in the Physical Sciences*, vol. 1, University of Pennsylvania Press, 1969, pp. 291–314.
– Harvey E. White, *Introduction to Atomic Spectra*, McGraw-Hill, New York, 1934, pp. 29–32.

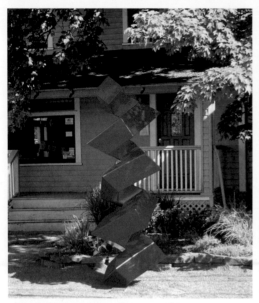

*Alpha Helix for Linus Pauling*
2004, powder-coated steel, 3 m in hight
This memorial for Linus Pauling is located in
front of Pauling's childhood home in Portland.

large image
*Angel of the West*
2008, stainless steel, 3.7 × 3.7 × 1.2 m
Studio shot of the sculpture featuring a 3 m
tall antibody molecule surrounded by a 3.7 m
diameter ring. The sculpture is shown with
the artist to give an illustration of the scale.

**JULIAN VOSS-ANDREAE** (*1970 in Hamburg, DE) is a
sculptor based in Portland (OR). Starting out as a painter,
he later changed course and studied quantum physics at
the Universities of Berlin, Edinburgh (GB), and Vienna.
For his graduate research, Voss-Andreae participated in
a seminal experiment demonstrating quantum behav-
ior for the largest objects thus far, which became the
inspiration for many of his sculptures. Voss-Andreae's
work has quickly gained critical attention and is in-
cluded in multiple institutional and private collections
in the US and abroad. His sculptures have been featured
in many art as well as science publications, including
*Nature and Science*.

www.julianvossandreae.com

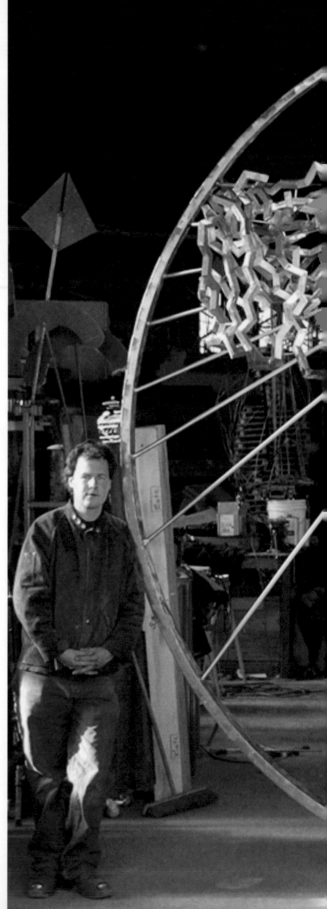

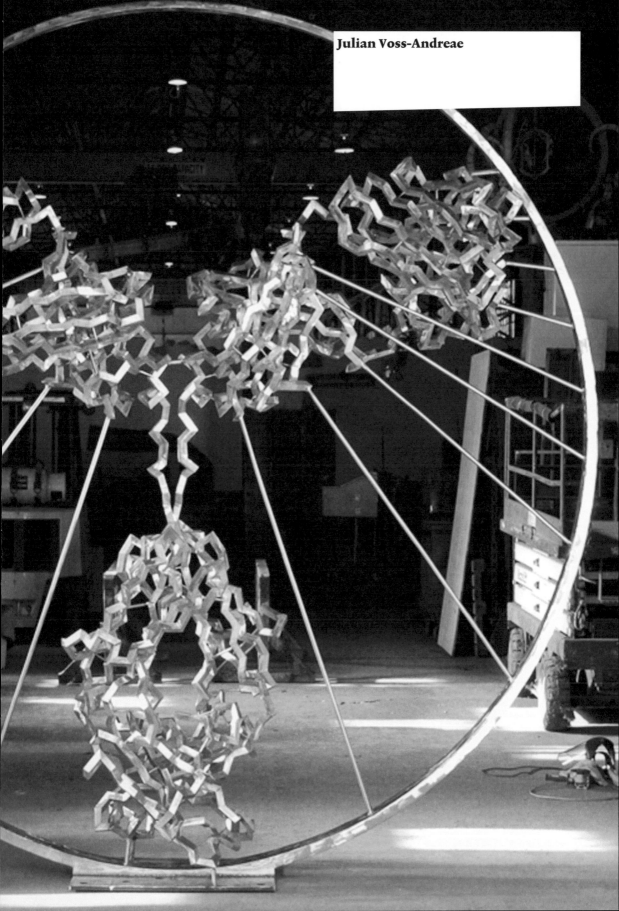
Julian Voss-Andreae

# Unraveling Life's Building Blocks:
## Novel Sculpture Inspired by Proteins
Julian Voss-Andreae

There are a number of common themes woven through the fabric of my sculptural work. One such theme is the idea of the fundamental building block, the smallest unit that, upon assembly, displays an extraordinary transformation from geometric simplicity to organic complexity. Some of my recent works were inspired by quantum physics, the study of the building blocks of the physical world.[1] A larger body of work, begun in 2001 after I switched careers from quantum physics to art, is concerned with the structure and conceptual potential of proteins, the molecular building blocks of all life forms. This article presents a selection of these works complementing others that I have described earlier.[2] The article's final section places the work in the context of contemporary efforts that aim at expanding the current paradigm beyond the confines of scientific reductionism.

## Protein Sculptures
When we cut an organism into parts small enough to be handled intellectually, we lose its essential property of being alive, both literally and emotionally. Perceiving the parts of a living being as inanimate often lets us presume that the "aliveness" of the whole being is just an illusion. But perhaps the opposite is also true: Because the whole is alive, all its parts are in the same sense alive and should therefore be worthy of an equal emotional attachment. Among the smallest molecular parts specific to life are the proteins. It is through proteins that life accomplishes the transition from one-dimensional DNA, the carrier of genetic information, to three-dimensional organisms.[3] Proteins are chains of amino acids arranged in a specific sequence that is encoded in the DNA's sequence of base-pairs, the "rungs" on the DNA "ladder." The structure of a protein is largely determined by its sequence of amino acids. Inherently still one-dimensional, the linear molecular chain folds into an often well-defined, three-dimensional object. I use the application of compound mitered cuts, the rotation of every other part, and subsequent reconnection, as an elegant way to recreate the structure of proteins from the ubiquitous one-dimensional building materials, such as lumber or steel tubing. My process is to search for proteins that satisfy two conditions: their structures must have been determined, and the molecule must have aesthetic as well as conceptual appeal. After downloading the structural data, I run a custom-developed computer algorithm to generate the cutting instructions that provide the starting point for my sculptures (fig.1). The basic ideas and processes are described in detail elsewhere.[4]

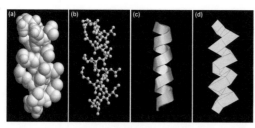

FIG 1 One protein depicted in four different ways. The figure shows a coiled amino acid sequence known as *alpha helix*, commonly found in many proteins. Panel (a) depicts the alpha helix as a "space fill" model: All (non-hydrogen) atoms of the molecule are drawn as intersecting spheres. Panel (b), a "ball-and-stick" model, has smaller atoms that are connected by rods to indicate the chemical bonds. Panel (c), the "ribbon" model, reduces the protein to its backbone which is depicted as a smoothened ribbon in space. Panel (d) shows the alpha helix as a miter-cut object: this technique was used for the sculptures presented here. Instead of being presented with the backbone smoothed into a curve, each amino acid corresponds to a straight miter-cut piece.

FIGS 2, 3 *Light-Harvesting Complex*, 2003, wood, casting resin, and candle, 56 × 64 × 64 cm. The left panel is a top view showing the two concentric rings of alpha helical proteins. A candle placed in the center of the structure serves as the only light source. The right panel shows a side view with the helical structures casting moving shadows on the wall of the small chamber where the piece is displayed.

Due to the inherent properties of the miter-cut representation, sculptures based on smaller proteins evoke the impersonal aesthetic language of modernist sculpture.[5] A good example is *Alpha Helix for Linus Pauling*[6] (fig. 1 (d)), based on a 15-amino acid sequence. As the number of amino acids increases to several hundreds or even thousands, an exciting transition takes place: The cold and crystalline feel of a small number of polyhedral faces gives way to something much "warmer" and the more complex aesthetics of the organic world starts to emerge.

### Light-Harvesting Complex

Plants and photobacteria (bacteria capable of photosynthesis) absorb the sunlight, thereby providing us and virtually all other creatures with the energy and low entropy we need to maintain life. Photobacteria have beautiful and well-understood photosynthetic apparatus embedded in their cell membranes. Instrumental to the initial absorption of the light is a structure known as the *light-harvesting complex*, an array of two concentric rings of proteins. Coiled protein segments transverse the cell membrane and hold light-absorbing pigments in between the rings. Intrigued by both its structure and its function, I created a sculpture based on the light-harvesting complex. Each of the two protein rings is made up of nine identical subunits, which I portrayed using ½-in-diameter (13 mm) wooden dowels. The whole complex consists of 850 amino acids, corresponding to the same number of one-inch-long (25 mm) pieces of wood. Each protein subunit is anchored in position in a layer of transparent casting resin on a wooden disc. The sculpture is placed on the floor of a dimly lit room so that the structure casts moving shadows on the wall (figs. 2, 3).

The shadows evoke plants moving in the wind. It seems as if the macroscopic plants of our world have become ephemeral shadows, while the microscopic, and ordinarily not perceivable, basis for their existence has become the tangible object.[7]

### Unraveling Collagen

One of the many helical structures of vital importance to us is collagen, our bodies' most abundant protein. In collagen, three amino acid spirals, reminiscent of a rope, wind around each other to create a meta-spiral. Collagen mainly provides our bodies with structural support.[8] In a sculpture inspired by collagen, I emphasized its structural function by reducing each of the sculpture's faces to a cross-braced outline to reveal the dominant force lines in a way that resembles many modern steel buildings, utilitarian structures, and bridges. For aesthetic and conceptual reasons, I departed from the actual molecular structure by opening up the intertwining helices toward the top (figs. 4, 5). In this way,

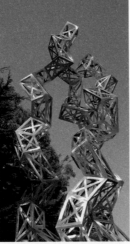

**FIGS 4, 5** *Unraveling Collagen*, 2005, stainless steel, 3.4 m in height. Inspired by the most abundant protein in our bodies, *Unraveling Collagen* is based on the collagen structure. In contrast to the tightly coiled molecular structure, the sculpture's three strands unravel toward the top.

the sculpture also becomes a metaphor for aging[9]: It is the degradation of collagen that famously leads to the wrinkles that accompany aging. At the same time, the playful upwards movement of the sculpture imparts a sense of aging as growth, a journey toward completion, where "unraveling" becomes "unfolding;" the fulfillment from innate potential into reality.

### Heart of Steel

Hemoglobin, the oxygen-carrying molecule that gives our blood its red color, is another well-known protein of vital importance to our existence. Its color stems from iron atoms, which are essential in capturing oxygen from the air and distributing it to the whole body. I created a sculpture based on the hemoglobin structure and alluded to the basis of our body's ability to breathe by letting a similar reaction occur on the artwork's surface: Initially sanded to a bright, silvery sheen, the steel sculpture started forming a reddish oxide layer soon after its unveiling at an outdoor gallery. As the sculpture's entire body became successively saturated with oxygen, it acquired an increasingly deeper coloration (fig. 6).[10]

**FIG 6** *Heart of Steel*, 2005, weathering steel and glass, 1.6 m in height. The images show a time-sequence of the hemoglobin-based sculpture's metamorphosis: photo (a) was taken right after unveiling, (b) after 10 days, and (c) after several months of exposure to the elements.

The intricately shaped steel piece is complemented by a large, blood-red glass sphere in its center, evoking the image of a drop of blood.[11] The sculpture reacts sensitively to wind and touch, answering each push with an unexpected shiver, echoing the complex vibrational dynamics of large biomolecules.[12]

### Nanos

The small protein microcin, synthesized by a certain strand of the common intestinal bacterium E. coli, features a most unusual structure resembling a lasso whose tail folds over and enters the noose. It is this knotted structure that kills off other bacteria by interfering with its victim's protein synthesis machinery.[13] *Nanos*, named after the Greek word for dwarf, is a 6'-ft-tall (1.8 m) sculpture based on microcin's structure. In addition to referring to the nanoscale these molecules inhabit, the name hints at the anthropomorphic character of the sculpture, with the noose on top evoking an oversized head (fig. 7). It is remarkable how much the sculpture resembles abstract modernist sculpture, even though it is, strictly speaking, representational. I emphasized this resemblance by giving the stainless steel the irregular sander finish pioneered by American abstract expressionist sculptor David Smith, which has influenced subsequent generations of artists and designers and has since become associated with the look of modernist sculpture.

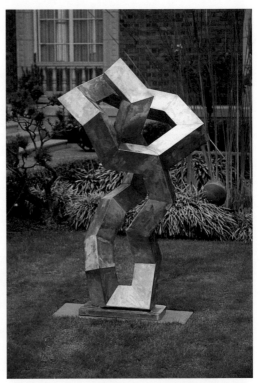

**FIG 7** *Nanos*, 2006, stainless steel, 1.8 m in height. While resembling an abstract modernist sculpture, *Nanos*, like all other sculptures presented in this article, is actually representational. Its shape is based on the unusual structure of a small antibacterial protein.

### Birth of an Idea

In 2007, I completed a sculpture (*Article Frontispiece*) based on the structure of an ion channel protein for Roderick MacKinnon, who received the 2003 Nobel Prize in Chemistry for his seminal work on such a molecule. Found in the nerve cells that make up our brain and its nervous connections to the rest of our body, ion channels control the passage of specific atoms through the nerve cells' membranes. Intimately connected to our intellectual and emotional responses to the world, this mechanism is at the very foundation of the living nerve cells' characteristic activity, the filtering and relaying of information through selective firing. When I was commissioned to create this sculpture (fig. 8), I was inspired by the ion channel's potential to symbolize the "spark," the small but all-important idea at the beginning of eve-

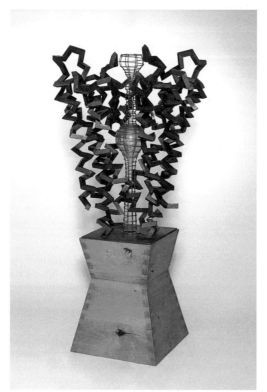

FIG 8 *Birth of an Idea*, 2007, steel, colored glass, and wood, 150 × 80 × 80 cm. This sculpture is based on the structure of the potassium channel protein. Roderick MacKinnon, who commissioned *Birth of an Idea*, won the 2003 Nobel Prize in Chemistry for his work on this structure and provided the experimental data that were used as a starting point to create this sculpture.

rything we do. Although we will probably never be able to point at one structure in our brain where that proverbial spark emerges, the ion channel provides a beautiful metaphor for it because it functions as the smallest logical unit in the vast network of our brain. Inspired by depictions of the potassium channel's interior[14], I created an object welded from steel wire to represent the pore's cavity. This pore object, surrounded by a protein scaffold made from blackened steel, is lacquered in a trans-

lucent blue. Like an "isodensity plot" of a molecule's electron density,[15] the pore object features bulges at the locations the ions populate during their single-file passage through the protein. The largest bulge corresponds to the channel's main cavity, where the ion's surrounding water molecules are stripped off to be replaced by specific protein atoms. The main cavity contains a yellow blown glass bubble evocative of a rising balloon. The sculptural pedestal is fabricated from hand-planed, one-inch-thick (2.5 cm) wooden boards connected by the ancient technique of finger joints, mirroring the fourfold rotational symmetry of the protein.

### Angel of the West

When I was contemplating the structure of our immune system's key molecule, the antibody, I noticed an interesting similarity between this molecule and the human body both in proportion and function: Shaped like a "Y," the antibody features a pair of identical protrusions resembling arms that are able to move due to a flexible region in the molecule's center. These "arms" end in "hands," highly specific regions that hold on to an intruder, for example a virus particle, thereby tagging it for destruction through the immune system. In order to allude to the similarity between man's body and his antibody, I designed the sculpture to subtly evoke a Renaissance icon deeply anchored in popular culture: Leonardo da Vinci's 1490 study of the human proportions, *Vitruvian Man*. When I superimposed the frontal view of the antibody's 1,336-amino-acid structure, as provided by Eduardo Padlan,[16] onto the *Vitruvian Man*, I was struck by the fact that the two images coincide perfectly (fig. 9). For my design, I decided to utilize this powerful similarity and let the antibody molecule

FIG 9 *Antibody Structure Superimposed on Leonardo's Vitruvian Man*, 2006, computer sketch of the idea for *Angel of the West*. Eduardo Padlan's 1994 composite model of the antibody molecule was superimposed on Leonardo's 1490 *Vitruvian Man*, revealing a striking resemblance between man's body and his antibody, in proportions as well as function. **163**

stand in place of Leonardo's man while turning the surrounding circle into a tapered ring. I then added thin rods under the arms radiating out from the position where the center of the head was located in the drawing. This set of rays emanating from a central source makes the image reminiscent of spiritual imagery.[17] With its wing-shaped "arms", the image is evocative of an angel.[18] Our antibodies can, in fact, be viewed as legions of tiny guardian angels, constantly protecting us from illness and disease. Their ability to bind very specifically to certain molecules is also the reason the antibody molecule has become an indispensable tool in biomedical research, crucial for understanding the machinery of life and therefore an appropriate symbol for The Scripps Research Institute that commissioned the sculpture as the signature piece for their new Florida campus (fig. 10). I chose the name *Angel of the West* as a play on Antony Gormley's monumental sculpture *Angel of the North* (1998) in Gateshead, GB. The "West" in my sculpture refers to the Western approach to healing through the tools of Western science. The fabrication of the sculpture resembled a gigantic three-dimensional puzzle with about 1,400 pieces, laser-cut from steel sheet of varying thicknesses to fit the structural requirements.[19]

## Art and Scientific Reductionism

Despite our increasingly heavy reliance on science-derived technology, only a minority of people today recognize science as a vital part of human culture, or have

**FIG 10** *Angel of the West*, 2008, stainless steel, 3.7 × 3.7 × 1.2 m. Commissioned as the signature sculpture of The Scripps Research Institute's new campus in Jupiter this sculpture plays off the striking similarity between the human body and our immune system's key molecule, the antibody.

experienced feelings of wonder from scientific observations in the same way as they would from, say, a beautiful sunset. After an era of relative faith in science, culminating in the immediate post-World War II era, the public's attitude toward the natural sciences shifted around 1970.[20] My generation, born during that time, grew up with a new sense of mistrust that was triggered by the growing suspicion that the reductionist approach inherent in science and technology, and its profound effects on our lifestyle, could not be separated from the global environmental and spiritual crisis that was then becoming increasingly apparent. Scientific reductionism, the assumption that complex systems can be completely understood through an understanding of their components, is deeply ingrained in the very structure of the natural sciences and has been an extraordinarily successful guiding principle in the West since the Age of Enlightenment.[21] Art, by contrast, is non-reductionist in its very nature: The profound effect of a great work of art cannot be comprehended by adding up the effects the work's separated parts would have. Nor can that artwork's impact be reduced to the intellectual knowledge of specific interpretations of it. True appreciation of art seems impossible in a frame of mind that clings to the object-subject dichotomy that has become so deeply entrenched in Western thinking for the past few centuries. According to Einstein, in art, "We show [what we behold and experience] in forms whose interrelationships are not accessible to our conscious thought but are intuitively recognized as meaningful."[22] The presented works take the notion of artistic counter-reductionism to another level: departing from a mere structural representation of proteins, the exemplary specimens of reductionist biology, these works take living beings' components, typically considered inanimate, and bring them metaphorically back to life. In this way, these sculptures, born from scientific data, are capable of imparting an artistic experience of life that complements the understanding provided by reductionist science alone and thereby inspire a more holistic view of nature.

## Acknowledgements

I would like to thank the people who have allowed me to do this work: Special thanks go to my parents Sibylle and Peter Voss-Andreae, as well as the collectors and patrons who have supported my work. I am also indebted to George Weissmann, Colin J. Thomas and several anonymous reviewers for contributing ideas. And last but not least, I want to thank my beloved wife, Adriana, for continually inspiring me and for her great help with this manuscript.

## Notes

**1** See: Julian Voss-Andreae, "Quantum Sculptures: Art Inspired by the Deeper Nature of Reality," in: *Leonardo*, vol. 44, nr. 1, 2011, pp. 14–20, doi: 10.1162/LEON_a_00088; Philip Ball, "Quantum Objects on Show," in: *Nature*, vol. 462, no. 416, 2009, p. 416, doi: 10.1038/462416a.

**2** See: Julian Voss-Andreae, "Protein Sculptures: Life's Building Blocks Inspire Art," in: *Leonardo*, vol. 38, no. 1, 2005, pp. 41–45, doi: 10.1162/leon.2005.38.1.41.

**3** I use the term "*n*-dimensional" (where *n* = 1, 2, 3) in this article as it is commonly used to describe objects of the real world (as opposed to mathematical entities): An object is *n*-dimensional if it extends significantly only into *n* of the 3 dimensions of physical space. Its extent into the remaining 3-*n* dimensions is negligible compared to its extent into the other *n* dimensions, i. e. smaller by some orders of magnitude.

**4** See: Voss-Andreae 2005; Julian Voss-Andreae, *Protein Sculptures*, BFA thesis paper, Lambert Academic Publishing, Saarbrücken, 2010, available online at: http://julianvossandreae.com/Work/Thesis/Thesis.pdf, accessed 05/15/2013.

**5** See: Voss-Andreae 2005, chapter 5.1.

**6** See: Voss-Andreae 2005.

**7** See: A. Chugunov, "Изваяние Невидимого" [Invisible Monuments], in: *Computerra*, vol. 45, no. 713, 2007, pp. 26–28, available online at: http://julianvossandreae.com/Artist/resume/articles/2007_12_05_Computerra.pdf, accessed 05/15/2013; "Julian Voss-Andreae, Protein Sculptor" (interview), in: *PDB Newsletter*, no. 32, Winter, 2007, available online at: http://julianvossandreae.com/Artist/resume/articles/2007_01_PDBnewsletter.pdf, accessed 05/15/2013; Voss-Andreae 2005, chapter 4.3.

**8** The symptoms of scurvy drastically illustrate what happens to our bodies if, due to a lack of Vitamin C, we fail to keep up the regular synthesis of new collagen.

**9** See: Julie Wallace, "Protein Sculptures for the People," in: *AWIS Magazine*, Spring 2008, pp. 14–17, available online at: http://julianvossandreae.com/Artist/resume/images/2008_AWIS.pdf, accessed 05/15/2013; B. Wand, "'Unraveling Collagen' structure to be installed in Orange Memorial Park Sculpture Garden," in: *Expert Review of Proteomics*, vol. 3, no. 2, 2006, p. 174.

**10** Philip Ball, "Column: The Crucible," in: *Chemistry World,* vol. 5, no. 3, 2008, pp. 42–43, available online at: www.rsc.org/chemistryworld/Issues/2008/March/ColumnThecrucible.asp, accessed 05/15/2013; Cele Abad-Zapatero, "Escultor de proteínas (Protein sculptor)," in: *El País*, September 19, 2007, p. 45, available online at: http://julianvossandreae.com/Artist/resume/articles/2007_09_19_ElPais.pdf, accessed 05/15/2013.

**11** I should note that this sculpture is not (nor is any of my work) intended to be a scientifically accurate model. For example, my placement of the red glass sphere in the center of the sculpture was a purely artistic decision and does not correspond to the location of the iron in the actual molecule.

**12** See: Jennifer Couzin, "Blood and Steel," in: *Science*, vol. 309, no. 5744, 2005, p. 2160, doi: 10.1126/science.309.5744.2160d.

**13** See: Vivienne B. Gerritsen, "Entanglement," in: *Protein Spotlight*, issue 72, July 2006, available online at: http://www.expasy.org/spotlight/pdf/sptlto72.pdf, accessed 05/15/2013.

**14** See: Fig. 5 (B) in: D. Doyle et al., "The Structure of the Potassium Channel: Molecular Basis of K+ Conduction and Selectivity," in: *Science*, vol. 280, no. 5379, 1998, p. 74 and fig. 2 in Yufeng Zhou et al., "Chemistry of ion coordination and hydration revealed by a K+ channel-Fab complex at 2.0 Å resolution," in: *Nature*, vol. 414, 2001, p. 43–48, esp. 45, doi: 10.1038/35102009.

**15** Such structures' "shape," governed by quantum mechanics, is a spatial probability distribution of the likelihood of measuring an electron. In order to transform this kind of information into something we are accustomed to dealing with, scientists often visualize molecules through a pseudo-surface that is defined by a specific, constant likelihood of finding an electron, the "isodensity plot."

**16** See: Eduardo A. Padlan, "Anatomy of the antibody molecule," in: *Molecular Immunology*, vol. 31, no. 3, 1994, pp. 169–217, doi: 10.1016/0161-5890(94)90001-9.

**17** One of the images that guided my design was Gianlorenzo Bernini's famous 1666 alabaster window at St. Peter's Basilica, Rome, depicting the Holy Spirit as a dove.

**18** Images of angels, winged humans, date far back into pre-Christian times. A well-known example is the *Nike of Samothrace* from about 200 B.C.

**19** The creation and installation of the *Angel of the West* was covered by Oregon Public Broadcasting Television's art series *Oregon Art Beat*: V. Patton (producer), "Quantum Sculptures with Julian Voss-Andreae," on view at Oregon Art Beat Oregon Public Broadcasting Television on December 18, 2008, available online at: www.youtube.com/watch?v=LqsQYVFAgP0, accessed 05/15/2013.

**20** Tor Nørretranders, *Spüre die Welt. Die Wissenschaft des Bewusstseins*, Rowohlt, Reinbek bei Hamburg, 1997, chapter 14.

**21** John Cornwell (ed.), *Nature's Imagination*, Oxford Universtiy Press, Oxford (GB), 1995, chapter 6 by Gerald M. Edelman and Giulio Tononi.

**22** Quoted from: Heinz-Otto Peitgen and Peter H. Richter, *The Beauty of Fractals*, Springer, Berlin, 1986, p. 1.

# III

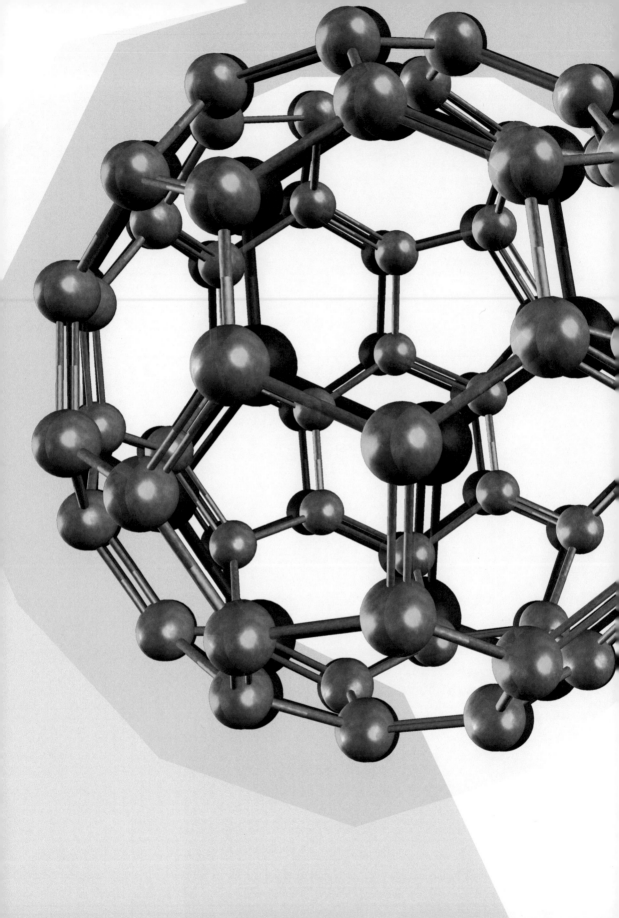

Harold Kroto
**Art and Science II:**
**Geodesy in Material Science**

## Introduction

In 1988 Ken McKay and I carried out a fascinating little project primarily for fun which inadvertently made a major contribution to our understanding of carbon particles whose structures at nanoscale dimensions had heretofore been impossible to understand although several attempts had been made over many years resulting in quite erroneous conclusions which had been accepted for several decades.[1]

## Geodesic Domes

After the Fullerenes had been discovered[2] I thought, in the late 1980s, it might be neat to build my own mini-Buckminster Fuller dome (like the one pictured in figure 1 but a little smaller!) and purchased molecular modeling kits to do it. FIG 1 There was no thought at the time that this was a research project – it was just a fun project to build a large beautiful model to display essentially like a sculpture in our laboratory. The image of Buckminster Fuller's famous dome at the Montreal Expo 1967 shown in figure 1 is from Graphis 1967.

The original little fun project with Ken McKay led us first to some fascinating work by the mathematicians Goldberg and Coxeter on what are now called Goldberg polyhedra. When the models were constructed, much to my surprise they were not smoothly spherical like the dome above. I had assumed this would be the case from my cursory perusal of the images of all the domes

169

FIG 2 I had seen. Instead each model that we constructed (figs. 2a, 2b) was essentially a closed icosahedral monosurface consisting of a hexagonal network of struts that swept from one, of twelve, pentagonal cusps to another.

I remember being quite perplexed at the time as to why the models were not spheroidal as I had expected. Then I returned to study images of Fuller's domes much more carefully and realized that although the hexagons were in general fairly symmetric those in the neighborhood the pentagons were quite distorted as can be seen in figure 3.

Then I realized that I (and apparently everyone else) had overlooked something that had been under our noses in the literature for years. I had looked at electron microscope images of spheroidal carbon particles several times in the past and only now realized what I must have been looking at. Several years earlier high resolution electron microscope images of onion-like structures had been published. A typical example of these elegant images is shown in figure 4 where a picture taken by Daniel Ugarte is depicted. The electron microscope yields an image that can be considered as a sort of cross-section of the spheroidal particle that actually consists of concentric spheroidal shells, much like an onion. Thus one can effectively get an image of the structure that one has effectively sliced into two hemispheres to reveal the inner structure, much as cutting horizontally through a tree trunk reveals tree rings. What I realized was that I and other had missed the fact that the rings were not quite circular but possessed subtle curvature variations which betrayed the fact that they were actually quasi icosahedral as were our Giant Fullerene models. I had seen what I wanted to see

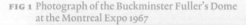

**FIG 1** Photograph of the Buckminster Fuller's Dome at the Montreal Expo 1967

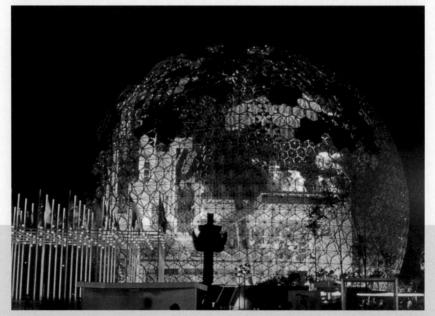

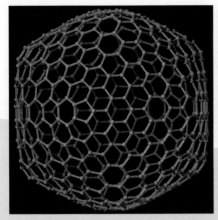

FIG 2A Giant Fullerene C$_{540}$

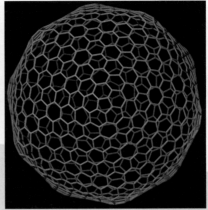

FIG 2B Giant Fullerene C$_{960}$

FIGS 3A, 3B Two images taken from inside the Expo67 Dome. Particularly interesting from the science/art point of view is the asymmetry of the hexagons which abut the pentagons. This distortion was necessary to produce the near spheroidal structure of the Expo67 Dome. The Giant Fullerenes possess their own unique quasi-icosahedral "Giant Fullerene" shapes consisting of relatively smooth surfaces which sweep between the 12 pentagonal cusps necessary for closure of each Fullerene.

FIG 4 Set of Giant Fullerenes of gradually increasing size

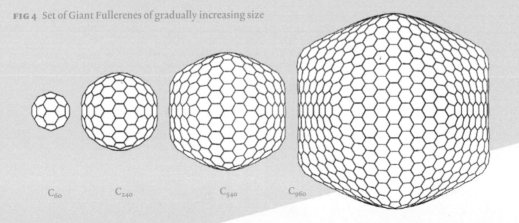

C$_{60}$    C$_{240}$    C$_{540}$    C$_{960}$

FIG 5  Schematic diagram depicting four Fullerene Cages in an onion-like concentric arrangement

FIGS 6A, 6B  Simulated high resolution electron microscope images of a carbon particle consisting of 5 concentric Fullerene cages seen along two different axes; the left hand image shows 6-fold symmetry whereas the right hand image shows 10-fold symmetry.

FIG 7  Actual high-resolution electron microscope image of an onion-like spheroidal carbon particle. Flattening of the shells is most obvious in the arcs between 8 o'clock and 11 o'clock.

FIG 8  Actual high-resolution electron microscope spheroidal carbon particle consisting of only two shells. The hexagonal shape of the outer shell is very clear and is totally consistent with the simulation shown in fig. 6.

rather than what was actually there. To find quantitative confirmation of this conjecture Ken wrote a computer programs to create a set of Giant Fullerenes of ever increasing size. The cages were then placed one inside the other as shown in figure 5. In an electron microscope a beam of electrons is passed through an FIG 5 object and if the beam encounters an array of atoms which possess some phase relation as they do when the electrons pass along a channel in which a graphite wall lies, then the atoms may be diffracted and a dark line appears in the resulting pattern (figs. 6a, 6b). One then observes what is effectively a cross section of FIG 6 the particle. The Fullerenes tend to show polygons with something between six-fold and ten-fold symmetry. Of course perfect icosahedral symmetry is very unlikely but flattening should be, and is, quite common (figs. 7, 8). FIGS 7, 8

## Conclusion

In this paper an account is given of a project which was originally initiated to satisfy the aesthetic creative impulse to build a three-dimensional model or sculpture based on a molecular structural recipe. In the event the resulting model turned out to have some unique and unexpected shape characteristics which led to further scientific investigation that explained some important nanoscale structural observations that had been seen many years beforehand and mistakenly explained. The account is a rare example of artistic creativity resulting in a key scientific advance.

## Acknowledgements

I wish to thank Ken McKay and David Wales my colleagues in the original scientific investigation, and Daniel Ugarte, and Morinobu Endo for their electron microscope their images.

First published in: *Acta Chimica Slovenia*, vol. 57, no. 3, 2010, pp. 613–616.

### Notes

1 See: Harold W. Kroto and Ken McKay, "The Formation of Quasi-icosahedral Spiral Shell Carbon Particles," in: *Nature*, vol. 331, no. 6154, 1988, pp. 328–331, doi: 10.1038/331328a0.
2 See: Harold W. Kroto, James R. Heath, S. C. O'Brien, Robert F. Curl, and Richard E. Smalley, "C60: Buckminsterfullerene," in: *Nature*, vol. 318, no.6042, 1985, pp. 162–163, doi: 10.1038/318162a0.

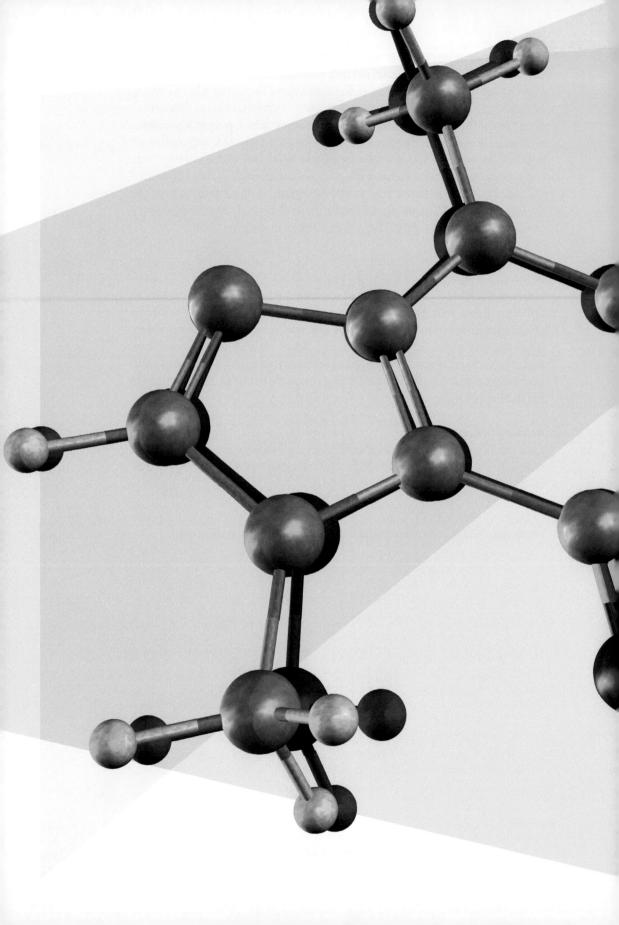

# Pierre Laszlo
## On Self-Assemblies of Nanostructures and Why They Strike Us as Beautiful

Black. Primal black. Hard black. Hard, opaque black. The hardest black, the hardest of blacks. Not the soft black evocative of a black hole, all absorbing. Polished black. Black with a sheen. Yes, that oxymoron, shiny, lustrous black.[1] Gleaming, glistening more from reflection than from emission.[2] A slate-like black. Paintings reminiscent of slates, of engraved slates. All-black pictures.

I'm alluding here to works by Pierre Soulages. Those I have in mind are paintings patterned with sets of incised parallel lines (figs. 1, 2). If not incised, then FIGS 1, 2 at least as if traced by individual hairs of the paintbrush. Lines usually running parallel to one another, often all of them horizontal or vertical[3] and as *means* to an end, a *luminous* black.

One such painting hangs in the atrium of La Maison Française / House of France DC, which adjoins the French Embassy in Washington, D.C. Why did both the architect and supervisory council opt to represent France with a work by Soulages, as abstract or seemingly remote as the image may appear?

Emphasis on "seemingly:" one can argue that these images of Soulages evoke the Rouergue region in southwestern France where the artist was born and spent his youth. The Rouergue is the area around Rodez, a city on the banks of the Aveyron and south of the Lot – two rivers which run East to West, much like the Dordogne and the Tarn. I submit that the slate roofs of houses in that area (*lauzes* is the name for the flat roofing stones that slightly overlap one another) inspired Soulages in this sub-set of his work.

175

But why such patterning with parallel lines? To answer that, I turn to an altogether different arena for the dialogue between art [4] and science, where the one discipline helps to explain the other. Indeed, I call on nanoscience to help us understand Soulages's work in hopes that we might become even more attuned to its beauty.

FIG 1 Pierre Soulages, *Peinture, 222 × 157 cm, December 28, 1990*, oil on canvas, private collection

FIG 2 Pierre Soulages, *Peinture, 63 × 102 cm, December 9, 1990*, oil on canvas, Collection Essl

## Alignment of Nanowires

Consider, in particular, self-assemblies of nanowires or nanotubes, which several laboratories have recently displayed (figs. 3–6).[5]

<span style="float:right">FIG 3</span>

Figure 3 is drawn from a paper published in 2006 by a group of laboratory scientists in Beijing. They used a strong electric field to orient and align a set of silver nanowires. As shown, the wires are compelled to align themselves parallel to the electrical field and to one another, thus forming a sheet, if not a bundle.[6]

Another way to generate bundles of nanowires – as one might guess – is to use some sort of glue to bind them. It is possible to assemble metallic nanowires entirely made of gold or of gold and nickel segments. Figure 4 shows a single bundle of nanowires formed in bulk water.[7]

<span style="float:right">FIG 4</span>

Yet more fascinating is the abrupt change, when ordering sets, as with nickel nanowires,[8] shown here in their normal, randomly oriented state, and then in their aligned state (figs. 5, 6). In this case, application of a magnetic induction field has caused the ordering, a phenomenon which can be seen in several similar examples.

<span style="float:right">FIGS 5, 6</span>

FIG 3 Silver nanowires assembled by an electric field (scanning electron microscope pictures)

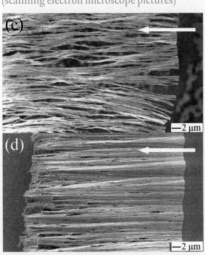

FIG 5 Nickel nanowires, prior to ordering (scanning electron microscope picture)

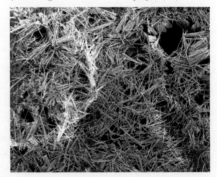

FIG 4 Bundles of silver nanowires using adhesive and solder (scanning electron microscopy image). This image shows a single bundle of nanowires formed in bulk water.

FIG 6 Nickel nanowires, which ordering has made into a bundle (scanning electron microscope picture)

Why does the metaphor of self-assembly so stir the imagination of scientists? To answer this, I can do no better than to quote from a book review I published a few years ago: "How does this particular metaphor relate to the craft of woodwork, that of the cabinetmaker who puts together a carefully wrought piece of furniture? How does it relate to other crafts, such as clock building or assembling other mechanical devices? How does it relate to sociology and to behaviors which congregations or crowds of people are wont to display? How does it relate to particular biological processes, which came to be studied and unraveled during the last few decades, such as the mechanism of muscular action understood at a molecular level?

By raising and by answering such questions, one grasps a distinctive merit of the self-assembly metaphor. It has a unifying role. Its very fuzziness brings together under a single umbrella all these areas. Is it then a surprise if, within granting agencies, academic committees and administrative officers go for such a metaphor? They do so in the wish to ingratiate themselves with legislators and, ultimately, with the electorate and the taxpayers.

But the self-assembly metaphor has yet another merit. It draws upon a powerful factor that, in itself, explains its success. It connects with the notion of robots. More precisely, it amounts to a fusion between the concept of a robot and the software which the robot is programmed to follow. The self-assembly metaphor harbors the notion of a molecule that, once it has been designed for a given function, will carry it out on its own. The design becomes consubstantial with the action, in a zenith of teleology."[9]

## Bundling

My contention brings up another question: what is aesthetically pleasing about a set of engraved parallel lines (Soulages) or a set of aligned elements, such as the self-assembly of nanowires or nanotubes? I would argue that the answer can be found in history, if not prehistory. As supporting evidence, I'll offer the Roman *fasces,* a political symbol which has endured in various forms to this day. The fasces is "a bundle of rods surrounding an axe that was carried by the lictors before chief magistrates in ancient Rome as a symbol of their authority. The lictor's job was both ceremonial and practical: to represent the authority of the magistrate by carrying the fasces and to bind prisoners."[10]

The rods were traditionally of birch[11] or elm, and were tied with a red ribbon or a leather strap. The axe or axes – there were sometimes two – were bronze, and their blades projected out beyond the bundles. Bearers of fasces preceded consuls (and proconsuls), praetors (and propraetors), dictators, curule aediles, and the Flamen Dialis (high priest of Jupiter). "The fasces in particular were the most striking visual feature of magisterial authority on parade,"[12] as in a triumphal march held for a victorious Roman general. There were other occasions that included the ceremonial display of fasces.

A relief held at the British Museum shows one example, where "...lying behind the bundle and the axe is a long tapering rod. One of the methods of freeing slaves was by the *vindicta* ceremony, usually performed before the praetor. The ceremony was a fiction of a lawsuit concerning property. The slave, having no legal rights, was represented by the magistrate's lictor or some other person, who was called the *assertor libertatis.* This man, taking up a rod (*vindicta*), touched the slave and declared that he was free. The master, of course, made no defense,

and the praetor pronounced judgment in favor of the assertor. The master then turned the slave round and gave him a slap (*alapa*) and henceforth he was a freeman."[13] This vindicta was derived from the wand, staff, or rod associated with divinity.[14]

The fasces carried into modern times, and, used as a Republican symbol in many countries, was subject to various political systems. Indeed, resurrected in Mussolini's Italy, it gave rise to the word "fascism" and its derivatives. But it was hardly confined to use by a dictatorial state, and remained a symbol of the State's authority in countries with a democratic rather than an authoritarian bent. In 1790, during the French Revolution, for example, the Constitutional Convention chose the fasces as the emblem of the Nation.[15] The seal of the French Republic, after 1848 and again after 1870 (marking the birth of the Third Republic), included a fasces held by an allegory of Liberty (fig. 7).[16]   FIG 7

The United States, too, has used the fasces as the symbol of authority of the people. It can be seen in the Oval Office at the White House; it is used as symbol for the National Guard, on the flag, on the mace of the House of Representatives, on the seal of the Senate, on the building of the Supreme Court (fig. 8),[17] and   FIG 8 in many other versions for the Federal Government or of the individual States. The reverse side of the United States "Mercury" dime, the ten-cent coin minted from 1916 to 1945, bears a fasces and an olive branch (fig. 9). The origin of the   FIG 9 Latin word *fascis* is also interesting. It connotes a package, an assembly, a bundle tied with a rope, but it can also mean a faggot made of twigs or branches, or

FIG 7 Armorial bearings of the French Republic          FIG 9 United States "Mercury" dime, reverse side

FIG 8 Fasces relief on the facade of the Supreme Court in Washington, D.C.

a bunch or a sheaf of wheat. Thus, it alludes both to forestry and agriculture. As for the Latin word *lictor*, while reminiscent of the verb *ligāre*, to bind; it is actually derived from another verb, *licio*, meaning to lead, to drive, and is ultimately associated with the spinning of flax. It was part of a colloquial Latin vocabulary.[18]

In sum, the fasces was emblematic of law and order, and represented the State as guarantor of the citizens' obedience to the rules of law. Why is it, then, that a bundle of rods was to be invested with such a moral, even an ethical value? To answer this new question will give us insights as to why we confer an aesthetic value on such an image as well.

## Quality and Quantity

First, I suggest we return to the ancient crafts of basketry and forestry – woodwork being derived from the latter. Before weaving a basket, the craftsman (or -woman) gathers materials: willow branches, wicker, reeds,[19] even pine needles! Typically, these are all of the same length and diameter. Once bundled, they resemble the self-assemblies of nanowires we looked at earlier.

Forestry differs from weaving in that its end product is a pre-requisite to the weavers' work. Once cut into logs, tree trunks and large branches become more easily moveable. They leave the woods to enter various seats of population, ultimately finding their way into domestic uses, such as heating and feeding kitchen stoves. Typically, a delivery consists of a set of logs of like shape and size. A faggot is a bundle of branches used in feeding the flames once it has been kindled with twigs, for example. Another use for bundles of branches is to make brooms from plants such as common broom, French broom, or Spanish broom.

Does it not follow, then, that bundling natural supplies into man-made artifacts, turning them from highly diverse into highly similar utensils and defining them newly, is a move towards abstraction? Accounting occasioned by commercial transactions propelled the advent of writing on clay tablets and other surfaces millennia ago. Numerals were an abstraction that heralded the birth of arithmetic – it became clear that addition, subtraction, multiplication, and division applied to sets of numerals irrespective of what was being counted: sheep, horses, pigs, or wives. What's more, counting on one's fingers is as elementary as it is ancient: fingers also constitute a set of elements, with similar sizes and shapes, one more or less resembling the other.

As such, I would conjecture that we humans tend to find beauty in the regular and more or less interchangeable arrangement of discrete elements. And further, that beauty is inseparable from the ability of the mind to embrace abstraction, made easier, perhaps, by a likeness among individual elements. That said, let me next address the objection which immediately springs to mind.

## In Favor of the Unique and Original,
## Against Machine-made Artifacts

Do we assign an aesthetic value to matches in a matchbox, to toothpicks in their own packing,[20] hiking sticks, or ski poles bound together? Were we not brainwashed by the Romantics, in their hatred of industrialization, into dismissing such mass-produced artifacts as uninteresting?

Since this particular objection is not easily dispelled, I will try to tackle it. Social acceptability, first? Recalling reactionary manifestos that date back as far as the Middle Ages – much as William Morris and his Arts and Crafts Movement were to do – the pursuit of beauty in manufactured objects captured the imagination between the two World Wars. It was then that industrial designers in various countries gained influence: the Bauhaus in Germany from 1919;[21] Charlotte Perriand in France during the 1930s; Raymond Loewy in the US, who streamlined the Gestetner duplicator starting in 1920. The Museum of Modern Art in New York established the world's first curatorial department for architecture and design in 1932;[22] and in Italy, offshoots of Futurism – such as the magazine *Domus*, founded by Giò Ponti in 1928 – also took hold. Further, automobile designers, such as Pininfarina, began work in the 1930s, to be joined only a few years later by the Olivetti company, which became synonymous with handsome product design.

Complementary to the impact of such architects and industrial designers, was the belated influence of Marcel Duchamp, who turned ready-mades into artifacts worthy of exhibition, thus also contributing to a change in the public eye. And in that context, permit me a personal story: I have a paperweight on my desk which might be unique. It is an iron stake I picked up off the tracks of a railroad in North Carolina and later had silver-plated at a jeweler's. To my mind, it is an extremely handsome object, a ready-made turned into a precious art object. Duchamp would be proud.

To summarize, mass production is not incompatible with aesthetics; far from it, in fact. This is the first argument. The second argument has to do with the object's scale. When in 1959, Richard P. Feynman set a goal of putting the entire *Encyclopedia Britannica* onto a single pinhead to emulate the informational content of the DNA molecule, he showed himself farsighted. It would take another few decades for nanoscience and -technology to take off. Miniaturization brings with it a sense of wonder at all the functionalities a tiny object can do. We marvel at a printed circuit, and how micro- and nanolithography have allowed the grouping of myriads of logical functions onto a miniscule silicon chip. And one may claim that the sense of wonder for a miniaturized artifact also carries a strong aesthetic component.

Indeed, appreciation of the images of self-assemblies of various nanostructures here (figs. 3–6) has to do largely with their scale – thereby with their relative unfamiliarity. In centuries past, there might well have been a time when the individual strands of homemade spaghetti were admired for their uniformity in size – isomorphous with the sets of nanowires and nanotubes in this essay. To the extent that familiarity breeds contempt, however, such ready-mades fell below the radar of artistic appreciation[23] as soon as pasta became mass-produced.[24] Surely a time will come when bunches of linear nanostructures will look so familiar that aesthetic appreciation of them will also wane.

Demography may have been a factor in the switch from positive to negative in public perception of the beauty of mass-produced objects. In any case, the switch occurred at a time when the population of the planet started escalating from two or three billion people to its current seven billion figure. Which raises another question: Why are scientists sensitive to feedback from technology, even though the latter stands downstream from science laboratories?

## Recapitulation

The standard approach to molecular aesthetics – defined as admiration for the beauty of molecules, for which the DNA double helix is emblematic – is very much confined to chemistry. That said, I do not mean to imply that non-chemists cannot be involved. Indeed, this edition and several other publications include contributions by artists and humanists alike.[25] As a rule, appreciation of molecular beauty gives itself, as its single referent, a molecule, or a set of molecular objects, or representations thereof. Outsiders to professional chemistry and professional chemists alike look at molecules and readily turn them into "art objects."

Admittedly, my approach in this essay is somewhat different. I chose for the topic of study one of the simplest iconic arrangements: a bunch of equidistant parallel lines. I found them in details of paintings by Pierre Soulages, where, you will recall, they were simply means to an end. I related them to pictures of self-assemblies by nanoobjects, in which seemingly similar manifolds are present, yet this time, as goals rather than means. My next step was to conjecture an archetypal origin for such assemblies. To flesh out this conjecture, I related them to the *fasces*, those emblems of law and order which lictors carried as symbols of their authority over the citizenry of Rome, symbolism that endures to this day. At that point, another conjecture became necessary, one on the choice of a bundle of sticks to signify "order" and the rule of law. I then hypothesized a quite logical inference: that this symbolism was derived from crafts such as basket weaving or lumbering. Doubtless a move towards abstraction, even in more remote antiquity, made it possible for people to associate numbering, accounting, and writing with sets of rod-like objects.

In following this sequence, and in an attempt, both to reconstitute a chapter of intellectual history and define a genealogy of images whose usage persists today, I postulate the following:

There is no separation between art and science, whether in principle or in fact. The two spheres freely and continuously borrow from one another.

Any image carries with it a multitude of meanings and it is the task of the commentator, beyond mere description, to elucidate as many of these meanings as possible: that being part of the field known as "iconology."[26]

Yet, how can one vouch for the pertinence of this elucidation? Are the meanings I propose idiosyncratic and fanciful imaginations, or are they pertinent? Did I overlook other meanings, perhaps ones even more relevant to the subject matter? Since I am so close to this work, it would injudicious and irresponsible on my part to pass judgment on the quality of the analysis presented here. I hope others, then, will enter the dialogue.

### Notes

1 See: Pierre Soulages, "La lumière comme matière," in: *Rue Descartes*, no. 38, 2002, pp. 112–117, doi: 10.3917/rdes.038.0112; Laurent Wolf, "Exposition," in: *Études*, vol. 412, no. 1, 2010, pp. 100–103.
2 See: Simone Korff-Sausse, "Promenade dans les musées. L'esprit du temps," in: *Champ psychosomatique*, no. 56, 2009, pp. 215–221, doi: 10.3917/cpsy.056.0215.
3 See: Pierre Soulages, "Le désir du peintre," in: *L'en-je lacanien*, no. 15, 2010, pp. 185–208.

4 Not to overlook – and here strictly as an aside – are war scenes in paintings, which almost irrespective of the culture, whether Western or Eastern, show the stereotype of the "war machine" depicted with sets of parallel elements such as lances, muskets, etc. One example should suffice: Velázquez' *The Surrender of Breda*, ca. 1634/1635. See: Anthony Bailey, *Velázquez and the Surrender of Breda. The Making of a Masterpiece*, Henry Holt & Co., New York (NY), 2011.

5 With techniques such as atomic force microscopy (AFM), scanning electron microscopy (SEM), and scanning tunneling microscopy (STM), whose end products are photographic images. I won't elaborate here on the complex methodologies used to translate tiny electric currents into images such as those we know from our more macroscopic world.

6 See: Yang Cao, Wei Liu, Jialin Sun, Yaping Han, Jianhong Zhang, Sheng Liu, Hongsan Sun, and Jihua Guo, "A Technique for Controlling the Alignment of Silver Nanowires with an Electric Field," in: *Nanotechnology*, vol. 17, no. 9, IPO Publishing, Bristol, 2006, pp. 2378–2380, doi: 10.1088/0957-4484/17/9/050.

7 See: Zhiyong Gu, Hongke Ye, and David H. Gracias, "The Bonding of Nanowire Assemblies Using Adhesive and Solder," in: *JOM*, vol. 57, no. 12, 2005, pp. 60–64, doi: 10.1007/s11837-005-0185-z.

8 See: A. K. Bentley, M. Farhoud, A. B. Ellis, G. C. Lisensky, Anne-Marie Nickel, and W. C. Crone, "Template Synthesis and Magnetic Manipulation of Nickel Nanowires," in: *Journal of Chemical Education*, vol. 82, no. 5, 2005, pp. 765–768, doi: 10.1021/ed082p765.

9 Pierre Laszlo, "Essay Review of Theodore L. Brown: 'Making Truth. Metaphors in Science', University of Illinois Press, Champaign (IL), 2003, xi + 215 pp.," in: *HYLE*, vol. 10, no. 1, 2004, pp. 47–51.

10 Marian Eide, "The Politics of Form: A Response to Jeffrey T. Schnapp," in: *South Central Review*, vol. 21, no. 1, Spring 2004, pp. 50–53, doi: 10.1353/scr.2004.0007.

11 It would be interesting to relate this to the use of "birching" to enforce pupils' obedience and discipline in French and, more notoriously, English schools during the nineteenth century. See: George Benson, *Flogging: The Law and Practice in England*, Howard League for Penal Reform, London, 1937. I'll resist the temptation of such a digression.

12 Anthony J. Marshall, "Symbols and Showmanship in Roman Public Life: The Fasces," in: *Phoenix*, vol. 38, no. 2, Summer 1984, pp. 120–141.

13 W. H. Manning, "A Relief of Two Greek Freedmen," in: *The British Museum Quarterly*, vol. 29, no. 1/2, Winter 1964–1965, pp. 25–28.

14 See: Ferdinand Joseph M. de Waele, *The Magic Staff or Rod in Graeco-Italian Antiquity*, J. van der Doesstraat, The Hague, 1927.

15 See: Jean Starobinski, *1789. The Emblems of Reason*, University Press of Virginia, Charlottesville (VA), 1982.

16 See: Pierre Nora (ed.), *Realms of Memory: Rethinking the French Past*, vol. 3: Symbols, Columbia University Press, New York (NY), 1998.

17 See: Matthew Eric Kane Hall, *The Nature of Supreme Court Power*, Cambridge University Press, New York (NY), 2011.

18 "It would be strange if a verb so old and so intimately connected with the home life of very ancient times should not have imbedded itself in the terminology of agriculture." See: Norman W. DeWitt, "A Semantic Study of Licio," in: *Classical Philology*, vol. 13, no. 3, 1918, pp. 311–313; Norman W. DeWitt, "A Semantic Note on Ilicet," in: *The Classical Weekly*, vol. 47, no. 4, 1953, p. 58.

19 Deserving of mention here are those musical instruments which began as bunches of reeds, from the organ to other wind instruments such as the bassoon – still known as the *faggot* in German and *fagotto* in Italian – which derived from the dulcian, an assembly of two reeds. See: James B. Kopp, "The Emergence of the Late Baroque Bassoon," in: *The Double Reed*, vol. 22, no. 4, 1999, pp. 73–87.

20 See: Henry Petroski, *The Toothpick. Technology and Culture*, Knopf, New York (NY), 2007.

21 For the motif of parallel lines see: Paul Klee, *Pädagogisches Skizzenbuch, Bauhausbücher No. 2.*, Bauhaus, München, 1925, and his paintings of 1928, 1929, and 1932, whose titles refer to a "fertile country."

22 As is well known, Steve Jobs' insistence on clean design became a hallmark of the Apple Company from the end of the twentieth century to the present day.

23 See: Oretta Zanini De Vita, *Encyclopedia of Pasta*, California Studies in Food and Culture, vol. 26, University of California Press, Berkeley (CA), 2009.

24 I'd venture to bet that, in our postmodern age, some artists have been exhibiting spaghetti, whether in sculptures, hyperrealist paintings, photographs, or installations.

25 See: Jeffrey Kovac, Michael Weisberg (eds.), *Roald Hoffmann on the Philosophy, Art, and Science of Chemistry*, Oxford University Press, New York (NY), 2011.

26 See: Erwin Panofsky, *Studies in Iconology. Humanistic Themes in the Art of the Renaissance*, Oxford University Press, New York (NY), 1939.

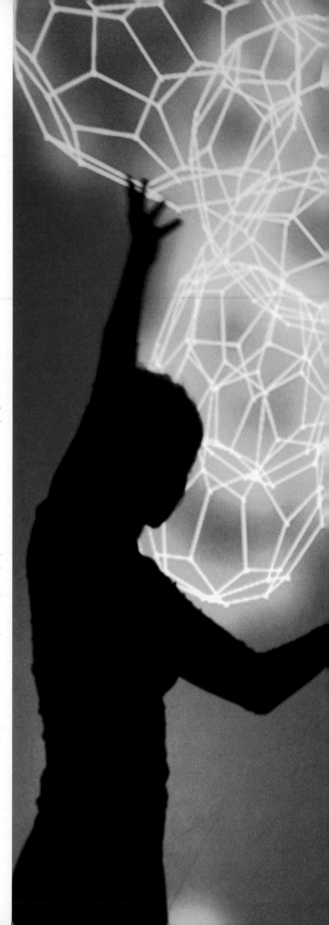

*Zero@Wavefunction (zerowave)*
2002, *MANIPULATE THE BUCKYBALLS with your SHADOW*, Los Angeles County Museum, 2003

**VICTORIA VESNA** (*1959 in Washington, D.C.) is a media artist and professor at the Department of Design Media Arts at the UCLA School of the Arts and director of the UCLA Art Sci Center (Los Angeles, CA). Her work can be defined as experimental creative research that resides between disciplines and technologies. She explores how communication technologies affect collective behavior and how perceptions of identity shift in relation to scientific innovation. Her most recent experiental installations – *Blue Morph*, *Water Bowls*, and *Hox Zodiac* – aim to raise consciousness around environmental issues and natural and human-animal relations.

http://victoriavesna.com

**JAMES K. GIMZEWSKI** is a professor of chemistry at the UCLA and scientific director of the Art Sci Center. He is also director of the Pico and Nano core laboratory at the California NanoSystems Institute. He pioneered research on electrical contact with single atoms and molecules, light emission and molecular imaging using STM. His accomplishments include the first STM manipulation of molecules at room temperature, the realization of molecular abacus using buckyballs, the discovery of single molecule rotors and the development of nanomechanical sensors based on nanotechnology, which explore the limits of sensitivity and measurement.

www.chem.ucla.edu/dept/Faculty/gimzewsk

**ABOUT THE ART SCI COLLABORATORS**
2012 marks a decade of an artistic collaboration (2002–2012) between media artist Victoria Vesna and nanoscientist James K. Gimzewski. Their work is focused on the idea of change and consciousness at the intersection of space-time and embodiment. Participants interact with the works in mindful ways, resulting in rich visual and sonic experiences within a meditative space. By reversing the scale of nanotechnology to the realm of human experience, the artist and scientist create a sublime reversal of space-time.

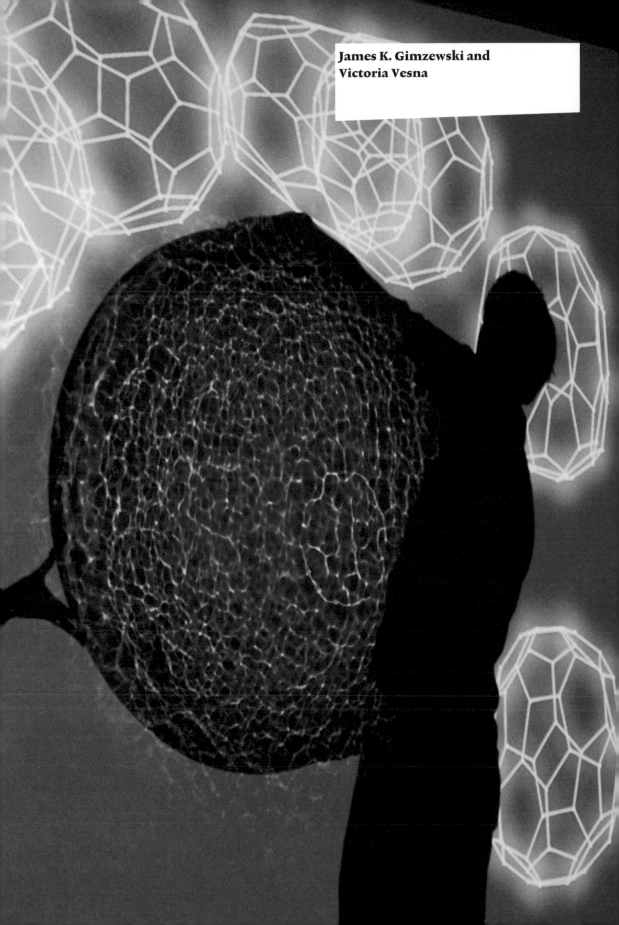

James K. Gimzewski and
Victoria Vesna

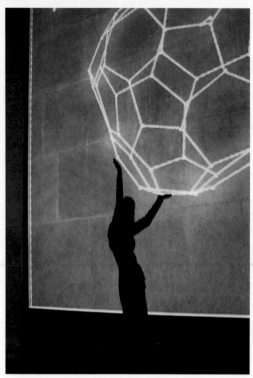

both images
*Zero@Wavefunction (zerowave)*
2002, MANIPULATE THE BUCKYBALLS *with your*
SHADOW, Los Angeles County Museum, 2003

The *Zero@Wavefunction* installation and interactivity is based on the way a nanoscientist manipulates an individual molecule (billions of times smaller than common human experience) projected on a monumental scale. When visitors pass by, they cast a larger than life shadow and activate responsive molecules, named buckyballs after Richard Buckminster Fuller. The visualizations of the buckyballs respond to the movement of the person's shadow and allow manipulating the molecule. Movement has to be slow in order to change the structure of the buckyball – force does nothing.

Albert Einstein's greatest contribution to humanity is the discovery that matter and energy are inter-convertible. Matter appears, changes, and disappears. Nothing is solid, not even a rock. The atoms and electrons in a rock are as subtle and alive as the ocean is. These particles are described in quantum mechanics by a complex function known as a wavefunction. A wavefunction contains all the probabilities and energetic possibilities of particles: space, energy, and sometimes time. Wavefunctions are basically connected, and when two come close to one another, they are both changed. In fact, they have a probability to create nothing: zero.

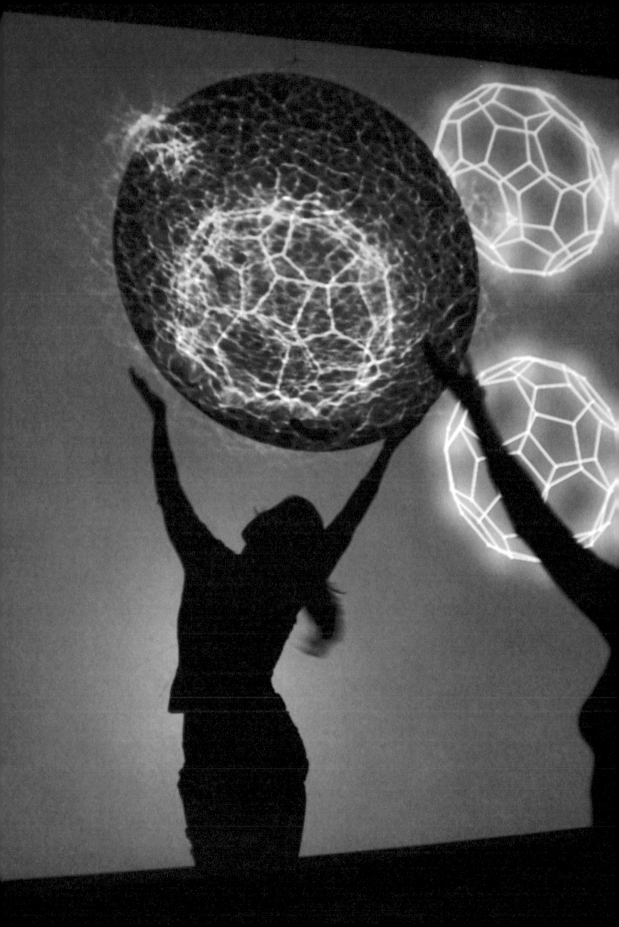

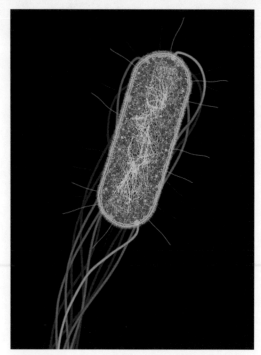

both images
*Myelin Sheath*
2009, watercolor and ink

In his cellular landscapes, David S. Goodsell depicts the biological mesoscale – the range of scale between molecular biology and cellular biology, which is currently impossible to image directly. The illustrations synthesize an atomic image of cellular subjects, based on data from atomic structure, electron microscopy, and biophysical analysis. This illustration from the Goodsell's book *The Machinery of Life* shows a cross section through a nerve axon, showing the many layers of myelin that serve as insulation for transmission of nerve signals.

**DAVID S. GOODSELL** (*1961 in Honolulu, HI) is an associate professor of Molecular Biology at The Scripps Research Institute (San Diego, CA and Jupiter, FL). He received his Ph.D. in Biochemistry from the University of California, Los Angeles. In his research, he develops new computational tools to study the basic principles of biomolecular structure and function, currently employing these tools to search for new drugs to fight drug resistance in HIV therapy. He has been involved in many science education efforts, such as collaborating with the Center for BioMolecular Modeling (Milwaukee, WI), designing models and visual materials for an NSF-funded program on "Proteins in Active Learning Modules."

http://mgl.scripps.edu/people/goodsell

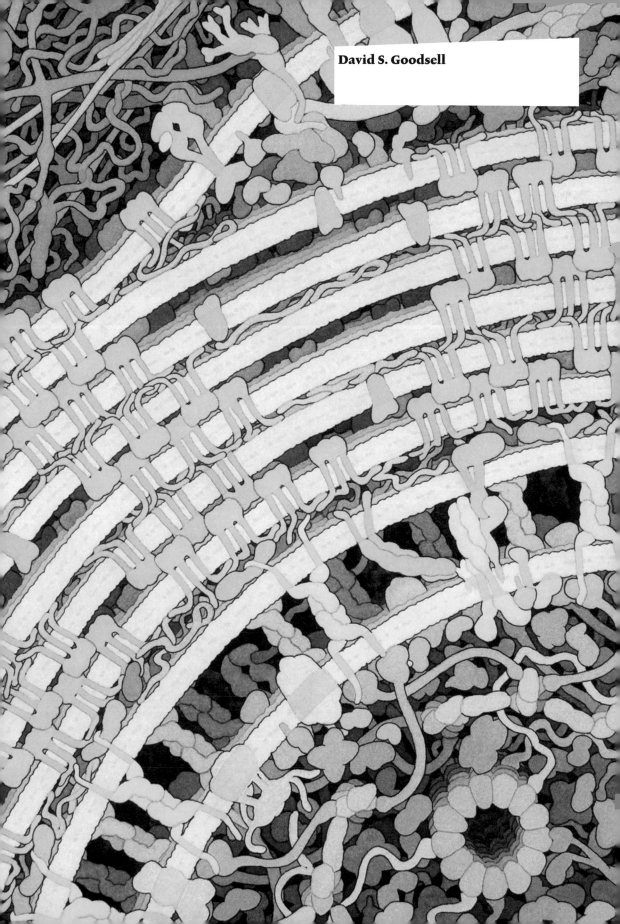

David S. Goodsell

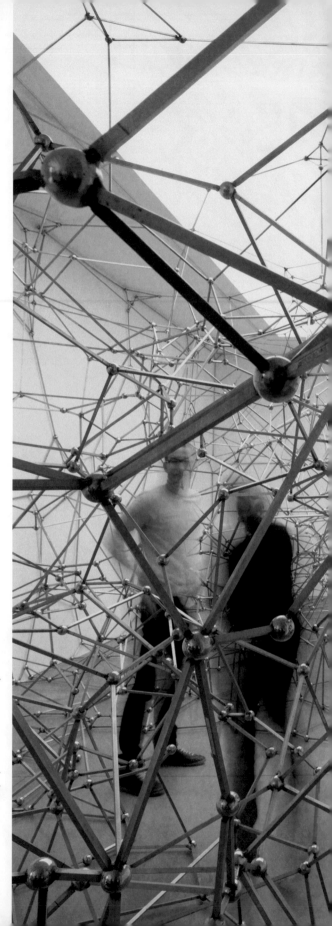

*FIRMAMENT III*
2009, 10 mm square section stainless steel bar
and 38 mm diameter stainless steel bearings,
381 × 1094.2 × 697 cm, installation view, Xavier
Hufkens, Brussels, permanent collection
of Middelheimmuseum, Antwerp, Belgium

**ANTONY GORMLEY** (*1950, GB) has had a number of solo
shows at international institutions including the Centro
Cultural Banco do Brasil [Bank of Brazil Cultural Center]
(2012); Deichtorhallen Hamburg (2012, DE), the State Her-
mitage Museum, St Petersburg (2011, RU); Kunsthaus
Bregenz (2010, AT); Hayward Gallery, Southbank Centre
London (2007); Kunsthalle zu Kiel (1997, DE); Malmö
Konsthall (1993, SE); and Louisiana Museum of Modern
Art, Copenhagen (1989). Major public works include the
*Angel of the North* (Gateshead, GB), *Another Place* (Crosby
Beach, GB), and *Exposure* (Lelystad, NL). He has also par-
ticipated in major group shows such as the Venice Bi-
ennale (1982 and 1986, IT) and the Kassel Documenta 8
(1987, DE). Gormley won the Turner Prize in 1994 and
was made an Officer of the British Empire in 1997. Since
2003, he has been a member of the Royal Academy of
Arts and since 2007, a British Museum Trustee.

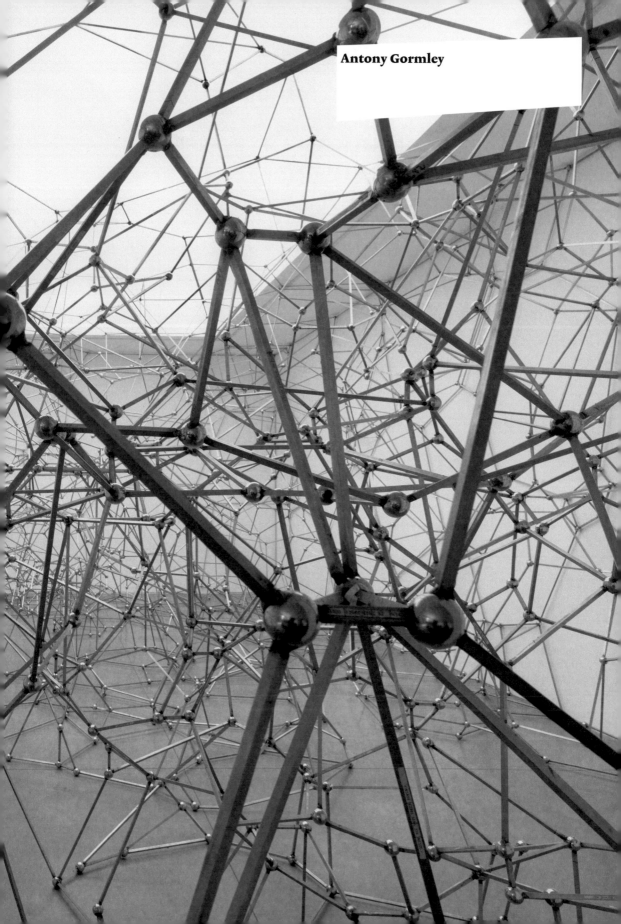

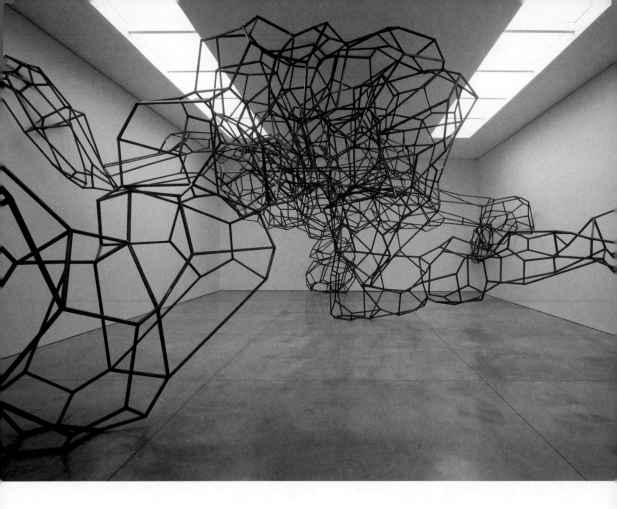

*FIRMAMENT*, the ancient name for the night sky, refers to the sky or the vault of heaven. The Latin origin of the word reminds us that the firmament is that which firmly supports the sky overhead. Stars anchor points in space, from which we gain our bearings.

It brings to mind an assembled matrix of volumes that map a celestial constellation, while also implying the form of a body lost within it. Literally a drawing in space, the non-regular polygonal structure of *FIRMAMENT* looms over the viewer, giving a sense of both claustrophobia and landscape, testing our experience of space.

Antony Gormley's work has always been about our sense of perception, testing what it feels like to experience our physical presence in certain conditions of time and space. In these installations, the viewers are asked to readjust, continually, their relationship to the field as they navigate through it.

left
*FIRMAMENT*
2008, 30 mm square section mild steel tube, 560 × 1113 × 1970 cm, installation view, White Cube, Mason's Yard, London, Collection of Jupiter Artland, Scotland

top right
*FIRMAMENT II*
2008, 32 mm square section mild steel tube, 1070 × 1100 × 810 cm, installation view, MARCO, Monterrey, Mexico, commissioned by MARCO

bottom right
*FIRMAMENT IV*
2010, 75 mm square section mild steel tube and 150 mm diameter steel spheres, 840 × 1990 × 1250 cm, installation view, Anna Schwartz Gallery, Sydney

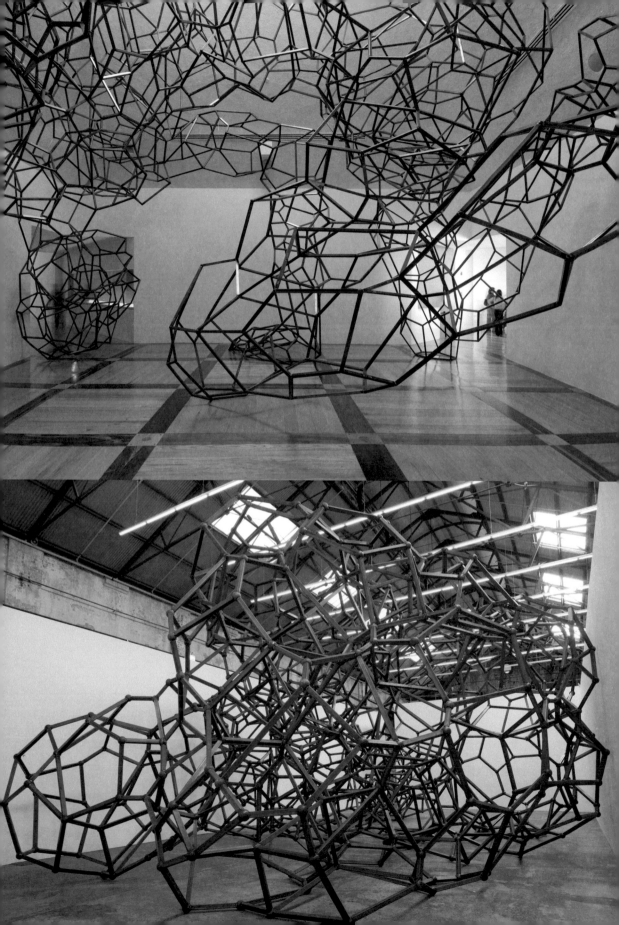

# IV

Tami I. Spector
**The Aesthetics of Molecular Forms**

With the publication of Gilbert N. Lewis's 1916 article, "The Atom and the Molecule," the conceptually ambiguous visual and conventional molecular structures contrived by nineteenth century scientists transformed into the valence structures that chemists now use on a daily basis.[1] Thus, rather than understand a bond as a "tie which enable[s] an element [...] to attach itself to one or more atoms of other elements" with "no hypothesis as to the nature of the connection," as chemists did in the nineteenth century, they now envision bonds as a space of high electron density probability between two atomic nuclei.[2] One might think that valence structures, represented at their simplest by line drawings that indicate atomic connectivity – where each line is a two-electron bond and each vertex an atom – act as mere heuristics that illustrate real molecules; in fact, they developed into discrete scientific entities that constitute the science they underwrite, while simultaneously embedding representations of molecules with an aesthetic that delights and motivates scientists. Theodore Brown has shown us that molecular representations are "extended metaphors [that] give rise to metaphorical entailments [...] [which] commonly form the basis for theory formation."[3] This scientifically generative aspect of molecular representations also gives them aesthetic potency, where, as Joachim Schummer writes, "[i]t is the molecules [and here he means the representations of the molecules], and only the molecules, for which claims of beauty and artistic creativity are justified, no matter what sensual qualities the corresponding materials have."[4] As the epistemology of nanoscience in the last few decades has rewritten chem-

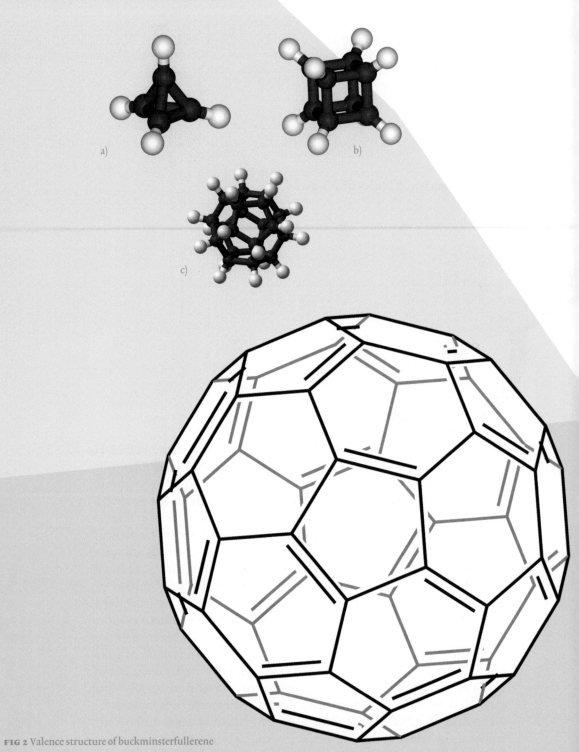

a)

b)

c)

**FIG 2** Valence structure of buckminsterfullerene

istry, the ways in which we visualize molecules scientifically also transformed,
evolution of the aesthetics of molecular forms within the context of the nano-
science revolution from 1985 forward, from the discovery of buckminsterfuller-
ene – the quintessential early molecule of the nano-chemical pantheon – to the
aesthetics of molecular machines and scanning probe microscopy (SPM).

There are various ways to understand the molecular aesthetics of nano-rep-
resentations.[5] In Plato's conceptual framework of ideal Forms, molecules, as
abstract intellectual objects dissociated from our tactile senses, are reflected
in objects in the tangible world; as perfect, unknowable universals, molecules
underlie our perceived reality. According to Plato, the four elements of fire, air,
water, and earth compose the world as we know it, and, through a complex line
of geometric reasoning, he assigns these elements to four foundational ideal
Forms: the pyramid, a "solid which is the original element and seed of fire;" the
octahedron, "intermediate in size" and, therefore like air; the icosahedron, the
"greatest" (largest) body, which reflects water; and the cube, "for earth is the
most immoveable of the four and the most plastic of all bodies."[6] Much like
molecules, these four ideal Forms were described as "so small that no single
particle of any of the four kinds is seen by us on account of their smallness: but
when many of them are collected together their aggregates are seen."[7] Their
visualized forms, the Platonic solids – like molecular representations – offer a
tool for us to grasp the unknowable realm of the real and thus, gain access to
true knowledge, although they themselves are imperfect simulacra. Similarly,
from Timaeus's geometrically based affirmation that the ideal Forms express
the most beautiful of the "infinite forms," we may infer that their representa-
tions as the Platonic solids are also beautiful, but only imperfectly so.[8]

Contemporary chemists and mathematicians have lost sight of the philosophi-
cal origins that anchor the beauty of ideal Forms, with consequent slippage be-
tween concept and form: we now consider many other geometric forms beauti-
ful, and molecular representations of the Platonic solids manifest themselves
as aesthetic objects of desire with a material result; chemists have synthesized
cubane, dodecahedrane, and substituted forms of tetrahedrane.[9] Cubane and
tetra-t-butyltetrahedrane are high-energy, crystalline solids with melting
points of 131 and 135° C, respectively.[10] Virtually indistinguishable physically,
they are individuated and aestheticized as molecular icons by molecular repre-
sentations only (fig. 1).                                                          FIG 1

With the revelatory discovery of buckminsterfullerene in 1985, the aesthetic
fascination with carbon-based polyhedral structures extended to nanotechnol-
ogy (fig. 2). Chemists first saw evidence of the buckyball as a peak in a "time of   FIG 2
flight mass spectra of carbon clusters prepared by laser vaporization of graph-
ite and cooled in a supersonic beam" corresponding to a cluster containing
sixty carbon atoms.[11] Although this is not what the researchers initially sought,
the preponderance of this peak in the mass-spectrum pointed them to an alter-
nate, unexpected path of inquiry, and ultimately defined their scientific careers.
Robert F. Curl Jr., Sir Harold W. Kroto, and Richard E. Smalley received the
Nobel Prize in Chemistry in 1996. Following the conventional plot, episodes
and details of scientific discovery, Curl, Kroto, Smalley and coworkers initially
found the molecular structure associated with the C60 peak ambiguous. After a
long day in the lab they went out to eat Mexican food, where they discussed and

scribbled possible structures for C60 on napkins; in its reaffirmation through repetition, this fable was based on an assumption common among them, that the structure must include the six-membered rings from the graphite used to generate the C60 peak. Later at home, Smalley cut hexagons and then pentagons out of paper and, played with them until around 3:00 a.m. the scales fell from his eyes when they clicked together into – aha! – a soccer ball.[12]

For as notable as their serendipitous discovery was, perhaps even more remarkable was the publication of the unsubstantiated molecular structure of buckyball (in the guise of a soccer ball) as a letter to *Nature* entitled "C60: Buckminsterfullerene" before there was clear experimental evidence of its existence.[13] Breaching the semi-private realm of the research group where "epistemic things are no longer private dreams but not yet sanctioned facts," they leapt the hurdles of proof normally necessary for scientific publication.[14] In fact, they waited five years – until other researchers discovered an alternate method for the production of buckyball in significant quality and purity – to spectroscopically confirm their theoretical structure.[15] Clearly, aesthetics helped drive the authors' "unusually beautiful (and probably unique) choice" of "the truncated icosahedron" and compelled its publication in one of the most important scientific journals before completion of the evidence.[16] As Kroto wrote in his 1996 Nobel Prize lecture, "I remember thinking that the molecule was so beautiful that it just had to be right – and anyway even if it were not, everybody would surely love it, which they did – eventually!"[17]

Since its christening as buckminsterfullerene, images of its structure have proliferated. Visually, Smalley's paper buckyball, like the truncated icosahedron (one of the thirteen Archimedean solids) mathematicians had studied for centuries, emphasized the surfaces rather than the vertices of the model; the photograph of a soccer ball included in the letter to *Nature* reinforced this emphasis.[18] The cover of the same publication issue, however, translated the structure into something more familiar to chemists: a valence structure. Valance structures communicate a sense of the molecule's spatial geometry, while ignoring subtler aspects of bonding such as electron densities and polarizabilities; they reduce experimental evidence, stripping it bare of noise, impurities, and the fact that chemists collect most chemical and spectroscopic data from kinetic molecular ensembles, presenting instead an idealized abstraction of a single, motionless, molecule. The white line drawing of buckminsterfullerene on the November 14, 1985 cover of *Nature* did just this; moreover, presumably to enhance its visual appeal, the editors displayed it on a black background in a cloud of white dots, as though embedded in a crystalline sphere of stars, and thereby connected to interstellar space.[19] Until STM captured it in 1990, representations of buckyball remained fairly close to this original image.[20] Some appear in color, others replace the vertices with balls to show them more explicitly as atoms in ball and stick models, and some space-filling (molecular models represented the atoms as balls, which are sized relative to the radius of their electron clouds, and steer clear of any lines depicting bonds). Yet in essence, all remain true to the visual vocabulary of chemical structures established in the late nineteenth century.

Its compelling, elegant molecular form, the fit of its experimental properties with its structural manifestation, and its subsequent status as the third known allotrope of carbon imbue buckminsterfullerene with a primal Platonic essence. Beyond this, however, the molecular representation of buckyball

is aesthetically potent because it simulates a real-world object – in this case, a soccer ball. Schummer posits that the aesthetics associated with molecular systems resembling ordinary objects result from the "interpretive ambiguity" established by the link between two disparate symbolic domains, or a Gestalt switch.[21] Within this philosophical framework, a molecule that looks like a soccer ball will necessarily elicit an aesthetic response.

Buckminsterfullerene's static valence structure was not only scientifically inspired but also a source of scientific inspiration that immediately led to speculation about its potential applications. In theory, it could serve as a molecular ball-bearing, encapsulate other atoms to form host-guest complexes, and tether medicinals – ball-and- chain fashion – to its surface for site-specific drug delivery.[22] Not only does it look like a real-world object, theoretically it acts like one, too. Valence structures of buckyballs that encapsulate and tether other atoms and molecules have become the most common variants of the standard image of the molecule. These representations have relocated buckminsterfullerene from just another beautiful form into the realm of a (nano)technological object – a protomolecular machine that "put the nano into nanochemistry."[23]

Although molecular machines find their prototype in buckminsterfullerene, and the molecule sometimes serves as a component in molecular machines, chemists do not view it as such.[24] They define molecular machines as synthetic mechanico-functional supramolecular systems that respond kinetically to an external stimulus. Typically, molecular machines contain switches that can be turned on or off, opened or closed, using various forms of energy to gate molecular motions. Implicitly, a switch has the ability to animate actions; consider turning on a light, for example. In fact, many molecular switches start or stop the flow of electrons within "molecular wires." Fraser Stoddart's Light-Gated STOP–GO Molecular Shuttle exemplifies typical molecular switches (fig. 3).[25] FIG 3 Nanoscientists most often illustrate molecular switches with diagrams that juxtapose molecular structures and "technomorphs." Chemist James M. Tour's illustration of the "first motorized nanocar" exemplifies these conventions:

FIG 3 J. Fraser Stoddart et al., A Light-Gated STOP–GO Molecular Shuttle

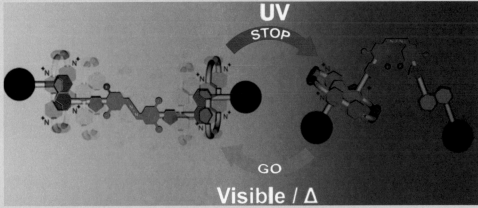

the standard molecular representations E (a valence structure) and F (a space-filling model) are placed within the same figure as the technomorphs A–D (fig. 4).[26] As fully mechanized images, technomorphs provide conceptual accessibility to nonchemists, but have absolutely no chemical meaning.[27]

Aesthetically, according to Schummer, if we place the two different sign systems, one of which lacks visual ambiguity, side by side, we resolve the tension of the Gestalt switch associated with the "interpretive ambiguity" embedded in the standard representations of molecules that resemble real-world objects.[28] An alternate and opposing perspective on the juxtapositional aesthetics of nano-chemical machines comes from Barbara Maria Stafford's analysis of early modern European emblems and heraldic shields where "such tiled images or two-dimensional spatial groupings of unit cells set side by side allow the viewer to

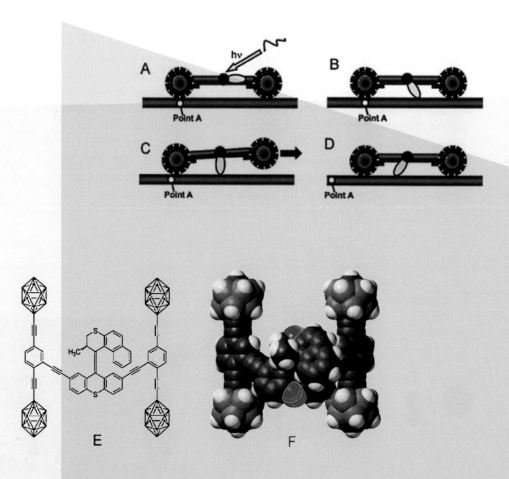

FIG 4 James M. Tour, Propulsion scheme for the motorized nanocar

compare many different situations simultaneously. Interlocking decontextualizes ordinary objects and recontextualizes them as strange."[29] Unlike Schummer's analysis, which claims that the aesthetics of such systems comes from a sense of familiarizing dissimilar objects within a frame, Stafford's model defamiliarizes them, and this quality, as she notes, calls attention to the "virtuoso manipulation of material components" that articulates the artifice of their construction.[30]

Robert Boyle's seventeenth-century mechanical framework for chemistry provides yet another context for understanding the aesthetics of the static representations of nanomachines. Boyle postulated that the corpuscular nature of matter was best understood as a mechanical entity. He, and later mechanical philosophers such as Isaac Newton, believed that, as primordial structures, corpuscles mirrored the mechanical motions and interactions of the natural world. Alan Francis Chalmers convincingly argues that because Boyle's corpuscles possessed strict mechanical properties, they wholly avoided chemical atomism; they "reduced chemistry to mechanism."[31] Like Plato's ideal Forms, these corpuscles undergirded all matter but, while differentiated by their shape, size, and motion, were not blatantly ideal in Plato's sense. In twenty-first century nanotechnology, Boyle's corpuscles manifest themselves in a literalized mechanical world of molecules represented by the idealized form of the technomorph.[32] Like Boyle's corpuscles, such depictions have minimal, or no, normative chemical structural features. Instead, they possess an inertial impetus, in Boyle's case a literal impetus or "impressed force" contained in each corpuscle for mechanical action; technomorphs statically depict molecular machines that contain the potential for dynamics within.[33] Representationally, nanoscientists illustrate the concept of a molecular switch by juxtaposing two technomorphs side by side with arrows in between that symbolically include the source of energy needed to tigger the switch (fig. 3). While absolutely static, the conceptual space between each structure creates our perception of a dynamic quality.

The representational imaginings of molecular machines communicate a machine aesthetic where form articulates function above all else.[34] Although we are accustomed to real-life machines, and are not impressed by their novelty as such, our sense of awe is recaptured by images of nanomachines: they represent a physically unknowable realm "yet express the 'cold rationality' of [their] designer."[35] Although they are not actually machines, representations of nanomachines have the look and feel of machines, and a sense of transparency that, like cutaway models, reveal "an epiphany, [and] an avenue to knowledge."[36] Technomorphs express a sense of molecular agency with visual metaphors; they transform molecular machines, via chemical and physical forces, from the inanimate into the animate.

The visual expression of molecular agency also inhabits self-assembling systems. Self-assembling systems express the dynamics of a perceived chemical agency by performing overt kinetic acts; left on their own and under the right conditions, graphite sheets form cylindrical structures, and "living" DNA and protein molecules spontaneously assemble into supramolecular entities. Self-assembly moves nanotech out of the purview of an aesthetics of scale and into an aesthetics of temporality and ephemerality. If we look at Jean-Marie Lehn's figure of the formation of "double helicate" and "triple helicate" structures from a "mixture of oligobypyrimidine strands and of Cu(I) and Ni(II) ions,"

FIG 5 (fig. 5) we see valence structures of the separated reactants on the left and the self-assembled products on the right, where the molecular structures encode their elegance – as an instantaneous transformation of starting materials – into a complex product.[37] It is the space, the instant, between reactants and products that captures our imagination. Linked by a sensation of disruption – a moment of awe expressed in astonishment – it captures the transient sensation of sublimity.[38] Stafford argues that symbolically interlocked visual systems represent and bind our neural processes. She writes, "Just as the intarsia-like emblem is pieced together from a multiplicity of juxtaposed fragments, each of which belong to some dispersed, invisible whole, assembly, synchronization, and the combination of complex streams of information are predicated on the coordination of features of a given datum spread over an interconnected system." In her words, such systems "compress space and time."[39] In the blink of an eye, in the space over the arrow, many become one. Molecular scientists have long been fascinated with this unknowable space; we draw and computationally simulate "transition states" between reactants and products, capturing fleeting moments in time into structures on the page. We create faster and faster methods, like femtosecond spectroscopy, to try to home in on this inherently unknowable space. Like Plato's ideal Forms, the space remains inaccessible, ripe with imaginative yearning.

In the context of this essay, the title of the *Wired* magazine article "Self-assembling DNA Makes Super 3-D Molecular Machines" holds particular promise as a rich source for aesthetics inquiry.[40] In the *Science* article "Folding DNA into Twisted and Curved Nanoscale Shapes," on which the *Wired* article is based, Hendrik Dietz and colleagues describe a method for engineering DNA "through programmable self-assembly."[41] Employing the techniques of "scaffolded-DNA-origami," they demonstrate how to design "a DNA bundle bearing three 'teeth'" and then use hierarchical assembly to combine these bundles into circular objects of various sizes that resemble nanoscale gears.[42] The nano-engineering used to manufacture these structures interests scientists, yet most aesthetically fascinating are the transmission electron microscope (TEM) "photographs"
FIG 6 of the 25–50 nanometer-sized gears and other twisted DNA structures (fig. 6). Although reported in the popular press as "3-D Nano Machines," the mechanical aspect of these nanocogs is illusory; they are simply abstracted images of static machine parts. More machinelike is the "nanoscale DNA box" designed, by means of self-assembly, at the Copenhagen Centre for DNA Nanotechnology.[43] This "functionalized DNA box" has an operable lid that opens with an oligonucleotide key, giving it the feel of a dynamic molecular machine. Again, the most astonishing aspect of this technology is not the ability to design such a self-assembling system, but the ability to capture "images" of the $42 \times 36 \times 36$ nanometer box in its closed and open states at the nanoscale using atomic force
FIG 7 microscopy (AFM) (fig. 7).

Both the transmission electron micrograph of DNA gears and the atomic force microscopy image of the nanobox, are bare-bones relatives to other nanomicroscopy images, yet in the words of chemist David S. Goodsell, they "give the feeling that one could simply reach out and touch the atoms."[44] This awe in "seeing" atomic-scale objects has not faded, even though available technologies have made such images scientifically commonplace. Despite their current ubiquity in the scientific literature, however, nano-microscopic images as legitimate

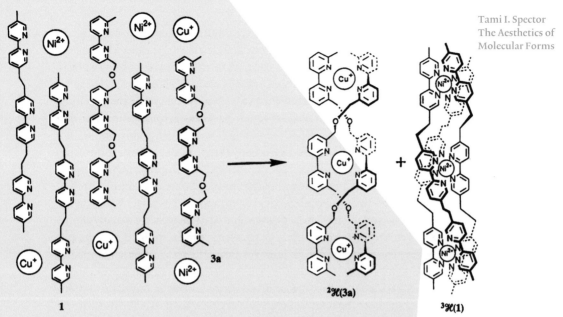

**FIG 5** Jean-Marie Lehn, Self-recognition in the self-assembly of the double helicate $^2H(3a)$ and the triple helicate $^3H(1)$ from a mixture of the oligobipyridine stands 1 and 3a and of $Cu^I$ and $Ni^{II}$ ions

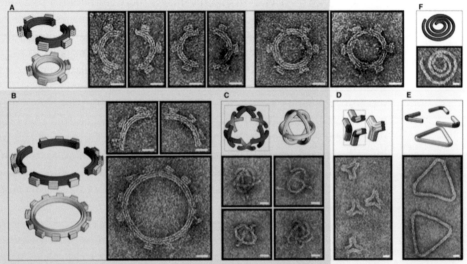

**FIG 6** Hendrik Deitz, Shawn M. Douglas, and William M. Shih, TEM of folded and twisted DNA

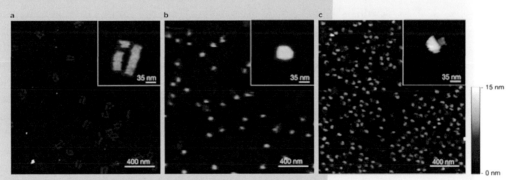

**FIG 7** Ebbe S. Andersen, Mingdong Dong, Morten M. Nielsen, Kasper Jahn, Ramesh Subramani et al., atomic force microscopy (AFM) image of a DNA box, adapted by permission from Macmillan Publishers Ltd

scientific evidence have not gone uncontested. What makes their acceptance as evidence conditional relates intimately to how scientists produce the images: as its name implies, the transmission electron microscope works by passing an electron beam through a thinly sliced sample, and the transmitted light that passes through that sample giving "rise to a 'shadow image' of the specimen with its different parts displayed in varied darkness according to their density."[45] Typically, the images produced using TEM are gray, grainy, and shown from above. Scanning tunneling microscopy (STM) and AFM both differ from TEM but are only subtly different from each other. Both employ a metallic probe with a tip the width of an atom to map the atomic surface of a sample. Both of these types of scanning probe microscopy (SPM) appear to resolve objects on the nanometer scale and, relative to TEM, STM, and AFM images, are usually significantly manipulated.[46] In part, this is by necessity: the numeric signal data provided by the STM or AFM probe, as it moves along the surface being mapped, is unreadable to most people – including scientists – until translated into a visual contour map. To enhance that readability, scientists often manipulate SPM images: they exaggerate the relative height scales of the map to make the troughs deeper and the peaks higher, color them in bright contrasting hues, and display them from a side perspective. Such manipulations make the contours of the atomic surface more evident and the images more aesthetically pleasing than traditional overhead-view, black and white microscope images. The content of such images can be understood with little further explanation, and typically, a short figure caption conveys the scientific essence of the image. By comparison, nanomicroscopy images that are less drastically manipulated prove more difficult to read outside of the context of a scientific paper. Astounding as the AFM images of the nanoscale DNA box appear from a scientific perspective, there are manipulated minimally; the barely distinct colors and blurred edges have little inherent visual impact. Yet, scientists more generally accept this relatively indistinct image, and the gray-scale images associated with TEM, as legitimate evidence of the molecular level objects and phenomena they represent, perhaps because they perceive them as less manipulated than the more highly mediated images associated with SPM.

One of the most familiar and controversial images from the world of STM is Donald M. Eigler's quantum corral, a representation of the surface electrons of copper confined within a circular fence of 48 iron atoms. Blue iron atoms surround red electron waves in close-up.[47] This repeatedly replicated image provides an extreme example of the manipulations that SPM images undergo in scientists' hands. Article titles such as "Fact and Fantasy in Nanotech Imagery" and "Truth and Beauty at the Nanoscale" disclose significant unease about the validity and ethics such highly mediated SPM images represent in the cultural and philosophical literature.[48] Scholars warn us "that the process of making pictures with scanning probe microscopy can lead to excessive manipulation of variables such as color, and that excessive manipulation is tantamount to misrepresentation."[49] These concerns are nothing new: there have been concerns about the truth and objectivity of the machine-made image since the advent of photography. In science studies, Michael Lynch and John Law's paper on birdwatching gets to the heart of this representational conundrum when they write, "[a]s anyone who has attempted photography is aware, photography does not simply capture what the eye sees: the chemistry of emulsion film differs from

that of the eye; still photography documents a frozen moment, and often the 'wrong' moment; light and color come out differently, and often unexpectedly." They continue, "[d]epending on the case, these differences can be turned to advantage or disadvantage."[50]

Among the numerous studies on specific ways contemporary scientists manipulate "photographic" images to highlight evidence, Kelly Joyce's work on MRI is most helpful for understanding SPM images. Like MRI, SPM yields numeric information that is "transformed via computer software" into images disguised as photographs, and the rhetorical practices associated with MRI pictures also readily apply to SPM images.[51] One of the rhetorical tactics posited by Joyce situates MRI in relation to other types of medical evidence as "superior to other ways of knowing the body," as more "true" and "accurate."[52] In the rhetoric of medical practice, the accuracy of the diagnosis by MRI images far surpasses that of a physical exam; in nanochemistry the truth-value of SPM images surpasses that of analytical and spectroscopic data. A recent *Chemical & Engineering News* concentrate titled "Molecular Machines Spotted on the Move" reports the "direct observation of the movement using scanning tunneling microscopy" of one of Stoddart's molecular switches, which to date has only been inferred from "spectroscopic data."[53] The ability of the rhetoric of SPM to enliven its associated images and elevate their ontological status is revealed when we look at the actual published STM images of the bistable rotaxane molecules (fig. 8). As shown, the "direct observation" of the molecules is visually oblique, FIG 8 differentiated from the background only as vaguely shaped "dumbbell" protrusions on a reddish-black Au(111) surface as is the supposed "spotting" of their movement; the implication that they are caught in the act of moving is an observation only deduced by side-by-side images that show that the molecule has changed position.[54] Yet even for this, as for all SPM images, the perception that

FIG 8 Tao Ye et al., STM of a bistable rotaxane molecule

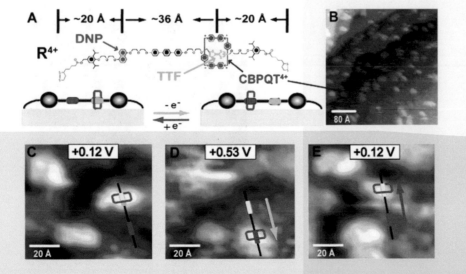

the image is unmediated privileges it as scientific evidence over valence structures and computational and physical molecular models, none of which image actual molecules.

So while SPM images are not "real" images of atoms and molecules, their evidentiary status derives from their photographic likeness, as this rhetorical strategy indicates, and their aesthetic power, derives from their conflation with photography. Though photographs "capture" images by the interaction of light with chemicals on film, or electronically by translation of light into digital data, and SPM "creates" them by translating the electrostatics of a molecular surface into an image, they possess significant material and aesthetic contiguities: the photographer chooses what to photograph, how to photograph it, and how to crop, highlight, and scale the photograph to best effect; the viewer interprets the photograph within written or verbal contexts and their individual experiences. The scanning tunneling microscopist determines what to scan and how to digitally enhance the SPM image. In scientific papers the figure captions contextualize the image, and viewers bring their own scientific knowledge to bear on its interpretation. In addition to creating a narrative of neutrality and authority, figure captions are intrinsic to the aesthetics of SPM images in the scientific literature. John Berger writes, "[i]n the relation between photograph and words, the photograph begs for an interpretation, and the words usually supply it. The photograph, irrefutable as evidence but weak in meaning, is given a meaning by the words. And words, which by themselves remain at the level of generalization, are given specific authenticity by the irrefutability of the photograph. Together the two then become very powerful; an open question appears to have been fully answered."[55] Without the figure caption, the sublime astonishment inspired by looking at the SPM of a nanoscale DNA box opening and closing, or a molecular machine moving, is inaccessible.

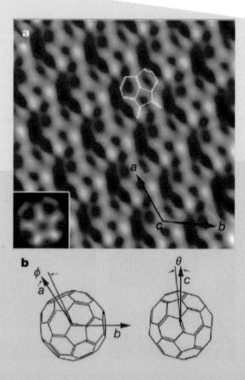

FIG 9 J. G. Hou et al.,
STM of Buckminsterfullerene,
adapted by permission from
Macmillan Publishers Ltd

The multiple image frames that have become conventional for representing scanning probe micrographs in the scientific literature extends the aesthetics expressed by the juxtaposition of figure caption with figure (fig. 9). These conventions, shown by figures 8 and 9, include using multiple colorized SPM images at various scales, highlighting different aspects of the scanning domain displayed alongside valence structures, and, when appropriate, technomorphs; the overlay of arrows, axes, and other orienting pointers on the micrographs themselves, extend those previously discussed for molecular machines. As for molecular machines, the juxtaposition here of the visually ambiguous micrograph with familiar valence structures and pointers resolves the micrograph's "interpretative ambiguity." Despite figure 8's dry caption, "Structure and motion of a bistable rotaxane molecule, absorbed on Au{111} investigated using electrochemical scanning electron microscopy,"[56] the diffuseness of the image (yellowish illuminated blobs on a red-black background) and the mundanity of its valence structures, together form a coherent whole. Aesthetically, the figure captions map the domain of experimental data onto the domain of SPM images and the valence structures symbolically link the images to chemistry: they synthesize the noumenal realm of atoms with the figurative world of images.

The SPM images discussed in this paper implicitly provide unique access to the atomic world, allowing us to experimentally examine single and very small collections of molecules in condensed phase states.[57] Using SPM technologies, we can monitor the solid-state "interaction of single $C_{60}$ (buckminsterfullerene) molecules" with a platinum surface, "observe" the "single-molecule station changes within bistable rotaxane molecules" (molecular machines), and move single xenon atoms around on a nickel surface to spell out IBM.[58] Scanning probe microscopy's single-molecule representations communicate a particular aesthetic resonance for chemists because they establish direct "visual affinities" between what we see and what we have always envisioned. The 2001 STM of $C_{60}$ shown in figure 9 "reveal[s] an identical internal fine structure that closely matches the well-known cage structure" of buckyball that we have been looking at since it's "discovery" in 1985.[59] Since the late nineteenth century, chemists have visually communicated their ideas and results using valence structures of single molecular forms, and the coherence between these idealized drawings of single molecules and SPM images compel us. As we expected, buckyballs look like buckyballs, an ouroboros of representational continuity; we are "at home amongst appearances."[60]

Revised version of: Tami I. Spector, "Nanoaesthetics: From the Molecular to the Machine," in: *Representations,* vol. 117, no. 1, 2012, pp. 1–29.

## Notes

1 Gilbert N. Lewis, "The Atom and the Molecule," in: *Journal of the American Chemical Society,* vol. 38, issue 4, 1916, pp. 762–785. doi: 10.1021/ja02261a002.

2 Colin A. Russell, *The History of Valency,* Humanities Press, New York, 1971, p. 90.

3 Theodore L. Brown, *Making Truth: Metaphor in Science,* University of Illinois Press, Urbana and Chicago, 2003, p. 30.

4 Joachim Schummer, "Aesthetics of Chemical Products: Materials, Molecules, and Molecular Models," in: *HYLE: International Journal for Philosophy of Chemistry,* vol. 9, no. 1, 2003, pp. 73–104.

5 For examples of previous works on molecular aesthetics see, Tami I. Spector, "The Molecular Aesthetics of Disease," in: *HYLE: International Journal for Philosophy of Chemistry,* vol. 9, no. 1, 2003, pp. 51–71; Schummer 2003, pp. 73–104; Roald Hoffmann, "Molecular Beauty," in: *The Journal of Aesthetics and Art Criticism,* vol. 48, no. 3, 1990, pp. 191–204; see also this volume pp. 122–141.

6 Plato, *Dialogues, vol. 3 – Republic, Timaeus, Critias,* Oxford University Press, New York, 1892, p. 476.

7 Ibid.

8 Schummer 2003, pp. 73–104; Plato 1892, p. 474.

9 Joel F. Liebman and Arthur Greenberg, "A Survey of Strained Organic Molecules," in: *Chemical Reviews,* vol. 76, issue 3, 1976, pp. 311–365, here: 327. doi: 10.1021/cr60301a002; Leo A. Paquette, "Dodecahedrane – The Chemical Translation of Plato's Universe," in: *Proceedings of the National Academy of Sciences of the USA,* vol. 79, no. 14, 1982, pp. 4495–4500.

10 Philip E. Eaton and Thomas W. Cole, "The Cubane System," *Journal of the American Chemical Society,* vol. 86, issue 5, 1964, pp. 962–964, doi: 10.1021/ja01059a072; Günther Maier et al., "Tetra-tert-butyltetrahedrane," in: *Angewandte Chemie International Edition,* vol. 17, issue 7, 1978, pp. 520–521, doi: 10.1002/anie.197805201.

11 Harold W. Kroto et al., "C60: Buckminsterfullerene," in: *Nature,* vol. 318, 1985, pp.162–163, doi: 10.1038/318162a0.

12 The story of buckminsterfullerene's discovery is now immortalized in the Nobel Prize lectures of Harold W. Kroto, Richard E. Smalley, and Robert F. Curl Jr. and in the 1992 BBC Horizon video *Molecules with Sunglasses.*

13 Kroto 1985, pp. 162–163. They submitted this article just thirteen days after the experiments generating the C60 peak began and *Nature* published it two months later.

14 Hans-Jörg Rheinberger, "Scrips and Scribbles," in: *Modern Language Notes,* vol. 118, no. 3, 2003, pp. 622–636, here: p. 634, doi: 10.1353/mln.2003.0062.

15 Wolfgang Krätschmer, Konstantinos Fostiropoulos, and Donald R. Huffman, "The Infrared and Ultraviolet Absorption Spectra of Laboratory-produced Carbon Dust: Evidence for the Presence of the C60 Molecule," in: *Chemical Physics Letters,* vol. 170, issues 2–3, 1990, pp. 167–70, doi: 10.1016/0009-2614(90)87109-5.

16 Kroto 1985, p. 162.

17 Harold W. Kroto, "Symmetry, Space, Stars and C60," Nobel Lecture, Stockholm, Sweden, December 7, 1996, p. 59.

18 Kroto 1985, p. 162.

19 Ibid., 163.

20 R. J. Wilson et al., "Imaging C60 Clusters on a Surface Using a Scanning Tunneling Microscope," in: *Nature,* vol. 348, 1990, pp. 621–622, doi: 10.1038/348621a0.

21 Joachim Schummer, "Gestalt Switch in Molecular Image Perception: The Aesthetic Origin of Molecular Nanotechnology in Supramolecular Chemistry," in: *Foundations of Chemistry,* vol. 8, issue 1, 2006, pp. 53–72, doi: 10.1007/s10698-005-3358-5.

22 Vince Stricherz, "UW Researcher Says Giant Meteor or Comet Collision Caused Mass Extinction," in: *University Week: The Faculty and Staff Publication of the University of Washington,* March 1, 2001.

23 Philip Ball, "Putting the Nano into Nanochemistry," in: *Chemistry World,* December 2005, p. 28, available online at: www.rsc.org/chemistryworld/Issues/2005/December/nano.asp, accessed 01/17/2013.

24 For an example of buckminsterfullerene use in a molecular machine see Guillaume Vives et al., "Molecular Machinery: Synthesis of a 'Nanodragster'," in: *Organic Letters,* vol. 11, issue 24, 2009, pp. 5602–5605, doi: 10.1021/ol902312m.

25 Ali Coskun et al., "A Light-Gated STOP–GO Molecular Shuttle," in: *Journal of the American Chemical Society,* vol. 131, 2009, pp. 2493–2495, doi: 10.1021/ja809225e.

26 James M. Tour, "Transition to Organic Materials Science. Passive, Active, and Hybrid Nanotechnologies," in: The Journal of Organic Chemistry, vol. 72, issue 20, 2007, pp. 7477–7496, doi: 10.1021/jo070543s.

27 Joachim Schummer extended the definition of technomorph to apply to these types of representations in "Gestalt Switch in Molecular Image Perception," p. 64. In 1996 Bruno Latour used the term "technomorphs" to define the application of machine-likeness onto living systems in his *Aramis, or The Love of Technology,* Harvard University Press, Cambridge, MA, 1996, p. 225.

28 Schummer 2006, pp. 53–72.

29 Barbara Maria Stafford, *Echo Objects: The Cognitive Work of Objects,* The University of Chicago Press, Chicago, 2007, p. 46.

30 Ibid., 47.

31 Alan Chalmers, *The Scientist's Atom and the Philosopher's Stone: How Science Succeeded and Philosophy Failed to Gain Knowledge of Atoms*, Boston Studies in the Philosophy and History of Science, vol. 279, Springer, Dordrecht, 2009, p. 157.

32 There are numerous books that explore Boyle and his mechanical philosophy including Chalmers, *The Scientist's Atom and the Philosopher's Stone* and William R. Newman, *Atoms and Alchemy: Chymistry & the Experimental Origins of Scientific Revolution,* University of Chicago Press, Chicago, 2006.

33 Peter R. Anstey, *The Philosophy of Robert Boyle*, Routledge Studies in Seventeenth Century of Philosophy, vol. 5, Routledge, London, 2000, p. 134.

34 Barry Brummett, *Rhetoric of Machine Aesthetics*, Praeger Publishers, Westport, 1999, pp. 1–28.

35 Alan Holgate, *Aesthetics of Built Form*, Oxford University Press, Oxford, 1992, p. 199.

36 Brummett 1999, p. 34.

37 Roland Krämer et al., "Self-recognition in Helicate Self-assembly: Spontaneous Formation of Helical Metal Complexes from Mixtures of Ligands and Metal Ions," in: *Proceedings of the National Academy of Sciences of the USA*, vol. 90, 1993, pp. 5394–5398, here: p 5395.

38 Spector 2003, pp. 69–70.

39 Stafford, 2007, p. 52.

40 Michael Eisenstein, "Self-Assembling DNA Makes Super 3-D Nano Machines," in: *Wired*, August 6, 2009, available online at: www.wired.com/wiredscience/2009/08/nanodna, accessed 1/17/2013.

41 Hendrik Dietz, Shawn M. Douglas, and William M. Shih, "Folding DNA into Twisted and Curved Nanoscale Shapes," in: *Science*, vol. 325, no. 5941, 2009, pp. 725–730, doi:10.1126/science.1174251.

42 Ibid., p. 729.

43 Ebbe S. Andersen et al., "Self-assembly of a Nanoscale DNA Box with a Controllable Lid," in: *Nature*, vol. 459, 2009, pp. 73–76, doi: 10.1038/nature07971.

44 David S. Goodsell, "Fact and Fantasy in Nanotech Imagery," in: *Leonardo*, vol. 42, no. 1, 2009, p. 53, doi: 10.1162/leon.2009.42.1.52.

45 "The Transmission Electron Microscope," available online at: www.nobelprize.org/educational/physics/microscopes/tem/index.html, accessed 1/17/2013.

46 Scanning probe microscopy (SPM) is the over-arching terminology that encapsulates, among others, atomic force microscopy (AFM) and scanning tunneling microscopy (STM).

47 M. F. Crommie, C. P. Lutz, and D. M. Eigler, "Confinement of Electrons to Quantum Corrals on a Metal Surface," in: *Science*, vol. 262, no. 5131, 1993, pp. 218–220, doi: 10.1126/science.262.5131.218.

48 Goodsell 2009, pp. 53–57; Chris Toumey, "Truth and Beauty at the Nanoscale," in: *Leonardo*, vol. 42, no. 2, 2009, pp. 151–155, doi: 10.1162/leon.2009.42.2.151.

49 Toumey 2009, p. 152.

50 Michael Lynch, John Law, "Picture, Texts, and Objects: The Literary Language Game of Bird-watching," in: Mario Biagioli (ed.), *The Science Studies Reader,* Routledge, London, 1999, pp. 317–341, here: 334.

51 Kelly Joyce, "Appealing Images: Magnetic Resonance Imaging and the Production of Authoritative Knowledge," in: *Social Studies of Science*, vol. 35, no. 3, 2005, pp. 437–462, here: 440, doi: 10.1177/0306312705050180.

52 Ibid., p. 438.

53 Bethany Halford, "Molecular Machines Spotted on the Move," in: *Chemical & Engineering News*, vol. 88, no. 25, 2010, p. 26.

54 Tao Ye et al., "Changing Stations in Single Bistable Rotaxane Molecules under Electrochemical Control," in: *ACS Nano*, vol. 4, no. 7, 2010, pp. 3697–3701, here: p. 3698, doi: 10.1021/nn100545r.

55 John Berger, Jean Mohr, *Another Way of Telling*, Vintage International, New York, 1982, p. 92.

56 Tao Ye 2010, p. 3698.

57 Gas phase single-molecule studies using mass spectrometry and ultrafast laser spectroscopy have been used for decades.

58 J. G. Hou et al., "Surface Science: Topology of Two-dimensional C60 Domains," in: *Nature*, vol. 409, 2001, pp. 304–305, doi: 10.1038/35053163; Tao Ye 2010, p. 3698; D. M. Eigler and E. K. Schweizer, "Positioning Single Atoms with a Scanning Tunnelling Microscope," in: *Nature*, vol. 344, 1990, pp. 524–526, doi: 10.1038/344524a0.

59 Hou 2001, p. 304–305.

60 Berger 1982, p. 129.

Joachim Schummer
**Molecular Aesthetics: Blind Alleys and Promising Fields**

Since the advent of synthetic organic chemistry in the mid-nineteenth century, chemists have frequently pointed to the creativity, imagination, and aesthetic inspiration required for chemical synthesis.[1] Most famously, in *Chimie organique fondée sur la synthèse* (1860), Marcellin Berthelot compared chemo-synthetic work to that of the "arts" because, comparable to artists and unlike other natural scientists, chemists create their own objects of study on a regular basis[2]. In the nineteenth century, the term "arts" referred not only to the fine arts but also to crafts and engineering – as opposed to the sciences. While modern commentators have tended to overlook the ambiguity of the word itself, efforts by chemists to relate their science to the formative arts are undeniable.

Compared to these ongoing efforts – frequently part of a helpless strategy to popularize chemistry – serious research about aesthetics is still underdeveloped. While classical anthologies on aesthetics in science have largely focused on mathematical physics – following an almost campaign-like advance by Paul Dirac, Eugene Wigner, Richard Feynman, Werner Heisenberg, and others in the 1960s and early 1970s[3] – chemistry stands in a certain isolation. Before 2000, only a handful of papers on chemistry appeared in aesthetics journals;[4] the first, and thus far, still only collection of papers on aesthetics in chemistry was not published until 2003, which included artistic contributions and a virtual exhibition entitled *Chemistry in Art*.[5]

In contrast to the wide opportunities for aesthetic studies of chemistry, particularly on the role of aesthetic values in the practice of experimentation and theory building,[6] the dominant focus has been on the beauty of molecules. Indeed, chemists aesthetically favor molecules that are either symmetrical or look like ordinary objects. That double preference seems to echo the formative arts, where geometrical abstraction and imitation of nature both have a long tradition.

In the following essay, I will scrutinize, first, whether molecules can be objects of aesthetics at all; second, if symmetry is a useful aesthetic criterion for beauty; and third, I will explore the hidden aesthetic potential behind molecules that "look" like ordinary objects. To offer insights, we must start with the oldest molecular theory, one which was, in fact, built on aesthetic ideas and which is frequently referred to in contemporary claims about the beauty of chemical products.

## Plato's Molecular Aesthetics and the Problematic Status of Molecules

In the still ongoing dispute over the priority of the aesthetics of art versus the aesthetics of nature, Plato held an early and radical view: the formative artists try only to imitate nature, yet material nature is merely an imitation of the true ideas of nature, so their artworks are of limited, third-class value.[7] Further, if artists try to arrange their imitations of nature so as to cater to the perspective and aesthetic views of the beholder – trying to compensate for perspectival distortions by the human eye, for example – they are "cheating" on nature.[8] Their disregard for the truth of nature disqualifies the beauty of their works. Thus, whoever seeks support for molecular aesthetics in Plato should note this: he would have harshly criticized the artistic production of molecules and their colorful graphic representations!

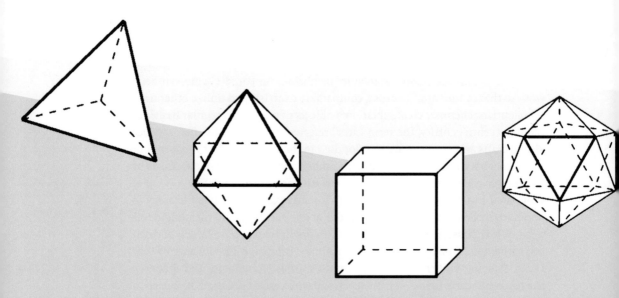

FIG 1 The Platonic solids: tetrahedron, octahedron, cube, and icosahedron, representing the ancient elements fire, air, earth, and water.

While he was to grumble about the formative arts and artists, Plato praised nature as the embodiment of beauty in his *Timaeus* dialog. From the presupposed beauty of the ultimate components of nature, he tried to infer their shapes, using aesthetic criteria as guidelines for theoretical knowledge.[9] Starting with simple triangles, he built up the famous series of regular polyhedra, the so-called Platonic solids (fig. 1), which should correspond to the four elements: fire, FIG 1 air, earth, and water. He believed that the polyhedra were invisibly small and would react with each other so as to rearrange their triangle components and form different polyhedra. Remarkably, this oldest molecular theory of chemical reactions[10] was developed on aesthetic grounds.

The molecular entities Plato devised as the embodiment of natural beauty had, philosophically speaking, a hypothetical status. Like today's chemical molecules, they were neither objects of human sensation nor simply intellectual ideas, but purported real entities, devised by intellectual reasoning, but beyond the scope of sensation. They inherited their beauty from the underlying geometrical ideas Plato considered the true candidates of beauty. Even today, the hypothetical status makes it difficult to treat molecules by any of the existing aesthetic theories; those are tailored either for perceptible objects, such as sculptures or paintings, or for intellectual objects, such as ideas or concepts embodied by particular artworks.

Although some chemists – particularly organic chemists – deal with molecules in their daily practice as if they were ordinary objects, molecules are, according to the best of our physical and chemical knowledge, quite complex theoretical entities. Strictly speaking, the talk of molecules as stable and isolated classical entities makes sense only within the scope of a model approach that disregards most of quantum mechanics, reduces the interactions among atoms to the ideal of covalent bonds, and disregards all intermolecular interactions.[11] As popular and useful as it is in most of organic chemistry, that approach fails markedly with metals, salts, and, in many cases, even with simple substances such as water. Neither standard spectroscopic measurements, such as infrared (IR) or nuclear magnetic resonance (NMR) spectroscopy, nor diffraction methods by x-rays, neutrons or other particles, nor electron microscopies and the more recent scanning tunneling spectroscopies (STS) provide direct images of molecules. Unlike widespread popularizations of chemistry and nanotechnology, measurement data must be processed heavily to yield the cheerful molecular images that decorate book covers and magazine titles.[12]

Thus, similar to Plato's tiny polyhedra, today's molecules resist standard aesthetic appreciation for ontological and epistemological reasons. Those who ignore the issues typically confuse molecules with molecular representations and models, a standard distinction in the epistemology of science. If, on the other hand, one wishes to solve the problem with reference to Plato's own theory, it becomes difficult to avoid the conclusion that the artistic production of molecules – like that of the other imitating arts – is at best obsolete play.

## Mathematical Symmetry as a Questionable Aesthetic Criterion

Among the molecules chemists have praised for their beauty, those with high mathematical symmetry stand out. Several chemists have confessed, in fact, that aesthetic appreciation was a major impetus for their synthetic research of symmetrical molecules.[13] Note that mathematical symmetry is largely inde-

pendent of whether a molecule is considered a classical or quantum-chemical entity; it applies to molecular models such as the ball-and-stick models used in teaching, and to quantum-chemical molecules alike. Thus, symmetry would appear to be an ideal property to settle the widespread epistemological confusion between molecules and molecular models. Symmetry is a mathematical description of geometrical forms according to the invariance with regard to certain transformations, such as reflection on a mirror plane, rotation around an axis at a certain angle, or lateral translation by a certain distance. In this approach, the higher the symmetry, the simpler the form, making symmetry a measure of mathematical simplicity.

Questionable, however, is whether mathematical symmetry is a useful aesthetic criterion for beauty.[14] In ancient Greek aesthetics, particularly following the works of the sculptor Polykleitos, symmetry played a dominant role, although its meaning was at total variance from that of today. Symmetry described balanced proportions between different lengths, such as between the size of the head and the size of the body or the whole of a sculpture, or between opposed compositional elements – such as between static and dynamic parts. Rather than from mathematics, the measures of balanced proportions were drawn from natural models such as the perfect human body. Contrary to the still prevalent popularization of physics, mathematical symmetry was totally unknown in antiquity and, as such, played no role in classical aesthetics. Instead, it was developed only in nineteenth-century mineralogy as an approach to classify crystals.[15]

Thus, if chemists praise the beauty of their symmetrical molecules, they find little support in classical aesthetics. The exception would be in Plato who, of course, considered the "Platonic bodies," which happen to be highly symmetrical in the modern sense, beautiful. Yet, for Plato, only the mathematical ideas behind the bodies were the true candidates of beauty. The making of corresponding material models – either of molecular or human size – would have been but the proliferation of second-grade material imitations.

Plato's aesthetic preference of the regular polyhedra was probably based on epistemic criteria, specifically here, mathematical simplicity in terms of recurrent angles and edges, which allowed him to identify beauty with truth. Both became disentangled, however, with the advent of modern aesthetics and epistemology. In particular, Immanuel Kant pointed out that people tend to confuse epistemic satisfaction, resulting from easily grasping or recognizing something, with aesthetic pleasure.[16] While the latter resists simple explanation and usually enjoys some duration, symmetrical objects please only momentarily and tend to bore quickly once their mathematical construction has been understood. As Kant expressed it, "All stiff regularity (such as approximates to mathematical regularity) has something in it repugnant to taste; for our entertainment in the contemplation of it lasts for no length of time, but it rather [...] produces weariness."[17]

If mathematical symmetry were the ideal of beauty, classical artists striving for beauty would have produced nothing other than perfect spheres, which of all bodies bear the highest degree of symmetry. Artists did more than that, of course. And, as many art theorists have demonstrated, mathematical symmetry has played a key role in art only as the counterpart to disorder or as background for highlighting symmetry breaks. It has found its way into the use of orna-

ments in architecture and into minimal art – which follows the antique idea of artistic symmetry as a balance between order and disorder.

The preference for mathematical symmetry and its confusion with beauty, can even seriously mislead scientific research. Plato's idea that Nature favors simple regular forms was disproved in a theoretical study of 1937 by Hermann A. Jahn and Edward Teller.[18] They showed that under certain quite common conditions, regular molecular polyhedra are unstable compared to distorted polyhedra, in which electronic energy states are split for lower states to be populated. More recently, it has also become clear that their fondness of symmetry has made chemists blind to an enormous technological potential that materials scientists are harvesting instead. While synthetic chemists have been producing purified substances that approach the ideal crystal with perfect translational symmetry, materials scientists have explored impure materials, with dislocations and other crystallographic irregularities in the nanometer range. This has opened up an entirely new field of properties, one recently subsumed under the realm of nanotechnology. Taken against romantic ideas about the aesthetic guidance of science, the two cases illustrate that this can, but need not, go at the expense of both epistemic and technological goal achievement. In sum, mathematical symmetry neither offers an aesthetic criterion for beauty, nor provides epistemological or technological guidance in chemistry.

## Making Molecules Look Like Ordinary Objects and the Aesthetics of Molecular Representations

In addition to their fascination with symmetrical molecules, chemists have been particularly enthralled by molecules that "look" like ordinary objects since the 1980s.[19] Because molecules are invisible – indeed the result of a model approach that reasonably applies only to certain substance classes (see above) – it is rather a set of molecular images that have raised their fascination. These images are captivating because of their ambiguity. On one hand, they refer to entities in the molecular world; on the other, to objects of the ordinary world, like a handled basket, a wheel on an axis, or two interlocked links of a chain (fig. 2). From a classical chemical point of view, these two worlds are disparate and disconnected from one another: most of the molecular properties that

FIG 2

a wheel on an axis
or
*rotaxane*

a basket
or
*basketane*

two links of a chain
or
*catenane*

a rotor
or
*rotane*

FIG 2

217

chemists are interested in are simply missing in ordinary objects and vice versa. However, owing to their ambiguity, the images connect these two worlds in a productive manner that stimulates the imagination of combining both worlds into one. One way to do so appeared in cartoons of little humans walking

FIG 3 through and playing with molecules like ordinary objects (figs. 3a, 3b). Another way was to reproduce by chemical means the ordinary world in miniature. Indeed, since the 1980s, chemists have imitated all kinds of ordinary world objects on the molecular level, from funny things like dogs and pigs to technological artifacts like gears, turnstiles, and elevators. They have developed a whole battery of molecular systems and devices with various mechanical and electrical functions: molecular machines and circuits, for example. The field inspired by the aesthetic phenomenon of ambiguous images has come to be known as supramolecular chemistry and, more recently, as molecular nanotechnology.[20]

Umberto Eco's semiotic theory of aesthetics[21] helps to understand the aesthetic inspiration that triggered the historical development.[22] Faced with ambiguous signs, the interpreter is prompted to lower the tension of ambiguity by developing new, potentially reconciling interpretations of the signs and by contemplating and revising their form. Supramolecular chemists have both tried to solve the ambiguity by reproducing the ordinary world on the molecular level, and developed a new, chemical language of technomorph signs which they frequently use in combination with classical structural formulas. To do so, in accordance with Eco's aesthetic theory, creates a new productive tension. It is a tension that calls for reinterpretation and semiotic revision as a reiterative process, and chemists perform those tasks by exploring further parts of the ordinary world on the molecular level and by adjusting their sign language. In Eco's theory, the process eventually reveals more about the interpreters and their imagination than it does about the original signs. Judging from the specific ordinary world areas they select to imitate on the molecular level, chemists reveal a deep fascination with mechanical and electrical engineering.

FIG 3A                                    FIG 3B

## Conclusions

Since the early 1980s, chemists have repeatedly alluded to molecular aesthetics when praising molecules that either look like ordinary objects, or bear a high degree of mathematical symmetry. At a closer look, however, such aesthetic approaches face at least two serious conceptual obstacles. First, mathematical symmetry is a questionable aesthetic criterion that has been lumped together with the old artistic idea of symmetry only through the mindless popularization of science. Second, and more importantly, molecules evade standard aesthetic theories because of their particular ontological status: they are neither simple empirical entities – but inaccessible by sense perception and thus cannot "look" like something – nor mere conceptual entities (or ideas) that can be judged by corresponding aesthetic values. If made accessible to the senses, it is not a molecule but a molecular representation – a model, a drawing, or a 3-D-computer animation – that becomes the object of aesthetic judgment.

Thus, molecular aesthetics inevitably becomes the aesthetics of molecular representations. We can do one of two things. One, every now and then, when funding becomes available or when the need to polish chemistry's public image becomes particularly strong, we launch a campaign to praise the beauty of the colorful images that chemists produce with the help of some hired artists. Or two, we develop a serious research program in aesthetics that analyses aesthetic preferences and styles in the rich production of molecular representations. On one hand, this opens up a huge field for cultural and visual studies of science by investigating the chemical practices of image production within a wider cultural context, thereby embedding chemistry into society at large. On the other, as has been illustrated in the previous section, we can look for cases in which aesthetic ideas have been the driving forces of research programs or even triggered entirely new fields, such as supramolecular chemistry, to firmly establish the thesis that aesthetics is an inherent part of science.

**Notes**

1 See: Robert Root-Bernstein, "Sensual Chemistry. Aesthetics as a Motivation for Research," in: *Hyle: International Journal for Philosophy of Chemistry*, vol. 9, no. 1, 2003, pp. 33–50, available online at: www.hyle.org/journal/issues/9-1/root-bernstein.htm, accessed 10/02/2012; Silke Jakobs, *"Selbst wenn ich Schiller sein könnte, wäre ich lieber Einstein"– Naturwissenschaftler und ihre Wahrnehmung der "zwei Kulturen,"* Campus Verlag, Frankfurt am Main, 2006, pp. 168–206.

2 See: Marcellin Berthelot, *Chimie organique fonée sur la synthèse*, Mallet-Bachelier, Paris, 1860.

3 See: Hallam Stevens, "Fundamental physics and its justifications, 1945–1993," in: *Historical Studies in the Physical and Biological Sciences*, vol. 34, no. 1, 2003, pp. 151–197.

4 See: Roald Hoffmann, "Molecular Beauty," in: *The Journal of Aesthetics and Art Criticism*, vol. 48, no. 3, 1990, pp. 191–204; István Hargittai and Magdolna Hargittai, "The Use of Artistic Analogies in Chemical Research and Education," in: *Leonardo*, vol. 27, no. 3, 1994, pp. 223–226; Joachim Schummer, "Ist die Chemie eine schöne Kunst? Ein Beitrag zum Verhältnis von Kunst und Wissenschaft," in: *Zeitschrift für Ästhetik und Allgemeine Kunstwissenschaft*, vol. 40, 1995, pp. 145–178; Robert Root-Bernstein, "Do We Have the Structure of DNA Right? An Essay on Science, Aesthetic Preconceptions, Visual Conventions, and Unsolved Problems," in: *Art Journal*, vol. 55, no. 1, 1996, pp. 47–55.

5 Tami I. Spector and Joachim Schummer (eds.), *Aesthetics and Visualization in Chemistry*, special issue of *Hyle: International Journal for Philosophy of Chemistry*, vol. 9, no. 1 and no. 2, 2003; available online at: www.hyle.org/journal/issues/9-1/ and www.hyle.org/journal/issues/9-2/, accessed 05/15/2013. After this paper was finished, two further anthologies appeared: Luigi Fabbrizzi (ed.), *Beauty in Chemistry. Artistry in the Creation of New Molecules*, Springer, Heidelberg et al., 2012; Tami Spector (ed.), *Arts and Atoms*, Leonardo/ MIT Press, Cambridge, MA, 2012 (e-book collection of papers previously published in *Leonardo* and edited and introduced by Tami Spector).

6 See: Philip Ball, *Elegant Solutions: Ten Beautiful Experiments in Chemistry*, Royal Society of Chemistry, Cambridge, 2005; Joachim Schummer, Bruce MacLennan, and Nigel Taylor, "Aesthetic Values in Technology and Engineering Design", in: Anthonie Meijers (ed.), *Philosophy of Technology and Engineering Sciences,* Handbook of the Philosophy of Science, vol. 9, Elsevier, Amsterdam et al., 2009, pp. 1031–1068.

7 See: Plato, *The Sophist,* 266 c–d.

8 Ibid., 236 b.

9 See: Plato, *Timaios,* 53e.

10 See: Friedemann Rex, "Die älteste Molekulartheorie. Zu Platons quasichemischem Gedankenspiel im Timaios (um 360 v. Chr.)," in: *Chemie in unserer Zeit,* vol. 23, issue 6, 1989, pp. 200–206, dio: 10.1002/ciuz.19890230604.

11 See: Joachim Schummer, "The Chemical Core of Chemistry I: A Conceptual Approach," in: *Hyle: International Journal for the Philosophy of Chemistry,* vol. 4, no. 2, 1998, pp. 129–162, available online at: www.hyle.org/journal/issues/4/schumm.htm, accessed 10/02/2012.

12 See: Joseph Pitt, "When is an Image not an Image?" in: Joachim Schummer and Davis Baird (eds.), *Nanotechnology Challenges: Implications for Philosophy, Ethics and Society,* World Scientific Publishing, Singapore, 2006, pp. 131–141; Joachim Schummer, *Nanotechnologie: Spiele mit Grenzen,* Suhrkamp, Frankfurt am Main, 2009, pp. 113–124.

13 See: Walter Grahn, "Platonische Kohlenwasserstoffe," in: *Chemie in unserer Zeit,* vol. 15, issue 2, 1981, pp. 52–61, doi: 10.1002/ciuz.19810150205; Armin de Meijere, "Sport, Spiel, Spannung – die Chemie, kleiner Ringe," in: *Chemie in unserer Zeit,* vol. 16, issue 1, 1982, pp. 13–22, doi: 10.1002/ciuz.19820160104; Hoffmann 1990; István Hargittai and Magdolna Hargittai, *Symmetry – A Unifying Concept,* Shelter Publications, Bolinas, 2000, pp. 419f.

14 See: Joachim Schummer, "Symmetrie und Schönheit in Kunst und Wissenschaft," in: Wolfgang Krohn (ed.), *Ästhetik in der Wissenschaft,* Felix Meiner Verlag, Hamburg, 2006, pp. 59–78.

15 See: Erhard Scholz, *Symmetrie, Gruppe, Dualität: Zur Beziehung zwischen theoretischer Mathematik und Anwendungen in Kristallographie und Baustatik des 19. Jahrhunderts,* Birkhäuser Verlag, Basel et al., 1989.

16 See: Immanuel Kant, *The Critique of Judgement,* McMillan, London, 1914, §§ 22, 26.

17 Ibid, p. 99.

18 See: Hermann A. Jahn and Edward Teller, "Stability of Polyatomic Molecules in Degenerate Electronic States. I. Orbital Degeneracy," in: *Proceedings of the Royal Society of London, Series A, Mathematical and Physical Sciences,* vol. 161, no. 905, July 1937, pp. 220–235; available online at: http://rspa.royalsocietypublishing.org/content/161/905/220.full.pdf+html, accessed 10/02/2012, doi: 10.1098/rspa.1937.0142.

19 See, for example: Fritz Vögtle, *Fascinating Molecules in Organic Chemistry*, Wiley, New York, 1992 (first published in German language in 1989).

20 See: Vincenzo Balzani, Margherita Venturi, and Alberto Credi, *Molecular Devices and Machines – A Journey into the Nano World,* Wiley-VCH, Weinheim, 2003.

21 See: Umberto Eco, *The Open Work,* Hutchinson Radius, London, 1989.

22 See: Joachim Schummer, "Gestalt Switch in Molecular Image Perception: The Aesthetic Origin of Molecular Nanotechnology in Supramolecular Chemistry," in: *Foundations of Chemistry,* vol. 8, no. 1, 2006, pp. 53–72.

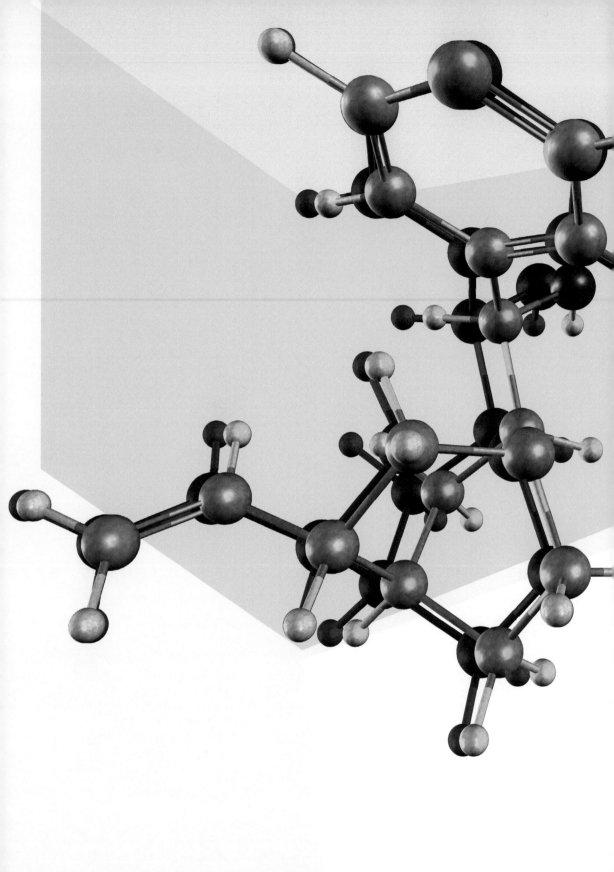

Chris Toumey
**Aesthetic Resources for Molecular Knowledge**

The Musée de Cluny in Paris houses a gallery which exhibits six late-medieval Flemish tapestries. Each piece in the series portrays a lady and a unicorn, among other objects, so the series is known as *The Lady and the Unicorn* (fig. 1). The first FIG 1 five pieces depict our experiences with the senses. For the sense of sight, for example, the lady holds up a mirror so the unicorn can see its own reflection.[1]

I am fond of those beautiful tapestries, and I sometimes think of them when exploring the questions of both how our senses can help us better perceive the nanoscale, and how we use certain technologies to depict it. As relates to the nanoscale, there is a paradox of the senses: the objects that exist there are too small for us to see with the naked eye, too small for us to touch with our hands, too quiet for us to hear with our ears, and so on. Indeed, we can better perceive the nanoscale by using specialized instruments – instruments that convert electronic signals into pictures to show us atomic surfaces in three-dimensional topographies. Consider the scenario with the unicorn: the creature does not ordinarily see what it looks like, but it can do so by taking advantage of the lady's mirror. Yet given that similarity, our sensory knowledge of the nanoscale entails a series of problems in the relation between a nanoscale object and a picture of the object that is far more complicated than looking into a mirror.

Understanding the relation between nanoscale objects and pictures of those same objects can be a valuable insight. From that understanding comes a certain, rather unhappy insight: that a picture of an atom or a molecule cannot possibly look like an atom or a molecule. If we stop right there, we might

conclude that pictures of nanoscale objects are so artificial and misleading – whether intentionally or not – that their value is negligible.

I propose a different way to come to terms with those problems. While, admittedly, these visual images are imperfect, we have a repertoire of aesthetic resources which helps us appreciate – even enhance – our visual perception of those images of nanoscale objects. These resources come, not from science, but from art history and other areas of the humanities. They remind us that our scientific appreciation of the nanoscale is enriched by knowledge from nonscientific thought: that aesthetic resources, so to speak, contribute to molecular knowledge.

**FIG. 1** *The Lady and the Unicorn, Sight,*
Musée national du Moyen Âge, Paris

## Light, Shading, Shape and Solidity of Nanoscale Objects

One of the best-known pictures of nanoscale phenomena is the *Quantum Corral* (fig. 2), which Don Eigler and his team devised at IBM Almaden Research Center in San Jose, California in 1993.[2] Using a scanning tunneling microscope (STM), FIG 2 the researchers positioned forty-eight iron atoms in a circle on a copper surface. An electron escaped from a copper atom in the center, and the STM captured both a signal of the iron atoms and the wave signal of the electron. The original STM micrograph was a two-dimensional top-down grey-scale image in which the copper substrate was light grey. The individual iron atoms appeared as distinct round objects, each one being dark on one side and light on the other.[3]

When the team enriched the image, the angle of view was tilted to give it a three-dimensional appearance. The iron atoms were colored blue and the electron wave signal orange. Lighting from the left side cast shadows on the right, giving the atoms a shading effect of three-dimensionality. The vertical dimension of the iron atoms was exaggerated such that they took the shape of inverted cones, and were also depicted as solid objects. Finally, the enhanced image made it seem as if the corral of atoms (fig. 3) was close enough for the viewer to FIG 3 touch, which is to say that the objects in the picture now had a human dimension: no longer too small to see or touch, but instead brought within range of two of our senses.[4] This was truly an attractive and entrancing image of life at the nanoscale.

The depiction also embodied a series of problems in the relation between nanoscale objects and pictures of those objects. Because atoms and electrons are much smaller than the wavelength of visible light, they are literally invisible: not blue, not orange, nor any other color. The shading is equally artificial, again because there is no visible light at that scale. Atoms are neither cone-shaped, nor solid objects, and iron atoms cannot possibly resemble the iron atoms as they appear in the *Quantum Corral*.

FIG 2 Donald Eigler, Christopher P. Lutz, and Michael F. Crommie, the time sequence for the creation of *Quantum Corral*, 1993

FIG 3 Donald Eigler, Christopher P. Lutz, and Michael F. Crommie, *Quantum Corral*, 1993 An electron from a copper surface is a series of waves within a corral of atoms.

## Micrographs: Making Scientific Images
## of Nano- and Microscale Objects

Allow me a short digression to review the ways that four instruments make images of nano- and microscale objects. The first of these was the transmission electron microscope (TEM) invented by Ernst Ruska in 1931. At the top of a column, a filament is heated to release electrons and shape them into a beam. A pair of magnetic lenses focuses the beam, which then passes through a sample. The part of the beam that cuts through the thinner areas of the sample will be stronger when it reaches the detector than the part that encounters the thicker areas. Roughly like an x-ray, the TEM shows a contrast between thinner and thicker areas of an object in cross-section.

The scanning electron microscope (SEM) was developed from the TEM. In this case, a thin gentle electron beam interacts with the surface of a sample. Electrons from the beam, known as backscatter electrons, are reflected onto a detector. My student, Emily Phifer, sees this phenomenon as roughly analogous to SONAR: in order to detect an invisible object, an instrument emits a beam; the beam hits a target; a signal is reflected off the target; and a detector receives the signal. In addition, a number of electrons – known as secondary electrons – are released from the surface of the sample, then captured by another detector. When the data from the two detectors are synthesized, the SEM yields extraordinarily detailed images of very small objects' surfaces. Taken together, the TEM and the SEM are the main instruments of electron beam microscopy, which also includes several related instruments.

Another family of instruments known as scanning probe microscopy (SPM) was launched in 1981, when Gerd Binnig and Heinrich Rohrer invented the scanning tunneling microscope (STM) at IBM Research in Zurich, Switzerland. In this case, an ultrafine tip – ideally only one atom wide at its apex – is mounted on a piezo-electric platform, a device which can precisely maneuver the tip in three directions. The tip is brought very close to an atomic surface, and then a mild electrical current causes electrons to move from sample to tip. This process, known as tunneling, can be quantified. As the tip moves back and forth across the sample, thousands of data points regarding the topography of the surface are recorded.

Next, software packages convert the data into a simple visual image. Typically, the higher points – large atoms or molecules – are rendered as light shades, while the lower points are seen as dark shades. These are often shades of gray, but can be depicted light to dark in any color. They are also top-down views of a surface. The images can also be enhanced by creating artificial color, shading, diagonal point of view, and other features.

The other hero of scanning probe microscopy is the atomic force microscope (AFM), invented by Gerd Binnig, Calvin Quate, and Christoph Gerber in 1986. Here, an ultrafine tip is mounted on a tiny cantilever, and dragged or tapped across an atomic surface, so that the end of the cantilever rises and falls in response to the topography of the surface. A narrow laser beam hits the top of the cantilever above the tip, and deflects up or down in response to the rise and fall of the cantilever. A detector captures these variations as the tip travels back and forth across the atomic surface. And then software programs convert that data into pictures of the surface, as is done with the STM.

I want to stress that the images of nanoscale phenomena made by an STM or AFM are not photographs. Instead, they are the result of a process of collecting

electronic data, converting it into visual sensations, and enhancing those visual sensations with color, shading, and three-dimensionality. The difference between the beginning and the end of the process is so great that a picture of an atom or a molecule cannot possibly be faithful to the object the way we think a photograph is. If someone asks, "Is that what an atom really looks like?" the honest answer is, "No, but this is the best approximation we can create."

This limitation is not unique to scanning probe microscopy. While atoms are sometimes depicted in wire-frame models, an atom is hardly an intersection of three wires. And while ball-and-stick models may show relationships between atoms and bonds, one does not conclude that atoms are solid balls and bonds are little sticks. Again, representations are not entirely faithful to natural objects. Few people seriously argue that atoms and molecules are fictitious, but there is no picture or model of an atom that is equivalent to a photograph of an object at the human scale.

The STM's ability to modify atomic surfaces was introduced in a pair of experiments in 1987 and 1988.[5] Subsequently the famous Eigler-Schweizer experiment aligned thirty-five xenon atoms on a nickel surface to spell "IBM," thereby demonstrating precise control of individual atoms.[6] The *Quantum Corral*[7] is the best-known descendent of the Eigler-Schweizer experiment.

Scanning probe microscopy, which also includes other instruments related to the STM and AFM, is a process of collecting a continuous electronic signal – usually with thousands of data points – to derive a picture of the atomic surface. The picture drawn from that data has little in common with a true photograph, where light reflected from the subject hits a receptor, whether digital or film. Neither is it similar to the view of a planet as seen through a telescope or to seeing a microbe through an optical microscope. A scanning probe microscopy image is a visual interpretation of an electronic signal from an invisible object. Scientists express this phenomenon in various ways:

An image created by scanning probe microscopy is *"an interpretation* [...] a mathematical reconstruction of reality."[8]

"An STM image is a map of the variation of electron density in space [...]. An STM image does not show atoms as such. [...] Instead, one images orbitals, or more correctly, the electron density of the orbitals."[9]

"Since the actual atomic entities under study cannot be mapped like the earth's geography or photographed like the surface of Mars, they must be represented indirectly through interpretation and conceptualization of experimental data. Relying on a universally acceptable set of iconic forms to communication and conceptualize their subject matter, the chemist's atoms and molecules are, to quote the renowned nineteenth-century popularizer of science, Edward L. Youmans, 'the offspring of thought-occupants of an imaginary world.'"[10]

"A picture of an atom or a molecule cannot possibly look like an atom or a molecule."[11]

With this in mind, Felice Frankel,[12] Julio Ottino,[13] and Chris Robinson[14] caution that the process of making pictures with scanning probe microscopy can lead to excessive manipulation of variables – color, for example – and that excessive manipulation is tantamount to misrepresentation. Photos are trusted, says Robinson, because we believe we can confirm them with our eyes, but we cannot do the same with pictures of the nanoscale.[15]

## Benefits of Early Cubist Theory

Even if the images derived from electron beam microscopy and scanning probe microscopy are imperfect, hence problematic, they are not worthless. Some of the ways to appreciate imperfect images can be found in early Cubist theory.

Paul Cézanne raised a question that the early Cubists were to pursue. He believed that painting had become mere "illusionism," limited to the three Euclidean dimensions of height, width and depth, and frozen in one point of view at one moment in time.[16] Why is it, asked the Cubists, "that a picture must represent a single moment in time and be seen from a fixed position in space?"[17]. In response, they sought new ways to see and depict objects, including a subjective perception as if "the observer is moving during the process of perception."[18]

At the same time, Henri Poincaré was arguing that perceptions of space were subjective. Different people have different experiences with the same space.[19] According to Bernhard Riemann, figures in non-Euclidean geometry change relative to their spatial position.[20] It is well documented that Picasso and other early Cubists learned about Poincaré's research, and possibly also Riemann, from Maurice Princet.[21] Finally, Henri Bergson's lectures on the value of intuition contributed to a sense of the subjectivity of perception.[22]

From the spirit of early Cubist theory, along with its expression in the works of Pablo Picasso, Georges Braque, Marcel Duchamp, and others, we can come to better understand imperfect images of nanoscale objects by adding new dimensions for seeing and appreciating them. I have in mind five such aesthetic resources for enriching our visual knowledge of the nanoscale: *simultanéité*; the addition of a temporal dimension; the addition of a tactile dimension; the principle of inter-instrumentality; and finally, the idea that the visual knowledge of the nanoscale is ineffable.

### A. *Simultanéité*

Early cubist painting was meant to solve problems of space and time that were evident in earlier representational painting. A new style of representation would expand one's knowledge of reality and, presumably, embody a more complete realism than the paintings limited to the three Euclidean dimensions, and from one perspective at one moment.[23] Here, instead, were multiple views of the same object within one picture, because *simultanéité* was intended to give the viewer more knowledge of the object. "The painter no longer has to limit himself to depicting the object as it would appear from one given viewpoint, but wherever necessary for fuller comprehension, can show it from several sides, and from above and below."[24] As Georges Braque suggested, the viewer needs three simultaneous perspectives to best know a house: plan, elevation, and section.[25]

FIG 4 Jean Metzinger's painting *Le Goûter* (1911) (fig. 4) serves as a good example of the principle of *simultanéité*.[26] Take the teacup in the lower left corner. Had the artist painted it only from a top-down vantage point, then we would not see what it looked like from the side; and if we saw it merely from the side, we would not know what it looked like from the top. Metzinger solved this by showing the teacup from both a side- and top-down perspective simultaneously.

Before him, Jean-Auguste-Dominique Ingres had painted *Le Bain turc* in 1862

FIG 5 (fig. 5).[27] While this picture includes select architectural details of a bathhouse,

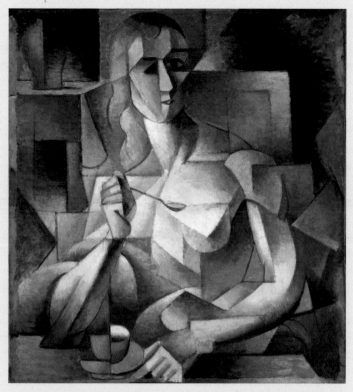

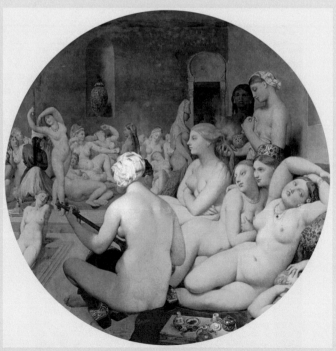

it also depicts more than twenty female nudes in various poses, which is to say that Ingres showed us the female body from more than twenty different per-

FIG 6 spectives at once. When Pablo Picasso created *Les Demoiselles d'Avignon* (fig. 6) in 1907,[28] he approached the five female figures in the same way. The nude in the lower right was especially radical: the viewer saw her torso from the back, but her head from the front, a treatment which seemed grotesque to viewers who were comfortable only with the classical style of seeing an object from a single perspective at a time.

But how to use *simultanéité* to enhance our knowledge of a nanoscale object? The *Nano Flower Bouquet* (2004), created by Ghim Wei Ho, a doctoral candidate working for Prof. Mark Welland at the Nanoscience Centre of the University of Cambridge, is an SEM image of a silicon carbide structure. It does indeed show petals and other flower-like parts that resemble a blossom bouquet.[29] The image is rendered in blue on the Cambridge lab's website and by any who copy it. At a workshop on imaging the nanoscale, held in Bielefeld, Germany, in 2005, one presenter commented on this image's similarity to a flower. Yet another attendee felt that the bouquet had the shape but not the color of a bouquet of flowers, since blue was not a color of flowers, but of things cold and lifeless. A third person disagreed. Some flowers are blue, she argued: the hydrangea, for example. For her, the *Nano Flower Bouquet* looked close to natural.

So the question arose: does this silicon carbide structure have a proper color, and if so, which color might it be? As a nanoscale object, the *Nano Flower Bouquet* has no color of its own because it is smaller than the wavelength of visible light. Still, the human eye needs to see some color, even if only shades of gray, to make sense of an image.

**FIG 6**  Pablo Picasso, *Les Demoiselles d'Avignon*, 1906, oil on canvas, 243.9 × 233.7 cm, legacy of Lillie P. Bliss, Museum of Modern Art, New York

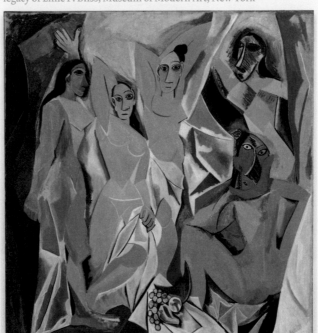

So I did an exercise in *simultanéité* of color, in one place, assembling versions of
the *Nano Flower Bouquet* (fig. 7, 8, 9, 10) in four different colors: blue, yellow, violet and green. By observing the same object in multiple colors simultaneously, the viewer can see that all of them are equally artificial. The scientific value of the *Nano Flower Bouquet* is in its silicon carbide structure, not its color. As such, any color that shows the structure of this object clearly is as legitimate as any other.

## B. Adding a Temporal Dimension

Adding time as a fourth dimension in a picture was another technique developed by the early Cubists. Marcel Duchamp's *Nude Descending a Staircase No. 2* (1912) (fig. 11) was among the most appealing of these. In a single painting, the FIG 11 artist gave the viewer height, width, depth, and showed the elapse of time.[30]

**FIGS 7, 8, 9, 10** The *Nano Flower Bouquet* in *simultanéité*

**FIG 11** Marcel Duchamp, *Nude Descending a Staircase (No.2)*, 1912, oil on canvas, 147 × 89.2 cm, Philadelphia Museum of Art

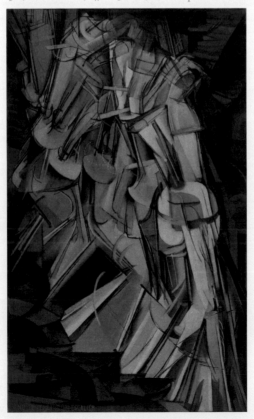

For images of nanoscale objects, the elapse of time can be problematic: at that scale, slight thermal vibrations are like massive earthquakes. Ordinarily, an atom is unable to sit still to have its picture taken. As for the xenon atoms spelling "IBM" in 1990, Eigler and Schweizer had to reduce the temperature inside their STM chamber almost to absolute zero. At the same time, however, they created a series of STM scans to record the process of moving the individual atoms; a six-panel sequence shows the beginning, when the xenon atoms are randomized on a nickel substrate, and the end, when they are neatly aligned in a pattern. They also showed the four steps in between.[31] Additionally, Eigler and his team have a series of four panels to show the process of creating *Quantum Corral* (fig. 2).[32] Sequences such as these help the viewer see temporal relationships among the object, the image-making process, and the image itself. By adding time as another dimension of the picture, their work is analogous to Duchamp's in *Nude Descending a Staircase No. 2*.

### C. Adding a Tactile Dimension

A third way of adding another dimension to our visual knowledge of the nanoscale – again, in the spirit of the early Cubists – is to generate a tactile perspective: to be able to touch and feel nanoscale objects.

We are apt to assume that atomic surfaces and the objects that lie upon them are far too small for us to touch. This is usually so, but there is a device that enables FIG 12 one to actually feel nanoscale objects. The NanoManipulator (fig. 12), manufactured by 3rdTech of Durham, North Carolina,[33] begins with an atomic force microscope (AFM) that can both touch and scan an atomic surface and the objects on that surface. Data from the AFM scan are converted to a three-dimensional image of the sample's surface. After viewing the atomic surface, the operator

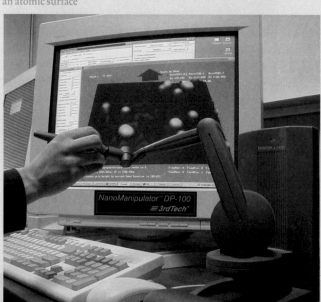

FIG 12  3rd Tech's NanoManipulator adds 3-D perspective and tactile feel to an atomic surface

can switch to a haptic mode. The last scan is held static, and the operator can use a haptic device – a feedback system connecting the electronic data of the scan to a hand-held stylus – to create the sensation of moving the tip of the AFM back and forth on the surface. The operator is thus given a virtual-reality feel of the shapes of molecules and other objects captured on the scan.

In a third mode, scientists can use the haptic device to push the AFM tip against those objects, that is, move them by hand as the NanoManipulator steers the AFM. Having done so, the operator returns to scanning mode to see how that action has changed the sample surface.

In short, this is a process of first seeing the nanoscale in 3-D; then feeling it in 3-D; then changing it with a precise 3-D force for immediate results in 3-D. With the NanoManipulator, one can feel and change an atomic surface in conditions close to real time.

### D. Inter-instrumentality

Catherine Allamel-Raffin has argued that we enhance our understanding of images of nanoscale objects by seeing them with the benefit of instruments "designed according to different physical principles."[34] Recall that the TEM, the SEM, the STM, and the AFM each derive differently a picture of a micro- or nanoscale object from the interaction of the instrument with the sample.

An exercise conducted at the University of South Carolina in February 2011[35] illustrates the principle of inter-instrumentality nicely. Catherine Allamel-Raffin indicated that a range of instruments is advantageous since different instruments have their own strengths and weaknesses: some operate only under certain conditions – vacuum for example – and certain samples cannot be imaged by some techniques. If possible, imaging a sample with two or more techniques may reveal more knowledge than imaging with just one instrument.

FIG 13 Micrographs of red blood cells from a scanning electron microscope

FIG 13

A team created a composite portrait by subjecting human red blood cells and hair to the imaging procedures of an optical microscope (also known as a visual light microscope), an atomic force microscope, a scanning electron microscope, and a transmission electron microscope (fig. 13).[36]

Although using a scanning tunneling microscope would have been useful, that was impossible, given that an STM requires a conductive sample. Biological materials such as blood cells and strands of hair are beyond the imaging abilities of the STM, even when they are dehydrated. Further, if the sample is coated with gold to make it conducting (a common practice in electron beam microscopy), the STM would image the gold coating rather than the sample itself.

The micrograph from the optical microscope revealed the shapes and sharp edges of dozens of red blood cells, showing that their outlines are far from consistently round or oval. When the strand of human hair was placed on the same slide, however, one could see the diameter of the hair in relation to the size of the blood cells.

For the AFM, the micrograph revealed an object entirely unlike the smooth doughnuts we ordinarily expect to see of red blood cells. Instead, its topography resembled a wad of old dough with rough and irregular details. Only the concave depression conformed to the usual picture of a red blood cell. Interestingly, a black region resembling a shadow to the right of the blood cell seemed a touch of *chiaroscuro* as fine as any that Rembrandt ever painted. Yet this was neither shadow nor any other light effect. Instead, when the tip of the AFM rastered to the right, it dropped suddenly off the edge of the blood cell, creating the black region. Meanwhile, a human hair imaged by the same AFM showed a surface covered in micro-scale folds and corrugations, but also smooth spots and crevices. Remember, the AFM is not designed to make a micrograph of something as large as a strand of hair, but since blood cells and hair are things we all can recognize, they are good objects for this study in inter-instrumentality.

Next, the Electron Microscopy Center at the University of South Carolina prepared blood and hair samples for an SEM (for which the blood cells and hair were coated in gold nanoparticles). At magnifications of ×2,500, ×10,000, and ×20,000, the red blood cells appeared to be smoother and more symmetrical than what we saw in the AFM micrograph. As for the hair sample, the SEM generated equally excellent pictures of its scale-like surface.

The blood and hair sample for the TEM were sectioned at a thickness of approximately 70 nm using a diamond knife, then stained with heavy metals. The picture of the blood cells showed the outline of the cross-section with little differentiation in the cells' interiors, supporting the fact that these cells lack major internal features such as nuclei. For the hair sample, the TEM image captured only a small area of the cross-section, but revealed a lot of detail for this area, particularly in four layers of the scale-like outer shell of the hair.

This exercise in inter-instrumentality shows us four instruments that offer just as many ways of seeing hairs and blood cells. They require different procedures for preparing the samples, they collect visual information in different techniques, and they deliver four different styles of pictures of these samples. Each has its own scientific value, but each also has its personal idiosyncrasies: not as dramatic as those of Vincent van Gogh, Paul Gauguin, or Salvador Dalí, perhaps, but still at enough variance for us to appreciate the principle of inter-instrumentality.

Is this the same as *simultanéité*? Similar, yes, but not the same. With *simultanéité*, one artist shows multiple perspectives within the same picture. With inter-instrumentality, four different instruments – our four different artists, so to speak – use different techniques to depict the same object in four different pictures.

### E. Our Visual Knowledge of the Nanoscale is Ineffable

At a 2009 workshop on nanoimages in Paris, Alexei Grinbaum presented a provocative idea about the relationship between nanoscale objects and their pictures. Christian thought contains a long-standing tension regarding iconography. Drawing from both Plato and the Second Commandment, early Christian dogma questioned whether images of God really looked like God. If they did not, wouldn't it follow that holy icons were equivalent to pagan idols? These questions are grounded in the idea that God is ineffable. With our many human limitations, we cannot know a transcendent deity entirely. Even with ten thousand images of God and a hundred thousand names for God, we would still have less than a complete knowledge of God.

In the eighth century AD, the iconoclasts – those who destroy sacred Christian icons – came to power in the Eastern Christian church. They felt that the relation between God and an image of God was so problematic that an icon was equivalent to limiting God, by reducing the transcendent being to a painted piece of wood. With this pious logic, they justified their destruction of icons.

The theologian John of Damascus defended the creation and use of icons by arguing that these material objects could lead us toward an immaterial goodness, namely, God. A century later, the Second Council of Nicaea in 787 A.D. affirmed the views of John of Damascus when it decided that icons are legitimate. The Council decreed that an icon need not be a perfect depiction of an immaterial deity, that a Christian icon is appreciated as an artificial imitation of the prototype, God, and this is sufficient legitimization.

The nanoscale shares that property. We will never be able to see nanoscale objects with the naked eye or a visual light microscope. But because the nanoscale is visually ineffable, micrographs from scanning probe microscopy need not be perfect depictions of atoms and molecules. To have scientific value, they must only be visual approximations of nanoscale matter.[37]

### Conclusion

A year after Gerd Binnig and Heinrich Rohrer invented the scanning tunneling microscope, art historian Pierre Daix wrote the following, apparently without knowledge of the STM: "Atomic physics has demolished the belief in any simple correspondence between visual appearances and the intrinsic structures of reality, largely invalidating the notion of realism [...]. Seeing, we now know, is by no means a passive record, a mere tracing, of forms perceived by the eye."[38]

Daix was right. There is no such thing as a simple and direct photograph of an atom or a molecule. We see diagrams, schematics, and illustrations, as well as pictures made with scanning probe microscopy, but we never see atoms the same way we see an apple or a photograph of an apple. Instead, we see mediated interpretations of electronic signals of atoms and molecules. Our visual knowledge of these objects is far from perfect and far from complete.[39]

But it is not worthless. When, about a hundred years ago, the Cubists challenged the relationship between an object and the depiction of the object, they

bequeathed to us aesthetic resources for seeing the value of representations that were admittedly imperfect. As we work through our own questions about the relationship between a nanoscale object and its visual representation, we might imagine ourselves as neo-Cubist thinkers who, rather than expecting a perfect depiction of an atom or a molecule, are able to enhance our visual knowledge by adding information from more than one perspective.

## Acknowledgments

I was fortunate to be able to present the ideas in this paper at the symposium on Molecular Aesthetics at the ZKM | Center for Art and Media Karlsruhe in July 2011. Special thanks to Peter Weibel, Ljiljana Fruk, Sophie-Charlotte Thieroff, Maja Petrovic, Noemi Christoph, and Emily Phifer, who together made the symposium a success and a pleasure.

### Notes

1 See: *The Lady and the Unicorn, Sight*, available online at: www.musee-moyenage.fr/ang/homes/home_id20393_u1l2.htm, accessed 11/21/2012.

2 See: Michael F. Crommie, Christopher P. Lutz, and Donald M. Eigler, "Confinement of Electrons to Quantum Corrals on a Metal Surface," in: *Science*, vol. 262, no. 5131, 1993, pp. 218–220, doi: 10.1126/science.262.5131.218.

3 See: Four-panel process of creating *Quantum Corral*, by Micheal. F. Crommie, Christopher P. Lutz, and Donald M. Eigler, available online at: www.almaden.ibm.com/vis/stm/images/stm16.jpg, accessed 11/21/2012.

4 See: The *Quantum Corral* by Micheal F. Crommie, Christopher P. Lutz, and Donald M. Eigler, available online at: www.almaden.ibm.com/vis/stm/images/stm7.jpg, accessed 11/21/2012.

5 See: R. S. Becker, Jene A. Golovchenko, and Brian S. Swartzentruber, "Atomic-scale Surface Modifications Using a Tunneling Microscope," in: *Nature*, vol. 325, no. 6106, 1987, pp. 419–421, doi: 10.1038/325419a0; as well as J. S. Foster, Jane E. Frommer, and P. C. Arnett, "Molecular Manipulation Using a Tunneling Microscope," in: *Nature*, vol. 331, no. 6154, 1988, pp. 324–326, doi: 10.1038/331324a0.

6 Donald M. Eigler and Erhard K. Schweizer, "Positioning Single Atoms with a Scanning Tunneling Microscope," in: *Nature*, vol. 344, no. 6266, 1990, pp. 524–526, doi: 10.1038/344524a0.

7 Crommie, Lutz, and Eigler 1993.

8 James K. Gimzewski and Victoria Vesna, "The Nanoneme Syndrome: Blurring of Fact and Fiction in the Construction of a New Science," in: *Technoetic Arts*, vol. 1, no. 1, 2003, pp. 7–24, doi: 10.1386/tear.1.1.7/0.

9 E-mail from Philip Moriarty to Chris Toumey, November 7, 2010.

10 Tami I. Spector, "The Aesthetics of Molecular Representation: From the Empirical to the Constitutive," in: *Foundations of Chemistry*, vol. 5, no. 3, 2003, pp. 215–236, doi: 10.1023/A:1025692518934.

11 Chris Toumey in a lecture at the Gulbenkian Foundation in Lisbon (Portugal), December 15, 2010.

12 See: Felice Frankel, "The Power of the 'Pretty Picture'," in: *Nature Materials*, vol. 3, 2004, pp. 417–419, doi: 10.1038/nmat1166.

13 See: Julio M. Ottino, "Is a Picture Worth 1,000 Words?," in: *Nature*, vol. 421, 2003, pp. 474–476, doi: 10.1038/421474a.

14 See: Chris Robinson, "Images in NanoScience/Technology," in: Davis Baird, Alfred Nordmann, and Joachim Schummer (eds.), *Discovering the Nanoscale*, IOS Press, Amsterdam, 2004, pp. 165–169; Chris Robinson, "Chasing Science Culture," in: *Leonardo*, vol. 39, no. 3, 2006, p. 186.

15 Cf. Robinson 2004.

16 See: Pierre Daix, *Cubists and Cubism*, Rizzoli, New York (NY), 1982; Lynn Gamwell, *Cubist Criticism*, UMI Research Press, Ann Arbor (MI), 1980.

17 Mark Antliff and Patricia Leighten, *Cubism and Culture*, Thames & Hudson, New York (NY), 2001.

18 Paul M. Laporte, "Cubism and Science," in: *Journal of Aesthetics and Art Criticism*, vol. 7, no. 3, 1949, pp. 243–256.

19 See: Gamwell 1980; Antliff, Leighten 2001; Laporte 1949.

20 See: Antliff, Leighten 2001; Laporte 1949.

21 See: Antliff, Leighten 2001.

22 Edward F. Fry, "Picasso, Cubism, and Reflexivity," in: *Art Journal*, vol. 47, no. 4, 1988, pp. 296–310; Christopher Gray, "The Cubist Conception of Reality," in: *College Art Journal*, vol. 13, no. 1, 1953, pp. 19–23; Daniel-Henry Kahnweiler, "The Rise of Cubism," [originally published in 1920], in: Charles Harrison and Paul Wood (eds.), *Art in Theory 1900–1990, An Anthology of Changing Ideas*, Blackwell, Oxford, 1992, pp. 203–209.

23 See: Daix 1982; Gamwell 1980; Kahnweiler 1992; Jean Metzinger, "Note on Painting," [originally published in 1910] in: Charles Harrison and Paul Wood (eds.), *Art in Theory, 1900–1990*, Blackwell, Oxford, 1992, pp. 177-178.

24 See: Kahnweiler 1992.

25 See: Metzinger 1992.

26 See: *Le Goûter* by Jean Metzinger, available online at: www.philamuseum.org/collections/permanent/51056.html, accessed 11/21/2012.

27 See: *Le Bain Turc* by Jean-Auguste-Dominique Ingres, available online at: www.artchive.com/artchive/I/ingres/turkbath.jpg.html, accessed 11/21/2012.

28 See: *Les Demoiselles d'Avignon* by Pablo Picasso, available online at: www.moma.org/explore/conservation/demoiselles/, accessed 11/21/2012.

29 See: *The Nano Flower Bouquet*, by Gim Wei Ho and Mark Welland, available online at: www.eng.cam.ac.uk/news/stories/photocomp1.shtml, accessed 11/21/2012.

30 See: *Nude Descending a Staircase (No. 2)* by Marcel Duchamp, available online at: www.philamuseum.org/collections/permanent/51449.html?mulR=31732|15, accessed 11/21/2012.

31 See: Eigler, Schweizer 1990.

32 See: Four-panel process of creating Quantum Corral, by M. F. Crommie, C. P. Lutz, and D. M. Eigler, available online at: www.almaden.ibm.com/vis/stm/images/stm16.jpg, accessed 03/20/2012.

33 See: The NanoManipulator, available online at: www.3rdtech.com/NanoManipulator 4web.pdf, accessed 11/21/2012.

34 See: Catherine Allamel-Raffin, "The Meaning of a Scientific Image: Case Study in Nanoscience a Semiotic Approach," in: *NanoEthics*, vol. 5, no. 2, 2011, pp. 165–173; Catherine Allamel-Raffin, "De l'intersubjectivité à l'interinstrumentalité. L'exemple de la physique des surfaces," in: *Philosophia Scientiae*, vol. 9, no. 1, 2005, pp. 3–30.

35 See: Chris Toumey, "Compare and Contrast as Microscopes Get Up Close and Personal," in: *Nature Nanotechnology*, vol. 6, 2011, pp. 191–193, doi: 10.1038/nnano.2011.55.

36 See: Chris Toumey, "Images and Icons," in: *Nature Nanotechnology*, vol. 5, 2010, pp. 3–4, doi:10.1038/nnano.2009.458.

37 See: Toumey 2010; Alexei Grinbaum, "Nanotechnological Icons," in: *NanoEthics*, vol. 5, no. 2, 2011, pp. 195–202, doi: 10.1007/s11569-011-0125-z.

38 See: Daix 1982, p. 11.

39 See: Chris Toumey, "Truth and Beauty at the Nanoscale," in: *Leonardo*, vol. 42, no. 2, 2009, pp. 151–155.

*Apoptosome*
2005, an apoptosome protein complex assembling
in the cytoplasm of an apoptotic cell

The *Apoptosis* images come from my visual exploration
of what a chemical signal cascade through a cell would
"look like" if one were to follow the chain of molecu-
lar events along a pathway. The animation depicts the
events from activation of the death receptor through
degradation of the actin cytoskeleton using molecular
representations based on the known crystal structures of
the proteins or macromolecular structures involved in
the process. The magnification at each stage is provided
and represents cellular views at 5,000 and 8,000 and an
intracellular or molecular view at 10,000,000 to visual-
ize the proteins and molecular complexes. The *Apoptosis*
animation was published as a "visual review" in *Science's
STKE* (Drew Berry, "Molecular Animation of Cell Death
Mediated by the Fas Pathway," in: *Sci. STKE,* vol. 2007, issue
380, p. tr1, doi: 10.1126/stke.3802007tr1).

**DREW BERRY** (*1970 in New York, NY) is a biologist-ani-
mator whose scientifically accurate and aesthetically rich
visualizations reveal cellular and molecular processes
for a wide range of audiences. He received his B.Sc.
(1993) and M.Sc. (1995) degrees in cell biology and mi-
croscopy from the University of Melbourne (AU). Since
1995, he has been a biomedical animator at the Walter
and Eliza Hall Institute of Medical Research, Melbourne.
His animations have been exhibited at venues such as
the Guggenheim Museum and the Museum of Modern
Art in New York, the Royal Institute of Great Britain,
London. In 2010 he awarded a MacArthur Fellowship by
the MacArthur Foundation, Chicago (IL).

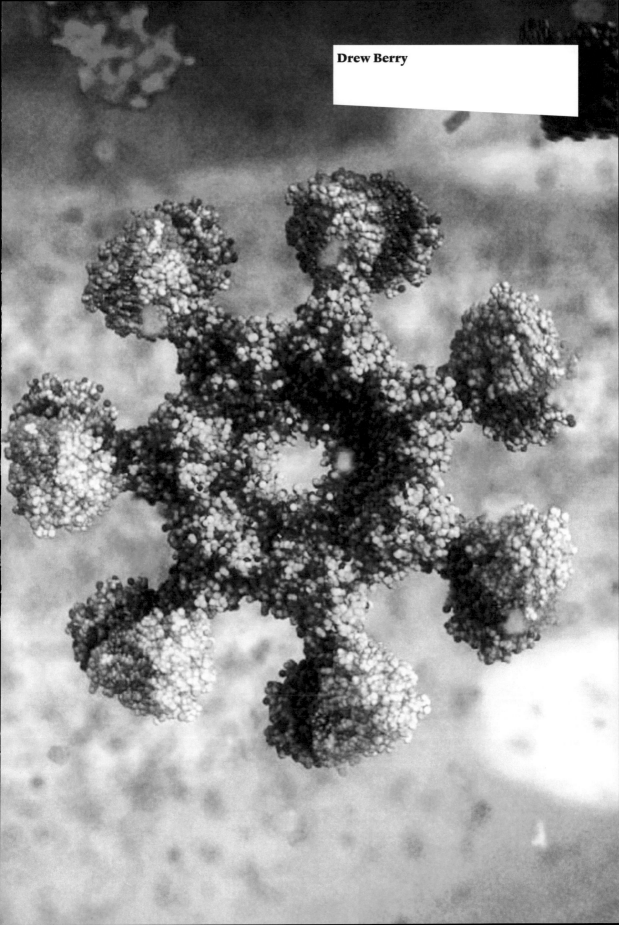
Drew Berry

*Hollow*
2010, music video for Björk's *Biophilia* project

Created for the music video for the song *Hollow* by Ice-
landic vocalist, Björk. The music video is a powers-of-10
exploration of the microscopic and molecular land-
scapes inside Björk's body, exploring her connection to
her ancestors through DNA, passed down from mother
to daughter.

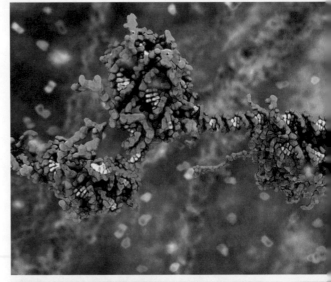

top left
*Hollow: Nucleosome Visualization*
2010, a visualization of three nucleosomes
from a chromatin fiber

middle left
*Hollow: Replisome Visualization*
2010, a "bling" DNA replisome, as requested by Björk

bottom left
*Kinetochore Visualization*
2010, mitotic kinetochore, created for the iPad biology
textbook *Life on Earth* by E.O. Wilson

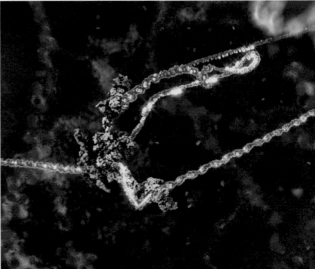

top right
*Apoptosis: Caspase 3 Activation*
2005, Caspase 8 enzymes (orange-brown) are
activating caspase 3 enzymes (red) in the cytoplasm
of an apoptotic cell.

middle right
*Apoptosis: Caspase 8 Activation*
2005, a view underneath the plasma membrane
(top left) with cytoplasmic ends of the Fas receptors
bringing together the subunits of a Caspase 8 enzyme

bottom right
*Apoptosis: Fas Ligand and Receptors*
2005, Fas receptors (green) on the surface of a plasma
membrane of a diseased cell (bottom). The Fas ligand
(pink, center) on the surface of a Killer T-cell plasma
membrane (top) is about to bind to the receptors and
initiate the apoptotic signal cascade.

*11 Tests (red/violet)*
2010, acrylic, stains, and spray paint on wood panel,
27.9 × 27.9 cm

Jaq Chartier's paintings explore scientific methods through experimentation with paint and process. All of her works are "tests" to discover something about materials and what they do. Inspired in part by images of gel electrophoresis, Chartier investigates the migration of various stains through layers of paint and acrylic gesso and resin. Each piece features an intimate view of materials as they react to each other, to light, and to the passage of time, including notes written directly on the paintings. Through experimentation, observation, notation, and by highlighting similarities between artistic and scientific practice, Chartier creates sensuous paintings that provide commentary on both the visual culture and everyday practice of scientific investigation.

**JAQ CHARTIER** (*1961 in Albany, GA) is a Seattle-based artist. She holds a MFA degree in painting from the University of Washington, Seattle (WA). Chartier's paintings have been featured in major exhibitions including *Genipulation: Genetic Engineering and Manipulation in Contemporary Art* at CentrePasqueArt – Kunsthaus Centre d'Art in Biel/Bienne (CH) and *Gene(sis): Contemporary Art Explores Human Genomics*, which was shown among others at the Henry Art Gallery (Seattle), and at the Mary & Leigh Block Museum of Art (Evanston, IL). She is represented by galleries including Morgan Lehman (New York, NY), Elizabeth Leach (Portland, OR), Base Gallery (Tokyo), and Platform Gallery (Seattle).

www.jaqbox.com

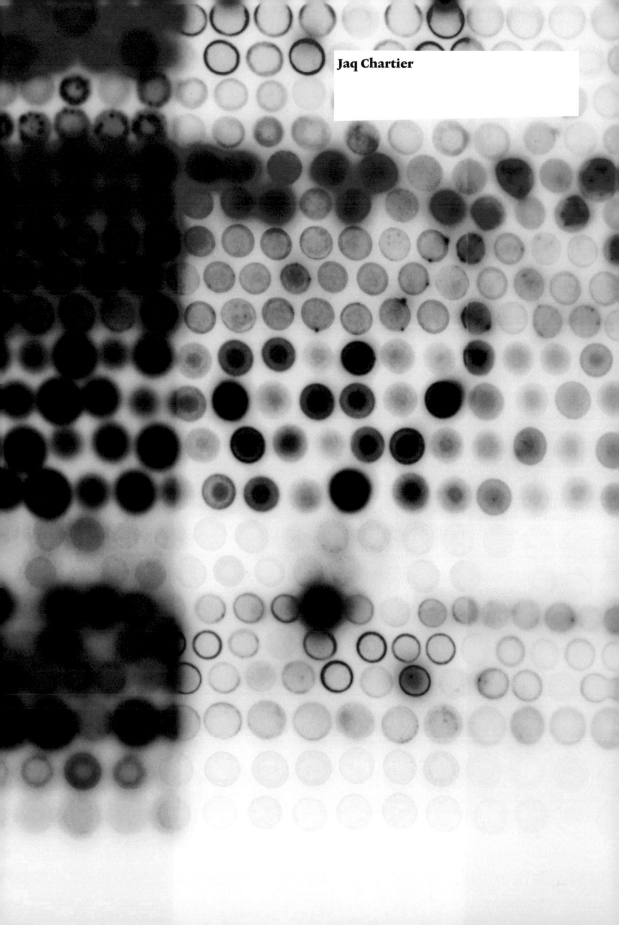

Jaq Chartier

left
*Purple-blue Variations*
2011, acrylic, stains, and spray paint on wood panel,
81.3 × 111.8 cm

right
*Density Tests (11 whites)*
2011, acrylic, stains, and spray paint on wood panel,
76.2 × 61 cm

*Hidden Fields*
2012, dance performance from the *danceroom Spectroscopy* project

**DAVID GLOWACKI** (\*1981 in Milwaukee, WI) is an American theoretical chemist based at the University of Bristol (GB). He obtained an M.A. in cultural theory as a Fulbright scholarship finalist at the University of Manchester and his Ph.D. at the University of Leeds (GB), studying chemical physics and dynamics in the Earth's atmosphere. His interests span a range of subjects including classical and quantum dynamics, algorithm development, energy flow in chemical systems, chemical kinetics, and atmospheric chemistry. He has published over 35 papers, including several in *Science* and *Nature Chemistry*. His best-known work is *danceroom Spectroscopy* (*dS*).

www.danceroom-spec.com

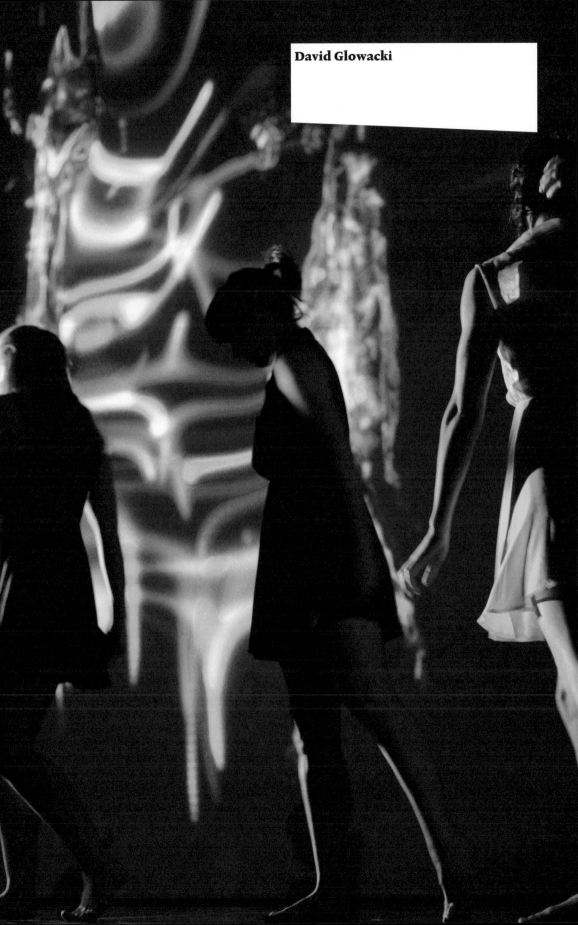

David Glowacki

# Using Human Energy Fields to Sculpt Real Time Molecular Dynamics

David R. Glowacki

with contributions from Philip Tew, Joseph Hyde, Laura Kriefman, Thomas Mitchell, James Price, and Simon McIntosh-Smith

## Time, Equilibrium, and Molecular Structure

Molecules, made from building blocks called atoms, are among the most useful microscopic functional units for understanding the properties and behaviors of the macroscopic world. Despite the fact that the natural world is characterized by perpetual change and fluctuation, neither the word molecular nor the word atom are famous for conjuring up images of dynamism and change. Rather, both of these words are usually associated with static images – namely, snapshots that are effectively architectural blueprints showing how atoms are arranged in molecular structures.

To date, much of the emphasis in chemistry has been on so-called structure function relationships, where a molecule's function and associated properties are understood with reference to its underlying atomic connectivity. For example, the orientation of molecular photoreceptors in the cells located in leaf chlorophyll helps us to understand how plants capture light from the sun. Or the highly connected bonding structure of solids like diamond (shown in fig. 1) can help us to understand properties such as hardness and conductivity. In what follows, we refer to the use of static images to understand molecular function as a time-stationary view.

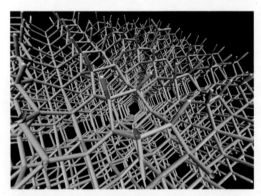

**FIG 1** Molecular snapshot of diamond as it might look if our eyes were able to see the nanoscale. This snapshot conceals the time-dependence of the system. In fact, every component is wiggling, jiggling, and vibrating, locked in an interdependent dance, where the motion of each part of the system depends on the motion of every other part of the system.

The time-stationary view is strongly linked to equilibrium thermodynamics, which is perhaps the dominant conceptual framework that has guided mathematical modeling of systems within chemistry and physics for the last few hundred years. A large part of the success and beauty of the equilibrium framework lies in its simplicity: whereas the motion of real molecular systems is characterized by complexity, involving chaotic fluctuations, coupled vibrations, and flexible dynamism, the equilibrium picture permits us to understand and predict molecular properties and behavior in terms of their time-averaged properties. This means that the precise details of how a system changes with time need not be considered. Instead we only need to consider one structure: the average. Indeed, it is these time-averaged equilibrium structures that we are typically shown in snapshots of molecular structures.

## Molecules: a Dynamic Perspective

The achievements of equilibrium thermodynamics in modern science cannot be understated – both for improving our fundamental understanding of the natural world, and for allowing us to build a range of sophisticated technological applications. However, detailed studies examining a range of different molecular systems, from gases to liquids to biomolecules, show that the time-stationary, equilibrium view obscures many details of molecular behavior and function. Indeed, time-dependent fluctuations, coupled vibrations, plasticity, and cooperative motions are key to understanding molecules. This recognition is leading to somewhat of a paradigm shift: understanding how physical processes far from equilibrium impact systems within physics, chemistry, and biology is now recognized as a grand challenge facing twenty-first century science.[1]

With advances in technology and computation, chemistry is increasingly attempting to go beyond the equilibrium view of molecules and develop methods that let us see how fundamental physical laws drive molecular change as a function of time. This heralds an important new way of thinking about molecules: Whereas structure previously dominated the way we think about molecular function, dynamics is emerging as an equally important consideration. Richard Feynman hinted at the fundamental role of the dynamic molecular world in his now-famous claim that "everything that living things do can be understood in terms of the jigglings and wigglings of atoms."[2]

In fact, Heisenberg's uncertainty principle (among the most fundamental principles of quantum mechanics) guarantees microscopic dynamism, and implies that every molecular structure is characterized by perpetual jiggling and wiggling, with vibrational motion and structural fluctuations that span a range of timescales and length scales. However, this dynamism is not always so obvious. A good example is diamond, amongst the hardest substances we know, whose structure is shown in figure 1. Hardness is generally associated with rigidity; so it seems rather counterintuitive to imagine that, at a molecular level, diamond is actually a dynamic and vibrating system. Seeing this fundamental molecular dynamism requires time resolution on the order of nanoseconds, and spatial resolution on the order of nanometers, far beyond what our eyes are capable of resolving.[3]

## Molecular Dances, Spectroscopy, and Energy Landscapes

Qualitatively, the vocabulary of molecular dynamism seeps into chemistry in interesting ways. For example, it seems increasingly common to hear chemists and biochemists invoke choreographic and dance analogies to describe the dynamics of molecular systems – referring to molecular dancefloors[4] or chemical choreographies.[5] The use of these metaphors is no doubt driven in part by visualizations of time-dependent molecular phenomena using computational methods.[6] For example, visualizing the motion of the diamond structure shown in figure 1 reveals a tightly correlated molecular dance[7], where the vibrational motion of every atom in the system depends on and affects the dance of every other atom in the system.

Mapping the real time motion of every component of a molecular system is a complicated task that is practically impossible for all but the smallest systems. Consequently, we require strategies for characterizing the most important components of the overall dynamical structure. In this respect, spectroscopy is a key tool within chemistry. The Oxford English Dictionary defines spectroscopy as "the branch of science concerned with the investigation and measurement of spectra produced when matter interacts with or emits electromagnetic radiation." Practically however, spectroscopy has come to mean a range of things to workers across different sub-fields within science. In the field of molecular dynamics, spectroscopy often refers to experimental techniques aimed at identifying the characteristic vibrations that guide molecular dances.

From a theoretical vantage point, chemists and physicists frequently invoke the idea of an energy landscape to: (1) understand how the atoms within a molecule dance, and (2) interpret the vibrational information provided by spectroscopy experiments. An energy landscape is effectively a map of the forces that an atom feels in different atomic arrangements. Indeed, the energy landscape metaphor has become prevalent within the discourses of chemistry, physics, and biology[8], and can

be used to rationalize the motion of almost any class of particle, atom, or molecule in the universe. Figure 2 shows a simple schematic of an idealized, two-dimensional energy landscape, where the energy is a function of arbitrary X and Y coordinates. In general, atoms move across energy landscapes in ways that are similar to humans: they prefer going downhill rather than uphill, they sail over wide-open spaces, and they move chaotically through denser topologies.

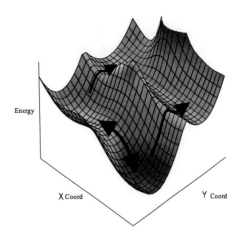

**FIG 2** 2-D schematic of a generic energy landscape, showing energy as a function of two idealized coordinates, X and Y. The arrows show characteristic paths that atoms might take over this landscape.

The energy landscape shown in figure 2 is simplified compared to more realistic models in two important respects: (1) real energy landscapes generally have a significantly higher dimensionality than two, since they depend on the interaction between any given particle with every other particle, and (2) real energy landscapes are not static. Rather, they are time-dependent, like waves on the sea, affected by fluctuating external fields and molecular configurations.

### danceroom Spectroscopy

In what follows, we describe *danceroom Spectroscopy* (dS), which is an attempt to fuse the ideas discussed above – namely, molecular dynamics, spectroscopy, and energy landscapes – in order to generate an immersive audio-visual aesthetic experience. The mathematics and algorithms that drive *dS* are entirely rigorous; this is important because it means that *dS* has potential application to a range of interesting scientific questions beyond the scope of this chapter. However, given that the initial motivation for *dS* arose from artistic and aesthetic considerations, the remainder of this paper will focus on *dS* as a platform for graphic and sonic generative art.

Musical tones arise from vibrational structure and wave mechanics, a discovery going back to Pythagoras. Leg-

end has it that he showed the connection between string lengths and pleasurable sounds as early as the 6th century BCE.[9] More recently, those interested in cymatics have devoted a great deal of effort to visualizing the wave structures that emerge when a range of materials are subject to sonic impulses.[10] With this sonic vibrational framework in mind, one of the principle questions motivating $dS$ was as follows: Using tricks from molecular vibrational spectroscopy, can we measure how arbitrarily large groups of people sculpt molecular vibrational dynamics, and then use that information to generate real time sonic feedback?

Addressing this question turned out to be rather involved, requiring us to develop a brand new framework in which arbitrarily large user groups could have the real time, whole-body immersive experience of being embedded in a molecular dynamics (MD) simulation as an energy landscape. Achieving this required innovations on a number of fronts, including the development of new algorithms, software, and hardware. In what follows, we will describe several aspects of the $dS$ project. After a brief outline of the mathematical and algorithmic framework that drives $dS$, we will outline the system that we have designed and implemented to run $dS$. We close with a number of observations that provide qualitative insight into how both performance artists and the public experience and interpret $dS$.

## $dS$ in brief

Briefly stated, $dS$ interprets people's movements as perturbations within a virtual energy field, and embeds them within a real time molecular dynamics simulation in order to facilitate both graphic and sonic interactivity, as shown in figure 3. Graphically, on a large projection screen, users see their energy fields along with the real time waves, ripples and vibrations created as their motion perturbs a virtual simulation of atomic dynamics. Simultaneously, the $dS$ software detects transient structures and vibrations amidst the apparent chaos of the atomic dynamics, and transforms them into sound, which is fed back to users. This feedback cycle (users graphically affect atomic dynamics, and atomic dynamics affect sound) gives users a textured visual and sonic experience, letting them experience the effect that their real time field perturbations have within a dynamic atomic system.

$dS$ has so far been deployed in two different capacities: (1) as an interactive public installation, and (2) as an artistic tool that knits together the visual, sonic, and choreographic components of a dance performance called *Hidden Fields* (HF). Development of $dS$ began in January 2011, when the original prototype code was written. Subsequent development was facilitated by a series of workshops and public installations held during the summer and autumn of 2011. In a second series of workshops held during March to July 2012, *Hidden Fields* was developed. Recent $dS$ and HF appearances include: the Arnolfini Art Gallery in July 2012 (Bristol, GB); a 360°, 21-meter projection dome in August 2012 (London 2012 Cultural Olympiad); and the Barbican Arts Centre in November 2012 (London).

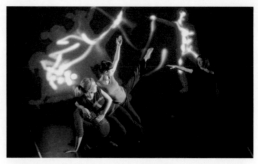

FIG 3 Snapshot of $dS$ in action, where four dancers' energy fields are being used to sculpt a molecular dynamics simulation. The photo shows the silhouettes of the dancers' fields. Simulated atoms reside within and react to the fields.

## MATHEMATICS AND ALGORITHMS
### Interactive Dynamics Framework

In its present form, $dS$ carries out an MD simulation involving $N$ atoms, each of which may move in two dimensions ($x$ and $y$). The simulation is run with each atom having the physical properties of either carbon, iron, hydrogen, helium, or oxygen (all amongst the most abundant elements in the universe). Within the simulation, each atom has a particular mass and associated set of electrostatic properties. The masses is known exactly, and the electrostatic properties have been previously calculated.[11]

A useful vantage point from which to discuss the simulation begins with Hamilton's equations of motion,[12] commonly used to discuss the dynamics of molecular systems in both classical and quantum frameworks:

$$d\mathbf{p}/dt = -dH/d\mathbf{q}$$
$$d\mathbf{q}/dt = dH/d\mathbf{p} \qquad \text{(E1)}$$

where $\mathbf{p}$ and $\mathbf{q}$ are vectors characterizing the $x$, $y$ momentum and coordinates of each atom in the simulation. $H$ is the so-called Hamiltonian function describing the total system energy, defined as:

$$H = \sum_{i=1}^{N} \frac{m_i v_i^2}{2} + V \qquad \text{(E2)}$$

where $i$ is an index that runs over a collection of $N$ total atoms, $m$ is the mass of an atom, and $v$ is its velocity. The first term in (E2) describes the total kinetic energy of the system while the second, $V$, describes the total potential energy. Within our system:

$$V = V_{int} + V_{ext} \qquad \text{(E3)}$$

where the total potential energy, $V$, is calculated as the sum of two terms, $V_{int}$ and $V_{ext}$, which correspond to potential energy owing to internal and external interactions, respectively:

$$V_{int} = \sum_{i=1}^{N} \sum_{j=i+1}^{N} V(r_{ij})$$
$$\qquad \text{(E4)}$$
$$V_{ext} = C_a \sum_{i=1}^{N} V_{ext}(x_i, x_i, t)$$

$V_{int}$ is calculated by summing over all possible atomic interactions, $V(r_{ij})$, where $r_{ij}$ is the distance between atoms $i$ and $j$. Mostly for computational efficiency, this term is presently calculated using a so-called Lennard-Jones interaction model,[13] which includes attractive interactions at long-range and repulsive interactions at short range. $V_{ext}$ is calculated as the difference between a raw depth matrix at time $t$, and an averaged background depth image, exploiting the fact that 3-D capture systems return depth, $z$, as a function of pixel position within a two-dimensional matrix indexed by $x$ and $y$. This has a close correspondence with the 2-D energy landscape shown in figure 2. In practice, $V_{ext}$ is calculated as a sum over $V_{ext}(x_i, y_i, t)$, which is the energy field that a particular atom located at $x_i$, $y_i$ 'feels' as a consequence of people's motion. $C_a$ is a scaling constant that can be interactively modified in real time to control strongly a particular atom type 'feels' the users' fields, and whether people are attractive or repulsive. Effectively, $C_a$ is responsible for coupling human motion to the atomic dynamics, allowing them to warp the potential energy landscape felt by each atom, and thereby sculpt the system dynamics. Unlike the first term, which depends only on the relative position of each atom with respect to every other atom, the second term explicitly depends on time, owing to the fact that people are not stationary within the exhibition space.

In general, the vector of forces acting on a set of atoms, $\mathbf{F}(t)$, can be written in terms of the system's potential energy – for example:

$$\mathbf{F}(t) = -dH/d\mathbf{q} = -dV/d\mathbf{q} \qquad (E5)$$

Substituting (E3) into (E5) gives

$$F(t) = \frac{dV_{int}}{d\mathbf{q}} - \frac{dV_{ext}}{d\mathbf{q}} \qquad (E6)$$

$$= \mathbf{F}_{int} + \mathbf{F}_{ext}$$

where $\mathbf{F}_{int}$ and $\mathbf{F}_{ext}$ are the force vectors arising from the internal energy and the external field, respectively.

## Mixing Quantum and Classical Mechanics for Smooth Interactivity

A significant utility of Hamiltonian mechanics is that it can be applied to both classical and quantum equations of motion. Initially, our intention was to propagate the system dynamics using (E1) and forces calculated using standard classical approaches, wherein each atom is represented as a point, and the force it 'feels' corresponds to the force field acting at that point. However, we found that this approach resulted in choppy atomic motion and unsatisfactory interactivity. This arose because noisy variations in the matrices returned from the depth sensors gave fluctuations in $V_{ext}$ that rivaled the effect of human 'energy landscapes.' Achieving more fluid dynamics and improved interactivity therefore required that we introduce some sort of non-locality into our dynamics propagation strategy, so that $\mathbf{F}$ depends on some sort of local average within the force field. To efficiently incorporate this non-locality, we implemented a mixed quantum-classical dynamics strategy based on the so-called frozen Gaussian dynamics approach, which forms the basis of several more sophisticated approaches that approximately model the quantum dynamics of molecular systems. Within this approach, $V_{ext}$ $(x_i, y_i, t)$, the effective potential energy felt by an atom centered at the coordinates $x_i, y_i$ is described using an integral over a Gaussian function. In two dimensions, the form this function takes is:

$$V_{ext}(x_i, x_i, t) =$$
$$\iint dx dy\, V_{ext}(x, x, t) e^{\left(\frac{(x-x_i)^2 + (y-y_i)^2}{2\lambda_i^2}\right)}$$

$$(E7)$$

where $\lambda$ is Gaussian width parameter that tells us how 'blurry' the atom is. Within $dS$, $\lambda_i$ is chosen to satisfy the quantum thermal width predicted by Heisenberg's uncertainty principle.[14] Effectively, $\lambda_i$ is a sort of measure for how wave-like the atomic particles are.

## SYSTEM DESIGN AND SETUP
### Image Processing, Physics and Graphics

A simplified schematic of our setup using a single sensor is shown in figure 4. In general, up to eight depth sensors send depth matrices via USB to a custom-built workstation. This occurs at either 30 or 60 Hz, the operational frequencies of our depth sensors. Following a depth matrix grab, the workstation calculates $\mathbf{F}_{int}$ and $\mathbf{F}_{ext}$, the internal and external forces acting on the atomic ensemble. Using these forces, the atomic dynamics are propagated forward a step using the frozen Gaussian equations of motion. The atom positions as well as $V_{ext}$ are then rendered at 60 Hz using a range of graphics parameters (discussed below) that may be specified on the fly to achieve a desired aesthetic effect. The graphics data is then sent out to a projector for users to see.

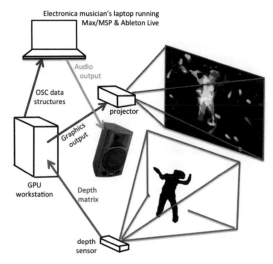

**FIG 4**
Schematic of the $dS$ setup with a single depth sensor.

## Sonics

As discussed above, one of the principal motivations for *dS* was to measure how arbitrarily large groups 'sculpt' molecular vibrational dynamics, and subsequently feed this data back to users in sonic form. *dS* includes three different means for sonifying the atomic dynamics. All of the sonics derive from analysis of the atomic dynamics, and subsequent encapsulation of this data in an appropriate open sound control (OSC) data structure for Ethernet transfer to an electronica artist's laptop. As shown in figure 4, the OSC data structures may then be processed by Max/MSP and sonified directly or forwarded on to music programs like Ableton Live to generate real time sonic feedbacks for users within the installation space. Each of the sonic structures detailed below has its own characteristic fluctuation timescale, combining to give a textured sonic experience: Collisional data fluctuates on very fast timescales, superparticles on intermediate timescales, and vibrational dynamics on the slowest timescales.

### Collisional Analysis

The simplest form of sonic feedback is to run a collision detection algorithm. The net result is that every atom wall and/or atom-atom collision event is tagged with OSC data, triggering an arbitrary sound chosen by the electronica artist.[15] This works fine for small numbers of atoms; however, it can quickly grow cacophonous when the ensemble has no more than a few users and less than ~250 atoms. It is possible to use a filter to limit the maximum number of sonified collisions per frame, but this diminishes user perception of interactivity. There are always a certain number of background collisions, and it is difficult to guarantee that only those which arise from user motion pass through the filter.

### Superparticle Clustering Analysis

To harvest meaningful data for sonification when there are a large number of atoms, we have developed a grouping algorithm which detects the transient formation of atomic clusters.[16] These clusters we refer to as 'superparticles', since their properties – position, velocity, and size – are similar to those of individual atoms. An illustration of the grouping algorithm at work is shown in figure 5, where the dancer in the foreground has used her energy field to manipulate the atomic dynamics to form a superparticle. The standard deviation of the average x and y coordinates of the atoms comprising the superparticle are delineated by the rectangle visible in the background of figure 5. Each superparticle has its own sonic channel, so that it may be easily assigned to a particular sound. The net result is that a dancer may modulate the volume of his/her corresponding sonic channel depending on his/her movement within the space. For example, a dancer's instrument goes silent with stillness. With increasing velocity, the volume increases.[17]

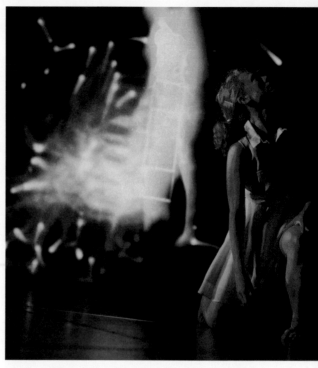

**FIG 5** An illustration of the superparticle algorithm. The dancer shown in the foreground has used her field to manipulate the atomic dynamics and form a superparticle. The average x and y boundaries of the superparticle are outlined by the rectangle visible in the background.

### Vibrational Analysis

The algorithm we use to determine whether there is any vibrational structure within the atomic dynamics is inspired by methods typically used to analyze vibrational spectroscopy experiments of molecular systems. By maintaining a moving time history of a vector containing all the atomic velocities, we calculate the so-called velocity autocorrelation function (VAC). Letting $\mathbf{v}(t)$ specify the vector of atomic velocities at some time step $t$, and $\mathbf{v}(t_o)$ specify the same vector at some previous time step $t_o$, the VAC is essentially a time series of size $n$ which measures how $\mathbf{v}(t_o+dt)$, $\mathbf{v}(t_o+2dt)$,... $\mathbf{v}(t_o+ndt)$ project onto $\mathbf{v}(t_o)$, where $dt$ is the dynamics time step. Fast Fourier Transform (FFT) of the VAC gives a spectrum whose peaks show any characteristic vibrational frequencies within the ensemble dynamics. A dynamic peak-picking algorithm identifies these peaks and packages their amplitude and frequency into an OSC data structure. If the dancers' movements create periodic vibrational motion within the on-screen atomic dynamics, appropriate peaks in the FFT vibrational spectrum undergo a characteristic beating motion perfectly in phase with the dancers' motion. This leads to sounds that are similarly aligned with the dancers vibrational motion.[18]

## Hardware
### Workstation
Our technical goals have largely been driven by our desire to adapt $dS$ to 360° projection environments with a latency no larger than 17 ms (60 Hz). This proved too intensive for a standard desktop or laptop. At present, $dS$ runs on a high performance custom-built 64-bit workstation with a hexacore CPU and two top-of-the-range graphical processing units (GPUs), one of which is used solely for graphics rendering over multiple outputs, and one of which is reserved solely for dynamics computations.

### Camera Mount
Installing $dS$ in 360° requires simultaneous depth matrix capture from at least seven sensors. Our camera mount consists of seven cradles arranged around a central axis. Each cradle fits snugly around a depth sensor's outer casing, and is mounted in a fashion that allows us to control the pitch and roll of each sensor as well as the distance of each sensor's focal point from the center of the circle. Following alignment, the cameras are fixed using a set of fasteners.

### Software
$dS$ is written in ~50,000 lines of C# code built on Windows 7 in Visual Studio 2010. We devoted considerable effort to making the code general, flexible, and user-friendly for use by musicians, dancers, and choreographers without requiring a programming specialist. All aspects of the system can be controlled via a multi-tab graphical user interface (GUI). Each of the different tabs in the GUI allows the system operator to interactively control a different component of the $dS$ system: (1) depth matrix capture and background calibration, (2) graphics rendering of both the atoms and $V_{ext}$, (3) relative orientation and position of each cameras' depth matrix within the composite field that makes up $V_{ext}$, (4) edge blending between depth images, (5) behavior of the superparticle clustering algorithm, (6) parameters controlling the collision analysis and detection algorithm, (7) the vibrational analysis and peak picking algorithm, and (8) the OSC output.

When using $dS$ to make *Hidden Fields* and also during public installations, we found that certain physics and graphics variables significantly impacted the aesthetic feel. Access to these variables for real time modification is provided on the main screen of the $dS$ GUI in the form of sliders and buttons. Physics-related variables accessible on this screen include: (1) the number of atoms, (2) the size of the atoms, (3) the temperature of the system, (4) the on-screen position where new atoms should be initialized, (5) how strongly the atoms feel $V_{ext}$, (6) whether each atom type feels $V_{ext}$ as attractive or repulsive, (7) how strongly the thermostat enforces the selected temperature at each dynamics step, and (8) whether different atom types generate OSC data upon collision. Graphics-related variables accessible on the main GUI screen include: (1) whether atoms flash when they collide, (2) the feedback incorporated into the atom rendering (e.g., high feedback results in trails for atomic trajectories), (3) the feedback in the rendering of $V_{ext}$ (high feedback allows human motion to create graphic

distortion), (4) the extent to which users are able to see $V_{ext}$, (5) the color of users' fields, and (6) a range of variables related to a graphical effect we named the 'warp' grid. The warp grid is a grid which can be distorted by $V_{ext}$, resulting in a range of interesting and subtle graphics effects that very much give the atomic dynamics a sort of liquid feel. It was inspired by asking: How might we imagine people's energy fields if we could see them? Different physics and graphics parameter combinations result in an enormous number of distinctly different states, a few examples of which are shown in the photos accompanying this chapter.

## AESTHETICS
In what follows, we offer some qualitative thoughts on the sort of aesthetic experience made possible with the $dS$ system. Our observations are broken down into two broad categories:

(1) We consider the artistic interaction that arose during the making of *Hidden Fields*, where $dS$ serves as an artistic tool and the collaborative glue facilitating interaction between a musician, a choreographer, a digital artist, and five professional dancers.

(2) We consider user feedback from those who participated in public $dS$ installations and/or watched the *Hidden Fields* performance.

Whereas the former group could be considered 'experts' insofar as they had received in-depth explanations of the ideas and technology driving $dS$, this was not necessarily true for the latter group.

### Observations from the Creative Artistic Process
#### Aesthetic Moods and Variability
Everything that a user might experience within $dS$ emerges from a single rule – namely, the frozen Gaussian equations of motion outlined above. This raises some interesting questions: Are different system states capable of producing a range of aesthetic moods? What are effective strategies for weaving together different states to produce a performance?

One way to address these questions is to examine the creative process which culminated in *Hidden Fields*. Using sliders and buttons on the $dS$ GUI, nearly every physics, graphics, and sonic parameter can be modified in real time by the system operator and/or the artists. This means that the number of possible parameter combinations is enormous. Among the most challenging and fun aspects of $dS$ is exploring this enormous parameter space to discover aesthetically satisfying combinations, which we henceforth refer to as system 'states'. The initial workshops that inspired the ideas behind *Hidden Fields* were organized in a fashion that allowed plenty of freedom for testing out and playing with different choreographic, visual, and sonic arrangements – either separately or as an integrated whole. During this exploratory process, we would stumble upon states that we liked, and were able to save the parameter combinations that had produced that state using a single click within the $dS$ GUI. This allowed $dS$ to fit smoothly within an organic artistic process, rather than be a distraction.

The *Hidden Fields* performance is composed of approximately twenty different states, with names like *Swaying, Puddle Jumping, Firation, Ghosts in the Grass, Butterflies, Heartbeats, Super-Terrific Mega-Trip, Earth from Space, Intergalactic Space Man,* or *Jupiter's Memories.* The name of each state was usually coined by one of the artists involved, to reflect a particular idea or feel which related to some aspect of the choreography, graphics, and sonics. In many cases, the name initially referred to only one of the three aspects listed above; however, we found that the names subsequently provided a concise thematic vision that helped guide our efforts to refine and weave together the other aspects. A good example of this is the process leading to the *Jupiter's Memories* scene. In its initial stages, this name mostly referred to the choreography and movement – for example, the dancers made gentle orbiting motions across the stage space, reminiscent of planetary motion. As rehearsals wore on, this name helped us to refine the visual state (cool blue sparkling atoms) as we imagined how to represent what Jupiter might encounter on a lonely journey through space. This name also helped us to refine the associated sonics: For this scene, the dancers' interactions with the simulation modulate the sonification of NASA data recordings taken during Voyager's flyby of Jupiter's moon, Ganymede.[19]

### Determinism and Chaos

*HF* raised interesting issues concerning the relationship between determinism and chaos. Choreography and dance often tend to follow structures that are rather linear and deterministic (of course there are exceptions, but we are speaking generally here). *dS*, however, is characterized by a certain amount of noise rather than deterministic certainty. This arises from well-known chaotic instabilities that inevitably arise in the numerical simulation of dynamical systems, often described as the butterfly effect. Hovering somewhere between chaos and determinism, the interactive experience enabled by *dS* may approximately be described as stochastic. We can never predict exactly how the *dS* system will react to the motion of human energy fields; however, over a large number of system instantiations, we can confidently build up an intuitive picture of its average response. This blurriness distinguishes *dS* from other interactive art tools, which are often more obviously deterministic. Consequently, we found ourselves exploring how to build choreographic, sonic, and graphical frameworks, which could harness and accommodate *dS*'s inherent blurriness to make emergent beauty.

Effective utilization of *dS* required all of the artists to understand and appreciate that the system was not deterministic nor should it be expected to behave as such. This recognition led to a shift in emphasis: Rather than focus our creative attention on tightly coupled choreography and musical accompaniment arranged in linear sequences, our approach took on much more of a jazz feel. Each *dS* system state was built around a particular combination of graphical, sonic, and choreographic phrases. Hence, we tended to focus on how best to interweave these phrases to highlight the feel, ambience, and ideas, which led us to discover the state in the first place.

The fact that both the visual and sonic effects are generated from the dancers' motions meant that specific timings between the graphics, sonics, and choreography were not emphasized nearly as much as they may have otherwise been. Particularly important in this respect was crafting a choreographic narrative for the dancers. This provided them with an intrinsic rhythm to drive *dS*, beyond merely reacting to it, and resulted in a beautiful range of dynamic variance. Such narrative schemes permitted a certain degree of flexibility and spaciousness for facilitating interaction among the dancers, musicians, programmer, and choreographer, but it also introduced a certain degree of uncertainty. For example, Joseph Hyde, who was the principle architect for the sonic contours of *Hidden Fields*, once said: "Every time I perform this piece, I'm always slightly scared, cause there's always a certain amount of variability that I know I can't control, and it might not work."

### Vocabularies

*HF* development relied on interaction between an interdisciplinary group with *dS* forming a sort of creative hub. Given the diverse backgrounds of this group, and in an attempt to facilitate artistic interaction rather than hinder it, much of our time together was devoted to exploring effective metaphors and vocabulary that allowed us to merge physics concepts with dance ideas, musical analogies, and interactive high-performance computing. Dance is perhaps particularly well-suited to this sort of cross-fertilization with the sciences,[20] since the 'dynamics' of dance share a number of important similarities with how scientists describe the 'dynamics' of molecular systems:

(1) Contemporary dance pieces exhibit correlated vibrational and periodic motion, but they also include a certain degree of variability and randomness.

(2) Dance often relies on varying degrees of cooperativity and correlation, which chemists and biologists increasingly recognize as important to molecular dynamics and function.

(3) Dancers and choreographers frequently use metaphors that suggest a manipulation of time, space, and energy – three concepts, which form the foundations of modern scientific thinking. The scientific language of dynamics and spectroscopy – for example, energy transfer, vibrational frequencies, coupled motion, field strengths, attractive and repulsive interactions, etc. – was remarkably easy to communicate to dance artists involved in *Hidden Fields*.

### Observations from Public Participants

Presently, *dS* offers people a sort of molecular sandbox wherein people can use their fields, either individually or in collaboration with other users, to sculpt the atomic dynamics, creating emergent graphic and sonic structure. The net result is that the individual and collective motion of arbitrarily large groups of people are able to create transient graphical and sonic sculptures.[21] Following are a few observations that we have gleaned from non-expert user feedback.

People were simultaneously confused by and attracted to seeing rather abstract energy representations of themselves, compared to the more literal video-game

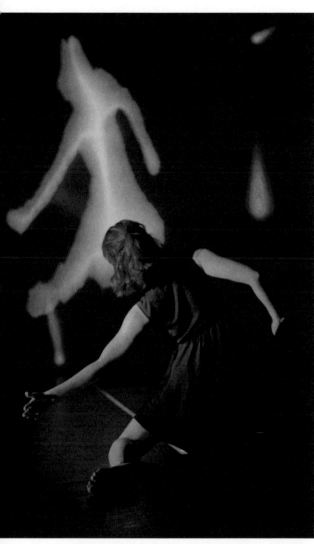

**FIG 6** One of the more literal states of *dS*, in which the dancers' energy contours are well-defined, there are relatively few particles, and all sounds are generated from particle-particle collisions.

type representations to which they are accustomed. People seemed to have had the least confusing and most engaging experiences when their initial encounters with *dS* presented them extremely literal, person-shaped energy fields embedded in a system comprised of only a few atoms with easy-to-interpret collision sounds, as shown in figure 6. These simple states offer a well-defined and literal relationship with the system's interactive graphic and sonic properties, accelerating understanding of the system, and increasing their interest in more abstract visual and sonic states. People who had seen *Hidden Fields* prior to interacting with *dS* tended to embrace more abstract representations of themselves, presumably having a better understanding of the system from watching the dancers.

The fact that *dS* is built on rigorous scientific principles had noticeable consequences for how people interpret their interactive experience. For example, people found satisfying the fact that the particles they saw being simulated were more than mere abstractions, with properties corresponding to those of real atoms. Also, people generally reported increased satisfaction with their *dS* experience if they had some sort of explanation of how the system works and the scientific ideas from which it derives. The scientific link added significant depth to how people interpreted their interactive experience. For example, the introduction to *Hidden Fields* contains a brief explanation of the system. And users who experienced *dS* having seen *Hidden Fields* had a distinctly metaphysical tone to their feedback compared to those who had not. They often hinted at how it left them with a sense of interconnectedness to nature and others, beyond the limits of their material body. Many of these feelings are beautifully encapsulated in a written review following the first ever *Hidden Fields* performance in Bristol:

"*Hidden Fields* followed a vague narrative scheme of birth, the exploration and discovery of the self and its connection with the world, interaction and connection with others, and eventual death and dissipation. It was fascinating and a little bedazzling to have to flicker the focus of your perceptions between the dancers and the motions they created on the screen. It must have been strange for the dancers to not be the sole object of attention during the performance, and indeed to have no following lights drawing the eye to their movements. But the essence of the piece lay in the interaction between the human element and its computer-projected analog on the screen, and it was necessary somehow to be aware of both. The images on screen were often abstract and strikingly beautiful. Waves of color would ripple across, or oscillating pulses of light would waver back and forth. Particulate clusters in roughly human form would merge with one another and then bifurcate with the appearance of fluid cellular division. Joseph Hyde provided electronic music, which drew on the visuals, reacting to them in real time, and gave them sonic contours. He began with the hum and hiss of white noise, the aural analogue of the chaos of the untuned TV screen with which was what the projections initially resembled. As forms began to emerge, along with the dancers, the music too began to resolve into individual notes and tones. Thick, angular atom trails slowly drew lines across the screen before

ricocheting off the edges, accompanied by oddly mammalian squeaks and cries of surprise. One of the dancers played a game of interrupting or evading these firefly atomic contrails, the first tentative exploration of how the self could affect the world through which it moved. Towards the end, the human shape became a container for shimmering colonies of pointillistic atoms. The dancers began to lose their energy, and their partners cradled their dying forms and lay them gently down onto the ground. Their atomic clusters lost coherence, and slowly dissipated out into the general particulate matter, which drifted all around them. It was a mystical image of essential indivisibility, of a certain continuity of being, and of the connection of all things, which was in keeping with the spiritual tenor of the piece as a whole. The projected visuals, with their semi-abstract and vibrantly colored but still somehow recognizably human forms, gave the impression of a technologically-enabled emanation of some inherent essence of spirit, and iridescent imprint of the soul. It all ended with the music crackling and humming with the background noise of the universe. The screen was a frosty white, etched with the black craquelure of shattered safety glass. The last of the dancers slowly made her way to the wings, her movements creating a ghost, which passed across the patterned screen like a watery shadow beneath thick ice, like life spiriting away in the face of the heat death of the universe. The whole was a fantastically beautiful and at times very moving meeting of science and art, human grace and technological ingenuity, rationalism and mysticism, dispassionate programming and emotional engagement. After the dancers had left, the floor was open once more, and the audience were free to project their own stories and selves onto the screen, to make sport and play in the Atomic World."[22]

## OUTLOOK

The relationship between computer science and more traditional fields of science (for example, physics, chemistry, and biology) has a long and rich history, with many of the early developments in computer science driven by attempts to solve scientific questions. While the relationship between arts practice and computer science is perhaps less well established, it is rapidly expanding, and arts practice is developing fluency with the algorithmic type thinking and language that dominates the discourse, models, and analogies used in modern science (across fields as diverse as physics, biology, nanotechnology, neuroscience, linguistics, economics, and sociology). So what can art offer science? Within the physical sciences, it is often the case that experiments to facilitate direct visualization of the subjects under investigation are not possible. In this respect, artistic visualizations have much to offer for helping us to effectively imagine phenomena and concepts that are invisible even to the eyes of scientists. And what can science offer art? Challenging the frontiers of how we understand the elegantly woven fabric of nature, science offers fertile conceptual territory for the arts, which is perched on the very horizons of knowledge and always under revision. The time for interaction between art and science is ripe, and it will be exciting to watch what unfolds on this horizon.[23]

## CREDITS AND ACKNOWLEDGMENTS

dS's eclectic mix of physics, chemistry, mathematics, high-performance computing, interactive technology, digital art, electronic music, and dance is reflected in the diverse backgrounds of a core group of collaborators: David R. Glowacki, the project leader and conceptual architect, is a theoretical chemical physicist and programmer who carries out research in molecular dynamics and also holds a master of arts in cultural theory; Philip Tew is a programmer and installation artist with interests in generative processing and physical modeling; Tom Mitchell is a lecturer in music technology with interests in adaptive sound design and interactive musical composition; Joseph Hyde is a professor, musician and electronic sound artist focusing on multimedia, dance, telepresence, and interactivity; Simon McIntosh-Smith and James Price are computer scientists with expertise in high performance computing hardware and software; and Laura Kriefman is a choreographer who experiments with a range of interactive technology. *Hidden Fields* rehearsals and performances additionally involved five professional modern dancers (Lisa May Thomas, Isabelle Cressy, Kathleen Downie, Emma Harrie, and Kerry Trevaskis), all of whom had three to ten years of professional dance experience/training. Direct funding has been provided by the UK Engineering and Physical Sciences Research Council (grant EP/I017623/1 and *Pathways to Impact* GR4016) and Arts Council England. Indirect funding has been provided by the Pervasive Media Studio (Bristol), the Arnolfini Centre for Contemporary Arts (Bristol), and NVIDIA corporation. We also thank the following individuals: Mike Ashfold, Becca Rose, Lee Malcolm, David McGoran, Paul O'Dowd, Paul Blakemore, Paul Gilbert, Nathan Hughes, Jacob Parish, Tim Gallagher, John Keating, Sarah Warden, Phillipa Bayley, Kate Miller, Maggie Legget, Mel Scaffold, Clare Reddington, David Hotchkiss, Ki Cater, David Coyle, Sri Subramanian

### Notes

1 See: Basic Energy Sciences Advisory Committee, *Directing Matter and Energy. Five Challenges for Science and the Imagination*, U.S. Department of Energy, 2007.

2 Adrian J. Mulholland, "Introduction. Biomolecular simulation," in: *Journal of the Royal Society Interface*, vol. 5, suppl. 3, 2008, pp. 169–172, doi: 10.1098/rsif.2008.0385.focus.

3 See: Eric J. Heller, *Why You Hear What You Hear. An Experiential Approach to Sound, Music, and Psychoacoustics*, Princeton University Press, Princeton, NJ, 2012.

4 See: Stephen Bradforth, "Tracking State-to-State Bimolecular Reaction Dynamics in Solution," in: *Science*, vol. 331, no. 6023, 2011, pp. 1398–1399, doi: 10.1126/science.1203629.

5 See: Eric S. Shamay, Kevin E. Johnson, and Geraldine L. Richmond, "Dancing on Water: The Choreography of Sulfur Dioxide Adsorption to Aqueous Surfaces," in: *The Journal of Physical Chemistry C*, vol. 115, no. 51, 2011, pp. 25304–25314, doi: 10.1021/jp2064326; Janice Villali and Dorothee Kern, "Choreographing an enzyme's dance,"

in: *Current Opinion in Chemical Biology*, vol. 14, no. 5, 2010, pp. 636–643, doi: 10.1016/j.cbpa.2010.08.007.

**6** See: Lisa Pollack, "VMD: Twenty Years of History and Innovation," available online at: www.ks.uiuc.edu/History/VMD/, accessed 03/13/2013.

**7** See: David. R. Glowacki, *Wiggling Diamond*, 2011, available online at: www.chm.bris.ac.uk/~chdrg/diamond.gif, accessed 03/13/2013.

**8** See: David R. Glowacki, Jeremy N. Harvey, and Adrian J. Mulholland, "Taking Ockham's razor to enzyme dynamics and catalysis," in: *Nature Chemistry*, vol. 4, no. 3, 2012, pp. 169–176, doi: 10.1038/nchem.1244.

**9** See: Heller 2012.

**10** See: Alexander Lauterwasser, *Water Sound Images. The Creative Music of the Universe*, MACROmedia, Newmarket, 2006; Hans Jenny, *Cymatics. A Study of Wave Phenomena and Vibration*, MACROmedia, Newmarket, 2001.

**11** See: Norman L. Allinger, Young H. Yuh, and Jenn H. Lii, "Molecular mechanics. The MM3 force field for hydrocarbons.1," in: *Journal of the American Chemical Society*, vol. 111, no. 23, 1989, pp. 8551–8566, doi: 10.1021/ja00205a001.

**12** See: Daan Frenkel and Berend Smit, *Understanding Molecular Simulation. From Algorithms to Applications*, Academic Press, San Diego, 2001.

**13** Ibid.

**14** See: Richard P. Feynman and A. R. Hibbs, *Quantum Mechanics and Path Integrals*, McGraw-Hill, New York, 1965; Bertrand Guillot and Yves Guissani, "Quantum effects in simulated water by the Feynman-Hibbs approach," in: *The Journal of Chemical Physics*, vol. 108, no. 24, 1998, pp. 10162–10174, doi: 10.1063/1.476475.

**15** See: David R. Glowacki, a video demonstration of *dS*'s sonic features (collisions, superparticles, and vibrational FFT analysis) 2011, available online at: www.chm.brisac.uk/~chdrg/dsCHIfinalLink.mov, accessed 03/13/2013.

**16** Ibid.

**17** Ibid.

**18** Ibid.

**19** See: NASA, *Sounds of Jupiter*, available online at: http://solarsystem.nasa.gov/galileo/sounds.cfm, accessed 03/13/2013.

**20** See: K. Farley, "Digital dance theatre: The marriage of computers, choreography and techno/human reactivity," in: *Body, Space and Technology*, vol. 3, no. 1, 2002, pp. 39–46; Jennifer Burg and Karola Luttringhaus, "Entertaining with science, educating with dance," in: *Computers in Entertainment*, vol. 4, no. 2, 2006, doi: 10.1145/1129006.1129018.

**21** See: David R. Glowacki, a crowd-source sonic 'sculpture' generated with the *dS* technology at a Barbican installation held during November 2012 is available online at: www.chm.bris.ac.uk/~chdrg/dS-barbican-i.wav, accessed 03/13/2013.

**22** J. Winship, *Sparks in Electrical Jelly,* available online at: www.sparksinelectricaljelly.blogspot.co.uk/2012/07/thebristol-harbourside-festival.html, accessed 08/2012.

**23** See: Richard P. Gabriel and Kevin J. Sullivan, "Better science through art," in: *Newsletter ACM SIGPLAN Notices – OOPSLA '10*, vol. 45, no. 10, 2010, pp. 885–900, doi: 10.1145/1869459.1869533; Anna Ursyn and Ruwang Sung, "Learning science with art," in: *Proceeding SIGGRAPH '07, ACM SIGGRAPH 2007 educators program*, 2007, article no. 8, doi: 10.1145/1282040.1282049.

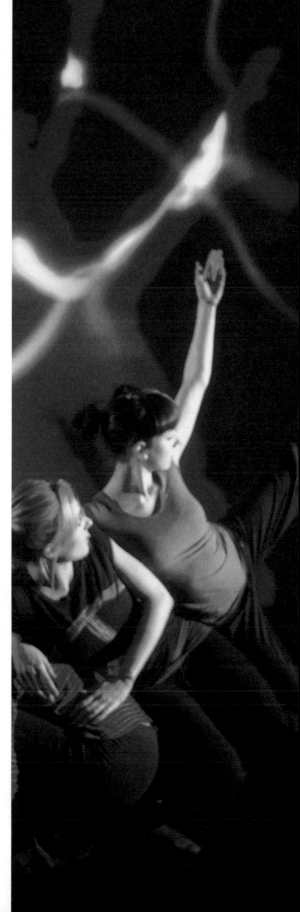

both images and next pages
*Eden*
2000–2010, self-generating, artificial ecosystem,
exhibition view *Sensesurround* exhibition, Australian
Centre for the Moving Image, 2004

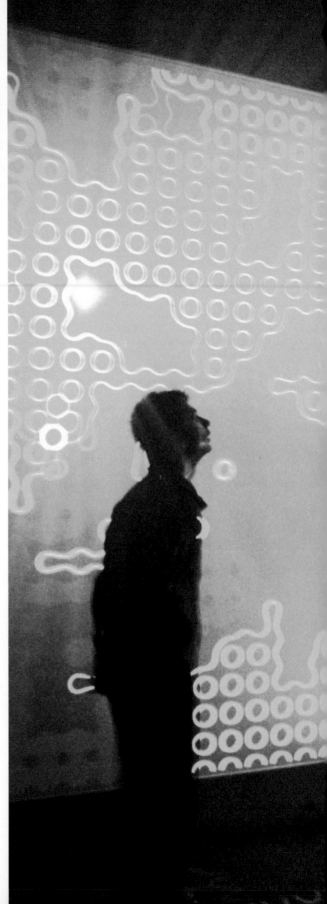

**JON MCCORMACK** (*1964 in Melbourne, AU) is an asso-
ciate professor and ARC Australian Research Fellow as
well as the director of the Centre for Electronic Media Art
(CEMA) and the Caulfield School of Information Tech-
nology at Monash University in Caulfield (AU). His most
recent exhibitions are *Codeform* and *Fifty Sisters* at the Ars
Electronica Center in Linz (AT), *Lexux Hybrid Art* (Moscow),
*Art, Pattern and Complexity* (Adelaide, AU). His works have
been featured in publications including *Digitized: the sci-
ence of computers and how it shapes our world,* (Peter J. Bentley
(ed.), Oxford University Press, 2012) and *Art + Science Now,*
(Stephen Wilson (ed.), Thames and Hudson, 2010).

http://diotima.infotech.monash.edu.au/~jonmc/sa

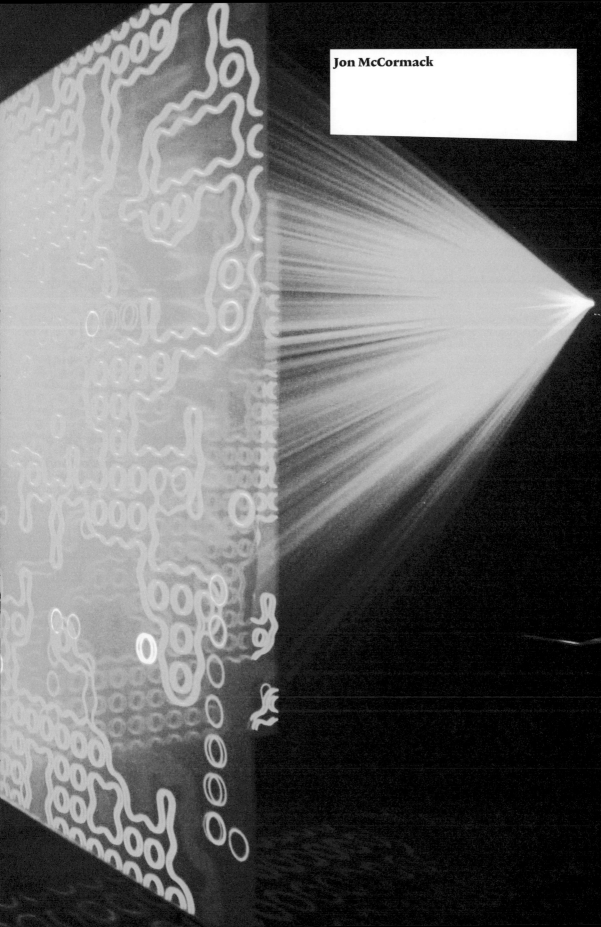
Jon McCormack

## Eden
### 2000–2010, an evolutionary ecosystem

*Eden* is an interactive, self-generating, artificial ecosystem. A cellular world is populated by collections of evolving virtual creatures. These creatures move about their environment, making and listening to sounds, foraging for food, encountering predators and perhaps mating with each other. Over time, creatures evolve to fit their landscape. *Eden* has four seasons per year and each year lasts 600 *Eden* days. One *Eden* year passes by in about fifteen minutes of real time. A simple physics dictates only three basic types of matter in the *Eden* world: rocks, biomass and sonic creatures. Creatures can learn about their environment, and then pass that learned knowledge on to their children. *Eden*'s creatures begin with little knowledge about the world they are born into. Over time, they learn how to find food and potential mates, while avoiding obstacles and predators. They also learn how to make use of sound, since they can make a variety of sounds and hear those made by other creatures in their immediate vicinity. Not only do creatures adapt to their environment, but they modify it, creating complex feedback dependencies between organism and environment, leading to ongoing dynamic change. Over time, many different and novel ways of existence are discovered by the system, ways that were never envisaged or planned by its creator. In this sense, contrary to the expectations of Lady Lovelace,[1] the computer has been able to originate something fundamentally new.

*Eden* is also an interactive system. A video camera looks down from above the installation and detects the presence and movement of people in the exhibition space. A person's presence within the exhibition space affects the production of food resources in the virtual *Eden* world. The longer people stay in the space – implicitly indicating their interest in the work – the more food will be produced in the virtual world near the location of the viewer. Over time, creatures learn that by making interesting sequences of sounds, visitors will stay longer in the exhibition space, providing more abundant food resources for them and their offspring. This allows the creatures to better survive and reproduce. Even though they have no explicit knowledge of their human audience, the creatures learn that making interesting sounds will lead to a more fertile world for them to live in.

A synergetic relation therefore develops between the human audience and the virtual creatures, linking the real and the virtual in an open-ended, emergent dialogue. *Eden* was inspired by time spent in the wilderness of Litchfield National Park, Northern Territory, Australia.

1 Ada Lovelace was a collaborator and muse to Charles Babbage, who in 1837 designed the "Analytical Engine," a mechanical precursor to digital computers. In considering the possibility of the machine being able to exhibit creativity she wrote expressly that it "can do what ever we know how to order it to perform," but it has "no pretentions whatever to originate anything," implying any creativity comes only from the programmer, not the program. See also: L. F. Menabrea, *Sketch of "The Analytical Engine" Invented by Charles Babbage, Bibliothèque Universelle de Genève*, no. 82, October 1842, available online at: www.fourmilab.ch/babbage/sketch.html, accessed 05/15/2013.

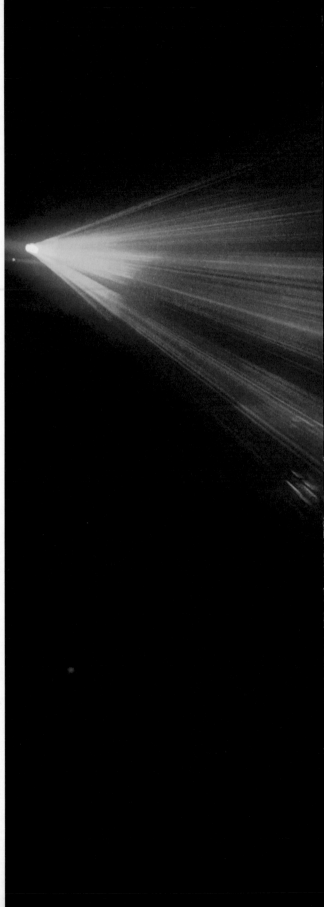

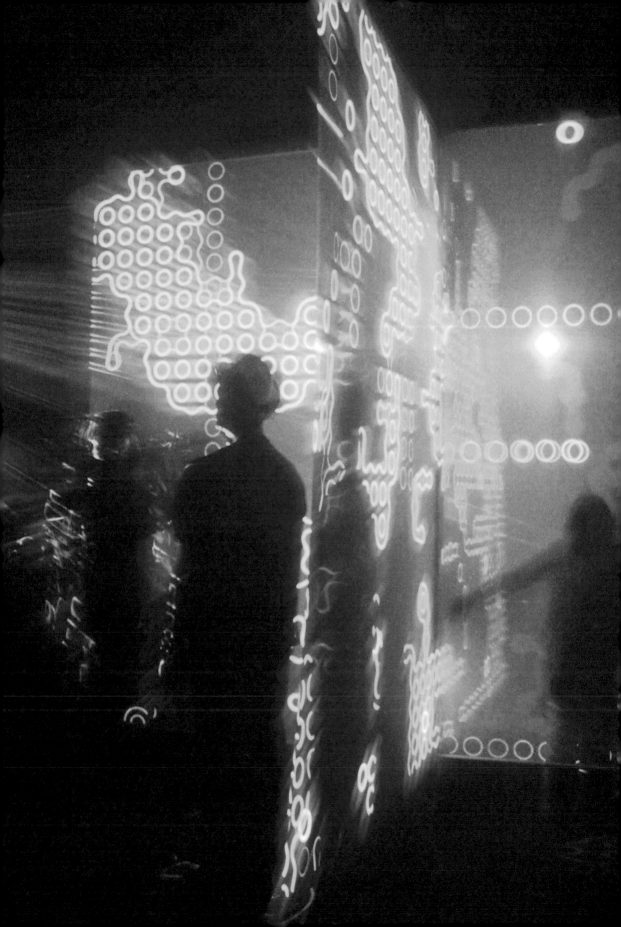

Robert Root-Bernstein
**Aesthetics, Media, Sciences, and Technologies:
An Integral Tetrahedron**

Sciences and arts are often portrayed as polar opposites: arts as subjective, qualitative, emotional, intuitive; sciences as objective, quantitative, dispassionate, logical. I argue, however, that science-in-the-making – the process of discovery itself – is just as subjective, qualitative, emotional and intuitive as any art.[1] Scientists share an aesthetic investment in their research, expressed through the media and technologies they manipulate, that is just as profound as that of any art.[2] Indeed, this scientific aesthetic is often indistinguishable from an artistic aesthetic, and one that can be expressed in similar ways and leads to a form of understanding that I call "aesthetic cognition."[3] An understanding of how arts influence sciences through aesthetic concerns can therefore be valuable to scientists striving for innovation. In particular, the newly emerging field of molecular aesthetics has the potential to create a new hybrid approach to human understanding that is deeper and more synthetic than either discipline alone.

To create a hybrid molecular "artscience," preconceptions about the relations between arts and sciences must be altered. Chief among these is the persistence of Comteian positivism among modern scientists. The early nineteenth century philosopher Auguste Comte described knowledge as ever more reliable (or "positive"), the greater its quantifiability and mathematization. The result is a "ladder" that rank orders scientific disciplines from mathematics – the most "positive," because provable – to the social sciences – the least "positive," because unquantifiable (fig. 1). According to some scholars, the arts have FIG 1 no positive status at all because they produce no testable knowledge.[4] The arts,

it follows, may benefit from an infusion of science to make them more "positive," but sciences cannot benefit from the arts.

Modern philosophers of science have generally rejected Comteian positivism, replacing quantifiability and mathematization with criteria such as internal consistency, scope of explanation, predictive capacity, and falsifiability. More importantly, philosophers such as Sir Karl Popper have separated our understanding of the psychology of discovery that leads to experimentation and hypothesizing from the logic analysis, quantification, and mathematization that tests its results. How a scientist generates ideas for testing, Popper argues, is just as non-rational (which is not the same as irrational!) as in any art, and is as imbued with subjective, emotional, and sensual elements. Popper once suggested to a conference of scientists that they adopt an approach to idea generation that resembles the art of acting: "I think the most helpful suggestion that can be made [...] as to how one may get new ideas in general [is] [...] 'sympathetic intuition' or 'empathy' [...]. You should enter into your problem situation in such a way that you almost become part of it."[5]

Popper's empathetic methodology is not uncommon among the most creative scientists. Peter Debye, who won the Nobel Prize in Chemistry in 1936, said in one interview that the key to his insights was, "to use your feelings – what does the carbon atom *want* to do? You had to [...] get a picture of what is happening. I can only think in pictures."[6] MIT metallurgist Cyril Stanley Smith stated, in even more sensual and intuitive terms: "In the long gone days when I was developing alloys, I certainly came to have a very strong feeling of natural understanding, a feeling of how I would behave if I were a certain alloy, a sense of hardness and softness and conductivity and fusibility and deformability and brittleness – all in a curiously internal and quite literally sensual way, even before I had a sensual contact with the alloy itself. [...] My work on interfaces really

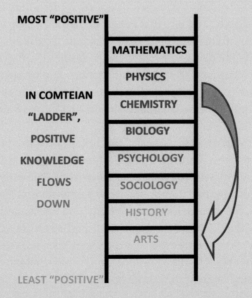

FIG 1 Comteian "ladder" of positive
scientific knowledge

began with a combination of an aesthetic feeling for a balanced structure and a muscular feeling of the interfaces pulling against each other!"[7] Nobel Prizewinner Wolfgang Pauli (Physics, 1945) added that such feelings are pre-logical and non-rational, beginning in the "unconscious region of the human soul," where, "the place of clear concepts is taken by images of powerful emotional content, which are not thought, but are seen pictorially, as it were, before the mind's eye."[8]

Aesthetics is an integral part of these sensual, emotional, intuitive forms of creative thinking. Nobel laureate (2000) Alan G. MacDiarmid said that his discovery of conductive plastics began one day when he was shown a polymer to which too much catalyst had been added. The result was an amazing silvery plastic material that was so beautiful he had to investigate its properties. "There were no scientific reasons whatsoever. My motivations have been driven by curiosity and color [...]."[9] Linus Pauling (Nobel Prize, Chemistry, 1954) also said that success in science comes from the aesthetic considerations posed by a problem: "What ideas about this question, as general and as aesthetically satisfying as possible, can we have that are not eliminated by these results of experiment and observation?"[10] Fellow Nobel laureate William Lipscomb (Chemistry, 1976) also expanded on this aesthetic theme: "I would certainly not separate aesthetics from science. When, after years of research I realized that a whole area of chemistry (of boron) was really quite different from anything that had previously been thought, I felt a focusing of intellect and emotions which was surely an aesthetic response. It was followed by a flood of new predictions coming from my mind as if I were a bystander watching it happen. Only later was I able to begin to formulate a systematic theory of structure, bonding, and reactions of these unusual molecules. Both the structures and wave functions describing the bonding were based on simple polyhedra of high symmetry and their fragments (figs. 2a, 2b). Was it science? Our later tests showed that it was. FIG 2 But the processes that I used and the responses that I felt were more like those of an artist."[11]

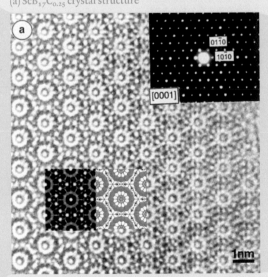

FIG 2A Structures of boron compounds:
(a) $ScB_{17}C_{0.25}$ crystal structure

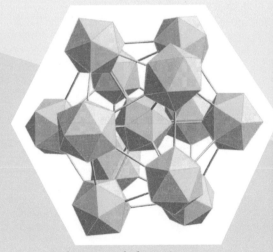

FIG 2B Thirteen-icosahedron unit
$(B_{12})_{13}B_{12}$ (supericosahedron)

Here is the problem: perversely, while science relies on consistency and reproducibility of results, the route to these results is invariably infused with subjective emotion and aesthetic intuition. The purpose of the scientific method is to eliminate the idiosyncratic, intuitionistic, sensual, emotional and aesthetic explorations of possibilities that generate ideas, imposing objectively verifiable arguments and results afterwards.[12] But to ignore the intuitive and aesthetic means by which scientific arguments and results originate does great harm to science-in-the-making and simultaneously belittles the very arts that feed scientific originality. As Lipscomb noted, "So little of these matters are accessible in our schools and universities [that] if one actually set out to give as little help as possible to both aesthetics and originality in science, one could hardly devise a better plan than our educational system."[13] Note Lipscomb's linkage of aesthetics with originality in science – precisely the point that I now want to develop.

My view of the interactions between sciences and arts is as different from Comte's as is possible because I am not interested in results, but in the processes that yield innovative insights that, in turn, yield results. In my conception of the universe of innovation, there are four major elements: sciences, technologies, aesthetics, and media, the latter two being the chief products of the arts. I conceive of their relationships in terms of an integral tetrahedron (fig. 3) in which every possible linkage among the components is present and equally robust. Thus, new sciences create new media; new media create new sciences; new media create new aesthetics; new aesthetics create new media; new aesthetics create new sciences; new sciences create new aesthetics; and all of these interactions help to create, and are mediated by, technologies. To simplify the discussion that follows, I will generally assume without explication the self-evident links among technologies and sciences, technologies and media, and media and aesthetics. My focus will be on the often inobvious ways that sciences interact directly with media and aesthetics.

The influence of sciences on media is clear-cut. Chemists invented paints, inks and dyes, photography, plastics, and many other media that artists make use of daily. Physicists invented polarizing filters, lasers, holograms, electronics, fiber optics, all of which have been adapted to artistic uses. The much more interesting question is whether the influences are symmetrical: do new media ever create new sciences?

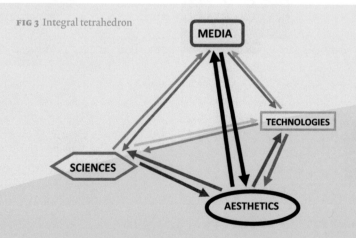

FIG 3 Integral tetrahedron

The answer is yes. One example directly relevant to molecular aesthetics is the way that the artistic medium of *moiré* helped to create diffraction gratings and a new science of analogue computation. Moiré is an optical effect caused by the overlap of two or more patterns at an angle that creates intersections between the patterns and results in a novel, third pattern. The term comes from fabric that has a "watered" or shimmery look (fig. 4). The moiré phenomenon was apparently known in China and the Middle East many centuries ago, and moiréd fabrics were purposefully produced for commercial purposes in Europe by the Reformation. Moiré itself became a popular art-pastime in Victorian England.[14] FIG 4

Modern artists such as Jesús Rafael Soto (fig. 5), Frank Malina, and François Morellet began exploiting moiré effects in paintings and sculptures by 1950, and the success of their explorations of optical art created a much wider appreciation of moiré than ever before. FIG 5

Among those people captivated by moiré phenomena was the physicist Gerald Oster, who not only began making moiré artwork himself, but more importantly recognized, through his analysis of the causes of the moiré effect, that it represented a novel way of generating solutions to complex calculations.[15] Oster realized that each set of lines in a moiré pattern represents a set of numerical solution to one equation. To obtain a moiré effect, one needs to offset several sets of lines, which represent several simultaneous equations (fig. 6). FIG 6 The resulting moiré pattern is the set of common solutions to that set of simultaneous equations. In other words, every moiré pattern is the analogue solution to a complex mathematical problem. Oster also contributed to the invention of a moiré microscope that could image patterns in materials otherwise too small to bring into focus.[16] In this instance, fabric and fine art forms of moiré directly influenced the invention of novel forms of both mathematics and science.

Another example of a new medium that helped foster new sciences is Richard Buckminster Fuller's invention of the geodesic dome, and his concept of geodesy more generally (fig. 7). Fuller elaborated his dome concept over the period FIG 7 1930–1960, demonstrating that the structure was the most stable and space-filling one possible. Applications of it ranged from the design of houses and playground apparatuses to radar domes, and as a design element, it became ubiquitous in modern society.

At least two sciences benefited from Fuller's architectural studies. One was the study of spherical viruses. In 1961, virologists Robert Horne and Peter Wildy realized that the same design principles that made geodesic domes structurally stable, and optimally designed to enclose the greatest volume with the least material, also made such dome structures perfect adaptations for the capsids of viruses (fig. 8), which had evolved to enclose and protect viral genetic mate- FIG 8 rial.[17] Both Horne, who was himself an artist, and Wildy cited Fuller's priority in working out the mathematical and structural details of such structures.[18] Similarly, the familiarity of Harold Kroto and Richard Smalley with geodesic dome structures (Kroto, in part, because he had seriously considered becoming a professional designer) played a crucial role in their recognition that a novel carbon molecule they had synthesized was a dome composed of sixty carbon atoms arranged like a soccer ball (fig. 9). They appropriately named the com- FIG 9 pound buckminsterfullerene.[19]

A third example of a new medium leading to novel scientific approaches is tensegrity. Tensegrity is a structural concept invented by a student of

FIG 4 Moiré fabric

FIG 5 Jesús Rafael Soto, *La Spiral*, 1950

FIG 6 Gerald Oster, *The Science of Moiré Patterns*, book cover, 1964

FIG 7 R. Buckminster Fuller, *Geodesic Dome*, 1965, patent drawing, figure 3 from Fuller's 1965 U. S. Patent 3197927

FIG 8 Graham Colm, computer assisted reconstruction of a spherical virus structure (rotavirus particle), 2008

FIG 9 Fullerite, a mineral formed by the crystallization of multiple buckyballs (Buckminsterfullerene, $C_{60}$)

Buckminster Fuller named Kenneth Snelson (although Fuller later tried to take credit for it![20]), in which structural integrity results from the tension of flexible elements acting upon inflexible ones, producing compression (figs. 10a, 10b). Not only has the vibrant field of tensegrity engineering produced everything from bridges to tents and ultralight structures for working in outer space, but the concept led directly to the development of a new research area within cell biology. As with the story of geodesy and the elucidation of virus structures, tensegrity cell biology resulted from the widespread penetration of tensegrity into modern culture. Snelson's tensegrity sculptures appeared in many museum collections and public spaces, and art journals carried instructional articles on how to make such sculptures at home.

Two individuals whose imaginations were captured by this novel art form were cell biologists Donald E. Ingber of Harvard University and Steven R. Heidemann of Michigan State University.[21] Since both decorated their dorm rooms

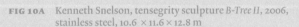

FIG 10A  Kenneth Snelson, tensegrity sculpture *B-Tree II*, 2006, stainless steel, 10.6 × 11.6 × 12.8 m

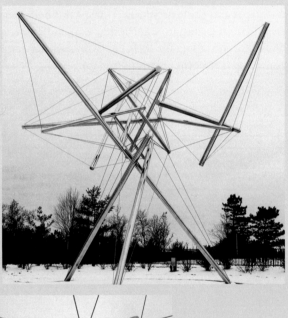

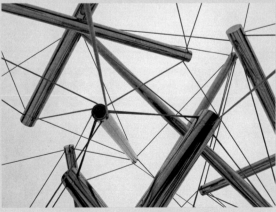

FIG 10B  Kenneth Snelson, *B-Tree II*, 2006, close-up of wire-rod tension

during their graduate studies with home-made tensegrity sculptures, they were unusually familiar with the medium. Ingber realized that the proteins within cells could be considered to be tensegrity structures, and suggested this to Heidemann at a cell biology meeting in the early 1980s. This insight led to the creation of a new field of study within cell biology that has generated hundreds of articles, and whose images have since captured the covers of dozens of journals including *Scientific American* and *Science* (fig. 11).

Another inobvious aspect of the integral tetrahedron is that new sciences can create new aesthetics. An example of direct relevance to molecular aesthetics is the popularization of x-ray crystallographic results. X-ray crystallography was invented in 1912 by the father-son team of William Henry and William Lawrence Bragg, who were awarded the Nobel Prize in 1915. By the 1950s, at the hands of scientists such as Helen Megaw, Dorothy Hodgkin, and John Desmond Bernal, the technique was solving the structures of enzymes and antibiotics and earning scientists a new round of Nobel prizes. Stimulated by a British government program designed to popularize science as part of the 1951 Festival of Britain, Megaw had the brilliant idea of transforming the patterns generated by x-ray crystallographic experiments into patterns for the use of fabric, wallpaper and china designers. Toward this end, Megaw helped set up the Festival Pattern Group in Manchester, England and convinced Bernal, Hodgkin, and other crystallographers to contribute their x-ray patterns, which were then converted into design patterns (fig. 12).

FIG 12 Stoddard Templeton carpeting produced for the Festival of Britain, 1951, left: an interpretation of the x-ray crystallographic pattern of insulin; right: an interpretation of the x-ray crystallographic pattern of pentaerythritol

FIG 11 Composite image of covers of major science magazines that have featured cellular tensegrity

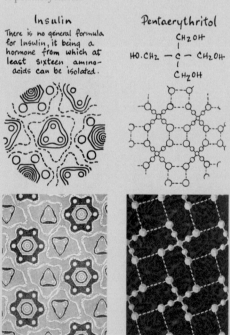

A proud homeowner could buy china decorated in a mica pattern, wear a tie or scarf printed with resorcinol or cover their walls or floors with Hodgkin's painted interpretation of the insulin crystal structure![22]

The science of chromatography also played a role in developing a new molecular aesthetic of "self-grown pictures." During the late nineteenth century, a chemist-turned-artist, Friedlieb Ferdinand Runge,[23] and a biophysicist, Stéphane Leduc,[24] began experimenting with making "pictures" by serial additions of various chemicals capable of interacting to produce highly colored precipitates. As the chemicals were adsorbed into – then diffused through – paper or gels, strange organic forms would spontaneously result, producing imaginary "gardens" the imagination could wander through (fig. 13). The new aesthetic medium garnered significant public interest, particularly as Leduc linked his images with the possibility that life itself had evolved from chemical origins in a manner similar to the way he created his "pictures" (figs. 14a, 14b).

FIG 13

FIG 14

**FIG 13** Self-forming image by Friedlieb Ferdinand Runge, in: Runge, *Das Od als Bildungstrieb der Stoffe*, Oranienburg, Germany, 1866

**FIG 14B** Self-grown picture by Stéphane Leduc, in: Leduc, *The Mechanism of Life*, Rebman, New York (NY), 1911, p. 145

**FIG 14A** Self-grown picture by Stéphane Leduc, in: Leduc, *The Mechanism of Life*, Rebman, New York (NY), 1911, p. 83

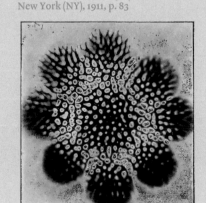

The links from Runge, and particularly Leduc, to early twentieth century art movements, such as Dadaism and Surrealism with their automatic forms of image making, are particularly clear.[25]

Notably, then, the links between aesthetics and science can run in both directions so that new aesthetic systems give rise to new scientific insights. One example is the discovery of the first "high temperature" superconductor (a material that transfers an electrical current without resistance) in the mineral perovskite by Karl Alexander Müller in 1986 (fig. 15). Müller revealed in interviews that his choice of perovskite was not rational, but based upon an unusual symmetry that endowed the mineral with special aesthetic qualities. "The perovskite structure was for me, and still is, a symbol of – it's a bit high-fetched – but of holiness. It's a mandala, a self-centric symbol which determined me [...]. I dreamt about this perovskite symbol while getting my PhD. And more interesting about this is also that this perovskite was not just sitting on a table, but was held in the hand of Wolfgang Pauli, who was my teacher [...]. I was always dragged back to this symbol."[26] Recall that Pauli was the scientist who proclaimed that science begins, not with logic, but with feelings that are pre-logical, emotional and pictorial. Given Pauli's and Müller's successes, this aesthetic approach to discovery is surely one that should be more widely taught to students of chemistry!

The discovery of "quasicrystals" provides another example of how a new aesthetic sensibility can permit scientists to perceive things they otherwise overlook. Quasicrystals are materials that are ordered but not periodic. The concept of such aperiodic orderings was developed mainly by mathematical physicist Roger Penrose, but as part of his second career as an innovative artist rather than as a physicist. Penrose and his biologist father were both extraordinary artists who invented such well-known objects as the impossible triangle and the endless staircase, both of which featured prominently in the artwork of their friend M. C. Escher. Escher, in turn, stimulated the younger Penrose to explore tiling surfaces with various interlocking figures. But Penrose became bored with mimicking Escher, and wanted to explore new possibilities – such as tiling a surface with regular shapes in such a way that the pattern never repeated itself. After a few years' effort, he discovered a pair of simple tiles that produced such a non-repeating "aperiodic tiling" (fig. 16).

FIG 15

FIG 16

**FIG 15** Model of a perovskite structure

**FIG 16** Penrose tiling

274

One of the unexpected outcomes of his artistic explorations was the discovery that these tilings had pseudo-five-fold symmetry. This artistic discovery was quite surprising: geometricians had long before proven that it was impossible to tile a surface with a regular pentagon, and yet Penrose's tiles often had the appearance of incorporating innumerable regular pentagons.

When Penrose's tiling art was popularized in Martin Gardner's January 1977 "Recreational Mathematics" column in *Scientific American*,[27] an even more surprising discovery soon emerged. For decades, crystallographers had been obtaining data showing apparent five-fold symmetry in the structures of various metal alloys, but having been taught that such symmetry was impossible, had literally been throwing the data away.[28] An Israeli chemist by the name of Daniel Shechtman decided that the five-fold symmetry was real and could be explained by Penrose's tilings (fig. 17). Shechtman was awarded the Nobel Prize in  FIG 17
Chemistry for his discovery of such pseudo-five-fold symmetric, non-repeating "quasicrystals" in alloys.

M. C. Escher had a more direct impact on molecular sciences by inspiring Nadrian ("Ned") Seeman to invent the first DNA nanostructures. Seeman was trained as a crystallographer whose interest was in studying proteins and in transient structures such as the Holliday junctions (DNA quadruplexes) that formed between pairs of DNA double helices, both of which were very difficult to crystallize. How, he wondered, could one produce stable structures that would reveal the secrets of these molecules? Sitting in a bar one day, he conjured up the image of Escher's lithograph *Depth* (fig. 18), which shows a series of sharks ordered  FIG 18
in a crystalline pattern in three dimensions.

FIG 17 J. W. Evans, Atomic model of five-fold icosahedral-Al-Pd-Mn quasicrystal surface, 2007

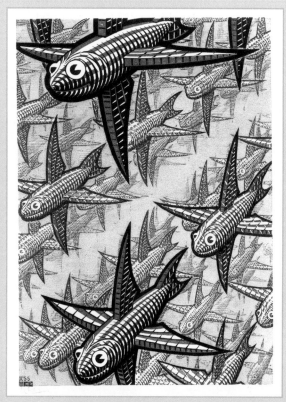

FIG 18 M. C. Escher, *Depth*, 1955, wood engraving in brown-red, grey-green and dark brown, printed from 3 blocks

Seeman immediately realized that he could synthesize stable DNA lattices that would link each "shark" to the others in three dimensions. Such stable lattices would not only permit the study of DNA interactions such as Holliday junctions, but also provide a matrix for incorporation of proteins that would oth-

FIG 19

erwise not crystallize on their own. The resulting structures (fig. 19) became one of the foundational technologies in the emergence of nanochemistry.[29] Art continues to be a driving force in Seeman's work in this area: "To be sure, one can learn a vast amount about a molecule from staring at an accurate model of it. More importantly, however, we also can come up with new structural ideas about DNA from looking at – as well as thinking about – things that are *not* DNA [...] paintings or sculptures. Paintings and sculptures often look different from our own mental images, those we held before looking at the art. These differences can prompt ideas, because they give us permission to consider the image in different terms. As a structural scientist, I have found that these differences can lead to interesting notions, even experiments, and new paths to explore. I am a visual person who looks to art for inspiration. [...] Art is an excellent way to discover new avenues of scientific exploration, as well as to see interpretations of discoveries that already exist."[30]

In short, the pathways between arts and sciences are two-way streets mediated by media and aesthetics. Artists are just as capable of imagining novel concepts, materials, methods, and connections as are scientists, and scientists who know art can benefit from these insights. To do so, however, scientists must let go of the notion that their knowledge is somehow superior to that of the artist and embrace, instead, the conviction that science is just as shot through with imagination and creativity, intuition and aesthetic assumptions, as any art.

Thus, we scientists must abandon our reliance on a "scientific method" that is as outdated and misleading as the positivist philosophy upon which it is founded. We must embrace instead a very different view of how science comes into being, a view that has perhaps best been described by Nobel Laureate (Physiology, 1965) François Jacob in his autobiography: "I came to understand that contrary to what I had believed the march of science does not [...] advance along the royal road of human reason, or result necessarily and inevitably from conclusive observations dictated by experiment and argumentation. I found in science a mode of playfulness and imagination. [...]

FIG 19 Concept behind Nadrian Seeman's DNA lattice for crystallizing molecules, in: Seeman, et al., "New Motifs in DNA Nanotechnology," draft paper for a talk at the Fifth Foresight Conference on Molecular Nanotechnology, 2011

The game was that of continually inventing a possible world, and then of comparing it with the real world."[31]

I certainly play with such possible worlds in my own scientific research, and use art and aesthetic considerations to explore these imaginary worlds. The problem I focus on is how all of the molecules involved in living systems have become integrated into one completely coherent, interactive network – something often referred to as an "interactome" – when the molecular constituents of inorganic nature rarely interact at all.[32] I believe that the solution involves molecular complementarity, the stereospecific (meaning shape-dependent) non-covalent (meaning weak and reversible) interactions of molecules. But in proposing such a solution, I am working far beyond any available data, so I have to *imagine possible worlds* in which molecular complementarity might produce the kind of networked set of molecular interactions observed in real living systems.

In order to explore these possible worlds, I have always relied on artwork. Some of this artwork is a combination of Escher-like tilings and Gestalt imagery in which I explore the ways in which shapes not only select, but also define, one another, co-evolving as a change in one shape forces modifications on the others (fig. 20). In another type of artwork, produced in collaboration with transmedia artist Adam W. Brown, we are actually creating imaginary chemical worlds

FIG 20

FIG 20 Robert Root-Bernstein, *Evolution II*, 2008

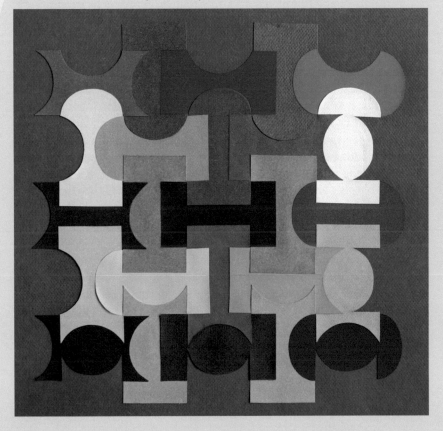

within sculpted apparatuses to explore whether the molecules behave as my im-
FIG 21 agination suggests they might (fig. 21). Doing such "experiments" as perfor-
mance art frees us to explore possibilities that scientific peer reviewers find too
radical. So like so many artists before us, we must break rules in order to discov-
er new ones.

The critical point is to realize that our vision of the world is constantly chang-
ing and that it takes a combination of sciences and arts to do so. Art is about
how nature might work; science is about how nature actually works; aesthet-
ics is about why we care about how nature works; and technology is about how
we implement what we understand. To make progress, we need to have all four
parameters working in tandem. This integration of ways of knowing is some-
thing that my wife and I have termed "synosia," namely, knowing what you
feel, and feeling what you know. The concept is not entirely novel. For example,
chemist Michael Polanyi argued in his book *Personal Knowledge: Towards a Post-
Critical Philosophy* (1958) that all creative acts – especially those of scientists – are
inseparable from strong emotional commitments, personal feelings and pas-
sions. Not only is objectivity impossible, but it is counter-productive because
it divorces the scientist from the primary, tacit forms of direct sensual experi-
ence and intuitive understanding necessary to imaginative research. This im-
aginative exploration of possibilities must, of course, be constrained by rigor-
ous and skeptical testing in order to qualify as science, but without the sensual
feelings and emotional passions, we, like Polanyi, are doubtful that the best sci-
ence would ever be done.

Thus, I have proposed that in addition to formal, logical ways of knowing
the world, there is a complementary way that I call "aesthetic cognition."[33]
Aesthetic cognition asserts that all understanding is embodied, generating
emotional and sensual responses that are identical to those associated with the
arts. Moreover, there is a "meta-logic" to these intuitive responses that is em-
bedded in what we call aesthetics. We *feel* that a scientific hunch will pay off be-
cause it has the same aesthetic attraction – consistency, quality, beauty, surprise,
insight – that we find in the greatest art. Yet such an attraction is not infallible:
a beautiful idea is not necessarily right, but an ugly one is surely wrong.

Aesthetics, then, is not an accidental outcome of good research, a serendipitous
bonus that adds icing to the cake of research; aesthetics is a way of thinking
about science that motivates research and informs its very content. Robert B.
Woodward (Nobel Prize, Chemistry, 1965) made this point clear when he said
the attraction of chemistry was, for him, its sensual aspects: "It is the *sensuous*
elements which play so large a role in my attraction to chemistry. I love crys-
tals, the beauty of their form – and their formation; liquids, dormant, distill-
ing, sloshing(!), swirling; the fumes; the odors – good and bad; the rainbow of
colors; the gleaming vessels of very size, shape, and purpose. Much as I *might
think* about chemistry, it would not exist for me without these physical, visual,
tangible, sensuous things."[34] How like the statements by Karl Popper, Peter De-
bye, Cyril Stanley Smith and Wolfgang Pauli with which I began this essay. How
unlike the usual description of the "scientific method" with which we pepper
our scientific talks and textbooks.

So here's the challenge: can we invent a molecular aesthetic that so completely
melds arts with sciences that one can experience what it is like to *be* a molecule?
Can we develop a molecular motivation so complete that we can understand

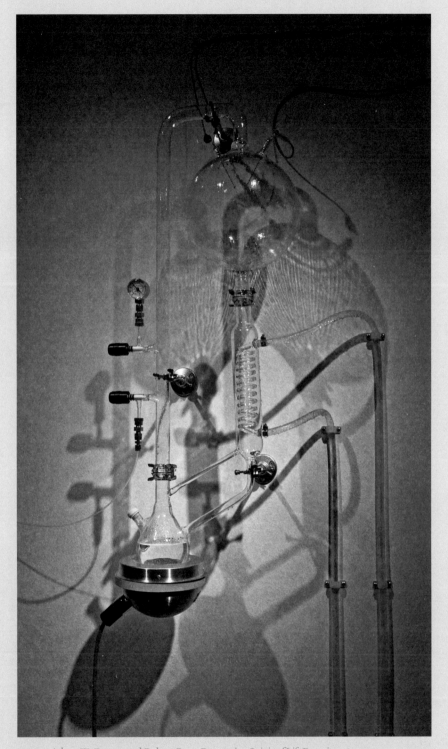

FIG 21 Adam W. Brown and Robert Root-Bernstein, *Origin of Life Experiment 1.4*, 2011

what a chemical system *wants* to do, how it will *behave*, even before we test it? Can we develop personal intuition so deep that we can *feel and see* what a new material will be like before we make it? Can we find ways to communicate the *sensuousness* of chemistry so that it can be experienced *as art*? Indeed, can we *make art* out of our scientific insights so that not only scientists, but every aesthetically stimulated individual can share the beauty of our research?

Please note that I am not asking for artists to come and interpret what chemists are doing, or to take the work of the chemist as inspiration. I am calling for something that is much deeper and more profound: I am calling for a true integration of the making of art and science simultaneously so that the inspirations of the scientist are manifested, not only as science, but also as art, neither one an interpretation or analysis of the other, but simultaneous modes of understanding that, like two eyes, reveal a stereoscopic vision impossible from any single perspective.

A very large proportion of the very best scientists have always been both artists and scientists, and there are good reasons for this fact. In order to be innovative, the chemist must be motivated and guided by aesthetic considerations, and in order to develop a sense of aesthetics, the scientist must also be an artist. Thus, as the physical chemist Max Planck wrote at the outset of his autobiography, "a creative scientist must be an artist [...]."[35]

In short, the purpose of this essay is to ask whether we can we replace the Comteian ladder of knowledge that places arts at the bottom rung and positive sciences at the top with a new tetrahedron that merges aesthetics, media, technologies and sciences into an integral and ineluctable whole. If we can do that, we will move beyond art and science to an *artscience*[36] that simultaneously inspires us to understand Nature and through understanding, inspires us yet again. Our work will yield, not only understanding manifested in new chemical theories and products, but beauty manifested as new artistic media and aesthetics. Making discoveries will yield art, and making art will yield discoveries! Then we will be able to achieve the deepest kind of knowledge, which is to know what we feel and feel what we know.

## Notes

1 Robert Root-Bernstein, *Discovering*, Harvard University Press, Cambridge (MA), 1989; Robert Root-Bernstein and Michele Root-Bernstein, *Sparks of Genius*, Houghton Mifflin Company, Boston (MA), 1999.

2 Robert Root-Bernstein, "The Sciences and Arts Share a Common Creative Aesthetic," in: Alfred I. Tauber (ed.), *The Elusive Synthesis: Aesthetics and Science*, Boston Studies in the Philosophy of Science, vol. 182, Kluwer Academic Publishers, Dordrecht, 1996, pp. 49–82.

3 Robert Root-Bernstein, "Aesthetic Cognition," in: *International Studies in the Philosophy of Science*, vol. 16, no. 1, 2002, pp. 61–77, doi: 10.1080/0269859012011837.

4 Thomas Kuhn, "Comment," in: *Comparative Studies in Society and History*, vol. 11, issue 4, 1969, pp. 403–412, doi: 10.1017/S0010417500005466; also in: Thomas Kuhn, *The Essential Tension: Selected Studies in Scientific Tradition and Change*, The University of Chicago Press, Chicago (IL), 1977, pp. 340–351.

5 Hans Adolf Krebs and Julian H. Shelley (eds.), *The Creative Process in Science and Medicine*, Excerpta Medica, Amsterdam, 1975, p. 18.

6 Peter Debye, "Peter J. W. Debye (interview)," in: Robert Colborn, *The Way of the Scientist. Interviews from the World of Science and Technology*, Simon and Schuster, New York (NY), 1966, p. 81.

7 Cyril Stanley Smith, *A Search For Structure*, The MIT Press, Cambridge (MA), 1981, p. 353.

8 Werner Heisenberg, *Across the Frontiers*, Harper & Row, New York (NY), 1974, pp. 179–180.

9 Eugene Russo, "Nobel Impact," in: *The Scientist*, vol. 14, no. 24, December 2000, p. 10.

10 Linus Pauling, "The Genesis of Ideas," in: *Proceedings of the Third World Congress of Psychiatry 1961*, vol. 1, University of Toronto Press and McGill University Press, Toronto, 1963, p. 47.

11 Dean W. Curtin (ed.), *The Aesthetic Dimension of Science*, Philosophical Library, New York (NY), 1982, pp. 3–4.

12 See: Root-Bernstein 1996, 1999.

13 Curtin 1982, p. 19.

14 Jearl Walker, "Moiré Effects, the Kaleidoscope and Other Victorian Diversions," in: *Scientific American*, December 1978, p. 182.

15 Gerald Oster and Yasunori Nishijima, "Moiré Patterns," in: *Scientific American*, May 1963, p. 54.

16 Gerald Oster, "Moiré Optics: A Bibliography," in: *Journal of the Optical Society of America*, vol. 55, October 1965, pp. 1329–1330.

17 R. Buckminster Fuller, "Conceptuality of Fundamental Structures," in: Gyorgy Kepes (ed.), *Structure in Art and in Science*, George Braziller, New York (NY), 1965, pp. 66–88.

18 R. W. Horne and P. Wildy, "Symmetry in Virus Architecture," in: *Virology*, vol. 15, issue 3, November 1961, pp. 348–373, doi: 10.1016/0042-6822(61)90366-X.

19 Gary Taubes, "The Disputed Birth of Buckyballs," in: *Science*, vol. 253, September 27, 1991, pp. 1476–1479, doi: 10.1126/science.253.5027.1476.

20 See: Valentín Gómez Jáuregui, "Controversial Origins of Tensegrity," in: Alberto Domingo and Carlos Lazaro (eds.), *Evolution and Trends in Design, Analysis and Construction of Shell and Spatial Structures: IASS Symposium 2009*, Editorial de la Universitat Politécnica de Valencia, Valencia 2009; available online at: http://hdl.handle.net/10251/6781, accessed 10/05/2012.

21 Donald E. Ingber, "The Architecture of Life," in: *Scientific American*, January 1998, pp. 48–57; personal interviews with Steven Heidemann.

22 Linda Jackson, *From Atoms to Patterns*, Richard Dennis, London, 2008.

23 H. H. Bussemas, G. Harsch, and L. S. Ettre, "Friedlieb Ferdinand Runge (1794–1867): 'Self-Grown Pictures' as Precursors of Paper Chromatography," in: *Chromatographia*, vol. 38, no. 3/4, February 1994, pp. 243–254, doi: 10.1007/BF02290345.

24 Philip C. Ritterbush, *The Art of Organic Forms*, Smithsonian Institution Scholarly Press, Washington, D.C., 1968, pp. 71–75.

25 Ibid.

26 Gerald Holton, Hasok Chang, and Edward Jurkowitz, "How a Scientific Discovery Is Made: A Case History," in: *American Scientist*, vol. 84, no. 4, 1996, p. 372.

27 Martin Gardner, "Mathematical Games: Extraordinary Nonperiodic Tiling That Enriches The Theory of Tiles," in: *Scientific American*, January 1977, pp. 110–119.

28 Paul J. Steinhardt, "New Perspectives On Forbidden Symmetries, Quasicrystals, and Penrose Tilings," in: *Proceedings of the National Academy of Sciences*, U. S. A., vol. 93, December 1996, pp. 14267–14270.

29 Nadrian Seeman, http://en.wikipedia.org/wiki/Nadrian_Seeman, accessed 02/25/2012.

30 Nadrian Seeman, "Knowledge in Context," in: *Leonardo*, forthcoming.

31 François Jacob, *The Statue Within: An Autobiography*, Basic Books, New York (NY), 1988, p. 8.

32 Robert Root-Bernstein, "A Modular Hierarchy-Based Theory of the Chemical Origins of Life Based on Molecular Complementarity," in: *Accounts of Chemical Research*, February 27, 2012, doi: 10.1021/ar200209k.

33 Robert Root-Bernstein, "Aesthetic Cognition," in: *International Studies in the Philosophy of Science*, vol. 16, no. 1, 2002, pp. 61–77, doi: 10.1080/02698590120118837.

34 Crystal E. Woodward, "Art And Elegance In The Synthesis Of Organic Compounds: Robert Burns Woodward," in: Doris B. Wallace and Howard E. Gruber (eds.), *Creative People at Work*, Oxford University Press, Oxford, New York (NY), 1989, p. 227.

35 Max Planck, *Scientific Autobiography and Other Papers*, Frank Gaynor (trans.), Philosophical Library, New York (NY), 1949, p. 4.

36 Robert Root-Bernstein, Todd Siler, Adam W. Brown, and Kenneth Snelson, "ArtScience: Integrative Collaboration to Create a Sustainable Future," in: *Leonardo*, vol. 44, no. 3, 2011, p. 192.

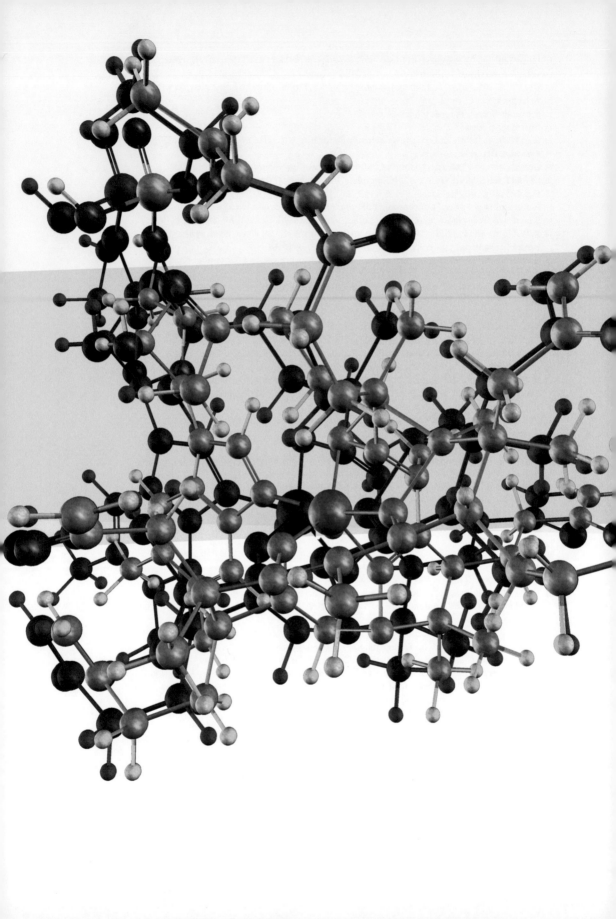

Roald Hoffmann
**Abstract Science**

*Abstraction, not just mathematics, has its place in science as it does in art.*

Is there an analogue in science to abstract art? A riposte might be, "Why should there be? Why ask science, so strongly tied to reality, to mimic the aesthetic games of the world of art?" Well, both art and science are created by human beings, and both are creative endeavors. So it might be interesting to look at any correspondences. No one-to-one mappings will be found, but let's relax that criterion and search for non-literal, imaginative analogies.

**Abstraction in Art**
It is not easy to define abstraction. Is the incised design in a 3,500-year-old Japanese Jomon jar (fig. 1) abstract art? Are the colored shapes of pre-Colombian FIG 1 Huari textiles abstract? Yes and no. Their imaginative power over us derives from form, color, texture, juxtaposition – all certainly elements of abstraction. Although we may not be privy to the layers of meaning from different cultures that are implicit in these objects, they do not appear to have been made in willed opposition to representation.
Although abstract art has been with us for only about one hundred years, sometimes it seems that there are more abstract art movements than there are scientific "-ologies." The list begins with cubism, and will not end with postmodern painting. Recognizing that there are degrees of the abstract, my perception of the essence of this artistic direction involves several factors.

First of all, abstraction is oppositional, wanting to be seen as alternative to such ideals as naturalistic representation and the figurative. I will not say "alternative to reality," for (to paraphrase René Magritte) the two-dimensional surface of the most photorealist painting still is not its subject. Not unexpectedly, much theory of the abstract disclaims a definition by opposition. Art desires a broader conception of what stirs the imagination.

Abstraction is also reductive. By that I mean that abstract art often takes some element of the artistic universe and explores all the tensions that it can get out of that element. Mondrian's squares create visual jazz, Mark Rothko's broad color swaths can evoke joy or destructive tension. And Alexander Calder's mobiles move, ever so slowly, around inner peace. The element abstracted may be a force, as in Elizabeth Murray's works that break out from a shaped canvas.

Here is a spirited early statement on abstraction by one of its founders, Kazimir Malevich. In his *From Cubism to Futurism to Suprematism: The New Realism in Painting*, published in 1915, he writes: "I have destroyed the ring of the horizon and left the circle of things ... in which the artist and the forms of nature are confined ... [The new art] moves to its own goal – creation." Like all reductive philosophies, abstraction from time to time lays claim to "purity." Such a claim is risky, as one might reflect where else in history such claims have been made, and for what purpose.

**What Can Chemistry Be Against?**

To be abstract, chemistry might thus have to be oppositional. But opposed to what? Nature, of course. Much good chemistry comes from imitating nature, because this ultimate tinkerer has been at it for a long time. At a chemical level in the biological universe, there is an almost bizarre seizing upon anything that works, and subsequent perfection of it by evolution: Here oxygen is carried

FIG 1 A Japanese bottle from the Late Jomon period (ca. 1,500–1,000 BCE)

by a red blood cell's heme group with iron (as in mammals), there it's a binuclear copper complex (as in mollusks and arthropods). So nature, among other things a chemist with lots of time on its hands, has found some effective strategies for making molecules and using their properties. It provides a "literature" that's worth reading, not exterminating.

Chemists in the laboratory are torn between emulating nature and doing things their own way. A protein, through its own curling and its tool kit of sidechain options, shapes a pocket where, say, a molecule with only right-handed symmetry fits. But it not only fits, it has something done to it – a specific bond in that molecule is cleaved, or an atom is delivered to it. The chemist's fun, much like abstract art, is in achieving the same (why not better?) degree of shape control that nature does, but doing it differently, perchance better, in the laboratory.

Here's an example, in the form of effective and specific delivery of hydrogen to an organic molecule. Nature does it, but Thomas R. Ward at the University of Basel in Switzerland and his coworkers have done it as well. As shown below, they attached a reactive inorganic piece (that's the Rh with its ligands) through a binding link (biotin, a type of B-vitamin) to a small "handed" protein (streptavidin). The latter is the equivalent of a baseball glove; the Rh piece a very lively deliverer of hydrogen, firmly ensconced inside. The close bond leads to a strongly "handed" chemical reactivity.

## Unnatural Products

Through synthesis, contemporary chemistry makes the objects of its own contemplation. In this way it comes close to art. For many molecules, utility is a distinguishing feature and a source of value, so that this science is poised between art and engineering. A kind of abstract art movement within chemistry is the effort expended on the synthesis of molecules with (chemical) formal elements that are prominent, but without apparent utility. A cube made out of DNA, a $C_{20}H_{20}$ molecule dodecahedral in shape, an amine that is not basic at all, a molecule whose overall oxidation (or loss of electrons) paradoxically causes reduction (or gain of electrons) of one piece of it – these curiosities carry the elements of surprise, of violation of the given. But are such molecules not more like surrealist art? Surrealism works off transgressions of normal conventions – Salvador Dali's wilted watch, René Magritte's play with reality.

## Analysis as the Path to Abstraction

A characteristic modus operandi in abstract art, from Russian constructivist times, has been the concentration on one or another component of the artistic whole. Issues of form – the center or the periphery, inclusion or exclusion, see-through or opaque, balance, color – are isolated. Ad Reinhardt's beautiful all-red and all-black paintings are a fine example of this concentration. The contemplative process here can lead to an exploration of the emotional possibilities of just that formal element. One sees this motif at work in Paul Klee's abstract paintings, or in Mark Rothko's color fields (fig. 2). Roberto Bertoia, a FIG 2 colleague at Cornell, works out beautifully in small wood constructions the feelings of confinement, protection and communication (fig. 3). FIG 3

Of course, science, from its Cartesian roots, has operated in just this way. If you want to understand something, take it apart, see how the pieces work, put it together (although too few people like to put things together...). Change only

one variable at a time, if you can. If you want to see how a chemical reaction proceeds, write a mechanism, a sequence of elementary steps. Once the mechanism is recognized, have research programs develop on the pieces and extend the work. Taking things apart, as science does, is a move shared with abstract art.

## Games in a Simplified World

Just as in abstract art, what emerges in science after things are taken apart ranges from Hermann Hesse's *The Glass Bead Game* (where the rules are only alluded to) to real understanding. In chemistry, there are many examples of paring away to get at the essence of an idea (rather than a molecule). One can see this in stereochemistry, which intently explores all the ways in which a molecule can be distinguished from its mirror image.

As another example, consider the synthesis of the two interlocked rings of cate-
<span style="letter-spacing:0.1em">FIG 4</span> naries, or the three of Borromean rings (fig. 4). The structures are real, and models of the molecules do look like physical rope knots or the Olympic symbol. But within chemistry I think there is a beautiful feeling of abstraction to them.

In another way, the small theoretical industry spawned by the work Charles Wilcox, Roger Alder, and I did on stabilizing square-planar carbon also has an abstract feel to it. That molecule's geometry is about as far as possible from that of a normal carbon atom with four atoms bonded to it at the corners of a tetrahedron. Our transgressive whim could be seen as playing games with

**FIG 2** Mark Rothko, *White Center (Yellow, Pink and Lavender on Rose)*, 1950

high-energy structures. However we, and others, immediately had therapeutic designs – for the molecules, not humans – to ameliorate the energetic suffering of such preposterous bonding configurations.

## Giving the Aleatory Its Due

One recurring theme in twentieth century abstract art is the tension generated by seeming chance at work, seen famously in Jackson Pollock's action paintings, but also apparent in conceptual art. And randomness exists in another way in ceramics, for instance, in the studied interplay of clay with plant, wood material or interposed objects controlling reduction or oxidation in wood-kiln firing in Bizen and Shigaraki Japanese ceramics (fig. 5).

FIG 5

An interesting counterpart in chemistry is the recent growth of combinatorial chemistry or diversity-based organic synthesis. The idea is to come up with a set of facile reactions that generate not one, but millions of diverse molecules within one beaker. In part, but only in part, this work has a biomimetic motivation. For at some stages nature introduces steps that are dispersed, to populate niche-seeking molecules. Most do nothing, but a few succeed. The workings of the immune system and the diverse structures resulting out of terpene synthesis are examples. But the laboratory generation of vast "libraries" of potential enzyme inhibitors or fuel-cell catalysts has a feeling of seeing the aesthetic value in chance.

FIG 3 Roberto Bertoia, *LPH3*, 2008

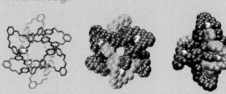

FIG 4 Three views of the three interlocked molecular loops of Borromean rings

FIG 5 Jun Isezaki, *Big Flower Vase*, bizen pottery piece

## Organic Synthesis as Music

Music is the most abstract art form. Programmatic tone-poems and birdsong or burbling-brook mimicry aside, music is more than imitation. As Igor Stravinsky said, "For at the root of all [musical] creation one discovers an appetite that is not an appetite for the fruits of the earth."

On one level, music is a patterned sequence in time of audible tones varying in frequency and volume, with overtones and harmonics. What makes music so much more than this dry definition is the strong psychobiological resonance that sound sequences have for humans. No art form is more abstract, I think, and no art form has an easier way into the psyche.

If time is the critical variable of music – in that for both melody and rhythm, the moment before and the moment after matter deeply – then perhaps organic synthesis proffers a rough scientific analogue. Take a sketch of the synthesis of penicillin by John C. Sheehan of MIT, made in the World War II era (fig. 6). Note that an RNCNR (it's called DCC, for dicyclohexylcarbodiimide) piece is added in, in the center of the scheme, and then at the lower left of the reaction, the piece comes off again, carrying along the elements of water. DCC (now widely used in laboratory synthesis of peptides) is an "activator"; it makes possible the formation of the crucial four-membered ring in penicillin. The process is firmly embedded in time. If the steps were reversed at any stage, one would have a different reaction, a different melody. Or even a failed synthesis, a discordant descent into chaos, black gunk in the flask.

What makes a chemical synthesis, arguably the most intellectually developed part of chemistry, very different from a musical work is that the synthesis is motivated by its aim – to make one type of molecule, and no other. A movement of a Beethoven quartet will have its crescendo and coda. But in the end there is silence again; the emotionally wrenching, contrapuntal path in time to that silence is what remains, to be experienced only when the piece is played again.

FIG 6

FIG 6 The synthesis of penicillin

penicillin V potassium salt

## Heating It Up

Abstract art is cold. And so is science. I put it this provocatively so as ultimately to work against this caricature, a prevalent one, I am afraid, of both abstract art and science. How can they both be "cold?" The way into emotion in abstraction (and the appreciation of science) is not direct. It has to be learned. Figurative portrayal, or even just the slightest evocation of the figurative gesture, may signal grief, tension, fear or love most directly. Sometimes it's done in just a few lines; this is how cartoons work I've seen people cry in the Rothko chapel in Houston, but they came with some appreciation of abstract art, and a contemplative mood.

Science's cross is our insistence on depersonalizing experience, if it is to be crowned as reliable knowledge. The dehumanizing process has been enhanced in the past two-hundred years by the third-person, neutered language of that ossified ritual format of our stock-in-trade, the scientific article. What violence that dull language, that rigid format, does to the scientific imagination! How it dissipates in jargon the underlying thrill of feeling, say, the reactivity of a molecule turned upside down by clever substitution! Here science and abstract art have shared the consequences of dealing out the figurative and emotional.

Immanuel Kant understood that the artistic response is stirred by paired responses in us. These replies are both the instinctive emotional reaction to an object or a process, and the cognitive play with what we see or hear. One way to characterize the problem of perception that abstract art and science share is that when the figurative, natural or personal are pushed aside, the cognitive is emphasized. And thinking seems less warm. Oh, beauty comes back, no way of keeping its subversive pleasures out of the soul. But the initial impression of a shift in emphasis from the emotional to the cognitive is … coldness. Once again, music is the (magical) exception.

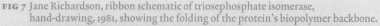

FIG 7 Jane Richardson, ribbon schematic of triosephosphate isomerase, hand-drawing, 1981, showing the folding of the protein's biopolymer backbone.

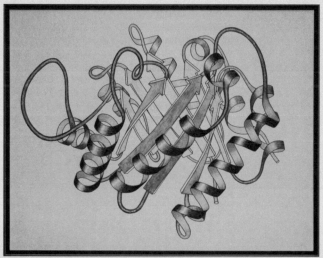

To restore emotion is harder for science than for abstract art. Form and color combine to make Wassily Kandinsky's compositions kinetic and joyful. The formal tensions at work in Bertoia's enclosures and Reinhardt's paintings reward the viewer with the feeling that something is at stake. We are drawn in to look intently and the thought emerging out of that contemplation carries emotional import, as the abstraction shapes a passage to the soul. As Reinhardt wrote: "May not one side of me speak up for the side of the angels?"

### The Obvious, Last

In science, we distance reality by representing it, in molecular models or mathematical equations. There is risk in that distancing, but also tremendous power – for instance, the calculus, along with a mathematical technique called perturbation theory, allows us to calculate the path of a Mars lander to a few meters. The representations of science are both iconic and symbolic – they look like the thing and they are arbitrary. The lines in the ball-and-stick model of a molecule do give one a rough idea of the relative microscopic distances; the atom labels are just a convention. The representations are then manipulated on paper, on computer screens and in our minds with all the conventions of art – and that includes abstract art. So we focus in a cubist way on one part of a molecule, distorting it, and we indicate forces with Klee arrows. And when we need to represent essences, to focus in on what matters, we simplify, often in the way artists did in the beginning of abstract art in the twentieth century.

FIG 7 Consider the problem of representing the essential backbone of proteins – biopolymers whose chains are sometimes helical, or sometimes stretched out with a pleated appearance. Its similarities and differences from protein to protein must be perceived. In the early 1980s Jane Richardson of Duke University invented a "ribbon" representation that is based on the reality of molecular structure obtained from experiment (fig. 7). The ribbon representation, an abstraction I would say, was a genial idea. First done by hand, now computerized, this way of seeing has shaped the way we imagine proteins in our mind's eye.

Abstraction, both through equations and simplified representations of molecular structure, is an essential mechanism of science. But analogies to abstract art and music also enter in other ways – in the opposition to the natural, in playful and purposeful pursuit of essences, in the way time and chance are given their due. In science and art both, we create and discover meaning.

### Acknowledgment

I am grateful to Bruce Ganem for discussions.

First published in: *American Scientist*, vol. 97, no. 6, 2009, pp. 450–453.
Reprint with permission of *American Scientist*, the magazine of Sigma XI, The Scientific Research Society.

**Bibliography**
Roald Hoffmann and Pierre Laszlo, "Representation in Chemistry," in: *Angewandte Chemie International Edition*, vol. 30, no. 1, 1991, pp. 1–16, doi: 10.1002/anie.199100013.
Mel Gooding, *Abstract Art*, Tate Publishing, London, 2001.

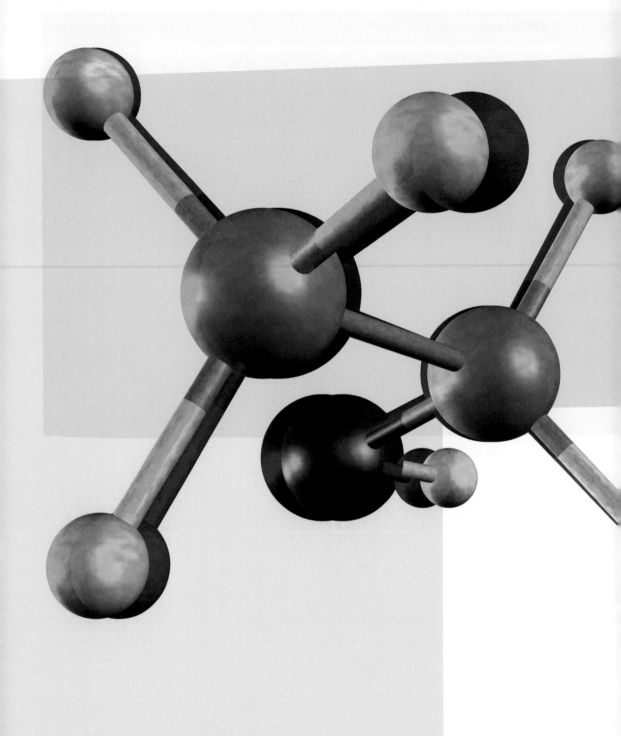

Thierry Delatour
**Molecular Songs**

Since my teenage years, I have been fascinated by twentieth century musical creations and sound synthesis. In 1993, I accumulated fourteen years of research laboratory experience in the study of molecular vibrations, and earned my spurs in digital synthesis and sound sequencing. At that time, some questions forced themselves upon me: could it be possible to translate the microscopic atomic vibrations in molecules into audible sound vibrations? If so, what kind of auditions could be obtained? Would it be possible to create molecular musical works that were both artistic and useful for the scientist?

The work presented here is the result of research of the rigorous and exhaustive translation of scientific data called *vibrational spectra* into sounds and music (see, for example, Track 1). The approach is both artistic: sound design and musical composition, and scientific: obtaining additional information from scientific experiments by means of the unusual acoustic display of data. Further, it is multisensory in that it uses the audition channel in addition to the traditional visual one.

This text will detail the method for translating molecular vibrations into sounds, and I hope to show that much more acoustic information – such as molecular sounds, musical scales, and musical pieces – can be obtained by this process.

To demonstrate how creating a molecular music is indeed possible, I will focus on four different topics:

1. The introduction to theoretical and practical aspects of spectrometry; a step necessary to specify the nature and properties of molecular vibrations, and to optimize the impact of the spectrometric data which must be converted further;
2. The methodology for basic acoustic conversion of molecular vibration spectra;
3. The strategy of extending the previous basic method into a more powerful and general acoustic conversion method;
4. A critical reflection about molecular music followed by the applications of this process.

## Theoretical and Practical Aspects of Vibrational Spectrometry

FIG 1 Molecular spectrum is a two-dimensional diagram (fig. 1) showing bands or peaks above or below a baseline. Such a spectrum results from an interaction between electromagnetic waves (infrared, visible, or ultraviolet) with the matter (molecules, crystals...). The x-axis, expressed in frequency $\nu$, wavelength $\lambda$ or wavenumber – the inverse of wavelength – $\sigma$ unit, is related to the energy of this interaction. The y-axis, expressed in various units (transmission percentage, absorbance A, or arbitrary unit), is related to the intensity of this interaction. With specific peak positions and intensities, each spectrum of a chemical substance sample represents a true fingerprint of this substance.

It is key to understand what we mean by electromagnetic wave. From an undulatory point of view, the simplest, monochromatic, electromagnetic wave has the aspect shown in figure 2: an electric field ($\vec{E}$) and a magnetic field ($\vec{B}$), perpendicular to each other and describing a sine wave in a perpendicular propagation direction z and at a speed equal to the speed of light, for example $c = 3.10^8$ m/s in vacuum. This wave is characterized by its wavelength $\lambda$, which is the distance between the nearest points of equal field intensity at a given time.

Wavelength is used to define the frequency as $\nu = c/\lambda$ (in Hertz, GHz, THz...) and the wavenumber $\sigma = \nu/c = 1/\lambda$ (in $m^{-1}$ or $cm^{-1}$), which is the often used spectroscopic unit.

Electric and magnetic field oscillating directions can change with time and space, defining specific wave polarization characteristics. Apart from the special case of the laser radiation, usual electromagnetic waves, such as those contained in sunlight, are both polychromatic and unpolarized. Any monochromatic wave can also be described in terms of an energy quantum (photon), which has an electromagnetic energy $E_{PH}$ defined by Planck's formula (fig. 2).

FIG 1 Typical aspect of a molecular spectrum: example of the N-methylacetamide infrared absorption spectrum

FIG 2 Typical aspect of a monochromatic electromagnetic wave: Planck's formula

Let us now consider matter at the molecular level. Molecules are made of atoms linked by chemical bonds; these bonds result from random electron motions between the atoms that act as a sort of dynamic cement. More generally, there are different molecular motions that contribute to the whole dynamic process:

- electronic transitions between specific spatial zones of the atoms or molecules;
- molecular rotations (except in the solid phase);
- molecular vibrations, the result of periodic atomic displacements within the same molecule;
- additional external vibrations, occurring in solids (in crystals, for example);
- global microscopic translations, occurring solely in molecules in the gas phase.

At the microscopic level, atomic and molecular energies are quantified, meaning that discrete electronic, rotational, and vibrational energy levels exist, and absolute frequencies or wavenumbers may be derived from them using Planck's formula (fig. 2). The translation movement is the only one that cannot be quantified, since it is not spatially limited. For each energy level, wave functions describing statistical spatial distributions of particles, atoms and electrons alike, can all be defined. FIG 2

A closer look at molecular vibration movements and their quantification shows, that numerical values of vibrational frequencies are typically located in the 12–120 THz region, an extremely high and completely inaudible frequency domain. If we translate this into more manageable wavenumbers, this domain is some 4,000–400 cm$^{-1}$.

A global molecular movement can be described as a combination of simple elementary movements known as normal modes of vibration. In the pure liquid ethanol molecule (fig. 3, left), for example, the CH$_3$ symmetric stretching mode FIG 3 occurs near 2,900 cm$^{-1}$, the O-H stretching mode near 3,300 cm$^{-1}$, and the O-H bending, near 1,400 cm$^{-1}$. For a molecule containing N atoms, a set of (3N-6) normal modes exist – or (3N-5) if the molecule is linear. For each normal mode, vibrational energy E$_v$ is quantified and mathematically expressed as a function of an integer – including zero – vibrational quantum number, v. There are both fundamental (v = 0) and excited (v > 0) vibrational energy levels. For each vibra-

FIG 3 Left: some vibrational normal modes for the ethanol molecule; right: corresponding energy diagram

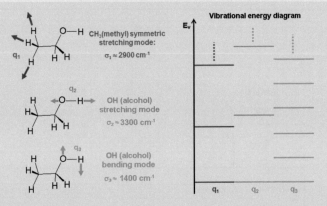

tional level, there is a related vibrational wave function $\psi_v$, which can be defined by two multiplicative terms: the time-dependent term is a cosine function, and the spatial-dependent term is a function of a vibrational normal coordinate q (for a diatomic molecule, q is simply the algebraic variation of the bond length). The hierarchy of vibrational energy levels is illustrated in figure 3 (right).

FIG 3

Electromagnetic waves of appropriate energies can induce transitions between vibrational energy levels, leading to vibrational spectra. The peak- or band- frequencies observed in these spectra are proportional to differences between vibrational energies, and not to absolute energies. The important question concerns what the molecular interaction processes leading to such spectra are.

The vibrational absorption process needs infrared electromagnetic radiation, and is symbolized by an incoming photon and a rising vertical arrow; vibrational emission is symbolized by the inverse diagram (fig. 4, left). In these two processes, the photon energy corresponds to the exact energy difference between the two considered energy levels, and the interaction energy is related to the scalar product of the incoming electromagnetic wave electric field ($\vec{E}$) with a molecular bond dipole moment ($\vec{p}$).

FIG 4

In contrast to absorption, the molecular scattering process (fig. 4, right) needs an incoming electromagnetic wave much higher in energy than the energy difference of the vibrational levels. Moreover, apart from Rayleigh scattering, where photon energy is retained, the Raman scattered photon energy is very close to the energy of the incoming photon. The Raman scattering process involves the formation of an induced molecular dipole moment $\vec{P}_{induced}$ by the incoming radiation electric field. This can be mathematically expressed with a formula involving the polarizability tensor $[\alpha]$. Obtaining the components of this tensor is very useful for understanding the structural properties of molecules.

All of this theory is not much help if one cannot actually prove experimentally that it works. Scientists use sophisticated infrared and Raman spectrometers to obtain vibrational spectra.

FIG 5

Figure 5a shows the principal components of a modern Fourier transform infrared spectrometer (FTIR): an infrared polychromatic source, a chemical sample

FIG 4 Radiation-matter interaction processes in vibrational spectroscopy
Left: molecular absorption and emission;
Right: molecular scatterings

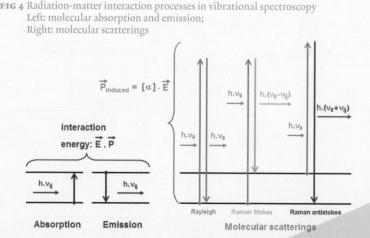

compartment, an infrared detector and spectral data managing unit, and the optical device for frequency discrimination known as a Michelson interferometer. In such a device, the incoming polychromatic light is separated by a beamsplitter into two beams of equal intensity: one of them is reflected by a fixed mirror, and the other is reflected by a second mobile mirror from a symmetrical position relative to that of the fixed one; so an optical step difference δ – positive or negative – appears between the two beams. For each wavelength, all recombined signals interfere constructively when the optical step difference is zero, and interfere more or less destructively on both sides of this symmetrical mirror position. The resulting recombined signal appears as an interferogram to the detector (fig. 5b). Mathematical processing of the Fourier transform of this interferogram gives the spectral transmission of the system.

To get an infrared spectrum of a chemical substance, one must record and compute 1. the transmission of a reference (solvent) 2. the transmission of the sample containing the chemical substance; then the transmission or absorption of the chemical substance alone can be computed (fig. 5c).

The principle of a classical Raman scattering spectrometer is shown in figure 6a. In this case, the chemical sample is irradiated by the monochromatic light FIG 6 of a laser. The scattered light is typically collected at ninety degrees from the laser beam direction, although it may be collected at zero degrees (retro-scattered light) in some instances. The scattered light frequency components are spatially dispersed by a powerful grating monochromator, and detected by a highly sensitive device (CCD – charged coupled device – or photomultiplicator). Finally, to get a meaningful signal, a processing and managing unit is employed. By using an additional analyzer (fig. 6b), this spectrometer can give more information about the polarizability tensor components of the studied chemical substance.

Both spectrometers are used nowadays in analytical chemistry and forensic science to provide data on new or unknown compounds.

But how can we use the methodology described above to convert the vibrational spectra into acoustic signals?

**FIG 6** (a) Raman scattering spectrometer;
(b) use of an additional analyzer

**FIG 5** (a) Michelson interferometer; (b) infrared interferogram; (c) infrared spectrum, deriving from Fourier transforms of sample and reference interferograms

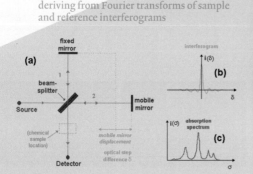

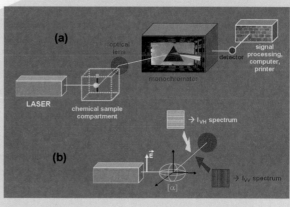

## Basic Method for the Acoustic Conversion of Molecular Vibrational Spectra

The basic conversion principle is actually quite straightforward. To explain it, we can use a simple molecule, N-methylacetamide. First, a vibrational spectrum, a N-methylacetamide infrared spectrum, as shown in figure 7 (left), is recorded, and all of its central spectral band frequencies are marked. This can be done either from the spectrum display on a computer, or even with a pen and a ruler (dotted lines in spectrum, and fig. 7, right). By dividing all these frequencies, typically located in the 12–120THz (or 4,000–400 cm⁻¹) domain, by a same high value factor (coincidently equal to the numerical value of the speed of light in cm/s), a set of transposed frequencies in the acoustic domain 4,000–400Hz is obtained. By tuning the same number of sine generators in accordance with these frequencies, and playing them simultaneously, a *molecular sound*, – one that can even be slightly transposed again, if needed – is produced.

Some synthesizers, used in additive mode, allow such molecular sounds to be played with a different tuning for each keyboard touch. In my first experiments, done with a Korg Wavestation (fig. 7, right), Tracks 2 to 7 feature such N-methylacetamide molecular sound, mapped from the C1 to C6 keys of that keyboard. Track 8 serves as an example of MIDI sequence using the N-methylacetamide spectrum: here, the already generated molecular sound is played in a large variety of tunes with a reverberation effect.

Instead of simultaneously playing all the sine transposed central frequencies of the molecular vibrational spectrum, these frequencies can be described separately versus time, thus actually playing the degrees of the molecular scale of the chemical substance. For example, Track 9 plays a MIDI sequence using the degrees of the formic acid musical scale.

FIG 7 Molecular sound generation, using the basic acoustic conversion method

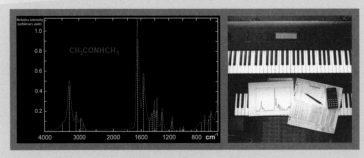

FIG 8 Molecular sound waveforms homothetic to infrared interferograms of (a) liquid water, (b) ethanol, (c) benzene, and (d) N-methylacetamide

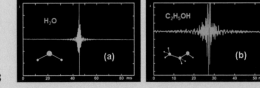
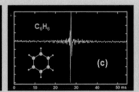
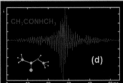

298

The next logical step for the acoustic conversion of a vibrational spectrum is the simultaneous transposition of *all* its frequency components – not only the transposition of its central frequencies. This operation is equivalent to using all the sampling points of the vibrational spectrum file to compute a corresponding waveform file. With this aim, an interesting opportunity arose within the infrared interferogram files: replacing the optical step difference dimension δ by the time dimension.

Figure 8 shows the molecular sound waveforms homothetic to infrared inter- FIG 8
ferograms recorded from thin films of liquid water, ethanol, benzene, and N-methylacetamide. These sounds can be played once – Tracks 10 to 13, or looped – as in Tracks 14 to 17. While all these sound waves are fast time-decreasing, the timbre differences among chemical samples are quite obvious.

Quite conceivable are "live performances," that would use such interferogram signals directly picked up from the spectrometer.

More generally, molecular sound files may be obtained by computing inverse Fourier transforms of vibrational spectra. A classical inverse Fourier transform computation process implicitly sets all spectral element phases to zero. The resulting wave (fig. 9b) has a more or less fast time-decreasing aspect. Temporal FIG 9
aliasing also occurs, which, theoretically, divides the useful audition time of the waveform by two. However, keeping the entire time domain here – aliasing included – has its advantage: it helps obtain a perfect wave loop.

To preserve significant signal intensity further from the beginning of the waveform, another inverse transform computing process can be designed. The simplest one sets each spectral element at a different, randomly chosen phase value. The resulting wave (fig. 9c) shows "long-distance" intensity variation, intensity "clusters," which can vary for each computation with a new set of random phases, and which produce some curious "noise" due to this kind of phasing. Here too, temporal aliasing exists and perfect sound loops can be produced.

FIG 9 (a) inverse Fourier transforms of a spectrum; typical waveforms shapes obtained: (b) by setting all spectral elements phases to zero, and (c) by setting a distinct random value to each spectral element phase

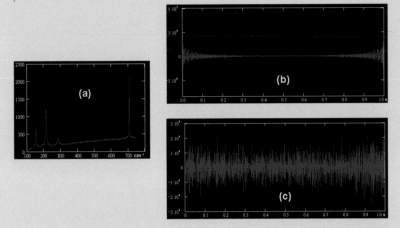

The latter process has been applied to a high-tech chemical sample: a carbon nanotubes array. A carbon nanotube can be produced by rolling up a graphene sheet (fig. 10a), a one-atom thin layer made of bonded carbon. This compound has been studied extensively in the past decade. Arrays of such nanotubes can be created (fig. 10b), and the local structure of such a sample may be strongly affected by laser pulse impacts. Figures 10c and 10d show that powerful impacts on two different sample zones lead to local destruction, poor and noisy related Raman spectra, and noisy sounds (Tracks 18 and 19). A less powerful and destructive impact does not corrupt the local structure as much on a third zone of impact. This is confirmed by the related spectrum showing the typical nanotube radial breathing modes (RBM) (fig. 10e), and by a slight audio resonance due to the remaining RBM Raman peaks (Track 20).

## Advanced Method for Acoustic Conversion

In this general method, a piece of music, which results in a global acoustic pressure waveform, is considered to be a combination of elementary waveforms, each describing the temporal variation of a musical parameter. At least one of these waveforms describes the acoustic pressure parameter; the other possible waveforms are control signals (pitch, filter cut-off, spatial panning, etc.) that separately modulate the acoustic pressure waveform.

FIG 10 (a) graphene sheet and carbon nanotube; (b) carbon nanotubes array; (c) and (d) carbon nanotube local spectra corrupted by powerful laser impacts; (e) less corrupted carbon nanotube local spectrum

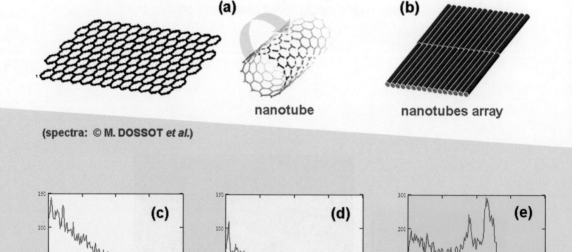

(a)   nanotube   (b)   nanotubes array

(spectra: © M. DOSSOT *et al.*)

(c)   (d)   (e) (RBM)

300

Track 1     Atmospheric water vapor molecular sound

Tracks 2–7     N-methylacetamide molecular sound, played octave per octave from the C1 to C6 keys of a digital synthesizer

Track 8     Example of musical piece playing the N-methylacetamide molecular sound

Track 9     MIDI sequence using the degrees of the formic acid molecular musical scale

Track 10     Molecular sounds homothetic to the infrared interferograms of liquid water

Track 11     Molecular sounds homothetic to the infrared interferograms of ethanol

Track 12 — Molecular sounds homothetic to the infrared interferograms of benzene

Track 13 — Molecular sounds homothetic to the infrared interferograms of N-methylacetamide

Track 14 — Molecular sounds homothetic to the infrared interferograms of liquid water

Track 15 — Molecular sounds homothetic to the infrared interferograms of ethanol

Track 16 — Molecular sounds homothetic to the infrared interferograms of benzene

Track 17 — Molecular sounds homothetic to the infrared interferograms of N-methylacetamide

Tracks 18 & 19 — Sounds of carbon nanotube corrupted local structures, computed with random phased spectral elements (see: figs. 10c and d)

Track 20 — Sound (random phased spectral elements) of a less corrupted carbon nanotube local structure (see: fig. 10e)

Track 21    Musical piece showing time evolution of the crystalline structure of calcium carbonate precipitated from aqueous solution at 40°C

Track 22    Same musical piece as Track 21, but here transposed one octave higher, and with a reverberation effect

Tracks 23–25    Acoustic rendering of aragonite crystal anisotropy ($I_{VH}$ spectra, zero-phased computed waveforms); 23: initial piece; 24: rhythm waveform; 25: global musical piece

Tracks 26–28    Acoustic rendering of aragonite crystal anisotropy ($I_{VV}$ spectra, zero-phased computed waveforms); 26: initial piece; 27: rhythm waveform; 28: global musical piece

Tracks 29–31    Acoustic rendering of aragonite crystal anisotropy ($I_{VH}$ spectra, random-phased computed waveforms); 29: initial piece; 30: rhythm waveform; 31: global musical piece

Tracks 32–34  Acoustic rendering of aragonite crystal anisotropy ($I_{VV}$ spectra, random-phased computed waveforms); 32: initial piece; 33: rhythm waveform; 34: global musical piece

Tracks 35–37  Transposition by +2 octaves of Tracks 23–25 (see text)

Track 41  MIDI sequence related to liquid water interferogram: fixed note onset times and durations, and pitches proportional to the interferogram sampling point intensities; played sound: liquid water sound of fig. 8a

Track 42  Same as in Track 41, but with note onsets and durations proportional to the absolute values of the interferogram point intensities

| | Track 43 | Same as in Track 42, but playing a sampled piano sound |
|---|---|---|
| | Track 44 | Pitch and rhythm MIDI sequence playing the degrees of the N-methylacetamide molecular scale |
| | Track 45 | Same as Track 44, with a tempo × 4 |
| | Track 46 | Pitch and rhythm MIDI sequence playing the degrees of the formic acid molecular scale |

The QR Codes lead to Thierry Delatour's *Molecular Songs*. If you do not have a device that can scan QR codes, you can get access to the tracks via ZKM's YouTube channel.

In the first stage, the vibrational spectrum of a given chemical substance is considered a basis upon which one or more elementary molecular waveforms can be constructed to describe musical parameters. Depending on the time scale, the nature of the musical parameter, and the implementation, these waveforms may be discrete or continuous, and have short or long durations.

In the second stage of this method, a temporal combination of the constructed molecular waveforms produces a piece of molecular music; this combination uses whatever algorithms seem appropriate to yield a good auditory fingerprint of the chemical substance, whether for scientific or artistic purposes.

Several examples to illustrate the process are described below. The first example is related to the crystallization versus time for the substance called calcium carbonate $CaCO_3$. When synthesized in aqueous phase, this compound (composed of charged $Ca^{2+}$ and $CO_3^{2-}$ ions), which is not very soluble in water, precipitates as a solid, according to the following reaction:

$Ca^{2+}_{(aqueous)} + CO_3^{2-}_{(aqueous)} = (Ca^{2+}, CO_3^{2-})_{solid}$

To be more precise, three different crystalline structures of this solid, known as vaterite, calcite, and aragonite coexist, showing distinct low-frequency Raman scattering spectra (fig. 11). Depending on the experimental conditions, and particularly on the temperature, one of these structures becomes more abundant than the others after a certain period; for example, vaterite and aragonite might disappear and the calcite form dominate after eight hours at 40°C.

**FIG 12** Figure 12 (left) shows the Raman spectra of calcium carbonate, as taken at two minutes, and two, four, and seven hours after the beginning of the crystallization process at 40°C. From the first spectrum at t = 2 min, a related waveform – inverse Fourier transform with all spectral element phases set to zero – is computed and transposed from −7 octaves to +2 octaves, leading to ten homothetic waveforms. After as many duplications as are required to range a delay of 16 s, all these transposed waveforms are combined, giving a new "super-waveform" (fig. 12, top right). The same process is applied to the other three spectra, and the whole sound material is mixed in accordance to the reaction kinetics, so that one hour of reaction delay is represented by 16 s (fig. 12, bottom right).

Track 21 plays the resulting musical piece. The same work is heard one octave higher and with some additional sound effects in Track 22.

The next example is a sonic illustration of crystal anisotropy. For this purpose,

**FIG 13** sets of Raman scattering spectra are recorded as follows (fig. 13, top left): the laser-source beam is reflected by a beam-splitter and impacts an aragonite crystal, which is correctly orientated and can be rotated to be perpendicular to the laser

**FIG 11** Raman spectra of calcium carbonate crystalline structures: vaterite, calcite, and aragonite

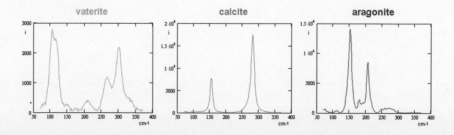

beam. The retro-scattered light then passes through the beam-splitter in the direction of the spectrometer entrance objective. An analyzer is placed vertically or horizontally just before the objective. This enables to get the $I_{VH}$ and $I_{VV}$ polarized Raman spectra, for any rotation angle of the crystal. As stated above, these spectra are very useful for calculating the values of crystal polarizability tensor components (fig. 13, top right).

Acoustic waveforms related to such spectra are computed versus crystal rotation angle and/or analyzer orientation. Subsequently, initial audio mixing of all waveforms is made versus time, considered here to be proportional to the rotation angle; the result is an initial musical piece (fig. 13, bottom right).

Additional sound processing can be made by using the sound material of this initial piece to control the clock speed of an analog sequencer, which triggers an analog synthesizer set to give percussive sound. This results in a rhythm waveform, whose beat frequencies are related to the spectral content of the initial piece signal (fig. 13, bottom right).

Mixing both, initial piece and rhythm waveform, leads to a global piece of music (fig. 13, bottom left). The end result can be seen in the following figures and the audio tracks on the previous pages.

FIG 12 Acoustic conversion of calcium carbonate crystallization process

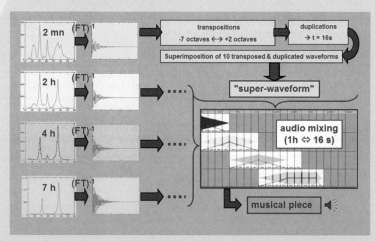

FIG 13 Raman spectroscopy experiment on crystal anisotropy, and conversion process scheme for its acoustic rendering

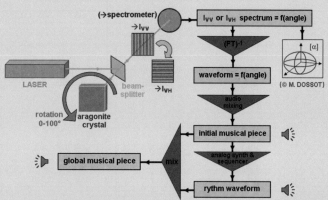

FIG 14 Figure 14a shows the $I_{VH}$ and $I_{VV}$ Raman spectra evolution versus crystal rotation angle. For each analyzer orientation, initial audio mixing (example: $I_{VH}$, fig. 14b) is made with zero-phased computed waveforms; the related initial piece, the rhythm waveform and the global musical piece can be heard respectively in Tracks 23 to 25 for $I_{VH}$, and Tracks 26 to 28 for $I_{VV}$.

For each analyzer orientation, initial audio mixing (example: $I_{VH}$, fig. 14c) is also made with random-phased computed waveforms; the related initial piece, the rhythm waveform and the global musical piece can be heard respectively in Tracks 29 to 31 for $I_{VH}$, and Tracks 32 to 34 for $I_{VV}$.

Tracks 35 to 37 (for $I_{VH}$), and 38 to 40 (for $I_{VV}$) play the same works as in Tracks 23 to 28, but with initial pieces transposed two octaves higher.

The two examples following illustrate the effect of molecular sound pitch modulation. The first one uses the liquid water interferogram leading to the sound of figure 8a. By means of appropriate programming, a pitch MIDI sequence is made, containing a number of notes equal to the number of interferogram sampling points. On Track 41, this sequence plays the water molecular sound of figure 8a; the onset times and durations of the notes are fixed, but their pitches are exactly proportional to the intensities of the corresponding interferogram sampling points.

In the second example, the MIDI sequence is somewhat modified: the pitches are unchanged, but the note onsets and durations are now proportional to the absolute values of the intensities of the interferogram sampling points. This sequence is first played with the molecular sound of figure 8a (Track 42).

However, any other sound can be used here; in Track 43, a sampled piano sound plays the last MIDI sequence.

The final example illustrates a rigorous control of the rhythm for the notes
FIG 15 of a molecular scale. In figure 15 (left), the infrared absorption spectrum of

FIG 14 (a) $I_{VH}$ and $I_{VV}$ aragonite Raman spectra evolution versus crystal rotation angle perpendicular to its (010) crystalline plane; (b) audio mixing of the related zero-phased acoustic waveforms ($I_{VH}$ example); (c) audio mixing of the related random-phased acoustic waveforms ($I_{VH}$ example)

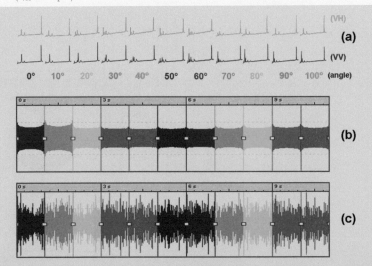

N-methylacetamide is displayed once again with its marked central band frequencies; it is rotated 90° left to present the frequencies – or, in other words, the musical pitches – in a vertical scale. Figure 15 (right) shows the beginning of a related MIDI sequence which is computed as follows: each track is dedicated to a sine frequency of the N-methylacetamide molecular scale, and any single "brick" represents one short note followed by a silence; then each track plays repeated notes at a pitch and rate proportional to a particular N-methylacetamide infrared absorption central frequency. All the scale notes are played together at the beginning of the sequence, and then each one continues in its own "life."
This sequence is played with a slow tempo (Track 44), and with a tempo four times faster (Track 45). By comparison, the same work is made for formic acid, and the result is played with the same fast tempo (Track 46).
These final MIDI sequences are not random music pieces: the acoustic conversion process used here is rigorous, and such musical pieces can be computed for minutes, days, years or even longer periods.

## Discussion
### The Molecular Instrument

1. Let us remind ourselves of the intrinsic physical and chemical properties of molecules and chemical substances, as natural constraints and rules of the game for creating molecular music:
   - The objects considered belong to the microscopic domain, so the rules of classical mechanics do not apply: their internal movements are described by specific wave functions, quantified energy levels and vibrational frequencies, which derive directly from the rules of quantum mechanics.
   - Each molecule has its specific geometry and symmetry, atomic masses and chemical bond force constants, leading to an unique set (fingerprint) of vibrational frequency values. Moreover, a N-atom molecule may be considered as a $(3N-6)$ – or $(3N-5)$ – coordinate object, leading to the same number of molecular vibrational modes and fundamental spectral bands.

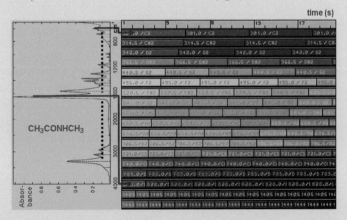

FIG 15 N-methylacetamide infrared spectrum (left), and construction scheme for a MIDI sequence controlling the rhythm and pitches for the notes of its molecular scale (right)

- Low-intensity harmonic bands – for each normal mode – and combination bands – between different modes – may also be present in vibrational spectra. The situation is even more complex in the solid state, due to the existence of additional external vibrational modes.
- Due to the anharmonicity phenomenon, ratios between harmonic and fundamental frequencies for a given normal mode slightly differ from integer number ratios.
- Theoretically, there are no definite spatial limits to the amplitudes of vibrational modes coordinates; this fact is mathematically translated by complex molecular wave functions formulae.
- Spectral bands' broadness may be important, depending on physical or chemical parameters, such as the nature of the molecular environment.
- For a given vibrational mode, a vibrational transition by the absorption or scattering process may be either allowed or forbidden, according to mathematical and physical rules called *selection rules*; these rules are not identical for these two kinds of processes, so, spectra information – presence / absence of some bands, relative band intensities – may differ between infrared absorption and Raman scattering vibrational spectra, which are then complementary.

2. Regarding the specific properties of molecules or chemical substances, and when they are considered musical instruments, we can point out that:
- Unlike one-dimensional (strings or pipes), or two or three-dimensional (percussions) oscillators, a molecule may be considered as a (3N-6)-dimension musical oscillator, where N is a number of atoms in the molecule.
- Each oscillator generates its own series of quasi-harmonics, in which the fundamental term is the most intense one. Low intensity combination terms
- between oscillators of the former type – may also exist.

3. Finally, the musical characteristics of vibrationally excited molecules can be summed up as follows:
- There is frequent perception of fuzzy resonances, due to the broadness of the spectral bands.
- Inharmonic timbres appear, due to irrational numerical values of spectral bands center frequency ratios.
- Aperiodic molecular waveforms exist, and can be used at different time scales for appropriate time descriptions of each chosen musical parameter.
- The significance of the octave in the present context is diminished, since the vibrational center frequencies are often spread in a large spectral domain.

Applications of the Present Acoustic Conversion Method

1. Scientific applications include:
- Audio identification of chemical substances. This may either be done classically from basic inverse Fourier transform computations, or require additional coding occasionally, as shown in the previous examples.
- Audio realtime control of stability or evolution of chemical samples. This application may be useful for chemical reaction kinetics or spatial analysis, and for monitoring industrial processes.

– Aid in the understanding of structures and molecular interactions. This application may require efficient additional coding of molecular sounds, and specific musical pattern recognition for each scientific context.

2. Musical applications include:

– Discovering and managing new sonorities. These may be static for stable and homogeneous chemical samples, or dynamic for space- or time-varying composition. Their characteristic timbres derive directly from the broadness of vibrational spectral bands and from irrational numerical values of spectral bands center frequency ratios.

New rules of musical composition. According to the present acoustic conversion process, molecular waveforms are true designers for sound organization. Depending on the considered atoms and chemical bonds, molecular scales often show more than twelve microtones spread across a large spectral domain, and typically differ from the equal-tempered molecular scale. In the same way, molecular rhythms present irregular tempi.

## Future Research

Molecular music is truly at its beginning. The following research possibilities, leading to new scientific and artistic developments, deserve mention:

– Design of protocols for chemical acoustic analyzes: for families of similar substances, or for very different substances; for chemical samples showing time- or space-varying composition.
– Audio comparison of molecular waveforms derived from experimental vibrational spectra with those derived from computed vibrational spectra.
– Systematic exploration of molecular microtonal scales.
– "Live-spectroscopic" performances, requiring spectrometer, computer, and real-time sound generator systems.
– Spatial audio descriptions of molecular waveforms, for example, by means of an array of miniaturized speakers, each one dedicated to a molecular waveform sampling point.
– Application of the present conversion method to other spectroscopic techniques: ultraviolet-visible spectroscopy, nuclear magnetic resonance, electron surface chemistry analysis ...

## Acknowledgments

I would like to thank C. Carteret, M. Dossot, B. Humbert (Laboratoire de Chimie Physique et Microbiologie pour l'Environnement, Villers-les-Nancy), M. Redolfi (Centre International de Recherche Musicale, Nice / AUDIONAUTE studio, Beaulieu), K. & L. Kortex (L'onde associée, Nancy), and F. Lepeltier (L'Oeil et la Mémoire, Villeneuve lez Avignon) for their encouragement.

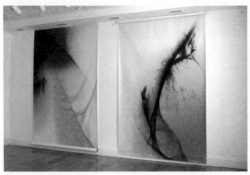

*Bloodlight Portraits*
2011, laser light dispersed through a drop of blood,
photographic paper

large image
2011, laser light dispersed through a drop of blood,
projection

The portraits are created by projecting a laser beam
through a drop of blood taken from the sitter and cap-
turing the projection directly on photographic paper.
The white laser beam, reflecting in the drop of blood, is
fractured into all the colors of the spectrum, creating
the pictures of light waves' interferences.

Inherent to existence is a tendency to create infinitely
complex and beautiful patterns, structures, and forms
spontaneously and "out of nowhere." We see them ev-
erywhere whenever we look at nature: the sand on the
seashore; cloud formations; a butterfly's wing; the hu-
man face. Exactly the same qualities of self-organizing
structures manifest themselves in the pictures of light
wave interference, part of the *Bloodlight* series of works
on photographic paper, where chaos and order have had
equal weight in the creation of the individual pieces.

**GINTS GABRĀNS'** (*1970 in Valmiera, LV) work includes
installations, objects, Video art, paintings, stage design
and net.art. He holds a degree in scenography from the
Art Academy of Latvia (Riga). His work was shown in
many solo exhibitions, *Bloodlight* (Alma Gallery, Riga,
LV, 2011), *The Bright Sky* (Watermans New Media Gal-
lery, London, 2010), *Not a wave, not a corpuscle, Nuit Blanche*
(Musée Carnavalet, Paris, FR, 2008), and *Paramirrors*
(Latvian pavilion at the 52nd International Art Exhibi-
tion of La Biennale di Venezia, IT, 2007), among others,
as well as in group exhibitions such as the 4th Moscow
Biennale of Contemporary Art (2011).

www.gabrans.com/html/bloodlight.php

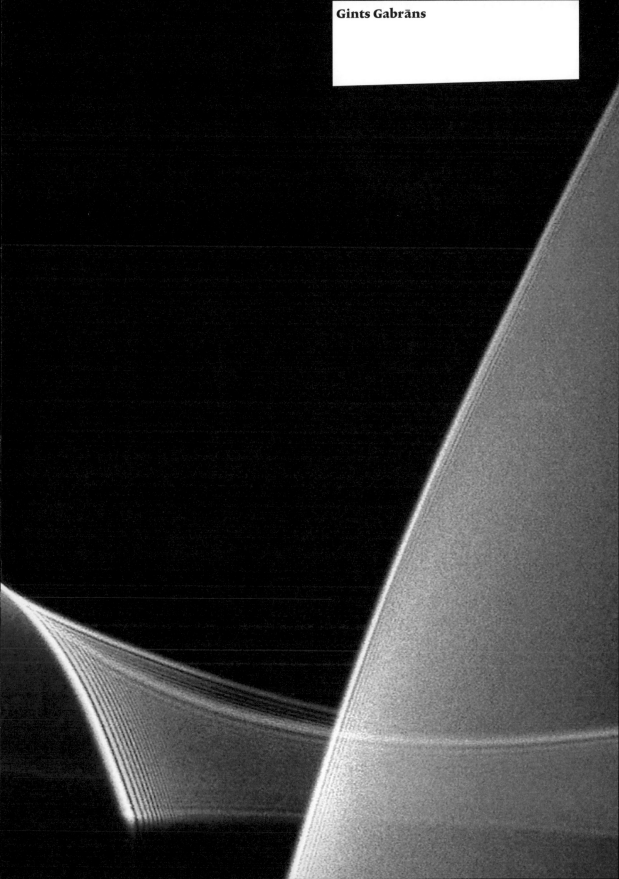

Gints Gabrāns

*Not a Wave, Not a Corpuscle*
2008, 8 halogen spotlight, aluminium,
fog screen, water, ~~video~~ projection, 3.5 × 3 × 1 m

This work is dedicated to those who, in their imagination or by some other means, have either already "gone through a wall," or intend to do so. The wall in this work is made of light, which, from the aspect of physics, is made up of photons which have a dual nature – they are at once a wave and a particle. Can you imagine such a thing? And what kind of thinking method will you adopt: the rationally logical or the irrationally intuitive, and imaginative one?

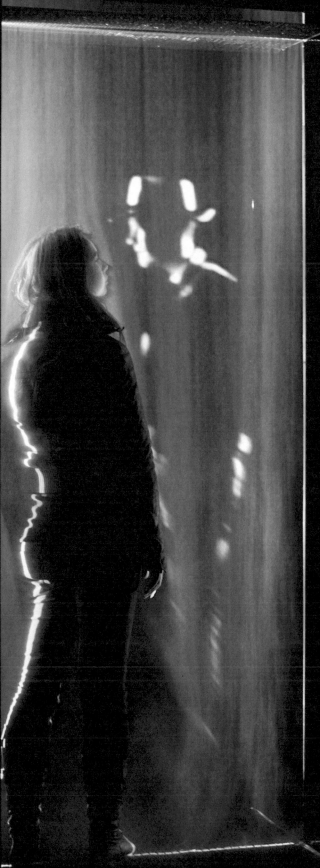

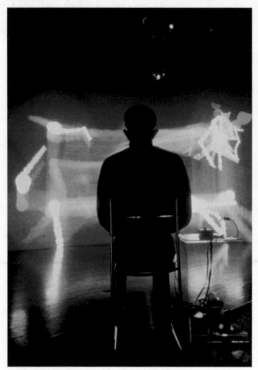

*Molecular Informatics ~*
*Morphogenic Substance via Eye Tracking*
1996, Version 1.0, installation view, Canon ARTLAB,
Hillside Plaza, Tokyo

large image
1998, Version 3.0, installation view, EXIT: festival
international, Maison des Arts, Creteil and via98,
festival international, Le Manege/Maubeuge

**SEIKO MIKAMI** (*1961 in Shizuoka, JP) is an artist and
professor at the Media Art Lab at Tama Art University in
Tokyo. Since the 1980s, she has been showing large-scale
installations about information society and the human
body. Most of her works comprise interactive media art
installations incorporating human perception. She has
exhibited at Canon ARTLAB (Tokyo, 1996), Museum of
the Joan Miró Foundation (Barcelona, ES, 1999), Musée
des Beaux-Arts de Nantes (FR, 2000), DEAF Rotterdam
(NL, 1995, 1996, 2004), Kulturhuset Stockholm (2006),
transmediale (Berlin, 2007), Yamaguchi Center for Art
and Media/YCAM (JP, 2010), and at the Art Museum of
China (Bejing, 2011).

www.idd.tamabi.ac.jp/~mikami/artworks

Seiko Mikami

## Molecular Informatics ~
## Morphogenic Substance via Eye Tracking

The work is an interactive media art installation incorporating "eye tracking input" technology. Structures of molecules are generated in real time according to the movements of the viewer's eyes. The viewer wears a pair of virtual reality eyeglasses equipped with an eye tracking sensor and via the eye movements of observing, creates the space, consisting of molecules and molecular formations. This movement, created by the human, physical part, is transformed into data that pinpoints the viewer's location within the three-dimensional space, therefore both real time change and generation occur within the virtual world.

The space can be navigated simply through one's gaze, which, in turn, is converted into XYZ coordinate data to create the structures simultaneously. The eyeglasses are first calibrated to match different eye sizes and pupils. Exhibition visitors can watch a projection that shows what the participant is currently viewing. At the same time, another projection system at the back of the exhibition acts as a telepresence recorder. Its projector is on a motorized base that tilts and pans with the participant's eye movements.

It is extremely difficult for humans to control their gaze, which is why eye tracking technology is used in lie detection. Experimental proof shows how our gaze expresses our unconscious affects, and how we are unable to control it intentionally. Eye movement is affected both by conscious and unconscious processes. What assumes the core of this project is the gap between the controlled willed process, and the uncontrolled passive process. I demonstrate how the eyes use tracking to mediate the space that exists between the self and the body.

**VERSION 1.0,** shown at Canon ARTLAB's sixth project (Hillside Plaza, Tokyo, 1996), was designed for one person's participation. It attempted to show the gap between one's consciousness and unconscious processes via the different functions within the field of the gaze.

**VERSION 2.0,** shown at DEAF96 (Dutch Electronic Arts Festival, V2_Institute for the Unstable Media, Rotterdam, NL, 1996), was designed for two people; it dealt with the issue of territoriality between the two participants by employing their gazes. While the trace of two gazes crash and/or deviate, various configurations are generated.

**VERSION 3.0,** shown at EXIT: festival international, Maison des Arts (Creteil, FR, 1998) and via98, festival international (Le Manege/Maubeuge, FR, 1998), incorporates a 3-D sound recognition program. A visitor can hear another person's eye movements in space via sound, just like the sonar (sound navigation ranging) of a submarine (lower sounds farther distance, louder sounds closer distance). If viewers come very close to one another and verge at the same point, the trace forms will crash into each other and break up into polygons.

**VERSION 4.0,** shown at *Singular Electries* (Fundació Joan Miró, Barcelona, ES, 1999), and at transmediale 02 (Berlin, 2002) is an updated version. Computer enhancements – especially in speed and memory – had a huge influence, and the audience could interface with his own or others' past performances. Dialogue with one's own memory of the body was expressed.

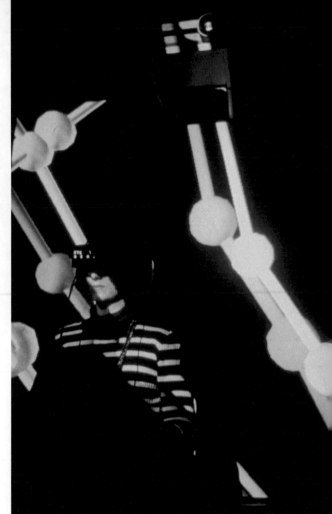

*Molecular Informatics ~*
*Morphogenic Substance via Eye Tracking*
1998, Version 3.0, installation view, EXIT: festival international, Maison des Arts, Creteil and via98, festival international, Le Manege/Maubeuge

bottom right
1996, Version 2.0, installation view, DEAF96, Rotterdam

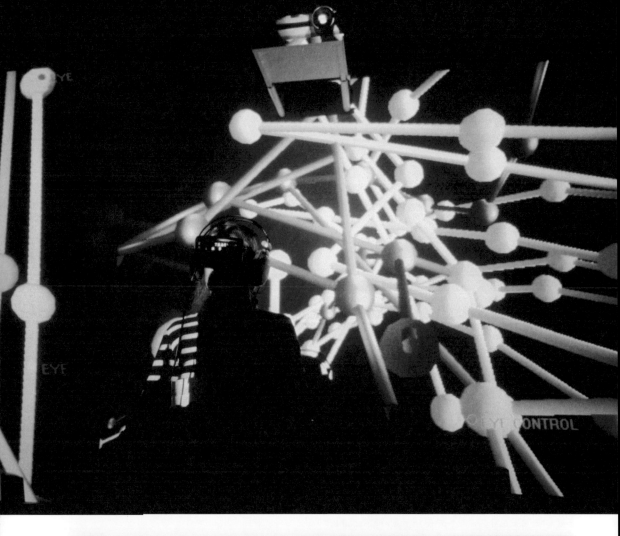
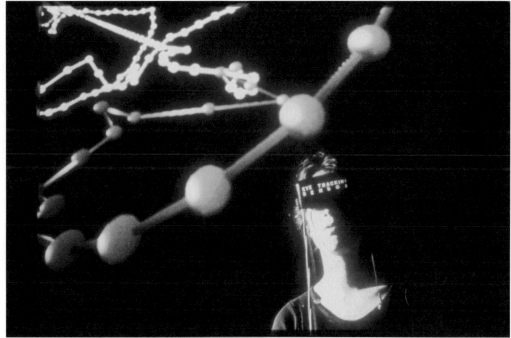

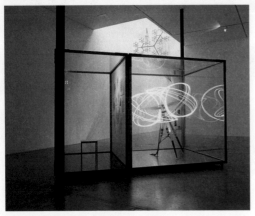

*The Blind Aesthetic*
2011, glass, steel, mechanical system, light
250 × 220 × 230 cm

*The Blind Aesthetic* forms the centerpiece of the lower gallery. Housed in a large glass cabinet stands a complex mechanical arm, at the end of which is a single light travelling at significant speed. The arm moves through a series of stepped ratios based on harmonics, creating a sequence of loops of light described in mathematics as torus knots. The speed and intensity of the light causes its path to burn onto the retina, and thus for this geometry to be revealed fleetingly to the viewer. In the same glass box but divided by a wall is a second, smaller chamber containing a simple desk and stool together with a sequence of small models made by an absent inhabitant. A significant discrepancy exists between the "blind" models that have been created in the second chamber, and what is actually taking place in the unobservable first chamber next door.

**CONRAD SHAWCROSS** (*1977, London) lives and works in London. He studied at the Slade School of Art (London) and the Ruskin School of Art (Oxford, GB). Attracted by failed quests for knowledge in the past, he appropriates redundant theories and methodologies to create ambitious structural and mechanical montages, using a wide variety of materials and media. Different technologies and natural forces inspire him, but his mysterious machines and structures remain enigmatic, filled with paradox and wonder. His work has been exhibited widely, at The National Gallery (London, 2012), Art Brussels (2009), and the Saatchi Gallery (London, 2004), among others.

www.conradshawcross.com

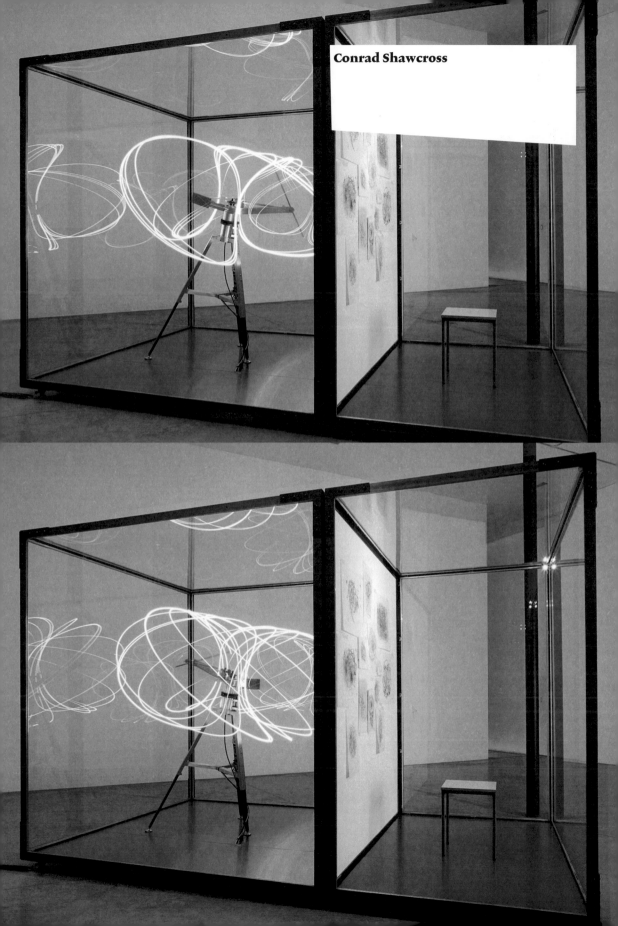

*Ocular Revision*
2010, documentation of the first imaging experiment
large image
2010, exhibition view, *Surveyor*, Albright-Knox Art
Gallery, Buffalo, 2011
The circular cabinet contains the electrophoresis rig,
camera, power supply and blue-light transilluminator.
Pictures of evolving map images are shown on sus-
pended circular projection screens.

*Ocular Revision* is an artwork using an alternate mecha-
nism for the analysis and display of the DNA image.
Typically, DNA is visualized in a rectangular chamber
containing a porous gelatin that has an electrical field
across it. When DNA is inserted into one side of this
gelatin, the electrical current pulls it across the gel at a
rate corresponding to its molecular mass and thus dif-
ferentiates DNA of different sizes. *Ocular Revision* uses a
custom, experimental, circular gel electrophoresis ap-
paratus to visualize DNA bands. I designed this circular
rig to be polarized from inside to outside of the circle,
and thus to pull the DNA through the gel from the pe-
rimeter toward the center of the circle. This novel circu-
lar apparatus is designed as a focal point for reflecting
upon a shift in the life sciences from the study of "life
itself" to a more reductive focus upon non-living DNA.
The work also inverts the interpretation of a key trope
used in contemporary genomics, and the basis of the
terms "genetic map" or "DNA mapping." The images
("Genetic Maps") produced by *Ocular Revision* are created
from specially processed DNA, which, when run in the
rig, resemble geographic maps of the Eastern and West-
ern hemispheres. These map-like images are visualized
upon twin circular projection screens flanking the in-
strument cabinet, which houses electronic components
for electrically polarizing, and blue-light trans-illumi-
nating the electrophoresis gel.

**PAUL VANOUSE** (*1967 in Minneapolis, MN) has been
working in emerging technological media forms since
1990. His biological experiments, electronic cinema, and
interactive installations have been exhibited in venues
such as the Albright-Knox Art Gallery (Buffalo, NY), New
Museum in New York, Museo Nacional de Bellas Artes
in Buenos Aires, Louvre in Paris, Haus der Kulturen der
Welt in Berlin, Centre de Cultura Contemporania in
Barcelona (ES). Vanouse's work has been supported by
the Creative Capital Foundation and the Renew Media
Foundation in New York, among others. He is a profes-
sor of visual studies at the University of Buffalo.

www.paulvanouse.com/index.html

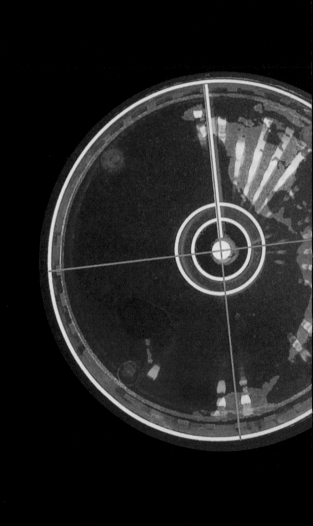

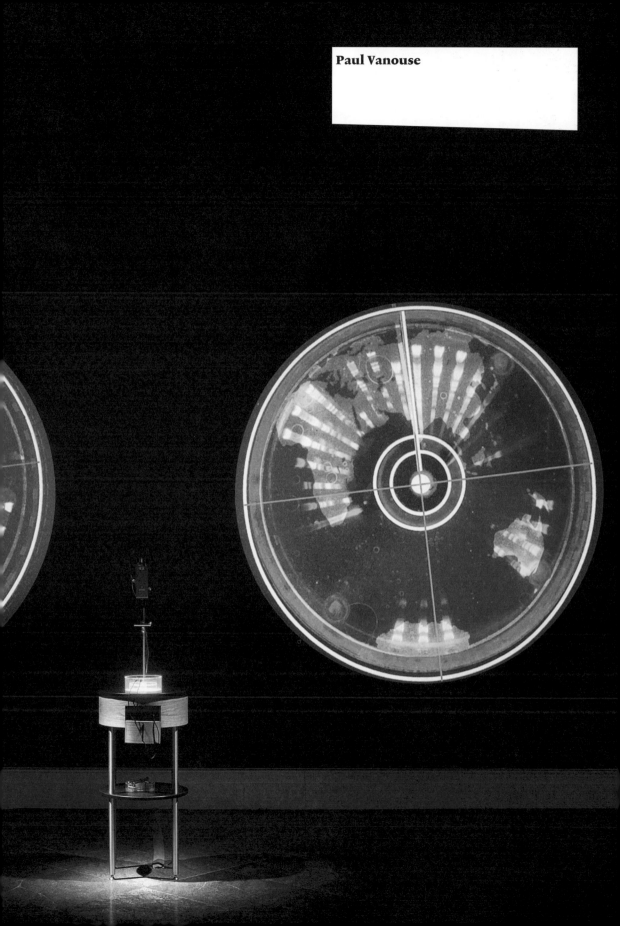

**Paul Vanouse**

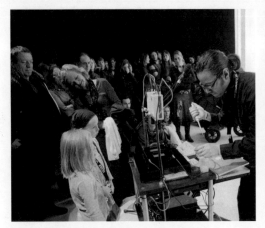

*Latent Figure Protocol*
2007–2009, performance, transmediale 11,
Haus der Kulturen der Welt, Berlin, 2011

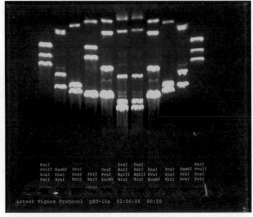

*Latent Figure Protocol*
2007–2009, figure was produced with the DNA of
bacterial plasmid pET-11a. Enzymes used to process
the DNA are listed in each column.

large image
*Latent Figure Protocol*
2007–2009, close-up

## Latent Figure Protocol

2007–2009, media installation
*Latent Figure Protocol* (LFP) takes the form of a media in-
stallation that uses DNA samples to create emergent
representational images. The installation includes a live
science experiment, the result of which is videotaped
and repeated for the duration of the exhibition. Em-
ploying a reactive gel and electrical current, *LFP* produc-
es images that relate to the DNA samples used. In the
first experiment, a copyright symbol is derived from the
DNA of an industrially produced organism (a plasmid
called pET-11a), illuminating ethical questions around
the changing status of organic life and the ownership of
living organisms.
A DNA fingerprint is often misunderstood by the lay
public to be a single, unique identifier. Its complex
banding patterns imagined as an unchanging sentence
written by Mother Nature herself that corresponds to
each living creature. However, there are hundreds of
different enzymes, primers, and molecular probes that
can be used to segment DNA and produce banding pat-
terns. The banding patterns that appear tell us as much
about the enzyme/primer/probe as the subject that they
appear to reproduce. My point is that the DNA finger-
print is a cultural construct that is too often naturalized.
The "wet-biological" techniques used in the *LFP* utilize
restriction digestion of DNA samples and gel electropho-
resis. The *LFP* imaging process relies upon knowing what
size DNA is required for each band to move at the proper
speed to make the correct image, and what enzyme com-
binations will cut the DNA to these sizes. A custom *LFP*
simulation program facilitates this. *LFP* is essentially do-
ing molecular biology in reverse. Usually scientists use
imaging techniques to determine an organism's genetic
sequence, whereas *LFP* utilizes known sequences in on-
line databases to produce "planned" images.

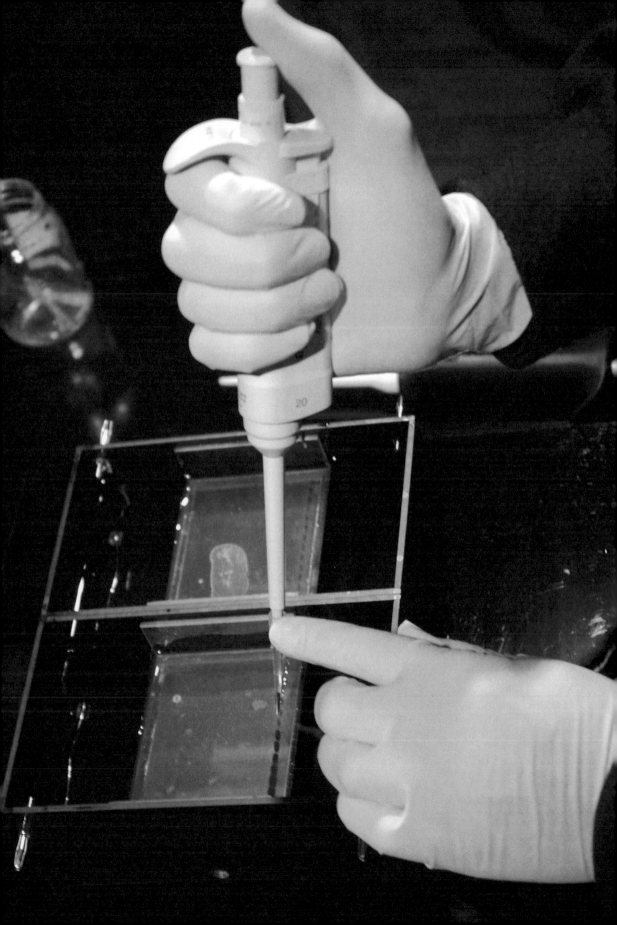

# VI

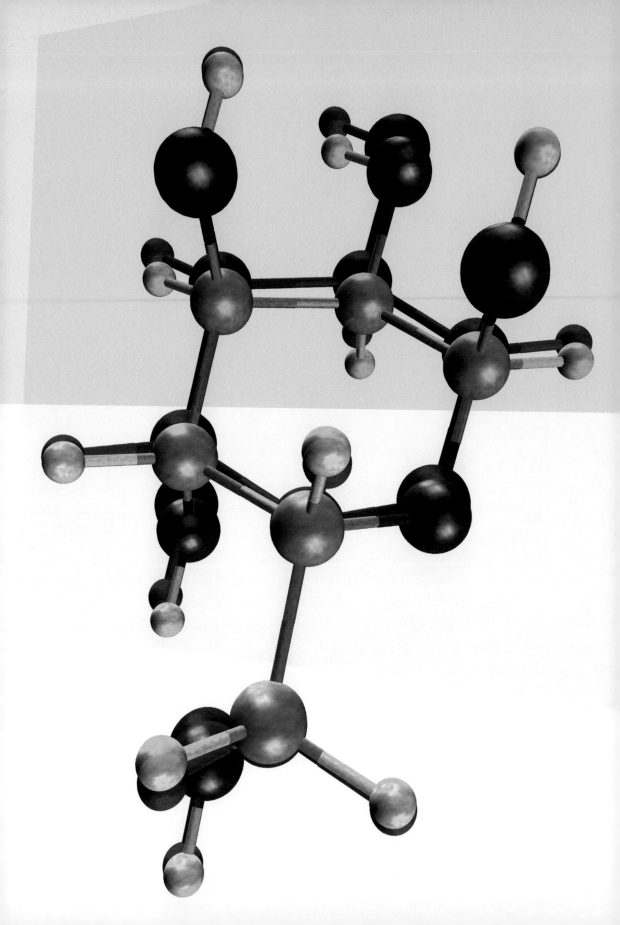

Eric Francœur

**From Tangible to Virtual Structures: Episodes in the Art and Science of Protein Structure Representation**

Proteins are the workhorse of the biological world, the lynchpin of biochemical processes in every living organism. They are complex organic molecules whose properties or functions are directly linked to their intricate three-dimensional structure. Developing the ability to extend the human gaze into the architecture of proteins is one of the great achievements of the twentieth century biochemical and biophysical sciences.

The path to understanding protein structures was strewn by a series of enormous scientific and technical challenges that demanded decades of patient and painstaking work. Along the way, one particular challenge arose, one of representation. Indeed, how does one represent such complex structures? How do you make these complex structures – composed of thousands of atoms – tractable, viewable, and shareable? There were no readymade solutions. Protein structure scientists were akin to explorers having to develop a cartography system as they make their way through a landscape with features never seen before. In the face of so many challenges, that of representation might seem accessory, if not indeed trivial. Yet, as we will see, representation was clearly at the heart of producing and sharing knowledge about protein structures.

The purpose here is not to provide an extensive survey of representational practices in the realm of protein structure work. Rather, it seeks to document and show how, in the second half of the twentieth century, different practitioners – at different times and for different purposes – developed and deployed tools, techniques, and graphical conventions to represent the complex molecular structures of proteins.

The text is divided in three sections that correspond to the three great domains of representational practices in the area of protein structures. The first, "Tangible Structures," deals with the use of physical models, particularly in the work that led to the first protein structure to be determined; the second, "Drawn

Structures," looks at the question of laying these constructs down on paper; and the third, "Virtual Structures," explores the dawn of the use of computer graphics in the representation of protein structures.

## Tangible Structures

Leaving proteins aside for a moment, let us consider DNA, another important biological macromolecule, whose structure was determined in 1953 by James Watson and Francis Crick, at the Cavendish Laboratory in Cambridge. The picture of Watson and Crick with their model of the DNA structure (fig. 1) may well be one of the most iconic photographs of twentieth century science. This large demonstration model, and smaller ones created by Watson and Crick in the course their work, acted as powerful devices both to demonstrate the DNA structure, and convince close collaborators of the validity of their conclusions.[1] The persuasive, or simply evocative, power of the models is well illustrated in the following passage from a letter that Max Perutz, a collaborator of Watson and Crick at the Cavendish Laboratory, wrote to Sir Harold Himsworth, the head of Britain's Medical Research Council: "The structure and the X-ray data supporting it (the double helical structure) will be published in [...] *Nature*. However to appreciate the beauty of the idea you have to see the models in the flesh. I wonder if you would like to come and have a look at them."[2]

As important as they were for demonstrating the structure of DNA, models also played a critical role in determining the structure, through a process aptly named "model building," meaning the creation of a structure which satisfies a number of theoretical and empirical requirements. In his account of this work, Watson discusses the use of models and how it was inspired by the earlier work of Linus Pauling on the conformation of the polypeptide chain: "The key to Linus' [Pauling's] success was his reliance on the simple laws of structural chemistry. The $\alpha$-helix had not been found by only staring at X-ray pictures; the essential trick, instead, was to ask which atoms like to sit next to each other. In place of pencil and paper, the main working tools were a set of molecular models superficially resembling the toys of preschool children. We could thus see no reason why we should not solve the problem of DNA in the same way. All we had to do was to construct a set of molecular models and begin to play [...]."[3]

FIG 1 James Watson and Francis Crick with their demonstration models of the structure of DNA

The determination of the α-helix was one of Pauling's great triumph, and a major step in determining the structure of proteins. By the 1930s, it had become widely accepted that proteins were macromolecules whose primary constituent was a chain of amino-acid residues, known as the polypeptide chain.[4] This chain is composed of repeating chemical units, amino-acid residues, forming the backbone, with various chemical groups forming side-chains at regular intervals. The basic chemical structure of the polypeptide chain was known (fig. 2) FIG 2 but there was no consensus on the three-dimensional conformation, or fold,[5] of this chain in proteins. Because rotation was considered possible around all the single bonds along the chain, a vast number of such folds was theoretically possible, although it was suspected that there was only a limited number of regular folds held together by small forces, such as hydrogen bonds. Francis Crick described the situation as follows:

"It may not be obvious why models had to be built at all, since the simple chemical structure of a unit of the backbone [of the polypeptide chain] was established. All the bond distances were known and all the bond angles. However, there can be fairly free rotation about bonds called single bonds [...], and the exact configuration of the atoms in space depends on just how these angles of rotation are fixed. This usually depends on interactions between atoms a little distant from one another down the chain and there may be several plausible alternatives, especially if the connections are weak ones."[6]

Figure 3 shows Pauling next to a space-filling model of the α-helix. While the FIG 3 skeletal models used by Watson and Crick embody only the bonds between atoms, which makes measurements easy, space-filling models embody the "size" of atoms and are very useful to study steric hindrance, that is how atoms can get in the way of one another in a structure, thus constraining the possible

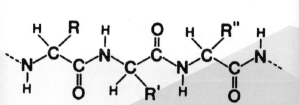

FIG 2 The polypeptide chain, a chain of amino acid residues which are the basic building block of proteins. The R indicates the side chain, a group of atoms that is different in each type of amino acid.

FIG 3 Linus Pauling standing next to a model of the α-helix, August 1954

conformations. It is assembled from space-filling atomic models that had been designed by Corey and Pauling.[7] For years, the Caltech chemistry department workshop fabricated these, not only for internal use, but also for sale to various laboratories around the United States. The demand was high, but production was very slow, labor intensive, and dependent on a small number of skilled craftspeople. No guarantee to meet the demand was ever made, and orders were filled as the state of affairs in the shop allowed. By the late 1950s, it was decided that the workshop would no longer provide models to outside institutions. That did not stop the Harvard biochemist John Edsall from requesting more models, explaining that, "as knowledge of protein chemistry becomes more complicated, we are acquiring the urge to build more complicated models. Is there any possibility that we could get more of your models?"[8] Edsall, like many others, was turned down. The lack of quality space-filling models became a major concern for the research community. In April 1960, a report entitled "The Need for Better Macromolecular Models" was published in *Science*.[9] Its author, John R. Platt, a biophysicist from the University of Chicago, argued that molecular models were essential to understand, in quantitative terms, theories of biology at the molecular level, such as DNA structure and protein synthesis and structure. The lack of good, affordable models for the representation of biological macromolecules was a "major bottleneck" for the progress of biochemistry and molecular biology. After much wrangling, committee work, and the financial involvement of the National Institutes of Health, space-filling models known as the Corey-Pauling-

FIG 4   Koltun models (CPK) were finally commercialized in 1966 (fig. 4).[10] These models have left their mark on a generation of researchers as the ultimate physical modeling tool. Even in this era of computer modeling and visualization, the initials CPK remain significant, as they are often used as a synonym for space-filling representation in molecular graphics software.

FIG 4 Cover from the first Ealing catalog selling CPK space-filling models. Kendrew skeletal models were also sold via this catalog.

While Watson and Crick were "toying around" with the structure of DNA, some of their colleagues at the Cavendish laboratory were dealing with a problem of enormous complexity, the structure of proteins. In 1937, Max Perutz had started work on the structure of hemoglobin – the protein responsible for the transport of oxygen in blood. He was joined in 1945 by John Kendrew, a physical chemist, who started to work on the related but much smaller myoglobin – a protein which stores oxygen in cells. The myoglobin structure was to be the first to be determined at the atomic level.

One has to appreciate the challenge Kendrew was facing: myoglobin is built of a single polypeptide chain composed of 153 amino acid residues that contain about 1200 atoms (not counting the hydrogen atoms), whereas vitamin B12 – previously the largest structure solved crystallographically – contained only 93 atoms.

By the late 1950s, Kendrew's X-ray crystallographic studies of myoglobin had finally yielded a three-dimensional high resolution (2Å) electron density map of the structure. This map was composed of ninety-six electron density contour sections, plotted on a transparent material, and stacked at appropriate intervals. Since the distance between two covalently bonded carbon atoms is 1.54Å, and most covalent bonds in protein structures are actually shorter, this map could not resolve neighboring bonded atoms. Nevertheless, by combining data about the structure of amino acids and knowledge about the secondary structure of proteins, it was, in many cases, possible to deduce the structure at atomic resolution; it could be shown, for example, that most of the myoglobin structure was composed of $\alpha$-helices.

In order to "refine" the electron density map, Kendrew and his colleagues first built a three-dimensional physical grid to transfer the density map onto an enormous array of two thousand five hundred, six-foot metal rods to which colored clips could be attached to represent the electron density at specific spatial coordinates (fig. 5). Skeletal models could be worked into that representa- FIG 5 tion to obtain an atomic-resolution structure.

FIG 5 John Kendrew and the "forest of rods," which allowed his team to build the first model of the structure of myoglobin

This model building exercise allowed Kendrew and his colleagues to turn the fuzzy electron-density map into a discrete molecular structure, where atoms and groups were duly identified and their spatial coordinates revealed – at least for those sections where the map was sufficiently clear. To understand the nature of that work, imagine being given an unfocused, three-dimensional photograph of a structure built out of Lego blocks. Knowing which Lego blocks were used, and taking advantage of the constraints they impose on assembly, it might be possible to reproduce the structure in the photograph. This second structure would then become a model of the first. In some ways, this is what crystallographers do in model-building, with the caveat that the "structure," the three-dimensional photograph it is produced from, has little to do, ontologically, with the model produced by the scientists. In other words, even if they could bring their photograph of molecules completely "into focus," the scientists would not see anything that looks like a structure of discrete static points joined by rod-like bonds. Kendrew's model-building work relied on three key elements. The first was extensive information about both the three-dimensional structure of individual amino-acids and the secondary structure of proteins, especially the $\alpha$-helix, which was a dominant structural feature of myoglobin.[11] This is what is sometimes called the "stereochemical information." It is important to note that additivity is a key assumption here, meaning that given similar physical conditions, the structural properties of a molecular group remain constant as that group becomes part of a bigger molecule. The second key element was the actual molecular models; they embodied the adequate structural values of bond lengths and bond angles. The final element was the amino acid sequence of myoglobin, which was being worked out simultaneously at the Cavendish lab.

Kendrew and his team were finally "able to summarize the results of the analysis up to this stage in the form of a model which showed the position in space of the helical polypeptide chain segments, of the haem group, and of most of the side chains."[12] A photograph of this model, along with tables presenting and discussing the amino-acid sequence of myoglobin, was published in *Nature* in 1961 (fig. 6)[13] The photograph is testimony to the complexity of the structure, most of the details lost in the apparent entanglement of its components. The spatial relationship among groups is very difficult – if not impossible – to evaluate or appreciate. A white cord helps to identify the course of the polypeptide chain and makes it the only easily identifiable feature. The discussion of

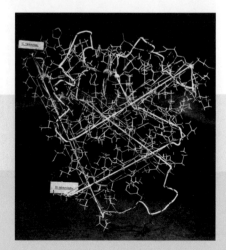

FIG 6 A photograph of the original
myoglobin model

particular features of the structure starts with a reference to the photograph of the model, but no attempt is made to directly correlate the photograph with specific features discussed in the article. That this photograph was of rather limited usefulness as a scientific visual display, inasmuch as it did not really help reveal the structure as a scientific object and make it analyzable, is fairly obvious. The problem of reporting early protein structures at the atomic level is vividly captured in the following passage from Sir Lawrence Bragg, here commenting on Max Perutz's later structure of hemoglobin:

"Perutz is working on his vast haemoglobin model, tidying up the details and getting the best atomic positions. There is enough detail for a complete book on chemistry in one such molecule! [...] The whole question of publication is difficult. How can one convey all the information in a huge molecule? A list of coordinates is of no help unless one builds a model. The 'paper' sent to colleagues should be a model!"[14]

Later, the biophysicist Victor Bloomfield would quip that protein X-ray crystallography was akin to a dog chasing cars: "Both are probably foolish and certainly heroic endeavors. But in both cases, the real problem is: suppose you manage to catch one, what in the world do you do with it?"[15] Not surprisingly, shortly after the publication of the article, Kendrew started to receive requests for a copy of the model of myoglobin. One of the earliest came from Jacques Fresco, from the Department of Chemistry at Princeton:

"We wonder whether you might also have an arrangement for obtaining a copy of your model. It would be useful for didactic purposes, and in addition it would provide us with something to meditate on."[16]

A few years later, after some uncertainties concerning the structure of the non-helical regions had been cleared, Kendrew made arrangements with a model-maker in Cambridge to produce small scale models of myoglobin (fig. 7). FIG 7 Kendrew oversaw the distribution of a few dozen of these to various research

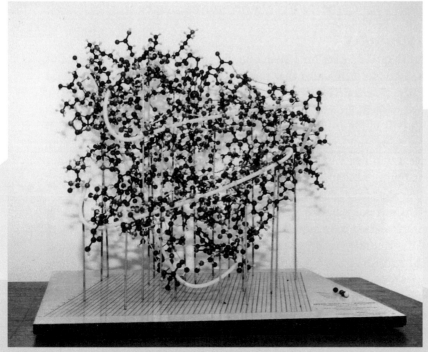

FIG 7 One the myoglobin model produced by A. A. Barker, a Cambridge model maker, under the direction of John Kendrew

institutions over the next few years. Produced at the rate of about one a month, they sold for GBP 210 (or about USD 600) at the time. These models were not only great instructional tools, but also constituted a sort of "trophy" for those who collaborated with Kendrew on the determination of the structure.[17] For Allen Edmundson, it was definitely worth the expense. He wrote:

"The model of myoglobin was partly purchased because I was the chemist who determined the amino acid sequence used in the construction of the 3-D model of myoglobin ... It also served a wonderful teaching function because I was one of the few individuals who had been trained sufficiently to correlate sequences with three-dimensional structures determined by X-ray crystallography. At the time, I gave short series of lectures at the University of Illinois, Department of Biochemistry, Chicago campus; lectures at Kansas State University, where I was a visiting professor; and guest lectures at my home institution which was Argonne National Laboratory [...] The model moved with me not only for these individual lectures, but also as part of my luggage when I transferred from Argonne to professorships in Biology, Biochemistry and Microbiology at the University of Utah in Salt Lake City. After 23 years of moving and constant perusal by students and faculty alike, the plastic spheres representing atoms began to deteriorate and finally cracked and fell off the stainless steel pedestals holding them together. We finally abandoned the model when we moved from the University of Utah to the Harrington Cancer Center in Amarillo, TX, but we were unanimous in our opinion that it should be given a hero's burial, for all the good that it had done."[18]

Just as the space-filling atomic models used at Caltech, the skeletal models designed and produced by the Cavendish Laboratory workshop proved very popular with visiting scientists. By 1958, the task of mass producing the models became too much for the Cavendish workshop, and the job was farmed out to a small local firm, Cambridge Repetition Engineer (which can probably still supply them today). Known as Kendrew skeletal models,[19] they became a key tool for the determination and study of protein structures for the next two decades.

**Drawn Structures**

As useful as models were for visualizing the complex structures of proteins, sheer convenience demanded that these structures be represented graphically. The "paper" sent to colleagues could not simply be the model, as Lawrence Bragg had wished. Presented with this challenge, some artists and scientists deployed skill and ingenuity to transcend the limitations of two-dimensional representations, and to offer us new and fruitful ways of looking at protein structure. I will focus here on this art/science interaction through two outstanding figures in field of the graphical representation of protein structure: Irving Geis and Jane Richardson.

Irving Geis was trained as an architect, but made his career as an artist and illustrator. He started contributing illustrations to *Scientific American* in 1948. In 1961, he was commissioned by the magazine to illustrate a John Kendrew article on the structure of myoglobin.[20] Kendrew and Geis met at Harvard, where Kendrew was visiting. Kendrew had brought along the myoglobin model (most probably the same that appeared in the *Nature* article). Geis took numerous FIG 7A pictures of the models (fig. 7a) and from these produced studies and sketches FIG 7B which he shared with him for comments (fig. 7b). It took Geis six months to

Annotated photograph of the myoglobin
model, taken by Irving Geis in 1961.

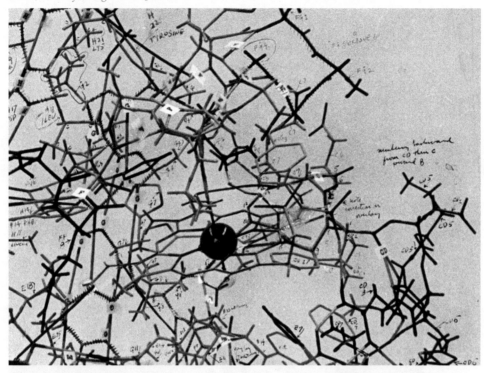

A sketch of the myoglobin structure produced by Irving Geis.
It bears annotations from both, Geis and John Kendrew.

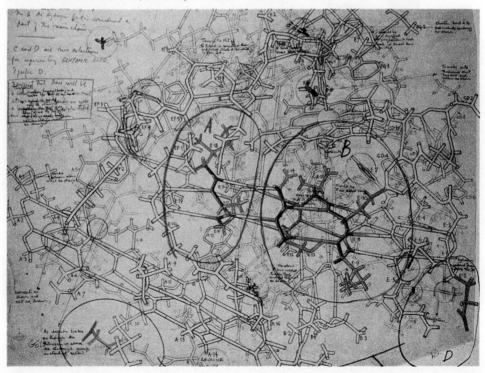

337

create a striking color illustration of the whole myoglobin structure which appeared as a two-page layout in the article (see this volume p. 371 bottom). It turned out to be the most expensive figure ever commissioned by *Scientific American* at the time and not everybody was appreciative: the editor-in-chief of the magazine, Dennis Flanagan, reportedly described it as "a mass of crumpled chicken wire."[21] While still a "busy" representation, it was much clearer than the photograph of the model which had appeared earlier in *Nature*. A color code[22] marks the various sections of the structure and the use of fading helps to differentiate features as seen from front and back. It is to this considered a classic of protein structure representation.

In 1964, Geis met Richard Dickerson, a protein crystallographer who had worked with Kendrew on the structure of myoglobin. The two men started collaboration on what became the first textbook on protein structure, *The Structure and Action of Proteins*.[23] Considered a classic of the genre, the book was universally lauded for the quality of its illustrations. Geis was given full co-author credit, which was not a common practice for the textbook illustrator. As Dickerson

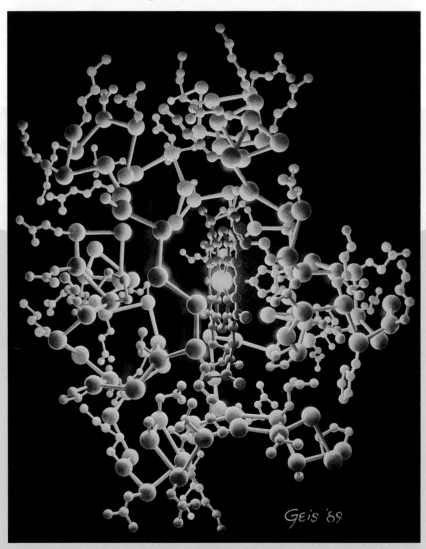

FIG 8 A painting of the structure of Cytochrome C produced by Irving Geis.

later explained, the decision to credit Geis as a co-author was more than simply practical:

"He became a co-author because I couldn't afford him as an illustrator. But even more than that, we developed a mutual symbiosis from which we both benefited. I could describe what needed to be illustrated about protein structure, and Irv would come up with clever and original graphic methods of putting the point across. It was never clear whether Irv illustrated my books, or I wrote Irv's captions. In the end, it didn't matter; together we could do more than either could have done alone."[24]

By the late 1980s, Geis had produced, by his own count, more than seven hundred molecular drawings and paintings, many as illustrations for books and articles, and some simply as works of art. Since the work had given him a unique insight on biomolecular structures, he was regularly invited to lecture on the topic at universities and research centers.

For Geis, there was no doubt that representation was a necessary interpretation, and that talent and knowledge had to work hand in hand:

"He [Geis] once commented that his job was not to draw a protein exactly as it was, but to show how it worked. A computer could draw a protein, given the right set of coordinates. But who would tell it exactly what to show? If some key aspect of protein structure was eclipsed and out of sight, the computer would be stuck. But Irv the artist could just tweak it a bit, and move it out in the open where it could be seen and the molecular mechanism thereby understood. He called this process 'selective lying,' and claimed that this was one of the special talents of a knowledgeable artist."[25]

Indeed, who would tell the computer what to draw? By the early 1990s, sophisticated graphics software and equipment allowed researchers themselves to produce lavish, "photorealistic" color renderings of protein structures. With little or, more often, no training in graphic design, it must have been tempting for these researchers to pull out all the stops and go for effect rather than substance. Gert Vriend, a bioinformatician and designer of a molecular graphics system, coined the term "molecular pornography" to describe the phenomenon. Vriend and others sought to tame the field by proposing rules for the production of effective molecular renderings. One such set of rules starts with a clear injunction: study the masters, "the artistry of legends such as [Irving] Geis."[26]

Geis was described by Dickerson as the "Leonardo da Vinci of protein structure." In that case, there is little doubt that Jane Richardson can be called the "Renaissance woman" of the field. Although she showed a marked interest for science from a young age (she won a major national fair prize in 1958 for her calculation – based on her own observations – of the Sputnik orbit), Richardson majored in philosophy at Swarthmore College and took a Master's degree in the same discipline from Harvard. She tried her hand at teaching high school, but found herself ill suited for the job. As a technician, she joined the MIT laboratory where her husband, David, was completing his PhD.[27] She soon became hooked on protein crystallography, and had become a full fledged research scientist by the time he was offered a position at Duke University.[28]

As more and more protein structures were determined in the 1970s, Richardson became increasingly interested on the recurring structural motifs that appeared in them, and even drew a parallel between some β-sheet motifs and Greek keys, a pattern often found on Grecian urns.[29] In the late 1970s, she started a complete

survey of the field. This work culminated in 1981 with the publication of *Anatomy and Taxonomy of Protein Structures*, a remarkable piece of what Richardson herself called "descriptive natural history," and which sought, in particular, to classify proteins in terms of their structural features.

This paper was the first time all the known protein structures (75 at the time) were illustrated "with a consistent system of representation,"[30] that schematized whole structures. To produce the drawings, Richardson started from scratch, spending over a year "working out the visualization system, learning the techniques, and making nearly 100 drawings [...]."[31] The schematic ribbon diagram system she developed (known today as the Richardson ribbon diagrams) relies on disparate components that look, surprisingly, in her words, "visually unified and intelligible." There are thick arrows for the β-strands, flat spiral ribbons for FIG 9 helices and ropes for loops (fig. 9). Richardson also developed a keen insight into human visual perception and on how to communicate three-dimensional information using "monocular" two-dimensional drawings. For example, in the case of a twisting arrow viewed on edge, she points out that "the most satisfactory convention shows both faces of the arrow around the changeover point, which seems logically peculiar more nearly matches binocular vision."[32] There is also the case of two β-strands crossing at a shallow angle, which, she notes, provide a classic example of the "Poggendorff illusion."[33]

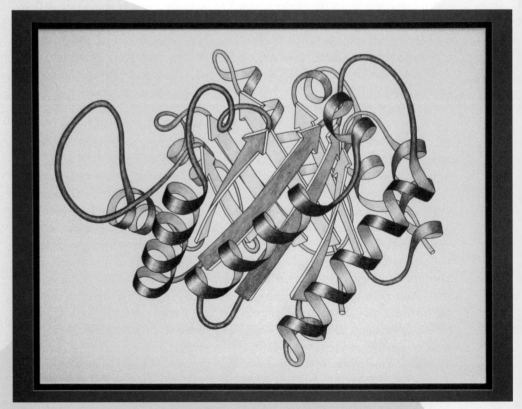

FIG 9 Jane Richardson, ribbon schematic of triosephosphate isomerase, hand-drawing, 1981

"In ordinary perception of such structure in three dimensions, the two eyes would see slightly around behind the edges of the front arrows, so that in a binocular image the edges of the back arrow would appear offset outward where they emerge from the top ones. In a mono drawing, those back lines must be slightly offset in order to appear straight and continuous."[34]

Her drawing process shows painstaking attention to detail. She used one of the rare molecular graphics workstations[35] available at the time to choose the viewpoint and obtain print-outs which acted as templates. The drawings were first done in pencil, then traced in ink. David Richardson provided "quality control," touching up line quality under a microscope as required.[36]

The Richardsons remained active in field of macromolecular visualization in the decades following. In the early 1990s, taking advantage of the growing graphic capacity of personal computers, they developed *kinemage*, a software package for the interactive display of molecular structure.[37] This software would serve for many years as "companion" to the journal *Protein Science*, which distributed structure files on floppy disk along with its printed version.

## Virtual structures

Richardson's drawings of protein structures constitute an interesting bridge between natural history and cutting edge technology. It relied on the drawing skills akin to that of an eighteenth century botanist and on a state-of-the-art graphics workstation. This allowed her to carefully inspect her "specimens" from all angles, and select the best viewpoint for the drawing, something which would have been difficult to do otherwise, short of building a model of each structure. Since such interactive molecular graphics systems were relatively rare, they were extremely expensive at the time. Richardson had to travel close to three hundred miles to work on the closest one available, which was housed at the National Institutes of Health in Bethesda, Maryland.

As computer graphics have now become much more powerful and affordable, scientists have increasingly used this technology to create dynamic representations of macromolecular structures. The usefulness of molecular graphics revolves, not only around the capacity to display the structure of complex (or simple) molecules on a computer monitor, but also around the capacity to interact with and transform this display so as to gain different perspectives on a given structure, highlight specific features, or occlude others. While some molecular graphics packages are simple aids to the visualization of molecular structures, others act as a "front-end" for molecular dynamics simulation systems, in other words, as an interface between the user and the simulation algorithms. Today, there are dozens of molecular graphics packages available, catering to all level of users and types of computer platforms. Anybody with a computer, an internet connection, and a web browser can easily explore the intricate beauty of protein structures in a way that most scientists could only dream of two or three decades ago.[38]

The earliest efforts to combine the representation of molecular structures with the dynamic properties of a computer display can be traced back to the high-tech environment of the MIT in the mid-1960s. This is where Cyrus Levinthal, professor of biophysics, and his collaborators took advantage of one of the earliest interactive graphics system available to develop a visually-oriented, computer-based "molecular-model building system."

In the 1960s, MIT was a frontrunner in the development of computer technology. In 1963, it became the host site of Project MAC, a unique time-shared computer system which, for the first time, provided a research community with the possibility of real-time interactive computing, mainly through a series of teletype terminals scattered around the campus.[39]

MIT was also at the forefront of computer graphics technology, thanks in great part to a Computer-Aided Design research program sponsored by the United States Air Force. Notably, this program gave rise to the Electronic Systems Laboratory Display Console, otherwise known as the "Kluge."[40] The Kluge was the first computer terminal able to show, through axonometric projection, three-dimensional objects on a cathode-ray tube. Three-dimensional perception was achieved by having the displayed object rotate on the screen and having the user control the rate of rotation of the image through a trackball-like device known as the "globe" (an hemisphere, in fact). The user could interact with the displayed objects through a variety of interfaces, notably buttons and a light-pen. As a vector-based display, the Kluge could only represent white lines on a black background. Although limited by today's standards, it had the familiar trappings of a graphics workstation and eventually became one of the terminals available to Project MAC users (fig. 10).

FIG 10

Cyrus Levinthal was not, at first glance, the dream user for Project MAC. Although originally trained as a physicist and reportedly very adept at mathematical modeling, the molecular biologist nevertheless later admitted that he "started with a rather strong distaste for computers and computing; at that time it did not seem that they could be useful to biology."[41] In late 1963, Robert Fano, the director of Project MAC, introduced Levinthal to the Kluge. Its capacity to produce images changed Levinthal's mind about computing. He became, in his own words, immediately enthused at the idea of employing this display system to create models of protein structures.

To make sense of Levinthal's enthusiasm, it helps to keep in mind that the skeletal and space-filling models discussed above were state-of-the-art in terms of macromolecular representation. Yet even with them, building the physical model of a macromolecular structure, which might contain hundreds or thousands of atoms, let alone exploring its various possible conformations, was at best very difficult. The models had to be supported by metal rods or suspended by wires and could easily be displaced (or sag out of place), greatly reducing the accuracy of the resulting structure. Collapsing models were a common occurrence, and the suggestion to build space-filling models underwater, so as to reduce or cancel the effects of gravity, was floated once or twice. Levinthal had first-hand experience of the problem: "At that time several MIT associates and I were trying to do molecular modeling as an aid in thinking about intracistronic genetic complementation. Our models kept falling down and we were having all the usual problems associated with models."[42] He saw the Kluge as a possible solution to what was perceived at best as an annoyance, and at worst, a serious hindrance to research.

Assisted by Project MAC personnel, Levinthal set out to learn programming, and within a few months, was able to develop a set of programs to construct, display, and analyze macromolecular structures in real-time on the Kluge. The result was described as a new, exciting way of looking at molecular structures;

Levinthal and some of his collaborators "went on to study proteins, protein crystals and whatever structural data we could get our hands on."[43] The representation of the structures was very schematic, composed uniquely of white lines representing the bond between the atoms. In static images, three-dimensional perception is completely lost.[44]

The visual and the numeric were closely intertwined in the combination of real-time computing and graphic interface: The user was able not only to witness but also, through the display, to interact with the computations, and – if necessary – to control, correct, and tweak them. Although this approach to computing is common now, it was radically new at a time when batch processing was still by far the norm. The display was particularly useful for debugging: a single glance at the display could reveal a badly programmed structure which would have been hard to detect in a list of numbers. For Robert Langridge, who used the system to refine crystallographic data of DNA structures, the system meant faster processing times and doing away with cumbersome models to visualize the resulting structures.[45]

The combination of the digital and the visual in the study of molecular structures comes forth clearly in Levinthal's project of using the interactive graphic display to address the problem of protein folding.[46] In the early 1960s, it had become widely accepted that the linear sequence of amino acids in a protein was sufficient to predict its native (functional) three-dimensional structure. The prediction of protein structure from amino-acid sequence was conceived as a potentially promising alternative to determining these structures by X-ray crystallography, then a long and complex process.

FIG 10 The Kluge computer display. CPK space-filling models are visible in the foreground, next to the globe. **343**

The thermodynamic hypothesis of protein folding held that, of all the possible conformations of its polypeptide chain, the native structure of a protein had the lowest internal energy. Checking systematically for all the possible conformations of the polypeptide chain of a protein to find the one with the lowest energy term was not an option, as the number of such possible conformations was (and still is) simply beyond the means of any available computing power. By the mid-1960s, however, some researchers had started to devise computer programs in which short virtual polypeptide chains were submitted to energy minimization algorithms. Such algorithms produced conformations with lower total energy, but they could only be expected to alter the structure to the bottom of a local energy minimum, rather than reach the global energy minimum corresponding to the conformation of the protein in its native state. Levinthal believed that using the graphic display to combine the skills and knowledge of a user with the analytical capacity of the computer might provide a solution to this specific problem.

The key was to have the user identify why the conformation was stuck at a particular local minimum and make alterations to the structure so as to return the algorithm to a "downhill" path. Levinthal characterized this interactive work as a combination of "manual manipulation and energy minimization."[47] He attempted to predict the structure of cytochrome C, a protein whose structure Richard Dickerson was in the process of determining crystallographically at the California Institute of Technology.

Yet this prediction attempt failed completely. A "plausible" structure was proposed, but it did not prove to be unique – several equally plausible structures could be postulated, rendering the whole process dubious. When Dickerson finally solved the structure of cytochrome C, it became clear that the predicted structure was completely wrong. In retrospect, one can point to many reasons for this failure, not least of all the fact that Levinthal, like many of his peers, had underestimated by a wide margin the complexity of the problem. Although some progress has been made since, the results of protein structure prediction methods even today are still far from the accuracy provided by experimental methods. Yet, all this work was not in vain: from Levinthal's cogitations on protein folding came two short and very influential notes on the concept of "folding pathways:" the idea that specific local interactions between atomic groups guide the folding process of proteins.[48]

In 1967, Levinthal left MIT to become chair of the Department of Biology at Columbia University. At that point, any effort to use the computer graphics resources at MIT to do macromolecular analysis effectively ceased. At the time of the move, Levinthal abandoned his work on protein structure, because, as he commented later, "it seemed to me that most of the activities which were directed at predicting structure from sequence data were, at the time, more game playing than serious science."[49] This particular failure did not dampen his enthusiasm for the application of computer graphics to scientific research. It would, on the contrary, become his main center of interest in the following years.

One can point at a number of reasons for this. First, the simple capacity to visualize macromolecular structures with an ease and flexibility that other means did not afford was in itself an achievement, one which, in the eyes of many, warranted further development. Second, although it had failed in the ambi-

tious project of protein folding prediction, the molecular graphics system had proved useful in more mundane and straightforward analytical tasks. Third, molecular graphics held many promises, the most prominent of which was to make much easier the whole process of structure refinement in protein X-ray crystallography, by providing a means for virtual model building.

The National Institutes of Health financed a state-of-the-art computer graphics system for Levinthal at Columbia and, by the early 1970s, he had put aside "wet" molecular biology to focus on the application of computer graphics to scientific research. Many of the researchers who had worked with Levinthal at MIT went on to create their own molecular graphics laboratory in various research institutions in the United States.[50] For them, molecular graphics was not simply a means to an end, but had become a field of research and development in its own right.

While the subsequent development of the field was by no means spectacular, it was steady, nonetheless. By 1974, nineteen computer modeling systems with molecular graphics had been described in the literature,[51] a fair achievement if one considers the cost of each of these facilities, not only simply in terms of hardware, but also in terms of software development; there was no off-the-shelf molecular graphics software, and basic hardware incompatibilities made it difficult to "export" software from one platform to another. By then, the field was gaining its autonomy: it had its practitioners; its centers, funding sources – even its scientific society and periodical: *The Society for Molecular Graphics* (launched in 1981) and *The Journal of Molecular Graphics and Modelling*.[52]

## Conclusion

Our experience of protein structures do not come to us unmediated. In fact, the idea of protein structure as an extension of structural theory in chemistry is, in itself, a theoretical model, a representation that has proven very useful to making sense of our world. While this representation raises interesting epistemological issues, it also has raised many practical ones. Just as we don't look at the finger that points at the moon, we often tend to take for granted the manifold representational practices at the heart of scientific activity.

In the case of protein structures, the question of representation, in its most practical sense, was far from secondary. My aim here was simply to lift the veil on the activities of those who – for various purposes and by different means – took the challenge of macromolecular representation head-on. Doing so allowed us to glimpse beyond the sanitized accounts of scientific journals, into a world of embodied mechanical metaphors, with all the difficulties it entails, of art and creativity at the service of understanding and of virtual spaces that have become new frontiers.

## Notes

1 See: James D. Watson, *The Double Helix: A Personal Account of the Discovery of the Structure of DNA,* Norton, New York (NY), 1980.

2 Max Perutz in a letter to Sir Harold Himsworth, 04/06/1953. Public Record Office (United Kingdom), file PRO FD1/426.

3 James D. Watson 1980, p. 34.

4 See: Robert C. Olby, *The Path to the Double Helix: The Discovery of DNA,* Dover Publications, New York, 1994, chapter 2.

5 To refer to the three-dimensional conformation of the polypeptide chain in fibrous proteins, scientists would use – often interchangeably – expressions such as "fold," "configuration," or "structure."

6 Francis Crick, *What Mad Pursuit: A Personal View of Scientific Discovery,* Basic Books, New York, 1990, p. 55.

7 For more information on the use of models in research on the conformation of the polypeptide chain, see: Eric Francoeur, "Molecular Models and the Articulation of Structural Constraints in Chemistry", in: Ursula Klein (ed.), *Tools and Modes of Representation in the Laboratory Sciences,* Kluwer Academic Publishers, Dordrecht et al., 2001, pp. 95–115.

8 John T. Edsall in a letter to Robert B. Corey, 03/16/1959, California Institute of Technology Archives, Papers of Robert B. Corey.

9 See: John R. Platt, "The Need for Better Macromolecular Models," in: *Science,* vol. 131, no. 3409, 1960, pp. 1309–1310.

10 As the name indicates, these models are quite similar to the ones produced at Caltech. What distinguishes them particularly from their predecessor is a special connector, designed by the biophysicist Walter Koltun.

11 Most proteins, we now know, contain few or no a-helices at all. It was a happy coincidence that myoglobin was composed mainly of such helices, and it certainly made the work of John C. Kendrew and his colleagues much easier.

12 John C. Kendrew, "Myoglobin and the Structure of Proteins," in: *Science,* Vol. 139, No. 3561, 1963, pp. 1259–66.

13 See: John C. Kendrew, Hillary C. Watson, B. E. Strandberg, Richard. E. Dickerson, David. C. Phillips, and Violet C. Shore, "A Partial Determination by X-Ray Methods, and Its Correlation with Chemical Data," in: *Nature,* vol. 190, 1961, pp. 666–670.

14 As quoted from: Horace F. Judson, *The Eighth Day of Creation: Makers of the Revolution in Biology,* Cape, London, 1979, pp. 593–594.

15 As quoted from: Jane S. Richardson et al., "Looking at Proteins: Representations, Folding, Packing, and Design," in: *Biophysical Journal,* vol. 63, 1992, pp. 1185–1209.

16 Jacques Fresco in a letter to John C. Kendrew, 06/22/1961. Bodleian Library, Western Manuscript Department, Ms. Eng. c.2410, file C.302.

17 See: Richard Dickerson, personal communication to the author, 05/11/2002.

18 Allen Edmundson, personal communication to the author, 06/04/2002.

19 The models were originally designed in the 1940s by W. C. Bunn, an X-ray crystallographer at Imperial Chemical Industries. John C. Kendrew improved on this original design by developing a barrel connector which allowed solid assembly of the model components in any desired configuration.

20 See: John C. Kendrew, "The Three-Dimensional Structure of a Protein Molecule," in: *Scientific American,* vol. 205, no. 6, 1961, pp. 96–110.

21 Sabrina Richards, "Painting the Protein Atomic, 1961," in: *The Scientist,* vol. 26, issue 8, 2012.

22 *Scientific American,* a popular science magazine, was one of the rare publications where such colorful scientific illustrations could be found at the time. It is only in the 1980s that science journals would start publishing color figures.

23 See: Richard E. Dickerson and Irving Geis, *The Structure and Action of Proteins,* Harper and Row, New York (NY), 1969.

24 Richard E. Dickerson, "Irving Geis, Molecular Artist, 1908–1997," in: *Protein Science,* vol. 6, issue 11, 1997, pp. 2483–2484. Geis and Dickerson collaborated on two more textbooks: *Chemistry, Matter and The Universe* (1976) and *Hemoglobin: Structure, Function, Evolution and Pathology* (1983).

25 Dickerson 1997, p. 2484.

26 Cameron Mura, Colin M. McCrimmon, Jason Vertrees, and Michael R. Sawaya, "An Introduction to Biomolecular Graphics," in: *PLoS Comput Biol,* vol. 6, no. 8, 2010, doi: 10.1371/journal.pcbi.1000918, available online at: www.ploscompbiol.org/article/info%3Adoi%2F10.1371%2Fjournal.pcbi.1000918, accessed 04/19/2013.

27 See: Sonya Bahar, "Ribbon Diagrams and Protein Structures: A Profile of Jane S. Richardson," in: *The Biological Physicist,* vol. 4, no. 3, 2004, p. 5.

28 The present article focuses on one narrow aspect of Richardson's work. For a wider view of Jane S. Richardson's and David C. Richardson's scientific work in the 1970s and 1980s, see: Richardson et al. 1992.

29 See: Jane S. Richardson, "β-sheet Topology and the Relatedness of Proteins," in: *Nature*, vol. 268, 1977, pp. 495–500, doi: 10.1038/268495a0.

30 Jane S. Richardson, "Early Ribbon Drawings of Proteins," in: *Nature Structural and Molecular Biology*, vol. 7, 2000, p. 624, doi: 10.038/87654.

31 Ibid.

32 Jane S. Richardson, "Describing Patterns of Protein Tertiary Structure," in: *Methods in Enzymology*, vol. 115, 1985, 341–358, doi: 10.1016/0076-6879(85)15025-1.

33 This illusion was first described by the physicist Johann Christian Poggendorff in the nineteenth century.

34 Richardson 1985, p. 371.

35 That workstation, developed by Richard Feldmann (1976), was located at the National Institutes of Health in Bethesda, Maryland. See: Richard Feldmann, "The design of computer systems for computer modeling," in: *Annual Review of Biophysics and Bioengineering*, vol. 5, 1976, pp. 477–510, doi: 10.1146/annurev.bb.05.060176.002401.

36 See: Richardson 2000, p. 624.

37 See: David C. Richardson and Jane S. Richardson, "The Kinemage: A Tool for Scientific Communication," in: *Protein Science*, vol. 1, issue 1, 1992, pp. 3–9

38 Proteopedia.org is the best site to start looking at protein structures. It relies on a Java-based applet to allow its users to explore the structures interactively.

39 See: Robert M. Fano and Fernando J. Corbató, "Time-sharing on computers," in: *Scientific American*, vol. 21, no. 3, 1966, pp. 128–140.

40 In hacker culture, the term "kluge" refers to an inelegant, yet effective, solution to a software or hardware problem. It is not clear how this epithet became attached to the ESL display console.

41 Cyrus Levinthal, Introduction: "A brief history of computer graphics," in: *Workshop on Computer Graphics in Biology*, Verve Research Corporation, 1976, pp. 1–5.

42 Ibid.

43 Cyrus Levinthal, "The Beginnings of Interactive Molecular Graphics," unpublished manuscript, 1989.

44 To see the digitized version of a 16mm movie on proteins made using the display, see: http://purl.org/efranc65/movie.

45 See: Robert A. Langridge and Andrew W. MacEwan, "The Refinement of Nucleic Acid Structure," in: *IBM Scientific Computing Symposium on Computer Aided Experimentation*, IBM, 1965.

46 See: Cyrus Levinthal, "Molecular Model-Building by Computer," in: *Scientific American*, vol. 214, no. 6, 1966, pp. 42–52.

47 Cyrus Levinthal, "Computer Construction and Display of Molecular Models," in: *IBM Scientific Computing Symposium on Computer Aided Experimentation*, IBM, 1966.

48 See: Cyrus Levinthal, "Are there Pathways for Protein Folding?" in: *Journal de Chimie Physique* 65, 1968, pp. 44–45.

49 Levinthal 1989.

50 For more details, see: Eric Francoeur, "Cyrus Levinthal, the Kluge and the Origins of Interactive Molecular Graphics," in: *Endeavour*, vol. 26, issue 4, 2002, p. 127.

51 See: Garland R. Marshal et al., "Computer modeling of chemical structures: Applications in crystallography, conformational analysis, and drug design," in W. Todd Wipke et al. (eds.), *Computer Representation and Manipulation of Chemical Information*, John Wiley & Sons, New York (NY), 1974, pp. 203–237.

52 These were originally called The Society for Molecular Graphics and *The Journal of Molecular Graphics*. As the computer graphics technology developed and became more established and routine, the focus of the society and the journal turned to modeling.

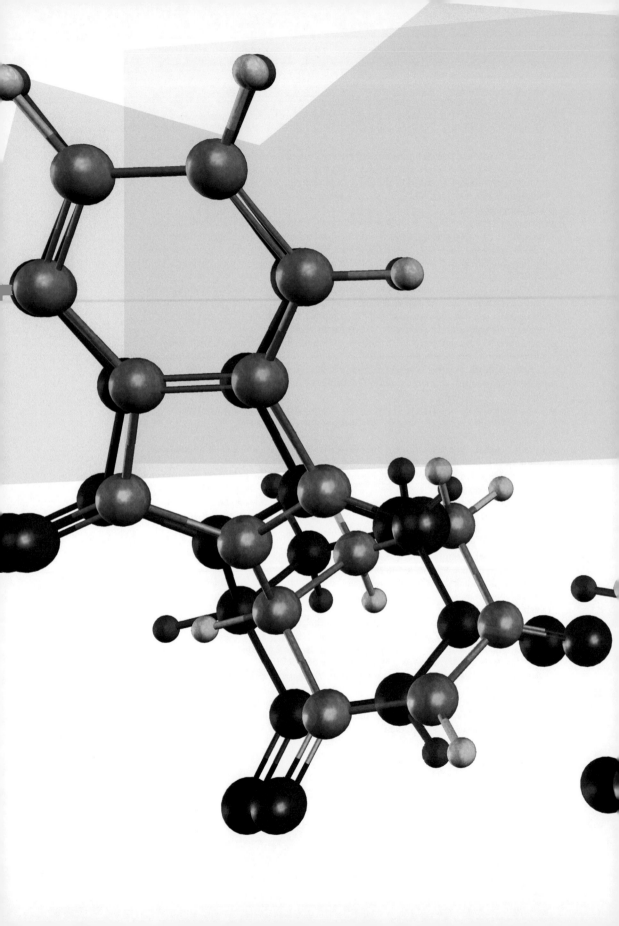

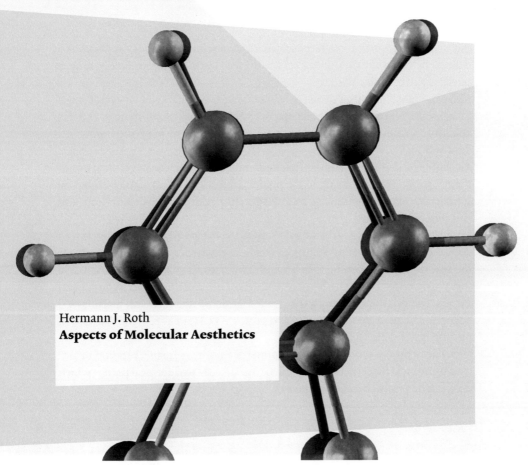

Hermann J. Roth
**Aspects of Molecular Aesthetics**

What does the term "molecular aesthetics" mean? Does it refer to the laws governing structures, the symmetry of atomic links, to the variety of molecular forms, to the comparability between objects we find beautiful? Answering this question is no mean feat!

But for a start, and translated without philosophic fuss and bother, the Greek word αιστηεσισ (*aisthesis*) simply means "perception" or "sensation."

The same root is contained in the medical term anaesthetic, connoting a drug which eliminates sensation or, more precisely, the sensation of pain. According to this definition, one might construe "molecular aesthetics" as the perception or sensation of molecules, the observation of their form, the perception of their attributes, the knowledge of their effect; in other words, construe that every molecule also has an aesthetic in so far as one can perceive it visually. Yet as we know, this is neither possible with the naked eye, nor at a microscopic level. Thus, even Ernst Haeckel's *Kunstformen der Natur* of 1904 (*Art Forms of Nature*, Dover Publications, New York (NY), 1974), which proposes the transition from the visual to the microscopic sphere, cannot help us any further. At an electron microscopic level, the outlines of gigantic macro-molecules or molecular associations are divined rather than exactly perceived.

When characterizing molecules, we find ourselves in the sub-microscopic sphere. The molecules become visible through their structural formulas. As the shortest, most precise, and informative descriptions of molecules, those formulas represent something I might call "molecular icons." Although an enormous amount of preparatory art belongs to the task, synthesizing aesthetically sophisticated connections is no longer an "art" today. Consider the asterane and

the nano-kid pagodane, in whose structures one can decipher the form of a mantis, or cyclacene designated as nanotubes. Both are intentionally synthesized "artistic" molecules.

Although most anything seems possible today, it would make far better sense to focus more on observing molecular aesthetics of natural substances, and less on anthropogenic objects, namely, those made by man by applying human understanding.

An enquiry about the attributes that lend molecules their formal structural aesthetics, would lead, above all, to the phenomena of symmetry, namely: bilateral symmetry, rotation symmetry, centrosymmetry, translation permutation, and chirality or handedness.

Dimerization – a frequently taken, immediate way to attain a symmetric molecule – is best obtained by adding or oxidizing two identical modules. The dimerization should then be indicated on two natural substances. Truxin acid FIG 1 (fig. 1) originates through the photo-addition of cinnamic acid. Symmetrical dimers also originate through the condensation of two identical modules via a spacer, which, in the simplest case, represents a $CH_2$ group, as may be seen in dicoumarol (see also fig. 1).

Depending on the type of link, unsymmetrical, mirror-image, rotation or cen-FIG 2 trosymmetrical dimerizates are formed (fig. 2) from two identical parts – which need not be symmetrical themselves.

cinnamic acid

truxin acid

**FIG 1** Dimerizations

dicoumarol

monomers

mirror-symmetric dimers

centro-symmetric dimers

**FIG 2** Types of dimerizations

Should dimerization occur in a certain way, secondary natural substances result for economic, energetic, or sterical reasons; these are then constructed according to the geometric pattern of a playing card, such as the King of clubs, Queen of hearts, or Jack of spades. One could easily write an entire volume on this subject, or else fill an elaborate book with illustrations – which I have, in fact, done,[1] and Peter Weibel kindly wrote the detailed introduction to that book, entitled "Molekulare Symmetrie" [Molecular Symmetry]. For purposes here, however, we will restrict ourselves to four molecular proofs. In figure 3, FIG 3 we see Acetylaranotin, Caulerpin, Calycanthine and C-Toxiferine. The identical half molecules stand in a relationship of a double reflection: horizontal and vertical. It is interesting in this connection to note the phenomenon of reflection (*Spiegelung*) in the sphere of music. The horizontal reflection of a melody, or a more extended series of tones, are relatively easy to compose and are often encountered in musical genres. The *Minuet al Rovescio* from Joseph Haydn's *Sonata in A Major, No. 41* (1773) might serve as a classic example of linear reflection. The structure of the antibiotic Gramicidin S which can be seen in figure 4 seems FIG 4 somewhat more complex. From an aesthetic standpoint, one might draw a comparison to a picture of mine entitled *Hommage à Theo van Doesburg* (2008) which, initially, also appears complex. In fact, it is formed centrosymmetrically.

FIG 3 Four natural playing cards

FIG 4 H. J. Roth, *Hommage à Theo van Doesburg*, 2008

FIG 5 Johann Sebastian Bach's *The Musical Offering* (1747) contains a canon (fig. 5) based on a double reflection of the series of notes or tones. In design, this composition may well be compared to the construction plan of a "playing-card-symmetrical" natural substance, such as Gramicidin S.

Linking several modules yields ring-formed, rotation symmetrical forms comprised of three to twelve components that satisfy high aesthetic standards. By this, I allude here to their formation according to laws. In the case of the biosynthesis of natural substances, figures 3, 4, 6, and 12 are preferred as units. Added to this are proofs for each: Enterobactin, Porphin, Enniatin B and Valinomycin (see figs. 6–8).

FIG 6 Enterobactin (fig. 6), which serves for the utilization of iron in micro-organisms, constitutes a twelve-part ring, which emerges through the condensation of three serine components. Porphin, the central structure of porphyrin, is constructed from four modules. Its symmetry resembles the pedestals of certain wells or baptismal fonts. In the crypt of Speyer Cathedral, for example, there is a

FIG 7 baptismal font whose form may be likened to that of a Porphin molecule (fig. 7).

FIG 5 Johann Sebastian Bach, *The Musical Offering* (1747), canon

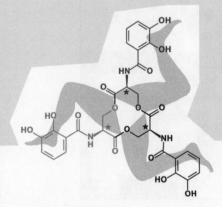

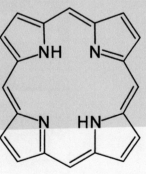

FIG 6 Enterobactin

FIG 7 Formula of Porphin and metamorphosis of Porphin by H. J. Roth

The antibiotic Enniatin B is a hexameric ring constituted of two alternating components. The prominent ionophore Valinomycin represents a 12-membered ring, which is formed by four alternating components. The aesthetics of the fundamental structural principles become apparent when comparing the schematized ground plans of Enniatin B and Valinomycin (fig. 8).

FIG 8

The structural formulas of simple organic molecules are frequently compared to words such as anagrams, metagrams and palindromes, and to certain melodies. Words are comprised of letters. The symbols of the atoms contained in chemical links are letters or pairs of letters; the symbols of the tones contained in a melody are notes or letters and syllables.

## Anagrams

Anagrams (verbal) are words which, after alterations to the sequence of letters, result in a second word and this acquire a different meaning, such as:
meat – team, laser – earls, decimal – medical, discounter – reductions.

Molecular anagrams are isomers, namely, molecules that differ from any given molecule by way of an altered series or position of the same atoms, and that consequently display other attributes. A verbal and molecular anagram comparison is shown in figure 9.

FIG 9

## Metagrams

Metagrams (verbal) are words that acquire a different meaning when a single letter is modified, such as: wild – wind, mess – miss, part – port, liver – lover, pudding – padding, etching – itching.

Molecular metagrams are isosteres, namely, molecules which differ as a result of changing a single atom or functional group in the one, and which thus acquire other chemical, physical, biological, physiological and pharmacological attributes. Four verbal and four molecular metagrams are shown in figure 10.

FIG 10

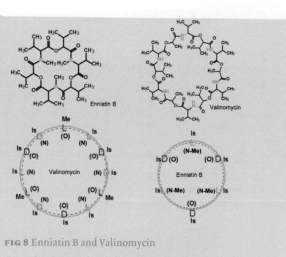

FIG 8 Enniatin B and Valinomycin

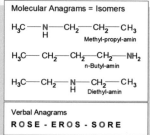

FIG 9 Molecular and verbal anagrams

FIG 10 Molecular and verbal metagrams

## Palindrome

Palindrome, a term derived from the Greek *palindromos*, meaning oscillating, connotes a word, phrase, number, or other sequence of units that may be read the same way in either direction, and conveys the same visual impression or meaning nevertheless.

> *non*
> *on – no*
> *level*
> *Ave – Eva*
> *rotator*
> *amoc – coma*
> *nurses run*
> *Madam I'm Adam*
> *Dennis sinned*
> *never odd or even*
> *too bad I hid a boot*
> *rats live on no evil star*

As a phenomenon, the palindrome is not only to be found in the linguistic and molecular spheres, but also in music, ornamentation and architecture.

The term is best known, however, in relation to words. If one orders the palindrome according to an increasing number of letters, it becomes apparent that in the case of odd numbers, a mirror axis goes through the middle letter, whereas for even numbers, the axis cuts between two of the same letters (fig. 11). The same also holds true in the molecular sphere. This becomes evident in palindrome-like dicarboxylic acids and palindrome-like ketones (acetone to myristone) (fig. 12).

Pentamidine and Curcumin (fig. 13) are introduced from the sphere of synthetic drugs and secondary natural substances. The Haydn minuet I alluded to above was also composed as a perfect musical palindrome, incidentally.

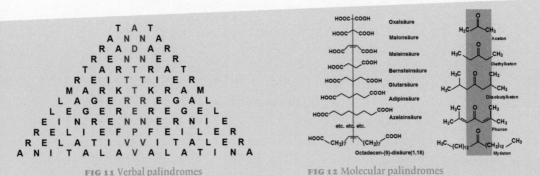

FIG 11 Verbal palindromes

FIG 12 Molecular palindromes

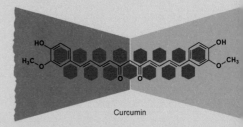

Curcumin

FIG 13 Two molecular palindromes, Pentamidine and Curcumin

## Translation

The principle of a translation can be recognized effortlessly in many native and synthetic polymers. Examples of this are shown in figure 14.

In the case of linear polymers, one can readily refer to a "molecular ornamentation." Simply compare a Greek key with polyethylene glycol! By the same token, one can wreathe "molecular garlands" with a linear cellulose string. The structural kinship of molecular and architectonic frieze groups is apparent in figure 14. Rubber and gutta as a comprehensive plastering in which transplantation operations may be undertaken at will.

Molecular tubes arise through the spontaneous self-organization we know from cyclodextrins or from TMV (tobacco mosaic virus) (figs. 15, 16).

FIG 14 Molecular and architectonic friezes (H. Roth 1993)

FIG 16 Cross-section of TMV

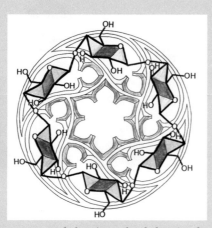

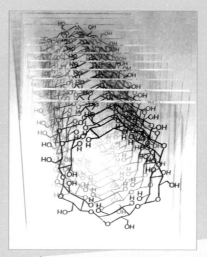

FIG 15 α-cyclodextrine and cyclodextrine channel by H. J. Roth

Similarly, and unquestionably belonging to the natural substances, are the three crystalline modifications of carbon substances: graphite, diamond, and fullerene. The diamond, which we limit ourselves to here, exhibits a three-dimensional, extremely stable crystalline grid; conceptually, one could "cut out" single symmetrical figures from it. The adamantane is the smallest of these units. Continuous linking leads to the diamond crystal grid via the diamond, triamantane, tetramantane, and so on.

FIG 17 To avoid making such considerations too complicated, we project the three-dimensional diamond grid on the two-dimensional level (fig. 17) from which a regular, translative network emerges. The schooled eye – if happily located in a head with a gifted imagination – can see in it a multiplicity of figures and forms: ravens, knights and judges.

**FIG 17** Pictures of ravens, knights, and judges in a diamond crystal grid by H. J. Roth

## Chirality

We define molecular asymmetry as the precondition or attribute of chiral links. Chiral objects behave towards one another much like a picture and its reflection do. However, like human hands, they cannot be brought into perfect congruence. Mirror-image-like pairs of chiral links are called enantiomers. Architects and biologists know enantiomorphs as pairs of mirror-image-like objects, such as coiled pillars or snail shells placed right and left of center. Since all receptors and enzymes are chiral, enantiomers show a different reactivity and reaction course. With respect to the chiral receptors in the human body and in animals, enantiomers are substances or drugs that act differently. Remarkably, enantiomorphic links (drugs, pheromones, secondary natural substances) often display differing and/or counter effects, such as thalidomide, olean, disparlure, carvone or the simple amino acid, asparagine.

### Thalidomide (marketed as Contergan in Germany)

We are aware today that both enantiomorphs are equally effective sedatives, and that only the **S**-enantiomer teratogen works. And yet, even after the administration of the **R**-enantiomer, the ominous **S**-enantiomer was formed through rapid enzymatic racemization (fig. 18).

FIG 18

The pheromone **olean**, produced by the olive fly (*Dacus oleae*), is a dioxa-analogon of spiro(5.5)undecane. Remarkably, the **S**-form attracts the female while the **R**-form attracts the male (fig. 19).

FIG 19

*S*-thalidomide

teratogen

*R*-thalidomide

<u>not</u> teratogen

same activity as hypnotics

FIG 18 Thalidomide

attracts the female

attracts the male

Olean

(1,7-Dioxaspiro(5,5)undecan)

7*R*,8*S*-Enantiomer

7*S*,8*R*-Enantiomer

FIG 19 Two pheromones, Olean and Disparlur

attracts the male

drives away the male

Disparlur

(*cis*-7,8-Epoxy-2-methyl-octadecan)

Another pheromone is **disparlure** (see also fig. 19), a sex attractant produced by some moths. While one enantiomer attracts the male, the optical antipode drives it away. The scent of **carvone** (fig. 20) recalls that of caraway, the progenital *carum carvi*. However, only the **S**-enantiomer does so; the **R**-enantiomer smells like mint. The sense of taste is also influenced by chirality. For example, the **S**-enantiomer of asparagine is bitter, the **R**-enantiomer is sweet.

When, in pondering an object, the symmetric or chiral judgment seems impossible, then one must consult the mirror image. Hydrocarbon **twistan** (fig. 21) is a prime example.

To conclude, should we wish to link the term aesthetic to the term art, it would seem appropriate to quote the great German painter, engraver and art theoretician, Albrecht Dürer, who recorded this:

"Art lies hidden in nature, and he who can wrest it from her, has it."

FIG 20

FIG 21

1 Hermann J. Roth, *Naturstoffe: Molekulare Spielkarten*, self-published 2009.

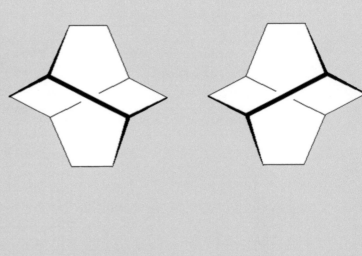

FIG 20 Enantiomers with different smells and tastes

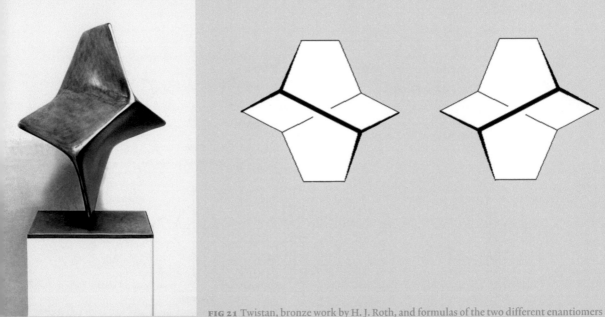

FIG 21 Twistan, bronze work by H. J. Roth, and formulas of the two different enantiomers

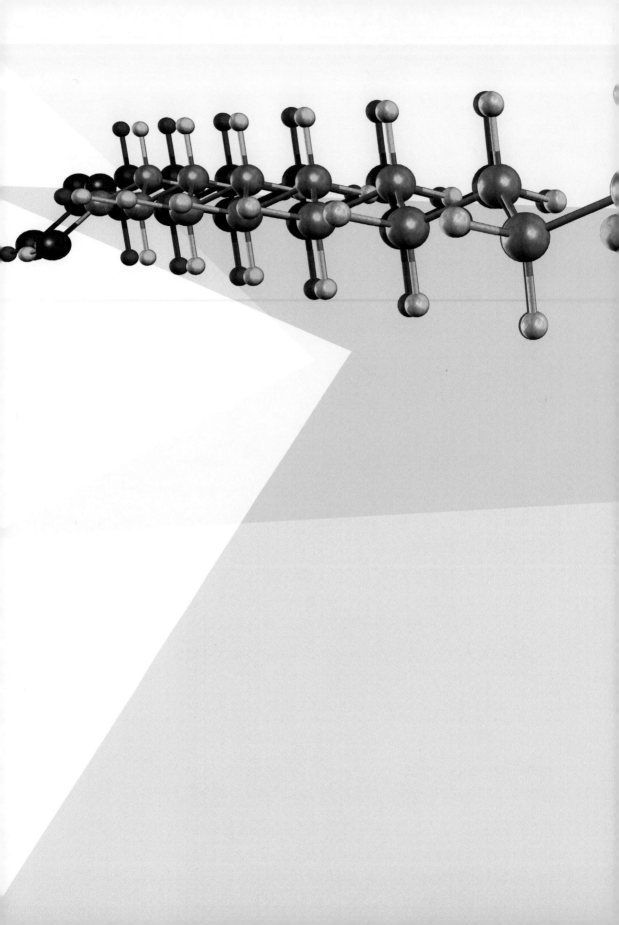

Wolfgang M. Heckl
**Moleculism**

Both the invention of the scanning tunneling microscope – for which Gerd Binnig and Heini Rohrer were awarded the 1986 Nobel Prize for Physics – and soon after that, the invention of the scanning force microscope, enabled atoms and molecules to be made directly visible in real space for the first time. Furthermore, the structural principle of a tip that scanned the nanoworld made possible American physicist Richard Feynman's dream of juggling with individual molecules to explore the nanoworld directly. This innovation was the starting point for making use of the findings of quantum mechanics for which Democritus' proposal – that all material can be divided into the smallest of particles – originally provided a physical basis. As such, this was also the birth of nanotechnology, a multidisciplinary technology that not only forms the practical basis for various material sciences from nanoelectronics to nanobiotechnology and nanomedicine. But it has also prompted a new appraisal of the paradigm shift in the culture of the natural sciences and technology, as well as in the fine arts and painting.[1]

The focus here is on supramolecular self-assembly processes, which I call moleculism, because the processes give the molecules that make up a painting their place in three dimensions, and as such, enable a work of art to take on meaning. Spontaneous molecular organizational processes are also the point of departure for our research on molecular evolution, which in the Earth's infant stages some four billion years ago, marked the starting point for the development of orderly living systems made up of organic molecules.[2]

Photographs of atomic surfaces sometimes look like abstract paintings; the mineral molybdenum disulfide for example, is a case in point. In it, one can recognize sulfur atoms as individual, and in some cases (as a result of the electron density clouds being smeared) as light volumes: apparently interlinked spherical bodies in the shape of a hexagon. At the same time, the photograph of the mineral made using the scanning tunneling microscope shows that it is possible to extract a single atom from a crystal structure, thereby creating a gap in the atomic chain. Beforehand, the atomic crystal surface comprising sulfur atoms was a sealed chain. As the atomic distance is 0.16 nanometers, the arbitrary removal of an atom using the atomic tip of the scanning tunneling microscope creates the so-called atomic bit, for which in 1993 John Maddocks and I were honored by the Guinness Book of Records "for the writing of the smallest hole of the world" (fig. 1).

FIG 1

In the "Nanocene," the evolutionary age of our bottom-up search for knowledge, I have addressed the question of how science and art interrelate from the point of view of a physicist who is attempting to analyze the creative impetus behind his work. The analysis of this process, by which, by means of nanoscopic processes, the transfer of pigments from a brush to canvas creates a macroscopically visible work of art, prompted my coining the term moleculism – a diminutive form of the term pointillism – to describe the properties that characterize my painting.

## Moleculism

As simple as understanding the process the artist uses might seem, deliberately configuring nanoparticles on a canvas seems to me, on closer inspection, to be somewhat mind-boggling. Particularly the macroscopically visible end result should be cited as that, considering the wide gap between the molecules' dimensions, beginning in single molecules – typically a mole (six times $10^{23}$) of color molecules – and ending in a form one can see with the naked eye.

The following example illustrates the process and as such, the term moleculism: Figure 2 is an early work (1995) depicting a laughing shark.[3] The photograph was taken using a scanning tunneling microscope of some 10,000 individual adenine molecules (see fig. 3). When transferred from a solution to a surface (the painting process in moleculism), these molecules spontaneously configure in such a way as to create a mono-molecular film consisting of small, individual, tightly packed molecules. However, unique in the work are the (dark) molecular faults that inhibit the emergence of a sealed molecular film. The faults range from spontaneous individual molecule defects (see fig. 2 arrow 1) to an interface that occurs arbitrarily during the molecular painting process in the crystallographic configuration of the local molecular domains (see fig. 2 arrow 2) which served as the starting point for the completion of the picture. The domain boundary became the basis for the contours of a shark's skull, to which two important molecular elements were added. The possibility, using the atomic tip of the scanning tunneling microscope, not only of applying individual molecules to the painting surface – as illustrated in the following example – but also of ablating specific individual molecules, forms the basis of the painting process that will follow: using the atomic brush to electromechanically scratch out specific molecules from the sealed layer. This is clearly visible on the two-molecule wide, and twenty-molecule long ablated line (see

FIG 2
FIG 3

**FIG 1** The world's smallest hole, attributed to
Wolfgang M. Heckl and John Maddocks by
the *Guinness Book of Records*, 1993

**FIG 2** *HAI 1995 STM*, molecular art made up of adenine molecules

molecular art™

**FIG 3** Chemical CPK model of an adenine molecule

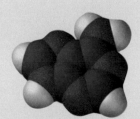

fig. 2 arrow 3), which measures around ten nanometers, and was the technology used to give the shark's head both an eye and a laughing mouth. Thus the first consciously painted molecular picture was created, which, magnified millions of times, can be perceived here.

By using the atomic brush in a reverse process, individual molecules can be applied to a painting base (in this case, the silver surface), as the following illustration of a coronene molecule demonstrates. Magnified some ten million times in the scanning tunneling microscope, the pigment molecule shows itself as a bit occasionally surrounded by interfering electron-scattering waves in the form of concentric circles (fig. 4, see also fig. 5 for the chemical formula of a coronene molecule).[4]

FIGS 4, 5

This is the singular elementary process of painting as observed from a "moleculistic" perspective, when colorants are adsorbed on the painting surface. This typically occurs with several moles, rather than individual molecules. Analyzing the process on a nanocale shows that it can be broken down into several individual processes:

I. Adsorption by wetting the painting surface with the molecules collected by the brush. This procedure can be explained in molecular terms by the solid wetting theory,[5] which involves bringing the pigments (usually distributed in a solvent) into contact with the surface of solid matter, the painting surface. For the wetting, or the transfer of the pigments, the fact that these are present in nanoparticular form and are adsorbed on the surface of the solid matter with a binding constant higher than that of the solvent molecules – which can evaporate – is pivotal.

This triggers the second process:

II. Spontaneous self-organization by the molecules under given conditions – such as adsorption constants, temperature, time, electromagnetic interaction between pigment, and substrate – and lateral interaction among the molecules themselves through chemical bonding. These conditions affect the flow, evaporation, and configuration of the color that emerges, and are visible macroscopically. Molecular chemical bonding here is determined by the energy minimization principle which leads to the color pigments self-organizing on the painting surface and whose structures can be foreseen using molecular dynamics calculations and computer modeling. In the self-organizational phenomena,

FIG 4 Electron scattering waves surrounding a single coronene molecule, center

FIG 5 Chemical formula of a coronene molecule's structure

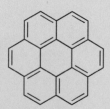

one can distinguish various levels of hierarchy that moleculism brings into play.

1. Self-assembly, whereby given units – e.g. atoms, molecules, LEGO bricks – interact with one another according to defined regulations for neighbors (in particular stereochemical specific bonds) under external conditions, and they create a topologically concise structure (amorphous, chaotic clusters, expressly disordered).

2. Self-structuring or bundled self-assembly: a process which leads to an ordered system in one, two, or three dimensions and can be defined by suitable lattice parameters (e.g. a crystal).

3. Self-organization, or a higher level of self-structuring, in which the desired design of elementary components or the inherent interaction rules lead to emergent structures, but whereby features peculiar to the system emerge that could not be foreseen, e.g. the molecular coding system DNA, molecular machines, schools of fish, or swarms of birds with swarm intelligence.

4. Self-construction, or a system built using molecular tools such as molecular motors, ratchets, transport and storage components, functional molecular machines based on a molecular construction plan (ribosome, enzymes, myosin-actin transport system, etc.).

With regard to moleculistic painting, the first and second processes are brought to bear in particular. Decisive from here is the intervention of the artist himself, who at a third, macroscopic level, lends expression to his will to create, while the first two processes have occurred involuntarily and been dictated by nature. III. Through experiments in molecular design at macroscopic level, however, the artist may also exert subsequent influence.

This complex procedure of molecular arrangement, which is neither deterministic in nature, nor able to be precisely analyzed – let alone consciously controlled in nanoscopic detail – plays a role in the final result of a painted work nonetheless.

Representing several other cases, the following example may show the parameters more clearly. It relates to the processes described above when painting with mordant red (Alizarin $C_{14}H_8O_4$) in a solution of 8-cyanobiphenyl molecules on graphite (fig. 6, see also fig. 7 for the chemical formula of the molecule). FIGS 6, 7 Through a polarization microscope, one can see the lumps of pigment nanoparticles that seem to spread arbitrarily across the surface (fig. 8). The molecular FIG 8

FIG 6 Mordant red (Alizarin) as a macroscopic color swab

FIG 7 The molecular formula of mordant red

332 ① • 7　★★★□
Krapprot
red madder
rouge de garance

**FIG 8** Polarization microscopic shot of mordant red color particles on the paint surface

10 μm

**FIG 9** Molecular self-organizing of the mordant red color pigment molecules

40 nm

**FIG 10** Chemical structure formula of the trimesic acid molecule

**FIG 11** Self-organizing molecular composition made up of trimesic acid molecules ($C_9O_6H_6$) and co-adsorbed solid (greenish) and rotating (blueish) coronene molecules ($C_{24}H_{12}$) enlarged one million times; captured by the scanning tunneling microscope and

**FIG 12** *DNA*, 1990, acrylic on canvas, 70 × 100 cm

366

self-structuring in the highly magnified dash of color shows the individual mordant red molecules as a highly ordered, two-dimensional layer, with an interface, as well as individual molecular faults, clearly recognizable (fig. 9).  FIG 9

Using mixtures of molecules, this process of molecular construction can be highly aesthetic, in turn, self-structuring in this particular case, its tendency to self-organization being the structuring principle. Individual coronene molecules are deposited in a structure mask comprising trimesic acid molecules (chemical structure in fig. 10, appearing in red in the scanning tunneling image in fig. 11) arranged in sixes in a plane on the graphite painting surface (in red) (fig. 11). The tightly adsorbed coronene molecules appear greenish, and individual rotating coronene molecules, blue. Unusually, several lattice sites in the middle of six trimesic acid molecules are not occupied, such that the black graphite of the painting surface appears to show through (fig. 11).  FIG 10  FIG 11

Under the heading of moleculism, a new approach to observing any form of painting may be taken. Ultimately, the picture stands as a macroscopic expression of moleculism with stylized DNA strands and recognizable contours of its individual DNA molecules (fig. 12). The challenge of transferring to sound images any information about the atomic and molecular composition of paintings – information gathered using the scanning tunneling microscope by means of a mathematical transfer algorithm – is described elsewhere, but represents a dimension of making atomic nanoworlds visible and audible.  FIG 12

The aim of that project was to develop a new way of portraying atomic and molecular soundscapes, thereby forging a link between science and art in the field of quantum physics. To this end, by setting them to music, the imagery created using the scanning tunneling microscope gave a fascinating insight into the uncharted world of atoms and molecules transported into the world of sound. We investigated a hitherto neglected form of access to the world of the smallest material compounds, namely, the auditory channel. Contrary to the visual channel, the auditory may well allow people to register a different part of reality.[6]

Translated from the German by Jeremy Gaines.

**Notes**

1 See: Wolfgang M. Heckl, "Die Nanoskala – Schlüssel zum Verständnis der Natur," in: Barbara Könches, Peter Weibel (eds.), *unSICHTBARes. kunst_wissenschaft*, Benteli, Bern, 2005, pp. 76–93; Wolfgang M. Heckl, "Das Unsichtbare sichtbar machen – Nanowissenschaft als Schlüsseltechnologie des 21. Jahrhunderts," in: Christa Maar, Hubert Burda (eds.), *Iconic Turn. Die neue Macht der Bilder*, DuMont, Cologne, 2004, pp. 128–141.

2 See: Stephen J. Sowerby, Wolfgang M. Heckl, "The Role of Self-Assembled Monolayers of the Purine and Pyrimidine Bases in the Emergence of Life," in: *Origins of life and evolution of the biospheres*, vol. 28, no. 3, 1998, pp. 283–310, doi: 10.1023/A:1006570726326.

3 See: Wolfgang M. Heckl, *Science & Art*, 2011/2012, published by the author, ISBN: 978-3-940396-36-5.

4 See: M. Lackinger, S. Griessl, W. M. Heckl, and M. Hietschold, "Coronene on Ag(111) Investigated by LEED and STM in UHV," in: *The Journal of Physical Chemistry B*, vol. 106, no.17, 2002, pp. 4482–4485, doi: 10.1021/jp014275s.

5 See: F. Trixler, T. Markert, M. Lackinger, F. Jamitzky, and W. M. Heckl, "Supramolecular Self-Assembly Initiated by Solid–Solid Wetting," in: *Chemistry – A European Journal*, vol. 13, no. 27, 2007, pp. 7785–7790, doi: 10.1002/chem.200700529.

6 See: Wolfgang M. Heckl, "Das Unsichtbare sichtbar machen," in: Maar/Burda 2004, pp. 128–141; Wolfgang M. Heckl, *Künstlerische Verbindung von Bild- und Tonkanal in der Quantenwelt – Atomare Klangwelten*, von der Andrea von Braun Stiftung gefördertes Projekt, 2003.

Portrait photo of Irving Geis by his daughter,
Sandy Geis, circa 1990

large image
The hemoglobin molecule – four symmetrically
arranged myoglobins. It can change from oxygen-
binding configuration to an oxygen-releasing con-
figuration in response to the organism's demand
for oxygen; watercolor, illustration by Irving Geis

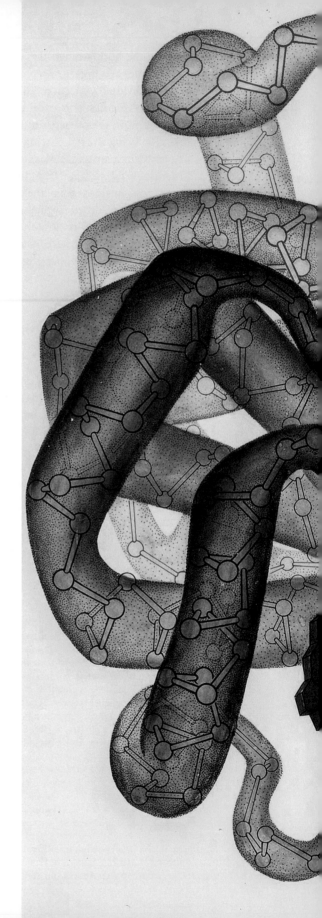

**IRVING GEIS** (\*1908 in New York, NY, †1997 in New York)
was an American artist who worked closely with biolo-
gists. His hand-drawn work depicted numerous struc-
tures of biological macromolecules, such as DNA and
proteins, including the first crystal structure of sperm
whale myoglobin. Geis illustrated textbooks on im-
munology, chemistry, and biochemistry. Co-authoring
with Dr. Richard E. Dickerson, he produced and il-
lustrated several textbooks: *The Structure and Action of
Proteins* (1969); *Hemoglobin: Structure, Function, Evolution,
and Pathology* (1983); and *Chemistry, Matter, and the Uni-
verse* (1976). He was awarded a Guggenheim Fellowship
(1987) for a project to assemble his work into an archive
of molecular structures.

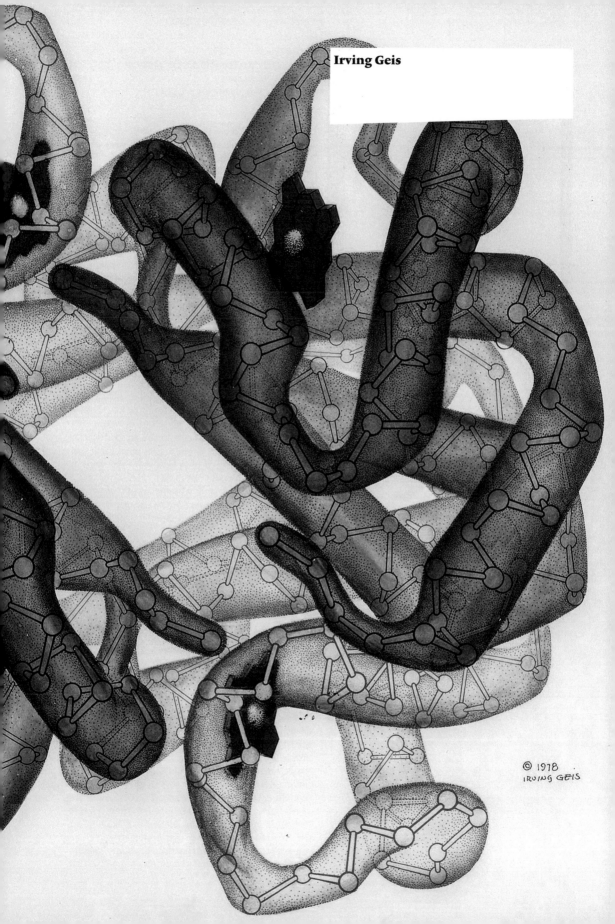

Irving Geis

© 1978
IRVING GEIS

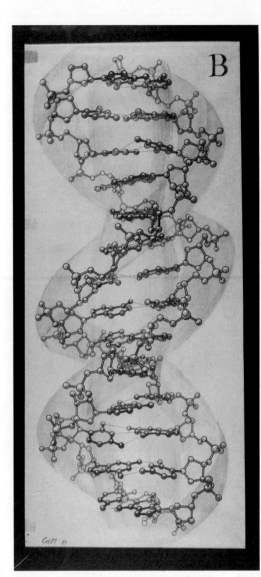

B-DNA – from the single crystal analysis of Dr. Richard E. Dickerson, watercolor, 1984, illustration by Irving Geis

**Obituary**
**Irving Geis, Molecular Artist, 1908–1997**
Richard E. Dickerson
(Molecular Biology Institute, UCLA)

On July 22, 1997, the world lost one of the giants of scientific illustration and communication: Irving Geis of New York. He died at the age of 88 of a cerebral hemorrhage, attended by his wife Miriam and his daughter Sandra, a photographer with the *New York Times*. This memoir is written to say a few words about Irving Geis as I knew him: as an artist, a scientific illustrator, and a human being. We first met in the summer of 1964, but it wasn't science that brought us together, it was art. On the last day of the International Congress of Biochemistry, a display went up in the New York Hilton of prints by John Held, Jr., recently reprinted from the original linoleum blocks. When I enquired about them, the concierge told me that the exhibit would not open until the following Monday, but that I could go up to 200th Street and talk to the man who had reprinted them; perhaps he would sell one.

So I wandered by subway to the very northern tip of Manhattan, and knocked on an apartment door. Irv Geis answered, and we discussed prints and John Held, Jr. I bought two prints from him, and then just as I was leaving, Irv noticed my lapel button from the Biochemical Congress and asked, "Are you a biochemist?," "Sort of," I replied. Irv volunteered, "I once illustrated an article for *Scientific American* on the protein myoglobin for a man from Cambridge named John Kendrew. Ever heard of him?" In astonishment I responded, "I certainly have. I was a postdoctoral with him on the myoglobin project in 1958-1959!" He pulled me into the apartment to show me the original painting of myoglobin, and a 33-year collaboration began.

The myoglobin painting of 1961 has been reproduced in countless places. Less well known but equally meritorious, and in the same style, is his 1966 painting of lysozyme, which illustrated an article by David Phillips, now Lord Phillips of Ellesmere. That painting graces the cover of this issue of *Protein Science*.

Irv and I wrote three books together: *The Structure and Action of Proteins* in 1969, *Chemistry, Matter and the Universe* in 1976, and *Hemoglobin: Structure, Function, Evolution & Pathology* in 1983. He became a co-author because I couldn't afford him as an illustrator. But even more than that, we developed a mutual symbiosis from which we both benefited. I could describe what needed to be illustrated about protein structure, and Irv would come up with clever and original graphic methods of putting the point across. It was never clear whether Irv illustrated my books, or I wrote Irv's captions. In the end, it didn't matter; together we could do more than either could have done alone. I have only lately come to appreciate the extent to which *Hemoglobin* was a masterpiece of typography and book design – clean, simple, attractive, yet informative. His drawings of hemoglobins under various conditions have never been matched. When you work closely with Irv, it is easy to become lulled into thinking that all artist/illustrator/designers are that good.

We and our families spent three memorable summers at the Benjamin writing center in Aspen, 1971–1973, working on a freshman chemistry textbook: *Chemistry?, Matter & the Universe*. It was here that Irv revealed a marvelous sense of humor as a cartoonist, a talent that he had used earlier to illustrate Darrell Huff's *How to Lie with Statistics*. "That book showed the importance of a good image," Irv commented. "Huff could just have well entitled it *An Introduction to Statistics*, and it would have sold a few hundred copies for a year or two. But with that title [and with Irv's cartoons, I might add] it's been selling steadily since 1954." My children were then in junior high school and grade school, and Irv became unofficial grandfather-in-residence to them all. My oldest boy worked as a gofer and general handyman/assistant for Irv one summer, and was star-struck with the idea that he was helping a real artist! Irv's daughter Sandy was grown up and on her own, but she came to visit Irv and Miriam in the Colorado mountains.

Irv loved the west, and his brother lived in Southern California. "Why don't you and Miriam simply move out here?" I asked. "There are two reasons why not," he replied. "For one thing, everything I need as an artist and illustrator is close at hand in Manhattan; I couldn't duplicate that in any other city in America. And the second reason is Miriam. She wouldn't be happy out west; she thinks that civilization stops at the Hudson River." "So do I, Irv," I replied. "So do I."

Being around Irv, I absorbed homilies about art that are hard to forget. He once commented that his job was not to draw a protein exactly as it was, but to show how it worked. A computer could draw a protein, given the right set of coordinates. But who would tell it exactly what to show? If some key aspect of protein structure was eclipsed and out of sight, the computer would be stuck. But Irv the artist could just tweak it a bit, and move it out in the open where it could be seen and the molecular mechanism thereby understood. He called this process "selective lying," and claimed that this was one of the special talents of a knowledgeable artist. "Knowledgeable" was the key. Most artists have no idea what they are drawing, he commented. He was once making an elaborate illustration of a folded protein, surrounded by space-filling $H_2O$ molecules. A fellow artist watched him for a bit, and then remarked that Irv need to "put a few more lima beans over on the left."

Another of Irv's aphorisms is unforgettable. He had no use for artists who splash brilliant but arbitrary colors over their work to impress the casual viewer. "Color is a language," he said, "and as with any other language, one mustn't babble!" With the advent of widespread and easy-to-use computer graphics, and new scientific journals that fall all over one another in competition for four-color flash, it seems to me that a lot of babbling is going on today, of a sort that Irv would not have approved.

Irv was very taken with the importance of using art to put across scientific concepts. On more than one occasion, he likened himself to Andreas Vesalius, whose informative and artistic engravings taught the Renaissance public about the new field of human anatomy. Irv thought of his own role as that of a molecular Vesalius, using art to teach the modem public about the equally new field of

molecular anatomy. But in view of his many-faceted talents, as artist, illustrator, interpreter, and scientific lecturer (an achievement of which he was very proud in his later years), it is more fitting to say that Irving Geis was the Leonardo da Vinci of protein structure.

The article was adapted from Geis' funeral address, July 25, 1997, and first published in: *Protein Science*, vol. 6, no. 11, November 1997, Cambridge University Press, pp. 2483–2484, doi: 10.1002/pro.5560061126.

Myoglobin fold. The main polypeptide chain and the heme (red disc) where oxygen is reversibly bound to the central iron atom; acrylic painting, 1987, by Irving Geis

Myoglobin – watercolor painting by Irving Geis, commissioned by *Scientific American*, published December 1961 to illustrate John Kendrew's article: "The Three Dimensional Structure of a Protein Molecule." The painting, created before the age of computer graphics, has become a historical icon in the history of science. It was the first time that this newly discovered structure was illustrated in three dimensions and it established Irving Geis' reputation for visualizing complex molecular structures. The painting prominently displays a heme group, with a single atom of iron at the center.

**371**

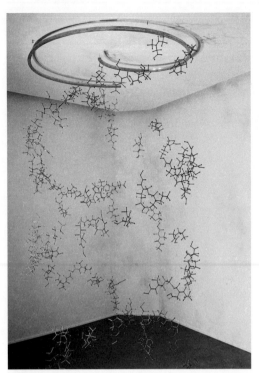

both images
*Olfactory Analysis*
2012, installation, exhibition view,
Kunsthalle Kiel, 2012

*Olfactory Analysis*, a further development of the installation *Identity Analysis* (2003/2004), is a spatial abstraction of the artist's genetic code. *Olfactory Analysis* is again derived from the body data of the artist. Out of the chemical analysis of her own perspiration, which can also be viewed as another form of identity code, six major molecular structures were identified and reconstituted in the installation in a multiple repetition. The volatile smell is translated into a visual, fragile space of freely moving molecules. The body, in its accumulation of olfactory molecules, is made physically perceptible as an "experience space."

**HELGA GRIFFITHS** (*1959 in Ehingen, DE) is a multi-sense artist working on the intersection of science and art. She has a BFA from the Mason Gross School of the Arts (New Brunswick, NJ). Griffiths completed her postgraduate studies at the Stuttgart State Academy of Art and Design and continued with further studies in new media at the Staatliche Hochschule für Gestaltung Karlsruhe [Karlsruhe University of Arts and Design] (DE). She has exhibited her multisense-installations in several biennials, such as Bienal de La Habana (CU) and Seoul International Media Art Bienniale. Her work has been shown in international museums, the Henie Onstad Kunstsenter, Oslo, Palais de Tokyo, Paris, and the ZKM│Center for Art and Media Karlsruhe among them.

www.helgagriffiths.de

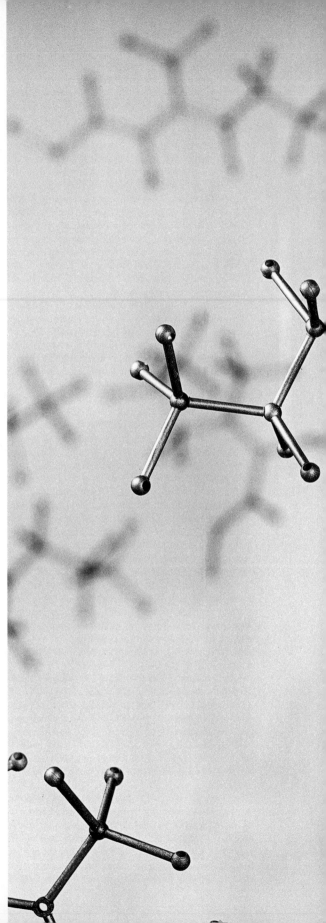

Helga Griffiths

### Identity Analysis

The walk-through installation *Identity Analysis* is an abstraction of the human DNA code consisting of four thousand test tubes filled with fluorescein solution. This installation, which presents the artist as a readable code, can be regarded as a metaphor of human architecture. The genetic structure of the artist has been transformed into a transparent, fragile, walk-through sense space which incorporates visual, acoustic, haptic, and dynamic elements.

Fluorescein, which is used both in science and technology, glows when irradiated with ultraviolet light, giving out a mysterious, almost unreal, green light. An extract from the actual genetic code of the artist is contained as a striped pattern in the petri dishes on the floor.

On entering this spiral-shaped coded space, the visitors feel themselves transported into an alien environment of transparent laboratory-like elements. They can pass their hands over the suspended glass surfaces and fill the room with ringing glass sounds.

In this installation the artist reveals herself by displaying her own genetic structure, the most personal information of any individual, and allows the visitors to enter the innermost sphere of her being. A new perspective is opened, in which the visitor – with his or her own individuality – becomes a part of the installation and relates to the artist's identity.

This installation breaks with the traditional representation of the body by allowing the visualisation of nanoworlds and the interchange of visible, perceptible worlds. The body is a human experimental space on which, in which, and with which, research is carried out. The illumination with green fluorescein shows both the scientific aesthetic and the fragility and artificiality. *Identity Analysis* is a transparent container of fluids defined by the intimate perspective of an electron microscope.

left
*Identity Analysis*
2003/2004, walk-through installation, detail, installation view, Henie Onstad Kunstsenter, Oslo, 2004

right
*Identity Analysis*
2003/2004, walk-through installation, installation view, ZKM | Center for Art and Media Karlsruhe, 2005/2006

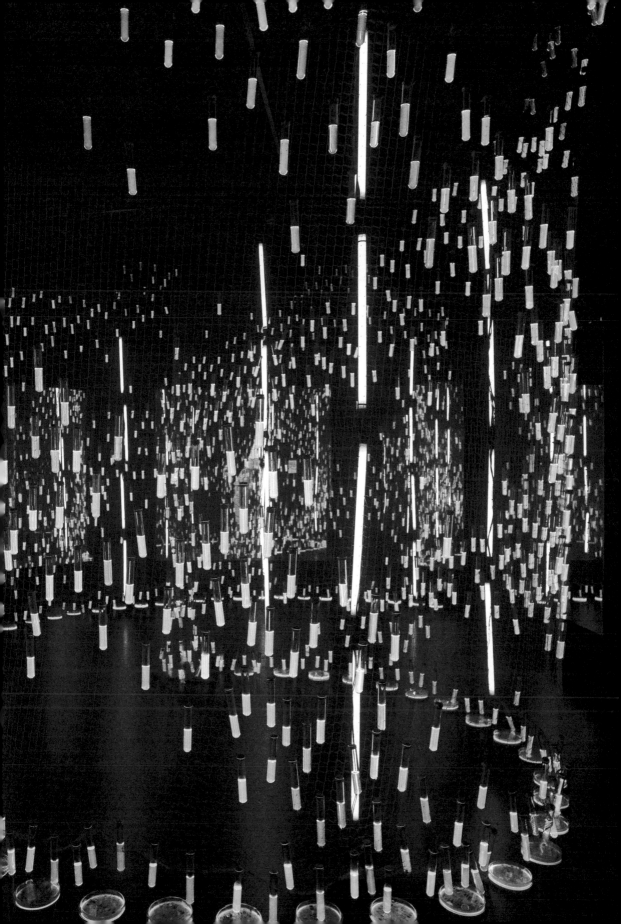

*Ascension in violet (Hommage à John Coltrane)*
1992, ambient structure, exogenous tension, painted wood, 225 × 105 × 40 cm, collection Enrico Baleri, Bergamo

*La Commune della Cultura*
1971, proposal for a self-governing museum, transformable in time, competition for the Centre Pompidou, Paris. Model shows maximum extention.

**LEONARDO MOSSO** (*1926 in Turin, IT) is an Italian architect and artist. He studied architecture at the Politecnico di Torino (IT). From 1955 to 1958, he worked in the studio of Alvar Aalto in Helsinki (FI) and from 1961 to 1986, he was a professor at the Politecnico di Torino. Together with Laura Castagno, he founded the Centro Studi di Cibernetica Ambientale e Architettura Programmata and the Centro Studi Aaltiani di Torino – later the Istituto Alvar Aalto – in 1970. His work has been shown in numerous group shows, such as *Lichtkunst aus Kunstlicht*, ZKM | Center for Art and Media Karlsruhe (DE) and solo exhibitions such as *Leonardo Mosso: Landschaft – Struktur und Geschichte*, Karl-Ernst-Osthaus-Museum Hagen, (DE).

large image
*Polychrome Wolke*
1989–1992, seven ambient structures of exogenous tension, 500 m², collection Dr. Jürgen Schneider, Königstein im Taunus (architects Kramm + Strigl)

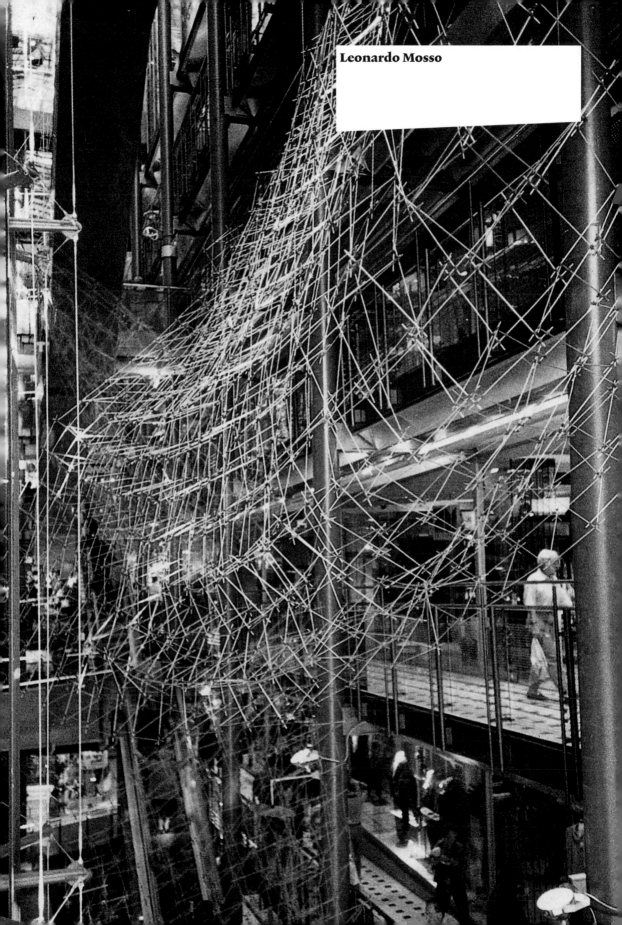

Leonardo Mosso

**For Leonardo Mosso**
Sandra Bonfiguoli

Leonardo Mosso's work, his *modus operandi* and his crea-
tions themselves, initiate a play of references and in-
tuitions that recall the dissertations of other disciplines.
Not a practice of inter- or transdisciplinarity but rather
an ability to open up discourses and appropriate ideas.
It is as though Mosso were offering a dictionary of terms,
not clearly defined but, rather, sufficiently ambiguous.
Plastic, soft in a way such that they can be carted around
from one discipline to another. Words allow a strange
translatability, one which is never complete yet never ar-
bitrary: an opportunity to create discourse, transferring
the work to other semantic fields.

The present writer is not an expert in art criticism, but
has had the opportunity to encounter Mosso and his
work on several occasions, and to exchange ideas depart-
ing from common experience. Mosso and I both have
a dual background, like two eyes each viewing things
from a different perspective. Leonardo is an architect
and an artist whose work makes numerous references
to mathematics and physics, while I myself am a math-
ematician and physicist who has landed on the shore of
architecture. The result is a play of proximities in which
each of us asks the other questions about the area in
which we are least familiar and thus which we desire.

It is this strange entanglement of discourse that I would
like to express here, though it's almost impossible to do
so in words. When we talk, Leonardo and I are always in
close proximity to his works, and their significance leads
our ambiguous words, used outside their disciplinary
context, to a destination of meaning. A mode of com-
munication in which it is the utterance itself which com-
bines words, somatic gestures, and the meanings of the
works. Leonardo as an artist has a real passion for math-
ematics and physics. The vocabulary he uses to explain
his work (or does he use it only with me?) and his *modus
operandi* is physical-mathematical: cartesian axes, system,
structure, morphogenesis, cube, logarithmic
curve, progression, endogenous and exogenous

**378**

tension, system statics, dynamics, joints and finally, the
name of a woman, Laura. In his spacious studio situated
on a cold green hill, Leonardo stands close to me and
asks me questions. The studio is crammed with works
that storm the ceiling, plunge down, arrange themselves
in curves remarkably diverse in their systematic regular-
ity. Leonardo is at work. He touches his creations, shows
them off, makes them fall and modifies them according
to a "logarithmic" curve.

The artist counts, sliding his finger along the sides of
the frame (two steps up and one to the right, then up
two more and two to the right), and the structure con-
tracts, with surprising results. Some structures close,
collapsing in on themselves, others open up in rapid
explosive movements; structures which were up to now
static (recalling in their orthogonality the idea of "or-
der") fall in a configuration that is neither disorder nor
a new state of equilibrium, but rather a strange point
of dynamics. It is exactly that moment after a wall has
started to crumble and is no longer a precise structure,
though it is still possible to perceive both its former
state and the destiny to which it is doomed. And yet it
is frozen there, immediately after the beginning of the
movement, before its rapid conclusion. Leonardo moves
skillfully along the framework of the world his work has
created (sensitized?) deforming the nicely ordered weft
of the "Laura" joint, according to his beloved logarith-
mic curve. I know what he expects from me; disciplinary
information, a mathematical intuition that could em-
phasize even further his own mathematical passion, a
passion which controls the manipulation of the work, a
play of rhythmical steps in a progression (geometric or
arithmetic?) leading to the correct spatial point, closing
the joint and deforming the tissue into new structures
seemingly contingent but in reality, necessary.

Observing Leonardo as he deforms the modular and se-
rial order of the system (a topological transformation)
according to the numbers of a logarithmic curve, and

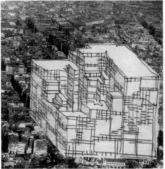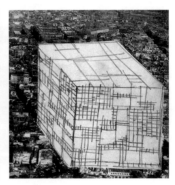

emotionally tries to drag a further piece of intuition out of me (I don't answer, although I too am involved in the game, possessed by a sensation of mathematical feel) I recall certain reflections and images (or impressions). The first reflection-impression is that Leonardo Mosso is an architect, and his works display the background of their author; what remains is a quintessence of architecture that, according to Umberto Galimberti lies in the fact that the work's "initiation" (archo) stems from a definite end. "Architecture begins in the present. Beforehand it was not possible, since in cyclical time, which is based on repetition of the identical, there can be neither beginning nor end". In Mosso's works, the end (community self-management), the method of structural planning ("for a non-objectified architecture") and their opening to time are all aspects of a general theory.

The artist's work and his creations clearly display this research, albeit in a disembodied form which has lost its tectonic dimension. Another impression I have in front of his works reminds me of an idea which belongs to science, both Greek and modern, according to which nature is a geometric and numeric entity. Mathematics is not only a useful instrument to describe it, but the key to unlocking its secret. I think Mosso's work refers to an idea of nature mediated by art. There is only one nature (an identical geometry) which governs the world and the cosmos. This is a Renaissance idea. Mosso's works arrange themselves among the things of the world, river banks, houses, trees and other items, as if these displayed the only essential thread that is the very nature of things. In this mode of artistic endeavor lies also a receptiveness to nature exclusive to the mathematician.

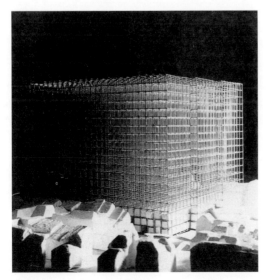

First published in: *Leonardo Mosso. La Città Transparente / Die Transparente Stadt*, exhib. cat., Badischer Kunstverein Karlsruhe, 1994, pp. 63–65.

*Snakes on a Plain*
2008, collaboration with students from the
Woodbury School of Architecture, San Diego

large image
*Cellular Mesh*
2002, stainless steel

**CHRISTOPHER PUZIO** (*1971 in Paterson, NJ) is a San Diego based artist who works in metal to create sculptural and environmental elements. He received his education at Cranbrook Academy of Art in Detroit (IL) where he focused and developed his passion for contemporary metalwork and design. His work was featured amongst others in the Museum of Contemporary Art San Diego's exhibition *Here Not There: San Diego Art Now* (2010). In addition to his work as a studio artist, he is responsible for coordinating fabrication and shop related curriculum at Woodbury University School of Architecture in San Diego. Christopher Puzio lectures widely on the topic of art, craft, and design.

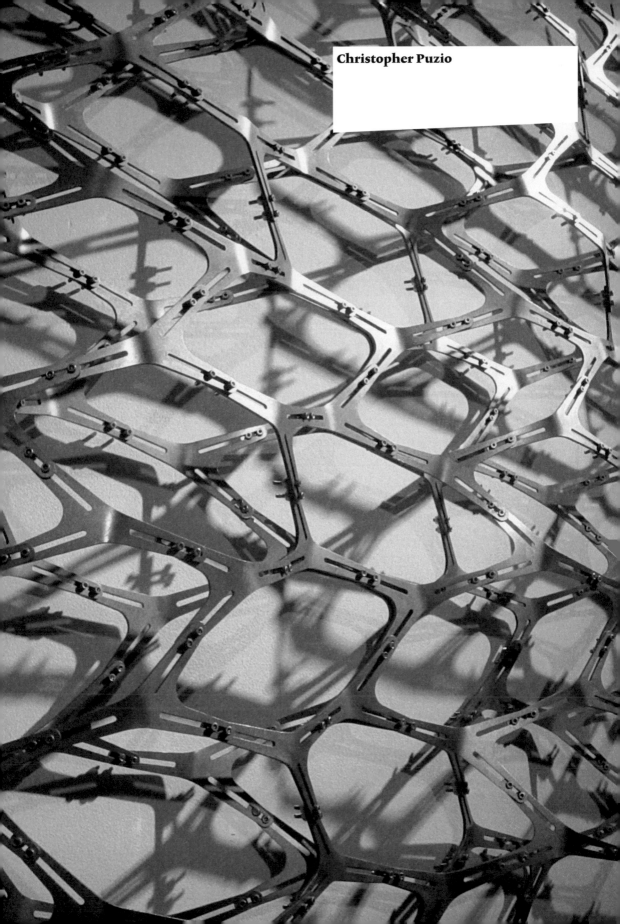

Christopher Puzio

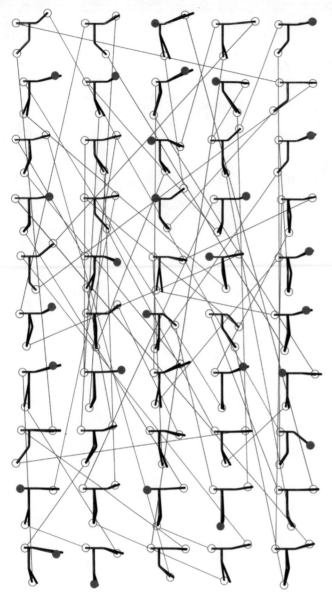

*Atomic Loops*, 2002

## Atomic Loops

With this piece, Christopher Puzio has developed an assembly that is composed of a family of fifty atomic building units. These units have no specific directional orientation, yet can be assembled by means of a prescriptive sequence into closed loops.

Common to all units are the following characteristics: 12 lengths of tube steel are machined and given a 30-degree bend. Tubes are welded together in pairs at 90 degrees. The relative rotation of the rods prior to being welded is left as an open variable within the fabrication process. These modular pieces comprise the family of fifty atomic units which share many dimensional and directional characteristics, yet no two are the same.

By selecting a sequence of six units and connecting them at random, one will be able to make the resulting string connect into a closed loop. Each string of six has a unique geometric composition resulting in only one closed loop, whose geometry is specific to that sequence. If the sequence order is changed for any given six units, the resulting loop will have a uniquely original geometry. Since each loop can only close into a singular geometric loop, all rotation is canceled out by the locked geometry. In other words, while the pin connections that join the units on axis allow for rotation, the geometry of the loop becomes rigid and fixed once the loop is closed. At the next largest scale, these loops can in turn be connected together into six loops of six units. Resulting structures are indexed, quantified, and reprogrammed to form alternate structural configurations.

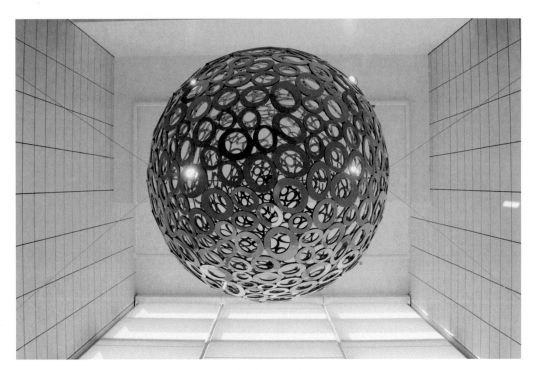

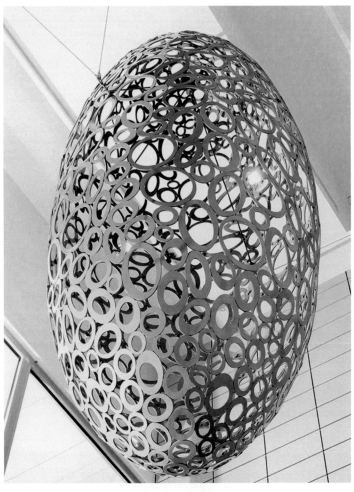

*Star Cluster / Cell Cluster*
2011, 396 × 183 × 183 cm,
aluminum and stainless steel

large image
*Mr. Smith*
2011, cast aluminum, plywood, and components,
height 396.2 cm, dimensions variable

Tony Smith described his individual sculptural works as
instantiations of a "spatial matrix," an underlying math-
ematical and geometrical basis to the material world.
Developed as a building system in varying degrees by
Alexander Graham Bell and Richard Buckminster Fuller,
the system consists of a tetrahedral grid that theoreti-
cally expands endlessly in all directions (Smith employed
other geometric systems as well). Made of laminated ply-
wood struts, triangular panels and cast aluminum joints,
the piece privileges the idea of the system as much as
the final sculptural form. *Mr. Smith* is a kit for making
sculptures that adhere to Smith's spatial sense without
directly quoting any of his completed works. The sculp-
ture attempts to contribute to a material discourse of
space frame systems through the design of a joint that
maintains the integrity of the system while accepting ei-
ther a strut or a panel in the completion of a form. This
allows us the latitude to alternate between an emphasis
on either surface plane or structure while playing with
positive and negative space.

bottom left and right
*Fullerene*
2003, extruded aluminum, synthetic rubber tire,
component, 243.8 cm diameter

*Fullerene* is a 243.8 cm diameter truncated icosahedron,
or buckyball, constructed of extruded aluminum chan-
nel and solid polyurethane mountain bike tire. Like the
structures of Richard Buckminster Fuller on which it
is based, it is antagonistic towards all received cultural
and local knowledge, claiming a sovereign status for
both the efficiency of modern materials and engineer-
ing, as well as technological expressionism. Also similar
to Fuller's work, *Fullerene* is enthusiastically embraced
by a broad public who engage in non-prescriptive ways
with it, both as a playful object and as an architectural
enclosure.

**DANIEL YOUNG** (*1981 in Toronto, CA) and **CHRISTIAN
GIROUX** (*1971 in Kingston, CA) have been making art
together since 2002. They produce sculpture, public art,
and film installations. Their work is the product of an
ongoing conversation concerning the modernity of the
mid-century, the production of space, and the built en-
vironment. Young and Giroux rework modernist forms
of abstraction using consumer goods and industrial
prototyping methods, construction systems and com-
ponentry to produce sculptural objects that partake in
architectural discourse. Their film works constitute a
form of research on sculptural form in the built envi-
ronment that ranges from the architectural to the do-
mestic scale.

http://cgdy.com

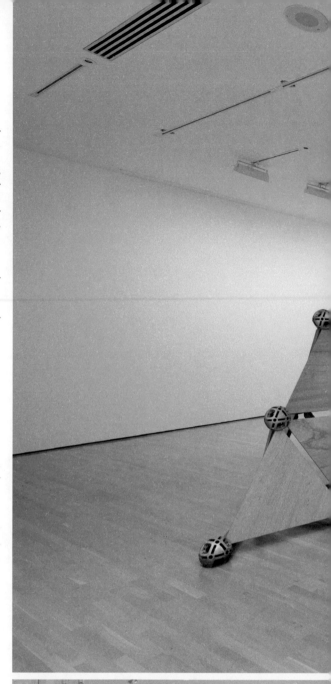

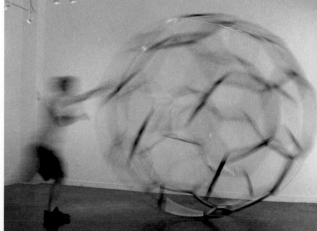

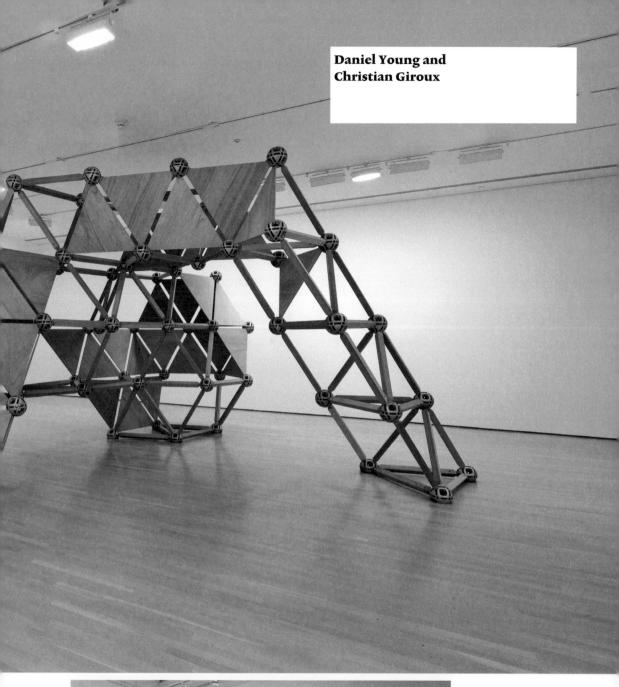

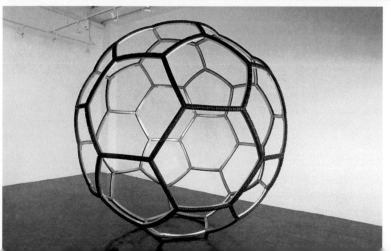

385

# VII

Ljiljana Fruk

**Double Life of the Double Helix:
Structural Beauty of the Molecule of Life**

The structure of DNA is probably one of the molecular images that enjoys the most media presence. It is used not only by scientists to illustrate scientific concepts, but also by institutions, companies, and advertisers, aiming to show their products to advantage (figs. 1a–1d).

FIG 1

The combined geometrical simplicity and topographical beauty of the DNA molecule result in a fascinating functional complexity. Given the major developments in molecular biology, genetics, and nanotechnology, it is hard to believe deoxyribonucleic acid (DNA) was still a mystery as recently as one hundred years ago. The story of finding the right clues, postulating theories, and finally deciphering the structure, has all the elements of a good thriller – an inkling, a few false leads, some clever outsiders, a bit of intrigue, and some highly insightful detectives. As with any other scientific discovery, it took a cast of many, working together diligently and often unaware of what the result might be, to set the stage before the story really unfolded.

The race to define the DNA structure involved some of the leading chemists of our time. One name stood out as the unquestionable authority on the structures of molecules: Linus Pauling. He, who postulated and then explained the nature of the chemical bonds, and contributed to almost every field of modern chemistry, was, however, led to a false conclusion concerning DNA due to the

lack of good experimental data. In the 1940s, he believed that if DNA were responsible for information transfer, as had been proven a decade before, and if it contained strands, traceable to the parent DNA, then there had to be a way by which those strands folded and unfolded. Around the same time, British biochemist Alexander Todd had shown convincingly that there was linkage, a true

FIG 2 bond among the basic components of the DNA: sugars (deoxyribose, fig. 2), and phosphorus (P) containing groups and four different bases.

Years before, Albrecht Kossel had isolated and identified the bases of DNA, enabling Phoebus Levene to shed more light on the basic components of nucleic acid, or those molecules found exclusively in the nucleus of the cells. It is humbling to realize that the formula of all life as we know it can be written in a

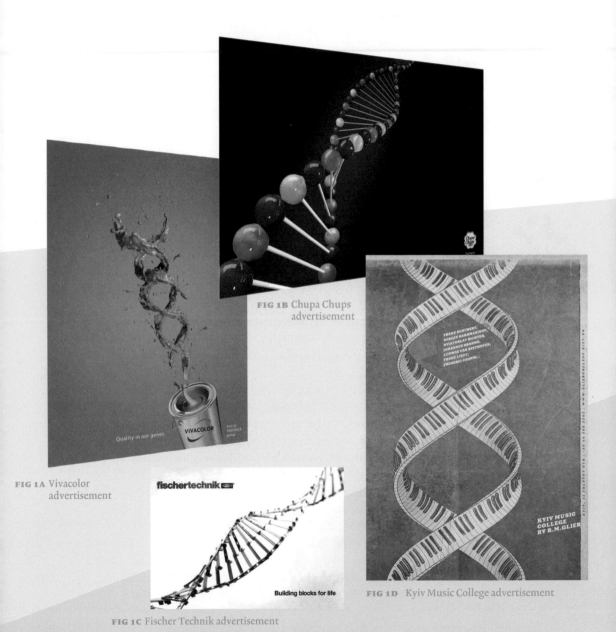

FIG 1B Chupa Chups
advertisement

FIG 1A Vivacolor
advertisement

FIG 1D Kyiv Music College advertisement

FIG 1C Fischer Technik advertisement

code containing just four letters, each of which corresponds to the abbreviated name of one of the bases: T (tymine), A (adenine), G (guanine), and C (cytosine). Might we as well have ended up with letters such as M (*marco*nine), E (*elisabeth-*anine), K (*kossel*ine), or L (*lily*ine) with the bases named after a romantic interest, role models, or an inventor? Certainly not! Western scientists have always had passion for Greek and Latin, the pure language of science. Romance aside, the bases got their Latin or Greek names from the source in which they were first discovered: adenine comes from Greek *aden* for pancreas, a gland from which it was extracted; tymine was first found in the thymus gland (Latin origin), cytosine was isolated from the cell (*cyto*, meaning cells in Greek), and guanine was named after bird guano, from which it was extracted.

Chemical methods have enabled us to determine molecule components. Based on that information and chemical principles, one can deduce the structures, but whether what we predict are actually those that exist is less certain. Can a molecule be photographed? Development of X-ray crystallography at the start of the twentieth century marked a change in how scientists see molecules. Suddenly, they were no longer just a set of arranged and interchanging letters that form gases, liquids, and solids with interesting properties, but emerged as the set of coordinates in space. X-ray pictures of a crystal – a well-ordered collection of molecules – are invariably abstract; they are collections of dotted patterns that stem from a dispersion of X-rays that hit atoms. For those dotted patterns to become molecular structure, a great number of calculations and a degree of refining is required. Needless to say, it took years at the beginning to get the structural information. Computers help us study even the most complex and largest molecules, such as proteins, but are no substitute for the astute skill, seasoned knowledge, and experience involved.

Linus Pauling had knowledge, experience, skill, and some crystallographic data on DNA when he started studying it. Familiarity with most of the trials and successes in deduction of its chemical structure and biological function, led him, in February 1953, to propose a structure he believed in good keeping with the experimental data.[1] Triple helix came into being, wherein three strands of

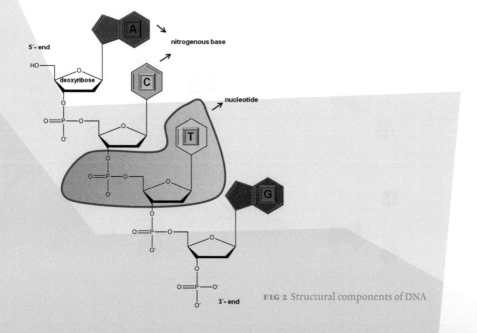

**FIG 2** Structural components of DNA

DNA came together and phosphate components, that are negatively charged, were positioned at its core (fig. 3, left). While spot on about the helical structure, Pauling was wrong about the position of DNA elements within this structure (fig. 3, right). If the crystallographic data had been more refined and he had not been pushed to solve the structure so urgently, he would have seen that his DNA structure just did not fit into what was known about DNA up until then. Scientists before Pauling, for example, had shown that the element sodium, which combined with chlorine, makes up table salt, plays an important role – in its ionic, positively charged state – in stabilizing DNA. A pinch of salt will keep DNA strong and healthy. After Pauling's structure was published, however, the question remained: if the basic physical principle of positive attracting negative is irrefutable, how does positively charged sodium get into the inner core of closely packed, negative phosphate groups?

In his enthusiasm, Pauling tried to fit the data he had into the structure he considered right, thinking that once the global structure was known, the details would follow intuitively. He admitted that his fit was not perfect, but he did not take a step back to look at the larger picture.

Much like artists, scientists need to move away from their work to see it in its entirety in a three-dimensional space and in the larger context. As it often happens in life and science alike, the tragic characters have usually passed through a stream of unlucky coincidences. While Pauling was working with the bad set of crystallographic data, his assistant had access to an excellent set presented by Cambridge scientists at a small conference in Europe. Since the assistant failed to see its importance, he failed to mention anything to his supervisor. While Pauling did not go down in history as a scientist who discovered DNA structure, he has won two Nobel prizes for his work nevertheless. In the search for scientific truth, even the greatest inventor can stumble upon the obstacles made up of misleading clues.

**FIG 3** Left: DNA structure proposed by Pauling with phosphate groups in the core of the helix
Right: Real DNA structure with phosphates on the surface

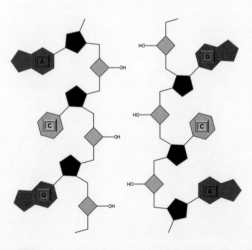
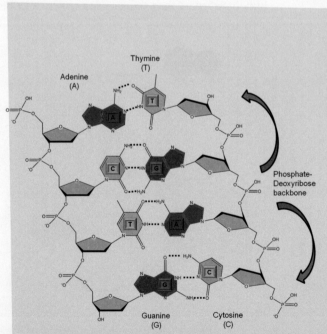

A mere two months after Pauling published his structure, two scientists in Cambridge, James Watson and Francis Crick, used high quality X-ray data produced by Rosalind Franklin[2] and Maurice Wilkins (fig. 4) to postulate a new structure of DNA – a double helix with characteristic rise (the distance between two successive units) and a pitch, used to describe how many units there are within a single full turn of the helix.[3] Theirs was a structure of a silent melody, with bases which can be likened to musical notes, and that come in different variations, lengths, and repeated units.

FIG 4

When the double helix was proposed, everything known about DNA – including its potential role in transferring hereditary information – fell into place, and was stunning in its simplicity and functionality. Apart of being a double, rather than a triple helix, there was another major difference from Pauling's structure: the phosphates were positioned on the outer rim and the bases in the core of the helical structure (fig. 3, right). This simple exchange of basic building blocks position made all the difference, both to the function and the understanding of the experimental data; now, the positive sodium ions needn't fit in anywhere: they could simply position themselves on the surface close to the negative phosphates.

Most importantly, two linear strands could be connected by bonds formed between their bases in the core. This same positioning of the building elements is a constant throughout the molecule, and is the chemical backbone that was to become both a pillar of molecular biology and a widely recognizable image (fig. 5). Sugars to which bases are bound are connected through phosphates, creating a linear DNA strand. A double helix is made by joining two linear strands with a natural chemical glue known as a hydrogen bond. Such bonds, made between hydrogen (hydrogen bond donor) and certain elements – such as oxygen and nitrogen (hydrogen bond acceptors) – can be disconnected, and the double helix, unzipped, by a change in the temperature or other ambient conditions.

FIG 5

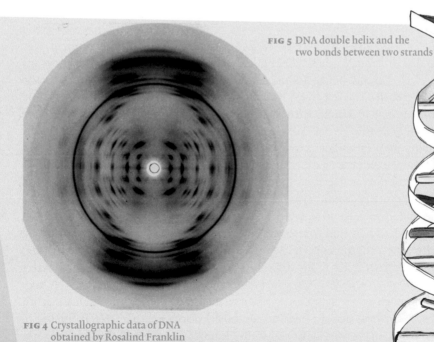

FIG 5 DNA double helix and the two bonds between two strands

FIG 4 Crystallographic data of DNA obtained by Rosalind Franklin

Once the double helix is unzipped, it can be re-zipped and the process, repeated over and over, while not indefinitely. Like all things natural, the DNA has an expiration date.

Once the structure of a particular molecule is known, the degree to which the positions of the basic elements determine its function becomes clear. Scientists studying bio-molecules want to understand more than molecular architecture and function; they often try to find answers to the greater question of life itself. Understanding basic principles of life could enable us to tailor existing, or create new structures based on natural principles. One of the interesting questions that came to light once DNA structure had been described was the nature of the sugar molecule that builds the double helix. Deoxyribose is a five-member-ring sugar, a pentose, but six-member sugars (hexose) – such as glucose or fructose – are more naturally abundant. Why has nature chosen a sugar substance, which is less available to build the omnipresent genetic carrier? It took more than fifty years after the discovery of the double helix to show that pentose is crucially important for the helical structure.[4] When hexose instead of pentose is used, the helical structure is still formed, but some of the core bases, which should be tightly bound, protrude from the helix. The repeating geometry of FIG 6 the double helix is destroyed, making the structure highly unstable (figs. 6a, 6b). The symmetry of life's molecule is based on a perfected structural role of each element.

When the structure of DNA was first published, Watson and Crick also noted that "it did not escape our notice that the specific pairing [referring to the bonding of two linear strands into double helix], we have postulated suggests a possible copying mechanism for the genetic material."[5] Indeed their two papers[6] in 1953 marked the beginning of a revolution, which, more than fifty years after, paved the way to genetic engineering, cloning, synthetic biology and a new understanding of the complexity and molecular beauty of life.

In 1953, the theories and experimental data concerning basic concepts of molecular biology and genetics started to fit together. As early as 1928, Fred Griffith showed that certain harmless bacteria could be transformed into something life-threatening if the extracts of deadly bacteria killed by heat treatment were added to them. While the heat-killed bacteria were not expected to show any effects, they did, in fact, induce some kind of good-to-evil transformation and that puzzled the scientists. Nobody was sure how something like that could happen, and no serious scientist believed in the alchemist's theories of life force. In 1944, Oswald Avery, Colin MacLeod, and Maclyn McCarty clarified this by doing some careful detective work, concluding afterwards that "a nucleic acid of the deoxyribose type is a fundamental unit of the transforming principle."[7]

Up until then, it had been generally believed that another group of molecules, called proteins, would carry genetic information and that DNA only played a secondary role. Now the tables had turned and the foundation of genetics was laid. A letter Oswald Avery send to his brother in 1943 bears the palpable excitement of the impending scientific discovery.[8] How much skill, creativity, and persistence it takes to identify one particular substance among many! Avery rightly states that it is "some job, full of headaches and heartbreaks!"[9] He goes on to describe the tediousness and frustration of finding the scientific truth, but also points out the implications of the discovery: that DNA is the key to information transfer. Quite rightfully, he holds that this will change the course

of genetics, protein chemistry and metabolism research. In 1944, while World War II was still raging, the history of biochemistry and molecular biology was written. Scientists working in the different fields of biology and chemistry produced an increasing amount of data that pointed out to the significance of DNA for the development of life as we know it.

Genetic information, saved in smaller code-packages known as genes, is encoded using four different bases. Each protein is produced in the cell and determines what we are, how we look like and how we live and die, and depends on the combination of ATGC codes which denote the bases composing DNA. Bases are structurally stabilized by sugars and phosphates, and they form specific pairs only so that *G* will bind to *C* through 3 hydrogen bonds and *A* to *T* through 2 (see: fig. 3, right). This "base pair specificity," the formation also referred to as the so-called Watson Crick pairs, is one of the fundamentals of the DNA copying mechanism.

When a double helix is unzipped to make two single strands, each strand can be used as a template to make two new double helices, and the information in

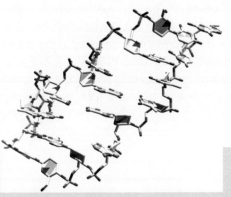

FIG 6A The structure of the double helix in which the natural sugar pentose is replaced by hexose

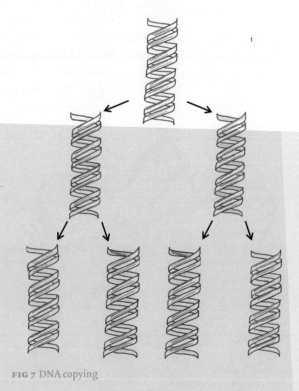

FIG 7 DNA copying

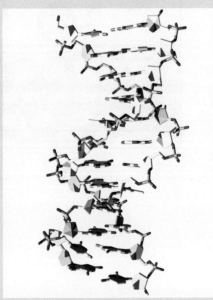

FIG 6B Pentose containing natural double helical DNA

FIG 7 one strand can be used as a negative for printing the other (fig. 7). A closer look at the geometry of the double helix shows that the space within is precisely adjusted and when the bases are paired, whether G-C or A-T, the sugars between two strands always remains $10.85 \times 10^{-10}$ m or 1.08 nm apart. A-T and G-C fit perfectly into this space between the sugars, but it gets a bit tight if A and G come close, and there will be excess space when T tries to pair with C. The organization of the whole structure is remarkably beautiful – and its beauty, perfectly complemented by its function. Small changes in the double helix, such as exchange of bases in a process called mutation (A-G rather than A-T facing each other, for example), might render it unstable. A mutated helix needs much less energy to get unzipped, and can interfere with the readout of the genetic information.

But surely, if DNA carries the information for all the proteins in our body and we are indeed made up of vast numbers of them, then there are many bases upon which to write that information. Bacteria, for example, have four million base pairs; single stranded human DNA has some three billion bases; and the number of possible combinations of all four bases is so enormous as to be virtually unthinkable. Further, the length of such DNA is greater than one would expect. Stretched out on the floor, the length of the average diameter of the building blocks and the length of the bonds, or the human DNA contained in the cell nucleus, would measure something between two and three meters long.

How is such DNA packed into a cell that measures only some 1 μm long, and contains an even smaller nucleus? The helical structure with its twists and grooves, known as major and minor groove (figs. 6, 7), can be wrapped into

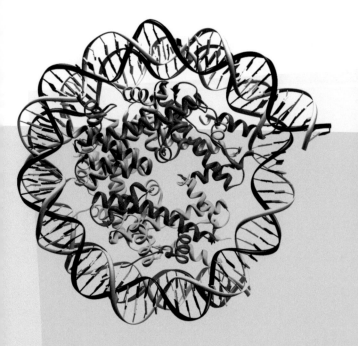

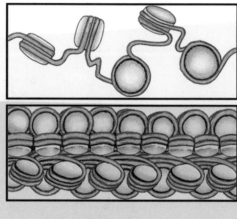

FIG 8A Wrapping of the double helix depicted in black around histone proteins

FIG 8B The formation of the disk-like helical structure with wrapped DNA shown in orange.

more compact units with the help of proteins called histones. To enable wrapping, histones have numerous positive charges on their surfaces, and those attract negatively charged DNA. Although proteins usually change over evolution, histone structure has remained nearly constant in the $1.2 \times 10^9$ years since the branching of plant and animal worlds. Their resistance to change shows that the critical role they play in development was established early on, and has not need make adaptations since. Between 160 and 240 base pairs of DNA bend – and are wound around – the histone core (fig. 8a) and a continuous wrapping FIG 8 leads to the formation of a flattened, disk-like superhelix (fig. 8b).

DNA wrapping is not a symmetrical process. There is a small preference for bending along the major and kinking along the minor groove (fig. 8c), so the morphology of wrapped DNA wearies along the 147 base pairs. Seen from above, the wrapping circle shows itself imperfect, containing both straight and bent areas. These might conceivably affect the binding of molecular machines key to the unwrapping and read out of DNA sequence.

Humans have histones to aid double helix packing into a more compact form to fit within the cell nucleus. Simpler organisms, such as bacteria, do not, yet their fairly long DNA must still be contained within the cell. Some bacterial DNA was found to be circular, a term which refers more to the continuity of the chain itself than the actual circular shape (fig. 9). Such circular DNA can be further coiled to FIG 9 form a superhelix which is much more compact than the original circular or linear DNA. The supercoiling process is important, not only for DNA packing, but for its unwinding, since it determines where the readout of genetic information will start. The timing and starting point of the unwinding process is crucial for

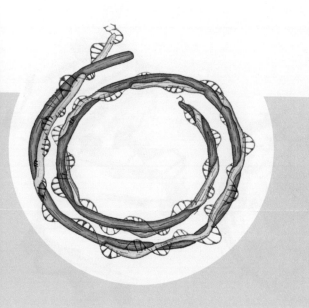

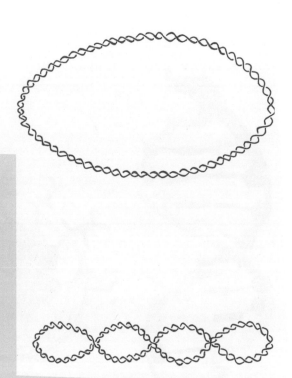

FIG 8C The imperfect wrapping of the DNA around histones with bends and kinks

FIG 9 Circular DNA and DNA coiled into superhelical structure (bottom)

information transfer as it determines both how much and which parts of DNA will interact with molecules in their immediate environment.

Structurally, superhelix can be either right- or left-handed, depending on the coiling. The left or right distinction is particularly important in the molecular world. Life's building blocks often have both spatial orientations, while only one is favored in our universe: we live in the left-handed world. The amino acids, molecular units of proteins, and molecules, which do the hard work in keeping us "alive and kicking," are all left-handed. Interestingly, though, the classical <span style="float:left">FIG 10</span> double helical DNA information carrier, B-DNA, is right-handed (fig. 10a). B-DNA has ten base pairs per complete turn, and two single strands are wound antiparallel to one another. The pair of bases is almost exactly perpendicular to the helix axis (figs. 5 and 6), the rise is 0.34 nm, and the consecutive phosphate groups on a single strand are exactly 0.7 nm apart. Generally, water plays a significant role in biological systems, and it is highly important for the stabilization of the double helix. There are at least 12–15 water molecules associated with each nucleotide in B-DNA. When the humidity conditions change, and there is a lack of water, the helix collapses into the A form (fig. 10b), bringing phosphate groups closer together (0.59 nm), the helical rise is reduced to 0.25 nm, and the helix is wider with 11 base pair helical repeat with twisted and tilted bases. That results in grooves having a different geometrical form than the B form, and in the A-DNA core taking the form of a hollow cylinder.

FIG 11 Another form, Z-DNA (fig. 11), discovered first in 1979, is found in the solutions with high salt content.

Unlike the A and B form, Z-DNA is left-handed. This Z-helix's pitch of 12 base pairs makes it slimmer than B-DNA, and it has no major groove at all. Due to its linearity, it is less stable than A and B forms, so it needs to be stabilized

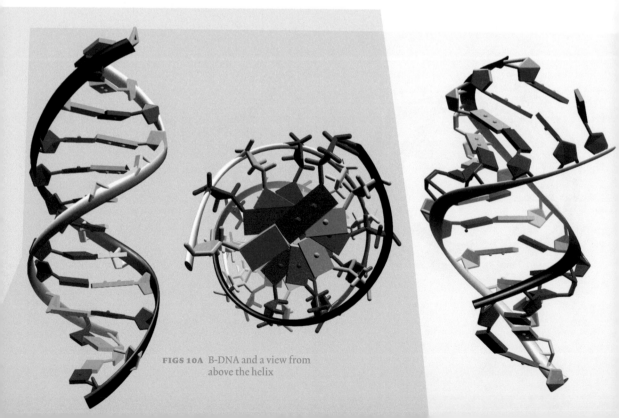

FIGS 10A B-DNA and a view from above the helix

with lots of salt. Interestingly, the presence of even as little as 1–2% of Z form in the lower organism can strongly influence the formation of superhelix, and can therefore affect the replication and information readout. Although until now, the real function of Z-DNA is not known, scientists suspect that it is involved in the regulation of the gene readout. Z-helix differs from other forms both energetically and structurally, and it could enable binding of a particular group of proteins that control the transfer of genetic information. The change of structure under different environmental conditions – such as high salt content – can trigger complex processes of protein binding which then regulate the way DNA is copied. This again implies the major significance of the helical structure, which, unlike a linear one, has greater potential for various structural changes. Molecular signals indicating the start or the end of a certain process can be encoded, not only within the base sequence, but also within the structural changes induced to the double helix. Indeed, particular proteins in cells known as topoisomerases are specialized to recognize the topology of the DNA and bind only to specific regions of a helical structure.

Straightforward as it seemed when Watson and Crick presented their structure, transfer of genetic information is not achieved by zipping and unzipping the double stranded DNA alone. After 1953, years of research were devoted to studying how the genetic readout occurs in any given cell, where thousands of free-floating molecules go about performing their large or small tasks. And although we have since witnessed rapid developments in genetics, which recently led to the assembly of an artificial life form,[10] the story continues.

Life on earth is sustained as long as DNA exists and the process of DNA replication ensures that. While indeed, DNA replication is the basis of biological inheritance and DNA is the star of the show, there are many supporting actors

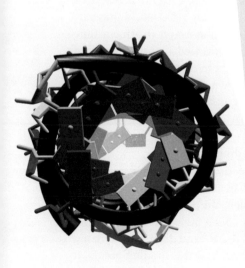

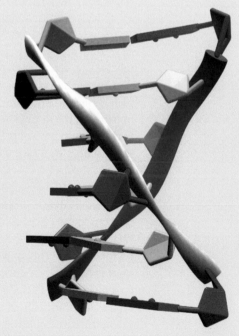

**FIGS 10B** A-DNA and a hollow core.
Adapted from the PDB crystal
structure databank.

**FIG 11** Z-DNA

and extras in other or equally important roles as part of this tightly controlled process. It is a finely tuned interplay of molecules, which all must be in sync and on time to make new DNA. Double stranded DNA unwinds at precisely determined points – the origins of replication. With the unwinding, the points reassemble much like the tongs of a fork and are actually called "replication forks". The replication itself occurs on both strands, a bit faster on one than the

FIG 12 other (fig. 12). As the new DNA is made, proteins called polymerases bring the building blocks, or nucleotides, into the right position.

They can read the position of the base on one strand and add an exact complementary strand to the growing one. Polymerases are molecular machines, which recognize short messenger strands positioned at the point where the growth must start to build up "fresh" DNA. Simpler organisms, such as bacteria – whose DNA is coiled into a superhelix – have special proteins known as gyrases, each of which recognizes the superhelix topology and helps relaxing the super strained structure to enable the beginning of replication.

In addition to polymerases and gyrases, there is a whole factory of different proteins that aid the DNA in unzipping and fresh strand making. When things go well and the cells are healthy, the proteins are able to perform their duties nicely. DNA polymerases, for example, will test if the preceding base pair is correct before a new one is added. The frequency of error is low and the high fidelity of DNA replication is crucial for the genetic information transfer. A complex machinery which makes one mistake per ten trillion base pairs has evolved. However, cells are always exposed to environmental stress, and the rate of mistakes can be increased by the influence of chemicals, whether in our environment, the things we eat, or different physical agents. Ultraviolet sunlight can, for example, cause the disruption of the double helix and formation

FIG 13 of T-T pairs (fig. 13). Such pairs cannot fit into the core of the double helix and a bulge is formed which stops the genetic readout until this mistake is corrected. Within our nuclei, the proofreading is done continuously from the moment we are conceived until our cells die.

Today, we also have design drugs at our disposal, those drugs that can artificially induce DNA damage or structural changes, and can act as blocking agents for DNA replication. Chemotherapeutic drugs used in cancer treatment function largely on this principle. Many of those drugs, as well as antibiotics, have planar rings within their molecular structure and can often insert themselves in between the double helix. Such insertion, known as "intercalation," results in the perturbation of the DNA structure and its inactivation. Artificially made intercalators (there are also some which occur naturally) are usually designed to interact through major groove, and therefore can interfere with the function of

FIG 14 all of the proteins that prefer major groove binding (fig. 14).[11]

While intercalators perturb the DNA structure, there are also some molecules that can loosely bind to the grooves. Rather than affecting the structure itself, they introduce an extra layer onto DNA, which can then interfere with the performance of topology-recognizing proteins. Such molecules, such as distamycine A, usually bind to the minor groove of B-DNA and displace stabilizing

FIG 15 water (fig. 15).[12] There is still controversy around how this binding occurs. It seems that there is no direct molecular binding, but that the molecules adapt their structure to the flexibility and the shape of the groove structure. The driving force for this malleability comes from the removal of the highly structured

water molecules in the minor groove and positioned around the helix, the so-called "spine of hydration."[13]

Beside the perturbing and displacing molecules, there are also some that directly react with the DNA structural elements. Cisplatin, one of the oldest and most effective chemotherapeutic drugs, binds to DNA bases and, once bound, distorts B-DNA in such way that the duplex becomes significantly bent, the major groove rendered more compact and the minor groove, wider.[14] More sophisticated drugs, such as anti-tumor antibiotics, use both the sequence recognition and minor groove binding, and chemical reactions with the bases to interfere with DNA replication. Although the nature of drug-DNA interaction can differ, the result is the same – once bound to the double helix, the molecules affect its topology and structural properties, and interfere with the protein binding, which ultimately leads to DNA inactivation.

Clearly, each interaction within – and on – the helical structure affects the replication, the information readout, and at the end, biological function. No other

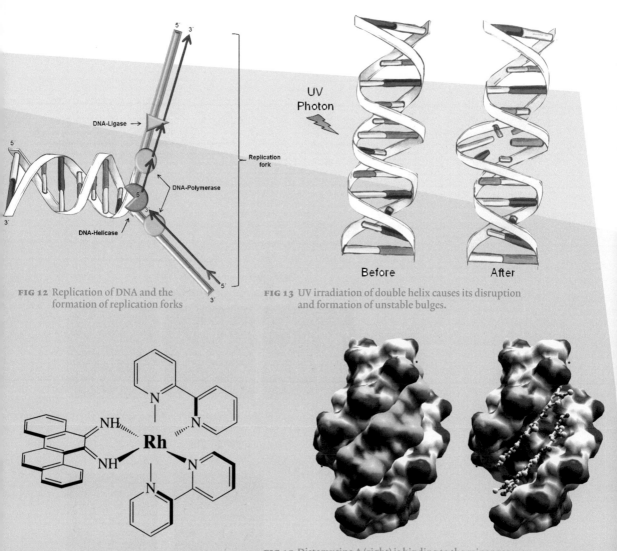

FIG 12 Replication of DNA and the formation of replication forks

FIG 13 UV irradiation of double helix causes its disruption and formation of unstable bulges.

FIG 14 Rhodium complex

FIG 15 Distamycine A (right) is binding to the minor groove of B-DNA, displacing the water molecules (blue, left).

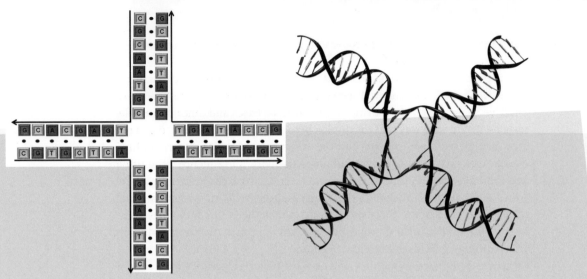

**FIG 16A** Stable branched structure made by short DNA strand design (adapted with permission from Ref. 13)

**FIG 16B** Holliday junction (from PDB database)

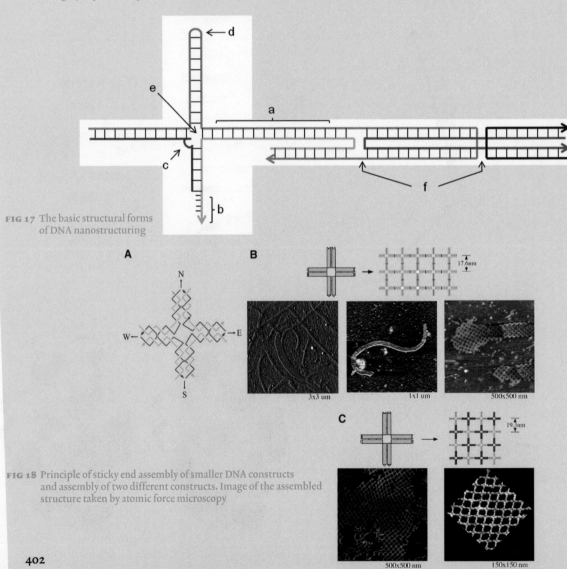

**FIG 17** The basic structural forms of DNA nanostructuring

**FIG 18** Principle of sticky end assembly of smaller DNA constructs and assembly of two different constructs. Image of the assembled structure taken by atomic force microscopy

structure is a platform for such a complex interplay of architectural design and chemical forces. Topology of the double helix is used to start and stop the replication and genetic information transfer, and it can be used to destroy DNA and induce cell death, each little change in the double helix structure having the potential to mark the beginning of the cell's downfall. We understand more now than we did fifty years ago about how DNA works and what the factors are that can influence it. We might be able to artificially design DNA and clone whole organisms, but at the point where knowledge meets a vast abyss of ignorance, wisdom is needed to plan future steps. No doubt we can write down the genetic codes of many life forms including the human. We understand the basic principles of the script, and how to re-write it, and we can read it, too. But we are still a great distance away from truly understanding it.

Of course, not everybody interested in double helix ends up deciphering the genetic code, creating new anti-cancer drugs, or making artificial life forms. Some people are only interested in DNA's molecular structure and basic architecture. Its structural properties, 3.4 nm helical repeat, base pairing/strand recognition, stability, and wonderful combination of stiffness and flexibility, have attracted the attention of scientists trying to build new materials, create new molecular architectures, and understand underlying mechanism of molecular structuring. These efforts led to the development of the DNA nanotechnology where DNA, rather than a genetic code carrier, is a versatile building block. The structuring potential of the DNA was hinted at in a theoretical paper written in 1982 by the scientist Ned Seeman. His strong background in crystallography had enabled him to gasp the structural power of the double strand.[15]

Seeman's first paper was a purely theoretical account of the vast possibilities of DNA design, which was then proven experimentally when simple geometrical forms were obtained by mixing short DNA segments of a particular sequence. One of the first and simplest forms to be created was a quadruplex structure with a stable branching point (fig. 16a). Similar, non-double helical DNA can FIG 16 be found in nature, albeit they are short-lived and often unstable. Replication forks (fig. 12) with their three-stranded, branched DNA are a good example, as is a Holliday junction (fig. 16b)[17], a particular structure found in yeast during the exchange of genetic information.

Ned Seeman and his colleagues, who later themselves became leaders in the same field, developed the concept of pre-designed structures which can be assembled from chemically synthesized DNA strands (fig. 17). Rules were postu- FIG 17 lated concerning the sequence of bases that would yield the most stable structures, as well as more complicated motifs such as junctions (fig. 17, d), bulge loops (fig. 17, c), crossovers (fig. 17, f) and helical regions (fig. 17, a).

Clearly, if DNAs can be assembled into different elements with different levels of structural complexity, it would be desirable to assemble them further into larger structures using a kind of LEGO system. Using one of Nature's little tricks helpes here, one that is based on short, non-paired DNA strands called sticky ends (fig. 17, b). Sticky ends can be used as glue to attach to another structure that contains the complementary sequence through formation of hydrogen bonds between complementary bases. Simple elements can be joined into larger structures (fig. 18) in such a way. Conveniently, this process can also be FIG 18 reversed and sticky ends can be disrupted, causing the disassembly of bigger structures on demand.

The smallest elements in DNA structuring are usually referred to as DNA tiles, and can be assembled further by means of sticky ends to form larger 2-D arrays (fig. 19).[18] By the addition of shaping DNA sequences, arrays can be turned into more complex 3-D structures. The simplest way of adding complexity to 2-D structures is by introducing small single stranded DNA at certain positions of the arrays. Such strands protrude from the planar structures, and can serve as anchor points for binding another DNA, they are sticky ends in z-direction (fig. 20).[19] In a similar way, additional molecules or nanoparticles, and nanometer-sized materials of different shapes, can be attached to the arrays at a predefined position. Providing that the rules of complementarity and base pairing are respected, anything small enough can be attached to DNA structures. Such programmable manipulation of the molecular assembly and design of novel structures has already found widespread application in electronics and nanomedicine.

Of course, all these developments in DNA architecture could not have been possible if the short strand itself could not have been made chemically. We have come a long way from the 1970s, when it took more than ten years glue together 77 nucleotides and make the first synthetic DNA.[20] Today, automated machines can make short strands within hours. Unlike biological synthesis, chemical synthesis is limited to a large extent by the efficiency of each synthetic step, and therefore, only DNA approximately 100 base long can be made with satisfactory

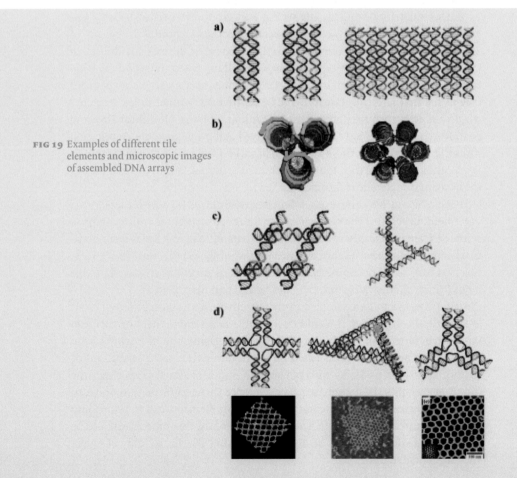

FIG 19 Examples of different tile elements and microscopic images of assembled DNA arrays

yields. If longer strands are required, biological machinery using proteins (such as polymerase) can be employed, although the length of DNA remains limited. Understandably, assembling long artificial – but functional – DNA is a rather challenging task, which requires significant expertise, a great deal of patience, and more than a solid financial background.

DNA nanostructuring is limited by size, and a number of synthetic DNA is needed to design symmetrically patterned 2-D and 3-D structures. To address these issues, a new approach based on origami, the ancient Japanese art of paper folding, was introduced in 2004. DNA origami uses viral DNA (some 7,500 bases long) and a computer algorithm to design smaller DNA sequences, known as staple strands, which can hybridize onto large DNA templates to obtain different, pre-programmed structures (fig. 21).[21]

FIG 21

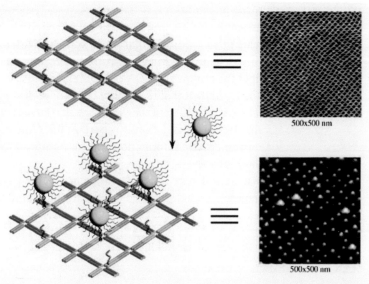

FIG 20 Design of a protruding DNA arm, which acts as sticky end for the immobilization of different molecules or nanoparticles (bottom) onto a planar DNA structure. AFM image of the bare assembly and the one with immobilized nanoparticles is shown right.

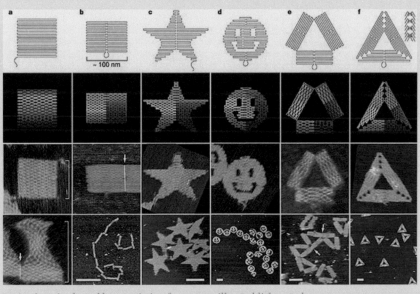

FIG 21 DNA origami, adapted by permission from Macmillan Publishers Ltd

The beauty of molecular origami is that virtually any 2- or 3-D shape can be made with the right staple strands in hand, although the number of those strands to be used is still large: designing a simple rectangle of 100 × 100 nm requires approximately 200 folding strands, for example. Continuous improvement of the microscopic methods that enable us to see the structures on a nanometer scale have also led to new developments in molecular design and fine-tuning of the molecular architecture. Further, 3-D shapes have been made – such as cubes with movable lids, which contain molecular locks and keys to

FIG 22 open or close – (fig. 22),[22] as well as complex geometrical shapes, such as tensegrity or curved 3-D objects.

Indeed, there seems to be no end to the DNA structures waiting in the wings to be designed and explored. Nevertheless, the question about their potential for practical applications remains. The future will show if excitement about the many possibilities is sustainable, but we recognize already today that the fine assembly of different elements could support the design of electronic devices, drug carriers or molecular repair systems. With or without future applications, the fascinating world of nanostructuring has opened up, and the years to come hold the promise of many new developments. Some of the developments have already shown that the beauty of DNA lies less in the simplicity of its molecular structure, than in the flexibility that stems from it. Moreover, we have seen that flexibility is not only important for a fine interplay of different elements during genetic information transfer, but also for architectural design at the molecular level.

Science will meet science fiction soon enough. It is difficult to imagine any other molecule than the molecule of life itself to stand tall at the meeting point.

Ljiljana Fruk would like to thank Dennis Bauer for his help with the graphics.

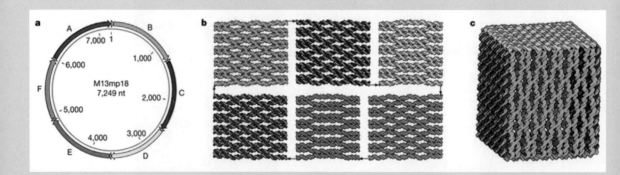

FIG 22 Cube designed from viral DNA (a) using staple strands (b) and origami methodology, adapted by permission from Macmillan Publishers Ltd

## Notes

1 See: Linus Pauling and Robert B. Corey, "Structure of the Nucleic Acids," in: *Nature,* vol. 171, no. 4347, 1953, p. 346, doi: 10.1038/171346a0.

2 See: Rosalind E. Franklin and Raymond G. Gosling, "Molecular Configuration in Sodium Thymonucleate," in: *Nature,* vol. 171, no. 4356, 1953, pp. 740–741, doi: 10.1038/171740a0.

3 See: James D. Watson and Francis H. Crick, "Molecular Structure of Nucleic Acids: A Structure of Deoxyribose Nucleic Acid," in: *Nature,* vol. 171, no. 4356, 1953, pp. 737–738, doi: 10.1038/171737a0.

4 See: Martin Egli, Pradeep S. Pallan, Rekha Pattanayek, Christopher J. Wilds, Paolo Lubini, George Minasov, Max Dobler, Christian J. Leumann, and Albert Eschenmoser, "Crystal Structure of Homo-DNA and Nature's Choice of Pentose over Hexose in the Genetic System," in: *Journal of the American Chemical Society,* vol. 128, no. 33, 2006, pp. 10847–10856, doi: 10.1021/ja062548x.

5 James D. Watson and Francis H. Crick, "Genetical Implications of the Structure of Deoxyribonucleic Acid," in: *Nature,* vol. 171, no. 4361, 1953, pp. 964–967, doi: 10.1038/171964b0.

6 See: John S. Cairns, Gunther S. Stent, and James D. Watson (eds.), *Phage and Origins of Molecular Biology,* Cold Spring Harbor Laboratory Press, Cold Spring Harbor (NY), 1992.

7 Daniel G. Gibson, John I. Glass, Carole Lartigue, Vladimir. N. Noskov, Ray-Yuan Chuang, Mikkel A. Algire, Gwyn. A. Benders, Michael. G. Montague, Li Ma, Monzia M. Moodie, Chuck Merryman, Sanjay Vashee, Radha Krishnakumar, Nacyra Assad-Garcia, Cynthia Andrews-Pfannkoch, Evgenia A. Denisova, Lei Young, Zhi-Qing Qi, Thomas H. Segall-Shapiro, Christopher H. Calvey, Prashanth P. Parmar, Clyde A. Hutchison III, Hamilton O. Smith, and J. Craig Venter, "Creation of a Bacterial Cell Controlled by a Chemically Synthesized Genome," in: *Science,* vol. 329, no. 5987, 2010, pp. 52–56, doi: 10.1126/science.1190719.

8 See: Clara L. Kielkopf, Kathryn E. Erkkila, Brian P. Hudson, Jacqueline K. Barton, and Douglas C. Rees, "Structure of a Photoactive Rhodium Complex Intercalated into DNA," in: *Nature – Structural & Molecular Biology,* vol. 7, no. 2, 2000, pp. 117–121, doi: 10.1038/72385.

9 Xin Chen, Boopathy Ramakrishnan, Sambhorao T. Rao, and Muttaiya Sundaralingam, "Binding of two Distamycin A molecules in the minor groove of an Alternating B–DNA Duplex," in: *Nature – Structural & Molecular Biology,* vol. 1, no. 3, 1994, pp. 169–175, doi: 10.1038/nsb0394-169.

10 See: Bingh Nguyen, Stephen Neidle, and W. David Wilson, "A Role for Water Molecules in DNA-Ligand Minor Groove Recognition," in: *Accounts of Chemical Research,* vol. 42, no. 1, 2009, pp. 11–21, doi: 10.1021/ar800016q.

11 See: Andrew Gelasco and Stephen J. Lippard, "NMR Solution Structure of a DNA Dodecamer Duplex Containing a *cis*-Diammineplatinum(II) d(GpG) Intrastrand Cross-Link, the Major Adduct of the Anticancer Drug Cisplatin," in: *Biochemistry,* vol. 37, no. 26, 1998, pp. 9230–9239, doi: 10.1021/bi973176v.

12 See: Nadrian C. Seeman, "Nucleic Acid Junctions and Lattices," in: *Journal of Theoretical Biology,* vol. 99, issue 2, 1982, pp. 237–247, doi: 10.1016/0022-5193(82)90002-9.

13 Nadrian C. Seeman, "Biochemistry and Structural DNA Nanotechnology: An Evolving Symbiotic Relationship," in: *Biochemistry,* vol. 42, no. 24, 2003, pp. 7259–7269, doi: 10.1021/bi030079v.

14 See: Robin Holliday, "A Mechanism for Gene Conversion in Fungi," in: *Genetics Research,* vol. 5, no. 2, 1964, pp. 282–304, doi: 10.1017/S0016672300001233.

15 See: Hao Yan, Sung Ha Park, Gleb Finkelstein, John H. Reif, and Thomas H. LaBean, "DNA-Templated Self-Assembly of Protein Arrays and Highly Conductive Nanowires," in: *Science,* vol. 301, no. 5641, 2003, pp. 1882–1884, doi: 10.1126/science.1089389.

16 See: Chenxiang Lin, Yan Liu, Sherri Rinker, and Hao Yan, "DNA Tile Based Self-Assembly: Building Complex Nanoarchitectures," in: *ChemPhysChem,* vol. 7, no. 8, 2006, pp. 1641–1647, doi: 10.1002/cphc.200600260.

17 See: Junping Zhang, Yan Liu, Yonggang Ke, and Hao Yan, "Periodic Square-Like Gold Nanoparticle Arrays Templated by Self-Assembled 2D DNA Nanogrids on a Surface," in: *Nano Letters,* vol. 6, no. 2, 2006, pp. 248–251, doi: 10.1021/nl052210l.

18 See: Har Gobind Khorana, Kanhiya Lal Agarwal, George H. Büchi, Marvin H. Caruthers, Naba K. Gupta, Kjell Kleppe, A. Kumar, Eiko Ohtsuka, Uttam L. RajBhandary, Jan Hans van de Sande, Vittorio Sgaramella, T. Terao, Hans Weber, and T. Yamada, "CIII. Total Synthesis of the Structural Gene for an Alanine Transfer Ribonucleic Acid from Yeast," in: *Journal of Molecular Biology,* vol. 72, no. 2, 1972, pp. 209–217, doi: 10.1016/0022-2836(72)90146-5.

19 See: Paul W. K. Rothemund, "Folding DNA to Create Nanoscale Shapes and Patterns," in: *Nature,* vol. 440, no. 7082, 2006, pp. 297–302, doi: 10.1038/nature04586.

20 See: Ebbe S. Andersen, Mingdong Dong, Morten M. Nielsen, Kaspar Jahn, Ramesh Subramani, Wael Mamdouh, Monika M. Golas, Bjoern Sander, Holger Stark, Cristiano L. Oliveira, Jan S. Pedersen, Victoria Birkedal, Flemming Besenbacher, Kurt V. Gothelf, and Jørgen Kjems, "Self-Assembly of a Nanoscale DNA Box with a Controllable Lid," in: *Nature,* vol. 459, no. 7243, 2009, pp. 73–76, doi: 10.1038/nature07971.

21 See: Rothemund 2006.

Robert E. Mulvey
**Molecular Architecture and Synergy
in Organometallic Chemistry**

As an organometallic chemist by profession, I study compounds that combine both organic groups and inorganic metals. Organometallic chemistry is a vast, constantly growing subject, since every metal in the periodic table of the elements (there are over sixty metals, not including those that are radioactive) can, in theory, be combined with an infinite number of organic groups. The importance of organometallic chemistry to the modern world can be gauged by the fact that in 2005, and as recently as 2010, the Nobel Prize in Chemistry was awarded to chemists researching in this field. Yves Chauvin, Robert H. Grubbs, and Richard R. Schrock shared the earlier prize "for the development of the metathesis method in organic synthesis,"[1] while the latter prize was shared by Richard F. Heck, Ei-ichi Negishi, and Akira Suzuki for their pioneering of "palladium-catalyzed cross couplings in organic synthesis."[2]

To the non-specialist, these Nobel laureates invented new general ways of joining together groups of atoms (in particular carbon atoms) in strategic positions to make molecules. These can be used in a plethora of applications ranging from pharmaceuticals and plastics, all the way through to agrochemicals and electronic materials. Nature is undoubtedly the supreme synthetic chemist, but we humans try our best to imitate and emulate nature by continually creating new, more efficient, and more economical synthetic methods.

As a synthetic chemist working in a particular branch of organometallic chemistry, I like to think of myself as a "molecular architect." This is because my research specializes in building new molecular architectures, not just for their

aesthetics, but also for useful purposes. I am of the conviction that the structure of a molecule is the engine that drives its chemistry and dictates its chemical properties. Change the microstructure, and you will change the macro-properties of the compound.

Organometallic chemistry is filled with a galaxy of beautiful molecules with eye-catching structures. Some of their shapes actually predate their existence; in general, organometallic compounds do not occur naturally, but are man-made and have to be artificially synthesized in a laboratory. You might say we are "one step ahead of nature" in this area.

FIG 1 There are five Platonic solids (fig. 1), so-called because the ancient Greek philosopher Plato associated each shape with a classical element (as opposed to a chemical element): the smallest, the tetrahedron, with fire; the cube, with earth; the octahedron, with air; the dodecahedron, with the universe or heavens; and the largest, the icosahedron, with water. Personally interesting to me is that at least one thousand years before Plato's time, the late Neolithic people of my native Scotland carved stone balls in these same shapes for ornamental purposes. Most of these balls – whose scientific name is *Petrospheres*[3] – have been found in Aberdeenshire in the Northeast of Scotland. Their names derive, not from the number of points (atoms) in the structure, but from the number of triangular faces in these deltahedra: four in the tetrahedron; six in the cube; eight in the octahedron; twelve in the dodecahedron; and twenty in the icosahedron. All of these highly symmetrical Platonic shapes appear time and time again in chemistry. They are particularly prominent in molecules of boron. A boron hydride (a compound containing a mixture of boron and hydrogen atoms) with

FIG 2 six boron atoms can form a perfect octahedron (fig. 2), for example.

Tetrahedron     Icosahedron

FIG 2 A boron hydride with six boron atoms can form a perfect octahedron.

Dodecahedron     Octahedron     Cube

FIG 1 The five Platonic solids

A larger cluster made up of two carbon atoms and ten boron atoms (referred to as a carborane) can form an icosahedron (fig. 3). Cluster molecules of this type with high boron content (known as high nuclearity to a chemist), are potentially of use in medicinal applications. In boron neutron capture therapy (bnct), for example, where the reaction of boron with a neutron generates a helium and a lithium particle (fig. 4), they can destroy localized cells in vivo. Understandably, this technique is being investigated as a potential treatment for brain- and skin tumours.

I find it rather comforting that little molecules of such breathtaking beauty might be the weapon that could destroy such horrible malignancies.

Boron lies at the top of group 13 of the periodic table, but my own passion for chemistry is centered more on group 1, specifically on the compounds of lithium, sodium, and potassium. These are collectively known as the "alkali metals." It was thought for a long time that organic ("living") molecules and inorganic ("dead") metals were incompatible, indeed, two entirely separate families. In an epochal paper in 1917[4], however, Wilhelm Schlenk and his colleague Johanna Holtz – then working at the University of Jena in Germany – pioneered organolithium compounds. For this breakthrough and other brilliant work, Schlenk was nominated for a Nobel Prize in Chemistry, but was passed over: it was thought organolithium compounds "were too unstable to be of much use"![5]

Just how wrong can anyone be? Nearly a century later, we find organolithium compounds and many other types of organometallic compounds absolutely indispensable. They are widely utilized in the manufacture of pharmaceuticals and other biologically important compounds, agrochemicals, perfumes and cosmetics, polymers, dyes, and many other important everyday commodities. Their use is still expanding today. The global chemicals giant FMC Corporation, for example, has recently opened new organolithium (specifically butyllithium) plants in China and India (Hyderabad) to supply the growing pharmaceutical market there.

Robert E. Mulvey
Molecular Architecture
and Synergy in Organo-
metallic Chemistry

FIG 3

FIG 4

$$^{10}\text{B} + {}^{1}\text{n} \rightarrow {}^{4}\text{He} + {}^{7}\text{Li}$$

FIG 4 Reaction of boron with a neutron generates a helium and a lithium particle

FIG 3 A larger cluster made up of two carbon atoms and ten boron atoms can form an icosahedron.

So what is the connection between this rather specialized chemical science and molecular aesthetics? The answer is that organolithium compounds and their sodium and potassium congeners adopt a fascinating variety of structures at the molecular level. To chemists – especially those who first discovered them – both these molecules and related organometallic molecules are as appealing, attractive, and mysterious as any beautiful woman – that is, until we get to know them better by investigating their chemical and physical properties. Just like the models that grace fashion magazines, these beautiful molecules adorn the covers, and inside pages, of chemical journals and periodicals. Many chemists since the 1960s have contributed to the development of this field, but I will focus in great part here on examples from my own research laboratory.

As we made and studied organolithium structures, it became apparent that FIG 5 small rings were a common feature. In figure 5, lithium and nitrogen atoms alternate in a four-membered ring with peripheral organic (carbon-based) shrubbery (denoted generically as "R"). Thinking as an architect, one can use this small ring as a basic building block to construct more complex architectures, much like a house-builder would use bricks. Molecular stacks and skyscraper-type structures envisioned by the architectural chemist can then spring up in the chemical laboratory. By changing the organic shrubbery, we can also build structures with ladder motifs. Further modifications can force such rings to break open and to generate helices.

FIG 6 The example in figure 6[6] shows a two-floor tower or stack where two Li-N rings join face-to-face to form the frame of the structure; the black organic groups form the facade.

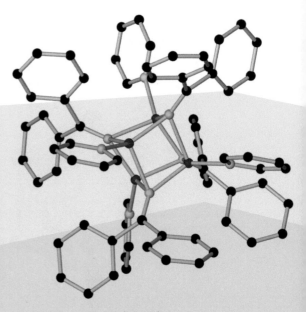

**FIG 5** Lithium and nitrogen atoms alternate in a four-membered ring. Thinking as an architect, one can use this ring as a basic building block to construct more complex architectures, much like a house-builder would use bricks.

**FIG 6** Li-N rings join face-to-face to form the frame of the structure; the black organic groups form the facade

The frame can also be extended. Over three floors, this lithium–sodium stack (fig. 7)[7] has a frame made up of (metal-N)$_2$ rings (horizontal beams), connected by vertical columns, and it is again completed by an organic facade. However, unlike what would happen in most man-made buildings, to take away the organic (carbon–based) facade from the inorganic (metal–nitrogen) frame, makes the construction crumble. In these particular cases, the two structures are mutually dependent.

By having an odd number of Li atoms within the structure, regular tower shapes can be formed into more asymmetrical arrangements. The example shown in figure 8[8] has five Li atoms that generate a trigonal bipyramidal (pentanuclear) core, with the organic groups bridging between Li atoms. Such architectures, containing five Li vertices, are extremely rare. One of my favorite structures (fig. 9)[9] comes from the work of Erwin Weiss and Paul von Ragué Schleyer, two eminent chemists who have made numerous seminal contributions to the development of alkali metal chemistry. In figure 9, I have stripped away the organic facade so one can see the carbon–lithium framework clearly. Derived from an alkyne (a compound containing a carbon–carbon triple bond), this structure is on its way to forming a molecular skyscraper with six Li-C rings all stacked one on top of the other.

Thinking again as an architect: to alter the orientation of the organic groups so that stacking is disallowed (because like groups repel each other), makes it

Robert E. Mulvey
Molecular Architecture
and Synergy in Organo-
metallic Chemistry

FIG 7

FIG 8

FIG 9

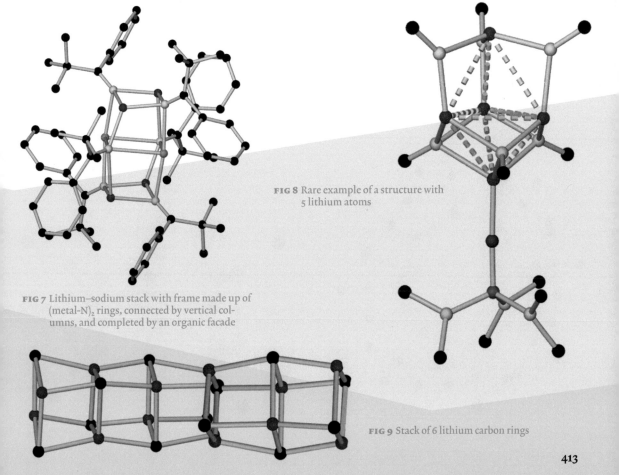

FIG 8 Rare example of a structure with 5 lithium atoms

FIG 7 Lithium–sodium stack with frame made up of (metal-N)$_2$ rings, connected by vertical columns, and completed by an organic facade

FIG 9 Stack of 6 lithium carbon rings

possible to design alternative ladder structures. Here, the horizontal beams are used to construct the framework and grow it laterally rather than the vertical columns used in the tower structures. The first ladder shown (fig. 10)[10] can be thought to have four (lithium–nitrogen) rungs in an almost flat arrangement. If the stack/tower structures are assembled through face-to-face association of rings, then these ladder variations are assembled through edge-to-edge association of rings.

A simple modification of the organic group can produce ladders that curve to make a convex shape (fig. 11). This curved ladder[11] also contains four rungs. If the organic groups at the ladder ends are removed, the structure will continue to grow and curve. The result can be a closed cyclic ladder (fig. 12). The example shown[12] contains eight rungs with the organic groups projecting outwards like the petals of a flower. Closer inspection shows the eight membered rings to be highly puckered rather than flat.

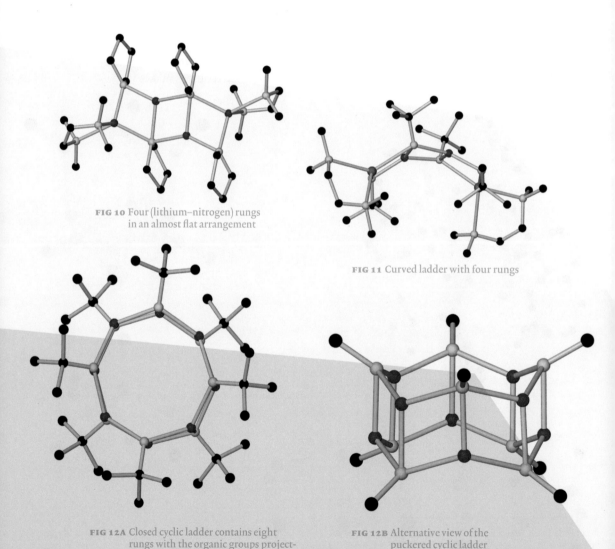

**FIG 10** Four (lithium–nitrogen) rungs in an almost flat arrangement

**FIG 11** Curved ladder with four rungs

**FIG 12A** Closed cyclic ladder contains eight rungs with the organic groups projecting outwards like the petals of a flower.

**FIG 12B** Alternative view of the puckered cyclic ladder

It is also possible to build ladders which keep growing ad infinitum. Belonging to an organosodium compound, the representative example shown in figure 13[13] has an undulating waveshape made up of an infinite number of four-membered rings. Only a small segment of the ladder is shown here. The dimensions ("steric bulk" to a chemist) of the organic group are key. If building in extremely large groups, unfavorable repulsions between atoms may put the small rings under strain and eventually break them open. A possible result of this ring opening is a helical chain (fig. 14)[14] rather than a ladder structure. In this structure, a turn of the helix consists of eight Li-N bonds: the structure repeats itself every eight bonds. To dissolve this helical compound in a solvent forms one of the most important reagents in chemistry: lithium diisopropyl-amide, or LDA for short.

LDA is a key tool for synthesizing fine chemicals and pharmaceuticals. How does it work? It selectively removes atoms from organic molecules, allowing the chemist to attach other atoms or groups at fixed points in the structure to build up the structural formula of the fine chemical or pharmaceutical. In plainest terms, LDA can transform simple organic structures into complicated ones.

What exactly do these illustrations of molecules show us? They are crystal structures which represent the spatial arrangement of atoms in a crystal. Two sets of crystals from my own laboratory are illustrated (fig. 15).

FIG 13

FIG 14

FIG 15

FIG 13 Organosodium compound with undulating waveshape made up of an infinite number of four-membered rings

FIG 14 Helical chain          FIG 15 Two sets of crystals          415

Crystals come in a vast assortment of shapes, sizes, and colors. They can resemble long needles or large rectangular blocks, for example. The wonder of growing crystals from solution (just like magic!) is one of the main reasons I was attracted to this area of science as an impressionable student. Many other chemists were probably similarly captivated: amazing tapestries of color can be generated by FIG 16 melting crystals and placing them between two glass plates (fig. 16)!

Crystal structures are determined experimentally. When a beam of X-rays strikes a crystal, the rays diffract in different directions, and one can calculate the positions of the atoms from the diffraction pattern. While diffraction patterns are scientifically important for that reason, I think they make beautiful FIG 17 art as well (fig. 17).

You may have noticed that the word "synergy" appears in the title of the article. The reason is that my recent research has focused on molecules containing two different metals. Our research group has discovered that if a sodium compound is combined with a magnesium compound, a new bimetallic compound can be formed. That the new compound has a unique structure, and differs from the two starting single metal compounds, points to a special, unique chemistry which cannot be replicated by either the sodium compound or the magnesium compound FIG 18 on their own. A simple illustration of this idea can be found in toluene (fig. 18), the aromatic compound which contains a hexagonal ring of carbon atoms.

When toluene reacts with a sodium compound, a change occurs only at the $CH_3$ position; therefore only at this position can molecular construction take place. Magnesium limits the situation even more, since magnesium compounds do not generally react with toluene. If we combine sodium and magnesium in our special synergic system, however, a remarkable new reaction takes place; two new construction points are opened in positions not possible with separated sodium or magnesium compounds. This reaction yields an amazing structure FIG 19 (fig. 19)[15], where toluene is trapped at the center of a large ring.

The green magnesium atoms are the new construction points. The ring itself contains twelve atoms made up of six nitrogen atoms, four sodium atoms, and two magnesium atoms. This type of structure is known as a host-guest compound in chemistry, the host being the twelve-atom ring and the guest being toluene. However, it is a special type which we call an "inverse crown."

The following is another example of synergic bimetallics. Ferrocene is an organoiron compound whose framework has many important applications: in polymers, magnets, bio-sensors, materials for non-linear optics, and in anti-tumor agents. For chemists to build outwards from this parent structure is vital. In general, neither sodium- nor magnesium compounds can achieve this state, but by combining these two metals into a synergic mixture, then almost magically, you generate four new construction points. This novel reaction is manifested in FIG 20 one of the most eye-catching structures (fig. 20) ever made by my group. Again, it is an inverse crown, but rather than a twelve-atom host ring, it is, this time, a sixteen-atom ring comprising four sodium atoms, four magnesium atoms, and eight nitrogen atoms. The ferrocene molecule is encapsulated in the center of the ring. Due to the combination of its striking appearance and the importance of the chemistry involved, this molecule was spotlighted on the front cover of *Angewandte Chemie*[16], one of the world's leading chemistry journals.

The largest inverse crown molecule we have made to date is a potassium-mag-
 FIG 21 nesium compound (fig. 21)[17]. Its host ring contains 24 atoms made up of six

FIG 16 The stunning tapestry of color generated by melting crystals which were placed between two glass plates

FIG 17 Image of X-rays strikes though a crystal

FIG 18 Formula of toluene

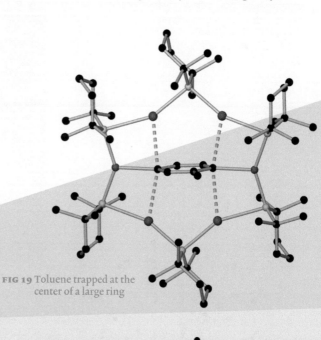

FIG 19 Toluene trapped at the center of a large ring

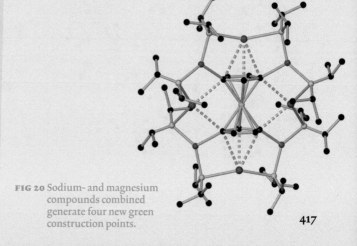

FIG 20 Sodium- and magnesium compounds combined generate four new green construction points.

417

K atoms, six Mg atoms, and twelve N atoms. This ring is so large that it encapsulates not one guest molecule, but six: guest molecules which are benzene rings. Seen from the side-view (fig. 21) this 24-membered molecule has a bizarre irregular shape, almost like a collapsed star.

FIG 22  On another journal cover, we recently tried to convey the idea behind the synergic effect with a Newton's cradle (fig. 22)[18]. On its own, the manganese, or single metal present here, cannot react with this organic molecule. If we add sodium, however, the two metals can cooperate, a reaction can take place, and a hydrogen atom will be ejected from the organic molecule, a phenomenon that enables synthetic chemists to build more complicated organic structures starting from a small ring seed.

FIG 23  We can, in fact, make a wide variety of inverse crown compounds of different shapes and sizes that trap different guests in the center of the ring. Illustrated is the structure of a lithium-manganese compound (fig. 23)[19] which forms an almost-square, eight-membered octagonal ring.

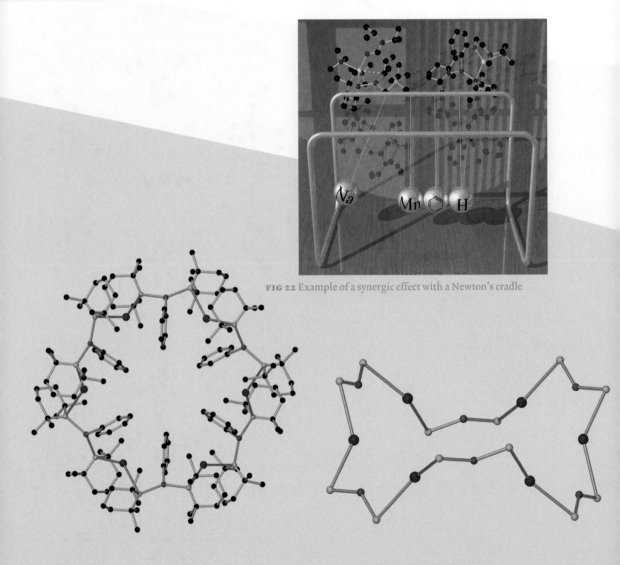

FIG 22 Example of a synergic effect with a Newton's cradle

FIG 21 Potassium-magnesium compound, front and side view

The atom in the center is oxygen. Since oxygen is a major component of ether, we refer to this compound as an inverse crown ether and abbreviate it to "ICE." Figure 24 depicts a molecule imprisoned in a block of ice.

We are taking a bit of artistic license here; organolithium compounds invariably decompose in the presence of water or air, so must be prepared in an inert nitrogen atmosphere. Given the very challenging nature of that preparation, the fact that we have made so many over the years speaks volumes for the skill, drive, and dedication of my co-workers, whose names appear among the references here.

FIG 24 Molecule imprisoned in a block of ice

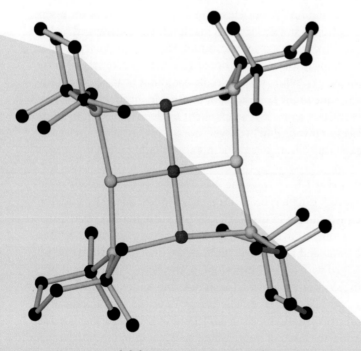

FIG 23 Structure of a lithium-manganese compound

The final structures I want to share are relevant to the field of hydrogen storage. One of the world's greatest challenges in science with regard to energy efficiency is to develop hydrogen storage technologies. Hydrogen storage in this context means the chemical form in which it is carried, whether in a compound, alloy or nanomaterial. Many scientists believe that hydrogen is the number one contender for the synthetic fuel of the future in mobile applications. The challenge will be storing and transporting hydrogen safely. Many scientists and technologists will be needed to meet this complex global challenge, but inorganic chemistry's contribution can be to deliver novel materials with high hydrogen storage capabilities.

For this reason, my research group has been trying to apply its inverse crown work to synthesize lightweight bimetallic molecules that trap hydrogen atoms in the center of the ring. This structure (fig. 25)[20] proves the concept viable. It is another example of an eight-membered ring made up of two sodium atoms, two magnesium atoms, and four nitrogen atoms. It differs from the other eight-membered rings shown earlier in this article inasmuch as this structure is "pulled in at the waist." And the reason it is pulled in is because the magnesium atoms are being strongly attracted to the two, small hydride ions at the center of the ring. While definitely a good start, potential hydrogen storage compounds will certainly require many more than two hydrogen atoms.

Considerable progress has been made since we first reported our small hydrogen storage structure. In a recent breakthrough, Sjoerd Harder – then at the University of Groningen, the Netherlands, now at the Friedrich-Alexander-Universität Erlangen-Nürnberg, Germany – reported the synthesis of an extraordinary cluster shaped like a large doughnut (fig. 26).[21] The periphery is just organic shrubbery. Its key feature is the metallic core consisting of eight magnesium atoms which have managed to trap a total of ten hydrogen atoms. This is the largest magnesium hydride cluster known to date. One of the essential demands on a hydrogen storage device is that it releases the trapped hydrogen and turns it into hydrogen gas for use as fuel. Showing promise, heating this molecule to a relatively low temperature of 200° Celsius converts all of its hydrogen to hydrogen gas. While this molecule could not be used practically for hydrogen storage due to the large amount of organic shrubbery needed to stabilize it, it nevertheless represents an excellent model with which to study and refine the processes involved in hydrogen storage/release at the molecular level. Many more exciting developments in this area should unfold in the near future.

In closing, I hope this article conveys the message that organometallic molecules of the alkali metals can be as beautiful as they are functional. By studying them further, chemists can begin to design tailor-made molecules of all different shapes and sizes much akin to the ways architects design buildings, as illustrated here in the tower and ladder structures. In the final illustration (fig. 27), these ideas are merged with a superimposition of the iconic Flatiron building (a ground-breaking skyscraper constructed in 1902 and located at the intersection of two of the world's most famous streets, 5th Avenue and Broadway in New York City) and an iron molecule from our laboratory.[22] The former is made of steel and terracotta, the latter of iron, carbon, manganese and sodium atoms, but to my eye, they are equally, and breathtakingly, beautiful.

FIG 25

FIG 26

FIG 27

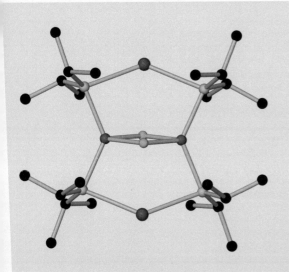

FIG 25 Proof, that the inverse crown work to synthesize
lightweight bimetallic molecules that trap
hydrogen atoms in the center of the ring works.

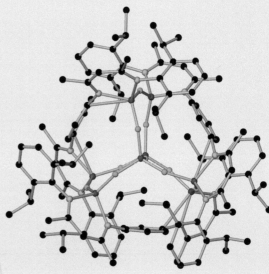

FIG 26 The largest magnesium hydride
cluster known to date

FIG 27 Iron molecule in the shape of the famous Flatiron building

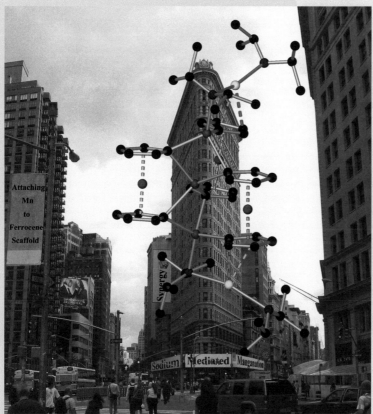

421

## Notes

1 www.nobelprize.org/nobel_prizes/chemistry/laureates/2005/, accessed 10/09/2012.

2 www.nobelprize.org/nobel_prizes/chemistry/laureates/2010/, accessed 10/09/2012.

3 Available online at: http://en.wikipedia.org/wiki/Petrosphere, accessed 06/12/2012.

4 See: Wilhelm Schlenk and Johanna Holtz, "Über die einfachsten metallorganischen Alkaliverbindungen," in: *Berichte der Deutschen Chemischen Gesellschaft*, vol. 50, 1917, pp. 262–274, doi:10.1002/cber.19170500142.

5 Thomas T. Tidwell, "Wilhelm Schlenk: The Man Behind the Flask," in: *Angewandte Chemie International Edition*, vol. 40, no. 2, 2001, p. 333, doi: 10.1002/1521-3773(20010119)40:2<331::AID-ANIE331>3.0.CO;2-E.

6 See: Donald Barr, William Clegg, Robert E. Mulvey and Ronald Snaith, "Crystal structures of $(Ph_2C=NLi\cdot NC_5H_5)_4$ and $[ClLi\cdot O=P(NMe_2)_3]_4$; discrete tetrameric pseudo-cubane clusters with bridging of Li3 triangles by nitrogen and by chlorine atoms," in: *Journal of the Chemical Society, Chemical Communications*, issue 2, 1984, p. 79, doi: 10.1039/C39840000079.

7 See: Donald Barr, William Clegg, Robert E. Mulvey, and Ronald Snaith, "Synthesis and crystal structure of the mixed alkali metal imide $Li_{4-x}Na_{2+x}[N=C(Ph)Bu^t]_6$: three (metal–nitrogen)$_2$ ring dimers in a triple-layered stack," in: *Journal of the Chemical Society, Chemical Communications*, issue 1, 1989, p. 57, doi: 10.1039/C39890000057.

8 See: Donald Barr, William Clegg, Robert E. Mulvey, and Ronald Snaith, "X-Ray crystal structure of $\{Li\cdot[O=P(NMe_2)_3]_4\}+\times\{Li_5[NCPh_2]_6\cdot[O=P\cdot(NMe_2)_3]\}^-$: a lithium 'ate complex, with a pentanuclear $Li_5$ clustered-anion having both $\mu_2$ edge and $\mu_3$ face nitrogen to lithium bonding," in: *Journal of the Chemical Society, Chemical Communications*, issue 4, 1984, p. 226, doi: 10.1039/C39840000226.

9 See: Maren Geissler, Jürgen Kopf, Bernd Schubert, Erwin Weiss, Wolfgang Neugebauer, and Paul von Ragué Schleyer, "Tetrameric and Dodecameric tert-Butylethynyllithium; A Novel Aggregation Principle in Organolithium Compounds," in: *Angewandte Chemie International Edition*, vol. 26, issue 6, 1987, p. 587, doi: 10.1002/anie.198705871.

10 See: David R. Armstrong, Donald Barr, William Clegg, Susan M. Hodgson, Robert E. Mulvey, David Reed, Ronald Snaith, and Dominic S. Wright, "Ladder structures in lithium amide chemistry: syntheses, solid-state, and solution structures of donor-deficient lithium pyrrolidide complexes, [cyclic] $\{[H_2C(CH_2)_3NLi]_3$.cntdot.PMDETA$\}_2$ and [cyclic] $\{[H_2C(CH_2)_3NLi]_2$.cntdot.TMEDA$\}_2$, and ab initio MO calculations probing ring vs ladder vs stack structural preferences," in: *Journal of the American Chemical Society*, vol. 111, no. 13, 1989, p. 4719, doi: 10.1021/ja00195a027.

11 See: William Clegg, Kenneth W. Henderson, Lynne Horsburgh, Fiona M. Mackenzie, and Robert E. Mulvey, "New Alkali Metal Primary Amide Ladder Structures Derived from *t*BuNH$_2$: Building Cisoid and Transoid Ring Conformations into Ladder Frameworks," in: *Chemisty. A European Journal*, vol. 4, issue 1, 1998, p. 53, doi: 10.1002/(SICI)1521-3765(199801)4:1<53::AID-CHEM53>3.0.CO;2-4.

12 See: Nicholas D. R. Barnett, William Clegg, Lynne Horsburgh, David M. Lindsay, Qi-Yong Liu, Fiona M. Mackenzie, Robert E. Mulvey, and Paul G. Williard, "Novel octameric structure of the lithium primary amide $[\{Bu^tN(H)Li\}_8]$ and its implication for the directed synthesis of heterometallic imide cages," in: *Chemical Communications*, vol. 118, issue 20, 1996, p. 2321, doi: 10.1039/CC9960002321.

13 See: Clegg et al. in: *Chemisty. A European Journal*, vol. 4, issue 1, 1998, p. 53.

14 See: Nicholas D. R. Barnett, Robert E. Mulvey, William Clegg, and Paul A. O'Neil, "Crystal structure of lithium diisopropylamide (LDA): an infinite helical arrangement composed of near-linear nitrogen-lithium-nitrogen units with four units per turn of helix," in: *Journal of the American Chemical Society*, vol. 113, no. 21, 1991, p. 8187, doi: 10.1021/ja00021a066.

15 See: David R. Armstrong, Alan R. Kennedy, Robert E. Mulvey, and René B. Rowlings, "Mixed-Metal Sodium–Magnesium Macrocyclic Amide Chemistry: A Template Reaction for the Site Selective Dideprotonation of Arene Molecules," in: *Angewandte Chemie International Edition*, vol. 38, issue 1–2, 1999, p. 131, doi: 10.1002/(SICI)1521-3773(19990115)38:1/2<131::AID-ANIE131>3.0.CO;2-9.

16 See: William Clegg, Kenneth W. Henderson, Alan R. Kennedy, Robert E. Mulvey, Charles T. O'Hara, René B. Rowlings, and Duncan M. Tooke, "Regioselective Tetrametalation of Ferrocene in a Single Reaction: Extension of s-Block Inverse Crown Chemistry to the d-Block," in: *Angewandte Chemie International Edition*, vol. 40, issue 20, 2001, p. 3902, doi: 10.1002/1521-3773(20011015)40:20<3902::AID-ANIE3902>3.0.CO;2-T.

17 See: Philip C. Andrews, Alan R. Kennedy, Robert E. Mulvey, Colin L. Raston, Brett A. Roberts, and René B. Rowlings, "An Unprecedented Hexapotassium-Hexamagnesium 24-Membered Macrocyclic Amide: A Polymetallic Cationic Host to Six Monodeprotonated Arene Anions," in: *Angewandte Chemie International Edition*, vol. 39, issue 11, 2000, p. 1960, doi: 10.1002/1521-3773(20000602)39:11<1960::AID-ANIE1960>3.0.CO;2-D.

18 See: Victoria L. Blair, William Clegg, Ben Conway, Eva Hevia, Alan Kennedy, Jan Klett, Robert E. Mulvey, and Luca Russo, "Alkali-Metal-Mediated Manganation(II) of Functionalized Arenes and Applications of ortho-Manganated Products in Pd-Catalyzed Cross-Coupling Reactions with Iodobenzene," in: *Chemisty. A European Journal*, vol. 14, issue 1, 2008, p. 65, doi: 10.1002/chem.200701597.

19 See: Alan R. Kennedy, Jan Klett, Robert E. Mulvey, Sean Newton, and Dominic S. Wright, "Manganese(II)-lithium and -sodium inverse crown ether (ICE) complexes," in: *Chemical Communications*, issue 3, 2008, p. 308, doi: 10.1039/B714880A.

20 See: Daniel J. Gallagher, Kenneth W. Henderson, Alan R. Kennedy, Charles T. O'Hara, Robert E. Mulvey, and René B. Rowlings, "Hydride encapsulation in s-block metal inverse crown chemistry," in: *Chemical Communications*, issue 4, 2002, p. 376, doi: 10.1039/B110117J.

21 See: Sjoerd Harder, Jan Spielmann, Julia Intemann, and Heinz Bandmann, "Hydrogen Storage in Magnesium Hydride: The Molecular Approach," in: *Angewandte Chemie International Edition*, vol. 50, issue 18, 2011, p. 4156, doi: 10.1002/anie.201101153.

22 See: Victoria L. Blair, Luca M. Carrella, William Clegg, Jan Klett, Robert E. Mulvey, Eva Rentschler, and Luca Russo, "Structural and Magnetic Insights into the Trinuclear Ferrocenophane and Unexpected Hydrido Inverse Crown Products of Alkali-Metal-Mediated Manganation(II) of Ferrocene," in: *Chemisty. A European Journal*, vol. 15, issue 4, 2009, p. 856, doi: 10.1002/chem.200802086.

## Acknowledgements

I am deeply indebted to a highly talented group of co-workers and collaborators whose names appear in the relevant references. Special thanks go to my University of Strathclyde colleagues, Dr. Charlie O'Hara and Dr. Jan Klett, for helping with the figures herein. Financial support from the EPSRC, the Royal Society, the Nuffield Foundation, and AstraZeneca is gratefully acknowledged.

Leonard F. Lindoy
**Art, Architecture, and Engineering
at the Molecular Level**

Members of our species, Homo sapiens, evolved in Africa around 200,000 years ago. Until around ten thousand years ago, no substantial buildings appear to have been constructed, people slept in caves or in temporary shelters made of perishable materials such as wood, straw, or bark. Very little remains from this long period of human history. There are stone tools – normally with chipped rather than ground edges. As for art, a few cave paintings in France, Spain, and Australia are still extant, but not much else has survived. Similarly, we know nothing about the people themselves – neither their names, nor what they looked like; nor who their leaders were. That there were exceptional individuals – people with highly developed talents and perhaps ones as aware as we are – seems likely, but even of that, we cannot be certain.

Around six thousand years ago, humankind began rather suddenly to erect megalithic structures. The huge monuments that began to appear in the Middle East bear witness to this paradigm shift in human history. Such megastructures – monumental constructions in stone – are typified by the pyramids and other great constructions scattered throughout that region. The pyramids, often adhering to precise geometric design and orientation, quite clearly represent both an enormous physical and a significant technical achievement.

Why did a shift occur at this time? There were a number of reasons. One is that the appearance of these structures paralleled the rise in population

along the great river valleys in the Middle East. Agriculture developed and, with it, larger settlements became established. Over time, there was a continuing transition from a culture of nomadic or semi-nomadic hunter-gatherers to one of farmers and city dwellers.

What of the monumental structures? Some are tombs, some memorials, some have a religious function occasionally coupled with an astrological aspect, as appears to apply to the considerable number of prehistoric stone circles spread throughout Britain and continental Europe. Stonehenge is a case in point – the large double stone circle built in two stages starting from about five thousand years ago on the Salisbury Plain in the South of England (fig. 1). The average weight of each large standing stone (sarsen) is some 25 ton while the lintels, each weighing up to 50 tons, appear to have been transported from a quarry (or quarries) many miles away. In terms of human commitment, their construction represents a truly prodigious effort and is estimated to represent the expenditure of many thousands of person-years. As we move on in time, construction starts to become considerably more sophisticated. An outstanding example of this development is the Al Khazneh (The Treasury) building in the Nabataean city of Petra (fig. 2), built some 2,100 years ago and located in the mountains in modern day Jordan.

FIG 1 Stonehenge on the Salisbury Plain, England

FIG 2 "The Treasury" at Petra in modern day Jordan

Standing in front of this edifice, one is struck by the physical as well as the creative commitment required to carve such an extraordinary building from the solid rock face.

Moving on, we now start to see the emergence of more complex structures. By around one thousand years ago, some show themselves, not only as great works of architecture, but also as impressive works of engineering. Durham Cathedral, located on a high ridge overlooking the River Wear in the misty North of England, is an impressive example (fig. 3). A Norman building (Romanesque in style) whose foundation was laid in 1093, the cathedral features three large towers and a huge nave with an impressive rib-vaulted roof. It comes as no surprise that UNESCO classified it as the largest and most perfect monument of Norman style architecture in England. The clever use of hidden flying buttresses not only enabled a significant expansion of the floor plan, but represents a noble and boldly aesthetic marriage of engineering and art in architecture.

The Taj Mahal in Agra, India, commissioned by Shah Jahan over a twenty-year period as a mausoleum for his third wife, Mumtaz Mahal, was completed in 1648 (fig. 4). A near perfect example of Mughal architecture, the building is distinguished by the fusion of Indian, Persian, and Islamic elements that produces a truly exquisite result.

FIG 3

FIG 4

FIG 3 Durham Cathedral in the North of England

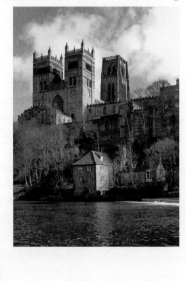

FIG 4 Taj Mahal in Agra, India

The human propensity for building macrostructures of various dimensions has, of course, continued up to the present. But what has motivated humans to build grandiose structures of the types cited above? Clearly personal vanity, a sense of patriotism, individual or collective need, and fear or love of a god have each played their part. However, there are two traits associated with the human psyche – challenge and creativity – both of which have also played their role. Humans ordinarily respond to challenge; why else would we trouble to hold events like the Olympic Games? Similarly, we enjoy practicing creativity; it is one of the attributes that sets us apart from the other animals.

A little over two hundred years ago, a new mindset emerged in human history; coinciding with the development of chemistry as a rational science. Only from around the beginning of the nineteenth century did we humans begin to unlock Nature's rules for generating chemical structures – using atoms and molecules as the building blocks. The resulting molecular structures can have dimensions that might be as small as one or two nanometers (a nanometer is $10^{-9}$ of a meter) in length. Landmark developments in chemical science beginning about this time underwrote the development of modern chemistry, spurred by better understanding of the manner by which atoms of the same – or different – elements are able to combine to form larger chemical structures. Provided Nature's rules are followed, chemists since that time have increasingly been able to build molecular structures in a planned and deliberate manner. A number of pioneering scientists contributed to this innovation, but only four will be mentioned here. Each of these was an outstanding individual and collectively modern chemistry owes a great deal to each of them.

French nobleman Antoine Laurent de Lavoisier (1743–1794) was the first to discover oxygen and hydrogen, and he also drew up a list of the other elements then known. He was also the first person ever to use a chemical balance and undertook a number of quantitative chemical experiments. He was able, for example, to demonstrate that mass is conserved in a chemical reaction. Unfortunately, he lost his head in the French Revolution.

John Dalton (1766–1844) who lived in Manchester, England, is famous for his atomic theory that popularized the idea of atoms combining in chemical reactions. He was the first to show that atoms can only combine in a fixed way, pioneering what chemists now call valency – the idea that atoms act as if a given number of "hooks" allows them to attach to other atoms in set ways (and proportions). Dalton distinguished himself in other ways, too. Since he was colorblind, he undertook research into the nature of that condition, such that "Daltonism" became its common name. He also made contributions to meteorology – making more than 200,000 observations in a meteorological diary during his adult life!

Friedrich August Kekulé von Stradonitz (1829–1896), known as August Kekulé, was another eminent pioneer of chemical science. Born in Darmstadt, Germany, he is counted among the founders of modern organic chemistry and he made other important scientific contributions, as well. He was FIG 5 the first to describe the correct structure of benzene (fig. 5) – a puzzle at the time – and to show how carbon atoms can be joined in particular ways. Knowledge of the structure of benzene provided the key to the understand-

ing of the structures of other related compounds; from that time on, and thanks to Kekulé, the description of the structural aspects of organic compounds enjoyed a firmer footing.

Finally, Siberian-born Dmitri Mendeleev (1834–1907) arranged the elements known in the mid-nineteenth century into a square grid classification such that a stepwise gradation in their properties, both down and across the grid, reflected the periodicity in the properties of the elements (when arranged in order of their atomic weights). It represented a prodigious intellectual achievement.

Where an element appeared to be missing, Mendeleev left a space, thereby predicting the existence of otherwise unknown elements. Mendeleev's genius was of a type shared by Charles Darwin, namely: the ability to examine a large amount of data and to synthesize it into a coherent entity. The modern version of Mendeleev's grid-like classification is known as the Periodic Table of the Elements (fig. 6). It now contains in excess of 100 elements, FIG 6 embracing metals, non-metals and "intermediate" metalloid elements. The elements define the elementary building blocks of all matter, not only on Earth but, indeed, throughout the entire universe. Each element is made-up of only one atom type, resulting in distinctive properties that are unique to that element. In one sense, the elements can be thought of as packages of information, a concept that will help elucidate material presented later in this essay.

FIG 5 Stick representation of the rigid aromatic
planar molecule benzene

FIG 6 Periodic Table of the Elements

A lesser mind shift took place in the chemistry world in more recent history with the development of what is known as supramolecular chemistry. Its rise as a subarea of general chemistry began in earnest about four decades ago – although its roots were older. In 1987, Donald J. Cram (USA), Jean-Marie Lehn (France), and Charles J. Pedersen (USA) shared the Nobel Prize for Chemistry for their respective contributions to supramolecular chemistry.

Until the 1970s, the preparation of single molecules, both organic and inorganic, had been almost the sole focus of synthetic chemists, and an enormous number of new molecules were – and still are – reported each year. The focus of supramolecular chemistry, however, was a different one: existing molecules, sometimes prepared especially for the purpose, were selected and mixed together in solution so that they could assemble to form larger aggregates with structures defined, at least in part, by the shapes of the individual component molecules. The aggregates, known as supramolecular complexes, are usually obtained as crystalline solids by letting them crystallize from their solution. Modern instrumental techniques allow their precise structure to be determined – in many cases the application of X-ray diffraction essentially reveals a "picture" of the resulting molecular assembly, along with its precise dimensions. The design of appropriate component molecules to produce such a predetermined assembly is a creative activity regularly carried out by supramolecular chemists; in many cases, it amounts to practicing architecture at the molecular level.

In general, the forces holding the component molecules together in a supramolecular complex can be individually quite weak (several types of interaction may be present), although such forces usually act in concert so that, overall, moderate binding is achieved between the component molecules. These forces are exactly the same ones that Nature uses to hold together biological molecules such as occurs in an enzyme, or indeed DNA itself.

If we can fully master the use of these forces, and couple this with the necessary synthesis of the appropriate component molecules, then it becomes possible to build larger and larger assemblies of higher complexity that display predesigned properties. Supramolecular chemistry has already moved some way towards this goal. For example, somewhat rudimentary mimics of particular biological systems have been produced that show some of the functions of their biological analogs. In general, however, there is still a considerable way to go before both the sophistication and the complexity of Nature's assemblies are consistently matched. Nevertheless, since none of the laws of science need to be broken to achieve such an end, such a goal is clearly feasible. I believe that we will see exciting outcomes of this type in the future.

Metallosupramolecular chemistry is another branch of supramolecular chemistry, in which positively charged metal atoms, termed metal ions, are employed to direct the assembly of organic molecules or "ligands" such that larger molecular structures are generated. In these the information inherent in the chosen metal, as well as in the ligands, is of utmost importance: it will act to control the manner in which the metal and the ligands assemble. For example, one metal ion may generate one arrangement with a given ligand type, while another metal will give rise to a different arrangement. In any case, the information in the respective metal ions can act both to direct the

assembly of the ligands and function as the "glue" to hold them in place in the final generated structure.

The building of molecular structures incorporating metal ions has been the major focus of my own research at the University of Sydney, and it is the area that will be given emphasis in the remainder of this essay. Included in the following discussion are some structures that have come out of our laboratory in Australia.

Before proceeding, I should comment on how molecules can be displayed. This can be done in several ways, but only two need to be mentioned here. The first is a full-bodied representation, which is usually referred to as space-filling. When the depicted structure is based on the results of an X-ray diffraction experiment, this type of representation comes closest to being a photograph of the real molecule. Alternatively, a molecule can be depicted in "stick" form – much like the human stick figures drawn by young children. An example of each is shown in figure 7; where three molecules incorporat- FIG 7 ing benzene rings are stacked one upon the other and viewed obliquely. The space filling representation is on the left, and the stick view, on the right. In the context of the present discussion, I should note that structures such as this one are sometimes not without artistic nuances. For example, to turn the stick version by ca. 90° yields a nice pattern (fig. 8, right side) that bears FIG 8 a resemblance to a cathedral's west window (fig. 8, left side). It's not as good, of course, but then again, it's not all that bad.

Permit me a mini-tutorial about how metal-ligand interactions may be used to generate larger molecular structures. A simple example that has been known for many years (fig. 9) may help. In it, a copper ion with a double FIG 9 positive charge (Cu²⁺) acts as the glue to bind two identical ligands (shown in stick representation) – each bearing a single negative charge – to form

FIG 7 Three stacked molecules shown in space-filling (left) and stick (right) representations

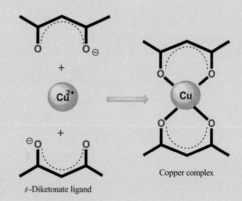

FIG 9 Assembling a copper complex from two β-diketonate ligands and one copper (Cu²⁺) ion. The dotted lines illustrate areas that are particularly rigid.

FIG 8 A cathedral window versus a view of one of the molecules shown in illustration 5, drawn in a modified stick representation

the final uncharged assembly, also called a metal complex. In this case, each negatively charged ligand is called a $\beta$-diketonate. The preparation is easily carried out by mixing solutions of the copper ion and the $\beta$-diketonate ligands dissolved in water (or a suitable organic solvent) together in a test-tube in a 1:2 ratio. The product forms as blue crystals – one of which can be used to obtain a "picture" of the molecule when analyzed by the X-ray diffraction technique. The copper ion in this case directs the oxygens (O-atoms) on the ligands to form a square planar arrangement, each oxygen forming a bond with the central copper ion. We say that the complex adopts a four-coordinate, square planar geometry. While copper often forms such a square planar arrangement, it sometimes also binds to one or two extra ligand molecules (L) above and/or below the square plane to give related five- or six-coordinate metal complexes (fig. 10). If instead of $Cu^{2+}$, a three positively charged metal ion, such as occurs for iron ($Fe^{3+}$), is employed in a reaction of the above type, then three negatively charged $\beta$-diketonate ligands are found to surround it to give a six-coordinate octahedral metal complex which is now uncharged (fig. 10). In the iron complex, six bonds between the oxygen atoms of the ligands and the central $Fe^{3+}$ are directed towards the apices of an octahedron, a figure with eight sides but only six apices. We say that the metal ion has octahedral coordination in this case.

When a number of ligands and metal ions come together to form a larger supramolecular assembly, there is a tendency for the simplest, least strained arrangement to occur such that the minimum number of components is employed. While this doesn't always happen, it occurs often enough to be used as a guiding principle when designing the construction of a new supramolecular entity. The ideas above can also be put to work to build larger structures. If we link three $\beta$-diketonate ligands to a central core by *flexible* linkages containing sulfur (S) atoms, as shown in figure 11, and react two of these units with three $Cu^{2+}$ ions in solution, then the metal ion/ligand mixture spontaneously self-assembles into the cage-like arrangement incorporating a central cavity, with each copper surrounded by a favorable square planar geometry (fig. 11).[1]

FIG 10 Examples of 5- and 6-coordinate copper (Cu) and iron (Fe) metal complexes incorporating $\beta$-diketonate ligands

**5-Coordination**

**6-Coordination**

**6-Coordination**

Again, this simple example exemplifies how one can use the information in the metal ion and the ligand (especially information about the latter's shape and electronic properties) to produce the desired structural outcome.

What happens if, in contrast to the above, we connect two β-diketonate ligands together with a *non-flexible* linking group such as a benzene ring (fig. 5). This was carried out in two ways to give two related rather rigid new ligands (fig. 12), **FIG 12** each of which contained two β-diketonate domains that are capable of binding simultaneously to two copper ions. Taking the left hand side ligand shown in figure 12 and reacting two of these with two $Cu^{2+}$ ions, we would expect to generate a metal complex of the type shown in figure 13, in which each copper **FIG 13** center is surrounded by four oxygen atoms in a square planar array, although we were aware that the copper centers might also bind to one or two solvent molecules as additional ligands to become five- (or six-) coordinate, with such ligands being only weakly bound, and hence readily removed (for example, by heating the solid complex).

**FIG 11** Using copper ($Cu^{2+}$) ions to direct the formation of a molecular capsule

**FIG 12** Two related semi-rigid ligand types incorporating β-diketonate domains

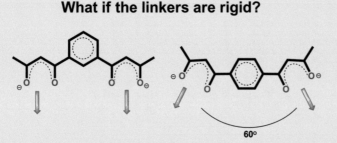

## What if the linkers are rigid?

60°

**FIG 13** The "blue print" for an assembled molecular platform incorporating two copper ions

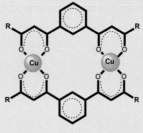

FIG 14 What was the result? Figure 14 shows the X-ray structure of the product displayed as a slightly modified stick representation.[2] The expected planar platform containing two $Cu^{2+}$ ions was generated; however, a solvent molecule (namely, a THF molecule – whose structure we need not worry about here) is weakly bound in an axial position on each copper center. As expected, these axial THF molecules are readily removed, and can be replaced by the somewhat stronger binding ligand, pyridine (see insert in fig.14) which binds to each copper center via its nitrogen atom. Establishing this was useful in terms of the experiment that followed: namely, an attempt was made to join two of the copper-containing platforms via linking molecules that connected each of the copper sites on one platform with the corresponding copper sites on the other.

FIG 15 The experiment succeeded with the aid of the two nitrogen-containing bridging molecules, known as dabco (see fig.15). The structure of the crystalline product is also given in figure 15.[3] In this new assembly, two dabco ligands link the platforms through pairs of copper centers and the arrangement resembles something like a turnstile (the dabco units could well be turning when the assembly is in solution but this was not established). Once again,

**FIG 14** The two copper-containing platform, showing a weakly bound solvent (THF) molecule bound to each copper center

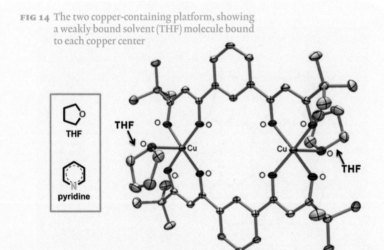

**FIG 15** Two linked platforms employing dabco as the linking molecules

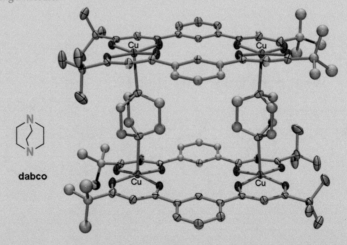

the example demonstrates that by following the rules, it becomes possible to design and build more elaborate molecular structures from simple metal ion and organic ligand building blocks.

Things get more interesting if we consider what might happen if we react this linked double $\beta$-diketonate ligand with a tri-charged metal ion such as $Fe^{3+}$. Now each metal center will want three negatively charged $\beta$-diketonate groups to surround it in an octahedral fashion. The simplest product, a triple helix, is what is obtained! The structure is shown in figure 16.[4] Being helical, FIG 16 it can exist in right handed and left handed forms and both occur in equal amounts alongside each other in the crystalline product. Thus, this small triple helix can be formed very simply by allowing the components to assemble in solution, and then letting the product crystallize. Of course, in no way does such a structure compare with Nature's double helix, but it might be seen as a most elementary start in that direction. It should be mentioned that other workers have now reported a considerable range of other synthetic double and triple helices of various lengths and elaboration.

Let us turn now to the other semi-rigid double $\beta$-diketonate ligand given in figure 12, right side. Lines drawn through the centers of the $\beta$-diketonate fragments are no longer parallel, but rather, meet at sixty degrees. This means that if one $Cu^{2+}$ ion interacts with two ligand molecules to achieve its favored square planar geometry, then, provided they do not point in opposing directions, the unbound portions of the ligands will be orientated mutually at sixty degrees to each other. They will be positioned such that the interaction

FIG 16 The structure of the triple helix held together by two iron ($Fe^{3+}$) ions

of two more $Cu^{2+}$ ions, together with a further ligand of the same type, will yield a triangular arrangement. The blueprint is given in figure 17. Again, such a structure is the simplest least-strained arrangement that "follows the rules" and, indeed, corresponds to what was obtained experimentally (see fig. 18).[5] In an extension of this study aimed at probing the generality of this reaction type, we expanded the size of the ligand by putting two benzene rings in the link between the β-diketonate groups, and used it in a similar reaction. As expected, this new ligand also underwent a similar assembly process with $Cu^{2+}$ (and also with the corresponding cobalt ion, $Co^{2+}$) to give a larger triangle whose inside area was now approximately double that of its smaller analog (see fig. 19).[6] The structure of the three-cobalt product was determined in this study.

FIG 17 

FIG 18

FIG 19

FIG 17 The blueprint for a triangular structure incorporating three copper ($Cu^{2+}$) ions.

FIG 18 The structure of the three copper–containing triangle obtained from an x-ray analysis

FIG 19 The x-ray determined structures of the small and large triangles. The green atoms in the small triangle correspond to copper while the mauve ones in the large triangle correspond to cobalt. Stick representations of the respective ligands are given below each corresponding triangle.

Can we link triangular structures of the above type in a manner related to that used for the two-copper platforms discussed earlier? By reacting the smaller three-copper structure with dabco, we found that we could.[7] On dissolving the triangle and adding dabco, a crystalline product was formed, and its structure proved to be a nice example of molecular architecture (fig. 20). FIG 20 This time, there was a difference in the way that dabco interacted with the copper centers; each $Cu^{2+}$ ion in the structure bonded to two dabco molecules – one above and one below the plane of the triangle – such that each copper was now six-coordinate. The result was that long towers – somewhat like mini Eiffel Towers – were produced. A great number of these towers were found to be arranged side-by-side in the crystal and their central channels, which contained some trapped solvent molecules, extended right through the crystal. Heating the crystals was found to drive out the trapped solvent molecules and yielded an unusual scaffold-like porous material. This is able to preferentially absorb other molecules into its channels – a potentially useful property for use in purifying or separating other molecular species of the right size and shape.

A further challenge was to react the above double $\beta$-diketonate ligand (in which the $\beta$-diketonate domains are orientated at sixty degrees to each other) with an "octahedral" metal ion. Again, we used $Fe^{3+}$.[8] Earlier research groups using different ligand-metal combinations had reported results that gave a clue that we might assemble a molecular tetrahedron with metal ions

**FIG 20** Stick representation of the rigid aromatic planar molecule benzene

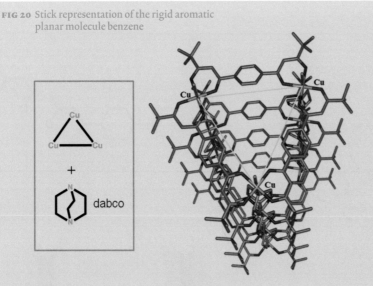

at its corners; in our case, such a structure would fall within the "rules" discussed earlier. A tetrahedron is exactly what we got (fig. 21). Thus, in contrast to square planar $Cu^{2+}$ (which gave a two-dimensional triangular structure), octahedral $Fe^{3+}$ generated a three-dimensional cage-like tetrahedral structure not unlike a small pyramid. We also made the corresponding larger tetrahedron, starting from the expanded double $\beta$-diketonate ligand used to prepare the larger triangle mentioned above (see fig. 19).[9] In this latter case, the volume of the internal cavity was increased some three-fold over that of the smaller tetrahedron. Other three-dimensional examples of this type have since been reported from different laboratories. After the passing of almost six thousand years since the first pyramids of our ancient ancestors were constructed, it has becoming increasingly possible for chemists to construct related structures at the molecular level.

We have also extended our studies to include the use of a related double triketonate of the type shown in figure 22.[10] This semi-rigid ligand, that carries four negative charges, was expected to bind to four metal ions – involving the three oxygens on each side of the benzene spacer unit that separates the triketonate groups. What happens if it is mixed with $Cu^{2+}$ ions? The rules we discussed still apply and indeed, in accord with them, three linked "boomerangs" are formed to give the beautiful structure shown in figure 23. Three of the six copper ions in this structure are in slightly different square planar environments; in other words, the environment of the "outer" copper centers differs from the "inner" ones. By repeating the experiment – this time adding equal amounts of copper ($Cu^{2+}$) and nickel ($Ni^{2+}$) to the reaction solution – it is possible to crystallize a corresponding (exotic) mixed-metal product in which three $Ni^{2+}$ ions are located in the outer positions, while three $Cu^{2+}$ ions occupy the inner sites (fig. 23). Again it is a striking structure

FIG 21 (margin note)
FIG 22 (margin note)
FIG 23 (margin note)

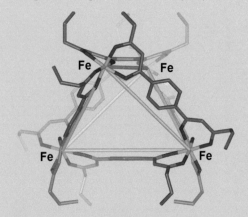

FIG 21 The tetrahedral structure that spontaneously self-assembles from six double $\beta$-diketonate ligands in the presence of four iron ($Fe^{3+}$) ions.

FIG 22 The double tri-ketonate ligand, with its four negatively charges, used to react with copper ($Cu^{2+}$) and nickel ($Ni^{2+}$) ions.

FIG 23 Two unusually shaped complexes formed from the double triketonate ligand with copper ($Cu^{2+}$) ions (left) and copper ($Cu^{2+}$) and nickel ($Ni^{2+}$) ions (right). The copper centers are shown in green, while those of nickel are plum-coloured.

whose unusual properties – yet to be fully explored – are of considerable intrinsic interest and give rise to a potentially useful new material.

A final study employs the different double β-diketonate ligand (shown in figure 24 that is related to the ones discussed earlier in this essay, see fig. 12). FIG 24 It differs in that the linking group between the β-diketonate domains is now flexible. When the flexibility of a ligand is increased, the possibility of it forming a larger range of potential product structures is opened up. We say that the ligand has more "degrees of freedom" – it can twist more readily to take up different arrangements around its bound metal ion. As before, we studied the interaction of this flexible ligand with iron ($Fe^{3+}$).[11] Initially, we obtained red crystals and, as expected, they corresponded to a helical structure of the general type discussed earlier. Three doubly charged ligands and two $Fe^{3+}$ ions assemble to give a triple helix, with both metal ions lying on the helical axis. In this cage-like, helical assembly the cavity inside the helix is filled with a solvent molecule (see fig. 24, left side).

If, on the other hand, we do not isolate the above assembly, but leave it in solution under suitable conditions, it rearranges into a new product slowly over a couple of months. That product, in turn, was isolated again as red crystals, which show different properties than those of the initial red crystals. The X-ray determination revealed the product to have a truly fascinating structure (see fig. 24, right side). It is a large assembly incorporating eight $Fe^{3+}$ metal ions and twelve ligands. Each ligand bears two negative charges, so collectively, the charges cancel. In this case twenty particles (eight metal ions and 12 ligands) come together slowly, but nevertheless spontaneously, to form the final product. The process can be likened to the pieces of a jigsaw puzzle assembling themselves to produce the whole picture!

FIG 24 Generation of a triple helix and a universal-3-ravel from reaction of iron ($Fe^{3+}$) ions with the flexible double β-diketonate ligand shown (see text)

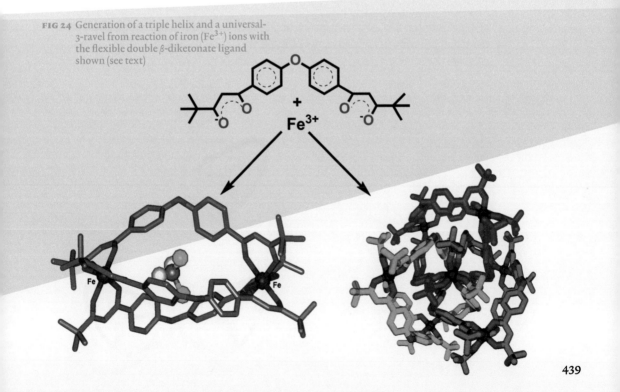

The individual assemblies arranged alongside each other in a crystal of the above product make an impressive repeating pattern, part of which (showing FIG 25 six adjacent assemblies) is reproduced in figure 25. Each individual assembly has an exotic, highly intertwined metallosupramolecular structure that is based on a universal 3-ravel motif – a previously unprecedented topology in supramolecular chemistry. The ravel terminology was only first proposed in 2008.[12] The ravel entanglement figure 24 (right side) may be considered as a type of "branched knot"; the strands are shown in different colors to help visualize how they intertwine. If we trace out the atom connectivity in the three FIG 26 strands, the fascinating universal-3-ravel motif can be seen clearly (fig. 26). The structure as presented in this illustration shows that the strands wind back in a three-bladed, propeller-shaped fashion so that a right-handed twist is present. However, equal numbers of both right- and left-handed structures, which are FIG 27 not superimposable, are formed alongside each other in the crystals (fig. 27).

We believe we understand what drives this stunning structure to take form. Aristotle said that nature abhors a vacuum, and in changing from the open football-shaped triple helical molecule initially formed (fig. 24) into the highly intertwined universal-3-ravel, the individual strands interact with one another and effectively fill the "internal" space. Such interactions help both to stabilize the structure and to aid its formation.

In short, the same elements of art, architecture, and engineering that have often been integral to the building of macrostructures also play a role in the construction of supramolecular structures. Although the scale of operation is enormously different, the opportunity to express creativity and to overcome challenge clearly exists in parallel in both spheres of human activity!

## Acknowledgement

The author thanks his co-workers and students, both past and present, for their contribution to the work presented in this chapter; their names are given in the listed references. He also thanks the ZKM | Center for Art and Media Karlsruhe for the invitation to participate in this project.

**FIG 25** This shows the symmetrical manner in which individual universal-3-ravel molecules pack together in a single crystal. This figure was obtained from an X-ray analysis study. Each blue sphere represents an iron ($Fe^{3+}$) center in the structure.

**FIG 26** The universal-3-ravel motif generated from the atom connectivity in the corresponding X-ray determined structure

**FIG 27** The different "hands" of the universal-3-ravel. These mirror images are not superimposable.

## Notes

1 David J. Bray, Bianca Antonioli, Jack K. Clegg, Karsten Gloe, Kerstin Gloe, Katrina A. Jolliffe, Leonard F. Lindoy, Gang Wei, and Marco Wenzel, "Assembly of a trinuclear metallo-capsule from a tripodal tris ($\beta$-diketone) derivative and copper(II)," in: *Dalton Transactions*, issue 13, RSC Publishing, Cambridge, 2008, pp. 1683–1685, doi: 10.1039/B717685F.

2 Jack K. Clegg, Leonard F. Lindoy, John C. McMurtrie, and David Schilter, "Dinuclear bis-$\beta$-diketonato ligand derivatives of iron(III) and copper(II) and use of the latter as components for the assembly of extended metallo-supramolecular structures," in: *Dalton Transactions*, issue 5, RSC Publishing, Cambridge, 2005, pp. 857–864, doi: 10.1039/B418870E .

3 Jack K. Clegg, Karsten Gloe, Michael J. Hayter, Olga Kataeva, Leonard F. Lindoy, Boujemaa Moubaraki, John C. McMurtrie, Keith S. Murray, and David Schilter, "New discrete and polymeric supramolecular architectures derived from dinuclear (bis-$\beta$-diketonato)copper(II) metallocycles," in: *Dalton Transactions*, issue 33, RSC Publishing, Cambridge, 2006, pp. 3977–3984, doi: 10.1039/B606523F.

4 Clegg, Lindoy, Mc Mutrie et al. 2005.

5 Jack K. Clegg, Leonard F. Lindoy, Boujemaa Moubaraki, Keith S. Murray, and John C. McMurtrie, "Triangles and tetrahedrons: metal directed self-assembly of metallo-supramolecular structures incorporating bis-$\beta$-diketonato ligands," in: *Dalton Transactions*, issue 16, RSC Publishing, Cambridge, 2004, pp. 2417–2423, doi: 10.1039/B403673E.

6 Jack K. Clegg, Simon S. Iremonger, Michael J. Hayter, Peter D. Southon, René B. Macquart, Martin B. Duriska, Paul Jensen, Peter Turner, Katrina A. Jolliffe, Cameron J. Kepert, George V. Meehan, and Leonard F. Lindoy, "Hierarchical Self-Assembly of a Chiral Metal-Organic Framework Displaying Pronounced Porosity," in: *Angewandte Chemie International Edition*, vol. 49, issue 6, Wiley-VCH, Weinheim, 2010, pp. 1075–1078, doi: 10.1002/ange.200905497.

7 Jack K. Clegg, Leonard F. Lindoy, John C. McMurtrie, and David Schilter, "Extended three-dimensional supramolecular architectures derived from trinuclear (bis-$\beta$-diketonato) copper(II) metallocycles," in: *Dalton Transactions*, issue 25, RSC Publishing, Cambridge, 2006, pp. 3114–3121, doi: 10.1039/B517274H.

8 Clegg, Lindoy, Moubaraki et al. 2004.

9 Jack K. Clegg, Feng Li, Katrina A. Jolliffe, George V. Meehan, and Leonard F. Lindoy, "An expanded neutral $M_4L_6$ cage that encapsulates four tetrahydrofuran molecules," in: *Chemical Communications*, vol. 47, issue 21, RSC Publishing, Cambridge, 2011, pp. 6042–6044, doi: 10.1039/C1CC11167A.

10 Feng Li, Jack K. Clegg, Paul Jensen, Keith Fisher, Leonard F. Lindoy, George V. Meehan, Boujemaa Moubaraki, and Keith S. Murray, "Predesigned Hexanuclear $Cu^{II}$ and $Cu^{II}/Ni^{II}$ Metallacycles Featuring Six-Node Metallacoronand Structural Motifs," in: *Angewandte Chemie International Edition*, vol. 48, issue 38, Wiley-VCH, Weinheim, 2009, pp. 7059–7063, doi: 10.1002/anie.200903185.

11 Feng Li, Jack K. Clegg, Leonard F. Lindoy, René B. Macquart, and George V. Meehan, "Metallosupramolecular self-assembly of a universal 3-ravel," in: *Nature Communications*, online journal, article number 205, February 22, 2011, doi: 10.1038/ncomms1208.

12 Toen Castle, Myfanwy E. Evans, and Stephen T. Hyde, "Ravels: knot-free but not free. Novel entanglements of graphs in 3-space," in: *New Journal of Chemistry*, vol. 32, issue 9, RSC Publishing, Cambridge, 2008, pp. 1484–1492, doi: 10.1039/B719665B.

*Splitting the Atom*
2000–2010, detail from the interactive installation
*Chemical Vision*

**DAVID CLARK** (*1963 in Calgary, CA) is a media artist interested in experimental narrative form and the cinematic use of the Internet. He has produced works for the Internet, narrative films, and gallery installations. Recent works include large-scale interactive narrative works for the web, such as *Sign After the X* (2010), an encyclopedic work about the letter X, and collaborative public media arts projects such as *Waterfall* (2010). Currently he is the Chair of Media Arts at Nova Scotia College of Art & Design (NSCAD University) in Halifax (CA) and is a researcher at the Cineflux Research group that is looking at questions of how cinematic form is changing with new technologies.

www.chemicalpictures.net

David Clark

G THE ATOM

## Chemical Vision
David Clark

Twenty years after his discovery of periodic law (1889), Dimitri Mendeleev's Faraday lecture before the Chemical Society in London included the following: "The law of periodicity first allowed us to perceive undiscovered elements at a distance which formerly was inaccessible to chemical vision."

If I am allowed to misunderstand Mendeleev's remarks, it is possible that he is suggesting such a thing as chemical vision. What a wonderful idea to think we could touch the world with our eyes, to know the world unencumbered by signs and representations, to know what the world really is, what substance it has, and what things really are. Mendeleev's great discovery, the periodic table, is a pinnacle of modernism. It sustains the atomist's hope that signs can be ascribed to all things; and those things, suspended in the proper order of differences and similarities, can be used as the building blocks of our picture of the world. Chemical atomism is perhaps the most pronounced of all the tendencies towards atomism that characterize modernism. But we live in a time after the atom has been split, when our sensorium is being ripped apart by the domination of physical senses and the suppression of the chemical senses. Logic is just another language game; the visual has become the virtual. We are rapidly losing our grasp of the real that has heretofore grounded our existence and knowledge of the world.

*Chemical Vision* is a large-scale, walk-through interactive installation that has resonances of a science museum. Architecturally, it is derived from the shape of the periodic table, or, more specifically, the Meyer table that has become synonymous with periodic law – an image which has become a meta-sign of the discipline of chemistry itself. In the installation, the viewer encounters enigmatic displays that reflect on vision, language, and the physical sciences: a Braille visual acuity chart constructed out of the chemical elements' abbreviations, a giant, motorized computer mouse on an Ouija board, also inscribed with the chemical elements. This museum doesn't explain, but shows us, the difficulties for art and science in the transition from the modernist world to our own. The mouse is a particular figure here; both the mouse that has lent itself to psychology experiments and the computer mouse that evokes an entire virtual world devoid of the chemical senses. What will be the progression of knowledge in this chemical-less dream world? What will become of mice and men?

*Chemical Vision* was first shown in an exhibition entitled *Scienced Fictions*, curated by Peter Dykhuis at the Art Gallery of Nova Scotia, in Halifax, Canada in 2000. It was exhibited again in the exhibition *Chemical Vision* at Museum London, Ontario (CA), in November of 2003, and in the exhibition *Chlorine Argon Potassium* at MICA Galleries, Baltimore (MD) in 2005.

*Braille*
2000–2010, detail from the interactive installation
*Chemical Vision*

top right
*Splitting the Ego*
2000–2010, detail from the
interactive installation *Chemical Vision*

bottom right
*Ouija Board*
2000–2010, detail from the
interactive installation *Chemical Vision*

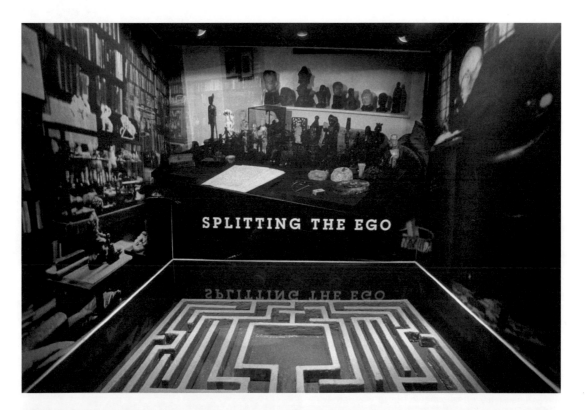

*Senza Titolo I (Crystal Growth)*
2012, 3-D animation, digital print on cotton, 50 × 28 cm

large image
*Crystal Growth I*
2012, 3-D animation, detail, digital print on cotton,
145 × 110 cm

*Crystal Growth* is a stereoscopic 3-D animation that envisions a path inside a cave where the formation and uncontrolled growth of crystals are visible. It is a work on the creative and destructive energy of Nature, on molecular aggregation, the transformation of forms and their recurrence from microcosm to macrocosm. In harmony with the process of crystallization, these mysterious three-dimensional presences give rise to the complex and unpredictable forms that elicit an archaic and primitive landscape.

The forms created and modelled in the digital 3-D images are inspired by nanomolecular images to which I attribute a new identity through a process of visual perception analysis. Each element is determined by means of a renewed perception: one can imagine a gram of matter containing the forms and energies of the universe. Stereoscopic 3-D vision dilates the enigmatic and ambiguous aspects of forms and confronts us with that disquieting aesthetic that threatens the coherence of our perceptual syntheses. It is a vision that invests the whole body of the viewer so as to allow for an immersive, emotional voyage through the universe, which appears in all its explosive energy.

**GIULIANA CUNÉAZ** (*1959 in Aosta, IT) lives and works in Aosta and Milan (IT). In her work she uses all media: from video installation to sculpture, from photography to painting, and even screen painting, in a technique of her own invention. In 2004, 3-D became an integral part of her work, forming an element of research for both video and for screen painting. Among other techniques, she used 3-D in *Quantum Vacuum* (2005) and *The God Particle* (2009). Among the numerous stereoscopic 3-D animations are *Matter Waves* (2010), *Mobilis in Mobili* (2011), and the *Zone fuori controllo* series (2012). Her work was exhibited at the Triennale di Milano in 2012.

www.giulianacuneaz.com

Giuliana Cunéaz

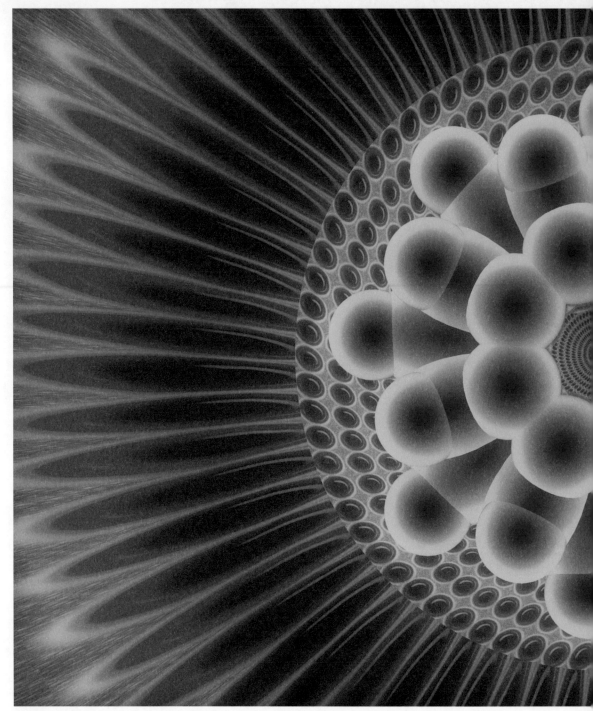

*The God Particle*
2009, 3-D animation, digital print on cotton,
270 × 150 cm

*A poet always sees the same thing, whether looking at it through a microscope or a telescope.*          Gaston Bachelard

*The God Particle* belongs to the screen paintings series – screens characterized by pictorial interventions. It mixes 3-D animation and painting on a 165.1 cm high-resolution plasma screen that poetically recapitulates the quest for the germinal element, the generator of all things. *The*

*God Particle* is the name Physics Nobel Prize winner Leon Max Lederman gave to the Higgs boson, the elementary particle that is believed to permeate the universe and endow all particles with mass. The work is inspired by recent experiments carried out at the CERN laboratory in Geneva, Switzerland, which sought to identify the engine of creation. Never before did a scientific study have so many theological implications. I wanted to mimic the proton explosion and the ensuing revelation of the bosons, because I believe that art retains a utopian and creative aspect that needs no experimental tests.

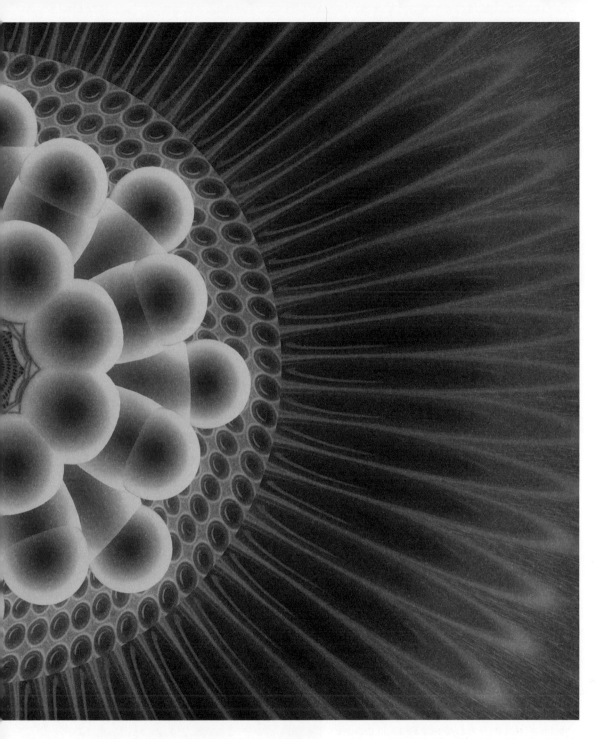

The God Particle embodies a problematic vision that oscillates in time where past and future seem to coexist. Since some of the images of the particle accelerator reminded me of an ancient mandala, I chose to work on this analogy. The mandala is perhaps the most ancient and universal symbolic emblem. For Buddhists, it represents the process of formation of the cosmos from its center. It is no accident, then, that the video, which represents an explosion, "happens" at the heart of a mandala painted directly on the screen using forms drawn from the realm of nanotechnology.

In this case, the painterly aspect creates a rather surprising dialogue with the animated 3-D forms. Even when the screen is turned off, the work changes its identity but retains a significant degree of painterly energy: the hundreds of painted images and symbols create a delicate, embroidered pattern across nearly the entire surface, turning the whole into something like an ancient tapestry.

iPhone with output monitor at Arecibo Radar
in Puerto Rico, November 1979

large image
900 tons Arecibo Radar dome (receiver) suspended
150 m above it's 305 m curved focusing dish,
a spherical reflector that is the largest on Earth
(Arecibo Observatory)

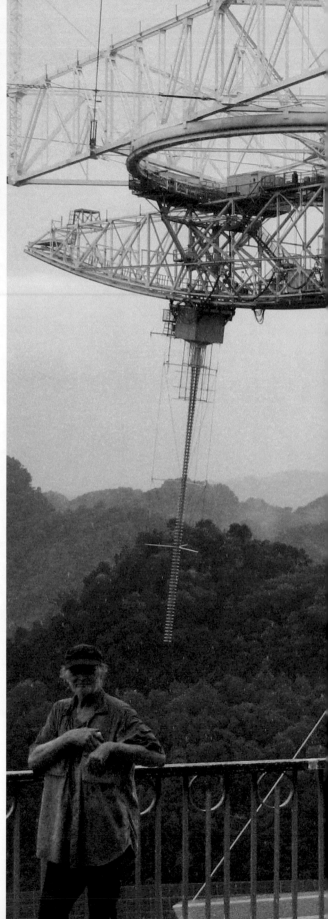

**JOE DAVIS** (*1950 in Wilmington, DE, US) is an artist and
a research affiliate in the Department of Biology at the
Massachusetts Institute of Technology in Cambridge
and at the Department of Genetics at Harvard Medical
School in Boston (MA). He received his BA in Creative
Arts from Mount Angel College (OR). His research covers
microscopy, molecular biology, microbiology, and bio-
informatics for the production of genetic databases and
new biological art forms. He helped to pioneer fields in
art and molecular biology and carried out several widely
recognized contributions to the search for extraterres-
trial intelligence. He also created works such as *Galaxy:
Earth Sphere* (1989), a landmark fountain on Cambridge's
Kendall Square.

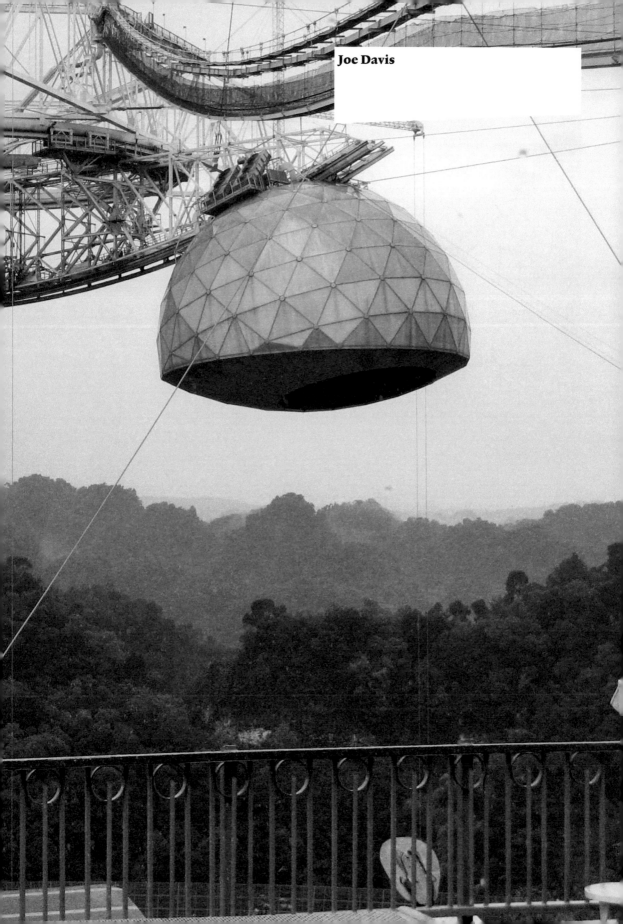

**Joe Davis**

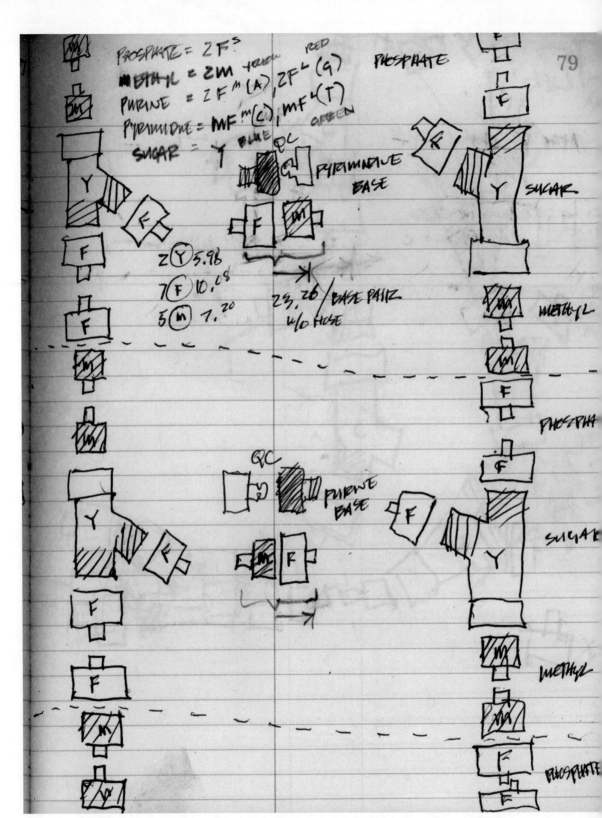

Page from one of Joe Davis' sketchbooks. The images show a drawing of DNA molecular model created with garden hose and garden hose connectors to teach DNA molecular structures to artists and children.

## Mnemosyne's Paradox
Joe Davis

*Of the female Titanes they say that Mnemosyne discovered the uses of the power of reason, and that she gave a designation to every object about us by means of the names which we use to express whatever we would and to hold conversation one with another... And to this goddess is also attributed the power to call things to memory and to remembrance (mneme) which men possess, and it is this power which gave her the name she received.*
Diodorus Siculus, Library of History 5.67.3

Mnemosyne, mythical daughter of Heaven and Earth, was the ancient Greek personification of memory, though no one can remember why. She was thought to be the original name-giver of all things, the inventor of all words. In the tradition of the Hellenistic pantheon, she was also the mother of the nine classical Muses and as such, mother of the arts and sciences. Her name is the Greek word for "memory" (Μνημοσυνη). She was responsible for all history, and although many ancient poets and philosophers referred to her, very little else is known about her. She was sometimes associated with a well or river from which one could drink perfect memory. As the mother of all words, it would be great to have her around right now. Some of us are having a hard time coming up with terms to describe what it is we do. The term "genetic art" is no good, since some of us do not carry on either classical genetics or the recombinant techniques of molecular biology – though perhaps all of us have been informed by these. Even the term "bio art" is problematic, because many of us are reluctant to be classified or aligned with what the popular press has repeatedly called a movement.

Artists working in broad areas of twenty-first century biology and life sciences have indeed made a few notable contributions to the arts and, perhaps somewhat less notably, to other fields. The world of molecular biology is anything but uniform. In the laboratory, one might normally expect to encounter specialists in microbiology and genetics, neuroscience, biochemistry, biophysics, medicine and physiology, crystallography, bioinformatics and computer science, and in fields surrounding scientific instrumentation and scientific imaging. Bioengineers, botanists, marine biologists, anthropologists, and population geneticists are also found in many laboratories. Most of these professionals routinely make significant contributions to the others. They work together in the laboratory and publish together in the literature. Some artists have formal relationships with laboratories in Australia and the United States and have had less formal, or temporary relationships with laboratories in Western Europe and elsewhere. It's probably safe to assume that the collaborative nature of these research environments has helped enable artists to find themselves working at laboratory benches. The early work of some of these artists is now increasingly recognized as having formed the basis for entirely new art forms. Along the way, artists have made some modest collateral contributions to science education, instrumentation, horticulture, and other fields. There has also been controversy over a few of artists' more fantastic claims and, in some cases, over alleged unethical activities.

Falsification or misrepresentation of data, plagiarism, and fraud are cardinal violations of principles of ethical conduct that are still widely observed among members of the international scientific community. The artist who publicly claims to have created something that someone else has created, or who claims to create something that has not actually been created at all, might continue to find success and support within the culture of critics and art curators. If however, such claims and self-promotions are based on dubious experimental results or on misrepresentations of collaborations with respected researchers, that artist will very likely find that her or his access to the laboratory and the scientific community has been seriously curtailed. Then again, hallowed and hopelessly outdated traditions hold that artists lack codes of ethical conduct to contend with anyway. We can forget for the moment that artists actually do complain occasionally about indiscretions such as forgery and plagiarism. Instead, "Artistic freedom!" is the battle cry, though it may eventually lead us into an interdisciplinary vacuum.

Even artists who legitimately work at the nanometer-scales of genes and molecules can expect certain, inevitable criticism. Problems arise from common sense, "gut reactions" to their infinitesimal constructions by a large cross-section of artists, arts professionals and the general public, all who have little or no scientific literacy. Many people are automatically confused.

The artist says, "Here is something never seen before or since. It is made with very pure substances that are smaller than the shortest wavelength of visible light. It cannot be directly resolved with even the most advanced of our imaging instruments. A suit of clothes tailored from these materials could only be detected by a highly select group of people who have special tool sets and skills. As it is, even these gifted few could not gaze directly upon it. Yet it is widely reported as undisputed fact. Here is an example of invisible art."

How can this be? Seeing is believing! If it is a fraud, we expect that when subjected to careful scrutiny, all fictions, fabrications of data, and fantastic stories will unravel systematically. The catch is that most critical observers can only suspect the truth. They can't actually know it. It is art and article of faith.

We are given to believe that all the pages of history are written in stone. Unfortunately, history may never be comprehensively recorded in the first place and memory is never lossless. The stones into which history is written are palimpsests, crossed out and remarked with endless retrospective interpretations and the indelible signatures of time and the elements. The long record of days is constantly re-imprinted, overlaid again and again.

We think we have witnessed a strange and wonderful thing, and it turns out to be nothing at all. The interval between what we remember and what we expect is tiny, massless and altogether variable. Time and space go on contracting and dilating ad infinitum. Even while the image of what we've seen still burns in conscious recollection, new truth is drawn from our appetites for belief

LB culture plates: part of a second set of Microvenus
cultures produced for DNA sequencing, 1992

– or omission – and hammered into place. Noble senti-
ments become indispensable frameworks for episodes
of "divine intervention." We need only dust off old para-
bles to cope with loose ends and contradictions.

We collate truth and new truth and give it a name. We
call it, "Yeti," "Nessie," "Flying Saucer," or, "Green Bunny."
We give the thing a real name and we think the thing it-
self is real. Names come to the lips of scholars and pious
amateurs who smile as they taste them, thinking that
they are known simply by their naming. We are highly
susceptible to suggestion.

Perhaps something very special happens. It has never
happened before. Looking at this new reality for the
first time, we are witnesses, but unable to tell others
what it is. Our companions are curious, and determined
to know what it is that we've seen. They make persistent
inquiries and so, we try to tell them.

Let's suppose that we have peered into the world's first
high-power microscope. We've seen bacteria for the first
time. Others want to know what's visible and so we try
to tell them: "Where unaided human eyes can see noth-
ing at all, there are miniscule transparent, gossamer
creatures like the wings of tiny insects. They are abun-
dant like fish in the sea, each one like a single drop of
rain, like beads of glass. There are so many of them it
is like seeing vast herds of buffalo on the prairie. They
abound in diverse forms. Some are cylinders. Some are
spheres. Some are helical like the threads of a screw.
Some swim like snakes. A few flutter like birds. Oth-
ers seem almost entirely sedentary and line up in long
strands like stalks of wheat."

Therefore our companions think bacteria are like wings
of insects and drops of rain. They think bacteria are
like herds of buffalo, like fish and snakes and birds and
stalks of wheat and threads of screws. They think bacte-
ria are like anything they're told is similar by someone
who has seen them, but none of them has seen bacteria
with his or her own eyes. They can't really know what
bacteria are. They can only know *of* them.

Before long, all manner of microscopes come into the
world. Soon almost anyone who wants to can lo-
cate a microscope and peer into the microcosm

to see it for themselves. They look at bacteria and see
that while they are like the wings of tiny insects, they
are not the wings of tiny insects. They see that while
they are abundant, like fish in the sea, they are not fish
in the sea. They see that while they are like drops of rain
and beads of glass, they are neither of those. They see
that while they are like snakes and birds, stalks of wheat
and threads of screws, they are not any of those things.
They see that bacteria are different from all of these
things apart, or all of these things together.

Eventually, they encounter someone who has not yet
peered into a microscope and they speak of bacteria.
Bacteria are both real and invisible, they say, but this
person – who has not seen them – doesn't understand.
So they, in turn, fall back on the names of the things
bacteria are like. They know from their own experience
that whatever explanations they can give will not be the
truth, but only part of it. They know that the person
who has never looked through a microscope will not
grasp reality from their words alone, even though all of
the words in the world are at their disposal.

In fact, to really know about bacteria, one must do much
more than merely peer at them through microscopes.
Much more powerful tools are needed. The rigorous stu-
dent will want to understand their activities and impact
in the environment, and want to learn how to identify,
select, and culture them. To know all about bacteria, one
would want to know what roles bacteria might play in
agriculture, medicine, infection, and disease. Someone
seeking this knowledge would want to know how bacte-
ria are used to elucidate molecular bases of heredity, me-
tabolism, and the origins of life. He or she would want
to know how bacterial genotypes and phenotypes are ad-
justed and manipulated. Details about cellular signaling,
membrane transport, vectors, introns, exons and RNAi,
promoters and origins of replication are all nested with-
in what there is to know about bacteria. This knowledge
means understanding transcription of nucleic acids and
translation, the synthesis of peptides and proteins, and
of the enzymes and biochemical operators that underlie
these processes. The study of bacteria is also a study of
many useful proteins that assemble into things such as

454

top
Davis' paintings of the 28-mer double-stranded Microvenus DNA molecule installed at an exhibition held at the Athens School of Fine Arts, 2006

bottom
*Bacterial Radio*
Installation view, *BioFiction* exhibition, Museum of Natural History, Vienna, 2011

nanoscale molecular motors and fluorescent markers. Bacteria can be assembled into macroscopic devices, too, to clean wastewater or produce electrical current. Perhaps most importantly, we have learned that a compact master plan for life itself is coded into substances found within each invisible bacterium, so now we want to acquire the tools and skills needed to resolve it, and find the wisdom needed to comprehend it.

We will have to learn all of this or remain forever ignorant. To peer through microscopes is not enough. The facts at hand are much too deeply invisible. The fabric of reality is much finer and far more intricate than the contexts of even the tiniest objects seen in the compass of a microscope objective. This search for reality is a search for invisibility within invisibility.

Human beings tend to forget reality and remember words instead. New vocabularies are invented and new definitions, entered into the dictionary. The more words whose definitions we can remember, the more clever and more highly esteemed we are thought to be. But the most clever among us does not regard the great transformations of the world without seeing them as they were seen when reality was seen for the first time.

The thing that has happened before is still happening now. It is still a miracle. The great mystery still hovers over the world. The objects and images in our galleries and museums, the results of all our experiments, our findings and observations, the wisdom and follies of our archons and scholars, all of our works of science and art, our great beacons of learning, the abstracts, catalogs and posters are but the cloak of our illusions. We think we know something and it is nothing. It is none of the things that we have ever named and it is all of them. It is like the wings of tiny insects, like glass beads and drops of rain. It is like herds of buffalo, like fish, and snakes, and birds, like stalks of wheat, and threads of screws. We are still struggling to find names for all the mysteries that trouble us. But the thing we have been searching for is still a secret. It is still invisible.

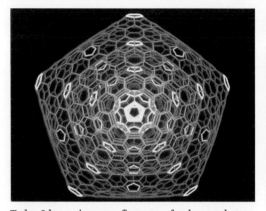

*Icosahedral Symmetry*: drawings from Richard Buckminster Fuller's patent application for *Geodesic Dome*, U.S. Patent 2, 682. 235 (1954) – top – intertwined carbon molecules in a *Hyperfullerene* (taken from F. Cure and R. E. Smalley 1991)

Today I have given you first some fundamental structural principles and subsequently shown you their use by nature. I didn't, however, start by studying these structures of nature seeking to understand their logic. The picture of the radiolarian has been available for 100 years, but I didn't happen to see it until after I had produced the geodesic structures from the mathematical sequence of developments which I reviewed for you earlier. In other words, I did not copy nature's structural patterns. I did not make arbitrary arrangements for superficial reasons. What really interests me therefore in all these recent geodesic tensegrity findings in nature is that they apparently confirm that I have found the coordinate mathematical system employed in nature's structuring. I began to explore structure and develop it in pure mathematical principle out of which the patterns emerged in pure principle, and developed themselves in pure principle. I then realized those developed structural principles as physical forms, and in due course applied them to practical tasks. The reappearance of these structures as recent scientists' findings at various levels of inquiry are pure coincidence – but excitingly validating coincidence.

Richard Buckminster Fuller,
*WDSD2: Mexico Lecture*, 1964, p. 59.

Richard Buckminster Fuller's modeling of linear structures was made current in 1991 with the discovery by S. Iijima of Nano Tubes made from carbon molecules. With Fullerenes and "Buckytubes," Fuller's geometry suddenly became a central component of the rapidly evolving field of Nano technology.

**RICHARD BUCKMINSTER FULLER** (*1895 in Milton, MA, †1983 in Los Angeles, CA) was an American systems theorist, architect, engineer, designer, inventor, and visionary. Rather than limiting himself to one field, Fuller worked as a *comprehensive anticipatory design scientist* to solve global problems affecting housing, transportation, education, energy, ecological destruction, and poverty. He also lectured at universities, including Harvard and MIT. Fuller held 25 patents, authored nearly 30 books, and received 47 honorary degrees. His most famous patent – the geodesic dome (awarded in 1954) – is a lightweight, cost-effective, and easy to assemble architectural structure that has been erected more than 300,000 times worldwide.

large image
Geometry Laboratory: Richard Buckminster Fuller with assistant fashioning a model at a studio in the Chicago Institute of Design, 1948.

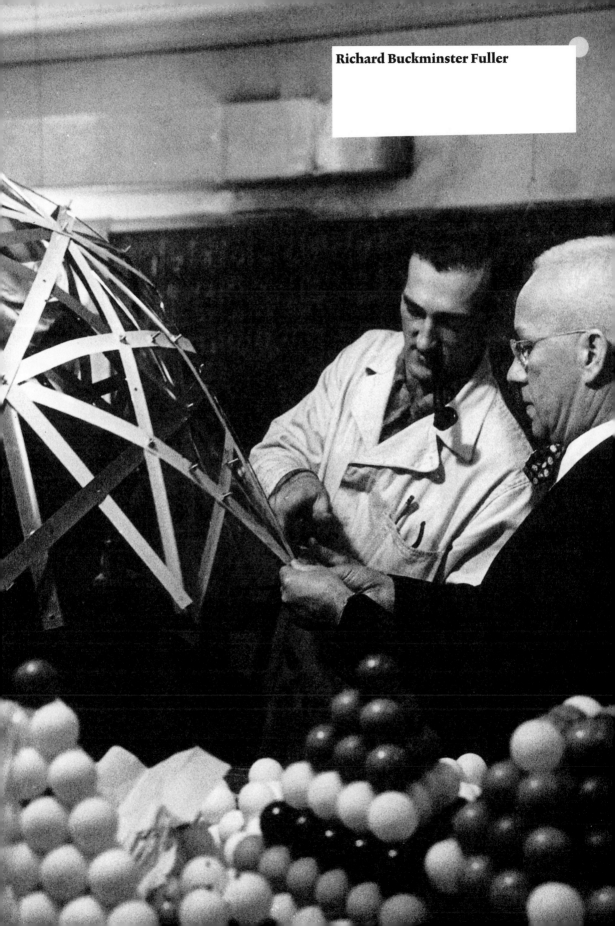

top right

Fuller's work emanated from a study of geometric principles, not from just copying forms from nature. Out of the sequencing of triangles and tetrahedrons, he came upon helix-cycles, each made of ten triple-bound tetrahedral cells. When turned in the same direction, they nest into each other, and tetra-helix cords formed of five-tetrahedron clusters are held together under tension around the transverse axis, but spring back apart from each other as soon as the tension ceases. In 1962, Fuller tried to use this to produce a geometric-theoretical explanation for the replication mechanism of DNA double-helix.

Richard Buckminster Fuller, 1948, sketch: sphere-packing as quantum model: numeric analysis of VE-growth in relation to light-quanta and gravitational-quanta

Richard Buckminster Fuller, 1948, sketch: nuclear growth of the Vector-Equilibrium

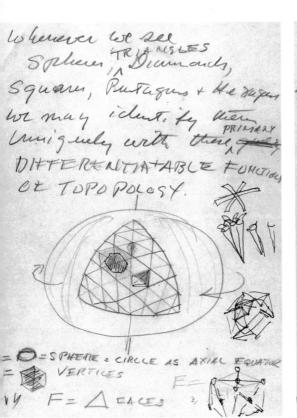

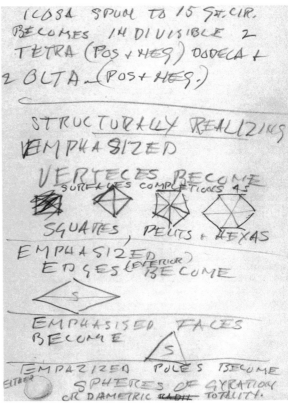

Pages from the manuscript *Noah's Ark 2*, January–July
1950: topology of vertex construction in squares,
pentagons, and hexagons

Generation of the various
facets of the *Geodesic Grid*

top right
*far_edge_elif*
2012, archival pigment print, 121.9 × 182.9 cm

bottom right
*slice_dynamic_grid_resolution*
2012, archival 3-D lenticular pigment print,
121.9 × 182.9 cm

Accelerating progress in nanometer-scale science and technology ever expands the toolkit with which we can develop molecular manufacturing. The ability to assemble things from-the-molecule-up could give rise to borderline, costless systems for controlling the structure of matter itself. To effectively foreshadow this age of nanofacture and hacking matter, Shane Hope uses molecular modeling research wares and crafts custom code to both practice generative molecular design and to algorithmically automate alternative representations of nanoscaled phenomena. Subsequently, Hope tinkers together thousands of these modded models into painterly monotype prints. The resulting "qubit built quilts" offer a visual analog to what the artist calls "technological singularity blindsightedness," meaning that the future's futures can't really be depicted.

**SHANE HOPE** (*1972 in Port Hueneme, CA) studied New Genres at the San Francisco Art Institute, Information Arts at San Francisco State University (CA), and attended the Skowhegan School of Painting and Sculpture in New York (NY). He received his MFA from the University of California San Diego, and thereafter joined UCLA's Department of Art as a research assistant in New Genres. Hope exhibited his work at Susanne Vielmetter Los Angeles Projects and Carmichael Gallery in Los Angeles, and participated in the 2009 Prague Biennale. He is represented by Winkleman Gallery in New York, and was featured in the Fall 2013 exhibition, *Dissident Futures* at the Yerba Buena Center for the Arts in San Francisco.

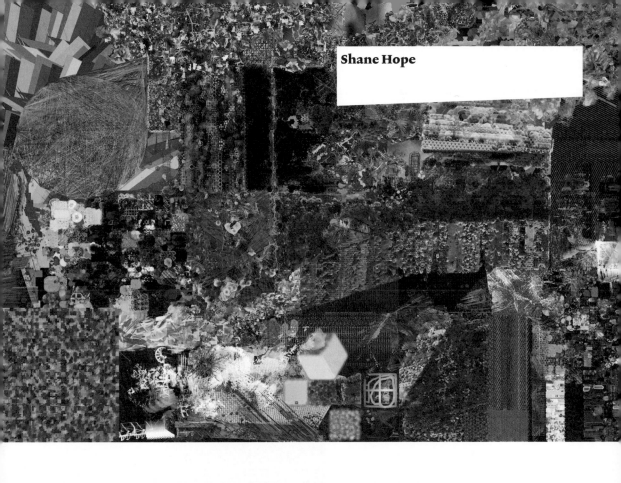

Shane Hope

large image and next page
*DNA Montgelas Park*
2013, 0.4 × 32 m, partially mirrored, engraved glass with
vitreous enamel and LED light, Montgelas Park, Munich

**ANDREAS HORLITZ** (*1955 in Bad Pyrmont, DE) stud-
ied photography and visual communication in Essen
(DE) with Otto Steinert and Erich vom Endt. This was
followed by residencies abroad and scholarly collabora-
tions and lectureships in Essen, Trier, and Cologne (DE).
From 1983 Horlitz focused on experimental photogra-
phy and, from 1987, worked with light boxes and instal-
lations. From 1995, he developed concepts for site-spe-
cific projects; works using glass, reflection, and light for
private collections, businesses, institutions, and church-
es. Andreas Horlitz has exhibited extensively in galler-
ies and museums. Publications on his work include the
books *Arbeiten / Works* (2005) and *Equilibrium* (2011).

www.andreas-horlitz.de

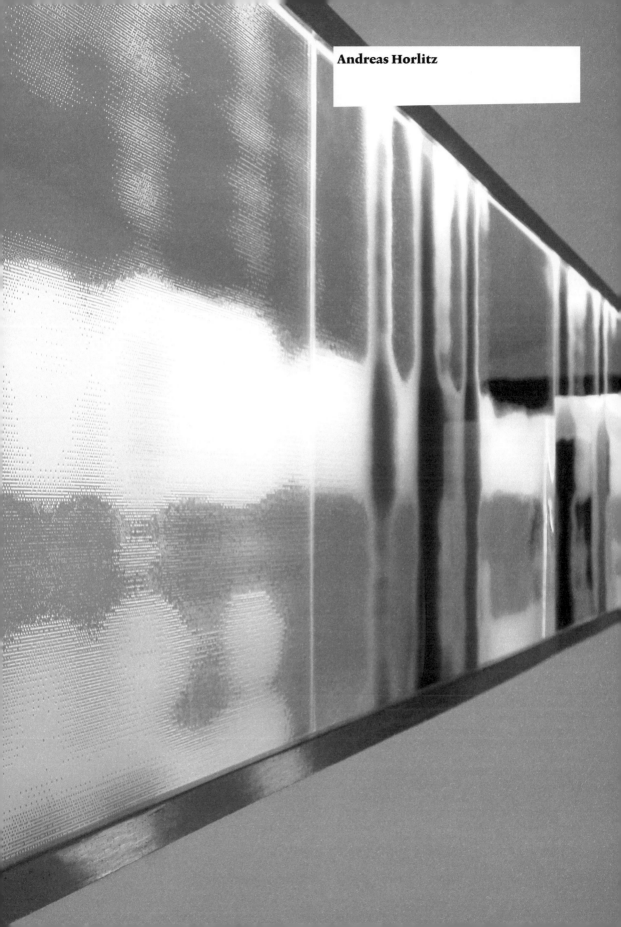

Andreas Horlitz

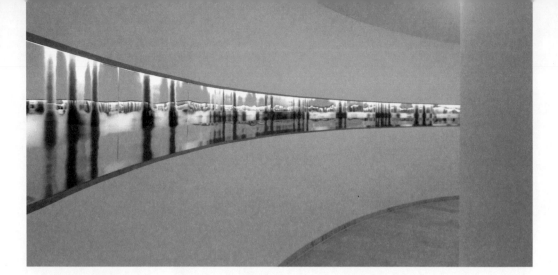

**DNA Montgelas Park**

*DNA Montgelas Park* (2013) is an installation inside an apartment building of the Montgelas Park residential and office complex, a project of Frankonia Bau GmbH in the Alt-Bogenhausen district of Munich (DE).

The 32 m-long passage that connects the underground garage with the staircase of the Montgelas Park residential building has a 40 cm-high frieze by Andreas Horlitz embedded in one wall. Running the length of the passage at eye-level, the frieze accompanies the passers-by along their way. Illuminated by LEDs, the partially mirrored, engraved, and colored glass of the frieze reflects the space and the viewer. A partially mirrored and engraved piece of glass showing an abstract motif of the Montgelas Park complex measuring 2 × 1.2 m is installed opposite the frieze at the entrance to the subterranean garage.

In this architecturally related work, Horlitz focuses on the building's immediate environment and the history of the site where the central reference point is nature, specifically the large population of trees in the park of the *Bundesfinanzhof* [Federal Fiscal Court] opposite the residential building. The frieze features representations of genetic sequences of several trees from the park. The abstract, scientific motif that results prompts associations with rhythms and sequences, and viewed from different angles, the light and glass installation always appears different and new.

The frieze's representations of DNA are based on the sequencing of samples taken from different trees by the artist. He collected leaves from various tree species (hornbeam, maple, cherry, chestnut, yew, and Norway maple), which were processed by a laboratory specializing in tree morphology. The trees' DNA was isolated and visualized by gel electrophoresis. The experts at the laboratory for tree pathology described the process as follows[1]:

"Using a Qiagen[2] plant kit we extracted chloroplast[3] DNA. During the PCR[4] a certain region of the chloroplast-DNA (trnl-trnf) was then duplicated. Through each use of different primers during PCR, two pieces of the trn of differing lengths were[5] amplified: a shorter piece (trnl 5' – trnl 3'), and longer piece (trnl – trnf). In order to generate as many tapes[6] as possible, the two PCR products of each sample were digested with a restriction enzyme (Hinfl)[7] at 37°C. The parts of each of the PCR products thus generated were separated in an agarose gel[8] and photographically documented under UV light."

Text by Carolin Reimann, Studio Andreas Horlitz

**Notes**

**1** Dr. S. D. Ferner's office for tree pathology in Freiburg did the analysis. This excerpt from the unpublished expertise dated June 8, 2012, was translated from the German by Justin Morris.

**2** Qiagen plant kit: Qiagen is a provider of sample and assay technologies for molecular diagnostics, applied testing, academic and pharmaceutical research; the extraction and purification of genetic information from plants and fungi.

**3** Chloroplasts: chloroplasts (from the classical Greek χλωρός chlōrós "green" and πλαστός plastós "formed") are organelles found in plant cells whose main function is photosynthesis.

**4** PCR: Polymerase chain reaction (PCR) is a biochemical technology to amplify a single or a few copies of a piece of DNA across several orders of magnitude, generating thousands to millions of copies of a particular DNA sequence. To this end an enzyme is used, DNApolymerase.

**5** Trn: Is the name of the duplicated region on the extracted chloroplasts' DNA.

**6** Tapes: the tapes contain the respective DNA fragments of the same length. Short pieces run at a faster rate in the gel matrix because they are smaller. Larger fragments, by contrast, run at a slower rate. Thus, among other things, it is possible to determine where the restriction enzymes have cut, and approximately how large the single fragments are.

**7** Restriction enzymes: Restriction enzymes, or restriction endonuclease (REN), are enzymes that cut DNA at certain positions. Each restriction endonuclease recognizes a specific recognition nucleotide sequence known as a restriction site, and then cleaves the DNA at that point.

**8** Agarose gel: Agarose gel electrophoresis is used to separate and analyze macromolecules (DNA, RNA, and proteins) and their fragments.

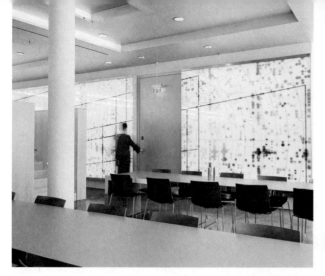

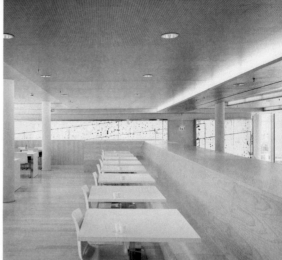

both images
*Simulacrum*
2006, 3–5 × 12 m, installation with engraved,
partially mirrored and printed glass, and LED light,
E.ON Energie AG, Munich

## Making the World Invisible Visible
The Role of Sciences, Signs and Life in
Andreas Horlitz's In Situ Works

In the large in situ mirror and glass work *Simulacrum* (2006), which is located in the canteen of the E.ON Energie AG in Munich, four approaches to reality are superimposed upon each other: the schematic representations of elementary particles and Maxwellian electromagnetic waves (iconic signs), and the microarrays of genetic data and the dot system of the Milky Way (indices). These signs of natural phenomena, which cannot be seen with the naked eye, merge in a blurred image thanks to the blending of light, reflection, transparency, and mattina. The systems that the artist extracted from the original materials are distinguishable only upon closer scrutiny: the quarks' blue-grey lineament, which increases dynamically from left to right, the dot pattern of the two Maxwellian magnetic fields, and the spiral-shaped Milky Way with its constellations to which the artist added circles and squares. The fourth and final pictorial layer, the microarray's spot system, is spread across the entire expanse. The warm colors of the canteen's interior decoration contrast with the cool impression of the milky sheets of glass. A parallel world of pixelated measurement data and abstracted and decontextualized images of reality interact with the large room and the bright light shining through the windows. It is a place where energetic moments of micro and macrostructures, invisible and visible phenomena, and signs and realities merge.

In the mural *Simulacrum*, Horlitz applied the new DNA analysis procedure with microarrays for the first time. This approach can be seen as a further development of the DNA works that he has been creating since 1997 (both in situ works and separate objects). The earlier works are based on the older method of sequencing in which DNA segments are separated in a polyacrylamide gel and analyzed by means of autoradiography. The early indexical in situ work *Text DNA 1997*, which consists of ribbon-like DNA sequences on mirror glass, is to be seen as an important precursor.

Text by Yvonne Ziegler originally published in: Burkhard Leismann and Verena Titze (eds.), *Andreas Horlitz. Equilibrium*, Hirmer Verlag, Munich, 2011, pp. 70–110, esp. pp. 70–72.

465

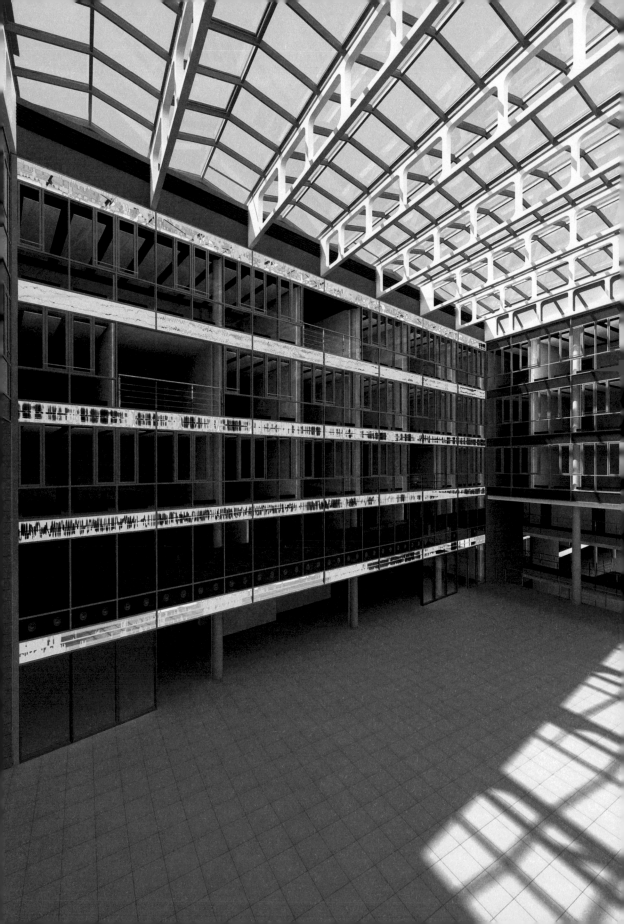

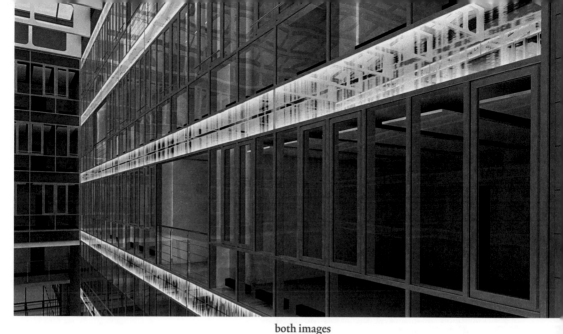

both images
*Genesis*
2003, je 0.6 × 32 m, installation, neon light and partially mirrored glass, European Patent Office, Munich

## Between Representation and Abstraction – *Genesis*

In a way, Andreas Horlitz's ideas for an integrative installation for the atrium in the new European Patent Office in Munich (DE) represent the quintessence of his previous work and designs in a scientific context. The concept for the in situ project with the title *Genesis* (2003) is based on five different scientific kinds of measurement:

genetics          DNA sequencing
neurology       brainwaves (eye activity)
astronomy      star spectra
geology           seismograms
chronobiology  actimetry

Three of these disciplines are directly related to human beings. The areas with which Horlitz was preoccupied in earlier works – including genetics, chronobiology, and astronomy – have now been extended by two further fields of activity: neurology and geology. Here, too, data can be obtained by means of electronic measurements; and as in the other scientific disciplines, the information is recorded in encoded form in distinct abstract patterns on paper. In a scientific context, these are used for analytical purposes; but Horlitz exploits them as abstract visual motifs.

The installation for the European Patent Office was conceived as an integral part of the interior design of the building. The proposals foresee applying the five motifs to the partly reflecting and engraved laminated safety glass balustrades around the four-story-high covered atrium. The glazing elements are 60 cm high and 3.9 m wide. One scientific text is allotted to each story. During the day, the glass strips will reflect the internal space and the people moving about within it. In the evening, light will shine through the glazing, making the visual motifs and the messages they convey stand out and accentuate the space. The simultaneous presence of the five different subjects (which draw attention to the responsibilities of the European Patent Office), the links that exist between them, and their possible interaction are also themes of the installation.[1] The many levels of knowledge and the way they flow together in this institution are interpreted through the design concept (which is related to the architecture) and through the linking of the various storys. Although it was not possible to implement this project, its conception exists and marks a further important step in Andreas Horlitz's artistic development.

A critical examination of images drawn from the natural sciences and the world of technology stimulated Horlitz to move away from traditional depictive photography and to turn to a special kind of representation in the form of pictograms. As such, his works possess an autonomous visual quality that goes beyond the encoded information they contain. The main aspect lies not in recognizing the motifs and deciphering the scientific information, but in the many insights that can be gained through the study and analysis of abstract patterns. The partly reflecting and engraved panes of glass used as a medium play an important role in this respect. The fact that the mirrored areas contain encoded scientific measurements in the form of abstract patterns and that they also reflect the images of observers means that these works are located somewhere between representation and abstraction, between concrete information and the world of mental concepts. They function, therefore, on various planes of perception. Therein lies their special attraction and also their complexity.

Text by Irene Netta originally published in: *Andrea Horlitz. Arbeiten/Works*, Verlag für moderne Kunst, Nuremberg, 2005, pp. 104–146, esp. pp. 136–140.

**1** The project dated March 18, 2003.

467

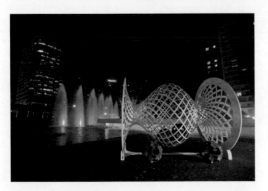

*Self-Assembly Line*
2012, polyethylene, aluminum, polyurethane, magnets, 2.1 m × 2.1 m × 3 m, exhibited on the occasion of the TED Conference, Long Beach, 2012

The Installation *Self-Assembly Line – From Order to Chaos* was first exhibited at the TED Conference in Long Beach, CA in February 2012. Subsequently, it was installed at The Scripps Research Institute in La Jolla (CA) at the entrance to the Molecular Biology Building.

**SKYLAR TIBBITS** (\*1985 in Laguna Beach, CA) is a trained architect and computer scientist whose research focuses on self-assembly and programmable material technologies for the built-environment. He was recently awarded a 2012 TED Senior Fellowship, had a 2011 TED Fellowship, and was named a revolutionary mind in the design issue of *SEED* Magazine (2008). Previously, he has worked at a number of design offices including Zaha Hadid Architects, Asymptote Architecture, SKIII Space Variations, and Point b Design. Tibbits has designed, collaborated, and built large-scale installations around the world. He has exhibited at the Guggenheim Museum New York (NY), the Beijing Biennale (CN) and lectured at the MIND08 conference, presented by the Museum of Modern Art (NY) and the SEED Media Group in 2008. Tibbits is the director of the Self-Assembly Lab at MIT and the founder of a multidisciplinary research based practice, SJET LLC. He is also a faculty member of MIT's Department of Architecture, teaching Masters and Undergraduate level Design Studios and co-teaching the course How to Make (Almost) Anything at MIT's Media Lab.

**ARTHUR OLSON** (\*1946 in Detroit, MI) is a structural molecular biologist and Professor at The Scripps Research Institute, La Jolla (CA). Trained as a crystallographer, he was part of the team at the Harvard University that determined the first atomic resolution structure of an intact viral capsid. He founded the Molecular Graphics Laboratory at The Scripps Research Institute, where, for over thirty years, his group has developed and applied computing to visualize, simulate, and analyze biomolecular interactions. His lab's AutoDock program, used for drug design, is the most highly cited molecular docking code. Olson directs a consortium of six institutions studying the evolution of HIV drug resistance. His FightAIDS@HOME project runs on over two million CPUs (central processing units) in IBM's World Community Grid. Olson's visualizations and animations have reached a broad audience through venues such as the Disney Epcot center, public television, and art and science museums around the world. His latest work in visualization focuses on tangible human interfaces for research and education in molecular biology utilizing 3-D printing and augmented reality.

www.selfassemblylab.net
http://mgl.scripps.edu

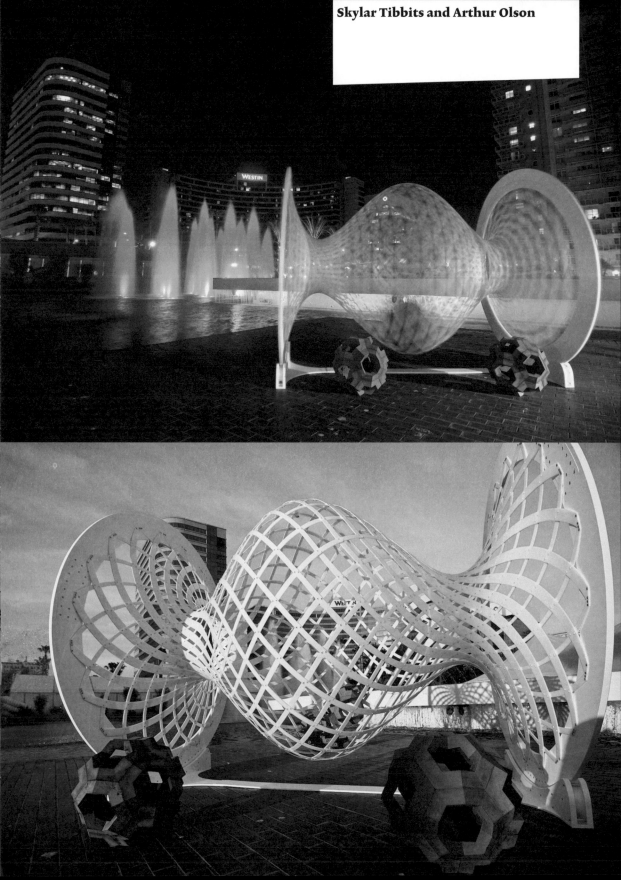

**Skylar Tibbits and Arthur Olson**

## Stochastic Self-Assembly of
## Human-Scale Virus Modules

The *Self-Assembly Line* presents a large-scale version of self-assembly virus modules as a user-interactive and performative structure. This is an installation that builds installations, where people engage the assembly process by rotating the enclosure, changing the speed or direction, and adding parts to influence the performance of self-assembly at the macro-scale.

## Background

Self-assembly is a fundamental process in building the structures of life and arises at all levels of organization – from the molecule to the ecosystem. *Self-Assembly Line – from Chaos to Order* was generated as a human-scale expression of this fundamental process, inspired by the study of the icosahedral virus structure and the process of its formation.

Nature implemented the symmetry of the icosahedron eons before the insights of Archimedes or Buckminster Fuller. This shape has the geometric symmetry to provide a highly parsimonious way to protect small stretches of self-replicating viral genetic material as it passes from host to host. The viral genes code for the minimal number of different protein molecules needed to ensure the viral life cycle in the context of host organisms. By using many copies of the same protein molecule, encoded by only a single gene, a protective spherical shell can self-assemble to encapsulate the DNA or RNA that defines those proteins. Evolution has selected the molecular shapes and interactions that enable this process. In 1977, Arthur Olson was part of the Harvard University team that used x-ray crystallography to solve the first atomic resolution structure of an intact icosahedral viral capsid. As Buckminster Fuller learned, icosahedral symmetry enables identical structural units and interactions to form the largest closed container from a given amount of material. Understanding virus architecture and knowing the molecular structure of the basic molecular units that form its capsid has lead to an understanding of how a virus can assemble itself.

Olson's visualization efforts at The Scripps Research Institute, along with the development of 3-D solid printing technology, led him to create physical models and use their tangibility to convey the nature of structural molecular biology. In this work, he developed a number of tangible molecular models that illustrate emergent molecular properties, including a human scale physical model of the protein subunits that form viral capsids. By mimicking the electrostatic charge complementarities of the viral protein subunits using the polar interaction of magnets, he was able to demonstrate the complete assembly of a full icosahedral viral capsid model by randomly shaking the individual units in a closed container (ref. Olson et. al., PNAS, vol. 104, no. 52, 2007). In 2011, Skylar Tibbits, an architect and designer at MIT who was interested in the concept of self-assembling structures on an architectural scale, and who had developed some self-folding structures himself, became aware of Olson's viral self-assembly model.

In discussion they decided to collaborate to produce a large sculptural scale installation that embodied the process of self-assembly in a kinetic installation that engages people in the physical interaction with the installation. The goals of the piece spanned between science, architecture, and art.

## Science Goals

The installation presents, at the architectural-scale, biomimetic processes that span from molecules to organisms. Making these processes explicit in a large-scale, dynamic, aesthetic context provides a universally accessible demonstration of phenomena that are usually hidden from common experience. The underlying mechanisms that promote self-assembly and the generation of structural complexity from stochastic input are fundamental to our understanding of living systems. Experiencing the dynamics of such mechanisms provides the conceptual scaffolding for understanding scientific ideas that range from thermodynamics to evolution, without necessarily framing it in those terms. The installation itself demonstrates how such concepts can be adapted to uses that encompass human ingenuity and expression.

## Architectural Goals

Architecturally, this system relates to aggregate construction scenarios and materials. Aggregates consist of loose-fill arrangements of materials that are contained with boundary conditions and auto-orient themselves based on size, external conditions, and structural forces. This scenario proposes a large-scale application of aggregate materials outside the scale of material properties and into the realm of construction methodologies. This installation proposes an alternate view on aggregates as a method for constructing large structures with programmed modules and stochastic energy input. More broadly, this approaches the scenario of self-assembly as a vision for constructing large-scale geometry as opposed to most current endeavors at micro and molecular scale-lengths. Self-assembly as a construction method relies on discrete and programmable components, simple construction and design sequences, energy input, and structural redundancy – fundamental elements that are demonstrated in the proposed installation.

## Art and Design Goals

This installation demonstrates the intersection of macro and micro worlds, as well as translation from molecular and synthetic phenomena to large-scale physical implementation. We aim to fuse the worlds of design, computation, and biological processes through a process of scaling up. While implementing the known structure of molecular systems, this installation also proposes the implementation of design and engineering to natural phenomena as a hybrid system. Part scientific research, part design speculation – we are neither restricted to the exact specifications of the biological realm, nor the limitlessness of the design world. The two can speak to each other while forming an interactive discovery of blown-up biological principles. Patterns emerge from within the interaction of the parts, and unknown formations or hierarchies are developed through explicit programmability and simple energy input.

## Take and Shake –
## Biomimetic Self-Assembly

Based upon the self-assembling virus models developed by Arthur Olson, an interactive display was commissioned by Autodesk for the TED Global Conference in Edinburgh, Scotland in July 2012, and a somewhat revised version recapitulated at Autodesk University Expo in Las Vegas (NV) in November 2012. The latter version is now on display at the Autodesk Gallery in San Francisco (CA).

The TED Global display consisted of a dozen chemical flasks, each containing one of three different self-assembling molecular models: Satellite Tobacco Necrosis Virus, Ferritin, and Catachol-dioxygenase, each with a different symmetry (icosahedral, octahedral, and tetrahedral, respectively). Each flask had a tag that briefly described the molecular function of the assembly. Additionally, each model was produced in three different colors (white, black, and red), to enable demonstration of the combinatorics of assembly. Attendees were encouraged to shake the flasks and observe the process of self-assembly within the three different models.

The Autodesk University Expo installation used a similar format, but the small flasks contained models of the icosahedral polio virus. In a larger flask, two different models of the virus were displayed; one was constructed as the mirror image of the other by reversing the magnet polarities on the assembly units. The two different models were also given two different colors. This enabled the demonstration of "chiral separation," where the two differently colored types of model units were shaken together in the same flask and, as assembly took place, two uniformly colored intact capsids emerged. The complexity of the combinatorics of the assembly was also illustrated, showing that the 12 pieces of the model could assemble in about 1,000,000,000,000,000 different ways.

http://bioselfassembly.net

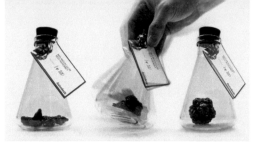

*Take and Shake*
2012, cast urethane resin, magnets, glass, rubber, paper, each flask 15.2 × 7.6 × 7.6 cm, exhibited at the TED Global Conference, Edinburgh, 2012

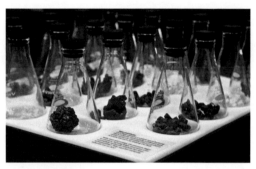

*Take and Shake*
2012, cast urethane resin, magnets, glass, rubber, each flask 15.2 × 7.6 × 7.6 cm, exhibited at the TED Global Conference, Edinburgh, 2012

*Viral Assembly Combinatorics*
2012, ink-jet print on paper, 21.6 × 27.9 cm, TED University

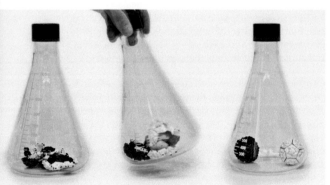

*Self-Assembly and Chiral Separation,*
2012, cast urethane resin, magnets, glass, rubber, 30.5 cm × 12.7 cm × 12.7 cm, exhibited at the Autodesk University Expo, Las Vegas, 2012

# Authors
Biographies

**ÉRIC ALLIEZ** (*1957, FR) is a French philosopher and currently professor at the Centre for Research in Modern European Philosophy (CRMEP), Kingston University, London and at the University Paris 8. He wrote his dissertation with Gilles Deleuze as advisor. Alliez was Directeur de programme at the Collège international de philosophie in Paris (1984–1986 and 1992–1998), Professor of Aesthetics at the chair of Aesthetics and the Sociology of Art at the Academy of Fine Arts Vienna (2000–2003), and from 2002 to 2003 associate research director at the École des hautes études en sciences sociales in Paris. Éric Alliez has worked as a visiting professor in Rio de Janeiro (BR), Warwick (UK), Vienna, London, and Karlsruhe (DE). He is a member of the editorial board of the journal *Multitudes* and editor of the works of Gabriel Tarde.

**THIERRY DELATOUR** is assistant professor in physical chemistry at the Université de Lorraine in Nancy (FR). He specializes in optical spectrometries and has done research on structures and stabilities of photolabile molecules, such as pigments implied in the primary mechanism of vision, organic dyes for analytical chemistry, and extraction of metallic ions. His interest in the practice of sound synthesis led him into research on the duality between spectra and waveforms for the acoustic conversion of microscopic vibrational phenomena. His publications include the essay "Molecular Music: The Acoustic Conversion of Molecular Vibrational Spectra," in *Computer Music Journal*.

**ERIC FRANCŒUR** is a historian and sociologist of science who specializes on issues of visualization and representation in science. He earned his Ph.D. in 1998 at McGill University in Montreal (CA). His work has focused particularly on the history of molecular modeling in chemistry and molecular biology. He was a research fellow at the Center for the Sociology of Innovation at MINES ParisTech, Paris, and at the Max-Planck Institute for the History of Science, Berlin. He is currently a senior lecturer at the École de technologie supérieure in Montreal.

**LJILJANA FRUK** (*1975, HR) studied chemistry at the University of Zagreb, and completed her studies in 1999. Having received the Overseas Research Award and University of Strathclyde Scholarship, she continued to pursue her Ph.D. at the University of Strathclyde in Glasgow (UK), where she worked on the development of advanced spectroscopic tools for DNA detection. In 2004 she was awarded both the Humboldt Fellowship and the Marie Curie International Incoming Fellowship to conduct postdoctoral research on DNA bionanotechnology and the design of artificial enzyme catalysts with Prof. Dr. Niemeyer at the Technical University Dortmund (DE). Since 2009, she has been a research group leader and lecturer in nanobiology at the Karlsruhe Institute of Technology (KIT), DFG-Center for Functional Nanostructures (DE). Her team works on the development of novel, photosensitive bio-nano hybrid systems for use in the design of new catalysts for nanomedical applications.

**WOLFGANG M. HECKL** (*1958, DE) studied physics at the Technical University Munich (DE). After obtaining his Ph.D. in biophysics, he continued his postdoctoral work at the University of Toronto (CA) and then at IBM with Nobel Prize laureate G. Binnig. In 1993, he was appointed professor for experimental physics after habilitation with Nobel Prize winner T. Hänsch at the Ludwig Maximilian University of Munich. Prof. Dr. Heckl became Director General of the Deutsches Museum [German Museum] in Munich in 2004. Since 2009, he has held the Oskar von Miller Chair of Science Communication at the Technical University Munich, both at its School of Education and in the Physics Department. He is active in various scientific associations, including the Deutsche Physikalische Gesellschaft [German Physical Society], the Excellence Cluster NanoInitiativeMünchen (NIM), and the Center for NanoScience (CeNS). Among his honors received are the EU René Descartes Prize for Science Communication, the Philip-Morris Research Award, and the Communicator Prize awarded by the Stifterverband für die Deutsche Wissenschaft. In 2008, he received the Order of Merit of Germany. Since 2007, he has been nanotechnology spokesman at the National Academy of Technical Sciences (acatech) and since 2012, Chairman of the Board of the Max-Planck-Institute for the Science of Light. The founder of the Open Science Lab at the Deutsches Museum, he also promotes cross-disciplinary science communication through his *Science & Art* painting. In August 2013 Hanser published Heckl's book *Die Kultur der Reparatur.*

**ROALD HOFFMANN** (*1937, PL) is a chemist and writer. He took his Ph.D. in 1962 at Harvard University (MA) and continued there as a junior fellow in the Society of Fellows from 1962 to 1965. Since then, he has been at Cornell University (NY), where he is the Frank H.T. Rhodes Professor of Humane Letters Emeritus. He has received numerous honors, including over 25 honorary degrees. He is the only person ever to have received the American Chemical Society's awards in three different specific subfields of chemistry – the A. C. Cope Award in Organic Chemistry, the Award in Inorganic Chemistry, and the Pimentel Award in Chemical Education. In 1981, he shared the Nobel Prize in Chemistry with Kenichi Fukui for applying the theories of quantum mechanics from the field of physics to explain chemical reactions and chemical compounds. His numerous publications include more than five hundred scientific articles, books (*Chemistry Imagined*, 1993, with artist Vivian Torrence; *The Same and Not the Same*, 1995; *Old Wine, New Flasks: Reflections on Science and Jewish Tradition*, 1997, with Shira Leibowitz Schmidt), collections of poems (*The Metamict State*, 1987; *Gaps and Verges*, 1990; *Memory Effects*, 1999; *Soliton*, 2002; *Catalísta*, 2002), plays (*Oxygen*, 2001, with Carl Djerassi; *Should've*, 2006; *We Have Something That Belongs to You*, 2009). Hoffmann also participated in the production of a television course about chemistry, *The World of Chemistry*. Since 2001, Hoffmann has been the host of a monthly series at New York City's Cornelia Street Café called *Entertaining Science*, which explores the juncture between the science and performance.
www.roaldhoffmann.com

**SIR HAROLD W. KROTO** (*1939, UK) is the Francis Eppes Professor of Chemistry at Florida State University, Talahassee (FL), and holds an emeritus professorship at the University of Sussex (UK). He obtained his Ph.D. in 1964 at the University of Sheffield (UK). In 1996, he was knighted for his contributions to chemistry and later that year, together with Robert Curl and Richard Smalley, he received the Nobel Prize for Chemistry for the discovery of C60 Buckminsterfullerene, a new form of carbon. He has won several scientific and education awards, such as the Royal Society of Chemistry Longstaff Medal in 1993, and the Faraday Award 2001. He has published over three hundred scientific papers. He founded Vega Website (www.vega.org.uk) which streams educational science programs, and also initiated the Global Educational Outreach for Science Engineering and Technology (GEOSET), available online at www.geoset.info.
www.kroto.info/index.html

**PIERRE LASZLO** (*1938, DZ) is emeritus professor of chemistry at the École polytechnique in Palaiseau (FR) and at the University of Liège in Belgium. He received a D.Sc. from the Sorbonne in 1965 (Paris), having done research at Princeton University (NJ) as a postdoctoral associate. He returned to Princeton as an as-

sistant professor from 1966 to 1970. Author of more than two hundred primary publications in the field of organic chemistry and of ten scientific monographs, he also has written a number of books for the general public, such as *Drôle de chimie* (2011), *Les odeurs nous parlent-elles* (2003), *Citrus: a history* (2007), *Pourquoi la mer est-elle bleue?* (2002), *Peut-on boire l'eau du robinet?* (2002), and *Salt: Grain of life* (2001). A scientist and a writer, his current interests combine history of chemistry and science writing. Pierre Laszlo has received many awards, including, in 1981, the prize of the French Academy of Sciences in honor of the French scientists killed by the Nazis during 1940–1944, and the Prix Maurice Pérouse from the Fondation de France in 1999 in recognition of his work as a science popularizer. www.pierrelaszlo.com

**LEONARD F. LINDOY** is emeritus professor of inorganic chemistry at the University of Sydney and conjoint professor at James Cook University in Queensland (AU), working in the field of supramolecular chemistry and macrocyclic chemistry. He graduated from the University of New South Wales (AU) with a Ph.D. in 1968 and D.Sc. in 1985. In 1993, he was elected a Fellow of the Australian Academy of Science and a Senior Member of Robinson College, Cambridge (UK). In 2006, he was appointed to a guest professorship at East China University of Science and Technology in Shanghai and awarded honorary professorships at Guizhou Normal University and Guizhou University (CN). He holds honorary doctorates from the Universities of Edinburgh (UK) and Wollongong (AU) and has received numerous awards, including the Centenary Prize of the Royal Society of Chemistry (UK) in 2009.

**ROBERT E. MULVEY** (*1959, UK) is head of inorganic chemistry at the Department of Pure and Applied Chemistry at the University of Strathclyde, Glasgow (UK). He earned his Ph.D. in 1984 at Strathclyde and spent two years as a postdoctorial researcher at the University of Durham (UK). His research interest lies in the field of alkali-metal organometallic chemistry. In 1989, he received the Royal Society of Chemistry Meldola Medal and in 2001, the Royal Society of Chemistry Award and Medal in Main Group Element Chemistry. In 2009, he was awarded the Royal Society Wolfson Research Merit Award. He is a fellow of both the Royal Society of Edinburgh and Royal Society of Chemistry, and a member of the American Chemical Society.

**ROBERT ROOT-BERNSTEIN** (*1973) is a scientist, humanist, and artist. He earned his BA in biochemistry and Ph.D. in history of science from Princeton University (NJ) and is currently professor of physiology at Michigan State University (MI), where he studies the evolution of metabolic control systems, autoimmune diseases, drug development, and the creative process in the sciences and arts. He was a postdoctoral Fellow in Theories of Biology at the Salk Institute for Biological Studies from 1981 to 1983 and a MacArthur Fellow from 1981 to 1986. He is an editor of *Leonardo, journal of the International Society for the Arts, Sciences and Technology* and writes a blog on creativity called *Imagine That* (available online at: www.psychologytoday.com/blog/imagine). In 2011, he exhibited an installation called *Origins of Life: Experiment #1.4* in Vienna together with the transmedia artist Adam Brown. His publications include *Discovering* (Harvard University Press, Cambridge, MA, 1989) and *Sparks of Genius* (Houghton Mifflin, Boston, MA, 1999). www.msu.edu/~rootbern/rootbern/Welcome.html

**HERMANN J. ROTH** (*1929, DE) is professor emeritus of pharmaceutical and medical chemistry at the University of Tübingen (DE). He received his Ph.D. from the University of Würzburg (DE) in 1956. From 1966 to 1983 he was director of the Pharmaceutical Institute of the University of Bonn (DE), from 1978 to 1981 president of the German Pharmaceutical Society, and from 1984 to 1994 ordinary professor for pharmaceutical chemistry and director of the Pharmaceutical Institute of the University of Tübingen. In 1999, he was awarded an honorary doctorate by the Benemérita Universidad Autónoma de Puebla (MX). Since 1972, he also has been working in the area of painting and graphic art, with a particular interest in visualizing the molecular aesthetics, symmetry, and chirality of chemical compounds. www.h-roth-kunst.com

**JOACHIM SCHUMMER** is a philosopher, chemist, and sociologist. He obtained his Ph.D. in philosophy from the University of Karlsruhe (DE) in 1994. Since 1995, he has been the editor-in-chief of HYLE: International Journal for Philosophy of Chemistry. He has taught at various universities, including the Universidade Federal do Rio de Janeiro (BR), University of Santo Tomas (Manila), Universität Bielefeld (DE), Universidad de los Andes, Bogotá (CO), and the University of South Carolina. His research covers the history and philosophy of science, nanotechnology, empirical studies of science, ethics, and aesthetics. His recent book publications include: *Das Gotteshandwerk: Die künstliche Herstellung von Leben im Labor* (Suhrkamp, Frankfurt a. M., 2011), *Nanotechnologie: Spiele mit Grenzen* (Suhrkamp, Frankfurt a. M., 2009), *The Public Image of Chemistry* (World Scientific, Singapore, 2007, edited with Bernadette Bensaude-Vincent and Brigitte Van Tiggelen), *Nanotechnology Challenges: Implications for Philosophy, Ethics and Society* (World Scientific, Singapore, 2006, edited with Alfred Nordmann and Astrid Schwarz), *Aesthetics and Visualization in Chemistry* (HYLE special issue, 2003, edited with Tami Spector).
www.joachimschummer.net

**TAMI I. SPECTOR** is a professor of organic chemistry at the University of San Francisco (CA). Trained as a physical organic chemist, her scientific work has focused on fluorocarbons, strained ring organics, and the molecular dynamics and free energy calculations of biomolecules. She also has a strong interest in aesthetics and chemistry, and has published and presented work on molecular and nanoaesthetics, the visual image of chemistry, and the relationship between chemistry and contemporary visual art. She is on the governing and editorial boards of Leonardo/ISAST, co-hosts the San Francisco based Leonardo Arts Science Evening Rendezvous (LASERs), and serves as the co-editor of an ongoing special section *Art and Atoms* for *Leonardo* journal.

**CHRIS TOUMEY** is a cultural anthropologist who works in the anthropology of science. He received his Ph.D. from the University of North Carolina in 1987, and is currently a research professor at the University of South Carolina's NanoCenter. His focus since 2003 has been on societal and cultural issues in nanotechnology, including narratives of the origins of nanotechnology, the question of democratizing nanotech, and problems and solutions regarding images of nanoscale objects. His current research concerns religious reactions to nanotechnology. His publications include *Conjuring Science: Scientific Symbols and Cultural Meanings in American Life* (Rutgers University Press, New Brunswick, 1996) and he regularly contributes to the journal *Nature Nanotechnology*.
www.christoumey.org

**PETER WEIBEL** (*1944) studied literature, medicine, logic, philosophy, and film in Paris and Vienna and is Chairman and CEO of the ZKM | Center for Art and Media Karlsruhe (DE). Since 1984, he has been a professor at the University of Applied Arts Vienna. From 1984 to 1989 he was head of the digital arts laboratory at the Media Department of New York State University in Buffalo (NY), and in 1989 he founded the Institute of New Media at the Städelschule in Frankfurt (DE), which he directed until 1995. Between 1986 and 1995, he had charge of the Ars Electronica in Linz (AT). He commissioned the Austrian pavilions at the Venice Biennale from 1993 to 1999 (IT). In 2007, he received an honorary doctorate from the University of Art and Design Helsinki, and in 2008, he was the artistic director of the Biennial of Seville (ES). From 2009 to 2012 he was a visiting professor at the University of New South Wales in Sydney. In 2011, he served as the artistic director of the Fourth Moscow Bienniale of Contemporary Art. He has also received numerous awards, including the French Order *Officier dans l'Ordre des Arts et des Lettres* [Order of Arts and Literature] in 2008, and the *Österreichisches Ehrenkreuz für Wissenschaft und Kunst 1. Klasse* [Austrian Cross of Honour for Science and Art, First Class] in 2010.
www.peter-weibel.at

## The Symposium

ZKM | Center for Art and Media Karlsruhe
July 15–17, 2011

PROJECT MANAGEMENT Peter Weibel, Ljiljana Fruk, Sophie-Charlotte Thieroff
ASSISTANCE PROJECT MANAGEMENT Maja Petrović
EVENT MANAGEMENT Monika Weimer, Hartmut Bruckner, Manuel Weber
VIDEO DOCUMENTATION Christina Zartmann, Evi Kontogeorgou
WEBSITE Lisa Naujack, Silke Altvater
PUBLIC RELATIONS Dominika Szope, Denise Rothdiener
MARKETING Stephanie Hock, Linda Mann

## The Installation
### *Molecules that Changed the World*

ZKM | Center for Art and Media Karlsruhe
July 15 – September 4, 2011 and June 19 – August 11, 2013

CONCEPTUAL DESIGN Ljiljana Fruk, Bernd Lintermann
ASSISTANT CONCEPTUAL DESIGN (KIT) Ishtiaq Ahmed, Dennis Bauer, Sinem Engin, Bianca Geiseler, Dania Kendziora, Marko Miljevic, Andre Petershans, Lukas Stolzer
PRODUCTION ZKM | Center for Visual Media
PROJECT COORDINATION Sophie-Charlotte Thieroff
ASSISTANCE Maja Petrović
SOFTWARE Bernd Lintermann
TECHNICAL SERVICES Manfred Hauffen
GRAPHICS Christina Zartmann

IN COOPERATION WITH

FINANCED BY

476

## The Book

| | |
|---|---|
| EDITORS | Peter Weibel, Ljiljana Fruk |
| SCIENTIFIC RESEARCH | Sophie-Charlotte Thieroff |
| EDITORIAL STAFF | Miriam Stürner, Jens Lutz (editors) |
| | Sophie-Charlotte Thieroff, Luise Pilz, Martina Hofmann (assistant editors) |
| IMAGE RESEARCH AND ASSISTANCE | Maja Petrović |
| COPYEDITING | Sarah Batschelet |
| TRANSLATIONS | Jeremy Gaines, Andrew Goffey |
| DESIGN | Andreas Koch, Büro für Film und Gestaltung, Berlin with Till Sperrle |
| LITHOGRAPHY | Büro für Film und Gestaltung, Berlin, Henrik Strömberg, COMYK Roland Merz, Karlsruhe |
| 3D-MOLECULES AND QR-CODES | Bernd Lintermann, ZKM | Institute for Visual Media |
| PRINTED AND BOUND | E&B engelhardt und bauer, Karlsruhe |
| PAPER | Fly Design, extra white, 115 g/m2 |
| THIS BOOK WAS SET IN | Lexicon |
| THANKS TO | Caroline Jansky, Maraike Steding, Moritz Büchner, Silke Altvater, Gloria Custance, Anna Kohlhauser |

| | |
|---|---|
| PRINTED AND BOUND | in Germany |
| ISBN | 978-0-262-01878-4 |
| LIBRARY OF CONGRESS CONTROL NUMBER | 2012954122 |

FOUNDERS

Baden-Württemberg
MINISTERIUM FÜR WISSENSCHAFT, FORSCHUNG UND KUNST

# Photo Credits

**PHOTO** ©

4–26, 84, 375 ZKM | Karlsruhe 49 Julian Voss-Andreae 52 (left) Published in: Pankaj Dhonukshe and Theodorus W. J. Gadella Jr., "Alteration of Microtubule Dynamic Instability during Preprophase Band Formation Revealed by Yellow Fluorescent Protein–CLIP170 Microtubule Plus-End Labeling," in: *The Plant Cell*, vol. 15, March 2003, pp. 597–611 55 Herbert W. Franke, first published in: Herbert W. Franke, *Magie der Moleküle*, Brockhaus, Wiesbaden, 1958 55 (fig. 18) Reprinted with permission from the American Association for the Advancement of Science, first published in: "X-ray Analysis of Hemoglobin," in: *Science*, vol. 140, no. 3569, May 1963, pp. 863–869, © 1963 AAAS 56f. Festival Pattern Group 58f. Council of Industrial Design / University of Brighton Design Archives 61 Astrid Visser 62, 461 Shane Hope 62 (fig. 26) Winkleman Gallery, New York 64, 66 From: Robert E. L. Masters, Jean Houston, *Psychedelische Kunst*, Droemer Knaur, München/Zürich, 1969 65 (left) From: Christoph Grunenberg (ed.), *Summer of Love. Art of the Psychedelic Era*, Tate Publishing, London, 2005 65 (right) intermediafoundation.org 68 (bottom) KAGE MIKROFOTOGRAFIE 69 Michael Badura 70 (left) Adapted by permission from Macmillan Publishers Ltd, first published in: Francis Crick, James D. Watson, "Molecular Structure of Nucleic Acids: A Structure for Deoxyribose Nucleic Acid," in *Nature*, vol. 171, 1953, pp. 737–738 70 (right) Wellcome Library, London 71 Hermann Josef Roth 72f. Courtesy Petra Maitz 80–82 Ingeborg Lommatzsch, Berlin 90–93 HA Schult 94f. Dieter Roth Estate Courtesy Hauser & Wirth 96f. Courtesy Black Box Gallery, Copenhagen 98 Collection Weisman Art Museum, Minneapolis 99 (top) Collection Monique Pignet 100 (top) Collection Parco d'Arte Vivente – Centro d'Arte Contemporanea, Torino 100 (bottom) Collection Valerio Ferrari 101 Collection Instituto Valenciano de Arte Moderno – IVAM 142–145 Blair Bradshaw 147–149 Steve Miller 150 Collection Hirshhorn Museum and Sculpture Garden, Washington D.C. 151 Courtesy Marlborough Gallery, New York 152 Columbus Museum of Art, Columbus 153 Collection of the City of Baltimore 158–164 Julian Voss-Andreae 158 Collection of The Linus Pauling Center for Science, Peace, and Health 162 (right) Collection of Shari and Alan Newman, Lake Oswego, OR 163 (left) Collection of Roderick MacKinnon, Rockefeller

University, New York City, NY 164 Collection of The Scripps Research Institute, FL 170 Iqbal Aalam 171 (top) CCS – Center for Computational Science, Department of Physics & Astronomy 171 (middle) Major Pepperidge 172 (fig. 7) Daniel Ugarte 172 (fig. 8) Mordkovich and Endo 176 Archives Pierre Soulages 176 (bottom) Collection Essl 177 (top left) Jialin Sun 177 (bottom left) David H. Gracias, first published in: Zhiyong Gu, Hongke Ye, and David H. Gracias, "The Bonding of Nanowire Assemblies Using Adhesive and Solder," in: *JOM*, vol. 57, no. 12, December 2005, pp. 60–64 177 (right) Joseph Yeager, Department of Chemistry, University of Wisconsin 179 (bottom) Matt H. Wade 189 David S. Goodsell, first published in: David S. Goodsell, *The Machinery of Life*, 2nd edition, Copernicus Books, Springer Science+Business Media, New York, 2009, fig. 6.9, with kind permission of Springer Science+Business Media 190–193 Antony Gormley 201 Reprinted with permission from *Journal of the American Chemical Society*, © 2009 American Chemical Society 202 Reprinted with permission from *The Journal of Organic Chemistry*, © 2007 American Chemical Society 205 (top) Reprinted with permission from the National Academy of Sciences, first published in: Roland Krämer, Jean-Marie Lehn, and Annie Marquis-Rigault, "Self-recognition in helicate self-assembly: Spontaneous formation of helical metal complexes from mixtures of ligands and metal ions," in: *Proceedings of the National Academy of Science of the United States of America*, vol. 90, pp. 5394–5398, June 1993, here: p. 5395, © 1993 National Academy of Sciences, USA 205 (middle) Reprinted with permission from the American Association for the Advancement of Science, first published in: Hendrik Dietz, Shawn M. Douglas, and William M. Shih, "Folding DNA into Twisted and Curved Nanoscale Shapes," in: *Science*, vol. 325, no. 5941, 2009, pp. 725–730, © 2009 AAAS 205 (bottom), 405 (bottom), 406 Adapted by permission from Macmillan Publishers Ltd, first published in: Ebbe S. Andersen, Mingdong Dong, Morten M. Nielsen, Kasper Jahn, Ramesh Subramani et al., "Self-assembly of a Nanoscale DNA Box with a Controllable Lid," in: *Nature*, vol. 459, 2009, pp. 73–76, © 2009 207 Reprinted with permission from the American Chemical Society, first published in: Tao Ye, Ajeet S. Kumar, Sourav Saha, Tomohide Takami, Tony J. Huang, J. Fraser Stoddart, and Paul S. Weiss, "Changing Stations in Single Bistable Rotaxane Molecules under Electrochemical Control," in: *ACS Nano*, vol. 4, no. 7, 2010, pp. 3697–3701. © 2010 American Chemical Society 208 Reprinted with permission from Macmillan Publishers Ltd, first published in: J. G. Hou et al., "Surface Science: Topology of Two-dimensional C60 Domains," in: *Nature*, vol. 409, January 8, 2001, pp. 304–305, © 2001 214–218 Joachim Schummer 224 Musée national du Moyen Âge – RMN 225 American Association for the Advancement of Science (Image originally created by IBM Corporation) 230 Legacy of Lillie P. Bliss, Museum of Modern Art, New York 231 (top) Marc Welland 232 3rdTech, Inc. 238f., 241 The Walter and Eliza Hall Institute of Medical Research 240 Drew Berry / Touch Press LLP 240 (bottom) E. O. Wilson Biodiversity Foundation, 2012 242–245 Courtesy Morgan Lehman Gallery, New York 258–261 Jon McCormack 266, 268, 270 (top left), 271, 272 (left), 277, 279 Robert Root-Bernstein 2012 267 Materialscientist, Wikimedia Commons 270 (middle left) Reproduced with permission of Edmund Scientifics 270 (middle right) Courtesy The Estate of R. Buckminster Fuller 270 (bottom left) Graham Colm, Wikimedia Commons 270 (bottom right) Dmitry D. Zaitsev, Ilya N. Ioffe, Wikimedia Commons 271 Collection: Frederich Meijer Gardens and Sculpture Park, Grand Rapids Michigan 272 (right) University of Glasgow Archive Services, Stoddard-Templeton collection, GB0248 STOD/201/2/15/1/1 273 (top left) Yale Collection of German Literature, Beinecke Rare Book and Manuscript Library, Yale University 274 (left) Generated by *CrystalMaker®*, a crystal and molecular structures program for Mac and Windows, CrystalMaker Software Ltd, Oxford, England (www.crystalmaker.com) 275 (right) The M. C. Escher Company, Netherlands, 2012, all rights reserved, www.mcescher.com 276 Reproduced with permission of Nadrian Seeman 284 The Metropolitan Museum of Art/Art Resource, NY 286 Private Collection 287 (top left) Courtesy of Roberto Bertoia 287 (bottom left) Reprinted with permission from the American Association for the Advancement of Science, first published in: Kelly S. Chichak et al., "Molecular Borromean Rings," in: *Science*, vol. 304, no. 5675, 2004, pp. 1308–1312, © 2004 AAAS 287 (right) Courtesy of Jun Isezaki 288 Illustration adapted from: K. C. Nicolaou and T. Montagnon, *Molecules that Changed the World*, Wiley-VCH, Berlin, 2008